Werner Haftmann    Painting in the Twentieth Century    Volume One

# Werner Haftmann

# Painting in the Twentieth Century

Frederick A. Praeger, *Publishers*

New York

Translated by Ralph Manheim

Copyright 1960 by Percy Lund, Humphries and Company Limited, London
*All rights reserved*
Library of Congress catalog card number 60-16468

BOOKS THAT MATTER
Published in the United States of America in 1960
by Frederick A. Praeger, Inc., Publishers
64 University Place, New York 3, N.Y.

This is a completely revised version of the German editions
published in 1954-1955 and 1957 by Prestel Verlag, Munich.
Printed in West Germany.

# Contents

5,451

To Eva-Maria Czakó

*Preface*

The original German text of this book was written between 1950 and 1953. Volume I was published in the autumn of 1954 and Volume II a year later, by Prestel-Verlag in Munich. In 1957 a second edition appeared, with few changes.

The work has been considerably expanded and modified for its publication in English. Unlike the original work, which dealt almost exclusively with the European continent and above all with France, Germany, and Italy, where the foundations of modern painting were laid, the present revised edition takes account of developments in England and the United States. Up to 1940 these developments, significant as they were, made little difference to the over-all picture. Since the Second World War, however, the contribution of England and America has not only been extremely important in itself, but has exerted an enormous influence on the art of the European continent. To disregard it would be to distort the whole picture of present-day art. Accordingly, I have been able in the first four books of Volume I to retain the general plan of the original edition, contenting myself with a few insertions and additions on the history of English and American art. But in connection with the developments since 1945, the necessary additions and changes proved to be so far-reaching that Book V of this edition may be regarded as a new product.

For similar reasons, in Volume II it has been possible, for the most part, to retain the original plates with few changes, but in the last chapter, devoted to present-day art, a considerable number of paintings by English and American artists have been added.

In the course of my work on the most recent period, it became clear to me that in a book of the present dimensions an exact chronological account of the varied and complicated developments of the last twenty years would be highly confusing and would seriously disturb the inner balance of the whole work. Consequently, I have broken down the enormous material according to the problems with which the artists were concerned.

I have been able to broaden my knowledge of American painting in the course of two protracted visits to the United States, in 1957 and 1959. In 1959 I had an opportunity to study, in particular, the rich material available in the library of the Museum of Modern Art in New York. I am deeply indebted to the entire staff of this unique institution, and above all to Mr. Alfred H. Barr, Jr., director of the museum, and to Mr. Bernard Karpel, curator of the library. In the course of a long stay in London in the winter of 1959 I was able to round out my material in the photographic collection of the British Council and in the library of the Tate Gallery. I am indebted to Mrs. Lilian Sommerville and her colleagues at the British Council and to Dr. Ronald Alley and Mr. Dennis Farr of the Tate Gallery for their kind assistance.

I wish to give special thanks to Mr. Ralph Manheim for his translation of the present work and for valuable advice. I am greatly obliged to Dr. Bruno Schindler and Mr. John Taylor of Lund Humphries, London, for their work in connection with the preparation and production of these volumes.

A gratifyingly large number of works have been devoted in recent years to the art of the twentieth century. Nevertheless a new attempt at a comprehensive survey hardly needs special justification. The justification lies in the magnitude and the vital importance of the subject itself, which cannot be illumined too much or from too many different points of view. For the profoundly revolutionary developments in painting, which set in about 1890, cannot be viewed apart from modern mankind as a whole, whose situation they illustrate. Modern painting is indeed the most striking expression of the universal process by which one cultural epoch with a long history yields its place to another. It bears witness to the decline of an old conception of reality and the emergence of a new one. The view of the world that is being superseded today is that which was first shaped by the early Florentine masters with their naïve enthusiasm for the concrete reality of the visible world, which they set out to define. It was the foundation of the Renaissance and of the various styles deriving from it down to Tiepolo, and sustained all the idealisations and stylisations evolved over a period of four centuries. This foundation was first breached by the Romantic movement, and the persistent nineteenth-century attempts at restoration were unable to mend the breach. Once again a direct confrontation with reality – outside tradition and the humanistic clichés derived from it – was imperative. The beginning came with Courbet. His vigorous realism rejected all preconceived ideas and marked the advent of a new way of seeing, untroubled by history, idealistic embellishment, or old habits. It touched off the stormy evolution which in a few decades culminated in the Impressionists' enthusiastic affirmation of the new visual experience. But at the same time, this way of seeing, thanks precisely to its freedom from presuppositions, led to a situation in which things seen, because of the way in which they were seen, began unexpectedly to point to a realm beyond optical vision, and a new relationship between man and thing, based on pure observation, became more important than the re-creation of the object. In the new conception of reality, the two components, subject and object, the self and the world, were of equal importance and both together called for unity.

This book deals with the methods employed to give a new pictorial definition to these two poles of a more complete view of the world and, more generally, to seek the ground of reality underlying them both. Logically, it must begin with Impressionism, the culminating point of the new 'visual experience freed from presuppositions'. However, it has been impossible to give a detailed account of the complex phenomenon known as 'Impressionism', since, fascinating as the subject may be, our primary aim is to produce a useful book on twentieth-century painting. Accordingly, the chapter on French and German Impressionism is no more than a rapid sketch. Its purpose is merely to mark the point of departure; in treating the subsequent development, we have attempted to follow more scrupulously the lines leading on the one hand to the pure realm of human expression, and on the other to a new definition of the world of things, and ultimately converging in an intimation of a deeper identity between them – which might be called the 'ground of reality' underlying what we are beginning to perceive more and more distinctly as the basic design of a modern style.

We have tried to follow chronological order; at the same time, however, we have sought to bring out, clearly and distinctly, the organic law of growth which, despite the chaotic exuberance of

the present era, governs modern art as much as the art of any other period. This has been very difficult and could not be done without some departures from strict chronological order. Because of the overlapping of generations and the modes of expression they embody, the so-called 'present' is a phenomenon of great complexity. It must not be forgotten that the greatest Impressionist masters were active as late as the third decade of our century: Degas and Rodin died in 1917, Renoir in 1919, and Monet in 1926, and each of these artists produced important works in his last period. Signac lived until 1935, the year of Liebermann's death. The Nabis did not begin to die out until the fifth decade of the century: Vuillard died in 1940, Bernard in 1941, Denis in 1943, Maillol in 1944, Bonnard in 1947. Of the great isolated artists, whose restless genius was so characteristic of the situation at the turn of the century, Munch died in 1944, and Ensor in 1949. Our immediate present is still illumined by the violent genius of Picasso who was born in 1881 and by the serene wisdom of Matisse (who died in 1954, at the age of eight-five). Perhaps it is their radiance more than anything else that makes it so difficult to discern the inner processes in recent art. But the tradition that has been taking shape in these developments gives new actuality to great masters such as Kandinsky, Mondrian, and Klee, who were roughly of the same generation as the Nabis: in 1955, Kandinsky would have been eighty-nine, Mondrian eighty-three, and Klee seventy-six. It is only by adhering to definite methodological principles that it is possible to find 'historical' trends in so complex a situation. Even though Munch was still active in 1944, his whole work, as well as his conceptions of art and life, must be associated with the turn of the century. As late as the twenties, Monet was still able to extract from nature the shimmering fairyland of his last period; yet there is no doubt that his way of seeing and concomitant way of thinking resulted from a conception formed around 1875, which by 1885 had given rise to a broad artistic current. Bonnard's marvellous last period did not come to an end until 1947, but this tends to make us forget that his thinking was firmly rooted in the decade preceding 1900 with its belief in the spiritual dignity of the so-called 'decorative style' and the possibility of transforming the lyrical experience of the object into painting. From the historical point of view the essence of an art is to be sought in the fundamental conception and basic design of an artist's thinking, not in the life-long process whereby he elaborates the basic conception or in the shifts of balance that occur in the course of the process. These fundamental conceptions or basic purposes provide the plan according to which the historian constructs 'history' out of the complex data he finds in reality; only in this way can he describe the process of temporal growth while dealing with simultaneous phenomena, and say, with seeming paradox, that a painting done in 1920 can be 'later' than one completed in 1940. It is solely his medium — logical discourse — that compels the historian to follow the highly unpleasant 'linear' method. He proceeds from stone to stone, and for the sake of deductive clarity easily leads his reader to mistake the abstract 'line' for the whole of reality. Needless to say, an isolated line of this sort is quite unreal. To write from a simultaneous point of view, that is to say, to grasp reality in its complex simultaneity, is technically almost impossible for an historian who has to deal with a vast amount of material. He must rely on his reader's powers of concentration more than on his own narrative skill. It is up to the reader to reconstruct in his mind the complex unity of 'the present' on the basis of the lines of development and bench marks given here. Essentially, however, the purpose is to gain a better insight into the tangled, chaotic growth which we call 'the present', to clarify and simplify in order to discover whether it conceals a basic general pattern, and if so, what this pattern is, and what hidden logic underlies it.

It seems to us that this pattern and logic can be discovered only if we treat the radical transfor-

mation in art as a European phenomenon. Twentieth-century art is a dense and fruitful dialogue transcending all national frontiers. Arguments and counter-arguments are so closely interwoven that any attempt to isolate them in terms of single nations would leave us with nothing but a torn fabric. The main partners in the dialogue  are France, Germany, and Italy. But time and again the other nations have joined in – Russia, Holland, Spain, Scandinavia. England provided a powerful impulse at the beginning, then remained silent for a time, and has only recently reappeared on the scene. As for America, its art, in the early years of the century, was largely a reflection of European developments. But in the thirties and forties American artists found their way to a new and unexpected expression which has recently begun to have repercussions on the art of the European continent. The author has treated all the European countries and America as a single whole. He has followed the dialogue of the main participants as carefully as possible, intent upon preserving the logical connections. But he has also noted every impulse that came from outside – from Russia or Holland, for example – and attempted to account for it in terms of its national origins. The developments in England and America have been briefly sketched in. The result is a closely woven fabric, three strands of which form relatively complete histories of modern art in three countries – France, Germany, and Italy. The other countries appear only in relation to their crucial contributions. In selecting names and ideas, the author has always tried to see each country from the outside. Matters of merely local interest have been neglected in favour of the general structure. In following such a procedure, the author has been compelled, to his regret, to omit many names and developments in which he personally takes a great interest.

This book has been conceived in every respect as reading matter. The author has rather stubbornly insisted that the usual illustrative material be left out, wishing, for once, to concentrate on history and the ideas at work in art. This purpose is stressed even in the appearance of the book. The documentary photographs included are intended only to provide a few sidelong glances at personalities and their environments. The developments described here are illustrated in a second volume consisting largely of reproductions.

The author has had solid foundations to build on. The comprehensive works of Christian Zervos (1938), Rene Huyghes (1939), and Bernard Dorival (1943-46) provide a key, particularly to the French material which they treat from different points of view. Carrieri's penetrating book on modern Italian art (1946) is an excellent survey of the Italian development. In Germany the interest in the problems of modern art was first reflected in the pioneer work of Meier-Graefe and Scheffler; since then Carl Einstein and Hans Hildebrand have written books which remain unsurpassed; their work has been carried on by Will Grohmann in his volume published in 1954. To Michel Seuphor we owe the first extensive attempt (1949) to study abstract art as a single stylistic phenomenon. The precious volumes of the 'History of Modern Painting' series, published by Skira, Geneva, since 1949, and the source publications issued by Wittenborn, New York, have made important material available to us. Sir Herbert Read, Siegfried Giedion, and Jean Gebser have kept aesthetic thinking in a state of mobility. The author acknowledges his debt to all these historians and critics. The vast number of monographs and articles cannot be listed separately here; the most important items are mentioned in the biographical notes at the end of the book. But we must not fail to acknowledge gratefully the exemplary contributions of the Museum of Modern Art, New York; its catalogues and monographs are among the most useful works available today.

Even though this book was written in a certain isolation, the author feels personally indebted to a large number of persons. It is difficult to decide in retrospect in what conversation and in the

presence of which painting a given idea took shape and to whom one owes it. However, I am particularly thankful, for many an inspiring conversation, to a number of artists, among them Professor Willi Baumeister, now dead, Werner Gilles, Professor Ewald Mataré, Professor Georg Meistermann, E. W. Nay, and Professor Fritz Winter; to the museum curators Prof. Dr. Ludwig Grote, Prof. Dr. C. G. Heise, and Prof. Dr. Alfred Hentzen for the inspiration I derived from exhibitions arranged by them; to the art dealers Günther Franke and D. H. Kahnweiler for their kindness and promptness in helping me with my work; to the critics Prof. Hans Hildebrandt and Dr. Franz Roh for many valuable suggestions and other help. My friends Dr. Otto Lehmann-Brockhaus, librarian of the Zentralinstitut für Kunstgeschichte, Munich and Dr. Erhard Göpel, have been of great assistance, the former by providing me with useful bibliographical data, the latter by going over parts of the manuscript. I am greatly indebted to Dr. Hans Melchers for compiling the index and for his work on the illustrations of this volume. I dedicate this book to Eva-Maria Czakó, without whose considerate and untiring help I should never have been able to write it.

BOOK ONE

The Turning Point in Art

As the nineteenth century was drawing to its end, the peoples of Europe were seized with a strange spiritual restlessness. By 1890 this had brought about great changes in the prevailing life-feeling and its stylistic expression. In the midst of a society characterised by luxury, security, and a cosmopolitanism fostered by travel and world fairs, of a society which seemed to be within reach of its ideal – a life devoted to lofty aims in a world securely subjected to the control of man, at a time when the prevailing faith in technology, organisation, and progress seemed to have been justified by experience, doubts suddenly arose. The assumptions and attitudes on which this style of life was built began to be undermined. Never before had the Western world been so radiant as in these years when men had already begun to ask in their hearts whether the glow might not betoken the sunset. It is not as though the elegiac mood, the disabused dandyism, the seductions of decadence were merely an ultimate refinement added to the splendour of the picture. Indeed, the spiritual élite itself, which had evolved this style of life and had worked perseveringly to translate it into practice, to develop it and give it its final form, arrived at a point where they could go no further without making entirely new, almost opposite assumptions.

In this borderline zone there was much solitude, sorrow, and intellectual despair. It was here that Van Gogh, Verlaine, Rimbaud and Gauguin played out the fantastic dramas of their lives, while Cézanne, in terrible solitude, buried in a provincial village, went to early Mass, and spent the rest of the day stubbornly studying his motif, gnawed by the persistent fear that he might be unable to realise in his painting what his penetrating vision had discovered to be the essence of nature. It was in those years that the archetypal figure of the tragic artist took form; in good part it is still our image of the artist.

*The Impressionist Vision*

The Impressionist vision of life was born in Paris, the heart of the civilised world, and it was in Paris that its crisis began. The happy years were past. Gone was the carefree spirit of the spring of 1874, when a group of young painters showed their works at Nadar's on the Boulevard des Capucines, and of 1877, when, by way of a joke, they baptised their new exhibition with the derisive name 'Impressionist', which Leroy, their severest critic, had given them in *Charivari*. Those had been happy years, marked by a miraculous harmony with the radiant world outside them. What pleasure they took in the merry throngs of boatmen and the glimmer of the light on the Seine near Argenteuil. Monet fitted out a houseboat, where, in a joyous setting, he painted the sunny mood that pervaded the world. Rowing was fashionable: it had been taken up in 1870 at the same time as beach bathing. The favourite restaurant of the oarsmen was La Grenouillère, a floating café at Marly. Boats of all kinds gathered there, with oarsmen in striped jerseys and fancy caps, while at the helm sat girls in bright dresses, sporting the colourful parasols that were the rage at that time. What a picture of *joie de vivre!* In *Yvette*, Maupassant describes the goings-on at La Grenouillère, which were not to his taste: these pleasures had little appeal for fashionable society, which preferred other places and forms of amusement – Epsom, Biarritz, the Riviera. But they did appeal to

the painters. In 1878, Caillebotte painted whole series of paddlers near La Grenouillère, as well as bathers in the most comical striped garments, preparing to dive. In the summer of 1876 Renoir began his large canvas showing a Sunday dance at the Moulin de la Galette; he worked out of doors, using the midinettes Jeanne, Estelle, and Margot as his models, and a few artist and writer friends as accessory figures. He produced a masterpiece – not only from the standpoint of art, but also considered as a conception of the good life.

The Impressionists' subject matter gives us a good idea of their feeling towards life; bright landscapes, river-banks with reflections in the water, women picking flowers, and carrying the parasols that had recently come into fashion, boating parties, bathers, the world of sport. As early as 1885, the Galerie Petit was able to organise an exhibition entitled 'Sports in Painting'. The main point is that all this is not the normal life of the countryside; it is Sunday in the country, *vie de dimanche*, week ends. In the background lurks the big city, which sends out the excursionists with their boats and 'fashionable baubles'. 'Life out of doors' is a slogan not of the peasant but of the city dweller. This is apparent when we recall the serious paintings of the Barbizon School, the works of Millet, Rousseau, Daubigny. Here we see nature in its reality, often terrible, following its own purposes, unconcerned with man, who is entirely alone in it. And where man appears, his gestures are ponderous, earthbound. Comparing the different human attitudes, we should say that the Barbizon painters were slow, cautious, unwieldy peasants, while the Impressionists were vivacious, unromantic, impulsive city dwellers to whom nature meant the gardens of their suburban summer houses.

Just as nature had become for them a part of the big city, they looked upon the big city in its various aspects as a part of nature. The crowds on the boulevards, the race course at Chantilly, the quais along the Seine, the beflagged streets on July 14 – all were part of the garden of their world. This is true even of the least 'natural' product of the big city, the machine. They looked on the railway, for example, as a fascinating subject. At the Impressionist show in April, 1877, Monet exhibited no less than seven views of the Saint-Lazare station. The impressive new iron bridges were similarly treated as images of contemporary reality. One of Caillebotte's paintings shows the massive lattice-work of a bridge and against the giant structure a few solitary, meaningless passers-by. The Impressionist outlook is characterised by an unconditional affirmation of modern life, a contemporary sensibility, a joyful, optimistic attitude towards nature; these painters accepted the glittering beauty of this world as a gift, and felt the forces of nature mastered by technology to be the friendly servants of human progress. It was technology that seemed to be transforming the world into a friendly garden. Never before had there been an art bearing witness to so joyful and wholehearted an affirmation of the phenomenal world in all its sensuous presence. 'We no longer separate the human figure from the background of the street', wrote Duranty in 1876; 'we must free the artist from his monastic cell where he is in contact only with heaven, and lead him into the world of men.'

Needless to say, this is not to suggest that society in the seventies readily recognised its sensibility in the Impressionist paintings. Painters of historical and military subjects – Bouguereau, Maignau, Regnault, Cormon, Cabanel – were still highly esteemed. A Meissonnier brought 300,000 gold francs; an Impressionist work, if the painter was lucky, one hundred. But twenty years later, the situation was very different. By 1890, Impressionism had gained full recognition among the élite; though it was still ignored by the public at large, an awareness that Impressionism gave pictorial expression to a view of life, that it was the aesthetic counterpart of contemporary ideals, was gaining ground from year to year, spreading from France to other European countries. This growing aesthetic acceptance of modern life went hand in hand with the belief that Impressionism ade-

quately reflected the age of science and democracy. Impressionism began to be identified with the prevailing optimistic materialism, and later on this aspect of it became the favourite target of idealist critics. For by the time Impressionism began to gain general acceptance and to become, as it were, a general style of life, it had entered a critical stage which gave rise to the new ideas that became the foundation of the twentieth century outlook.

*At the Frontiers of Impressionism*

The crisis began from within, as a kind of continuation of Impressionism and as a logical consequence of a more intense preoccupation with the pictorial means and of a new and deeper insight into nature and the things of nature. The emergence of a new generation played a certain part, although the artists who were particularly affected by the crisis could be more properly designated as younger cousins than as a new generation. These younger men had an extraordinary reverence for the older Impressionists, and it was the Impressionist theories that had kindled their enthusiasm. But it was this very enthusiasm that impelled them to probe more deeply, to reach out so far ahead that they finally attained to a limit beyond which lay a realm that had not entered into the Impressionists' range of vision.

A small, unacknowledged splinter group formed. It can be localised in the Paris art world of the time with a fair degree of accuracy. Durand-Ruel represented the Impressionists — by these he meant above all Monet, Sisley, Renoir, Manet, and Degas; he 'had no use' for Cézanne. Another enterprising art dealer was Goupil, who occasionally showed a so-called 'modern' work, but sold chiefly military and genre paintings, particularly those of Meissonnier and Henner, of a kind hated by the Impressionists. But Goupil had an able and sensitive Dutchman in his employ — Théo van Gogh, Vincent's brother. He persuaded his employer to put him in charge of a small new branch on the ground floor of a house on the Boulevard Montmartre. Here Théo van Gogh exhibited the Impressionist masters, but also a number of his younger painter friends. The situation was characteristic of 1885: military and genre paintings were in the foreground of public interest; the Impressionist masters were exhibited by Durand-Ruel in a gallery not far from the Grands Boulevards; while the younger painters who were feeling their way at the limits of Impressionism were shown at Théo van Gogh's place. In this little shop, the young artists were able to discuss their new ideas in a spirit of comradeship.

In 1885 the participants in these discussions were still quite unknown painters, who did not achieve recognition until the following decades. There was the severe, methodical Georges Seurat, then twenty-six years of age, seconded by his friend, the twenty-two-year old Paul Signac. They often discussed the theory of the refraction and optical blending of colours, which had been explained to them in 1884 by old Chevreul of the Gobelins tapestry works. There was a crippled dwarf, aged twenty-one, whose whimsy and cynicism concealed profound suffering, whose physical misfortune had made him a *bon vivant:* Count Henri de Toulouse-Lautrec. Then there was the cheerful, adroit Emile Bernard, who was never deterred from dropping into painters' studios. And there was a man of thirty-seven with an eagle beak, who often interrupted the exchange of arguments with his malicious jeers. He had formerly been a broker's clerk; as early as the 1870s, he had collected a number of Impressionist works, but now his passion for painting led him to turn painter himself — Paul Gauguin. That was the company Vincent van Gogh found in his brother's gallery when he came to Paris in 1886. In these conversations, Gauguin repeatedly mentioned the great 'construc-

tors', referring above all to Cézanne. Young Bernard who knew everyone, including Cézanne, told anecdotes about him and quoted his remarks. Cézanne was invisible yet present; he was never criticised, and those who ventured timid criticisms of the Impressionist masters regularly brought up his name. Even so, Cézanne was scarcely more than a mythical figure, and as late as 1890 Maurice Denis could say: 'He is a myth, perhaps even the pseudonym of an artist who specialised in entirely different investigations.' Those who wanted to see the paintings of this saint of Aix, had to go down into a cellar occupied by a little old man who made his living by selling paints, Japanese prints, and objets d'art – Père Tanguy. Out of this group around Théo van Gogh came the artists who appeared as towering beacons to the next generation: Seurat, Van Gogh, Gauguin and Cézanne.

## Seurat (1859-1891) and Neo-Impressionism

Seurat is one of those artists who, conscious of their genius, manage to express themselves fully even if their lives are short and their works relatively few. He had a very systematic mind, and from the outset he aimed at logical construction. At the age of eighteen, he copied Holbein, Ingres, Poussin and Raphael. He selected Poussin as his guide. In his works Seurat discovered a carefully worked out organisation of pictorial planes, a system of spatial relations, which he tried to reproduce logically, almost mechanically, by superimposed layers, exploiting the contrasts between light and shadow. His pursuit of a pictorial geometry which enabled him with great precision to develop planes from contrasts, compelled him to organise his surface very strictly. The most exact geometrical linear contrast was that provided by the right angle. Seurat used horizontal and verticals to obtain an articulation of the surface, matching the three-dimensional articulation of the planes. Whenever a line – rising, falling, or agitated – deviated from the basic geometrical figure, it acquired unexpected expressive energy, became a precious arabesque, fragile and alien, moving within the austere architecture of the painting – an expressive arabesque pointing to new dimensions of content.

His love of figure painting also stems from Poussin. But now the human figure, with all its mobility, had also to submit to the new discipline. Presented in rigorous profile or front view, simplified and reduced to its basic cylindrical form and pictorial mechanics, it rises like a pillar, sustaining the surface structure, and serving to delineate more firmly the arrangement in depth. This geometric approach to the structural elements of paintings was, to be sure, deeply rooted in the French tradition from the Fontainebleau masters to Poussin and Chardin, and down to Ingres, but never before had this method been applied so clearly and inexorably. (It was not taken up, not applied in all its rigour until thirty years later – by Piet Mondrian and Oskar Schlemmer). Seurat gained all these insights quite independently, through persistent study of the old masters. But it was through Delacroix and, above all, the Impressionists that he was able to extend his system to the realm of colour.

In 1884 the Salon des Artistes Indépendants was founded, in protest against the particular severity towards young painters displayed that year by the jury of the official Salon des Artistes Français. Seurat had submitted *Une Baignade*, a picture of bathers in the Seine, organised with admirable rigour, and remarkable for the dull glow of its colouring. The surface consisted of thousands of dots of pure colour (as close as possible to the colours of the spectrum), placed very close together. The result was a strange vibration. This luminous treatment of colour, obviously based on a definite theory, attracted attention. Odilon Redon and Camille Pissarro, both of whom

20

had good eyes and open minds, were very much interested. Master Degas—one of the 'constructors' in the sense employed by Gauguin in his conversations about art — was pleased with the rigorous construction. Very young painters such as Signac, Dubois-Pillet, Angrand, Cross, who pursued similar investigations, feeling that the small brush strokes of the Impressionists did not sufficiently eliminate the purely material effects of the pigment and failed to produce the immaterial glow which results from the optical mixture of spectral colours, joined Seurat, correctly assuming that he knew the secret. Unexpectedly, Seurat found himself at the head of a new school. With his systematic turn of mind, he would have liked to call this school 'Chromo-Luminarist', but he acknowledged that his theories were a logical consequence of the Impressionist ideas, and accordingly accepted the title 'Neo-Impressionism'. He was undoubtedly right, but the Impressionist masters were none too enthusiastic about the whole thing, feeling that the new school represented an unacknowledged 'secession'. At the eighth and last Impressionist exhibition in 1886, the classical masters — above all Monet — were no longer present: they kept aloof. Degas, Pissaro, and Redon had come out too strongly for the young artists; Pissarro had even taken over Seurat's techniques in his own work. Thus it was only logical that in the end the word 'Impressionist' was dropped from the title of the exhibition. For, in addition to Degas, Guillaumin, Berthe Morisot, and Pissarro, who might pass as classical Impressionists, the exhibition included Gauguin, Redon, Schuffenecker, Seurat, and Signac, who could be called Impressionists only in a relative sense. Nevertheless, Seurat insisted that he was merely carrying on the Impressionist tradition.

He himself had submitted a masterpiece. *A Sunday at the Grande Jatte*. It was a great work of art, and at the same time a *tableau-manifeste* or 'pictorial manifesto', embodying the programme of the new school. What, then, was the secret that Seurat had discovered? It did not consist in any special invention. With his systematic mind, he had merely applied the modern scientific theories of colour, the physics of colour. He had studied the experiments on light conducted by Maxwell and Helmholtz, and had carefully examined N. O. Rood's calculations of light values, set forth in his book written for artists, *The Theory of Colours*. He had asked Chevreul to explain the law of simultaneous contrast to him. Thereupon he deliberately and systematically applied the insights that Delacroix and the Impressionists had gained empirically and unsystematically. With Signac, he always insisted that this method was a 'necessary and logical consequence of Impressionism'. His purpose can be simply stated, but it was hard to achieve. How could colour and light, the pigments and the spectral colours, be fused harmoniously in a picture? How could the grey tones which seemed muddy and material when composed on the palette from complementary colours, be made to preserve the luminous, shimmering quality they have in the optical mixture of the spectral colours, where they seem almost white? How could the shadows and their reflections, instead of seeming muddy, be made to retain the luminosity they had in nature? Seurat's solution to this problem was as brilliant as it was simple. Instead of mixing his colours on the palette, he let the viewer's eye do the mixing. He broke up the colours into their prismatic components, and applied the resultant pure colours in small dots; seen from a certain distance, the dots produced the intended colour on the viewer's retina. Instead of preparing mixtures of pigments, which easily became muddy, he obtained a purely optical mixture. Colour and luminosity achieved unity in the viewer's eye. Paul Signac, in his book *From Delacroix to Neo-Impressionism* (1899), defined the Neo-Impressionists as 'those painters who formulated and developed the technique of the prismatic breaking up of colours; accordingly, the single colours and gradations of colour are not mixed on the palette, but by the viewer's eye'. He also traced the line leading from Constable, Delacroix, and Ruskin to the Impressionists, and from them to Seurat. Beyond a doubt, Seurat had gone as

far as possible in the mastering of outdoor light, which was the most important problem for the Impressionists. Having forced the quality of a single element – colour – to the utmost, he discovered the autonomous and quite magical quality of the pure pictorial means: once their material essence is fully realised, they change into a spiritual substance that exerts an attraction of its own. The discovery of the marvellous laws governing colour, and of its system constructed from contrasts, opened up an even more marvellous perspective: as the realm of colour became an orderly and balanced arrangement of contrasts, the picture as a whole was seen to be governed by a rigorous law of harmony. Suddenly Seurat understood what a 'picture' was – an orderly structure made up of rhythm, balance, and contrasts; art was 'a creation of a higher order than a copy of nature which is governed by chance' (Signac). *L'art c'est l'harmonie,* proclaims Seurat. 'Harmony consists in the analogy of contrary, and the analogy of similar, elements of tone, colour, and line, considered according to their dominants and under the influence of light, in gay, calm, or sad combinations.' Here we are led directly from the sensory-optical effects of line and colour to their expressive effects. The elementary tone contrasts (light-dark), colour contrasts (complementaries), and line contrasts (those forming a right angle) result not merely in a formal structure, but in an expressive structure. 'Gaiety = the luminous dominant, warm colours, lines rising from the horizontal; repose = balance between light and dark, between the warm and cold colours, the horizontal; sadness = the dark dominant, cold colours, descending lines' (Seurat). The entire picture, as a formal and expressive structure, is governed by harmony. It takes on a dignity of its own, in sharp contrast to naturalistic painting, photography, illustration. Once it has become involved in this play of logical laws, once it has fallen into the fine net of pictorial relationships, the picture acquires its form as though of itself; the painter merely helps by introducing order and clarity. Or, in the words of Signac: 'Before his fresh canvas, the painter should first of all determine what line and plane effects he wishes to obtain, what colours and tones he intends to apply. The Neo-Impressionist starts from the contrast of two tones, giving no thought to the surface to be covered; on each side of the demarcation line he contrasts his elements with one another and balances them until a new contrast becomes the motif of a new combination. In this way, proceeding from contrast to contrast, he fills his canvas. He plays with his colour scale. As he sees fit, he slackens the rhythm, tones down an element or accentuates it, modulates another nuance and so on ad infinitum. Wholly engrossed in the pleasure of directing the play and struggle of the seven prismatic colours, he is like a musician who varies the seven keys of his scale. He will atune line, tone value, and colour to the character he wishes to give to the picture. In thus subordinating colour and line to the emotion that stirs him, the painter becomes a poet, a creator.'

These statements are entirely new and, if clearly understood, represent the antithesis of Impressionism. For the aim is no longer the joyous affirmation and realisation on canvas of a spectacle of nature, but an autonomous painting. Of course Seurat and his friends started from Impressionism. All they ever wanted was to carry Impressionism further, but at the same time to make it more independent of mere 'temperament', to subject it to a law, to discipline it, to give it 'style' (twenty-five years later, the Futurists started from the same point). However, once they approached and understood the pictorial elements, the foundation on which they built changed radically. The painting became an autonomous creation, which from the dictionary of nature took only words that could be composed into a poetic statement, a visible communication from the realm of the psyche. And because the objects were removed from the changeable realm of nature and subjected to an abstract formal law, they took on the quality of fixity, permanence, solemnity, and magical penetration, which is characteristic of things that we see in terms of form.

Now the laborious 'pointillist' technique also acquired a special meaning. Seurat was not an 'open-air painter' in the Impressionist sense; he was a 'studio painter'. Once again painting returned to the workshop of the mind. Seurat still worked from sketches made out of doors, but the picture that embodied his central achievement took form in his studio. He worked on it night and day, a single picture took him a whole year. The painstaking work of placing dot after dot stimulated him in the way that some poets are stimulated by the rigid metre of their lines, which alone enables them to attain the heights. As the artist laboured to overcome the resistance of his medium, a great spiritual rhythm seized hold of the picture, the metric discipline ordered the planes and the ornament, and in this architecture of elements, the most sensitive of them, line, took on the character of an expressive arabesque, of mobile form. As Signac put it, Seurat's paintings were 'examples of an art of great decorative breadth, which sacrificed anecdote to line, analysis to synthesis, the transient to the permanent'.

The perspectives thus suddenly disclosed – so suddenly that the new painters scarcely realised their import and persisted in the fiction that they were 'Impressionists' – came as a shattering revelation to the young men who frequented Théo's gallery, in particular, to Van Gogh, Gauguin, and Toulouse-Lautrec. They soon went becond Seurat along the path he had opened up. But Seurat's theory and technique remained an important stimulus for the following generations. In 1886, Félix Fénéon took up his cause in his pamphlet *Les impressionistes en 1886*. From then on, the Neo-Impressionists exhibited as a group at the Salon des Indépendants. Beginning in 1887, the avant-garde Société des Vingt in Brussels repeatedly exhibited paintings by Seurat and other Neo-Impressionists. A few weeks before his death, on February 3, 1891, Seurat attended the famous banquet of the Symbolists presided over by Mallarmé. His art became a pillar of the Symbolist aesthetics, which was to dominate the last decade of the nineteenth century. Young painters from outside France, such as Van Rysselberghe and the Belgian Henry van de Velde, soon joined the first group around Seurat, Signac and Cross. Exhibitions were sent to Germany where the movement was received enthusiastically. A short time later, Henry van de Velde transformed Seurat's monumental arabesque and Van Gogh's expressive line into the abstract Jugendstil arabesque. At the turn of the century, Pointillism and Symbolism were the insignia of the European 'modernists'. Caricaturists were quick to exploit the figure of the painter of the soul, covering his canvases with dots and symbols. But Seurat's thinking survived the philistinism of the early years of the century. Kept alive and transmitted by Signac, it led to Matisse and the Fauves, to the Futurists, to Mondrian and the Stijl group, and to Schlemmer and the Bauhaus painters who, by further developing his theories, brought a new dynamic into our conceptions of colour, surface, and space.

*Vincent van Gogh (1853-1890)*

In February, 1886, Vincent van Gogh came to his brother Théo's shop. Gaunt, awkward, red-headed, highly – strung, he took everyone but himself for a genius. Given to dreams of universal brotherhood and love, he met with indifference everywhere. Like all lonely men, he was either taciturn or over-talkative. And when he did talk, Toulouse-Lautrec choked with rage, and Gauguin waved his carved stick like a rapier. He talked like a lout, his ideas were expressed in a hopeless muddle. The truth was that he grew muddled because he was full of ideas which got in each other's way when he tried to express them in this company. He would talk about Millet when he

meant the Impressionists, and when he wished to talk about the truth of nature, he praised Meissonnier. The others were horrified at such confusion. But Vincent worshipped them all, looking upon Seurat as a great classical master and upon Gauguin as a genius. He went to paint in the Cormon studio with Toulouse-Lautrec and Bernard. But essentially he was a man who had to fight his battles alone.

What brought him to painting in the first place was his overflowing love of things and his fellow men. He had been an unsuccessful salesman in an art gallery, and then a lay preacher in the Belgian coal mining region. He had always been drawn to men. He was a great Christian; though a religious dilettante, he was one of the 'poor in spirit' mentioned in the Gospels. Throwing himself wholeheartedly into his mission, he had lived among the wretched miners of the Borinage as one of them. For that reason, the religious authorities had forbidden him to preach. But a man of his stamp had to do something to express his love. And so Van Gogh took up drawing. In 1880 he began to practise it seriously under the smoky sky of the Borinage, in the miserable huts of the poor. Thanks to his previous employment with an art dealer, he had acquired a considerable knowledge of art — it was only the moderns, the Impressionists, that he had not yet seen. And so he began with Millet, in whose work he found the heavy, dark, solid tone of the earth and men with earthbound gestures. He was attracted by the reality of things, their silent eloquence. In 1882, when he first tried his hand at landscape painting, he was not in the least concerned with the picture, the scenery, or with natural appearance; he was interested only in the 'enormous power and solidity of the soil'. That was what he wanted to make visible. He flung his energies into the things of this earth with the unrestrained religious fervour which always characterised him. In his work of this period, there is no trace of 'technique', of preoccupation with his medium; his main purpose is to render the truth of things. He squeezed roots and trees directly out of his tubes, and modelled with his brush. 'Yes, there they are, growing, vigorously striking root.' During this period he had incredible insights, and some of his remarks amaze us by their profound truth. 'When you want to grow you must plunge into the earth,' he wrote to Théo in 1883. And so he dug deeper and deeper, in constant search of the images which are contained in things, yet at the same time lie behind them, which determine their essential being, which are their truth made form. And just as he bored into things, he bored into the faces of the wretched peasants round him, drawing like one possessed, trying, as he said, to discover 'the type', that which lies behind the individual face, the great mask of human suffering. Such, then, was the character of the man who now found himself among the sophisticated painters of Paris.

He had by then discovered many things — above all, that in order to get the most out of colour, one must not paint with muddy mixtures; also, that an artist working with a like-minded group could achieve more than an artist working alone. This was one of Vincent's *idées fixes:* he always dreamed of a great community of painters, which in his mind assumed an almost mystical, religious character, something of the order of a Franciscan brotherhood. He thought he had found both in Paris — good friends and the free bright palette of the Impressionists. The nights spent with Seurat, who never wearied of analysing the varied effects of the oil lamp or gas light on the café table, never ceased to be a revelation to Vincent. Soon he tried to paint in the Pointillist manner. Impressionism took hold of him, he wanted to be an Impressionist, and found any other kind of painting inconceivable. His Paris paintings still looked different from those of the painters round him; there was a throbbing, hallucinated, unwieldy quality about them which gave his motif a visionary quality. This he was always ready to account for by his own inadequacy. Gaugin followed his efforts attentively. He knew what was going on in Van Gogh, though he disliked this Dutchman's

utopianism, formlessness and Germanic cast of mind. Gauguin often lashed out at the Impressionists, asking, for instance, who could guarantee that their colours, intended to be those of a given hour, were really true. And he would add: 'All these true colours are lifeless, they're a lie...' Such remarks baffled Van Gogh. At other times Gauguin, in his casual way, let drop mysterious, marvellous phrases, so that one could not be sure whether he meant to be ironical – phrases such as 'colour orchestration' or 'the expressiveness of suggestive colour'. Or he would raise such questions as, 'Why shouldn't we get to the point of creating pure harmonies that reflect our states of mind?' Van Gogh remembered such remarks because they expressed ideas which were also at work within himself. He had great respect for Gauguin: throughout his short life, he believed firmly in 'Gauguin's victory', and always saw in him the master of the artistic community of his dreams.

Early in 1888, Vincent was seized with a yearning for the earth. He had to get away from the city, to test his brightened palette in the brightest light. In February, Vincent went to Arles in southern France. Here, in the roaring southern summer, it came to pass – perhaps for the first time – that a man completely merged with the world around him. Responding with his whole being to the call of things, this man became one with them and in the white heat of the fusion, images were wrought – precious, radiant, full of the sap of things and at the same time symbolising the passion and love that were kindled by this full presence of the world. In his creative fervour his personal vision became an hallucinated vision of the depths. As in a trance, the artist felt his way to the core of things and there laid his heart. His painting saved him from a catastrophic human situation. His mind, liberated from its armour of consciousness, was enabled to rediscover itself in the symbol. But when in his trance he made a false move, when the redeeming symbol failed to take form, the violence of his impetus flung him into the abyss of madness. In every one of his attempts to attain to essential reality, Van Gogh risked disaster. Such courting of self-destruction can be called pathological; Klee called it, 'Van Gogh's tragic attitude'. Vincent's painting was a response to an existential threat, his pictures were the formal expression of a provocation hurled at his very life-feeling and its defences. He was always at the brink of the abyss, always about to plunge into chaos; it was there that he found his images, and thanks to them he preserved his balance – as long as it was possible, that is, as long as his burning spirit withstood the provocation. This it did for exactly two years: towards the end of 1888 an incident with Gauguin threw him dangerously off balance; after that he never quite recovered, and in July 1890 he shot himself. But during those two years his life was exemplary – in his own flesh he lived the new conception of the artist's life, the new image of the artist, that radically changed our ideas concerning the psychology of the artist. This 'exemplary tragedy' became a hidden force behind the whole outlook of modern artists. And time and again, it was activated, particularly in the Germanic countries, in Nolde, in Kokoschka, in E. L. Kirchner. Not until several decades later was a new image of the artist put forward – by Mondrian.

The radiant beauty of the phenomenal world which the Impressionists optimistically regarded as an adequate truth disintegrated for Van Gogh the moment he resolved to paint in the true Impressionist manner and set out to treat natural appearance with his newly acquired bright palette. His confrontation with things was so naked, so direct, his love for them was so passionate and unrestrained, that he pierced the superficial radiance and entered into a vaster world. He would see a cypress standing in the glorious brilliance of a merciless sun; but on looking more closely, he perceived more than a mere tree; he also perceived growth. A flowering field was not merely a field, it was a rhythmic order disclosing the presence of chthonian forces in the fiery breath of summer. Always he peered into a world beyond the shimmering radiance, and this world demanded

to be made visible. Trained by the Impressionists, his eye had become keener, more penetrating. In his impetuous confrontation of nature, he glimpsed a vaster region beyond the boundaries of Impressionism. Behind the optical reality of the surface, he beheld a second, artistic reality that extended deep into the soul. This second reality could be experienced only in the lyrical rapture released by complete absorption in the object. It was an intermediate realm, a looking-glass world between things and man. Consequently, it could be brought to life in the human mind only by way of the visible world. This radically new attitude towards things made the actual presence of the motif a necessity for Van Gogh. Things were indispensable for him, they were the angels he had to wrestle with. Gauguin did not realise this necessity, which Van Gogh felt rather than understood, and when he visited Van Gogh late in the fall of 1888, he advised him to paint from memory, to render the crystallised images of his recollections. Van Gogh agreed with him, but found himself incapable of following his advice. His attempts to do so only entangled the fine threads that held his second reality in balance. For the first time, his effort to reach the second reality composed of things and self miscarried. It was this failure that accounts for his insane assault on Gauguin with a razor.

His effort to develop a new relation between man and thing was a self-destructive venture which, in a man of his inner tension, led inevitably to disaster. But to us it was a great gift. From then on, modern man would seek in things the mirror of his self; he would approach them passionately, fearfully, or cynically and hearken to them with an intensity determined by his temperament, his racial background, and his historical environment. The new feeling for things was embodied in such movements as German Expressionism, Italian Pittura Metafisica, and French Surrealism.

To render the new expressive reality in terms of painting, it was imperative to re-investigate the properties of the pictorial means. Under Seurat's influence Van Gogh made a careful study of the colour circle and came to look upon colour as an independent quality whose effects were governed by specific laws. As for Gauguin, he had little use for contrasts and the theory of colours in general; but he followed up a new method which he called 'the orchestration of a pure tone by means of all its derivatives'. By judicious use of related colour values, he achieved individual colours of such richness that they produce an emotional resonance. Now Van Gogh, in an explosion of creative energy, broke through the outer coating of things that had so fascinated the Impressionists, and beneath the coloured surface discovered something else – colour as an independent reality, what might be called 'autonomous colour'. Thus Gauguin's idea that 'colour by itself expresses something' turned out to be right, though it was confirmed by methods different from his own. This seemed perfectly clear to Van Gogh when he confronted a landscape or still life: he saw the flaming face of Helios glowing in the orange of a sunflower. But when the new knowledge overpowered the artist, when he gave himself utterly to the lure of intensified colour, an extraordinary magic flowed from the pure colour melody. It lifted things to the eternity 'which the halo used to symbolise, and which we seek to bestow by the actual radiance and vibration of our colouring'. The second reality was raised to the level of poetic truth. A slight distortion of visual appearance sufficed to reveal human depths, to bring spiritual realities to the surface. Van Gogh says, for example, that in painting the portrait of a fair man, he will 'exaggerate the fairness of the hair' and even use 'orange tones, chromes, and pale lemon yellow'. And he goes on to say: 'Beyond the head, instead of painting the ordinary wall of the mean room, I paint infinity, a plain background of the richest simple combination of the most intense blue I can combine and by this bright head against the rich blue background, I get a mysterious effect, like a star in the depths of an azure sky.' By means of the pure expressive values of colours, it also became possible to convey still other realities – 'the

26

terrible human passions' – which previously were represented only by gesture and mimicry. In painting the café at Arles at night, Vincent again enhanced and modified the colours, 'in order to show that this is a place where a man can lose his mind and commit crimes . . . an atmosphere of a glowing inferno, pale suffering, the dark powers that rule over a man in his sleep'. Colour became for Van Gogh a bridge to the realm where objects are signs, conveying messages from man's inner world.

The same is true of line. When Vincent let his eye run along the contour of an object, the contour took on a sinuous movement participating in the rhythmic pulsation and dynamism of the whole. Growth was made manifest in the sinuous soaring of cypresses and the serpentine tangle of olive trees. And that was not all. Conveying the life of the hand that traced it and the rhythmic beat of the contours it reproduced, line acquired a dance-like quality, it became rhythmic movement, an expressive script. At this point, we may mention another idea, still latent at the time, which was soon to impose itself on pictorial thinking. If we look closely, we notice that fortuitous arrangements of natural objects suggest dramatic relationships and tensions. An apple beside a bottle is not the same thing as an apple beside a loaf of bread. Forms always enter into relationships, encroach upon one another, conflict with, or support one another. In other words, a secret drama inhabits the spaces between them. It is not visible. But the tension is nevertheless there, like a field of energy extending from thing to thing; if it is conceived in terms of form, the transparent air must be endowed with a formal solidity. Van Gogh's rhythmic line with which he describes, circumscribes, connects things is his way of rendering this field of energy and of lending formal 'solidity' to the atmosphere. The problem of transforming the invisible formal tension between things into visible forms, which worried Cézanne, and which the Futurists set out to render directly, also preoccupied Van Gogh.

Such were the results of the drama of Van Gogh's life: the tragic conception of the artist, and a new vision of the relation between man and thing. These were entirely his own. He shared with Gauguin and Seurat an awareness of the expressive value of pure colour and line. All these ideas were to inspire the artists of the future, but Van Gogh himself did not live to see this. In 1889, Octave Maus, director of the Salon des Vingt in Brussels promised him an exhibition. Père Tanguy also asked him for new paintings; and in 1890, Aurier, a Symbolist writer, published the first article on Van Gogh in *Le Mercure de France,* declaring that he had renewed painting, purified the new art, etc. But Van Gogh, instead of thanking him, wrote him a letter explaining in detail that all this was not his achievement but that of Gauguin.

*Paul Gauguin (1848-1903) and the Pont-Aven School*

There was some truth in Van Gogh's protestations, not so much because of Gauguin's greatness as an artist, as because of the assurance with which he advanced his ideas. It was this assurance that accounts for his influence on those who knew him. Maurice Denis, who witnessed the new movements at the age of twenty and, with his clear intelligence, grasped their meaning, says justly: 'What Manet was for the generation of 1870, Gauguin was for the generation of 1890.' Gauguin's failure to understand Van Gogh's vision of things is explained by his very assurance and the iron-clad logic with which he formulated his conclusions. His advice to Van Gogh to paint from memory was a natural consequence of his discovery of the autonomous expressive power of line and colour. At the same time, he wrote to Bernard from Arles: 'I should like to get away as far as possible from

everything that conveys the illusion of an object.' For the same reason, he taught his friends that it was a good thing to have a model, but that if they wanted to paint it, they should draw a curtain over it: '...then the work will be yours – your personal experience!'

It was this uncompromising clarity which in a way made Gauguin the leader of a school. Van Gogh always regarded him as such, and in periods of humble repentance addressed him as 'Master'. Gauguin also saw himself as a leader. Like Van Gogh, he dreamed of a great artistic community; and like him he dreamed of a 'studio of the south', except that he envisaged it not in France but in the tropics. He exerted a vast influence on the young painters who gathered round him. In the summer of 1886, Gauguin made his first appearance at Pont-Aven, a small fishing village on the coast of Brittany 'a place with archaic customs and an atmosphere very different from that of our over-civilised surroundings'. He was a picturesque figure, he had been a sailor and stockbroker before becoming a painter. He was a hard drinker with a considerable reputation as a lover. Well known in artistic circles as a friend of the Impressionists, he had created quite a stir with the nineteen paintings he had contributed to the Impressionist Exhibition of 1886. He was a striking personality, somewhat irritating with his blend of cynicism and subtle intellectuality. It became known that he no longer painted exclusively from nature. Moreover, he talked a great deal about 'synthesis', by which he meant an intensification and concentration of the natural impression, obtained through the decorative elements of the picture; hence his advice 'to paint by heart', because in the memory coloured by emotion the natural forms were more integrated and entered into a hierarchical order. His term 'Synthetism' was much bandied about at Pont-Aven even after 1887, when Gauguin, whose talk was often punctuated by invectives against the decaying civilisation of Europe, boarded a steamer bound for the West Indies, where he hoped to find a paradise and new myths. But in the summer of 1888 he was back at Pont-Aven where he remained – except for a few unhappy autumn weeks spent at Arles with Van Gogh – until the end of 1889, when he moved to Le Pouldu, another Breton village. It was there that the group formed round him. It included Emile Bernard, Charles Laval, Paul Sérusier, Séguin, Filiger, and Meyer de Haan.

It should not be supposed that Gauguin started a full-fledged academy; the group consisted of artist friends who listened attentively to his informal talk. Only gradually were his dicta compiled into a 'doctrine', a kind of 'Manifesto of Symbolism', which was given systematic form only later, by Sérusier and Denis. But its major principles were formulated by Gauguin both in his statements and in his works. Gauguin was convinced that 'painting was entering into a musical phase'. Painting, 'like music,' he declared, 'acts upon the soul by the detour of the senses; its colour harmonies correspond to the harmonies of sound.' He believed a theory of pictorial harmony to be perfectly possible, and in his notebooks he made the attempt to formulate laws of colour analogous to the laws of music. Hoelzel and Kandinsky were to hold similar opinions. His systematic investigation of the artistic elements repeatedly drew his attention to the psychological significance of colour, by which, he thought, one could interpret a subject without resort to description and literature. As early as 1885, he wrote to Schuffenecker: 'There are noble tones as well as ordinary tones, tranquil, appeasing harmonies as well as those that arouse us by their boldness ... To express in painting is not the same as to describe, therefore I prefer a suggestive colour and, in composition, the symbol to the painted novel.' And in 1888 he wrote: 'What beautiful ideas can be conjured up by means of form and colour, now that we have no religious painting' – it was the same idea that led Van Gogh to compare the radiance of colour to the halo of the saints.

If the expressiveness of the pure elements suffices to suggest even remote ideas, the natural model loses its importance – 'art is an abstraction'. Painting becomes a method of expressing human

28

contents; it takes a path leading inward, entering the sphere of the great visual dream. In the Paris of the eighties, Odilon Redon had opened the way to this realm of the pictorial imagination in his dream fantasies, and of this the painters around Théo van Gogh were well aware. But Redon's method was illustrative; he described his dream, he did not entrust it to the magic tapestry of colours or the curves of the arabesque. Not so Gauguin, who literally passed the emotion through a formal filter. He advised one of his pupils: 'Do not copy too much from nature, take from nature by dreaming about it... always search for the absolute! Dream and then just go ahead and paint.' These dreams led deep into abstraction, myth, and presentiments of a great and simple universal order: 'I dream of tremendous harmonies in the midst of natural fragrances which intoxicate me ... Of ancient, sublime, religious things ... the veiled image of the unfathomable riddle ... a dream in the infinite space extending before me... My dream cannot be formulated, admits of no allegory; a musical poem, it needs no libretto.'

This dream was the poetic projection of a world of profound experience, which Gauguin, with his restless spirit, never ceased looking for in the outside world. His search took him to Tahiti, to the Marquesas Islands. He was a seeker of legends; they rose up inside him. He saw a naked Kanaka girl lying flat on her belly on her couch, with anxiously expectant eyes, and he at once associated her with the Polynesian legend of the walking dead. The result was the painting *The Spirit of the Dead is Watching*. 'I had to account for her terror with a minimum of literary means... The overall harmony is sombre, sad, disquieting, it has the visual resonance of a death knell, violet, dark blue, orange yellow. The yellow combines with the orange yellow, and the brown completes the musical harmony. In the background a few flowers, but being imaginary they must not seem real, and I make them look like sparks. To the Kanakas the phosphorescence of the night interprets the spirit of the dead.' But such a dream could also take on objective clarity in a seemingly purposeless arrangement of colours and rhythms. Then a musical rhythmic structure of coloured forms arose in the painter's subconscious; his next step was to qualify this structure by investing it with the signs of objective things. Gauguin referred to such signs as *excitants* – that is, stimuli which evoked a thing in the imagination. The late masterpiece *Whence Do We Come: What Are We? Where Are We Going?* was painted in this way. 'In a dream of the mystery of our origins and future, at one with all of nature,' he wrote, 'I painted a scene that had no tangible allegorical meaning. Only on waking, after the painting was complete, did I find the title, which was a thought that had nothing to do with the canvas.' The evocative power of the coloured signs suggested the subject matter.

The subject matter ranged as far as the world of myth. Gauguin attached great importance to myth. In his nocturnal conversations with Van Gogh, he kept returning to his hope of finding 'the new myth' in Martinique. The ancient, the sublime, the religious! He urged his friend to follow him to those distant islands where myth was still alive. Only there, he insisted, was it possible to rediscover a meaningful 'content' expressing the universal, the supra-individual, which might lead art away from easel painting and exhibition painting back to the fresco.

Gauguin felt the need to go back to the original sources of art. That is why he was always attracted by the expressive powers of primitive, exotic peoples. The important thing was to express yourself with the utmost force: 'If you cannot express yourself properly, talk like a savage, but say something, anything at all.' His classical remark: 'It's barbaric, but it's art' (*C'est sauvage, mais c'est de l'art*) was quoted all over Paris and Pont-Aven. Needless to say, Gauguin, like the other painters who frequented Théo's shop, and to an even greater extent than Van Gogh, fell under the spell of East Asian prints. That was in the spirit of the times. In the eighteen fifties Degas's friend Braque-

mond had discovered Hokusai, and in 1862 Madame Soye had opened her shop *La conque chinoise* in the Rue de Rivoli; in 1867 Japanese paintings were shown at the Paris *Exposition Universelle*. Since then *Japonisme* had been popular among painters. Everyone in Théo's shop was enthusiastic about the prints and analysed their formal elements, their two-dimensional effects, decorative arabesque and pure colours without modelling. All this was of the utmost importance to Gauguin. But he also sensed the element of folklore, the supra-individual inspiration that was present even in the most refined forms of the Asians. To him and his friends of Pont-Aven this was an art directly related to the popular art they saw in Brittany, the vigorous primitive Calvaries by local artists. The catchword 'from the people, for the people' now became plausible. The expression first occurs in a letter of Van Gogh; by way of Pont-Aven it soon entered the public domain. But Gauguin was firmly convinced that European culture had from the start been too rationalistic to give myth a place superior to folklore. The true source of art, he thought, could be rediscovered only in non-European cultures, in the exotic, primitive and barbaric. In 1888 he studied Oriental ceramics and in 1889 became enthusiastic over the Aztec sculptures shown at the Exposition of 1889. Here were symbols transcending nature, here the artist expressed himself in mysterious parables and, impelled by an inner necessity, invented forms that went counter to nature, forms which at the time were said to be 'deformed'. This was the basis of Gauguin's brutal words: 'The worst mistake of all is Greek art, however beautiful it may be.'

His desire to return to primeval conditions went beyond art; he sought to rediscover the sources of humanity, the condition of childhood in which a wooden hobby horse evokes deeper thoughts and dreams than the horses of the Parthenon. Among the tormented and cynical notes of his late period, we actually find this sentence: 'I have often gone far back, farther back than the horses of the Parthenon, back to the plaything of my childhood, the good old rocking horse.' It was just this – his longing for the original sources – that repeatedly drove Gauguin to leave this Europe of the 'Graeculi' and go among the 'superior savages'. The years he spent in Tahiti and the Marquesas were the tangible expression of his revolt against a view of life which, engrossed in the superficial activism of technology, progress, rationalism, and control of matter, had lost touch with the fountainhead of the primeval and the mythical. His tirades were those of a priest casting out anathemas. His artistic ideas culminated in the desire to rediscover the original source. It even led him (to Van Gogh's consternation – for he knew that Gauguin was at bottom a pagan) – to a Christian religious art. In 1889, he induced his friends of Pont-Aven to treat religious subjects. He himself painted the *Yellow Christ*, a *Calvary*, and *Jacob Wrestling with the Angels*. Indeed, it was this pagan in search of myth who actually developed the expressive techniques which Maurice Denis and Sérusier later took as the foundations of a new religous art, the French *Art Sacré*. Such ideas, born of utopianism and despair over a world without myths, gave an ecstatic, religious colour to the spiritual climate that Gauguin fostered at Pont-Aven. Verkade was so deeply stirred that he became a Catholic and later took the habit, while Sérusier set out for Paris like an apostle to spread the gospel of a new religious art. Gauguin is one of the forerunners of French Neo-Catholicism.

He tried to rediscover the profound content of art, which the Impressionists had entirely lost sight of – a significant new kind of figure painting that could claim to be a universal human symbol. Essentially, is striving was towards the fresco, a meaningful decorative art. His radical simplification of line, his pure colours which form a large ornamental pattern tied to the surface, all served this purpose. With this radiant surface pattern, harmoniously combining expressive

arabesques and symbolic colours, he strove to raise his dreams and inward emotion to visible existence. Referring to his paintings of Tahiti, he once wrote: 'Yes, all that exists. It is the equivalent of the grandeur, profundity, and mystery of Tahiti when one has to express it on a canvas.' This transformation of his dreams into visible realities was carried out with an intensity akin to the volcanic, instinctive brutality of the primitive creator of images. Hence his question: 'At the moment when the loftiest feelings fuse in the innermost depths of our being, at the moment when they reach the explosive point, and the whole idea bursts forth like lava from a volcano, is there not a flowering of sudden creations, brutal, if you will, but great and superhuman?' This question was to turn the heads of whole generations of painters who laboured under the illusion that if only they could express the violence of the psychic eruption in its full force, they could safely ignore the inner laws and order of the work. But the great freedom that was Gauguin's gift to modern art could never have produced masterpieces unless it had been subjected to a law. This law was discovered by Cézanne – Gauguin himself had known that.

*Paul Cézanne (1839-1906)*

For the young painters of 1890 the figure of Cézanne, the man, was entirely overshadowed by his art. This was inevitable in view of the fact that all Cézanne had ever wanted was to lose himself in his work. Behind the mask of petit bourgeois eccentricity, this most sensitive painter of the century tackled the subtlest problems of his time. The only evidence of this was his painting. It was not easy to see it. The only way was to ferret out Père Tanguy in his cellar. Thus only a small group of initiates were in a position to distil Cézanne's artistic wisdom from the finished forms. They found an entirely new way of dealing with nature. For Cézanne it was only in terms of nature that the artist could 'realise' his mind and at the same time painting was a method of 'realising' the world. *Réaliser* – that was his guiding principle. Like the Impressionists, Cézanne stuck close to his motif: his sole purpose was to bring his motif home to the senses, to 'realise' it in the human language of art; everything else – emotions, religious ideas, expressive deformation – was eliminated. His thinking was exclusively pictorial. His spirit dwelt in the intermediate realm between the thing of nature and the form distilled from it, shuttling industriously between the two, weaving subtle threads between thing and form, between the objective and the abstract, creating a fine-meshed web in which nature was captured and realised as form. In this web, which resulted from a continuous transposition, the gap between nature and form could be regarded as closed. Viewing Cézanne's painting, one could observe that over the perspective visual surface of nature, which the Impressionists had sought to render, there spread a non-optical and, in a manner of speaking, non-perspective warp and woof, which transformed the visible into pictorial form by subjecting it to a subtle system of laws. And a comparison with Van Gogh disclosed something very similar. Quite unlike Van Gogh, Cézanne did not identify himself with the things of nature in order to wrest expressive signs from them; rather, he identified himself with his design, and within this design things achieved a pictorial concreteness. As the work developed, he slowly disengaged the *images* of things from nature. This involved extremely meticulous work, directed by a specific theory of the relations between nature and form. In a stubborn effort to transform natural appearance, the artist passed it through the formal filter of line, tone, and colour, and with the help of the abstract and purely formal structure thus obtained proceeded to re-interpret the original datum.

'In art,' said Cézanne, 'everything is theory, *developed* and *applied* in contact with nature.' This may be illustrated by a simple example. The visual appearance of a bottle and an apple is 'developed' by its passage through the formal filter, or 'theory', into an abstract arrangement of forms, for example a cone beside a sphere; these abstract end-forms are then again 'applied' to nature and filled up with matter: the pictorial form is situated at the intersection of the two operations. Cézanne's famous dictum that 'nature must be treated in terms of the cylinder, the sphere, the cone' emphasises the formal aspect of the total process, the 'development'; another of his statements – 'I take the colours, the nuances, as I find them and they become objects without any meditation on my part' – stresses the other material aspect, the 'application', the direction towards things. Thus, Cézanne's painting is the result of an exact balance between the abstract patterns of pure form and the things of nature as they appear to us optically. The picture is the concrete result of this process of 'realisation', which has become visible in the independent world of the rectangle which is the picture. It is both an autonomous structure and a re-creation of a part of the outside world.

Consequently nature in the raw is useless for artistic purposes and the same is true of sunlight. Like sunlight, nature cannot be 'reproduced', it can only be 'represented'. Represented by what? 'By pictorial colour equivalents' is Cézanne's answer. He sought confirmation of his theories in the old masters, and found it often enough in the Louvre, for example, in Veronese's great canvas *The Marriage at Cana,* which filled him with enthusiasm: 'It is beautiful and alive, and at the same time it is transposed into a different and yet entirely real world. The miracle is there, the water is transformed into wine, the world into painting.' He found this transformation of the world into painting also in Poussin, whose works, it seemed to him, anticipated his own 'theory'. Hence his statements that he wished to re-create the museum after nature, and *refaire Poussin sur nature* – 'to do Poussin over again from nature'. *Refaire* = to do over again: this is important. He did not take over ready-made forms from Veronese, El Greco, or Poussin, nor did he take the final forms of nature. He began with the foundation, with visual appearance, and transformed it into formal equivalents. Reminiscences of art or nature could not slip in, for it would be evident at once that they were extraneous to the formal ensemble. Thus Cézanne felt quite justly that on the one hand he was carrying on a great tradition, while on the other he was 'the primitive of the way I have discovered'. This was also the opinion of him held by the ensuing generations.

Since art is not 'reproduction' but 'representation', it follows logically that 'Art is a harmony parallel to nature'. The picture is subject to its own laws. It is realised on the formal plane, which runs parallel to nature. Cézanne repeatedly stresses the formal element: 'A picture should first of all represent nothing but colour. Stories, psychology... all that is implicit in the picture.' In each of his works, we can hear the humming of the shuttle as it races back and forth between the two parallel planes – art and nature – each weft furthering the incorporation of the visible into the autonomous world of the picture.

The web grew so dense that the separate formal elements – line, tone, colour – grew into an indissoluble whole. For Cézanne, line and tone were transcended in the light values of the colour relations. 'There are no such things as line or modelling. Drawing is merely the relation between two tones, white and black. Contrasts and relations between light and shade – that is the secret of drawing and modelling.' He had no use for the term 'modelling' and replaced it with 'modulation', which struck him as a much better expression for the vibration of the surface produced by the varying distances suggested by each colour. He gathered drawing and modelling into colour, which for him was the supreme element in painting. 'Drawing and colour are by no

means two different things. As you paint, you draw. The more harmoniously the colours are combined, the more clearly the outlines stand out. When colour is at its richest, form is in its plenitude.' Thus the coloured organism of the picture absorbed line, tone and modelling. The picture became one dense web of spots of colour, an autonomous pictorial organism in which the objective points of departure, connected by his weaver's shuttle, had grown inseparably together.

At the same time, surface and depth were tied more closely together. The coloured surface vibrated in depth. With the help of colour, firm planes were defined, that could be interlocked by means of modulations (a secret known to Poussin). This space can no longer be called illusionistic, nor is it produced with the help of perspective. The picture is not a window opening on stage-space; it never becomes anything but a surface with spatial vibrations. This pictorial space is non-perspective, a purely artistic space. Thus the autonomous pictorial organism had also acquired an autonomous pictorial space, which was woven into it. In this mesh not a stitch was lacking. Now we can understand the touching gesture with which the aged Cézanne tried to explain his subtle method to Dr. Gasquet: 'My motif, this is how it is.' Here Cézanne spread his fingers, slowly moved his hands together, then pressed them convulsively, so that his fingers locked. 'This is what I have to get. If I pass too high or too low, all is lost. There must not be a single loose stitch, not a single hole for the truth to slip through. Everything that is scattered I bring together. All appearance is scattered, nature is always the same. And so I join these wandering hands together... If the colour values on my canvas correspond to the planes before our eyes, good; my canvas has locked its fingers, it does not waver, it is true, it is close-knit, it is full.'

This solid, close-knit pictorial organism also provided the medium in which the forms of things could enter into reciprocal relations. By the tangle of lines that he threw over his picture, Van Gogh had shown the dramatic relations among objects, the fields of energy by means of which they acted upon one another. Cézanne for his part transformed the atmosphere into a close-knit texture of colour spots, which he hammered into solid form with his rhythmic brushstrokes, giving consistency to the atmosphere – a procedure for which he was to be highly praised by the Futurists – and then he brought the formal particles of his pictorial atmosphere together in an order revealing the dramatic relations of the objects, just as iron filings transpose magnetic currents into formal diagrams. In this way he succeeded in rendering energies as forms. A round glass beside a bottle was not merely a material object nor an isolated formal structure, it was also a rotating energy side by side with a static energy. These energies acted upon one another and influenced the appearance of objects: for instance, the rotating energy nibbled at the static energy on the side of the bottle turned towards it; this was necessarily reflected in the densely woven structure of forms and modified the appearance of the object. It was in this way that Cézanne arrived at what we call his 'deformations'. These were not arbitrary, but were implied by his method of transforming the outside world into a formal pattern. Cézanne broadened the range of painting. To its 'biological' task of reproducing something visible was added the new, spiritual task of making something visible in the first place. Cézanne's 'deformations' were not intentional, they were the logical consequence of his way of seeing. He simply saw more keenly than the Impressionists; to his penetrating explorer's glance previously unsuspected phenomena became visible, and his sharp pictorial intelligence discerned that their causes operated behind the superficially visible and could be captured through pictorial equivalents. He made them visible by means of a close co-operation between eye and pictorial intelligence: 'In painting there are two things – the eye and the brain. One must support the other. We must work towards their reciprocal development

– the eye must be strengthened through the visual exploration of nature, the brain through the logical development and ordering of the artistic experience – it creates the means of expression.'

This combined power of the eye and the mind was directed not only at nature, but also, with its full impact, at the painting. The organisation of planes on the basis of colour relations, the inter-weaving of the planes into a surface, and the organisation of the surface as the pictorial organism and vehicle of the subject matter, resulted in the autonomous world of the picture. The autonomous painting with its autonomous space resulted as it were from a law of construction. Cézanne was a great 'constructor', like Giotto, Uccello, Piero della Francesca, Veronese, Poussin before him. His paintings, constructed, fitted together, built up carefully, are examples of a pictorial architecture which is no more than parallel to nature, and which provides a place for pictorial signs recording how nature has taken on reality in the human mind. In this architecture man's world of expression could achieve tangible form. Thus Cézanne is the father of all modern painting, its prophet and legislator, 'the primitive of a new way'.

Cézanne identified himself entirely with his work. Though he was by temperament violent, romantic, and sensual, he submitted to the inexorable discipline of his constructive methods; this accounts for the throbbing energy of his formal structures. He wove his entire being into his painting. Henceforth 'the image of the man' would be in the picture itself. He has put himself into it, and there you can discover him. Today there is much talk about the image of man in modern art. To seek this image in the visual appearance, the iconography of the picture, shows a complete misunderstanding of this fundamental idea.

One thing Cézanne knew above all else, namely, that rigorous, inexorable construction of form does not result in 'formalism', but rather enables the work to clasp its hands, as it were, in prayer and point the way to a realm which more religious epochs called 'revelation'. 'Nature is more depth than surface, the colours are the expression on the surface of this depth; they rise up from the roots of the world.'

*Consequences of the Critique of Impressionism*

The insight won at the frontiers of Impressionism can be summed up in a few schematic statements: Art is not nature, art is transformation of nature by the formative mind. With the help of organised coloured forms, it transfigures the world as it appears to the eye into a world that takes on reality in the human mind. It re-creates the outside world in a metaphor of coloured forms, whose sym-bolic character can at the same time make visible the response of man's inward world – the totality of self and world.

Taking Impressionism as our starting point, we see that artistic awareness advanced in two directions. First towards 'the autonomous picture'. By subjecting the structural elements to an exact analysis, Cézanne and Seurat came to conceive of the picture as an organisation of rhythmic coloured forms, so preparing the stage on which thing could be transformed into form. The second advance was towards the spiritual response to nature, which can be represented through the expres-sive character of the pictorial means. By persevering study of the elements, Gauguin and Van Gogh discovered their capacity for spiritual expression; they transformed line into an expressive arabesque, and colour into expressive colour. Both advances are crowned by Cézanne's monu-mental definition: Art is a harmony parallel to nature.

Painting now acquired a new range of subject matter. Gauguin, by taking advantage (in analogy

to music) of the soul's responsiveness to colour-chords, and by enhancing the expressiveness of colours to heighten their appeal, succeeded in communicating emotions and images which ordinarily come to us only in dream and myth. Van Gogh went so far as to use painting as a means of warding off an existential danger and of preserving his mental balance.

For the painter now responded actively to the world outside him. His purpose was not merely to reproduce things but to make visible in terms of form the relationship between things and himself. This is the inevitable consequence of the tragic view of life, which induces man to come to grips with the world, and which must end in man's mastery of the world if he is not to perish. Because nature was now seen as 'the other', as an alien reality to be mastered, painting assumed the character of a passionate struggle involving man in his entirety. It took on a heroic character. On the threshold of the pure realm of human expression, we find the tragic figure of the artist. Van Gogh, Gauguin, Cézanne are exemplary figures, in part because they lived the tragic life of the artist so intensely. With them, art reached the frontier zone where nature dissolves and recedes into the shadow, where the contours of our inner world loom more distinctly in the twilight, where nature and the mind become curiously indistinguishable.

*The Impressionist Response*

All these developments, some within the Impressionist movement and some in opposition to it, were the logical consequence of attempts to broaden it. It is interesting to note that the Impressionist masters themselves – including Claude Monet, the Impressionist *par excellence* – were drawn into the vortex. For Monet, too, the world begins to lose its clear outlines, dissolving into a glow of colour. In 1890 he began to paint his 'series' – groups of paintings showing variations on a single motif and treated in a different light. First came the series of haystacks, the twenty *Meules* that have become famous. Now he could record only the coloured surface of things, their mimetic aspect; the things themselves were dissolved in light and colour. In 1894 there followed the seventeen Cathedrals, and then the Poplars – but it was scarcely meaningful to give names of objects to these coloured husks, which were all that remained of the 'thing', and Monet chose names relating to the musical quality of the works, such as *Pink Harmony* or *Green Harmony*. (Whistler found himself constrained to do the same). The abstract titles indicate that by now the dissolution of the object was far advanced, and indeed, it was when Kandinsky, as a young man in Moscow, saw these works that the idea of abstract painting first occurred to him. The irresistible logic of his method impelled Monet to take the ultimate step: instead of directly recording the coloured surface, he proceeded to reproduce its immaterial reflections. In 1900 he completed his series of Water-lilies, in 1905 his Water Effects, and in 1912 his views of Venice, in which the image of the outside world becomes indistinguishable from its reflection in the mind. The fairylike magic emanated by the shimmering colours of these works cannot be attributed to the shifting effects of light alone. Although this world of reflections is achieved by the most material means, it comes so close to spirituality that German painters in search of expression, such as Nolde or Rohlfs, misunderstood Monet's painting as 'Expressionist' and took it as the starting point of their art. Cézanne's judgment was more accurate, as evidenced by his remark which is both critical and admiring: 'Monet is nothing but an eye – but what an eye!' This implies that Monet failed to take the radical step towards the world of human expression. His 'world of reflections', the dazzling mirage of a visual fairy-tale, reflected on the retina, was very different

from the world of reflections consisting of both man and things which make the world real to the human mind and which was most clearly anticipated by Van Gogh and Cézanne. (A short time later Marcel Proust was to write: 'The great artist is not the most intelligent or the most cultivated of men, but he is the man who knows how to become a mirror and so reflect his life.')

*Symbolism*

This shift of direction from the outside world to human inwardness, from thing to form, was not immediately recognised as the starting point of a new style. Before the ideas implicit in the art of Cézanne, Seurat, Van Gogh and Gauguin could be developed further and could fully assert themselves, a new climate had to be created in which they would be purified. The movement that created this climate at the end of the nineteenth century was Symbolism, which aimed to resolve the contradiction between the material and the spiritual world. Painting still adhered to the rigid principle formulated by Courbet: 'Painting is an essentially concrete art and can consist only of the representation of things both real and existing... An abstract object, invisible or non-existent, does not belong to the domain of painting.' But it is precisely the abstract, non-existent object that now, in Symbolism, became the focus of attention, and it was above all painting, as Achille Delaroche wrote, that was expected to 'break new paths, by resolving the contradiction between the sensory world and the spiritual world'.

Delaroche was referring to Gauguin's painting. He went on to say: 'Art as we see it today, Orphic art, seems to have come at the right moment.' This is true, in so far as the period when Impressionist painting entered a critical stage was also marked by a crisis in poetry. In 1886, Jean Moréas published his Symbolist manifesto and founded, with Gustave Kahn, the magazine *Le Symboliste*. Now poets also called for 'a creative spirit in art' and declared that the purpose of art was to 'clothe the idea in a sensuous form'. Symbolist poetry also began as a protest against the naturalistic outlook and the materialisation and mechanisation of life. The Symbolists regarded poetic language primarily as symbolic expression of inner life. Symbolist poetry found its sources in Gérard de Nerval with his idea of 'supernaturalism', and in Baudelaire, Lautréamont, and Villiers de l'Isle-Adam, that is in poets still influenced by Romanticism, to whom the dream of the universe was more real than any reality, and who had discovered that the tension between man and world implied the tragic view of life that was to be the lot of Van Gogh, Gauguin, and Cézanne – 'l'horreur de la vie, l'extase de la vie'. Baudelaire had anticipated it in his life, Huysmans was in the midst of it, and Verlaine and Rimbaud, like Van Gogh and Gauguin, were leading tragic lives that would be an example to future generations.

The masters in that period were Paul Verlaine and Stéphane Mallarmé. Mallarmé was the grand master. At his celebrated 'Tuesdays' the young generation of poets and painters sat at his feet. His pronouncements, translated into the language of pictorial form, defined the new conception of visible reality that the painters were seeking: 'Immersion in things, the image distilled from the dreams called forth by things – that is poetry. To designate a thing directly is to suppress three quarters of the poem's value, which consists in the joy of gradually gaining an intimation of the depths. To allude, to suggest – therein lies the dream. This is the perfect utilisation of the mystery that is the symbol. To conjure up a thing step by step, in order to show a state of mind, or inversely, to choose a thing and to distil a state of mind from it by a series of decipherings.' The Symbolist also spoke freely of *l'au-delà, le mystère, le symbole*, etc. – terms which soon became

catchwords of the age because they conveyed the anticipation of a higher reality, corresponding to the urgent new need for something different from realism and naturalism.

This emphasis on dream and mystery stimulated exploration of a new realm, but the realm itself remained vague – a vacuum into which the ideas of German Romanticism and idealism irrupted vigorously. Fichte's conception of 'the world as reproduction and creation of the I' and Schopenhauer's dictum, 'The world is my representation' – provided the philosophical background of the new insight that the universe is a creation of our ideas. Novalis played a great part in the dialogue (Maeterlinck and Morisse translated his works). Anglo-Saxons entered the field of vision – Edgar Allan Poe's spectral dream poetry and the sensitive lyricism of Shelley, Keats, Swinburne, and finally Dante-Gabriel Rossetti who provided a link with the English Pre-Raphaelites and their sensibility permeated by Dante and the *Quattrocento*.

Music came to the foreground. Wagner's symbolism exerted a profound influence. In 1885, a *Revue Wagnérienne* was published. Poets felt that *vers libre* enhanced the musical quality of poetry, they spoke of word sounds just as Gauguin had spoken of colour sounds. Verlaine said that poetry should be 'music above all else'. A great musical talent shared the new ideas – Claude Debussy, who never missed Mallarmé's soirées and who had received his first music lessons from Verlaine's mother-in-law. He wrote music based on texts by Dante-Gabriel Rossetti *(La demoiselle élue)*, Mallarmé *(Prélude à l'après-midi d'un faune)*, and Maeterlinck *(Pelléas et Mélisande)*. A formal analysis of his music reveals amazing parallels with Gauguin's aesthetics: an anarchic element directed against convention and academicism; exotic influence via Javanese and Spanish music; folklore elements under Russian influence; a return to austere medieval forms in the use of the ecclesiastical modes and the Gregorian chant, which was cultivated by the newly founded Schola Cantorum in Paris.

As was only natural, those who failed to find the object of their quest in the discipline of form, turned to mysticism and religion. Brunetières proclaimed 'the bankruptcy of science'. The nineties witnessed the flowering of every kind of mysticism, occultism, and religious dilettantism. (It was in that period that Gauguin painted his religious works). An anarchic element seized upon men's minds. Charles Morice who helped Gauguin to edit his *Noa-Noa* wrote: 'The occult sciences are one of the most important pillars of art. Every true poet is instinctively an initiate.' 'Initiation' was a favourite word. One of the most influential books of the period was Edouard Schuré's *Les Grands Initiés,* published in 1889, which attempted to show that all religions are merely a distorted echo of a lost secret doctrine. Paul Sérusier, Gauguin's pupil and founder of the Nabis, brought this book to Pont-Aven and forced it upon his friend Verkade, who kept brooding on religion, became a Catholic, and eventually entered the monastery of the painter-monks at Beuron.

That was one way – the way that led to the Church's doctrine of salvation. It was taken, among others, by Paul Verlaine, Léon Bloy, Huysmans, Francis Jammes, Charles Péguy, and Paul Claudel, that is to say, by the great writers who founded Neo-Catholicism and who inspire it to this day. All of these men came from this Symbolism. But so did André Gide. The great debate between Paul Claudel and André Gide, which remains significant for our present situation, reflected the deep division among the Symbolists, some of whom regarded the Church as the key to the higher reality, while others sought the key in finished form, in art as the self-realisation of the spirit – on the one side, the world as divine order; on the other, the world as a phenomenon to be mastered aesthetically.

In their search for the forgotten doctrine which was held to be the source of all religions, the theosophists were led to the sacred books in India, while others lost themselves in the speculation

of the Cabala. Magazines bearing such titles as *L'Initiation* or *Le Voile d'Isis* became the organs of this new Cabala. In 1888, Joséphin Péladan went to see Wagner in Bayreuth determined to renovate art through mysticism. On his return, he founded a Rosicrucian order, 'Ordre de la Rose-Croix du Temple et du Graal', which in 1891 was joined by a group of artists including Jan Toorop, Odilon Redon, Emile Bernard, and Ferdinand Hodler, who called themselves Rose-Croix Esthétique. In March, 1892, Péladan organised the first Salon of the Rose-Croix Esthétique at the Durand-Ruel gallery. According to the preface of the catalogue, its purpose was 'to destroy realism and to bring art closer to Catholic ideas, to mysticism, to legend, myth, allegory, and dreams'.

This climate marked by utopian ideas, religious needs, a vague search for expression, a stubborn will to form, and a consistent struggle against all naturalistic and material values, produced a literary generation that has left a lasting imprint on modern culture. From the group around Mallarmé came Laforgue, Verhaeren, Moréas, Morice, and Maeterlinck. Oscar Wilde, whose *Salome* was published in Paris in 1893 and staged in 1896, exerted a profound influence. Paul Valéry, André Gide, Paul Claudel, Francis Jammes, and Camille Mauclair embarked on their careers at about the same time. The story continues with Guillaume Apollinaire, Max Jacob, and Saint-John Perse; these in turn were followed by André Breton and his Surrealists, who still invoked the old names of Novalis, Gérard de Nerval, and Lautréamont. Thus the line leading from Symbolism down to our own time is clearly discernible in literature; in the history of art, we shall have to trace it in greater detail.

All of Europe contributed to the Symbolist 'life style'. We have mentioned the part played by England. But in those years Paris, the heart of Europe, was influenced also by northern and eastern countries. This may be illustrated by the repertory of the Symbolist *Théâtre de l'Oeuvre*, founded by Lugné-Poe in 1893. On its posters designed by the Nabis, we find the following names: Ibsen, Strindberg, Björnson, Hauptmann, Wilde, Maeterlinck, d'Annunzio. The movement reacted in turn upon other countries. In Germany, it influenced Dehmel, Rilke, Hoffmannsthal, and George, through whose translations of Verlaine, Mallarmé, and Rimbaud, French Symbolism gained an enthusiastic reception by the educated German public. In Italy it influenced d'Annunzio, giving rise to the literature of Romantic narcissism which was to draw the attention of the modern world to Italy for the first time.

In the field of philosophical aesthetics, Bergson, starting from Schelling, stressed the importance of intuition, so fulfilling the hope – as Delaroche wrote with reference to Gauguin – 'that a method analogous to Schelling's intuition will lead to the development of a kind of aesthetic agnosticism which will celebrate the highest Olympus of our dreams'. Apart from such philosophical theories, many fine threads linked the young art with the world of Symbolism. Mallarmé was a friend of Puvis de Chavannes and Odilon Redon, 'the Mallarmé of painting', as Maurice Denis calls him. Puvis' restrained classicism and poetic idealism confirmed the truth of his idea that 'for each clear idea there is a pictorial thought which translates it', and which should be respected accordingly. Even more stimulating were the dream phantasies of Odilon Redon, who arrived at all his ideas by 'gently subjecting myself to the coming of the unconscious', who claimed that his 'drawing did not define but inspired,' and whose ultimate goal was 'to transform human emotions into arabesques'. Redon always preferred poets to painters and this gave a literary colour to his entire art, but he alertly and approvingly observed the tendencies manifested in the works of the younger painters. We may also mention Eugène Carrière's dream-like grey monochromes and Gustave Moreau's idealist Pre-Raphaelitism. Moreau's large figure paintings, furnished with the phantasmagorical props of Burne-Jones and Rossetti, paralleled the influence of the Symbolist poets. In these years

he became a professor at the Académie des Beaux-Arts. From Moreau's studio came the artists whose works draw the formal conclusions of this tumultuous decade – Rouault, Matisse, the Fauves, who picked up the thread of the formal explorations initiated by Seurat, Gauguin, and Van Gogh.

For is is quite clear that the older Symbolist masters – Puvis, Redon, Carrière, Moreau – were more interested in poetic ideas than in artistic form. They expressed their emotions by prefigured formulas and with the help of themes taken from legend or history. Strictly speaking, they were eclectics, the last survivors of the classical tradition of figure painting, into which they merely incorporated their longings for the supernatural. They did not create a new formal vessel that could hold the new contents. Having in advance rejected the advice of Courbet and the Impressionists to attack the things of nature in an entirely new way, directly 'from below', they did not undertake the necessary analysis of the visible, which demonstrated form to be the spiritual essence of reality. Shadows of old traditions disturbed their vision and made them look for ideas where they should have looked only for form. Only during the transitional period around 1890 could their faded idealism be mistaken for a promise of the future.

At bottom the important question was how the ideas of the new painters would gain in breadth and react a wider audience. There are many threads connecting them with Symbolism. As early as 1886, the critic Fénéon, one of the leading younger essayists in the Symbolist group, had taken up the cudgels for Seurat and Gauguin in one of the numerous Symbolist magazines, *La Vogue*. In the classical Symbolist magazine, *Mercure de France* (founded in 1890) Aurier published the first article on Van Gogh. And from 1891 on, the *Revue Blanche*, closely connected with the Mallarmé group, was the militant organ of the young artists of the Pont-Aven group and of the Nabis, who derived from it.

*The Aura of Gauguin*

The personality and theories of Gauguin unleashed an aesthetic revolution in the Symbolist milieu. 'The Symbolist crisis favoured the spread of Gauguin's ideas to such an extent that they brought about a renewal in the applied arts – decorative painting, the minor arts, poster painting, and even caricature' (Denis).

A milestone in this violent reaction against Impressionism was the exhibition organised by Gauguin and his disciples on the occasion of the *Exposition universelle* of 1889, at the small Italian Café Volpini. This group, which called itself 'Synthétiste', included Gauguin, Bernard, Laval, Moret, Anquetin, Schuffenecker, De Monfreid, that is to say, the Pont-Aven painters and their friends. Gauguin with seventeen entries and Emile Bernard with twenty-three had the lion's share of the exhibition, which followed Gauguin's rule of thumb: expressive intensification of colour, simplification of forms. What most of all struck the young painters of the time was the deformation of the drawing, the arrangement of the colours in large planes, the expressiveness of the figures, which bordered on caricature. The art terms that the painters of Pont-Aven used to characterise their aesthetics, all of them designating formal aspects of the new movement were heard on all sides. 'Synthetism' was a favourite word, often used by Gauguin: it meant concentration and simplification of form, aiming at the most pregnant expression of an idea. Bernard claimed to have invented 'Cloisonnism', which consisted in surrounding the colour surface with a heavy dark contour that enhanced the expressive movement of the line as well as the glow of the colour, and produced an effect similar to that of medieval enamel and stained glass. 'Japanism' pointed to the kinship of

the new, boldly simplified decorative colour areas with East Asian prints. 'Idéisme' suggested that the painter took an expressive idea as his starting point. 'Neo-Traditionalism' – the term was coined by Maurice Denis when he was barely twenty – evoked the movement's connection with the oldest traditions of Egyptian, early Greek, Gothic, and folk art, at the same time associating it with the Neo-Impressionist decorative tendencies. The character of these tentative terms makes it quite evident that they were not coined by mystics and 'painters of the soul', but by painters of land-scapes and still lifes who were only gradually drawn into the contemporary current of ideas, and later, because of their connection with the poets, came to be designated by the overall term 'Symbolists'.

Symbolist critics, such as Albert Aurier, immediately associated the formal tendencies of the ex-hibits at the Café Volpini with the Symbolist principle that 'in nature, each thing is but a signified idea'. Thus men like Aurier regarded Gauguin, Moreau, Puvis de Chavannes, and the English Pre-Raphaelites indiscriminately as 'Symbolists'. This classification was superficial, literary, and unacceptable to painters: for the purpose of the new painters was not to evoke states of mind by representing a definite subject, but to convey the emotion aroused by an impression and to give it permanence through the pictorial structure itself. This conception characterised the gulf between Odilon Redon and Cézanne. Both sought pictorial equivalents for their emotions – Redon proceeded subjectively by giving pictorial expression to dreams and ideals, Cézanne objectively, by translating given sensory and emotional data into pictorial elements. But both expressed themselves – so it seemed to their young contemporary Maurice Denis – 'by resorting to a method which aimed at the creation of a concrete thing that is simultaneously aesthetic and representative of a sensibility'. This accounts for the great esteem in which *both* Cézanne and Redon were held by the younger generation. Paul Gauguin now seemed to reconcile the two diametrically contrasting procedures, and for this reason it may be said that the next generation lived in his aura. Denis says that for 'our age' he was 'a kind of Poussin without classical culture, who, instead of serenely studying antiquity in Rome, sought stubbornly to discover a tradition underlying the crude archaism of Breton Calvaries and Maori idols'. It was in the aura of Gauguin, who carried on his own ex-plorations among the Kanakas, far from Paris, that the new generations of artists founded their groups.

*The Nabis*

Gauguin's gospel was: 'Art is above all a means of expression'. His apostle was Paul Sérusier. In 1888, while a student at the Académie Julian, he went to Pont-Aven where he fell completely under the influence of Gauguin. Upon his return, he preached Gauguin's gospel to his fellow students who still looked upon Bastien-Lépage and the other realists as heroes. A number of his friends who shared his spirit of revolt against official art formed a group round him. They were Denis, Bonnard, Vuillard, Ibels, Ranson, and Roussel, who called themselves 'Nabis'. They were enthusiastic about the exhibition at the Café Volpini. Late in 1889, Sérusier joined Gauguin once again at Pont-Aven, and in 1890 painted with him at Le Pouldu. In the spring of 1891, a moving celebration was held at the Café Volpini, the meeting place of the Symbolists, on the occasion of Gauguin's departure for Tahiti. Sérusier was never to see Gauguin again.

Paul Sérusier came from a Catholic background, but later, under the influence of the Symbolists, took up theosophy for a time, seeking 'to take wing to the forbidden stars of absolute truth' (Aurier).

He had small talent as a painter, but he had a systematic, philosophical mind. He studied Plotinus and Schopenhauer, and at Pont-Aven he was infected by the starry-eyed idealism of Gauguin's group. He arrived at a sort of doctrine of redemption by combining Schuré's theory of a great universal soul, the source of spiritual light and intuition,with Gauguin's credo that painting aimed at a reality higher than sensory perception. He returned to his friends at the Académie Julian as a prophet, bearing a landscape sketch that he had painted on the lid of a cigar box and that Gauguin had retouched. It was forthwith named 'the talisman'. The friends met at Ranson's studio. To mark the esoteric character of his group, Sérusier called it 'the Nabis' (a Hebrew word meaning 'seer'). Surrounded by Denis, Vuillard, Bonnard, Roussel, Verkade, Maillol, Ranson, and a little later, Vallotton, Sérusier gave talks on esoteric and idealist philosophy and literature, on Plotinus and Pythagoras, and on proportion and the golden section, always with an eye to Gauguin's art. He made much use of the terms 'synthetic', 'symbolist', 'decorative', and illustrated his talks with Japanese prints, mediaeval stained glass, Italian primitives, and works of Cézanne, Redon, and Puvis de Chavannes. Cennino's treatises on painting were studied as the revealed word of the spirit of the 'pious Primitives'.

Sérusier's doctrine, which he later summed up in his little book *ABC de la Peinture,* systematises Gauguin's intuitive insights. Nature, he says, cannot logically be regarded as a model for art, since countless optical and psychic factors always transform nature into a mental image. To paint, consequently, is to correlate forms, suggested by such images, on a chosen surface. Numbers and proportions result in balance, 'without which no living creature could exist'. Horizontals and verticals, which according to this theory are pure creations of the mind and do not occur in nature, are the visible signs of this balance. Colour, which since the Renaissance had been subordinate to the 'valeurs' and the effects of light and shade, must be restored to its supremacy, for its harmonies made of pure and refracted tones are 'the new equivalent of light'. 'Art is a universal language which expresses itself in symbols.'

Sérusier aspired to a serious art based upon religious ideas, characterised by firm, simple drawing and expressively decorative colour. About 1895 Verkade acquainted Sérusier with the strange mathematical canon that had been developed by Father Desiderius Lenz of the Benedictine school of painting at the Beuron monastery. Thereupon Sérusier attempted to bring his own research on numbers and proportions into conformity with the 'sacred proportions' of the monks of Beuron, and to express the 'rhythm of the godhead' and 'absolute beauty' in simple numerical proportions. He believed that the works of the German and Italian Primitives were based on a mathematical canon of this kind; at the same time, like the monks of Beuron, he regarded the numerical proportions embodied in Egyptian and Greek art as 'the key to the house of ideal art'. In 1897 he met Desiderius Lenz at Beuron, and in 1898 translated the latter's 'On the Aesthetics of the School of Art at Beuron' into French. Through Maurice Denis, these ideas profoundly influenced the French Art Sacré.

Maurice Denis was introduced to the aesthetics of Gauguin's Synthetism by Sérusier. Gauguin's art suggested this significant question to him: 'If a tree which seemed to us very red at a given moment may be painted in pure purple, why can we not, by pictorial exaggeration, transcribe impressions that justify the poet's metaphors? Why not emphasise the curve of a beautiful shoulder to the point of deformation, why not exaggerate the shimmering white of a complexion, etc.?' Starting from such experiences and ideas, he arrived at his *Definition of Neo-Traditionalism* (published in 1890 when he was twenty years of age) in which he advanced bold principles far in advance of his time. The very first sentence reads: 'A picture, before being a war horse, a nude woman, or some anec-

dote, is essentially a flat surface covered by colours arranged in a certain order.' Art expresses human emotions and ideas by their aesthetic counterparts, by equivalents of beauty. Consequently, the artist is subject only to the laws of pictorial expression. He is free to use any kind of deformation. The work of art is a 'synthetic' expressive symbol of sensory impression and at the same time a clarifying transcription of that same impression as well as an independent reality pleasing to the eye. 'To stop reproducing nature and life by approximations or improvised visual illusions, but on the contrary to reproduce our emotions and dreams by representing them in harmonious forms and colours – this is the new approach to the problem of art.' The theme or bit of nature represented is but an occasion for a creation of the human mind. When the mind turns to high and sacred things, art becomes a transfiguration of nature.

To Denis, an orthodox Catholic, this theory held the promise of a restoration of religious art. It was at this point that the mysticism of numbers as practised by Sérusier and the monks of Beuron entered in. 'There is such a thing as a correspondence between the harmony of forms and the logic of dogma . . . All great artists have created in accordance with measurement, number, and weight; in this they imitated God.'

The basic conception of this fully developed new theory of expression culminated in the assertion that 'the impressions or psychic states released by an optical spectacle in the artist's mind generate signs or pictorial equivalents which can reproduce these impressions or states without necessarily copying the initial optical spectacle . . . every state of our sensibility is matched by an objective harmony that is capable of transcribing it.'

Denis attached great importance to the notion of *gaucherie*, or naive artlessness. In his detailed historical survey, in which he portrays himself and his Nabi friends as disciples of Cézanne and Gauguin, and expresses his conviction that the Nabi revolt in the Julian studio merely continued the earlier revolt of Van Gogh, Toulouse-Lautrec, and Bernard in the Cormon studio, he speaks of *gaucherie* as the original contribution of the Nabis: 'To the bold innovations of the Impressionists and Divisionists – whose influence made itself very much felt in the exhibitions of the Indépendants around 1890 – we newcomers have added artlessness of execution and forms simplified almost to the point of caricature: just that was Symbolism. In terms of subject matter, too, the Nabis wanted to go back to the simplicity of art's early beginnings, when its decorative and religious functions were taken for granted. On the basis of these ideas, Denis in 1919 founded his *Ateliers d'art sacré,* which strongly influenced Christian religious art throughout Europe.

*The Influence of the Nabis*

In 1891 the art dealer Le Barc de Boutteville opened a new gallery with an exhibition entitled 'Impressionist and Symbolist Painters'. Among the visitors were Mallarmé, Redon, and Puvis de Chavanne who congratulated the young Symbolists. The works shown were those of the Pont-Aven School and its Paris offshoot, the Nabis – Bernard, Bonnard, Denis, Sérusier, Vuillard. Gauguin was represented as well as the outsider Toulouse-Lautrec; there were also a number of works by the Neo-Impressionists Signac, Cross, Luce, and a few canvases by Impressionists of the old school. The public was disconcerted by the passionate rejection of naturalism, which was evident in all the exhibits of the younger painters. These painters were less interested in their subjects than in decorative effects, harmonious arrangements of forms and colours, bold arabesques, and expressive surfaces. Their frequently violent simplifications had a primitive ring, which were curiously reminis-

cent of the Gregorian chants that had recently been introduced at Notre Dame. The technique of short brushstrokes was in the best Impressionist manner, but the rigorous structure, the large areas of colour, the emphasis on the right angle, and the play of decorative arabesque on the surface were very different from Impressionism. The overall decorative tendency was particularly evident in Denis and Sérusier, who combined it with a compositional method that could almost be called archaic, recalling the *Quattrocento*, and pointing to Pre-Raphaelite influence.

At this showing two very young but highly talented painters – Pierre Bonnard and Edouard Vuillard – made their first public appearance. Both had moved that year (1891) to a studio they shared with Denis, and belonged as a matter of course to the Nabis. But while Denis was significantly baptised by his friends 'the Nabi of the beautiful icon', Bonnard was nicknamed 'le Nabi Japonard'.

Pierre Bonnard (1867-1947) was a born painter, endowed with extraordinarily keen vision. He was a lover of rich effects, subdued harmonies of subtle colours with warm luminous contrasts and cool complementary blues. He was enchanted by Renoir's delicate pigments and the vibrant surfaces of Monet's late period. He wanted to render these effects in terms of the two-dimensional surface, which he conceived of as the vehicle of pure painting. Gauguin's work provided him with his starting point, and Sérusier and Denis with the theoretical foundations to which Bonnard, the former law student, attached great importance. But he attached less importance to archaism and primitivism than to the decorative perfection of the Japanese woodcuts. Moreover, the ornamental and sensitive linear art exemplified in English book illustration and minor arts, which had been steadily gaining popularity among painters in Paris, seemed to him artistically superior to Gauguin's harsh archaism. He sought to infuse a 'style' into his glittering Impressionist surface by adopting the flat compositional design used by Japanese artists, in which line performed the function of a formal arabesque rather than of a contour or boundary. This function was now taken over by colour, but where colour areas met, their wavy boundaries imparted their vibration to the whole surface, producing a sumptuous overall effect of great expressive power.

Bonnard's friend Edouard Vuillard (1868-1940) was similarly oriented, and perhaps even bolder than Bonnard in his disregard for the traditional box-like pictorial space. Treated with a freedom to which even Japanese artists rarely aspired, the natural forms are integrated with the flat ornamental design. A closely woven tapestry-like pattern gives rise to a firm architecture, clearly articulated into planes and colour areas. Verticals and horizontals – Vuillard was even more given to right angles than Bonnard – lend structural solidity to the pattern, within which the arabesque is given free rein. The rigorous structure, which owes a good deal to Seurat, lends the warm sonorous colour ensemble a quality of quiet intimacy.

Both Bonnard and Vuillard were magnificent painters of keen sensibility, little concerned with the 'literary' aspect of painting or with the religious ideas that Denis wished to express in the new decorative style; they wanted to paint works that would feast the eye. For this reason they focused upon the surface, the vehicle of pictorial harmony. Much as they owed to the Impressionists, they were Impressionists no longer because they used the motif only as a pretext, their actual purpose being to produce a sumptuous ensemble and a sonorous décor. Their works show the influence of Monet's late period. Because he had concentrated on filtering coloured surfaces from things and their reflections, Monet had missed the mark – an expressive art – and produced a fairyland instead. Vuillard and Bonnard took the right direction, but perhaps they did not go far enough; they stopped at the sonorous décor. But it was so rich and dense that only one step forward was needed – the step taken by Henri Matisse, for example – to discover the expressive structure beneath the richly embroidered tapestry.

Another Nabi who soon rose to prominence was Félix Vallotton (1865-1925). More a draughtsman than a painter, he went beyond *Japonisme* and came close to the so-called modern style of the English applied arts. His illustrations for books and periodicals met with immediate success, and his woodcuts and illustrations, published in the *Revue Blanche*, beginning in 1894, greatly influenced the development of the woodcut and of the Jugendstil illustrators.

Symbolist writers saw their own theories reflected in this school characterised by large decorative surfaces, free-flowing arabesques, expressive equivalents of form, and idealistic composition, and looked upon the Nabis as the young generation of pictorial Symbolists.

*The Revue Blanche*

In 1891, these painters acquired their most important organ in the *Revue Blanche,* which became the gathering place of all the young rebels against convention. 'The word Symbolism,' said Rémy de Gourmont, 'is generally interpreted as freedom. The more violent young men translate it as anarchy.' Along with the contributions of famous Symbolist writers (and such future celebrities as André Gide, Léon Blum, Marcel Proust, Paul Claudel, Francis Jammes, and Alfred Jarry) the *Revue Blanche* published drawings and illustrations by the Nabis. In 1893, it ran lithographs by Bonnard, Vuillard, Denis, Ranson and Roussel, and in 1894 by Vallotton, Sérusier and Toulouse-Lautrec. Bonnard, Vuillard and Toulouse-Lautrec designed covers and posters for the magazine. Its art critics favoured the Nabis almost exclusively. Félix Fénéon, who became editor in 1894, had come out in defence of Seurat and Gauguin years before, and considered himself the legitimate mentor of the new movement. Beginning in 1891, small exhibitions were held in the office of the magazine, consisting mostly of works by the Nabis. The *Revue Blanche* was the birthplace of a new style of illustration, which gained wide influence; its most characteristic masters were Bonnard, Vallotton, and Toulouse-Lautrec.

The editorial offices were the centre of a lively intellectual movement that acted as a magnet. Toulouse-Lautrec was a daily visitor and the young painters were vastly amused by his sarcastic sallies. One day a taciturn guest from the North made his appearance: Edvard Munch. Later on, the Belgian Henry van der Velde attracted a good deal of attention in the group. Previously a follower of Signac, he had transformed the arabesques of Seurat and Van Gogh into a tense original ornament. He was also a devotee of the English arts and crafts movement. In 1899, he decorated the new premises of the magazine.

The *Revue Blanche* continued publication until 1903. It published the most influential writers of the late nineteenth century: Ibsen, Björnson, Strindberg, Hamsun, Peter Altenberg, Maximilian Harden, Arno Holz, as well as Oscar Wilde, Bakunin, Gorki, and Marinetti, while the publishing house connected with it printed (side by side with Lao-Tse) the works of Gide, Jarry, Julien Benda and Max Stirner. It was the *Revue Blanche* which enabled the ideas of Gauguin's disciples to exert the broadest influence and create a spiritual climate in which the greater insights of Cézanne, Van Gogh, and Gauguin, could assert themselves, free from decorative veils.

For this epoch which displayed an unprecedented interest in the applied arts, demanding that art be brought closer to life, it was only natural that 'the decorative element' should come strongly to the fore. For this we should be thankful, because the same group of artists, rejecting the complicated apparatus of the realistic theatre, created the new stage. In 1893 Bonnard, Vuillard, Denis, and Sérusier designed costumes and sets for the Théâtre de l'Oeuvre, founded by their

friend Lugné-Poe and supported by the *Revue Blanche.* That same year it produced Ibsen's *Rosmersholm* and Maeterlinck's *Pelléas et Mélisande.* In 1894 Vuillard decorated the home of the Natansons, founders of the *Revue Blanche,* in the new style. In 1913 Vuillard, Denis, and Roussel designed stage sets for the Théâtre des Champs-Elysées. Vuillard's great decorations for the Palais de Chaillot in Paris (1938) and for the palace of the League of Nations in Geneva (1939) belong to the same tradition, as do the great religious murals executed by Maurice Denis in Geneva in 1914 and 1917. All these works reflect the artistic conceptions of these pupils of Gauguin, who sought to get away from easel painting and return to murals. They believed that painting should become the handmaiden of an integral art, and that its task was to 'decorate' walls rather than produce pictures to be hung on them. For the same reasons, some artists took up tapestry; in 1894 Maillol, who was at the time still a painter and who in 1893 had been brought close to the Nabis by his admiration for Gauguin, wove tapestries – as did Paul Ranson. Toulouse-Lautrec and Bonnard created the new poster. Valloton was one of the initiators of the new 'artistic woodcut'. Bonnard created the modern illustrated book: in 1898 he was commissioned by Vollard to illustrate Verlaine's *Parallèlement,* which was followed by *Daphnis and Chloe* (1902) and Jules Renard's *Histoires naturelles* (1904). In 1903 Denis executed more than two hundred woodcuts illustrating Vollard's edition of *l'Imitation de Jésus-Christ.*

It is true that in this period decoration threatened to crowd out all other strivings in art; however, it brought the widespread realisation that painting no longer had anything in common with naturalistic reproduction. The reconquest of so-called decorative values essentially implied the assertion that art had an anti-naturalistic function. This was a climate favourable to all sorts of developments, for one thing to the art of Toulouse-Lautrec.

*Henri de Toulouse-Lautrec (1864-1901)*

Physically a cripple, this scion of one of the oldest noble families of France was an intellectual aristocrat with a highly critical and independent mind. At Cormon's studio and in Théo van Gogh's gallery he met Seurat, Gauguin, and Van Gogh, and shared many of their ideas and enthusiasms – for Japanese prints, for Cézanne, for Degas. In the offices of the *Revue Blanche* he met the Nabis. He liked Bonnard, but he loathed the ravings of the painters who called themselves 'seers', just as he loathed Van Gogh's irrational enthusiasms, Gauguin's sentimental proletarian tirades, and Seurat's scientific methods. He took from them only what was useful for his own aristocratic games. These he carried on for himself alone, apart from all artistic cliques, in his hermitage on the loneliest hill in the world, Montmartre.

He was first and foremost a gentleman – crippled, to be sure, deformed, a physical wreck, living in the shadiest surroundings – but by virtue of his blood a member of the highest social class. This may explain why he became a painter of 'society' – the most abstract form of the 'natural' organisation of the environment. This descendant of generations of counts was too far removed from nature to respond to landscapes or still lifes. Was he then – like Puvis de Chavannes – to paint Muses and their dances on Mount Parnassus? The Parnassus of his time was Montmartre. There the Muses danced in an up-to-date style. There 'society' provided the raw material for a pictorial form compounded of expressive gestures, physiognomies, and the atmosphere of the cabarets. In the magic realm of Montmartre the utmost realism and the most fugitive dream of life were to be found side by side. At the Folies Bergère and the Moulin Rouge contemporary

45

Maenads stamped their feet in dancing the can-can and the pipes of Pan could be heard amid a froufrou of lace panties. At the Cirque Fernando, so beloved of Renoir, Degas, and Seurat, athletic prowess freed itself from the trappings of the sports contest and stood there as a pure formal figure – in the human pyramid, in the trembling balance of the tight-rope-dancer, in the acrobatics of the clown, or the fragile arabesque of the equestrienne. In these playful forms society disclosed a style that could be recorded in formal terms. Far from the hackneyed traditional metaphors, fashion and yearning, reality and artistic exaggeration were woven into a visible dream world which in its actions and symbols embodied man's here-and-now, the purely ephemeral aspects of his vital dynamism.

Here society underwent a metamorphosis into expression, and that is what Toulouse-Lautrec took as his subject matter. Whereas Cézanne and Van Gogh attacked the world of things and disengaged their expressive forms, Toulouse-Lautrec set out to capture the world of people in their most stylised aspects and most transient gestures. As fanatically realistic as Cézanne or Van Gogh, he chose a different raw material – the stylised self-expression of man – and distilled its expressive formula. He was exclusively a painter of 'society' – not to be confused with a painter of fashionable society aiming at realistic portrayal of a given social attitude towards life, but rather a painter interested in the artistic reflection of society, in reflected images which in themselves were already highly expressive. What Cézanne and Van Gogh did in respect of things, Toulouse-Lautrec did in respect of man. He was the first painter of contemporary society after Tiepolo; this place belongs to Toulouse-Lautrec alone, although it must be remembered that Manet, Daumier, and Guys had taken steps in this same direction.

This accounts for Toulouse-Lautrec's seemingly perverse sympathy for the milieu in which he lived. This world of entertainment, dance, sexuality, was a mirror of the dreams of contemporary society, and it enabled him to reproduce society with its traditions, its gestures, and even its family spirit. The fact that Toulouse-Lautrec spent a long period in a famous *maison close*, where he lived in state, surrounded by the *pensionnaires*, shows that he had an entirely unsentimental sense of family life; it also shows to what extent Toulouse-Lautrec was at home in this looking-glass world.

He was a painter of figures: 'Only the figure exists. Landscape is merely accessory and should be no more.' This reflects the ideas of his time. Even Cézanne and Van Gogh shared this propensity for the human figure. Cézanne held that 'the figure is the consummation of art'; Van Gogh said, 'Figures, always figures' – and the same is true of Gauguin. But they did not take the models for their figures from contemporary society. Their models were things, landscapes, and man in them. The figures they painted lived in the shadow of Poussin, Millet, or the Polynesian gods. Toulouse-Lautrec's great innovation consisted in treating 'society' as a whole realistically, without sentimentalism or reminiscences of museum works. Montmartre was his landscape, which he expressed exclusively in terms of human physiognomy. He approached it with the penetrating eye and the passionate fervour which Cézanne and Van Gogh brought to things. His eye transformed everything into facial expression and gesture. This was the material from which he extracted his arabesque.

The lorgnette of this nearsighted dwarf concealed the eye of a hawk. For forty nights running, he watched la Lender, intent on capturing a certain bolero step. He could not be torn away from the footlights when Yvette Guilbert, who loathed the 'little monster', bowed to the public. He clung to his raw material, he was inseparable from the famous dancers of the Moulin Rouge – Jane Avril, Louise Weber surnamed La Goulue, Grille d'Egout, Nana la Sauterelle. He was there when La Goulue let loose her famous lines at the Elysée:

Ah! Mesdames, qu'on est à l'aise
Quand on est assis sur la chaise
Louis XIII.

He had the patience of a hunter. For the seemingly so casual portrait of his bosom friend Maurice Joyant, who, it might be mentioned, was Théo van Gogh's successor in Goupil's shop, he required fifty-seven sittings. Paul Leclercq tells us how he worked: 'He aimed his lorgnette at me, wrinkled his eyes, picked up his brush, and after seeing exactly what he wanted to see, he applied a few dabs of thin paint to his canvas. Then be put down his brush and declared: "That's enough for today!" And we went for a walk in the *quartier*.' Manual effort was of little importance; the main thing was to let the mind work. Seeing is a critical activity of the mind; it consists in selecting and discarding, in distilling the essential; it makes things not massive but light; it does not add, but subtracts. The actual execution, the painting or drawing, comes only at the very last, and the work is performed with such ease that the result gives the impression of being accidental. Reality has been transformed into an arabesque, a trace left behind by the critical mind which in the visual world ferrets out an expressive sign and responds to it. The result is a synthetic image, a striking figure, an essential feature or gesture which, conveyed to the surface, discloses the unique individual. Reality has become expression.

This critical abbreviation requires line, the flowing arabesque, which in turn requires the flat surface as its medium. The Japanese prints, Degas, and Seurat provided some of the means. The art circles of the time were well aware of the formal problems involved in the decorative surface. The aesthetics of the English 'modern style' in illustration and the decorative arts had become available to Toulouse-Lautrec at the right moment. He sublimated all these influences, spiritualised the decorative element, and isolated its essence. Thus his concise sign language achieved a maximum of suggestive force. It was this quality which in 1891 enabled him to produce the first modern poster – for La Goulue at the Moulin Rouge. With its terse appeal and ornamental surface, it was not only a striking innovation in the realm of publicity but also an enormous step forward in art.

Only a critical eye, looking at things from a vast aristocratic distance, could have compressed a mass of detail into so succinct yet graceful a figure. It was the eye of the dandy, the snob. The English gentleman of the *fin de siècle* had erected a way of life upon this attitude of critical aestheticism, this manner of looking at things from a distance. Moral and social values and the human responsibility they entailed were replaced by aesthetic considerations. In this conception of life the 'beautiful' was divorced from the 'good' and the 'true' and became the pure expressive value of life, an embodiment of the keenest awareness of being. Between birth and death, there was a transient energy called 'life'. It was essential to give this energy a maximum of opportunity for spiritual experience and enjoyment, 'that the flame of consciousness may burn as brightly as possible' (Walter Pater). The flame of consciousness! In it the impressions and experiences of the soul hardened into self-sufficient creation, images, verses, songs. Fan the ephemeral energy to white heat, and enduring aesthetic forms will emerge from the blaze. Only a concentrated life could produce a concentrated symbol. Thus the essential was not to prolong a watered-down existence, but to condense and compress it; that was the art of living: the haughty, masterful spirit raced headlong towards death. Here again we have the tragic conception of life, the aspiration to master the world by expressive form, that characterised the whole decade – but in this case, it was aristocratic, critically aloof, without despair. Walter Pater had thought out this view of life, Oscar Wilde had put it into practice. It assumed an almost exemplary significance for

intellectual Europe, so much so that, in reference to its conception of life, the period might be termed 'the English decade'.

This conception was engraved on the heart and mind of Toulouse-Lautrec. The French aristocrat became spiritually an English gentleman. He knew English as well as his native language. He loved London, he was a friend of Oscar Wilde. He recognised himself in the English aesthetics and literature of the time and found inspiration in the intriguing, decadent, red-headed English *chanteuses* who were crossing the Channel in increasing numbers. The goings-on at the Moulin Rouge were like a boisterous country fair by comparison. The hooves of the chorus girls, the heels of La Goulue tapping out the can-can, brought to mind the galloping of sturdy mares. And now May Belfort made her appearance. Dressed like a baby, in pink muslin and a lace bonnet, she sang old Irish and Negro songs in a little wispy voice, and delighted the audience with innocent sounding allusions such as:

> I've got a little cat
> I'm very fond of that.

With her kitten in her arms, she enchanted Toulouse-Lautrec at the Café-concert des Décadents. And then there was Loie Fuller, at the Folies Bergère. Wearing long iridescent veils, almost disembodied, she created an abstract arabesque. Dancing and leaping, she swept her veil across the stage, filling it with a whirling kaleidoscopic ornament. This was the ornament of the English modern style, the flexible Jugendstil arabesque. It accounts for Loie Fuller's tremendous popularity among aesthetes of the period.

Toulouse-Lautrec took it all in. The arabesque intrigued him because it translated movement and expression into pictorial tracery. English aesthetics opened his mind to the sensitive linear ornament of the English industrial arts. For the English gentleman who regarded life as a work of art saw to it that his objects of daily use conformed to the laws of aesthetics. This accounts for the supple chiselled ornamentation, the sensitive arabesque of the stylised *articles de mode* that were coming into fashion. In 1895, Toulouse-Lautrec, while visiting Oscar Wilde in London, met Aubrey Beardsley, the book illustrator whose 'decadent' linear art, which carried the Pre-Raphaelite nostalgic tendencies to the point of morbidity, demonstrated the expressive potentialities of decorative line.

With all its affectations, the English style was important to Toulouse-Lautrec – but only in so far as it opened up new possibilities. He could not directly adopt any of it. For all its elements were derivative, under the shadow of Florentine and Greek influences; the form remained anaemic. Anglo-Greek mysticism had devoured form and confined it to ornament. What point was there in conjuring up Lysistrata in drawing, when living Lysistratas were daily conspiring against the masculine world on Montmartre? French realism saved Toulouse-Lautrec from this world of shadows: like Cézanne, he always kept his eye on the world before him. He took from the English only what helped him in his own artistic task.

Toulouse-Lautrec's task centres on the human figure. He selected the most artificial material stylised by society. This was his model. By a series of decoding operations, he discovered its characteristic nature and transposed it into expressive arabesques and ornament. Material appearance was changed into spiritual reality. The most casual anecdote underwent metamorphosis into a permanent sign and entered the realm of the timeless as a self-contained form. In the architecture of his figures we still perceive the vibration of the gesture pulsating in time, because his penetrating eye discovered that even the most transient moment manifests itself pictorially

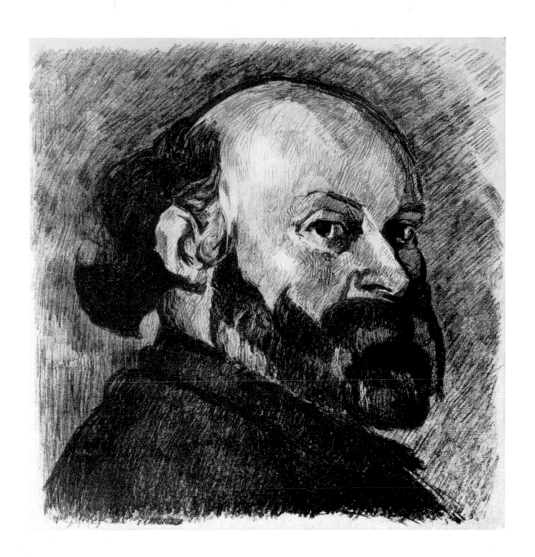

1. Paul Cézanne (Lithograph by Edouard Vuillard, 1914)

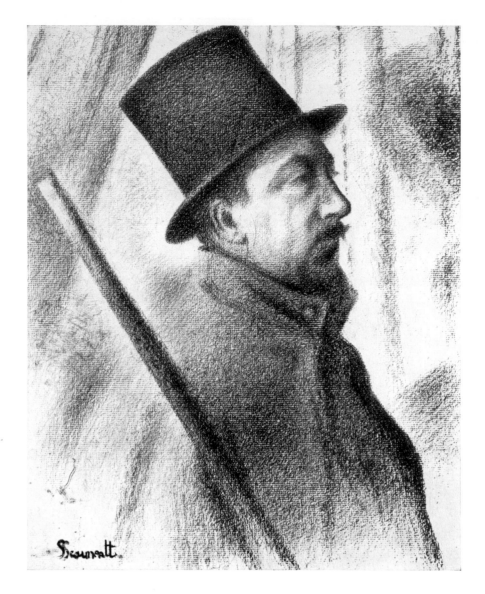

2. Paul Signac (Drawing by Seurat)

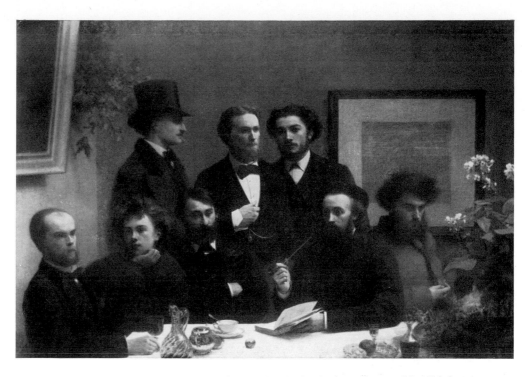

3. *Au Coin de Table.* From left to right: Paul Verlaine, Arthur Rimbaud, Eléazor Bonnier, Léon Valade, Emile Blémont, Jean Aicard, Ernest d'Hervilly, Camille Pelletan (Painting by Fantin-Latour, 1872)

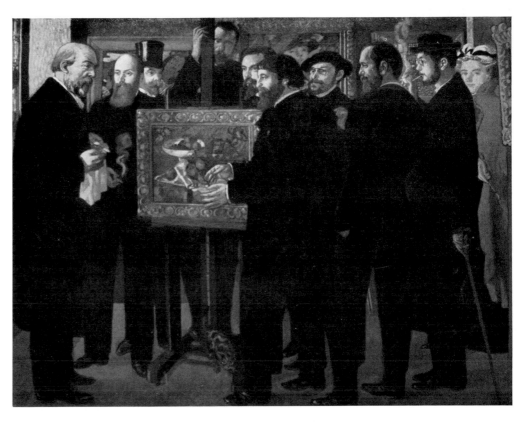

4. *Hommage à Cézanne.* From left to right: Odilon Redon, Vuillard, André Mellerio, Vollard, Maurice Denis, Sérusier, Ranson, Ker-Xavier Roussel, Pierre Bonnard, Marthe Denis (Painting by Maurice Denis)

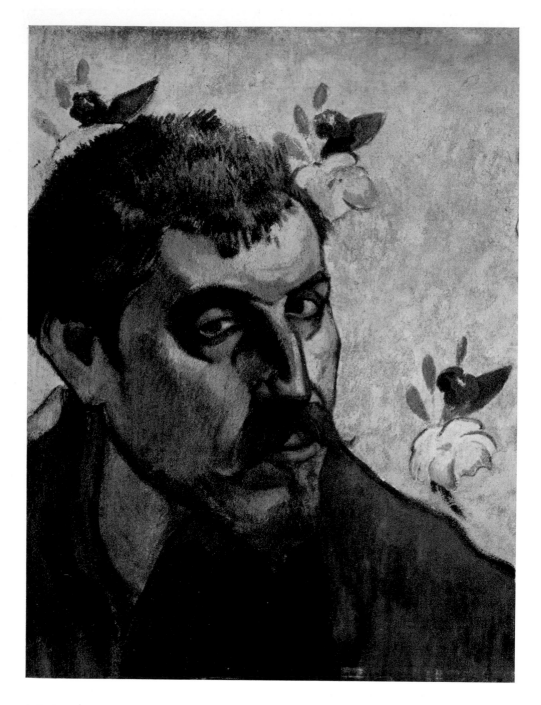

5. Paul Gauguin (Part of a Self-portrait *'Les misérables'*, painted for Van Gogh, 1888)

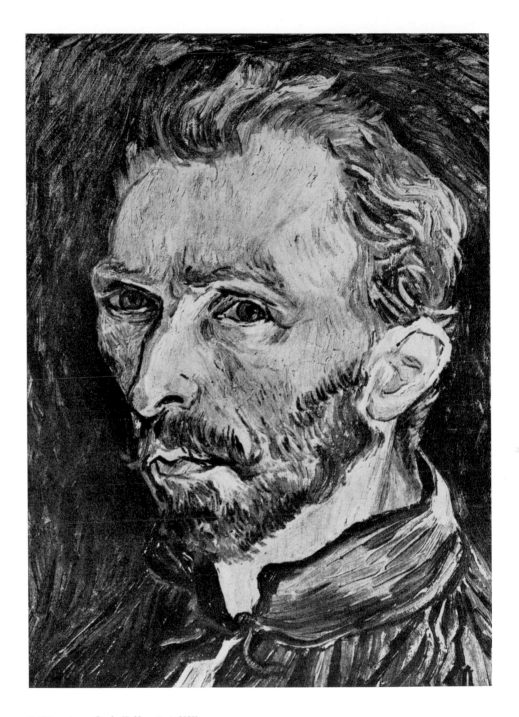

6. Vincent van Gogh (Self portrait 1889)

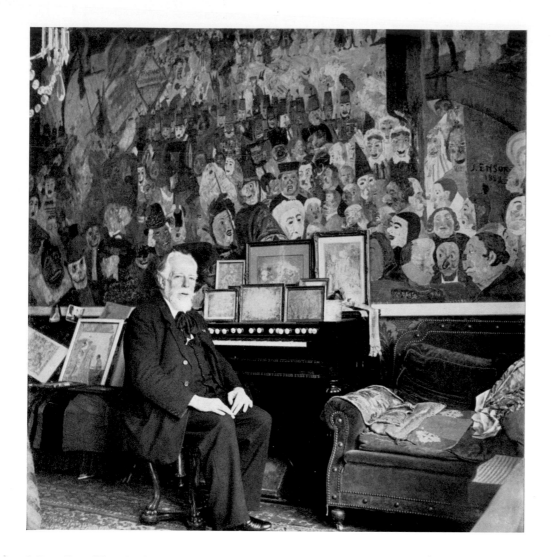

7. James Ensor (Photo Charles Leirens, Paris)

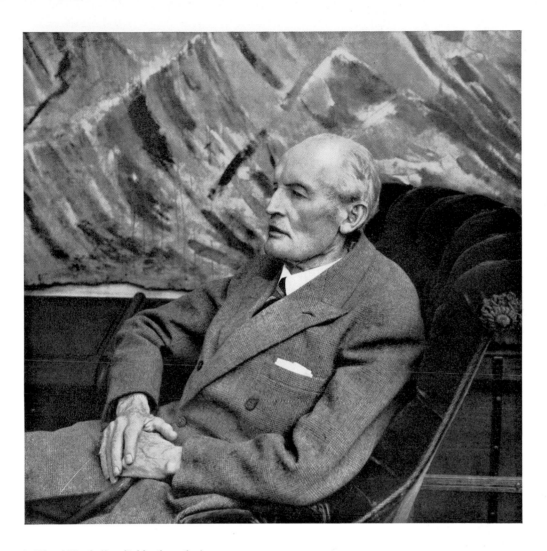

8. Edvard Munch (Supplied by the author)

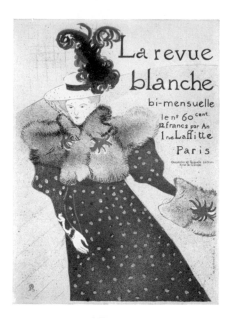

9. La revue blanche
   (Poster by Toulouse-Lautrec)

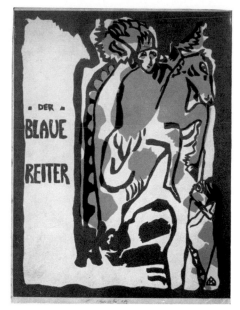

10. Der Blaue Reiter
    (Cover design by Wassily Kandinsky)

11. Der Sturm (Drawing for the cover by August Macke)

12. Cover for the periodical 'Dada'

as a spatial vibration and therefore can be reflected in the vibration of the pictorial organism. With Toulouse-Lautrec, even the figure in motion became a subject for the expressive painter.

### Balance Sheet of the Symbolist Decade

During the decade of French Symbolism, the new ideas broached by Cézanne, Gauguin, and Van Gogh came to be seen in a broader context. They were not developed or defined more exactly, but they were no longer isolated. They had acquired a philosophical background. The new conception of the object implied in the work of these painters now became accessible to a broader public.

Symbolism culminated in the idea that it was possible to distil a mental state from the object by means of a 'series of decodings'. In pictorial terms, this meant that the feelings aroused by objects call forth in the painter's mind pictorial equivalents which are capable of reproducing these feelings. This emphasis on feeling pointed to a clear shift of interest in favour of expressive values. Cézanne – though not Van Gogh and Gauguin – would have resisted this shift, keeping close to visible reality, which he regarded as his raw material. He took 'feeling' for granted. But the Symbolists regarded the new emphasis on feeling as the logical result of contemporary ideas. By carrying these ideas a step forward, they gained the vantage point from which they could see more clearly the limitations of Impressionism, Now the boundary separating Cézanne and his followers from Impressionism stood out with unexpected sharpness. It became clear that thanks to a more penetrating treatment of the object and new methods Impressionist realism had undergone an internal change into a 'meta-realism', and that the next task of painting was to develop methods for expressing and mastering the world. All the Symbolist painters stressed this logical result of the evolution of Impressionism. Only now were Cézanne, Van Gogh, and Seurat recognised as the founders of a new kind of painting, and their works drawn triumphantly from the dusty corners where they had been stored.

### The Situation in Germany

If we look eastward from this vantage point, it is as though after surveying a clearly articulated, sharply profiled, and brightly illumined plateau, we discovered a valley full of drifting mists, in which the shadows cast by the plateau can easily be mistaken for contours in the landscape. The swift advance of French painting from the classicism of Ingres and the Romanticism of Delacroix to Courbet's precise realism, the Impressionist exaltation of reality, and the consequent transformation of reality into meta-reality by the succession of painters from Cézanne to Toulouse-Lautrec – all this had no counterpart in Germany. Isolated individuals laboured in a shapeless cultural milieu which could not free itself from the gigantic shadow of German idealism. But even they did not penetrate to the object. This dominance of idealism is what distinguished Germany from France. German idealists do not treat nature directly, they stylise it. Because they laboured in the shadow of idealism, they did not develop an original pattern; they did not get to the bottom of things. Time and again, individuals broke loose. They glowed in the brightest light, but they soared high like rockets, and the shadows they cast added to the confusion; they did not propagate the calm, sharp, Cartesian light in which the ground of reality could be probed. Hans von Marées

and Leibl were both gifted painters who, following different paths, came very close to a vision of reality. But it suffices to compare Von Marées with Manet, or Leibl with Courbet to see how, in Von Marées' case, idealism, and in Leibl's, Romanticism threw everything into confusion and obscured the goal when it was already within reach.

This Romantic idealism is in itself a noble quality of the German spirit, and it asserts itself whenever Western man longs for clarification of the inner worlds, for images that rise to the surface from the innermost depths. At such moments, it opens vistas, points to goals, and illumines vast regions in which the singing, rhythmic, formal creations of the human mind have free range. This is its mission. It does not aim at play and form, it provides depth and background. But it works in a vacuum, and, to use a Freudian term, becomes narcissistic, giving itself profound prophetic airs in epochs when the mind divorces itself from old fantasies and tries to redefine human reality and its roots in the human imagination, by means of a new formal order. But the nineties were just such a period. The clear, non-idealistic French mind, intent on concrete reality, had defined this situation. The development begun by Courbet was continued by the artists who came after him and culminated in Cézanne. His conception of painting was a signpost erected at the frontiers of the world of objects, in the zone where they undergo a transformation. Securely grounded in form distilled from the visible world, it pointed to the unexplored region which could be made accessible by the expressive power of pure forms, and by them alone – the region of human expression. It was to this new situation that Germany was now called upon to respond.

*German Naturlyrismus*

In search of this response (and of nothing else), let us now descend into the misty valley during the critical years between 1890 and 1895. The official art of those years – the conventional heroic or Romantic-realistic painting of Makart, Piloty, Lenbach, Kaulbach, Böcklin – cannot be regarded as a response. Here and there timid voices arose, trying to say something about nature and the world of things. The influence of Courbet made itself felt but was soon drowned out by the more Romantic influences of Millet, Rousseau, the Barbizon school. This was the German Naturlyrismus which played an important part in the German mentality of the decade. From the very outset it was tinged by a Symbolist element, which came from Millet and Böcklin but also had literary sources, such as Björnson and Jacobsen. The movement had broader roots. It had connections with the Barbizon, the Scottish School of Cockburnspath, and the Breton painters. The works of these groups were shown at the Glaspalast in Munich in 1890. We have ignored the French variety of Naturalyrismus, because it was merely an offshoot of Barbizon Romanticism. In Germany the situation was somewhat different. The German feeling for nature was more fervent and intimate, a mixture of sentimentalism and true devotion. It was striving for expression. A glowing red sky over the moors, reflected in violet ponds, inspired strong emotions calling for expression by violent means. Birch woods, heaths, moors became symbols of overpowering feeling. The artists sought out primitive landscapes, of a grandiose simplicity, in which the drama of the rising and dying day was enacted in the simplest gestures.

The centres of this movement were small villages in the midst of moors or heaths, Dachau near Munich, and Worpswede near Bremen. Here in the midst of unspoiled nature gathered groups of friends who had fled from the pseudo-naturalism of the academies. Solitary artists such as Thoma or Kalckreuth had done much to inspire the movement. Fritz Mackensen (b. 1866) and Otto Mo-

dersohn (b. 1865), both natives of northern Germany, after studying at the Düsseldorf Academy and the studio of F. A. Kaulbach and Diez in Munich, went to Worpswede in the summer of 1889, and decided to stay there because they felt, as Mackensen said, that their sensibility 'could develop only through the wondering contemplation of nature'. They were joined in rapid succession by Hans am Ende, also from the Diez school in Munich, by Fritz Overbeck and by Heinrich Vogeler. By 1895, when the Worpswede painters exhibited their works as a group at the Glaspalast in Munich, Naturlyrismus had spread throughout Germany: many small groups had formed and the art-loving public had been won over. Mackensen was awarded the gold medal, and almost all the works exhibited were sold.

All the varieties of Naturlyrismus were devoted to the 'wondering contemplation of nature', but it was a contemplation dominated by 'feeling'. One look at nature, and it communicated a 'mood'. Feeling blunted observation. These painters of nature contented themselves with the traditional superficial optics. Things did not become formally transparent, they even remained rather conventional; the critical mind was simply submerged in waves of sentiment. This failure, however, concealed a certain advance. In stressing their psychic reactions to nature, these painters learned that its moods could be expressed without resort to allegory and mythological metaphors à la Böcklin, but solely through its objective features. They learned that the colours and forms of nature, the glow of the setting sun and beneath it the vast monotonous landscapes with their melancholy birches, evoked an emotional response in man, who consequently could suggest the whole range of his feelings in terms of these natural equivalents. Through them alone he was able to express himself. The method remained metaphorical, but if the colours were enhanced a bit, if the natural form was exaggerated or simplified, expression had greater weight. The expressive power of line and colour was discovered at the most obvious point, but it was discovered. The natural impression was transformed, if not into form, at least into poetry. Naturlyrismus here struck a vein which was more fully exploited by the early German Expressionists.

The painters of the Naturlyrismus movement had nothing in common with French Impressionism, with which they were even not acquainted. They were the legitimate offspring of the German Romantics, whom they outdid only in two respects – they came to grips with nature more directly, and they aimed at more violent emotions. Nature could occasionally assume an alien and terrible aspect, so that the lyrical veil of Romantic pantheism was torn, and man, left to his own resources, was confronted with an alien power, against which he had to assert himself. Here too the tragic outlook of the new decade made itself felt, permeating 'sentiment' with melancholy and a secret anxiety. Rilke with his extraordinarily sensitive mind detected this 'tragic' note in the paintings of the Worpswede school. 'We may as well admit,' he wrote in his book on the Worpswede painters, 'that landscapes are something alien to us, that we are terribly alone among trees that blossom and torrents that flow by. The farther back we go, the more alien and more cruel become the creatures we encounter. Thus we become convinced that in the background we shall find nature, the most cruel and most alien of all.' Thus the candid, belated German naturalism of Leibl, Thoma, and Schuch produced a legitimate offshoot which began to invade the realm of expression.

*German Impressionism*

There was still another current which from the standpoint of European art can be dealt with only briefly: German Impressionism. It would be beyond the scope of this book even to outline the

genuine independent contribution of German Impressionism or to do justice to its importance in giving free rein to artistic temperament and technique. At the turn of the century it had considerable influence in Germany, though this was soon restricted and overshadowed by the impetus of French Post-Impressionism, which now reached Germany directly. The German Impressionists achieved no influence outside Germany. Since the purpose of this book is to define the European stylistic pattern regardless of national particularities, we must content ourselves with a brief survey.

Impressionism came to Germany fifteen years late; the Germans merely took over the French method by way of the Dutch 'pleinairists' Jongkind and Israels who somewhat watered it down. Not until 1900, when the influence of Manet asserted itself more strongly, did the German Impressionists cast off the remnants of Naturlyrismus derived from the Dutch and the Barbizon schools and come into direct contact with Impressionist theories. But by then these same theories were under fire in France, so that the first French critique of Impressionism reached Germany at roughly the same time.

The most eminent representative of German Impressionism was Max Liebermann; its centre was Berlin, and its character was determined by the big city and the Prussian marches. The Prussian tradition of sober realism had produced Menzel, that keen, utterly unsentimental observer. Max Liebermann merely continued in the same direction. Berlin in the years of the great financial boom following the Franco-Prussian war was full of an optimistic faith in progress, technology, and ever greater opportunities for happiness. This was the atmosphere of Impressionism and the new Berlin was ripe for it. Max Liebermann came at the right time. If the advent of German Impressionism was attended by stormy controversy – resulting in a split of the Verein Berliner Künstler (1892) and the eventual formation of the Secession group in keeping with the classical technique of artistic revolutions – this may be explained, first by the propensity for polemics that characterises the press in every big city, and second, by the natural tension between the Imperial court – which championed tradition, ostentation, and idealism – and the self-confident young generation of the upper-middle class, which clearly discerned the spiritual affinities between Impressionism and democracy.

The scandal over the Secession was touched off by an exhibition of the works of Edvard Munch. But this was no more than a pretext: the artists of the Secession were actually uninterested in the new search for expression. The movement served almost exclusively as a forum for the new Impressionism, which was immediately taken up by the young generation. Inspired art dealers such as Cassirer soon took up cudgels for the new movement, and all painters who had any connection with Impressionism flocked to Berlin. These included the two other leading German Impressionists – Max Slevogt and Lovis Corinth. Thus the movement rapidly established itself although it seemed revolutionary. But it was revolutionary only from the German, not from the general European point of view; and it was victorious simply because it supplied a ready-made art to a social group that had been waiting for it. Thus it came about that down to the First World War, Impressionism enjoyed extreme popularity in the German capital and continued to be regarded as the latest fashion, a state of affairs that did much to prevent the newer ideas from maturing. Seen from this angle, German Impressionism was reactionary, and soon came to be regarded as such. Liebermann, Slevogt, and Corinth were excellent painters: but for all their incontestable intelligence, they were insensitive to the dynamic forces of the epoch and lacked the *esprit critique* which helps new ideas to take shape quickly and surely. Of these three painters, Corinth alone, with his impetuous temperament, found his way (in his late period) to a visionary Impressionism

which clearly reflects the influence of Expressionism. Liebermann, Slevogt, and Corinth were without doubt the most important German painters at the turn of the century, but we must conclude that, from the perspective of European art as a whole, they followed the wrong path. They were belated followers of French Impressionism. At the same time, second-rate artists came forward with ideas that correctly reflected the contemporary situation and were therefore important for the future.

*The Jugendstil*

These ideas came from the arts-and-crafts movement. They originated in a genuine revolution which started in England and affected the style of life all over Europe. This was a revolution inspired by an ethical conception: it aspired to save men from the industry and technology that were turning them into a 'great grey mass'. It aimed at giving beautiful craftsman-like form to objects of daily use in order to preserve the inalienable value of the individual. This reform movement had a broad philosophical background. In the realm of aesthetics, it was directed against historicism and its meaningless imitation of past styles. The incredible voracity with which the consumer goods industries absorbed styles from the Renaissance to Rococo had resulted in a ghastly mixture, culminating in the so-called 'studio style' of the nineties, a 'picturesque' jumble of all known styles. The English reformers had rebelled against this trend. They had developed an ornamental, decorative linear style of their own, which, instead of adapting artistic forms of the past, went back to natural motifs taken chiefly from plants. The linear patterns characteristic of this style reflected Pre-Raphaelite sensibility and were to some extent influenced by Japanese prints. In addition, the 'functional' character of the objects was stressed. Thus there arose, in the applied arts, a truly original style whose sensitive, elegant effects were in keeping with the refined aesthetics of the 'gentleman'. In the cultural climate of the Symbolist decade in Europe, to which English aestheticism lent a peculiar brilliance, this style became extremely popular. English decorative art and the ideas that inspired it were brought to France and Germany by the London monthly *The Studio* (founded in 1893).
The 'English style', as it was called, found favourable soil in Germany in the early years of the decade. Stifled by convention, academicism, and historicism, the German art world had been yearning for fresh air, and now the windows were opened wide. In 1895, Meier-Graefe founded the review *Pan* in Berlin; in 1896, the reviews *Jugend* and *Simplizissimus* were founded in Munich. The unacknowledged godfathers of these publications were the *Revue Blanche* and *Gil Blas*. The slogan *Aufbruch der Jugend* (Youth is on the March) had a magic effect, and the whole movement soon came to be known in Germany as Jugendstil. Like French Symbolism, it had anarchic features. It allied itself with German 'idealism', so that even its artistic expressions had a philosophical, almost religious character. Suddenly, the industrial arts were at the centre of public interest. In 1897, two exhibition rooms were reserved for them in the venerable Glaspalast of Munich. Earlier, in 1891, applied art had for the first time been exhibited as 'art' at the Champ de Mars in Paris. The well-made objects shown were the work of artists who, following in the footsteps of Rossetti, Burne-Jones, and Crane, 'had not been ashamed to design chairs and to bind books'. In 1895 a German named Bing opened his Galerie de l'Art Nouveau in Paris and, following the English example, commissioned artists to design rooms rather than paint pictures. 'In such a room I would see my soul everywhere as in a mirror,' wrote Hermann Bahr, the Viennese apostle of the Jugendstil in reference to Bing's gallery.

'To see the soul' – that was the essential. Here was a new vein of abstraction. The German idealists flung themselves into it without reserve. In 1899, Bahr put these words into the mouth of an 'artist': 'When I make a chair I pursue the same purpose as when I paint a picture or when a poet writes a poem – I want to communicate to others a feeling that has taken hold of me.' Artists had become aware of the possibilities inherent in abstraction, and of the 'music of colour' – a metaphor we have encountered in Gauguin. At that early date, Bahr looked forward to a public 'which no longer asks for the object, but is happy to listen to the music of colours. Why can we not learn to contemplate paintings in the same spirit as clouds in the sky?' Some of these statements may strike us as ludicrous but there can be no doubt that, for all its exaggerations and lack of clarity, German thinking had raised a number of significant problems which whilst present everywhere were not consciously and openly stated. The mere attempt to define the problems was useful. During the second half of this decade, Theodor Lipps attracted considerable attention among artists with a series of lectures at the University of Munich, dealing experimentally with the psychic effects of 'organised lines'. Endell, the sculptor and architect, wrote about the expressive potentialities of pure line and proportions. It was these ideas that led Hoelzel to develop his theory of the harmony of coloured forms. All this represents a parallel to the thinking of Gauguin and the Nabis.

The ornamental style which kindled these ideas was purely two-dimensional, its formal elements being based on line. At first (towards 1895), the linear ornament was developed from natural forms, partly under the influence of Japanese and English decoration based on plants. Otto Eckmann was the chief representative of this so-called 'floral style', which was also practised by Behrens, von Berlepsch, Erler, T. T., Heine, Leistikow, Pankok, Riemerschmid, and the sculptors Obrist and Endell. Eventually even this stylised nature came to be questioned. Eckmann himself went on producing ornamental motifs based on swans' necks, water lilies, vines, and wave movements; but in 1899 Muthesius, a champion of the new style, wrote: 'The periodicals that accompany our movement have condemned nature and plants. The centre of attention is now the so-called non-objective ornament, lines that "do not suggest any object". "Pure, beautiful form" – there, they say, is the art of the future.' Ornament became 'abstract linear ornament', and the 'floral style' found its competitor in the 'abstract style'.

The champion of the so-called abstract style was the Belgian Henry van de Velde, whom we have already encountered in the Neo-Impressionist circle round the *Revue Blanche*. Endowed with an exceptionally clear mind, he had abandoned painting for the applied arts, and his admirable ideas on modern interior decoration and the functional design of industrial products are influential to this day. He advocated the 'abstract style', because, in his opinion, stylised natural forms obscured and weakened the expressive force of line and colour. 'A line,' he said, 'is a force; it borrows its force from the energy of the man who drew it.'

This was in keeping with other ideas current at the time. Critics, but also such artists as Endell and Obrist, had been preaching in Munich (where Van de Velde was represented at the Secession exhibition of 1899) on 'the power of pure form over the human emotions', the analogies between painting and music, and the psychological eloquence of abstract forms. Clearly these ideas were in the air. An article published in *Pan* in 1897 runs: 'We must discover lines and colours which virtually contain the forms of reality. These are metaphysically far more real than the weak reflections of the essence, of the Platonic idea, which are adjusted to cerebral perception.' And contemporary satirical writers made facetious predictions such as the following: 'The time is coming when our public squares will be decorated with monuments representing neither men nor animals, but fanciful forms

that will fill all human hearts with drunken enthusiasm and unsuspected rapture' (*Jugend*, Aug. 12, 1898). Actually, the time was not far off when 'fanciful forms' – products of this intellectual milieu in Munich – were to supplant natural objects in the world of painting.

Thus the problem of abstract form was already in view in the German art world. On the basis of a study of Hans von Marées' work, Konrad Fiedler showed how a picture comes into being in the artist's mind; Adolf von Hildebrand investigated the problem of form in sculpture; Endell and van de Velde, soon to be followed by Hoelzel, were investigating the laws governing pure line and colour, the possibilities of expression inherent in them. These ideas were first applied in the ornaments and abstract decorations of the Jugendstil. It was in the relatively sheltered domain of the decorative arts that the first but resolute steps were taken to drop natural appearance in favour of abstract signs derived from the world of human expression. These radical ideas were the very typical response of German idealism to the aspirations of the decade.

In 'high' art, needless to say, they were applied more hesitantly. Combined with the parallel experience of Naturlyrismus, they led to a style of painting which might be called the 'Secession style' after the artistic groups that cultivated it most intensely. In Munich, the centre of the Jugendstil movement (which colonised Darmstadt in 1899 with Olbrich, Berlin in 1897 with Eckmann, Stuttgart in 1901 with Pankok, Weimar in 1902 with Van de Velde, and Düsseldorf in 1903 with Behrens) a number of *Jugend* illustrators formed the Die Scholle (The Soil) group, which typified the tendency to give deeper expression to the lyrical experience of nature by means of linear, decorative, and symbolic elements. The artists composing this group, all men in their thirties – Erler, Jank, Eichler, Feldbauer, etc. – attempted to combine Impressionist and Neo-Impressionist insights into the nature of colour with sweeping decorative effects, with a view to raising landscape painting to the monumental level and endowing it with a symbolic character. Stuck followed a similar path in figurative painting. These tendencies gave a new impulse to the Dachau school. The new Dachau artists – Ludwig Dill, Adolf Hoelzel, Arthur Langhammer – now sought flat ornament in the landscape of the moors; the silhouettes of objects provided a simplified expressive contour which served to capture and reproduce the emotion. All this was done very deliberately. Hoelzel, the most sensitive and intelligent of the Dachau group, began even then to experiment with abstract, ornamental figurations in black and white, seeking to discover the expressive possibilities inherent in this form, taking the same direction as Lipps in his experimental aesthetics and Endell in his theory of sculptural ornament. The secret goal was to spiritualise, accentuate, concentrate the ornament in such a way as to create a bridge from the applied or decorative arts to a new free domain, in which art would be pure expressive movement, a reproduction of psychic impulses by their equivalents in free coloured forms. This accounts for Hoelzel's slow but profound influence on the development of modern art in Germany, although he himself did not achieve freedm in treatment of harmonious coloured form until about 1925, in his late pastels.

These ideas had amazingly wide repercussions. Even among the sober-minded artists of Berlin, completely under the spell of Liebermann's Impressionism, a school of Symbolist Naturlyrismus formed around Leistikow, a friend of Eckmann, and Ludwig von Hofmann, who had studied in Paris and developed a decorative-idealistic, figurative style under the influence of Puvis de Chavannes. In Vienna, the new movement began abruptly with the founding of the Secession in 1897. It owes its specific features to Gustav Klimt, whose gift for assimilation was positively grotesque. Drawing upon the late period of English Pre-Raphaelitism, Jan Toorop's Belgian Symbolism, Mackintosh's Glasgow decorative style, and the Munich Jugendstil, he superimposed pompous decorative effects on the classical figurative style. In the words of Hermann Bahr, the official

critic of the Vienna Secession, he was motivated by a need for 'an intoxicating art, raging like a torrent of fire, and almost musical ... it is concerned with simple, pure, grandiose feelings, but seeks to express them by the most refined use of the most extreme artistic techniques'.

This 'Secession style', which at the turn of the century was generally accepted as the modern European style, was a strange mixture of Jugendstil, Naturlyrismus, and English decadence, combined with the distant influence of French Neo-Impressionism and Symbolism. In the caricatures of the time it is symbolised by a melancholy, long-haired, elegant Bohemian, living in a squalid studio, but tortured by a love of beauty and a striving to attain remote realms of the soul. He is surrounded by his paintings which show that he mistakes the rigorous composition of the Neo-Impressionists and their Pointillist manner for a method of creating phantasmagoria, and that he combines them ludicrously with 'soul noodles', as the linear ornaments of the Jugendstil were facetiously called at the time, and with a visonary 'daemonism' à la Stuck. Much as we may be repelled by the bad taste and lack of talent characteristic of those years, we must not overlook the extraordinary vistas they opened. A straight line leads from the 'abstract style' of the Jugendstil and the theories associated with it to Kandinsky's abstract painting, and – largely by way of Van de Velde and his functionalism applied to the common objects of daily life – to the new conception of architecture and the human dwelling developed by the Bauhaus, the world-famous research institute created by Gropius. Some of the crucial ideas that have revolutionised our visual environment were conceived in the period just outlined. But for lack of a genius capable of translating these ideas into artistic form, the idealistic aspirations of this period in Germany were largely confined to wishful thinking and theorising.

*Ferdinand Hodler (1853-1918)*

In the Central European Secessionist milieu, considerable influence was achieved by a vigorous Swiss artist – Ferdinand Hodler. He was born in Berne in 1853; in 1871 he entered the Ecole des Beaux-Arts in Geneva and made his debut with genre paintings in the conventional realistic manner. A trip to Spain in 1878/9 gave suppleness to his palette and made him receptive to the influence of a mild, well-mannered Impressionism. But his rough-hewn Swiss temperament, his propensity for primitive tragic feeling, deeply rooted in the life of the people and hence bordering on mysticism, drove him to abandon this intimate variety of Impressionism in favour of grandiose scenes and figures. He needed the primitive heroism of strong simple people. The popular legends celebrating the victorious struggles of a vigorous race against a hostile nature, the historical traditions and ancient costumes of Switzerland – here was the subject matter he was after. To describe this primitive strength, he resorted to simplification. A few large figures stand out as leaders of the chorus, expressing themselves in sweeping, exaggerated gestures. This slightly theatrical grandiloquence is set off pictorially by clearly marked, stylised contours and further emphasised by rhythmic repetitions. As a result there is little effect of depth; the important thing becomes the flat surface and the decorative element.

Thus Hodler's development ran parallel to the tendencies that were at the time gaining ground in Paris, and in 1889 he had the satisfaction of receiving a prize for his *Procession of Wrestlers* at the Exposition Universelle in Paris, and of being praised by Puvis de Chavannes. But he was still looking for a way of eliminating the realistic elements that interfered with his grandiose, decorative, heroic compositions. He went through a severe nervous crisis. His latent mysticism and

56

religious tendencies disturbed his mind and his robust vitality was undermined by dark visions. It was in this mood that he painted *Night* in 1890. It is a picture articulated by rigorous horizontals and verticals and simple planes: sleeping figures arranged in parallel rhythms; over one of the figures hovers a dark phantom, symbolising the night and death.

This was the break-through. In 1891 Hodler spent several months in Paris where he became enthusiastic over the pictorial conceptions of the Gauguin group and the new treatment of colour advocated by the Neo-Impressionists. Now this painter given to melancholy broodings and befogged by wildly Romantic ideas plunged head over heels into the Symbolist current, came under the influence of Sâr Peladan, and espoused the principles of the 'Rose-Croix Esthétique', according to which 'art should be dedicated to transcendental idealism and the regeneration of contemporary man'. Thus he found in France a philosophy suitable to his temperament and complete freedom in the expressive use of line and colour. At last he was able to cast off the realistic dross that had interfered with his great decorative effects. His heroic figures took on deeper meaning. Divested of theatrical grandiloquence, their gestures became purely expressive, conjuring up states of mind. He executed in rapid succession his famous paintings, *Those who are weary of life* (1891), the *Disillusioned Souls* (1892), the *Elect* (1894), and *Eurhythmic* (1895), all of them treating themes in the spirit of Rosicrucian mysticism and Pre-Raphaelitism. Shortly afterward he found his way back to Swiss historical subjects, such as *The Battle of Marignano* (Zurich), and the famous *Wilhelm Tell*, culminating in a large mural for the university of Jena: *Departure of the Jena Volunteers* (1908).

Although all these works are marred to some extent by shrill rhetoric, the two main stylistic features of Hodler's art — eloquent expressive gestures and eurythmics — now achieve their fullest effectiveness. The whole picture becomes an eloquent gesture, which is developed into a grandiose ornamental pattern. The basic melody is provided by an arabesque rhythmically repeated in the figures, which borrow from it their eurythmic movement. The artistic effect however is spoiled by a quality of 'soulfulness' which was greatly cherished by Jugendstil artists — the very same soulfulness which in the dance was soon to replace the lively staccato and rustling dynamism of the ballet with the gliding eurythmic curves of Mary Wigman.

One glance at Toulouse-Lautrec shows what is wrong. It is the same old story: the French artist processes his material and distils his arabesque from it, the German artist idealises his instinct and stylises. In the end the Frenchman creates signs, the German ornament. The path followed by Hodler's art can be defined in his statement of 1897: 'It may be said that decorative art is taking on an increasingly ornamental character.'

The German Secessionist artists were all in favour of this development. In 1897 Hodler was awarded the gold medal in Munich; in 1899, he was admitted to the Berlin Secession; in 1904, the Vienna Secession held a big show in his honour. The Germans hoped that his impassioned gesture and eurythmics would supply them with new means of expressing their idealistic aspirations. But all this failed to produce artistic form. The artist who embodied these aspirations in artistic images came from the far north. He was Edvard Munch.

*Edvard Munch (1863-1944)*

More than any other artist, Munch is the representative of the Symbolist decade and its aftermath. This fact is reflected in every detail of his life, including his travels, for a genius who mirrors an

epoch is led inexorably to the places and people in which the spiritual needs of the age find their fullest expression.

In 1889 the twenty-seven-year-old Norwegian, provided with a government scholarship, went to Paris, but it could scarcely be expected that he would meet the group of artists around Théo van Gogh. Yet that was exactly what happened. Here he encountered Vincent van Gogh's Panic will to expression, Gauguin's powerful flat decorative effects, Seurat's inexorably systematic mind, and Toulouse-Lautrec's figurative arabesque. In 1892 he was invited by the Verein Berliner Künstler to show his works in Berlin, and he was the unwitting cause of the public scandal which gave Max Liebermann the opportunity to form his Secession group and marked the emergence of German Impressionism. In 1893 he frequented Meier-Graefe, Bierbaum, Dehmel, Holz, and Scheerbart in Berlin. After the publication of Meier-Graefe's *The Art of Edvard Munch* in 1894, he became the centre of artistic polemics in Berlin. It was his Berlin friends who conceived the idea of a modern cultural periodical, which was embodied with the founding of *Pan*. In 1896 he was back in Paris, and at once became associated with the group of Symbolists around the *Mercure de France*. Henri Davray, the translator of Oscar Wilde, became his friend. He exhibited his *Frieze of Life* at Bing's new Galerie de l'Art Nouveau, and on this occasion Strindberg wrote an essay on Munch which was published in the *Revue Blanche*. He designed the sets for *Peer Gynt* produced by the Théâtre de l'Oeuvre. Back in Germany, he became interested in the new theatrical style developed by Max Reinhardt. He did the sets for a Reinhardt production of Ibsen's *Ghosts* and decorated a room in the newly opened Berliner Kammerspielhaus with a 'frieze of life'. He met Count Kessler and Van de Velde. Thus he was tossed like a drunken boat on the restless seas of this crucial European decade, carried hither and thither by the trade winds of the great contemporary movements, putting in to important trading stations to deliver and receive rare and strange cargoes and messages, so uniting the intellectual zone extending from Paris and Berlin to Oslo into a homogeneous whole.

It is in the course of his restless wanderings that Munch developed the cast of mind combining solitude and cosmopolitanism, dream and reality, drunken fantasy and touching affection for real life, aloofness and earthliness, which he embodied in images describing the innermost aspirations of his epoch. He is the great image-maker of the decade, not so much a 'painter' as an 'artist', less concerned with the anatomy of the pictorial organism than with creating images reflecting the inner life of his contemporaries. In 1908 a severe nervous breakdown forced this indefatigable traveller to return to his native Norway for good. From that time on, the flow of images stopped and the 'image-maker' became a 'painter'. A newly won robustness diminished his sensitivity to psychic realities, and oriented him towards 'life'. The large *Sun* – one of the murals he painted for the university at Oslo (1909-1911) – was the last of his universal images; now motifs and repetitions came to the fore. In 1912 Munch was given a place of honour at the great Sonderbund exhibition in Cologne, which was the first devoted to a retrospective survey of the achievements of modern art. He had entered into history side by side with the great dead, Cézanne, Van Gogh, Gauguin and had become a pillar of modern painting.

The Norseman's special psychic sensitivity, the indifference to sensuous reality that heightened his receptivity to psychic experience, account for the deep influence exerted by the northern spirit in the Symbolist decade. Ibsen, Strindberg, Jacobsen, Björnson, Hamsun, Kierkegaard, and Brandes enlarged Europe's capacity for psychic experience. The sturdy Western sense of reality was rather an obstacle to communication with the transcendent. These Scandinavians however, were amazingly sensitive. When their sensitivity was enhanced by neuroses, drugs, alcohol, or inherited second sight, they discovered wondrous things, day dreams that were true dreams. They saw

the world in a peculiar nocturnal light in which man moved about as transparent as a shadow. Everything became unreal, paradoxical, transparent, but seemed at the same time to acquire reality, clarity, and solidity on another plane.

This other plane was situated in the realm of the psyche. It resulted in an analytical technique which manipulated psychic impulses as though they were tangible realities and gained astounding insights into the mechanism of psychic impulses and counter-impulses (long before Freud made use of them).

Transmuted into art, this unravelling of the psychic mechanism resulted in profound existential tragedies. The neurotic elements assumed greater importance than the realities of life or even the life instinct. The lethal moment of consummation, the death instinct inherent in life, which English aestheticism called into play in order to enhance and concentrate awareness of life, operated, in these Scandinavians, beyond will and consciousness. It was the operative form of a transcendent reality which grew by way of the unconscious, the neurotic, the 'inner voice', and was invested with the full reality of Fate. These artists contributed a crucial nuance to the tragic conception of life elaborated in those years. They daemonised the tragic antinomy between the self and the world by throwing open the storehouse of the unconscious, by acknowledging the full reality of its images, and applying them to the world.

Munch thought in images. This manner of thinking requires the artist to discover the daemonic elements hidden in nature. Herein he relies on his psychic powers, the divining powers of the unconscious. Thus, Munch does not, for example, paint a nude young girl; instead he paints *Puberty* because the antennae of his psyche go beyond visual perception, transforming his model, and his conception of the picture responds unconsciously to this transformation. He did not paint a landscape but *The Cry*, a response of his unconscious to the Panic element in nature: 'I felt the great cry ringing through nature.' Painting, for him, does not deal with definite points of nature or 'reality'. His optics is that of 'second sight', he discovers a 'second reality', seat of the essential life process, and this is what the artist experiences and reflects. Consequently Munch's work does not portray a fixed point of reality, but a cycle; he does not record the visible in the form of a definite landscape or figure, but rather in a sequence of images, 'a frieze of life' as he actually entitled the series of his large canvases. Such second sight is more especially the instrument of visually gifted poets. The image does not challenge the eye from outside, but emerges from the inner zones of thought and unconscious fancy. In Munch the poet and the painter achieved an extremely rare, almost unique balance.

Munch's sensitivity to the dark zone was fed by three sources: his northern origins, his childhood experience, and the current interest in the twilight regions of the psyche (this was the period that produced the painters of dreams and masks, Odilon Redon and James Ensor, and finally Alfred Kubin, and rediscovered El Greco, Goya, Blake and Fuessli). Death and the Fates had cast their shadows on his early years. He lost his mother when he was five and a dearly loved sister shortly afterwards. His father, a gloomily religious man, gave up his post as an army doctor to devote himself to treating the poor. Death, the eternal presence of dire poverty, the image of his dejected father muttering his prayers each night sharpened the boy's eye for the nocturnal aspects of life. To this was added the clairvoyance resulting from protracted illness, which made him hypersensitive to all outside contacts. Later, habitual drinking kept him on edge. In 1881, at the age of eighteen, he entered the academy at Christiania and came into contact with the genre-painting of the Norwegian realists who specialised in scenes from the life of the poor. To this type of painting he brought his psychological insight. One of his early works was *Sick Girl,* and in the course of the

years he produced a long series on this theme, including *Death Chamber, Deathbed, The Dead Mother, Fever, Death*. Even as a student he identified surface and symbol. In 1889 he made an entry in his diary which expresses the same thing in simpler, more painterly terms: 'We should stop painting interiors with men reading and women knitting. We must paint living men, who breathe, feel, suffer, and love. I shall paint a series of such pictures. What should stand out in them is the sacred.'

The sacred is not disclosed in the dimension of the present. 'I see' does not adequately describe a revelation. Sensory perception has no spatial dimension. The sacred, on the other hand, implies a time interval during which the vision released by an external event grows inwardly. The past and the future permeate the present, investing it with the many dimensions inseparable from the sacred. Moses 'sees' the Burning Bush, but he 'saw' God. A small time interval is needed. When we want to make the visible transparent in the hope of glimpsing a transcendent reality shining through it, we do not speak of 'seeing' in the present tense alone; we must say: 'I see and I have remembered'. This strange mixture of perception and memory — a memory that can go back as far as the dead, and forward as far as the still unborn — appears in the mind as 'revelation', as 'vision', as an insight. The 'insight' is an end product, it presupposes the sensory activity of seeing, and hence it refers to something that lies in the past, but it immediately reacts upon this activity, and thus becomes a higher multi-dimensional, non-perspective present. The act of seeing is enriched with the time factor, the dimension of contemplation; it becomes intuition. The artist runs through this mental process at lightning speed, and when he is a painter like Munch, he says: 'I do not paint what I see but what I have seen' — not the burning bush but the sacred.

Why the sacred? Towards 1889, Munch frequented the Symbolist bohemia of Christiania. This group of artists may have been just a bit wilder than the intellectual anarchy that was current throughout Europe at the time. Its struggle against antiquated customs and laws, and against official Christianity, took on radical forms. Not content with demanding equality of the sexes, these young people advocated 'free love'. All covenants broke down, including that of faith. The tent was snatched away, and man was left alone beneath the sky, exposed to the things of the world. He was nothing more than a man, that was the only certainty that was left him. Munch, who was morbidly hyper-sensitive, was overwhelmed by a feeling of solitude, an anguished sense of the void. To fill the void, to replace the antiquated symbols that had previously screened it off, he searched for new symbols, and these he called 'the sacred'. But man was now alone, the sacred could come to him only as the human response to an outer or inner reality. When the stimulus came from outside, from the landscape, for instance, the sacred assumed the form of a 'Panic' force — which the ancient Greeks represented as nature gods. When the stimulus came from man's inwardness, as distinct from his 'natural' aspect, the sacred assumed the form of expressive psychological gesture. The Panic forces of nature and psychological expression are the two sources of Munch's images which he interpreted as symbols of existence. His themes were landscapes as symbols of the Panic element, and the human image as a symbol of psychological reality.

In each case it would have been possible to resort to allegory. Böcklin, for example, followed the Greeks in expressing the Panic forces as nature gods. Munch relied on the representative quality of colour and line. By giving resonance to his colours and transforming line into a melodious arabesque, he raised the motif to a Panic or psychological plane. The examples of Gauguin, Van Gogh, and Toulouse-Lautrec encouraged him to lay bare the autonomous representative quality of the pictorial means and to aim at 'musical' effects in his treatment of line and colour. His contemporaries saw this more clearly than we do. In 1891 the Norwegian painter Christian Krogh wrote of

Munch's *Jealousy:* 'The latest catchword today is "sonorous" colour. Have colours ever before been so sonorous? Perhaps this is music rather than painting.' The same metaphors had been constantly used by the artists of Gauguin's group. Line and colour are the vehicles of expression. In Munch's *Summer Night,* the only bright form is a hovering white female figure, fragile against the solitary cantilena of a curving horizon, her contour traced economically and delicately; behind her we see a dark figure with a prosaic outline, heavy and firmly planted: the sparse contours and the contrast of light and dark suggest the psychological drama of a painful farewell. In another picture fiery red clouds glow in the yellow sky, and the world is dark – greens shifting to blues; black shadows pass by swiftly and in the foreground, over a curve of a stooped shoulder, glows a forlorn profile in shrill orange – the picture is entitled *Despair*. *The Cry* is a single arabesque, an ornament of sound waves produced by a human figure whose thin, misshapen body resembles a trumpet; under their impact the whole landscape is twisted into a writhing arabesque traversed by the steep diagonal of a road, and we have the impression that the landscape itself is screaming. In *Spring Evening* (1899) – the scene is Karl Johan Street in Christiania – the passers-by in the orange glow of sunset look like ghosts, with their morbid yellow faces and frightened white eyes. These were the visions Munch owed to his 'second sight' and learned to express, suggest, or cry out in the language of colour and line.

This was Munch's contribution to the decade: he transmuted into painting the Panic and psychic realities that he perceived behind the visible. It was the most important contribution that the Germanic peoples of Europe could make to art during this transitional epoch, and herein Munch is related to Van Gogh. The Latins followed a different path. They were realists who looked for expressive structures in outside nature. Cézanne and Toulouse-Lautrec distilled form from visible reality, assuming correctly that 'psychological' expression was inherent in the construction and distillation of the form. Not so Munch. From the outset, his eyes were turned towards the depths, the 'psychological' element was the initial vision. In 'rendering the image', he took the form for granted or merely looked on as it came into being. For Cézanne form was the spiritual equivalent of the material world, for Munch it was the material equivalent of the spiritual world. Therein lies the difference between them. These two seemingly opposite paths led to the same region – the realm of human expression.

### James Ensor (1860-1949)

It was the Germanic spirit that carried the drama of the decade to the point of extreme tension. With an almost satanic assault upon life, it tore the two poles – the self and the world – asunder. The result was the most shattering doubt as to the reality of the world itself, a loss of confidence in human existence, and a tragic alienation between the individual and the outside world. It is almost self-evident that men thrust into this existential situation should have succumbed to psychoses of the schizophrenic variety, if, as Bleuler put it, the most salient feature of the schizophrenic is that for him 'the autistic world is the real one, and the other a sham'. Van Gogh's breakdown and Munch's life on the verge of the abyss were the natural consequences of their artistic missions. The third of the great Germanic masters of that revolutionary decade suffered a similar fate. His name is James Ensor.

He was born at Ostend in 1860. At the age of seventeen, he attended art school in Brussels, but two years later he was back at Ostend, and throughout his long life never left the stifling bourgeois

world of his native town. At the age of twenty he was an accomplished genius. In a few years of feverish activity he produced marvels in the attic that served him as a studio – portraits, still lifes, interiors, figures reflecting his surroundings. His paintings are of an indescribable perfection, his brush lightly caresses his objects, as though softly tapping them and listening intently for the sounds they will give off. With these light touches, he peels away the harsh outer husk of things and reveals a light which seems partly to fall on them and partly to emanate from them.

The intimate stillness of his painting has a gentle melancholy resonance, something of the sadness that overcomes men of sensibility when they lose themselves in the contemplation of things. And when his contemplative glance is directed at people, they too become invested with the quality of absorption, expectancy, and eternal sadness that comes upon living things when their motion is suspended. There is an aura of poetry about these forlorn eyes, these faces caught off guard, these delineations of suffering or weary resignation, for example, in *Dark Lady* or *Lady in Distress*.

In 1883 this stormy development came to a sudden end. Ensor began to paint less. In the same year he produced his first painting in which men are transformed into masks – *Indignant Masks*. And from 1885 odd phantoms – masks, skeletons, ghosts – make their way into his intimate world. In his apartment stood a precious old Flemish cupboard. In *Spectral Cupboard*, a little girl with a book open before her and her mother, absently knitting, are seated by a table – and here once again Ensor conjures up a gentle, tender light – when suddenly a skeleton peers out from behind the cupboard and everywhere rigid masks appear. A meddlesome ghost – like a puppet in a Punch and Judy show – thrusts his skull over the table. *Skeleton Examining Chinoiseries* takes us to an attic, where a skeleton, comfortably leaning back in a chair in the warming light of the sun, is examining objets d'art. And the series runs on – masks, ghosts, demons. One drawing shows the artist himself as a skeleton drawing *Intricate Doodles*. When the painter looks at mute things, they act as though, having been surprised in obscure diabolical activities, they had withdrawn into their immobility, like spiders pretending to be dead; but still a spectral laughter haunts the stillness.

Obviously something went wrong with the structure of the artist's personality. It should be remembered that in these years the attitude of Western man towards the world was undergoing a crisis. Ensor reacted with his whole personality. In *Demons Tormenting Me*, a drawing dating from that year, he portrays himself, small, surrounded by a garland of grimacing faces and phantoms. This strange flat rocaille ornament, writhing like a worm, has a pronouncedly schizophrenic character. The biographies suggest that Ensor was in a state of depression at the time. Colin speaks of 'a neurasthenic period of moral weariness'. Indeed, all his pictures suggest that Ensor's reactions to his environment had become pathological. He seems to look upon things with suspicion, as if they were trying to hide something and their outward appearances were only a sham. The same goes for his whole environment and the people around him. This situation of conflict made him feel completely isolated, and this in turn induced an attitude of defiance and hatred towards men. This is clearly a psychosis; the real world which the painter has come to distrust is replaced by a world of his own. Ensor's psychosis has all the characteristics of schizophrenia: things take on a hidden significance, the world changes into a weird realm of spectres, peopled by delusions and hallucinations revolving around persistent, obsessive themes.

If we analyse Ensor's hallucinatory world – as Fraenger did in part on the basis of the etching *The Cathedral* – we find three important features. First, images of panic – human crowds moving about meaninglessly, as though driven by a mass psychosis, angry, destructive mobs crying and muttering with fear. These evocations of panic-stricken crowds are hallucinations induced by an

anxiety neurosis, a persecution mania reflecting loss of confidence in the environment. Second, there are the figures of ghosts and the masks. These, too, express the individual's extreme alienation from his environment: he can see his fellow men only as phantoms, as ghosts eroded by death. Third, we find a peculiar experience of space: space becomes imaginary, appears to shrivel into shallow areas, to rush off wildly, and to rise again at a great distance as something new and monstrous; its reality crumbles. Plainly, these constantly recurring hallucinations are not artistic exaggerations, devised to clarify a real situation, but compulsive projections of a mental state. That is to say: the images resulting from Ensor's psychotic spells have an ego-symbolic character and express the painful, extreme tension between the self and reality, of which we have spoken above.

It would be superficial, however, to dismiss Ensor's art as a product of mental illness on the ground of its similarity to the works of schizophrenics. From an historical point of view, we should say, rather, that Ensor was normal. He shared the spiritual tensions of his time and refused to imitate the vulgar realist who looks upon the chaos to which he has become accustomed as a 'cosmos'. He faced and endured the tensions, he lived them; he did not escape from them, but, rather, exalted them, and identified himself with them. Because of this identification, the images he produced as personal symbols assumed the character of symbols of his epoch. In this way, he entered into the stream of history. In a sense, the true creator always risks his sanity, his very life, and cannot be judged by medical standards.

Towards 1885 — the year when phantoms began to creep into Ensor's paintings — his palette grew brighter. The influence of French Impressionism had reached him — direct observation recorded in shorthand, bright colours, bright light. It is quite strange to see how in these Impressionist works the spectres of the inner world step out into the light of day. For Ensor the very light inherent in colours became a medium of communication. He speaks of 'sensibilities of light'. He uses it for purposes of expression, as an aura. He treats the life and death of Christ in a series of paintings. Here again he identifies himself with his subject and expresses psychic movement through the light of the halo. He describes his *Adoration of the Shepherds, Entry into Jerusalem, Crucifixion, Ascension* as 'joyful', 'radiant', 'sad and despondent', or 'intensive' studies of light.

This is one of the formal aspects of his art. Some of the works produced in this manner are masterpieces. There is a still life with a fish (a skate) dating from 1892. It is a bright, iridescent painting, in which the smooth wet skin of the fish is contrasted strikingly with the rough dry surfaces of the basket and the straw. The perfection of this Impressionist feast of colours would fill us with joy: but suddenly the skate stares out at us with its demonic mask and then soft shadows of decay fall on the iridescent colours. He painted sea shells, larger than life, and it is marvellous painting, but many of the sea shells crawl like crabs in the loose composition, and one of them holds its opalescent orifice open as though listening to its own gurgling sound. Ensor also painted seascapes, in which he started with the shapes and opalescent colours of shells. It is an hallucinated kind of Impressionism.

The other aspect of his art is more vulnerable. It discloses his 'schizophrenic character' more pronouncedly. When the ghosts and demons make their irruption, the execution runs amok. The colours become strident, the composition disorderly, the line becomes descriptive and rigid. The hand moves in wild circles. We are reminded of old popular art, the paintings of unschooled peasants.

A similar duality is disclosed in the engravings, which continue the tradition of Callot, Goya, and Rembrandt — on the one hand, an extraordinarily sensitive line that caresses the objects; on the other, a crude insistence on detail, a mad Baroque tangle and disintegrating composition.

The tension between the world of things and the artist's hallucinated vision is clearly discernible in the objective forms. The contrast between Ensor's exquisite brushwork and his erratic, confused line, reflects his intense inner conflicts. He embodied the tension of the decade, the inexorable parting of the ways between the self and the world. He was seized by the tragic image of life.

By 1900 Ensor's creative powers were almost spent; from then on, he produced little. In 1914 he was seized with the strangely manic idea of repainting his famous canvases from memory. No doubt their ego-symbolic character had something to do with it. They were parts of his life, ego-symbols, fetishes which protected his horizon. He wanted to have them near him. Munch, too, kept repeating the pictures of his *Frieze of Life,* and Van Gogh never cast off his magic of the Sower that had first come to him from Millet. There is a manic, magic link between certain images and their creator, they are a part of his inner world.

James Ensor offers the clearest example of the personality structure of the Nordic artist in this period of crisis. He exalts the situation of conflict to the point of morbidity, and in the end the autistic world of hallucinations becomes the real world for him. He is unable to transmute natural appearance into form, but can only evoke it as an hallucinatory vision. Unlike Cézanne and other French artists, he does not take the world as raw material to be processed into form; his raw material consists of hallucinations, dreams that irrupt into reality. He manages to describe his autistic world with the help of entirely realistic, or even Impressionist techniques. He translates his inner message into the language and metaphors of the outside world, which, however, take on a spectral, hallucinatory quality. To express his states of mind, he must let himself fall to the depths of his image-making unconscious, until he is, as it were, assaulted by its dark power. Kubin, who records strikingly similar experiences in his autobiography, was subject to similar onslaughts of images. The visionary Impressionism that characterises Corinth's painting after his stroke suggests that he too went through experiences of this kind. Later on the Surrealists subjected these tidal waves of images to a bold scientific scrutiny, and their sharp analyses of such experience broadened the range of modern consciousness. Be that as it may, Ensor experienced the tragic conception of the world characteristic of the art of this critical period so completely that dream and reality, morbid hallucination and ultra-lucid perception, satanic hatred and loving affection for the world of things became hopelessly confused. The self and the world kept changing their relative positions, but always they remained alien and hostile to one another.

*A Backward Glance*

The last decade of the century saw a radical change of outlook. We have followed the dialogue on the nature of art that was carried on in that period. It was a dialogue between France and the Nordic countries; Italy took no part. The dialogue began at a time when realism was dominant, when the visible world was believed to be real in the fullest sense. Realism had taught the artist that in coming to grips with the world it was possible to cast off history and traditional images. Reality and man's attitude towards reality were the foundation, the prerequisite for the whole dialogue. There was no escape from this problem. What mattered was not the good, the true, and the beautiful, but the concept of reality. This basic fact determined the whole ensuing development.

First came the recognition and affirmation of visible reality. The return to things – away from tradition, the museum, idealism – was marked by the joy of a new beginning, by confidence,

security, self-assurance. The optimistic outlook of Impressionism reflected this youthful vision of the world.

However, the more keenly this reality was perceived, the stranger it became. Those who confronted it discovered that it could not simply be taken for granted. There was a hidden relationship between 'reality' and the beholder, and, moreover, visible reality pointed to a far larger, as yet uncharted realm that was reflected only indirectly in immediate sensory perception. The self and the world parted company and a tragic tension developed between them. As a result, the visible appearance of things came to be regarded as less important than the relationship between man and things. The logical consequence was that the task of art must be to give formal expression to this relationship. Thus art became a method of transforming natural appearance, of distilling from it the forms which raised nature to the level of a broader spiritual reality. Art did not content itself with reproducing the visible, but gradually began to *make* visible, in images, a reality that could not be perceived by the senses. Form now came to be conceived as the instrument for carrying out this operation and the picture as the stage on which it was to be enacted. Accordingly, ever increasing importance was attached to the independent expressiveness inherent in the formal elements of art – colour, tonality, line, and to the structure of the picture surface. This language of the pictorial elements was now investigated carefully, for it offered the only possibility of representing nature rather than reproducing it. This was the path followed by the French, by the Latin mind.

The Germanic mind reacted to the new ideas in its own way. The Germanic peoples had inherited ancient knowledge which from time immemorial had made them look beyond the world, the knowledge that had given birth to the proposition that the world is the creation of the individual mind. Summoned to speak in these critical years, the Germanic mind was prepared not only to doubt the reality of the visible, but to jump right over it. Almost totally unencumbered by reality, subjectivity became supreme and created a radical cleavage between the self and the world. Whereas the Latin mind processed the natural datum, distilling spiritual forms from it, the Germanic mind sought to subordinate the visible world to its autistic vision. Instead of processing nature, the Germanic mind stylised it, filled it with demons and hallucinations that varied in intensity, according to the degree of the artist's participation. This went so far that at an early date questions arose such as these. Might it not be possible to disregard images of nature entirely? Might not the inner message, expressed entirely in abstract forms, be the only worthy content of a picture? Visible reality was an element hostile to art, a fetter, a world of pretence. The antinomy between the self and the world now led to such an unbearable tension that the geniuses who fully experienced it – Van Gogh, Munch, Ensor – reacted to it pathologically. They lived in their flesh the tragic outlook which determined the artistic developments of the entire decade.

Both the Latin and the Germanic responses to the situation brought the same result. In both cases, critical analysis of reality opened up vistas of a scarcely explored region which had hitherto been defined only metaphorically – man's inner world of expression. Once this path was taken, there was no turning back unless European culture was to succumb to a sort of neurasthenic weariness. Many of its representatives were – and still are – willing to give up: a sense of impending disaster and death has overshadowed the decades that followed. Progress along a path never before trodden required a tremendous creative effort. For once on that journey, art was on its own, without support of a social bond. The Renaissance, which looked *ahead* to visible reality as its shining beacon, had definitively come to an end, for this reality was now left *behind*. This Renaissance whose reassuring covenants had already been questioned by the Romantics was now a thing of the past.

65

BOOK TWO

Towards Expression

The masters came into their own at the turn of the century. In 1899 there was the great Cézanne exhibition at Vollard's; in 1900, the memorial exhibition of Seurat; in 1901, the memorial exhibition of Van Gogh at the Bernheim-Jeune gallery; and in 1903, that of Gauguin at the Salon d'Automne. The Symbolist decade had developed the aesthetic sensibility of the public to the point where the original ideas of the masters could now be understood; and soon the Symbolist trimmings with respect both to form and content were discarded. In 1899 the Nabis held a last exhibition at Durand Ruel's, dedicated to Odilon Redon, 'the Mallarmé of painting'. Then the new generation swept them aside. The classical Nabis recognised the achievement of the new generation, but refused to follow it. In a review of the 1905 Salon d'Automne, Maurice Denis discussed the 'Matisse tendency', which he regarded as the newest and most vital of the new trends, but went on to say: 'There is something even more abstract – a kind of painting freed from all accidental elements, painting as such, the pure act of painting. This, strictly speaking, is the search for the absolute, and yet – strange contradiction – this is a limited absolute, because there is in the world something more relative but highly important – personal emotion.'

*Les Fauves*

The Société du Salon d'Automne was founded in 1903 by the architect Francis Jourdain with the co-operation of Bonnard, Marquet, and Matisse; its purpose was to champion the cause of the new art. The covers of the first catalogues have a pronounced Jugendstil character: this was only to be expected at the time. But the choice of the older masters whose works were exhibited at the Salon side by side with the young ones was in itself an indication of a new trend. Thus in 1903 the Salon held the great Gauguin exhibition; in 1904 it exhibited works by Cézanne, Toulouse-Lautrec, Renoir, and Puvis de Chavannes, in 1905 Manet and Ingres and in 1906 Gauguin for the second time. It was at this Salon, which cherished the tradition of Ingres's classical line, Manet's rigorously organised planes, and Gauguin's orchestrated colours, that in 1905 a new group of painters, centred round Henri Matisse, made its first public appearance, next to Bonnard, Vuillard, Roussel, and Vallotton who were given the places of honour. The art critic Louis Vauxcelles, discovering a child's bust in the *Quattrocento* style in the same room as the works of these violent painters, exclaimed: '*Donatello au milieu des fauves!*' (Donatello in the midst of the wild beasts!) Quickly taken up by the flippant art world, the name – les Fauves – stuck.

This group, which by then had developed a distinctive style, consisted of Matisse, Marquet, Rouault, Derain, Vlaminck, Friesz, Van Dongen, Manguin, Puy, and Valtat. Sérusier, the leader of the Nabis, dismayed, wrote to his friend Verkade: 'A new group is gaining ground; it comes from the Moreau studio. Their idea is to paint their emotions. All in all, their explorations (for the results are bad) are intelligent and may turn out to be fruitful. It is the same ideas we had at Huelgoat fifteen years ago.' This is true enough; the essential ideas of Fauvism had indeed been anticipated in Gauguin's works and writings.

Now, in 1905, the finished products were presented to the public. But the new style had been

developed slowly. In 1892, Henri Matisse, the twenty-three-year-old son of a well-to-do grain merchant in northern France had gone to Paris against his father's will and attended the Académie Julian. He had become a painter by mere accident. While recovering from an illness three years before – he was then a student of law – he had been advised by one of his friends to seek distraction in painting. He had followed the advice and found so much happiness in his new pursuit that he gave up his studies to devote himself to painting. In 1893, still a beginner, he was admitted to the Ecole des Beaux-Arts. He studied under Moreau in whose studio he met Georges Rouault, whom Moreau held in great regard. The two were soon joined by the highly talented Albert Marquet and the gifted young painters Camoin and Manguin.

Moreau was an excellent teacher and a still better mentor. He made no attempt to foist his own Pre-Raphaelite style on them, but left them perfectly free, and often sent them out into the streets to train them in observation. He believed they could learn more in the Louvre than at school. He was a serious artist with very definite ideas of his own about the decorative and formal elements of painting. He often achieved surprising results in his sketches and small canvases, characterised by exquisite decorative effects drawn from nature and by jewel-like colour. His large compositions were spoiled by their Symbolist trappings – a warning which his students took to heart.

And so Matisse and Marquet went to the Louvre where they copied Poussin, Chardin, Raphael, Ruysdael and Philippe de Champaigne. Chardin was Matisse's favourite. In the Louvre, the young painters began to analyse the elements of construction, 'the living part of the masters. We wanted to feel the warmth of the blood that flowed in their veins, by confronting nature and its mystery under the same conditions as they had' (Matisse). In addition they eagerly followed Moreau's advice to sketch in the street and at cafés. This was their programme: 'First, the emotion directly inspired by nature, second, the Louvre. The fully developed artist combines the two.' Only in 1897 did Matisse think he was ready to study the Impressionists. Marquet soon followed him. Their palette grew brighter. The influence of Cézanne was already making itself felt – Cézanne 'whose constructions are based on the energies of line and colour'. Such was Matisse's enthusiasm over Cézanne that in 1899 he bought a Cézanne with his own hard-earned money; Marquet preferred Monet.

What interested them most was colour, the constructive handling of its pure values. Here Gauguin and the Neo-Impressionists, particularly Signac with his pure decorative colour, were helpful. Matisse's own path lay somewhere between Signac and Gauguin. As he himself put it: 'Neo-Impressionism marked the first thoroughgoing organisation of the Impressionist methods, but its basis was purely physical. It is exclusively concerned with the sensation on the retina, which disturbs the repose of the surface and the outline.' Gauguin did not fall into that error but, according to Matisse, he failed 'to construct space by means of colour, which he uses excessively as an expression of feelings'. This criticism is crucial. The new generation of painters felt that the Symbolists obscured the purely pictorial values; they rejected the mysterious Symbolist colours, and insisted on pure colours. Symbolism was losing ground. The young painters found confirmation of their ideas in Persian miniatures and faiences, and in Coptic fabrics. Their newly won insights were: the picture is a 'spiritual space'; illusionist effects must be dispensed with; natural forms may be transmuted and subordinated to the spiritual order of the picture; light must not be copied but expressed by colour; the picture surface must be articulated into areas of plain colour, for it is by means of pure and plain colours that 'the maximum of expression' can be achieved. Pictorially speaking, 'expression' and 'decoration' are one and the same thing. Or, as Matisse put it: 'Expression, to my way of thinking, does not consist of the passion mirrored upon a human

face or betrayed by a violent gesture. The whole arrangement of my picture is expressive... Composition is the art of arranging in a decorative manner the various elements at the painter's disposal for the expression of his feelings... A work achieves the harmony of the whole.'

Such, then, was the goal pursued by the new revolutionaries from Moreau's studio. Soon others joined them. In 1899 Matisse met, at the Académie Carrière, the youthful André Derain, who was copying paintings in the Louvre at the time. Derain soon fell under the spell of Matisse's ideas. Derain had a friend four years older than he, Maurice Vlaminck, son of a poor family of Flemish origin, racing cyclist, musician, painter, *barbare tendre* enraptured by Sisley and Monet. To this group of searching painters, the great Van Gogh exhibition held by Bernheim-Jeune in 1901 came as a bombshell. On this occasion Derain introduced Vlaminck to Matisse, who listened to Vlaminck with interest, but could not suppress a smile when Vlaminck told him that Van Gogh was more to him than his own father, or that he wished he could 'set the Ecole des Beaux-Arts on fire with my cobalts and cinnabars, and transcribe my feelings with my brush without thinking of anything ever painted before'. Vlaminck was overwhelmed by Van Gogh; Matisse had by then gone somewhat further in his calculations. But he occasionally visited Derain and Vlaminck in the studio they shared at Chatou, and in 1905 he painted with Derain at Collioure.

These three artists formed the nucleus of Fauvism. Derain liked to recall those days: 'It was the era of photography. That may have influenced us and contributed to our reaction against anything that resembled a photographic plate taken from life. We treated colours like sticks of dynamite, exploding them to produce light. The idea that everything could be lifted above the real was marvellous in its pristine freshness. The great thing about our experiment was that it freed painting from all imitative or conventional contexts. We attacked colour directly.'

Thanks to Berthe Weill, who opened a gallery in 1902, Matisse and his group were provided with a permanent place to show their pictures; in addition they regularly sent their works to the Salon d'Automne, which was the main battlefield, and to the Indépendants. Their paintings brought them new followers. Berthe Weill introduced them to Kees van Dongen, a painter from Rotterdam who had moved to Paris in 1897. Derain met him in Picasso's studio in Montparnasse and sponsored his admission to the Fauve exhibition of 1905. But Van Dongen soon broke away from the movement and used the modern recipes taken from the Fauves for his portraits of fashionable society.

In 1904 the group was joined by Othon Friesz, a twenty-five-year-old native of Le Havre, who since 1898 had practised a kind of routine Impressionism at Bonnat's studio. Matisse had shaken him out of his rut and now he too was in search of a means 'of bringing painting into harmony with nature. Impressionism had put us on the right track, but it seemed to me that Impressionist paintings lacked form and had a merely documentary character – they were arranged, not composed. Colour seemed to point the way to a solution. Monet, Renoir, Seurat, Van Gogh – each of us made generous use of their ideas according to his talent. Study of complementary colours and contrasts convinced me that I could obtain the equivalent of sunlight by a technique based on orchestrated colours and emotional transpositions of nature, and that nature yields her secrets to passionate search and enthusiasm.' The source of these ideas was Matisse, who had developed them on the basis of Gauguin and Cézanne. Othon Friesz brought to the Fauves his two friends, also natives of Le Havre – the slighty older Raoul Dufy whom he had followed to the Bonnat studio, and who was won over in 1905 after seeing Matisse's *Luxe, Calme et Volupté*, and the younger Georges Braque, the last convert. In 1906 Friesz and Braque went to Auvers, where they painted a number of Fauve canvases.

For all these young painters, Fauvism was a transitional stage. Without being clearly aware of it, all of them were under the irresistible spell of Matisse who used Fauvism as a means of developing his pictorial ideas. He was convinced that he was on the right track and for some time carried the others along. He found powerful arguments in Gauguin, Seurat, Van Gogh, and Signac. But when the fourth of the great masters, Cézanne, emerged from obscurity, almost all the Fauves went over to him. All, that is, except Matisse – who from the outsed had taken some of his basic ideas from Cézanne and adapted them for his own purposes; his attitude to Cézanne was the most fruitful – Cézanne did not throw him off his feet, but gave him support. As for the others, the stronger talents assimilated 'Cézannism', the weaker were submerged by it.

Othon Friesz (1879-1949) went over to the new camp in 1908, the year in which Cézanne's ideas achieved their great break-through. '1908 marked for me the end of the conceptions advocating so called "pure colours", which first appeared in 1904. Colour was no longer the master of the canvas, volumes and light brought form back to life.' His Fauvism was rather timid: he stylised his subject with an eye to decorative effect, used pure, brilliant colours, and made them part of an 'ensemble' in the Matisse manner. His interpretation of Cézanne was equally moderate. Skirting the edges of Cubism, influenced from all sides, his art subsided into run-of-the-mill Cézannism, the modern counterpart of the run-of-the-mill Impressionism that was current in 1900.

The other native of Le Havre, Raoul Dufy (1877-1953), was a more lively and resourceful talent. His early works were influenced by Van Gogh and Matisse. His Fauvism was bold and carefree, and he used expressive colours and deformations. The motif played an important part, but the vivid colours set off its expressive qualities or transformed it into a subtle ornament. His vigorously deformed outlines, whose curves add firmness to the colour arrangement, are amazingly effective. Here he was certainly influenced by his younger fellow artist from Le Havre, Georges Braque. In 1908 Dufy went with him to Estaque, where Braque, who was primarily interested in construction, carefully studied Cézanne's ideas on form and space. Dufy, who was by temperament sensitive to the charm of lively colours, tried unsuccessfully to work in the ascetic Cubist manner. It was only much later, towards 1918, that he emancipated himself from it and found his personal style, a new delicate version of Fauvism, light and joyous, with a refined naïveté, always somewhat diminutive in outlook, cursorily applied bright, luminous grounds reminiscent of the technique of painting on glass, and playful arabesques in graceful staccato, which are mannered, precious, but in exquisite taste. It is very likely that Dufy developed this personal style under the influence of *haute couture*. During his years of Cubist asceticism he met the *couturier* Poiret, became interested in painted fabrics, lace and brocade, and designed prints for Poiret. These were so successful that the textile king Bianchini won him over from Poiret and conquered the world market with his designs. Beside Matisse's regal, serenely monumental art, Dufy's style suggests a joyful little arabesque of supreme elegance and charm.

The third painter from Le Havre was the most mysterious – Georges Braque. He was three years younger than Friesz, who had led him to Fauvism during a fruitful stay at Auvers. Braque mastered the new method in a series of nearly twenty paintings. With a palette of bright yellows, blues, and reds, he extracted a well balanced harmony of colours from his motif. He employed smaller units than Matisse. With decorative spots of colour he obtained a delicate rhythm, and over the surface he spun the melodious curves of a simply constructed arabesque suggested by the motif. The arabesque is conceived as a constructive rather than expressive element and has indeed something of the constructive firmness that characterises Cézanne's late water colours. Young Braque had quickly assimilated Matisse and was now ready to tackle Cézanne. In 1908 he made

a thorough study of Cézanne's ideas. His companions from Le Havre, who had hitherto influenced him, now followed him in amazement.

So much for the Le Havre group. The pupils of Moreau – Marquet, Camoin, Manguin, and Puy – were too close to their fellow student Matisse, his genius carried them along. We may disregard Camoin, Manguin and Puy: they were mere followers and soon succumbed to the seductions of late Impressionism.

Not so Albert Marquet (1875-1947), Systematic, even-tempered, he kept his distance from Matisse's rapidly developing theories. He could not escape them entirely, but he never lost sight of their frame of reference. He was well aware that the theories of pure colour derived from Neo-Impressionism, and the free arabesque from the Far Eastern engravings. His Fauve period was one of calculated study. His secret goal lay elsewhere, in his fascination with the looking-glass world and the lyrical, secret *Japonisme* of the late Monet. His idea was to give this art simplicity, grandeur, and style. And he succeeded with the help of Matisse, who was striving to restrain the restless shimmering of Impressionist and Neo-Impressionist painting and restore calm and repose to the surface and the outline. Marquet applied Matisse's methods to Monet. He replaced Monet's *vibrato* with clear, harmoniously arranged planes, whose simplicity results in a calm surface. In this way he achieved restful effects even when painting reflections in water (in which he was so much interested that one might almost speak of him as a marine painter) and restored the clear, sharp outlines of things. Thanks to these, the picture could now be organised. The momentary vibration was transformed into something static. This implied a new attitude towards the fugitive elements of the motif; and here once again, one of Matisse's discoveries proved helpful. Matisse had discovered that the motif arouses different sensations each time one looks at it, and concluded that nothing is fixed in nature. But the painter is free to synthesise his successive impressions, letting each one enrich the others. Matisse looked upon this as a part of the method he called 'the organisation of sensations'. As applied to Marquet's problem, this method consisted in defining the core of the sensations contained in the motif, in simplifying the gradations of colour and light and subordinating them to the essential colour and essential light. Once Marquet had won these insights, he gave up Fauvism. For what he was aiming at was not an expressive art, but a synthetic, restful, simplified Impressionism inspired by the rigorous composition of the Far Eastern artists. Marquet had disciplined Monet. That was what he had been aiming at. Now he abandoned the enhanced colour of the Fauves and strove for subdued tones, the fluid quality of thin colour. In this medium he produced his seascapes and port scenes with their charming reflections. They disclose a strange ambivalence, for they are at once casual and precise, vaporous and firm – the enigmatic ambivalence of East Asian art.

So much for the Fauves who had studied under Moreau. There remain the two painters from Chatou – Vlaminck and Derain. Maurice Vlaminck (1876-1958), who attached great importance to his Flemish origin and his *esprit nordique*, fell completely under the spell of Van Gogh in 1901. Even Matisse was able to discipline him only moderately. Vlaminck saw only Van Gogh's passion – not his ardent intelligence. For that he was too healthy – a racing cyclist. To paint was for him a physical act: he speaks in the same breath of *faire l'amour* and *faire la peinture*. 'Instinct is the foundation of art. I try to paint with my heart and my loins.' He had no use for tradition – the only master he recognised was Van Gogh. The architecture of a painting served only 'to support the intensity of colour'. He approached his landscapes with Van Gogh's jagged line, but without Van Gogh's hallucinated sensibility; like Van Gogh, he employed shrill colours as they came from the tubes, but without stopping to think that their jarring intensity would stand in the way of

colour harmony and that the result would be a roar rather than a song. In this early period Vlaminck was an enraged Expressionist, but without vision, and an ecstatic Impressionist, but without humility towards the motif. Enraptured by a revelation of beauty, he could only bawl and howl, but not weep and sing. And yet his howling concealed the mutilated rhythms of a moving melody. His paintings are scarcely more than slices of nature seen through a temperament but the primitive violence of this temperament lent them an expressive character This use of pure colour could not satisfy Vlaminck for long, and in 1908 he joined in the movement towards Cézanne. But even within the magic circle of Cézanne and under the influence of Cubism, he exalted expression. With an entirely new palette, which adds succulence to Cézanne's subdued greys and greens, but obliterates the subtle texture of the tones, he records his interpretation of the motif in fluid sonorous colours. Vlaminck's art marks the extreme limit of Expressionism to which the French spirit could attain.

His friend André Derain is, by comparsion, orderly, constructive, one might also say, classical. He was attached to tradition, loved the art of the museums, and copied in the Louvre. Even in his Fauve period, he preserved a monumental quality, a certain decorative breadth in the architecture of his pictures. He struck a middle course between Vlaminck's pure instinct and Matisse's subtle intelligence. It was he who first compared the tube of paint to a stick of dynamite. Nevertheless, he is much more careful than Vlaminck about exploding the charge. Even when he uses a cinnabar red or an ultramarine as it comes from the tube, he sees to it that the related tones are orchestrated in such a way that the cinnabar red or ultramarine achieves its full effect in the ensemble. Even in his moments of utmost freedom, he keeps himself under control. He disclosed the same admirable inner strength in his dealings with Cézanne and Cubism for in 1908 he too shifted to Cézanne's rigorous construction.

Shall we then conclude that Fauvism was an episode that began in 1901 and ended in 1908? If we leave Matisse out of account, the answer is no doubt in the affirmative. But what is this Fauvism? It is the new, fresh, direct response of a young generation to the free use of colour, bequeathed it by Van Gogh, Gauguin and Seurat. Discarding the Symbolist trappings, this new generation suddenly became aware of their freedom. In Seurat and Signac, they found pure, untroubled colour; from Van Gogh they learned to acknowledge the claim of artistic instinct; Gauguin showed them the large plain surfaces over which colour flows 'like lava from a volcano', and 'the swift flowering of the suddenly created work'.

Gauguin, Seurat, Van Gogh – according to their personal inclination, the new painters followed one or another of them, but essentially the new aesthetics is defined by the concept of pure colour and is a synthesis of the three masters' ideas. The new artists were opposed to the Symbolist fog. Like Courbet, they went back to the motif, but equipped with the new human and material weapons their masters had forged for them. With the dynamite of their colours they had exploded nature, and out of the flames constructed their pictures according to an entirely subjective pattern. By means of colour, they had destroyed the materiality of things. The architecture was defined by colour boundaries, not by the outlines of objects. All this sounds very Expressionist, and so it is. However, an important qualification is in order, for we are in the realm of the Latin spirit, which aims at form and order, leaving paroxysm to the Germanic peoples. Significantly, Vlaminck alone, who liked to insist on his Flemish extraction and his Nordic spirit, felt at ease in the area of paroxysm.

In the aesthetics of the Fauves, the destruction of the object goes hand in hand with the creation of a formal order. They deplored the lack of structure, permanence, and autonomy in naturalist and Impressionist painting. The motif interested them less for its representational content than, as Matisse

liked to say, for the 'shock', the pictorial and poetic inspiration it released. To this shock they sought to give permanent form. The elements of the picture were the surface, the outline, and pure colour. Perspective and depth were subordinated to surface; chiaroscuro and relief were rendered by colour relationships; and the combined effect of the three elements did away with illusionism. The dialectical interplay of the elements resulted in a harmony so active that it deformed the object at will, replaced illusionist space with a space constructed from colour, an *espace spirituel*, and supplanted representational colour by pure autonomous colour. The main statement of the picture lies in the colour harmony; the expression results from the arrangements of the coloured surface, and the viewer perceives an overall harmony before even becoming aware of the motif. Thus the abstract elements constituting the surface became the sole vehicles of expression. The break with Impressionism is obvious; the new style might be called a kind of Expressionism. Actually, this inaccurate term may suffice to describe the general aesthetics of Fauvism. But most of the Fauves adopted it only because it gave them a sense of freedom; for them it was a transition, they were headed elsewhere. Only the clear mind of Matisse, who remained disciplined throughout this confused and exuberant episode, carried the Fauve aesthetics to its logical conclusion. For it was his aesthetics. He broke not only with naturalism, but also with Romantic subjectivism. He found a lofty isolated region where the spirit, outside the conflict between the world and the self, carries on its formal games with its own serene equations – a rare, fragile possibility of happiness. He was the Valéry of painting.

*Henri Matisse (1869-1954)*

The poet Louis Aragon says: 'It suffices to leave Matisse to himself, and his hands transmute the most threadbare, most insignificant things into objects of real luxury.' These clear probing eyes behind the rimless professorial glasses were as critically discriminating as Toulouse-Lautrec's. However, they were focused not on the characteristic features of things, but on the aesthetic equation the human mind derives from things. They were focused on the rare object of choice, in a word, the luxurious. Hence his fondness for Persian tiles, Oriental silks, precious glass, sumptuous rugs, exotic birds, and women with the animal grace of odalisques. Both his personality and his art emanate a rare, almost unique aura of perfect accord with life and the world around him. From the moment he took up painting as a twenty-year-old convalescent, colour filled him with joy. His harmonious temperament is reflected in his writing, as when he says: 'We must learn how to discover joy in the sky, in the trees and flowers. How to draw happiness from ourselves, from a full working day and the light it can cast into the mist around us.'
Matisse sketched from early morning, filling one page after another of his sketchbooks, repeatedly going back to the same theme long after his model had been forgotten. Toulouse-Lautrec would watch a dance step forty nights running, in order to transmute it into an arabesque. Matisse began with the transmutation, the arabesque; he became engrossed in its play and perfected it, sketching page after page, until its spontaneous flow fully harmonised with his will. Like a dancer, he practised unceasingly, so that when the time came to tread the empty rectangular stage of his canvas, his movements would be fully under control. And then, tracing his expressive arabesque of leaps, bounds, and pirouettes, he introduced a human tension into a formless expectant space. For 'the hand is merely an extension of the sensibility and intelligence'.
Intelligence, logic, sensibility permeate his art. He calls into play the concentrated force of a cool

mind and an aroused sensibility to transmute the line describing the object into an artistic arabesque which transcends its representational significance and directly affects the viewer's sensibility. Like the dancer's figure. Matisse's arabesque is the visible sign of a spiritual order. It introduces tension into the rectangle of the picture, disturbs it only to achieve a higher balance, and invests it with the exquisite purity of an object beautiful in itself. Contemplation of it soothes our mind. Matisse wrote that he wished his art to be like a good armchair in which a man might rest from physical fatigue, in which he might find a little pleasure, luxury, happiness; in a more academic sense, this remark may be taken to mean that he wished his art to express the serenity of an Archimedes who goes on tracing his circles and equations undisturbed by what is going on around him. Continual, repeated manipulation of form is required to avoid heaviness, confusion, and inaccuracy, to produce a work whose rhythms seem spontaneously to transcribe the artist's emotion. 'Truth and reality in art begin only at the point where the artist ceases to understand what he is doing and what he is capable of doing, and yet feels in himself a force that becomes steadily stronger and more concentrated.'

Matisse is the Frenchman *par excellence:* in his eyes, the supreme virtues are reason, simplicity, and clarity. According to him, 'only one who is able to order his emotions systematically is an artist'. His sensibility is bent upon extracting the simplest formula of beauty from all his emotional responses. For this reason he confines himself to the surface, and his pictures seem to be purely ornamental arrangements of flat areas of colour. His arabesque is extremely economical, but in the clear curve of pure line the artist reveals his heart to the viewer, as though taking a deep breath of joy.

It is the secret of Matisse and his French genius that the vigorous, autonomous life of his ornament of colour, line, and light is never divorced fron the object, but stresses its reality as a springboard for the sensation that touches off the formal play and raises it to the plane of a higher artistic reality. 'I have always seen everything just as I have painted it,' says Matisse, 'even the things that critics have set down as clever, arbitrary ornament. I have invented no form.' And yet he did invent something: with the help of combinations of line and colour he distilled from the visible an aesthetic formula, and so perfected this formula by sensitive and intelligent work that it became a reality in its own right, a statement of man's creative mind, which transcends nature. It is a formula which implies acceptance of the created world – the joy of existence – but also asserts the lofty freedom of the human mind.

Matisse's development reflects his Cartesian love of method. In 1892 when he began to paint, he sketched from nature and copied paintings in the Louvre – his first subjects were taken from life and art. Only much later, in 1897, did he lay himself open to the influence of contemporary artistic theories, and soon passed from Impressionism to its logical continuation and transformation – Neo-Impressionism, Gauguin, Van Gogh, Cézanne. He developed his own theories on the basis of a critical study of the works of these masters. Disturbed by the restless surfaces and outlines of the Neo-Impressionists, he strove for restful, clear, simple surfaces and outlines. Troubled by Gauguin's emotional, enigmatic colour and the resulting absence of deliberate construction of space by colour, he looked for autonomous colour and an autonomous pictorial space constructed by the movement of colour. Disturbed by Van Gogh's restless vehemence and grandiloquent expression, he aimed at a human attitude of serenity and harmony; expression, he decided, had to spring spontaneously from the formal order. Nothing disturbed him in Cézanne. But only two of Cézanne's radiant ideas proved useful to Matisse as he drew up the balance sheet of his critical studies – the construction of the picture as a complex of energies, and the representation of light by colour equivalents, both illustrating Cézanne's dictum that art is a harmony parallel to nature. Cézanne's influence is disclosed in

the following saying by Matisse: 'Never struggle with nature to reproduce light; we must look for an equivalent, work parallel to nature, for the means we use are in themselves dead. Otherwise we would inevitably be led to place the sun behind the canvas.'

His critical investigation led Matisse to conceive of the principal elements of the picture as follows. Colours should be pure and used as the equivalent of light; the impression of space should not be obtained by the use of classical perspective but by the arrangement and the 'push and pull' quality of colours; surface and outline should be clear and simple, and their organisation should reflect the relative energies inherent in line and colour. The subject matter becomes expressive through the formal harmony of the picture, 'a harmony analogous to that of a musical composition'. This clearly defines Matisse's aesthetics. His life work was devoted to perfecting this aesthetics, to achieving the greatest possible clarity and simplicity. Although at first Matisse was somewhat influenced by Bonnard and late Impressionism, and although his early Fauve period, influenced by Signac, shows a certain amount of confusion and ferment, his development is a steady progress towards clarity.

In 1906, Matisse exhibited his large figurative composition, *Bonheur de vivre* at the Indépendants... Signac attacked him indignantly. Matisse's answer makes everything clear to us. 'I painted it in plain flat colours because I wanted to base the quality of the picture on a harmony of all plain colours. I tried to replace the *vibrato* with a more expressive, more direct harmony, simple and frank enough to provide me with a restful surface. Since I had a form that could be localised, a leg, for example, I should logically have used a flesh tone. But I saw myself obliged to use a cinnabar; the combination of red, green, and blue was sufficient to create an equivalent for chromatic light. I cannot copy nature in a servile way; I must interpret nature and subordinate it to the spirit of the picture. The relationship of all the tones I have found must result in a living harmony of colours, analogous to the harmony of a musical composition.' In this harmony of intensely coloured areas, light – like the objects – is represented, not reproduced as a local tone or local form. 'In my picture, *Music*, I used a beautiful blue for the sky, the bluest of all blues, green for trees, and a sonorous cinnabar for the figures. With these three colours I had my light harmony as well as purity of colouring. To be noted particularly is that the form was altered according to the reactions of the adjoining colours. For expression comes from the coloured surface which the viewer grasps as a whole.' Thus art does not describe, it is an *expression intime*. Things exist only in so far as they inspire our feeling of love for them. Art does not render anything material, but human emotion. Therein lies Matisse's radical break with Impressionist naturalism.

The painter's message is conveyed exclusively by pictorial means. 'The painter's idea cannot be conceived apart from the means he uses, for it is meaningful only in so far as it is embodied in these means, and the deeper his idea, the more complete they must be. I am unable to distinguish between the feeling I have for life and my way of transposing it. A work must carry all its meaning within itself, and impose it on the viewer even before he identifies its subject matter.' Repetitions of the outside world play only a very subordinate part in pictorial language. Everything derives its validity exclusively from pure form. There is nothing *behind* the canvas that speaks to the heart or the brain. The picture is a thing in its own right, it is nature radically transformed. It does not serve as a mediator or interpreter between nature and man. It *is*. This implies a break with Romantic subjectivism and Expressionism. It is art of the equation, the organisational form of inner life, the dialectic of the ordering, formative spirit.

Everything derives its validity from form: but where is the goal? In abstraction? In the object? The goal is to be sought in what encompasses them both – the state of mind. Matisse seeks to give form to 'a state of mind created by the things that surround me and influence me'. It is to this end

that he creates an autonomous living space, the *espace spirituel* of the picture – a space in which he himself is free: 'Often I step into my picture, and I am aware of what exists behind me. I express the space and the things that are there as naturally as if I had before me only the sea and the sky, that is, the simplest things in the world. I say this only to make it clear that it is not difficult for me to achieve unity, for it comes to me naturally – I think only of rendering my sensations.'

This is crucial for our understanding of Matisse. The central point is this, that Matisse is the only painter who succeeded in escaping from the system of reference defined by the co-ordinates of the world and the self. He transmutes both the world and the self in his crystalline art, achieving a harmonious balance between nature and spirit, between the senses and the idea, between life and lucid awareness. It is as though Matisse had discovered an infinitely thin area situated between the world and the self, in which the fields of energy of these two realms neutralise each other and one is altogether free to move out of the dualistic system. Here alone is it possible to achieve independent existence and serenity. 'A new picture is a unique event, a birth, which enriches the universe as it is grasped by the human mind, by bringing a new form into it.' Paul Valéry arrived at the same conception on the basis of his aesthetics of pure thought, and Matisse's Latin art is a similar stroke of good fortune. By producing these equations of pure form, Matisse succeeded in transcending the tragic outlook that has cast its shadow over modern painting. If we reflect on the subtle reasoning that led him to this art, we can understand why Matisse called it a *calmant cérébral*; it transcends the deadly tension between the world and the self, transmutes passion, and achieves the serenity of pure form – it reflects the artist's God-given capacity to experience happiness.

## Georges Rouault (1871-1958)

Among the new works that caused a sensation at the Salon d'Automne of 1905 was a series of darkly luminous pictures portraying whores and clowns. Their bitterness was too sorrowful to suggest satirical intent. They were reminiscent of Daumier and Guys, but without a trace of mockery. Their expression was vehement to the point of caricature. The colours glowed from the blackish grey tangle of bars with the melancholy brilliance of Gothic stained-glass windows. If Fauvism expressed an aesthetic experience, this master was not a Fauve. His painting sprang not from an aesthetic but from human experience. And indeed, this painter soon left the ranks of the Fauves.

Georges Rouault was born in Paris of a poor family. At fourteen, he was apprenticed to a stained-glass painter. In 1891 Gustave Moreau admitted him to his studio, where Rouault soon became his favourite student. In Moreau's Symbolist milieu, Rouault fell in with men who felt that the fashionable catchwords of the Symbolist decade – the Beyond, Mystery, the Mystical, the Religious – were too vague, and were consequently attracted by the Catholic Church. He became a close friend of Léon Bloy and became acquainted with his gloomy brand of apocalyptic Catholicism. Like Bloy, he came to look upon the world as the realm of Satan, a dunghill of depravity under the lewd rule of the Prince of Darkness. Far from trying to express happiness like Matisse, Rouault turned against happiness. His art solved no problems, but posed problems. Leaving the realm of aesthetics, it became a militant art, an indictment, a sermon, *propaganda fide*. Rouault strove to create *l'art pour l'homme*.

Throughout his career, Rouault was absorbed with the dark, sombre, sorrowful side of the world. For the most part he painted half figures, heads, or gloomy groups of two or three figures, death,

and apocalyptic landscapes. His pictures bring to mind an iconastasis. We behold the torment and lamentation of the world – and here and there the shimmering light of a possible redemption – the great hope. Jacques Maritain once described Léon Bloy as 'Job on the dunghill of modern civilisation'. This description also applies to Georges Rouault. Rouault himself tells us his feelings about his art: 'A cry in the night! A stifled sob! A laughter that chokes itself!' His clear vision, rooted in the Old Testament, of a world fallen from grace and of God's inhuman remoteness, reflects the same anguish and bitterness, the same tragic view of life as certain modern tendencies in religion.

In 1918, Rouault ceased painting, and until 1928 worked for Vollard, producing the series of fifty-seven plates illustrating *Miserere et Guerre*. In this work he employed a special technique: after a photo-mechanical transfer of the original composition to the copper-plate, Rouault worked it over with all sorts of engraving tools until the mechanical 'undercoating' almost entirely disappeared. During those ten years he also produced etchings, lithographs, and drawings for Vollard's *Réincarnations du Père Ubu* and for his own *Paysages légendaires*. In 1929 Rouault resumed painting, slowly, laboriously, tormented by misgivings, repeatedly returning to old pictures and themes, in order to enhance their expression. He was a true painter of icons!

In these prints and paintings, thick black outlines resembling the leads in stained-glass windows clearly define the objects and set off the sombre glow of the colours. Their luminosity is also that of old stained-glass windows, pointing formally to the realm of the sacred for which Rouault yearned with all his heart. The rich line and texture of these works, achieved by years of elaboration and revision, endows them with a unique, almost morbidly dark splendour, reminiscent of Rembrandt's last period. Indeed, Rembrandt and Daumier are among the sources of Rouault's art. He owes a great deal to his teacher Gustave Moreau, who no doubt awakened his sensibility to the sinful glitter and sombre magnificence of the flowers of evil, which he contemplates with horror – to the richness and luxuriance of sin, but also to its misery, and its morbid, leprous growths. That is how we must interpret Rouault's hermetic description of himself: 'I am the ivy of eternal misery that clings to the leprous wall behind which rebellious mankind conceals its vices and virtues.'

The divergent paths taken by the two Fauves, Matisse and Rouault, clearly reflect the old dilemma of the Symbolists – the alternative between art as the expression of a doctrine of religious salvation, and art as aesthetic mastery of the world. But both artists completely dropped the Symbolist trappings, radically simplified both motif and means of representation, and strove for the strongest statement through the simplest means; they erected their icons on the altar of aesthetics or religious dogma. In both cases the icons are anti-naturalistic formulas. Imitation of nature gives way to expression: the concept of 'expression' is central to the new aesthetics.

Throughout Europe 'expression' was in the air. While the Fauves were distilling this idea from the art of Van Gogh, Seurat, and Cézanne, the Germans arrived at it quite independently, and the Italians began to move towards it. A group of German painters gathered round Matisse at an early date.

*The German Following of Matisse*

In 1908 several German painters rented a studio on the Boulevard des Invalides in a building formerly occupied by the Sacré Coeur monastery. These painters were Hans Purrmann, Rudolf Levy, and Oskar Moll. Later they were joined by Friedrich Ahlers-Hestermann.

Rudolf Levy, a pupil of Kalckreuth and Zügel, that is, a product of the Impressionist German Naturlyrismus, had moved to Paris as early as 1903. In 1906 he got together with his friend Hans Purrmann, a pupil of Stuck, whose admiration for Slevogt had led him to Impressionism, and who joined the Berlin Secession at an early date. They met for drinks at the Café du Dôme, where they were often joined by the writer Wilhelm Uhde, the painter Alfred Weissberger (who died young), Jules Pascin, who had been noted for his drawings in Munich magazines, and who had since been using his expressive linear style to great effect in sketches of nudes in lascivious poses, the painters Eugen von Kahler and Ahlers-Hestermann, and the sculptors Lehmbruck and de Fiori. In 1907 the group received a new addition—Oskar Moll, a native of Silesia, who had become acquainted with Impressionism in the Berlin group of Corinth and Leistikow. At the avant-garde salon of Leo Stein and his sister Gertrude, Levy and Purrmann met Matisse. The master took a liking to the young Germans and agreed to give them lessons. Under Purrmann's leadership a small group formed, which did much to rescue German painting from its belated Impressionism and contributed a colourful, decorative note that Germans seldom develop spontaneously.

These Germans found their special note of beauty by enhancing their visual experience of nature through the use of colour. They remained closer than Matisse to the lyrical experience of the object; his intricate, abstractly decorative games were alien to them. In their German interpretation of Matisse, they stressed poetic qualities in natural objects. Their work is more 'representational' than Matisse's abstract melody. It remains closer to Impressionism, but it goes further than Impressionism by giving more body to the visual experience, thanks to an intelligent handling of the new means — the dance-like arabesque, the pure colours, the ornamental arrangement of decorative elements.

Rudolf Levy was the most lyrical of the group. He often sketched his motifs in tones of such exquisite delicacy that the poetry was transformed into a colour harmony. But the most vigorous was Hans Purrmann, who combined excellent taste with rigorous construction and never forgot the lessons of Cézanne. The development of all these painters remained peculiarly unaffected by the artistic events taking place around them. Oskar Moll alone was somewhat influenced by Cubism in the twenties, but his strong bent for decorative effects prevented him from actually becoming a Cubist and he merely employed a number of Cubist forms in his painting.

All of them remained under the spell of Matisse. Since the basic inspiration of Matisse's art was to be found in Mediterranean nature, they repeatedly went south, bringing back their joyous bright-toned paintings which contrasted sharply with the tormented Expressionist works at the German exhibitions of the twenties. Their late periods are characterised by a restrained, quiet lyricism. Purrmann subdued his colours but made them richer and more differentiated. Moll relaxed his forms and blurred their outlines, submerging them in pale misty colours, and occasionally coming close to the beauty of Far Eastern silk-screen paintings. Levy's tones became as subtle as pastels. We recall a few paintings — by Purrmann and Levy — which are full of pure, crystallised forms and glitter like precious stones. They show us what vast aesthetic culture and concentrated formal inventiveness a painter needs merely to transpose nature into a glowing ensemble of colours. Germans are often unable to appreciate this spiritual achievement rooted in an aesthetic vision. That is why these German painters influenced by Matisse are so little known in Germany.

French Fauvism is part of a comprehensive European movement. It cannot be studied in isolation. Once again, something was afoot; the restlessness was greater than ever. For it became apparent that all the movements of the last decade of the nineteenth century – Symbolism, the Secession style, the Jugendstil – had side-stepped any direct confrontation with reality and obscured the real world beneath metaphors and idealist concepts. Once again things were replaced by tags behind which they could hide. Beginning in 1900, there was a general movement to tear away the Symbolist wrappings which could not conceal the wound for ever. Once again the inadequacy of an art based on visible reality came sharply into focus. In this situation, faith in the old therapy of 'art for art's sake' broke down, and the mediating function of art and its long history were felt to be a burden and a lie; the traditional concept of art, it was held, stood in the way of a direct confrontation between man and the world. For the first time painters now turned against 'art' and its ready-made solutions, and it was not long before one of them went so far as to propose that all museums be burned down. This was merely a desperate expression of the need to clear away all the barriers that history had put between the painter and his reality. Another expression of the same need was the sudden magical attraction exerted by primitive art, the art of Negroes, Polynesians, children, and Sunday painters. Go back to the sources! Confront reality directly, beyond the conventions of 'art' and 'history'. 'The world is so full we are stifling,' wrote Franz Marc. 'What can we do to be happy but give up everything and run away, draw a line between yesterday and today?' But this flight 'from the ruins of memory' inexorably led the painter to the sphinx of reality and the question: What is reality? And this was inseparable from the question: What is man?

The French Fauves had started from this point. They too had attacked reality directly in a kind of furious onslaught. But the Symbolist veils they had pushed aside were thin and transparent, and directly beneath them they found the helpful ideas of Gauguin or Cézanne. Cézanne's refined logical constructions, the untiring energy with which he replaced allegorical or metaphorical elements with direct formal statements invited the young painters to go farther in the same direction. The French spirit conceived of the artistic exploration of the visible world as a scientific problem. Tackling the world of things by a series of logical steps, it preserved its continuity.

In Germany it was quite otherwise. Here everything was in a state of ferment; fragmentary consequences were drawn from fragmentary beginnings. There was insufficient trust in form and too much haste to weigh it down with Symbolist elements. The Jugendstil had sound ideas about the expressive powers inherent in coloured forms; but wherever the ideas were actually applied, allegorical and metaphorical elements were quick to creep in. The painters were bent upon poetic expression and let reality slip by. They indulged in rhetoric and neglected form. Those few German painters who preserved a sense of the central purpose of art remained very much alone. With no theory to support them, they could only fall back on reality and interpret reality in the light of their personal experience.

During the years in which the Fauves developed their aesthetics and the term 'expression' became current – 1905 may be taken as the crucial year – efforts to tackle nature directly, to re-formulate its relationship with the self, were in evidence all over Germany. The idea was to make nature expressive by enhancing its visual features. New groups formed, aiming at an art of Expression. In northern Germany Expressionism was represented by three artists working independently of each other: Paula Modersohn, Emil Nolde, and Christian Rohlfs.

*Paula Modersohn (1876-1907)*

Paula Modersohn developed her personal manner during the last seven years of her life. She died in 1907 at the age of thirty-one. In 1899, after studying painting in Berlin, she went to Worpswede, where she studied under Mackensen. In 1901 she married Otto Modersohn. She was a friend of Vogeler and Rilke.

Central to her art is the poetic vision of nature, characteristic of the Worpswede school. These painters were deeply sensitive to the emotional elements in the landscape, which create a link between man and things. Rilke's book on the Worpswede school, written in 1902, suggests the high degree of sensibility that had already been achieved. Those were the years in which young Germans eagerly read Jacobsen, the young Hamsun, and Björnson. Sensibility had developed to the point of perceiving nature as a poetic reality, of discovering the subtlest nuances of feeling in the visual surroundings. In addition, Paula Modersohn was sustained by her friendship with such sensitive writers as Rilke and Carl Hauptmann. Rilke, Worpswede, and the spiritual climate of the time, encouraged her probing love for the things of the outside world.

But above all Paula Modersohn herself was exceptionally sensitive to the grandeur of nature; it was perfectly clear to her that her artistic mission was to give expression to the deep feelings aroused in her by the outside world. Thus her innate disposition led her to an art of Expression. In her profound love of the world, she listened to the voices that arose from its depths and yearned to record them in terms of simple images, things, figures. As early as 1898 she noted in her diary: 'How happy I would be if I could give figurative expression to the unconscious feeling that often murmurs so softly and sweetly within me.' Because her sensibility sought to discover the inner core of visible things, her art is far removed from the great movements of passion; for the same reason, she always strove for 'great simplicity of form'. Her wish was 'to achieve greatness in simplicity'.

That was her aim throughout her short life. From the outset she strove for the utmost conciseness and economy of form. She found Mackensen and Kalckreuth too 'genre-like'. She discarded all anecdotal elements, harking only to the pure existence of things. She simplified their forms, stripping them of every suggestion of the brilliant, the artistic, the artificial, using the sparsest means. Her manner was laborious, almost awkward, as a result of her effort to state her emotion as clearly as possible. The emotion is the main thing. Soon she ventured to depart from nature. In 1902 she noted in her diary: 'There is really no need to be concerned too much with nature in painting. The colour sketch should exactly reflect something you have felt in nature. But personal feeling is the main thing. After I have clearly set it down in form and colour, I must introduce those elements from nature that will make my picture look natural.'

In such pursuits she found little help at Worpswede. And so she turned to Paris. She first studied there for a brief period in 1900. She was naturally enthusiastic about Millet and the new Breton landscape artists, Cottet and Simon, just as she admired Böcklin and Kalckreuth after returning to Germany in the autumn. But in 1903 she returned to Paris to 'examine Worpswede through critical glasses'. Her work now took on more precise form. But it was only in 1905, and during a last, longer stay in Paris in 1906, that her eyes opened to the really important things. She suddenly understood the significance of Gauguin and Cézanne and the use made of their ideas by the Pont-Aven painters. But she was so close to her work that she regarded the newly discovered ideas as her own and found it perfectly natural to incorporate Cézanne's great formal discoveries and Gauguin's powerful decorative effects in her own conceptions.

The bold ideas of modern French art helped her to achieve a magnificent freedom. And the ancient Greek and Gothic art of the Louvre gave her the 'great simplicity of form'. For all her newly won freedom, the main thing for her was still to strip things of all accessory elements in order that her love might penetrate to their core – to see the greatness of things, 'not to think about nature haphazardly' but to discover its hidden human values, and to represent these values and the things themselves with simple grandeur, in a 'Runic script' expressing the heart's emotion in the purest simplest form. She lived just long enough to produce a small number of finished works which show that she had become fully aware of the problems of the new painting, and to gain clear insights, such as this one, which she recorded in the summer of 1907 in a letter to Hötger: 'Our instrument must be an assimilated, digested Impressionism'. This was a definite break with Naturlyrismus. But at that point she died. One of her last wishes was to go to Paris, for she had learned that 'fifty-six Cézannes are being shown'.

In no respect can her development be regarded as complete. Nevertheless the strong, quiet, moving personality of this young woman permeates her human figures and has found its pictorial equivalent in the magnificent self-portraits with the loving sorrowful eyes.

Before any other North German artist, Paula Modersohn spontaneously found her way to the spirit of the new art of expression. For it was not until 1906 that Nolde, then thirty-nine, first came into contact with the new French painting through the Osthaus group at Hagen, and began to interpret Impressionism in an ecstatic manner; and it was in the same year that Rohlfs, then fifty-six, shifted from Neo-Impressionism to his Expressionist manner.

*Emil Nolde (1867-1956)*

What brought Nolde to painting was the eloquence of colour, its power to provide metaphoric expression of human feeling. The path leading to his coloured vision of the world as a personal expressive symbol was long, hard, and lonely. He matured slowly and painfully, uncertain of his goal and the means by which to attain it, and growing more and more lonely in his restless quest. His career is typical of the German situation of the period; homeless isolation. The spirit of the age assaulted each artist separately. Of course Nolde came into contact with individuals and groups who contributed to the development of the modern conception of painting. In 1898 he studied under Hoelzel, who was then carrying out his first investigations into the effects of pure colours and forms. During that period of his career – the Munich period – Nolde was influenced by the Dachau landscape painters, whose sense of nature accorded with his own feeling. Early in 1906 the Brücke painters invited him to join their association; and Nolde was actually a member of the Brücke for one year. Also in 1906, Schiefler introduced him to Munch, and in 1911 he met Ensor. But all these contacts were casual. Solitude was the destiny of this North German.

From the first Nolde showed a compelling interest in the artistic portrayal of fundamental psychic experiences. His first saints were Rembrandt, Goya and Daumier: he admired them for their expressive power, their ability to capture and summarise the characteristic. Even as a boy he displayed great interest in characterisation even if it ended in caricature. In the early nineties – he was then teaching in a school of industrial design at St. Gall – this interest was embodied in heads of peasants, drawn from nature. These drawings are naturalistic, but they reveal an underlying penchant for grotesque types. There is a spectral quality about them. The artist's physiognomic interest discloses the gnome-like chthonian features of the peasants. But the primordial forces are

stronger than the wit of the caricaturist. The chthonian power shines through, giving these early works a mask-like quality. In the large drawings of 1896 – *Mask of Energy, Sloth, Cave Woman* – the artist's physiognomic interests have been completely supplanted by his concern with grotesque types. A fantastic race of prehistoric beings portrays universal human passions as chthonian forces. The human face discloses the primeval features of a goblin.

At an early date this chthonian mythologisation of human features is extended to the landscape. In 1894 Nolde personified the Swiss mountains as giants and goblins – *Jungfrau* (Virgin), *Mönch* (Monk), *Wilder Pfaff* (Wild Priest). In this he imitates the popular imagination that had given those names to the mountains. After discovering the primeval traits in the human face, he discovered them in inanimate nature.

Nolde was to be always at home in this twilight zone of chthonian legend. The works of this period set the course for his entire development. Its purpose was to eliminate literary, illustrative elements, and to replace them with the direct expressive power of colour.

At the turn of the century Nolde worked towards a rigorous clarification of his technique. He frequented the Munich group of landscape painters, studied Stuck, and in 1900 went to Paris, where he was particularly impressed by Manet's 'beautiful brightness' and Daumier's 'dramatic grandeur'. It was only towards 1905 – when he met Osthaus, the great collector and art patron, who introduced him to the art of Van Gogh, Gauguin, and the modern French painters as well as that of primitive peoples – that Nolde, in his early paintings of flowers and gardens, found his way to colour and to the beginnings of his personal idiom. His psychological make-up had not changed, he had merely discovered a pictorial language in which he was able to express himself. He abandoned the earth tones of the Munich school, the tame sentimental lyricism of the Dachau painters, and the phantasmagorical colours of Stuck, and entered a world of luminous colour which owes its freedom to the influence of Van Gogh and the later works of the French Impressionists, above all Monet.

The years that followed were crucial in the development of Nolde's art. Their character is determined by the disquieting presence of three great painters – Munch, Van Gogh, and Ensor. They provide the background against which Nolde succeeded in breaking through to the passionate world of his personal vision. His themes were religious in a barbaric sense, marked by the violent attraction of the sacred which characterises the religious life of primitive peoples. It was now that he painted the series of ecstatic religious works, which begins with *Pentecost* and *The Last Supper* of 1909 and culminates in the great cycle of the *Life of Jesus* (1911). His painting became a desperate struggle, in which he fought to wring from colour the utmost in passion, expressive force and symbolic meaning. The religious series was followed by a number of figure paintings, characterised by a barbaric ardour and sensuality, which Nolde produced in his summer retreat on the island of Alsen in 1912 and 1913. Among them is the *Candle Dancer* – the will-o'-the-wisp of passion in the flickering light of a candle. This painting is probably based on the artist's recollection of the dancer Saharet, but in her Nolde discerned 'a fantastic creature of a primeval world'. Again Nolde was dealing with primitive emotions. But now it is the vehement, unusual colours and the lapidary lines that turn the dancer into a troll. The circle swings back to the early drawings. What they paraphrased illustratively is here expressed by the energy of line and the sensual symbolism of colour. The original purpose was achieved.

It was achieved thanks to French late Impressionism, which had reached Nolde a short time earlier, in 1905. But Nolde was immediately carried beyond it by the dynamism of his own development and by the examples of Munch, Van Gogh, and Ensor. Late Impressionism provided a powerful springboard. Nolde plunged at once into the realm of the ecstatic, into the torrent of images created

by his own imagination with its bent for the demonic, romantic, primeval. Here the intellectually controlled formal world of the French, with its serene eurythmic colour is invaded by a very Nordic, very Germanic Expressionism which, with its barbaric vigour, proceeds to shatter the beautiful rhythms. Colour became violent and threatening, expressing emotion by its pure symbolic force. Art rebelled against the intellect: 'a vague mental image of flame and colour' was enough to engender a painting. Like the art of the primitive peoples – which he studied in New Guinea (whilst on a visit in 1913/14) – Nolde strove for 'absolute authenticity, intense and often grotesque expression of force and life forms simplified to the utmost'. This art originates in a zone where the human personality is born of passions and instincts and invents vision as its first means of expression. It is an art far removed from the coolness and clarity of man in his classical dignity. It is at home in the regions where myth is born from primitive memories, and it erupts with a force that nothing can restrain.

The landscape, too, is brought closer to us than usual. The massive composition, the close-up view and the harsh colours endow it with an intensity that reveals the painter's state of mind. Glowing dark reds, flaming yellow and heavy grey transport the landscape to the ecstatic realm of nature myth that characterises Nolde's world-feeling. From the twenties on, he concentrated more and more on landscape. At the same time, the throbbing, flickering, ecstatic colours became gradually subdued; dramatic effects were replaced by epic ones. In the landscapes of his maturity, the mythical forces of nature are transmuted into the magic of sonorous colour, and nature itself becomes a glowing legend. These archetypal landscapes are the stage on which light enacts the eternally recurrent drama of its birth and death.

Nolde's art is certainly opposed to surface images of nature, but not to nature itself. In his uncomplicated, primitive mind, the attitude of the predatory ego, poised to break through the bars of reality and assault the world, yielded to a sense of deep kinship. To him nature was a reality that is situated beneath the visible, and merely shines through it. Nature was something mythical. If you approached it directly, you immediately encountered the mythical element in the form of a network of chthonian forces which also embraced man. Nolde's reaction as an artist to these forces was to sublimate them in images. In reference to the Greek world, this would be called pantheism; but in a barbaric world the nature religion which in ancient Greece was bathed in light takes on a chthonian character. Klee was entirely right when he called Nolde 'the demon of the lower realm'. While Nolde, for his part, once described Klee as 'a butterfly hovering in the star-studded cosmos', for Klee sought to attain the heart of creation by way of the air. Thus Nolde and Klee are not true opposites; both strove to reach behind the veil of natural appearance, though Nolde's earthly path is more limited. The true antithesis of Nolde is Matisse who knows the far-off place where the human spirit carries on its games, serenely engrossed in its equations, aloof from nature and its mythical exaltation. It is only in the light of this antithesis that we can understand why a whole generation whose spokesman was Sauerlandt looked upon Nolde as 'the pioneer of a national German art'. Although Nolde received a decisive impulse from French late Impressionism, it was his expressive feeling for nature that made his generation, struggling against Liebermann's Secession and the dominance of French Impressionism, regard him as an Expressionist rooted in the German spirit. Indeed, his art is the most Germanic variety of European Fauvism.

Christian Rohlfs cam of a Holstein farming family. Artistically, his path runs parallel to Nolde's. But his temperament was more lyrical. He had an inborn emotional receptivity for the evanescent aura in which tender feeling envelops the world of things. His world is disembodied, ethereal. Whereas Nolde invested the objects of nature with an ecstatic quality and raised them to the realm of legend, Rohlfs achieved lyrical effects by setting the corporeal world in vibration. His colour as well is far more immaterial and melodious than Nolde's. He kept his distance from his vision; he was more cautious, he did not let it overpower him.

For thirty years he painted landscapes at Weimar. In the course of time their intimate realism gave way to a restrained Impressionism – Liebermann had also studied at the Weimar art school. Shortly after 1900 Van de Velde, who had been appointed director of the school of industrial design at Weimar, introduced him to the central problems of the modern French movement. This great mentor acquainted him with Monet's late Impressionism and the luminism of the Neo-Impressionists, and spoke to him of Van Gogh and Gauguin. He also introduced Rohlfs to Osthaus, who was just starting his collection centred round the work of the French innovators. Osthaus persuaded him to move to Hagen, where he was to live from then on. Through Osthaus he met Nolde, and in 1906 spent a brief time with him at Soest. It was while in the open-minded Osthaus milieu, with its European interests, that the painter, nearly sixty-years-old, underwent a stormy development. Neo-Impressionism, Monet's late period, Van Gogh, intensified light effects, poetic and dramatic colour, freedom in treatment – such were the problems he had to master. By solving them, he hoped to enhance the expression of his lyrical vision. Monet's *Cathedrals* with their shimmering vibrant colours came close to this vision; once colour was given greater freedom and made to perform an anti-Impressionist expressive function – here Van Gogh was helpful – the outcome was bound to be a new Expressionist lyricism. Starting from these premises, he produced his first paintings in the new manner at Soest, during the summer months of 1905 and 1906. They are views of the mediaeval town, architectural pictures like Monet's *Cathedrals,* but painted with a thick, heavy brush – the script derives from Van Gogh – and with pure colours such as the Fauves also took from late Impressionism. The object is shown in close-up view and broad planes – as in Monet – but is more resolutely tied to the surface, and the pigment is articulated ornamentally in strong, pure, enamel-like tones. The picture has the character of a stained-glass window, illumined from within; it is the colour that generates the light. We find similar effects in Rouault. Although the two artists were not in direct contact, their theoretical problems led inevitably to the same solutions, which we may call Fauvism or Expressionism. Having attained this level, Rohlfs sought in his subsequent development to unify the diverse elements, which at first were merely juxtaposed, in order to strengthen the shimmering, hovering effect of his immaterial colour. His palette was reduced to the subdued triad of red, blue, and green, with a single dominant tone and pure, graduated accompanying tones. By means of continual contacts and transitions, the primary colours are made to vibrate, and the pigment acquires a delicacy reminiscent of enamel. Thus the artist organises his picture in conformity with his guiding idea. The result is a logical whole, compounded of nature and feeling, observation and rapture. A visual poem.

We have seen how these three North German artists, working almost indepentently of one another, responded simultaneously to the same summons. The crucial year was 1905 – the year the Fauves made their début in Paris. Falling in with Gauguin and Cézanne, Paula Modersohn strengthened and monumentalised her subject matter by constructive form; attracted to Monet and Van Gogh,

Nolde and Rohlfs expressed the legendary and lyrical by means of colour. Clearly, the source of the summons was a new approach to reality that was making itself felt throughout Europe. The watchword of the day was 'Expression', which in that period dominated all the arts. Characteristically, the North German artists worked in isolation and were slow to understand their mission. Each one experienced the impact of the new ideas in isolation. North Germany was entirely lacking in the youthful spirit of artistic comradeship that gave rise to the Neue Künstlervereinigung and the Blaue Reiter in South Germany, and to the Brücke in central Germany. These groups of young artists responded to the watchword of Expression with a joyous *élan* and a new aggressive spirit.

## The Brücke

The originators of the Brücke were Ernst Ludwig Kirchner, Erich Heckel and Karl Schmidt-Rottluff. They met in 1904 at the Dresden Technical School where they were studying architecture. They began to paint on their own. Great readers of Nietzsche, they were stirred by the unrest of the period with its forebodings of tremendous social upheavals and its vision of a new mankind. Determined to work towards a better future, they chose painting as their medium. Since Van Gogh and Gauguin, there had been much talk of artistic communities; in Germany this was the period of youth movements, and the three young artists felt that the cause of painting could be advanced by a group of artists that would raise up a revolutionary élite. Settling in 1905 in a vacant cobbler's shop which Heckel had discovered and rented in the Friedrichstadt quarter in Dresden, they regarded themselves as the nucleus of a movement. Here the three artists worked and lived together, and developed a common style. Aggressively bohemian and anti-bourgeois, they were inspired by a strong sense of mission. They felt themselves to be an élite – and with their humanistic Nietzschean background took Horace's *Odi profanum vulgus* as their motto. At that time young men all over Europe were fired by similar hopes for the future. The aggressive energy thus released, perverted to some extent by ideas of power, was one of the mainsprings of the great social revolutions of the twentieth century.

Without reference to this broad historical background, we could not hope to understand the state of mind of these young painters in the former cobbler's shop. Of the three, E. L. Kirchner was the most impetuous, brilliant, and sensitive. It was he who contributed new artistic sensations. In 1904 he saw the Neo-Impressionist exhibition in Munich; an important encouragement to use colour more freely. There were also magazines, such as *Pan* which published Vallotton's woodcuts with their broad flat surfaces, prints by Munch, and lithographs by Toulouse-Lautrec, Signac, and Cross, or *Die Insel* which reproduced the works of the same artists, and as early as 1902 had published a portfolio with colour lithographs by Bonnard, Vuillard, and Denis. In 1904 Kirchner visited the ethnographic section of the Zwinger and was carried away by the barbaric forms of Melanesian art. (At about the same time, Derain and Vlaminck were rummaging in junk shops for Negro masks and bringing their discoveries to Matisse and Picasso.) In Nuremberg, Kirchner saw late Gothic woodcuts, which also impressed him deeply by their expressive simplification. 'Cranach, Beham, and other mediaeval German masters' also served as 'footholds in the history of art', as Kirchner relates in his concise *Chronik der Künstlergemeinschaft Brücke*. All this gave rise to a desire for an expressive art characterised by simplified linear elements, broad flat areas of clear luminous colour, and the lapidary, primitive forms which are to be found equally in Gothic woodcuts and in South Seas and Negro art. This conception was identical with that of the Fauves.

The three artists set out to embody this conception in pictures, working slowly and tenaciously from models and analysing each other's production. The initial reminiscences of Bonnard, Vuillard, and the Jugendstil were gradually discarded, and direct abstraction of natural forms led to an original, concise, strongly expressive script, characterised by thick harsh outlines. The initial Neo-Impressionist colour pattern with its dots and minute divisions was gradually replaced by highly luminous planes. By 1907/8 this first Brücke style was fully developed; at the same time the direct influence of the Fauves was beginning to be felt.

In the course of their work in common, the styles of the three painters became so similar that today we can identify their early paintings only by what we know of the artists' personalities: Kirchner is restless and nervous, Schmidt-Rottluff coarse and robust, while Heckel is lyrical. Thus they merged into a group which in 1905 they named 'Brücke' (the Bridge). 'To attract all revolutionary and fermenting elements: that is the purpose implied in the name "Brücke",' wrote Schmidt-Rottluff to Nolde early in 1906, inviting him to join the group. For they felt that the group must be enlarged. In 1906 the Swiss artist Cuno Amiet, whose brilliantly coloured paintings, influenced by the Gauguin school and Hodler, had been shown in Dresden, was admitted. Nolde joined for one year and invited Schmidt-Rottluff to his house on the island of Alsen. In 1906 Max Pechstein, whose gaudy ceiling in the Dresden school for industrial design had made quite a stir, joined the group. The more marginal members included (in 1908) an authentic Fauve, Kees van Dongen. Finally, in 1910, Otto Müller of Berlin joined the Brücke. Only Pechstein and Otto Müller assimilated the Brücke style. The group also enlisted honorary, 'sympathiser' members among the general public, and from 1906 to 1912 issued a a small annual report and an annual gift album which are today precious documents of German Expressionism. The first Brücke show, held in the sample room of a chandelier factory, was totally ignored. The second, in 1906 at the Richter gallery, achieved a *succès de scandale*. The Brücke artists went on shocking the public for quite some time, for their Melanesian décor, coarse, simplified drawing, and plain colours seemed brutal and unidealistic even to the advanced art lovers who had just discovered Symbolism.

The Brücke artists neither stylised nor symbolised. Like the Fauves, they took their subjects directly from nature – nudes, still lifes, landscapes – and tried to extract expressive hieroglyphs from them. They invoked the right to deform nature for the sake of expression. Their painting, like Nolde's, was purely instinctive, subjective and ecstatic; nevertheless, it was a little more concerned with form and construction. At an early date, the rhythmic articulation of outlines, the arrangement of colour areas, the imbrication of planes were regarded as essential instruments of expression. These techniques implied a transition from Impressionism to Expressionism; by employing them in different ways, the Brücke artists gradually developed individual styles.

Towards 1910 the Brücke artists began, one by one, to move to Berlin, where Pechstein had taken a part in the Secession controversy and, with Nolde and a number of young painters, founded the New Secession (1910) in protest against the stubborn survival of Impressionism. Kirchner, Heckel, and Schmidt-Rottluff joined the New Secession. There they met Otto Müller who taught them the use of distemper. To preserve the purity of the Brücke, however, they soon resigned from the New Secession, and Pechstein, who refused to resign, was expelled from the Brücke. At the large exhibition held at the Gurlitt gallery, and at the Sonderbund exhibition in Cologne (1912), where Kirchner and Heckel were commissioned to decorate the chapel, the Brücke still appeared as a unified group. But their style had changed in the meantime; the drawing had become nervous and jagged with a tendency to Gothic pointed forms, the space more subdivided; the colours had become deeper and duller, and the composition seemed to be concentrated around an explosive

nucleus – distant echoes of Cubism. Within this expressive style, the individuality of the various artists stood out more and more clearly. This growing divergence became official in 1913 when the group disbanded over a minor squabble provoked by Kirchner's *Chronik*. But all the Brücke artists preserved certain basic features of their common style even in their later development which – apart from Kirchner who evolved a new style in the years between the wars – was marked by a tendency to moderation and normality.

*Kirchner (1880-1938): the Early Period*

Ernst Ludwig Kirchner was the restless spirit of the group. Bold, impulsive, self-confident, and aggressive, the son of a paper manufacturer, he rebelled against artistic conventions from the start and carried his friends along. His critical mind was remarkably quick to cast off the confused ideas of the Jugendstil and penetrate to the original ideas of the great masters – Seurat, Van Gogh, Gauguin, Toulouse-Lautrec, Munch, the Nabis, above all Bonnard and Vuillard. At an early date he was awakened to the vigorous shorthand of primitive art and of late Gothic drawing. His main concern was to distil primordial signs and hieroglyphs of this sort from nature, and to use them as means of expressing contemporary states of mind. His sensibility was always directly concerned with human emotions and this is what gives his work its poetic quality. It was this quality that he admired in Munch, and his poetic leanings also account for the dreamy Jugendstil reminiscences which for a long time coloured his work. But there is no trace of Symbolist composition and allegory. His approach was direct, regardless of whether he was painting nudes, landscapes, or portraits: only by confronting nature directly, can one transmute into a hieroglyph. In other words, he reacted exactly like the Fauves, and like them conceived of his paintings as simple flat surfaces, rhythmically articulated by vigorous outlines, and made to vibrate by decorative plain colours. By 1907 he had reached about the same point as the Fauves, but his manner was his own, more passionate, more impetuous, more vehement in human expression. The sentimentalism deriving from Munch and the Jugendstil had yielded to a vigorous, direct approach. His lapidary lines grew gradually finer, interlocking to form denser webs, their jagged angles suggested depth, their movement became erratic and explosive, and in this throbbing mobility they acquired extraordinary suggestive power. His colours became duller through his use of distemper which he learned from Otto Müller. In 1911, when Kirchner went to Berlin, he found the subject matter suited to his erratic script – the pace, the glare, the evil of the big city. This is the second Brücke style. Like an explosive charge, the jagged forms tear the composition apart. The pictures fully express the artificiality of the big city, the erratic lives of its inhabitants. Among these works are the magnificent Berlin scenes of 1912 and 1913, the *cocottes* strolling along the pavements, peering as though under an evil compulsion at the passers-by or the windows of fashionable shops. With their feather-boas and hats, they look like restless birds. Their fragile bodies and elaborate dresses tingle with a morbid exhibitionist eroticism. Fashions are the fantastic medium through which big city society stylises itself, signs standing for the collective image in which it likes to see itself. It was these signs that Kirchner employed for the hieroglyphs of his paintings, transmuting representational suggestions into striking formal signals that unmask the erotic appeal of the fashionable paraphernalia. The dense network of these jagged hieroglyphs captures the total human situation of a big city, as experienced on the Kurfürstendamm, the main boulevard of Berlin in the year 1913. Just as Nolde expressed the chthonian depths of nature, so Kirchner

expressed the psychological depths of megalopolitan anti-nature. He too opened up realities, made them visible, expressed them. His series of Berlin scenes provides magnificent examples of the most mature, most extreme Brücke Expressionism. But the frenzied breaking up of the object and the search for the expressive sign exposed this sensitive artist to the dangers which Munch, Ensor, and Van Gogh had faced before him. Shortly after his mobilisation in 1914, he suffered a nervous breakdown. He spent some time in a sanatorium in the Taunus, and then was sent to Davos. Here he gathered strength for a long new series of paintings in a new constructive style which will be dealt with later. On this path, his friends of the Brücke did not follow him.

## The Brücke Painters

In his early period Erich Heckel (b. 1883) closely followed Kirchner. By temperament he was more lyrical and reflective. Discerning the laws inherent in the new order of line and colour, he came close to the French Fauves towards 1908. With his strong sense of order, he succeeded in taming his anarchic will to expression. It was only in 1910 that the rhythm of his pictures grew ecstatic and his line jagged, while his melodious arabesque became fragmented and pregnant with expression – in all this he was influenced by Kirchner. The years between 1910-1914 marked a major period of German art. Its vitality was manifested in the open struggle between the demands of a rigorous pictorial architecture and an expressive will hostile to all restrictions, between order and explosive force. This conflict particularly characterises Heckel's work in his Berlin period. Even in his wildest products we detect a sense of order deriving from the serene world of Far Eastern art. In his most agitated moments he preserves a secret reflectiveness – this is Heckel's special and personal characteristic. It is also what gives his pictures their undramatic, lyrical quality. After 1914, freed from the overpowering influence of Kirchner, he quickly went back to moderation and restraint, to the well-balanced manner of the East Asians. In the last decades he has gradually settled down to painting vast landscapes in pale colours, with pleasantly rhythmic outlines.

Karl Schmidt-Rottluff (b. 1884) was the most vigorous of the Brücke painters. He had little use for Kirchner's intellectual problems his search for psychological counterimages. He had a tight grip on nature and built crudely monumental pictures from its simplified forms. In 1906 he painted with Nolde on Alsen and saw how Nolde made Impressionism expressive by intensifying and barbarising it. In 1907 he accompanied Heckel to Dangast on the Oldenburg coast, where he too succeeded in endowing Impressionism with a monumental character by radical simplification of form and by reducing colours to pure tonalities. He pursued this path, but during the Berlin period of the Brücke he enriched his art with the block-like forms of Negro sculpture. After the First World War he moved gradually away from this harsh vigorous manner; his script slowly lost its virile independence, and he went back to a kind of monumental landscape painting. His colours became considerably softer. But he fully preserved his forceful vision and his ability to extract from his motif the elements that release artistic emotion.

The versatile Max Pechstein (1881-1955) developed along similar lines. Kirchner's intellectualism was beyond the range of his decorative gifts. He followed Heckel and Schmidt-Rottluff, and adopted the Brücke style as a means of achieving vigorous, crudely coloured decorative landscapes, which he strove to make expressive by a superficial use of exotic techniques – in 1913 he visited the Palau islands.

Otto Müller (1874-1930) introduced an entirely personal note into the Brücke style. He was half Silesian and half gypsy. His father was a customs officer descended from a family proud of its scholars and theologians; his mother a deserted gypsy child who had been brought up by an aunt of Gerhart Hauptmann's near the Bohemian border. He was small and slender, with a sallow face, blue-black hair, and dark melancholy gypsy eyes. He wore an amulet because he believed in the power of the stars and went everywhere with a black poodle. He conversed with spirits and was steeped in magic. But he was no Mephistopheles, just a gentle subordinate who escaped from the demons into a self-invented paradise of images, the paradise of the gypsies.

The world portrayed by Otto Müller is a gentle, sparse, quiet world, of austere beauty – forest scenes, lake shores with figures, female nudes with pointed gypsy breasts in bold contour, peasant huts in a dark glory of colour planes, with a sunflower in front glittering like a melancholy star. His world occasionally takes on an almost mythical character. Then the gypsy mothers are transformed into Madonnas, round their homelessness there arises a new legend of redemption, and their children are crowned with haloes. All his paintings, including his nudes and landscapes, carry a suggestion of dark Galician legends. There is something sorrowful in the black water of the landscapes, and it is only by looking beyond the canvas, as it were, that we can master our disquiet.

His studies at the Dresden Academy in 1896 and his penchant for Böcklin and the Jugendstil idealism of Ludwig von Hofmann account for some elements of his art: his Arcadian figures and nature mythology. But it was only towards 1910, in the Brücke milieu, that he developed his technique. He joined the group in Berlin, but he was also close to the New Secession and was a friend of Lehmbruck. Kirchner's hieroglyphs and Heckel's lyricism were very important to him. In Müller all this took on a more eurhythmic – one is tempted to say, more classical – quality. He simplified the grand style of figure painting and gave it an Expressionist slant.

In his last period – from 1919 on he taught at the Academy in Breslau where he died in 1930 – his works lost their eurhythmic quality. Their colour harmonies grew sombre, their forms larger, and he sought to record landscapes and figures in more universal signs. His paradise grew darker, more sorrowful, more melancholy. It also grew more expressive, disclosing the painter's smiling sadness, his forlornness, and the warmth of his love.

### The Neue Künstlervereinigung of Munich

In 1904 Kirchner may have seen the first German exhibition of Cézanne, Gauguin, and Van Gogh, organised by the Kunstverein in Munich. But he retained a more vivid recollection of another exhibition – that of the Neo-Impressionists Seurat, Signac, and Luce. This exhibition was arranged by the Phalanx, one of the many art groups of Munich (the Phalanx also had its own art school). Its organiser was the Russian painter Wassily Kandinsky, chairman of the Phalanx, who had come to Munich in 1896.

Munich was at that time the centre of the Jugendstil movement. The boldest ideas on the psychological and decorative effects of free coloured forms were in the air, and Kandinsky entered into them wholeheartedly. After preparatory studies, he entered the studio of Stuck and, needless to say, came into contact with the Scholle artists. For some years he marked time, unable to develop his ideas. His recollections of Russia and Russian folk art inspired his fairy tale scenes in sumptuous Oriental colours, reminiscent of popular prints. This art is influenced by the Jugend-

stil, the Vienna Secession, and Stuck, but underneath all that we find the vivid colours of Russian legend. Beginning in 1903 he took long trips to Italy, Tunisia, the Netherlands, and time and again to France. As early as 1904, he had brought the Neo-Impressionists to Munich and studied their handling of pure colours; on his trips to France, he attentively studied not only Seurat, Gauguin, and Van Gogh, but also the new artists, Matisse and the Fauves. This was Kandinsky's Fauve period. But the works of these years, for all their formal compliance with the Fauve aesthetics, still retain the fairy-tale quality of Russian folk art. Although most of them are landscapes, and Upper Bavarian landscapes at that, their colours are already divorced from the optical impression and enriched by the primitive vigour of peasant paintings on glass, rustic furniture decoration, and wayside shrines. The colours are strongly orchestrated, without Matisse's refined, playful aloofness. Already one is reminded perhaps of a Russian choir.

Kandinsky's intensified Fauvism and his clear intelligence, which tended to express itself in a somewhat didactic manner, attracted a number of young Munich painters. First of all there was his friend Alexej von Jawlensky, a former Russian officer, Russian through and through, a man of great depth of feeling, more mystic than intellectual, who admired Kandinsky's clear mind. He too travelled extensively, and he too discovered Van Gogh and Cézanne in Paris. In 1906, he met Verkade, who was on leave from the Beuron monastery, studying painting in Munich. Verkade acquainted him with the Pont-Aven theories, and took him to a private collection where paintings by Maurice Denis and Bonnard hung in a room decorated by Van de Velde. In 1907 he saw an exhibition of Toulouse-Lautrec's lithographs at the Tannhauser gallery. In 1908 he visited two small Van Gogh exhibitions at private galleries in Munich, and on this occasion acquired a small Van Gogh. But he was most deeply impressed by Matisse, whom he also met personally. Now Jawlensky too became a real Fauve. He was more open than Kandinsky to French influence, but his paintings also have an oriental glow and warmth that carry us to a mystical realm far removed from Matisse's cool intelligence.

A third Fauve was Gabriele Münter, a pupil of Kandinsky who became his companion. Rather unreflectingly, she applied her friend's Fauve aesthetics.

The three friends conceived the idea of a new association of artists, which was founded in 1909. Their earliest adherents were Erbslöh, Alexander Kanoldt, Marianne von Werefkin, and the graphic artist, Alfred Kubin. A sensitive man with a strongly neurotic disposition, Kubin had described abstract colour visions in his novel *The Other Side*, published in 1909. Kubin's visions revealed a profound kinship with Kandinsky's own experience: 'I saw the world as a tapestry-like marvel of colours, all the most surprising contrasts dissolved into a single harmony. In the darkness, a symphony of sonorous colours resounded around me, and in it tenderly moving natural tones joined to form understandable chords.' These autistic visions of Kubin prove conclusively that experience of this kind reflected the spirit of the times. In the same year three other artists joined the new group – Vladimir Bechtejeff, Carl Hofer, and Moissey Kogan. Pierre Girieud, an untalented French follower of Sérusier, joined in 1910, and Franz Marc in 1911. But at this point we must stop, for late in 1911 the society split, when a number of artists led by Kandinsky and Marc resigned to found the Blaue Reiter. Before giving an account of this group, we must take a look at the events that had meanwhile taken place in European art.

The Neue Künstlervereinigung held its first show at the Moderne Galerie in the winter of 1909. A second followed in the autumn of 1910; among the guest exhibitors were some authentic Fauves who by then had gone over to Cubism – Braque, Derain, Van Dongen, Picasso, Rouault, and Vlaminck. If we reconstruct this exhibition, we find it to have been dominated by Kandinsky's

intensified Fauvism which was also the style of Jawlensky, Gabriele Münter, and, in a decorative variant, Werefkin. The others, such as Erbslöh or Kanoldt, also painted in the style of this expressive Fauvism, but their work was marred by the sentimentalism of the Jugendstil and the decorative monumentalism of the Scholle artists. At bottom, all of them were only partly carried away by Kandinsky's genius. But even then Kandinsky was experimenting with more novel means of expression.

The aesthetics of the Neue Künstlervereinigung was well formulated by Otto Fischer, who was the group's theoretical spokesman after Kandinsky's resignation. He wrote in 1912: 'Colour is a means of expression which appeals directly to the soul. Colour is a means of composition. The essence of things is captured, not by a correct drawing, but by the powerful and dynamic, compelling and fully mastered outline. Things are more than things when they are the expression of the soul.' Here, in other words, we have a 'synthetic' Jugendstil aesthetics, stylised with a view to form and expression, under the influence of the Fauves. Fischer does not dare to draw further consequences from his ideas. 'A picture does not express the soul directly, but rather, the soul as reflected in the object. A picture without an object is meaningless.' The last sentence is clearly directed against Kandinsky and his non-objective art. But that was the irresistible trend. Before we can deal with it, however, we shall have to investigate a new ring in the tree of modern art. The Neue Künstlervereinigung shows us the situation in 1910 – the organic transformation of the Jugendstil into Fauvism, which in its German version may, with a slight shift of emphasis, be termed 'Early Expressionism'.

Having reached the end of the road leading from Paris, via North Germany and Dresden, to Munich, and examined a stylistic trend active simultaneously throughout Europe, we may try to define the nature of this Fauvism or Early Expressionism.

*Fauvism and Early Expressionism*

The two terms designate one and the same style, an identical response to a specific stage in the development of European art. The French variety stresses the formal aspect – 'expression' implies 'form'; the German variety stresses the subject matter – 'form' implies 'expression'. Both are subordinated to the central concept 'Expression'.

Common to both is a youthfully carefree aggressiveness, which radically changes the psychological image of the artist. The figure of the artist as an esoteric Symbolist, a melancholy decadent, an exclusive dandy, a solitary priest, or Jugendstil aesthete has become an object of ridicule. The new artist conceives of himself as the primitive of a new future; he speaks, not in metaphors but directly, he is a revolutionary man of action. His conviction that he is a member of an élite does not express itself in proud and sad withdrawal to an ivory tower, but in readiness to attack, to engage in critical polemics. His basic inspiration is the freedom of the whole man. On the temporal level, he rebels against tradition and the existing rules of the game; on a more essential level, he rebels against the fetters imposed on the creative instinct and its spontaneous response to reality.

In France we witness an unmistakable reaction against the rank growth of Symbolism and Art Nouveau. The Fauves fight their way through the idealistic and Symbolist underbrush to the fountainhead of original growth. There they discover Seurat, Gauguin, and Van Gogh, and find themselves in a situation comparable to that which gave rise to the aesthetics of the Nabis. Indeed,

the two principles of this aesthetics – the picture is primarily a flat surface covered with colours in a specific arrangement, and the picture does not reproduce the object, but represents it through pictorial equivalents – are also the foundation of the Fauve aesthetics. But the polemical target has shifted. Whereas the Nabis turned against the Impressionists' superficial conception of reality, the Fauves, though fully supporting this criticism, were also determined to clear away the idealistic and Symbolist vapours that were obscuring reality. They go back to a direct confrontation of nature and this is clearly reflected in their choice of subjects – nudes, landscapes, still lifes. But to this confrontation with the world of things the Fauves brought a clear awareness of the anti-naturalistic function of art and consequently were freer than the Nabis from natural appearance. In *formal* terms this meant 'abstraction': form, colour, and space are 'abstracted', reduced to their fundamental pictorial formula, the exuberant forms of nature are simplified and deformed in accordance with the 'abstract' pictorial structure. In terms of *content* the result was an Expressionist art – the painter was free to deform natural appearance in order to express his feelings in accord with his inner necessity. Abstraction and expression are closely related; and the art of the Near and Far East and of primitive peoples is invoked in support of these positions. Thus the aesthetics of the Fauves develops from that of the Nabis. Both sought to stress the use of pure colours.

In Germany the development is far less consistent. The ground had not been prepared for the movement against realism, Jugendstil idealism, Naturlyrismus and the mists of Symbolism. For a long time the criticism remained negative, incapable of producing positive ideas. The new movement managed to single out a few ideas from the Jugendstil and Naturlyrismus; it learned from Munch, but at the same time it sought an escape from the metaphorical. Amidst this unrest Van Gogh and French Post-Impressionism came as a revelation. The critical point was reached in 1905; in 1906 we have the first solutions – the early Brücke style, Nolde's paintings of flowers, Rohlfs' views of Soest, Modersohn's last paintings, and in Munich, Kandinsky's and Jawlensky's oriental Fauvism. In a swift and stormy development late Impressionism was transformed into Expressionism. Expressionism disclosed the same stylistic features as Fauvism – direct confrontation with nature, abstraction, and expression – and rapidly assimilated direct Fauvist influences. But it was far more violent unrestrained, it manifested a passionate striving to capture the world, whereas, according to Matisse, 'expression is to be found not in passion, but in order'. Expression overshadowed form. Matisse's Persian tiles gave way to the bright coloured wood carvings of South Sea islanders and the folk art of Russian and Bavarian peasants.

Freedom from convention and from imitation went hand in hand with the liberation of instinct. 'Instinct is the basis of art,' said Vlaminck, and Nolde declared, 'Instinct is ten times more important than knowledge!' Through instinct reality is confronted directly and renewed. The world is no longer a source of suffering for the self. For now man ceases to take natural appearance seriously; what matters is his response to it, the image which the pictorial instinct evokes in the mind. Nature is no more than a pretext, and already the idea was emerging that it might be dispensed with altogether. The contact between the self and the visible is still maintained, but it has lost its potential charge; the artist had begun to take heed of images arising from his inner depths, the realm of eternal symbols. This accounts for the sudden interest in the art of primitive peoples, children, and Sunday painters. Nature is merely a stimulus that provokes inner images. Communication with nature has become an instrument for clarification of the inner world. What matters is not the natural object but the experience of nature.

At this point we must stop, for the Fauves followed only the path cleared by Seurat, Gauguin, Van Gogh – the path leading to pure colour. They did not ignore Cézanne's lessons, but they devel-

oped his aesthetics only in respect of the representation of the original impression by colour equivalents. They did not concern themselves with Cézanne's radically new ideas about space and form. This is where Cubism came in.

*The Early Picasso and Cubism*

Cubism is also a striving to fit the representational elements of the picture into the autonomous order of coloured forms, a task that seemed so urgent to the art theorists during that decade. The artists who proposed the new solution were Pablo Picasso and Georges Braque.

It is here that we first encounter the name of the artist whose genius was to dominate the development of art during the first half of the twentieth century – Pablo Picasso. He was born in Malaga, on the Spanish coast of the Mediterranean, in 1881. In 1896 his father, also a painter, was appointed professor at the Academy in Barcelona. In the same year, Picasso entered the Academy where he studied for a period of several years, interrupted only by a brief stay at the Madrid Academy. Artistic life in Barcelona differed little from that of other European centres: here too traditional painting was firmly established on foundations of realism and historicism, and here too there was a small nucleus of revolutionary bohemians who took their ideas from Symbolism and maintained close contact with Paris. Young Picasso was soon drawn to the bohemians. He became acquainted with the art of Toulouse-Lautrec and the French late Impressionists, but also with the pointed social critique of such draftsmen as Steinlein of *Gil Blas*. At the same time another stylistic current was making itself felt – the Jugendstil. It greatly appealed to the Spanish Baroque temperament with its tendency to overcrowding, and it was precisely in Barcelona that it produced a building unique of its kind, which is a veritable manifesto of Jugendstil architecture, the new Cathedral of that city. The *Jugend* and *Simplicissimus* of Munich, leading organs of the Jugendstil, were read by many young Spanish artists. Barcelona even had a kind of imitation of the *Jugend*, a magazine which bore the name *Joventut* – the group to which Picasso belonged played an important part in founding it.

In the autumn of 1900, when Picasso made his first short trip to Paris, he was thoroughly familiar with the new ideas that preoccupied European artists at the time. As he came for the first time into direct contact with the masters of modern French painting, he was struck by the sensuous power and splendour of their colour and their structural solidity. The nineteen-year-old Spaniard was impressed by Renoir's sumptuous painting and the colour schemes of the Neo-Impressionists, and his conception of composition was greatly influenced by Degas and Toulouse-Lautrec. His paintings of that period treated, with characteristic assurance, subjects taken from the 'social milieu' of Toulouse-Lautrec. Beneath the luminous cold colours, his portrayals of figures from the world of Montmartre show clearly that the young painter was deeply interested in describing human attitudes and the modes of contemporary existence.

Towards the end of 1901 Picasso went again to Paris, and until 1904, when he settled there for good, he shuttled between Paris and Barcelona. During those years he assimilated the new ideas. Like so many others, he started from Gauguin, Van Gogh, Toulouse-Lautrec, Vuillard, Denis, Degas, and Renoir. Certain exhibitions deeply influenced him – the Seurat retrospective held by the *Revue Blanche*, Redon's 'Pastels mystiques et décoratifs' (Vollard, 1900), the Van Gogh exhibition of 1901 (Bernheim), the great memorial exhibition of Toulouse-Lautrec (Indépendants and Durand-Ruel, 1902), and the Gauguin memorial exhibition (1903). The boldness and splendour of the

colour, the abstract flatness of the composition and décor, the expressive Symbolism diverted the young Spaniard, as it had diverted others before him, from the delicate, unobtrusive intellectuality of Cézanne. In 1901 Vollard exhibited several of Picasso's early paintings. These won him the friendship of the poet Max Jacob, who introduced him to the bohemia of Montmartre, which included young artists from all over Europe. The Bateau Lavoir, a dilapidated building in the Rue Ravignan, occupied by writers and painters, to which Picasso and Jacob moved in 1904, became the headquarters of this bohemian group of young Spaniards (from 1906 they included Juan Gris) and Frenchmen. It was here that Derain in 1905 enthusiastically displayed the first Negro mask he had bought from an antique dealer; occasionally Degas paid a visit.

It was in this environment that Picasso developed his first 'Blue Period' style. He now painted almost exclusively large figurative works of great emotional concentration. They portray poor people, outcasts of the big city, who frequented the bistros of Montmartre – the world of Toulouse-Lautrec but without artistic sublimation, poorer, more naked, with emphasis on expressive gestures. They still show traces of Jugendstil sentimentalism. They are also influenced by Steinlein and the specific tendency to social criticism which since the publication of Zola's *Assommoir* in 1877 had taken hold of painters such as Forain and Raffaeli, and in Germany had left a lasting mark on Käthe Kollwitz and the early Barlach. The gestures clearly go back to Degas, but Picasso emphasises their expressive function. The colours are reduced to a lyrical dominant tone, blue. This produces an unreal atmosphere in which the sparse concentrated outlines trace a dreamy, melancholy, somewhat fragile cantilena. Odilon Redon and Carrière used the same dreamy homogenous colours in their lyrical works.

By 1905 Picasso's composition becomes richer and more complex, taking on an almost classical ideality. He produces large figure paintings portraying strolling players – groups of harlequins, circus performers with their wives, disclosing the gentle helplessness and forlorn attitudes of these people when they are outside the arena. The colours are still homogeneous, but they have now shifted to a beautiful pink and terracotta. Contrasts are avoided: only here and there – in a harlequin costume, a basket of flowers – does the colour become more varied, though even then the tones remain subdued. The lyrical ideality of these paintings and the statuesque arrangement of the figures outlined with simplicity against an empty background bring to mind Puvis de Chavannes and Gauguin. Toulouse-Lautrec's music-hall themes and Degas's world of the ballet achieve in Picasso a kind of monumental lyricism. Each of these works breathes a poetic sadness, which animates the figures with their fragile angular gestures inherited from Symbolism, and many of them possess a deeply symbolic human significance, for example, *Les Saltimbanques* (1905), to which Rilke refers in his fifth *Duino Elegy*. The coloured ground on which Picasso paints his strolling players is like a hollow spiritual form. It is the pictorial expression of a frequent modern existential theme – life seen as helpless exposure in an indefinable void. It has been given various names – the dread of nothingness (Heidegger), the incomprehensibility of God (Barth), non-being (Valéry). Picasso's harlequins embody modern man's basic emotional and intellectual experience, his existential homelessness and melancholy freedom.

Towards 1905 a new spirit of freedom began to stir among the Fauves. It runs through European art like a convulsive throbbing and was also communicated to the restrained ideality of Picasso's art. It impelled him to search for more forceful means of expression and to go back to more primeval sources of art. He found encouragement in the Spanish tradition – the expressive art of El Greco and the pre-Roman archaic art of Iberia. The primitive art of ancient Spain, in the first millennium B.C., distilled a magic idol from the image of the Greek Apollo. Picasso must have

had this early development in mind when, abandoning his figures of players with their classical ideality, he turned to magical images, stripped of temporal references and so acquiring a universal symbolism. His forms and figures now become sculpturesque, archaic, magical. The magical element aroused his interest in the art of the primitives. This was by no means uncommon in 1905. At that time Derain, Vlaminck, and Matisse were rummaging through the antique shops in search of Negro masks; in Dresden, Kirchner studied in the ethnographic department of the Zwinger rather than in the Gemäldegalerie; in Munich Kandinsky was inspired by the primitive paintings of Bavarian peasants, and at Hagen the group around Osthaus acquainted North German painters with the art of the primitive peoples. Picasso's obsessive preoccupation with Negro art is merely another symptom of a general trend.

However, this irruption of expressive and primitive elements required a radically new pictorial structure. This was the hour of Cézanne. In 1907, when the great Cézanne memorial exhibition was held, the ground had been sufficiently prepared for Picasso to assimilate Cézanne's formal lessons.

The combined effect of all these ideas can be accurately gauged in a painting on which Picasso worked for several months. In the spring of 1907 he began a large figurative composition showing a group of nudes in a room (later entitled *Les Demoiselles d'Avignon*). The compositional structure is clearly influenced by Cézanne – it embodies the formal conquests of Cézanne's *Grandes Baigneuses*. This can be seen even more clearly in the early stages of the *Demoiselles*, which we can study from drawings. Originally a sailor was to be shown seated among the nude women, and a man with a skull was to be entering from one side – a symbol of death. These thematic elements are characteristic of Picasso's dramatic, macabre, gloomy imagination and in sharp contrast to Matisses's capacity for happiness (his *Joie de vivre* dates from the same year). The austere structure and the shallow pictorial space are in the spirit of Cézanne, but the strident decorative colours are still Gauguin's. Though in overall appearance this painting is still very close to classical figurative composition, the detail represents a complete break with classical, or even normal standards. Demonic, grotesque elements from many different worlds burst in on all sides. The austere sculptural figure to the left – a transformation of an archaic Apollo – originates in the early barbaric-Greek epoch of the Iberian peninsula; to the right, a demonic incursion of masks, reminiscences of sculptures from French Africa. This demonic zone breaks up the eurythmics of the composition. On the left it is flat, calm, massive; but on the right it spurts upward in demonic unrest, and here too the pictorial space is deepest. It is easy to see what has happened: Cézanne had provided a new foundation for the interlocking structure of the painting, but, in treating the individual forms, Picasso was inspired by primitive forms of art, falling under the magical spell of their powerful notations. In turning away from the mobile images of nature, and in turning to inner images, Picasso re-examines the earliest manifestations of the formative instinct. At this 'archaeological' stage of his development, Picasso consults the products of primitive art as to their store of images, the meanings of their signs, their abstract vocabulary. Natural forms seemed by comparison empty of content and poor in expression. The imagination had to draw upon a world of new signs and abstract forms. It was only natural that these forms should be looked for where they could be found, in periods and cultures which had not yet been submerged under the visual wealth of European realism. In all others respects, however, Cézanne dominates even this archaeological period of Picasso; concern for Negro sculpture was little more than a fruitful study of forms.

However, both form and composition are still 'copied', rather than developed, from Cézanne's ideas. Cézanne's fundamental principle was that the artist should develop a pictorial conception on the

basis of direct study of nature, and then apply his conception to nature; from this principle Cézanne derived his often quoted dictum (published by Bernard in 1906) that nature must be treated in terms of geometric forms, such as the sphere, the cone, the cylinder. Cézanne said this to Bernard only with the greatest reluctance. His idea was more complex. He wanted to transform sensory orders discovered in nature into form, to give them permanence and embody them in painting. Form was the product of a dialogue between the mind intent upon order and the object. Analysis of the object released the form. This analytical method was now to emancipate the new art of expression from all old forms, from all archaeological and ethnographic elements, and lead it to its own means of expression. It was in the course of his confrontation with Cézanne's ideas that Picasso – and Braque at the same time – developed the formal method which has been called Analytical Cubism.

*Analytical Cubism*

These two artists concentrated on form; colour was of less importance, and became almost monochrome: subdued dark tones, based on grey and ochre. But they were also concerned with constructing the medium in which form could acquire three dimensions, that is, with the problem of space. Courbet had sharply criticised Manet's flat pictorial space, observing that a picture was not 'a playing card'. But Manet's conception of space – as masterfully realised in his portrait of Zola, for example – marked the beginning of an effort to construct a non-perspective and autonomous pictorial space. Manet tried to solve his problem by exploiting the fact that different colours suggest different depths; he achieved a spatial effect by a fan-shaped arrangement of flat planes varying in luminosity. The same method had been applied long before in Far Eastern colour woodcuts, from which Gauguin took it, transferring it to the most specific element of painting, which is colour. He began to change the Impressionist space continuum made of light and perspective – that is, illusionistic space – by flattening it out on the picture surface, and created an impression of depth by the relations between pure colours. Gauguin's ideas, developed by the Nabis and then by the Fauves, culminated in Matisse's *espace spirituel* – a non-illusionistic pictorial space carefully constructed from vibrant colour areas.
Cézanne, who continually made analytical comparisons between illusionistic space and the requirements of pictorial space, found this solution unsatisfactory because the successive colour planes remained unrelated to one another. For this reason he set out to make the planes vibrate, to interweave and imbricate them in various ways. In his analytical treatment of objects, he sought to preserve their basic geometrical forms by means of these interlocking planes. Gauguin's flattened space gave way to a non-perspective three-dimensional space in which the objects preserved their materiality and solidity. Up to 1905/1906, the importance of Cézanne's discoveries had not yet been appreciated, for attention had been focused on colour.
But in these years artists were becoming increasingly attracted to primitive and archaic art, particularly Negro sculpture. Without doubt, this interest was originally occasioned by the expressive force, the primordial and magical character of these works. But a characteristic force resided also in the treatment of space: primitive art demonstrated a forceful conception of the physical being of its object, archaic art an awareness of the cubic power of things; the Negro sculptors, by interlocking positive massive forms and negative hollowed-out forms gave their magical forms an astonishing appearance of spatial power. And it is this which revealed to modern artists the

new expressive function provided by the relation between space and volume. All this made it easier to understand Cézanne. The great memorial exhibition of Cézanne was held at the Salon d'Automne in October 1907, and from 1908 on almost all the young painters went over to Cézannism. But Picasso and Braque did not stop at Cézanne's external, fully developed forms; they set out to get to the very bottom of Cézanne's aesthetics and develop it.

Georges Braque, whose early development as a Fauve we have already followed, was introduced to Picasso by Apollinaire and Kahnweiler, and in 1907 he visited his studio where he saw the final version of the *Demoiselles d'Avignon*. At that time Braque had begun to revise the Fauve aesthetics on the basis of insights gained by studying Cézanne and Negro sculpture. He had reached the same point as Picasso. In the summer of 1908 he went to l'Estaque near Marseilles, where he began to apply Cézanne's analytical method directly before the landscape, trying to obtain stronger effects by procedures taken from primitive art. He submitted his landscapes to the Salon d'Automne, but the jury, which included Matisse, rejected them. After the jury's deliberations Matisse told the critic of *Gil Blas*, Louis Vauxcelles, that Braque had sent in landscapes 'with little cubes'. On the occasion of the Indépendants of 1909, where Braque exhibited his landscapes of L'Estaque (in 1908 they had been accepted only by D. H. Kahnweiler, Picasso's first dealer and the champion of the group of painters around him), Louis Vauxcelles referred to them in his review as *bizarreries cubiques* ('cubical oddities'). The new movement was soon baptised 'Cubism'. Braque was not alone. During that same summer of 1908 Picasso, starting from identical premises, arrived at a very similar solution in still lifes of the simplest kind. In the winter of 1908, the two painters began to work together and their styles became so similar that their development in the few years that followed can be treated in one. Picasso is rather more dramatic and dynamic in form and colour; Braque is calmer, more static, more restrained and harmonious in his colours: one is Spanish, the other is French.

The procedure is analytical. The form is developed from the object. The plastic experience of the solidity of things is at first preserved. Its formal density is even exaggerated by analytical reduction of its form to a basic stereometric form. The atmosphere, too, by an exaggeration of Cézanne's theories, is formally defined by geometrical facetting. Space is firmly tied to the picture rectangle, the background fixed by a firm plane as in a relief. By means of interlocking geometrical facets resulting from the formal analysis of the objects and the solidified atmosphere, an autonomous pictorial space comes into being. The picture is self contained. It is no longer the representation of a segment of nature, but an architectonic formula expressing an abstract order. The shapes of the objects serve as elements of construction; they are reduced to stereometric building blocks, to the spheres, cylinders, cones which, according to Cézanne, are the elements of natural forms. Out of them the many-facetted crystal of the picture is pieced together in such a way that the images of things shine through its structure.

The formal analysis isolated geometrical features of things which could be used as elements of the pictorial structure. However, these did not fully capture the three-dimensional physical reality of things. But Braque and Picasso stubbornly pushed on with their analysis striving to render the full material reality of the object with its actual dimensions. Thus Picasso said: 'It is impossible to ascertain the distance from the tip of the nose to the mouth in a Raphael. I should like to paint pictures in which that would be possible.' In pursuit of these and similar objectives, the Cubists arrived by 1909 at an analytical dissection of the object. They began by separating the facets of objects, by spreading them out, and by blending them with the forms of other objects. Such combinations gave rise to the idea of simultaneity, the representation of different aspects of an object in

juxtaposition, so that the partial view of an object can be turned into a total mental view with the help of factual data, such as dimensions, ground plans, and profiles. The painter goes round the object, as it were, taking note of its most important formal and structural features as disclosed by partial views, and adds them up mentally to obtain a total image. Thus Braque and Picasso painted the object in 'simultaneous' views, juxtaposing views from the front, from above, and from all sides, and blending the resulting outlines in a formal structure that has an aesthetic value of its own, but at the same time analytically describes the object. Even though their method goes back to some of Cézanne's deformations, it is clear that they are beginning to treat the pictorial oganism as an independent entity. Now natural appearance supplies only the data and proportions which serve as the basis of the autonomous structure. The Cubist uses the fragmentary formal data of the visible as the elements of a formal intellectual game, which is governed by rules of its own and transforms natural appearance, but still retains the visual point of departure and allows for the reconstruction of the initial stimulus.

At this point we must mention a radical change in man's view of the world. Towards 1910, when juxtaposed simultaneous views of the object made their first appearance in painting, the concept of time was introduced into the static space of the picture. In the realm of science at roughly the same time, three-dimensional space, which can be visualised, gave way to the time-space continuum, with time playing the part of a fourth dimension which cannot be visualised but only expressed in mathematical formulas. The scientific development which divorced our conception of nature from the visible world and reduced it to concepts and mathematical formulas, greatly encouraged painters to move in the same direction and to render this abstract conception by pictorial forms which by their very nature could only be abstract.

And so, towards 1910, Picasso and Braque turned more and more to abstraction. The differences between the forms of objects and the formal signs designating the atmosphere, intermediate space, and background are increasingly blurred. The diverse data are pieced together into a structure governed by an autonomous counterpoint of dissonances and harmonies. The purely structural elements and their formal relationships begin to supplant the descriptive elements and their representational function. The object serves merely as a stimulus to the artist's formal imagination; he uses the pure forms abstracted from the object as elements with which to organise his picture. In the course of this process of construction, the material shapes of the objects may be deformed to such a point that they can be reconstructed only by a careful regressive analysis. As a result the object, whose solidity and materiality are still preserved in the 'facetting style', loses its stereometric, three-dimensional features. The picture becomes flat, a structure of interlocking planes set off in relief against the background, into which the suggestions of three-dimensionality are inscribed as into a grid without resort to effects of illusionistic lighting. The illusionistic element of lighting, formerly of capital importance for the constitution of pictorial space, becomes inapplicable in the autonomous painting. The consequence is the so-called *'plans superposés'* a delicately graded succession of overlapping and partly transparent planes that represent the third dimension. In short, everything in the picture is subordinated to the aim of developing the structural elements in all their purity and independence.

Thus Picasso and Braque carried Cézanne's theories to their inevitable consequences. In 1909/10 the new aesthetics attracted many young painters. Late in 1909 Albert Gleizes, his friend Metzinger, Francis Picabia, Herbin, Le Fauconnier, and Lhote, who had come to Cézanne by way of Impressionism, went over to Cubism. In the same year, Robert Delaunay joined the new movement; disturbed by Cézanne, he had subjected examples of mediaeval architecture to analyses related to those

of the Cubists, and was arriving at free construction through the formal dissection of the object. In 1910, the following artists joined the movement: Louis Marcoussis, a Pole who arranged pleasant decorative patterns with the analytical elements developed by Braque and Picasso; Roger de la Fresnaye, who for a time modernised his Cézannism with Cubist elements; Marcel Duchamp, whose brilliant and anarchic mind had recognised that Analytical Cubism, with its fragmentation of the object, reflected the psychology of modern man whom technology has alienated from the world of things. Fernand Léger, who started from the rigidly simple vision characteristic of the Sunday painters, found his way to the stereometric forms of the new style and began to experiment with them as a means of expressing the dynamic functionalism of the machine age; and Juan Gris, who had shared a studio with Picasso since 1906, but only now made up his mind to abandon his figurative style derived from Toulouse-Lautrec's posters for the Cubist aesthetics. In the two years that followed, every formal innovation of Cubist aesthetics was to be reflected in this broad phalanx of painters, each of whom interpreted it in accordance with his individual temperament.

In 1911 Braque began to introduce letters into his pictures. He may have been inspired by the inscriptions in Gothic paintings; in any case, the signs on the transparent windows of cafés encouraged him to experiment. The introduction of these fully formed signs from an alien world of forms creates, on the formal level, an unreal space, for the inscribed letters have the effect of a foil, as though defining a transparent plane behind which the poetic reality of the picture begins. In terms of content, the signs produce an effect of surprise and fascination; they communicate the magical shock that an isolated, real, familiar thing releases when presented in an unreal context.

From this it was only a step to the introduction of other 'real elements' into the pictures: newspaper headlines if one was doing a still life with newspapers, imitations of the grain of wood or marble, etc. These real details were like quotations, evoking recollections of objects, making the picture 'legible', and enabling the viewer to identify the intended object in the free rhythmical structure of the picture. The object thus recognised by its associations then assumes its full three-dimensional reality in the viewer's mind; it is re-created, reconstructed in the imagination, that is, seen in a new way, with a compelling force that illusionist art cannot equal.

The next step was to experiment with the introduction of actual objects into the picture. In 1912 the Cubists, instead of imitating the textures of certain materials, began to paste the materials themselves on the canvas — fabrics, papers, etc. Thus the 'collage' was born. This technique enriched the structure of the surface by novel tactile values; moreover, the introduction of isolated centres consisting of actual things carried visual illusion to the extreme, so producing a disquieting interchange between tangible materiality and total unreality. This quid pro quo carried to the point of the grotesque was justified by the aesthetic order that was arrived at in the end. The crux of the matter is that this art no longer describes or interprets the object; the things themselves are called into play, and with their help a new thing is constructed.

This, however, takes us beyond the confines of Analytical Cubism. For Analytical Cubism seeks to turn the 'natural object into an artistic object'. The accent is on the object. Consequently, the stylistic vocabulary of the first phase of Cubism was almost exclusively developed in still lifes. Thus Analytical Cubism is both representational and abstract. But its analytical method tended steadily to decrease the importance of the descriptive element and to transform the picture into an abstract crystalline construction in its own right.

By 1912 the theory of Analytical Cubism was fully developed. The exhibition of the group held at the Indépendants in 1911 had introduced Cubism to the public, and the art dealer D. H. Kahnweiler made it known to collectors. Guillaume Apollinaire discussed its theoretical foundations in articles,

and on the basis of these foundations Gleizes and Metzinger wrote a kind of aesthetic textbook of Cubism. Analytical Cubism was now a full-fledged style.

Because of the inherent dynamism of artistic thinking, this style was also to experience a crisis. It was brought on by three developments. First, the alert intelligence of the leading Cubists led them inevitably to reverse the terms of their problem: if one could arrive at an autonomous pictorial organism by analytical treatment of the things of nature, it was natural to ask whether the converse was possible, namely, to produce a free 'abstract' pictorial construction which suggests objects only in the course of its progressive growth, or, in other words, which arrives at them 'synthetically'. Analytical Cubism now gave way to Synthetic Cubism, which Picasso, Braque and Juan Gris developed in the years that followed. Secondly, Analytical Cubism split internally. The dissidents criticised the drab colours of strictly orthodox Analytical Cubism and sought to combine the Nabi and Fauve insights into the autonomous 'abstract' significance of colour with the rigorous forms of Cubism. Apollinaire gave this internal secession, led by Robert Delaunay, the name of 'Orphism'. Thirdly, the crisis was touched off by an idea inherent in Cubism but developed only in its rudiments by the Cubists, the idea of dynamism, of space-time, of movement. We have mentioned this before. Many Cubist paintings present a peculiar formal dynamic deriving from their content. Every object evokes associations and recollections; even an object at rest has a kind of psychological mobility. But most objects also possess a purely physical mobility – they are displaced, they move. Attempts were made to render the object in movement; and this required the introduction of the time factor, for movement takes place in time. Analytical Cubism, which arrived at its formal constructions by breaking up the object, and hence began with the still life, with the object in repose, was slow to acknowledge this idea. But suddenly a voice from outside, from an unexpected direction, brought it to the forefront of attention. The voice came from Italy, where Futurism was all the rage, and Futurism regarded movement and speed as the 'absolutes of modernity'. It now began to influence the Paris artists. Before proceeding to discuss the metamorphoses of Analytical Cubism into Orphism and Synthetic Cubism, we must turn to Italy and investigate the nature and development of Futurism.

*Italy and the Modern Spirit*

Futurism was Italy's first important contribution to European art after a century of apathy.

There can be no doubt that of all the nations that had gone through the Romantic revolution and seen the collapse of the great historical 'styles', Italy suffered most. Tiepolo had marked the last artistic high point in Italian painting which, after him, lapsed into an almost unbelievable provincialism. The young generation of 1900 felt that its paramount task was to awaken from this provincial slumber and to restore contact with the European world.

The first intimations of a broader European art, breathing a spirit of youthful freedom, came to Italy with Symbolism, the Jugendstil, and Secessionism. In 1895 the first Venice Biennale was held in the 'Giardini'. This first great international show clearly discloses the sweeping influence of European Symbolism. The exhibits included works by French, German, Austrian, and Swiss artists – Puvis de Chavannes, Moreau, Redon, Forain, Bernard, Stuck and Lenbach, Klimt, Böcklin and Hodler. The aesthetic pendulum swung between Paris and Munich. In 1902 the great international exposition of decorative arts in Turin acquainted the Italian public with the revolutionary developments in the field of industrial design. Artists were profoundly influenced by *Jugend:* it is no ex-

aggeration to say that the Italian youth at the turn of the century, the generation of Soffici and Papini, drew its first intimations of the new paths in art from this periodical, which first made them aware of Italy's failure to keep abreast of developments. The starting point for the young Italian artists was the struggle against Italy's acceptance of its inferior position in European art, and as a result the modern ideas developed in a climate of furious controversy. The artistic task was felt to be a national task, and the modern Italian art movement assumed an extremely nationalist character. The first phalanx of modern Italian artists was composed of fanatic nationalists, readers of Nietzsche, partisans of d'Annunzio, militarists who defended injustice if it served the interests of their nation. The influence of *Jugend* on this generation was not confined to art. It revolutionised the young Italians by calling their attention to the 'enemy within', namely indifference, inertia, complacency, and intellectual passivity. *Jugend* was the symbol of an activity that had produced living results in other countries. It aroused a desire to participate in this activity and brought into focus a number of problems of which Italian artists had been unaware – problems of form, colour, composition, and expression, which contributed to the realisation that painting was a high form of spiritual achievement, a method for the spiritual conquest of the world. *Jugend* cleared the way for an irruption of European modernism.

The first Italian bridge-heads were established in Paris. In 1900 Ardengo Soffici began to frequent the young artists of Paris, and a few years later his reports on developments in Paris, published in newly founded magazines, were read by an eager public. He was followed to Paris by Gino Severini, who in 1906 received the twenty-two-year-old Amedeo Modigliani in his Montmartre studio. A small Italian group, continually varying in composition, formed around Soffici and Severini. The wealthy and widely travelled poet F. T. Marinetti, who had contributed articles to the *Revue Blanche*, visited them occasionally.

Revolutionary forces stirred suddenly in all fields. Anti-clerical elements rallied under the slogan of 'Modernism', advocating radical reforms of the Church. Nietzsche's idea of the Superman – *Uomo Dio* – exalted the young Italians, inspiring the passionately blasphemous writing of such men as Giovanni Papini. Nationalism in politics, syndicalism in the labour movement, and pragmatism in philosophy were among the revolutionary ideas, each of which dealt a blow to the apathy of the nineteenth century. The generally restless atmosphere of those years must be kept in mind if we are to understand the way in which the painters reacted to the call of modernism.

It was in the literary milieu of Florence, which was under the spell of Gabriele d'Annunzio, then living in nearby Settignano, that the first organs of the new generation were founded. In January 1903, Giovanni Papini published the first issue of his magazine *Leonardo*, in collaboration with two painters – Adolfo de Karolis, who illustrated d'Annunzio's books, and Giovanni Costetti. Both painted in the routine Pre-Raphaelite manner of the period. These young men's ideas on art are expounded in the programme in the first issue: 'In art we love the ideal transfiguration of life, we aspire to beauty as the most effective embodiment and revelation of a deep and radiant life.' In other words, they did not go beyond Symbolist generalities. From Nietzsche they took their aristocratic atheism, and their aesthetics reflects Schelling's theory of intuition – the *essenza dell'uomo* is dream. The door was opened wide to Nordic Romanticism and mysticism – Novalis, Schlegel, Shelley, Blake, Poe, Meister Eckhart, Seuse, Angelus Silesius. The history of French Symbolism was repeated – ten years later. The whole thing was a curious mixture of Nietzsche and the general ideas of the Symbolists. The same applies to this group's highflown theories of art which, despite all their attacks on the trans-Alpine Jugendstil, were unquestionably derived from it. As for the aesthetic intentions, they culminate in sentences such as: 'Therefore

let us exalt life, but only a life woven of dreams, into which we shall be able to escape as into a mysterious garden overflowing with fragrant odours.' These dithyrambs are merely the Italian version of Jugendstil sentimentalism; nevertheless the purpose is a transformation and 'transfiguration of reality', a 'metaphysics of reality', as Papini wrote in his article on Doudelet, a mediocre imitator of Beardsley. For Italy, that was something very new!

*Leonardo* suspended publication in 1907. From 1908 its place was taken by *La Voce*, edited by the same writers, Giuseppe Prezzolini and Giovanni Papini. *La Voce* with its wide readership served as the organ of Young Italy. Its tone was extraordinarily aggressive and polemical, but it dealt with specific problems without indulging in the vague Romanticism of *Leonardo*. Its basic mood was one of embittered nationalism and sorrow over the fact that Italy had lost her pre-eminent position. This sorrow concealed the young generation's impatience with the tradition-bound, provincial cultural climate of Italy. The aim of the magazine was formulated by Papini in the very first editorial: 'Our purpose is not only to bring Italy back into contact with European culture, but also to restore the historical consciousness of her own culture.'

Ardengo Soffici began to send in his contributions early in 1909. With him the tidal wave of the new French aesthetics swept over Italy. Soffici sharply attacked the main currents in his country's painting – 'facile products of a stupid Verism abetted by photography or Symbolist-decorative charlatanism stealthily copied from German and English magazines'. He took to task Stuck, Böcklin, the Pre-Raphaelites, the whole style *'da giornale illustrato tedesco'*. Italy, he declared, should go back to her own great tradition and combine it with the freedom and discoveries of Impressionism. In a series of articles, 'Impressionism and Italian Painting', published in *La Voce* (1909), Soffici explained what Young Italy expected of Impressionism and what it criticised. His resolute and original statement clearly indicates the stage at which the pictorial thinking of the Italian avant-garde had arrived. Soffici praised Impressionism for its attack on classical illusionism – academic drawing, perspective, studio light. Its merit consists in 'having set aside the aesthetic norms and hierarchies', and for this reason the Impressionists are 'the primitives of a new epoch'. In proclaiming the eye to be the sole organ of pictorial activity, they freed painting from the tyranny of the art schools and juries, from the academic past. The results of Impressionism on the spiritual plane are, according to Soffici, 'freedom granted to every temperament, the legitimation of all techniques, the exclusive search for the characteristic and for expression'. He describes the swift Impressionist brushstroke as 'a mystical script, suitable for transposing and translating the feelings aroused in the viewer's mind by things'. His criticisms of Impressionism tend in the same direction: according to Soffici, painters who relied solely on their visual sensations were led to 'the idolisation of colour, the fetishism of the palette'. Classical Impressionism lacks the *concetto della mente* – Leonardo da Vinci's 'mental image'. For this reason it also lacks 'the magic power that is called style', solid structure, expressive power. Giotto and Masaccio, says Soffici, possessed this magical power. Impressionism has paved the way for a new painting; the task is now to give it a solid style. At this point Soffici calls attention to Cézanne and Degas, whose structural solidity results, according to him, from the *concetto della mente,* and who should therefore serve as the true models for a new Latin art.

In his current reviews, he sharply attacks official art for failing to put these insights into practice. In 1909 he speaks scathingly of the Biennale, with its 'monstrosities' which might serve at a pinch to adorn the rather boring pages of *Jugend,* and waxes indignant over the absence of Degas, Cézanne, Renoir, Gauguin, Van Gogh, Toulouse-Lautrec and Picasso, and the 'less important' Seurat, Sérusier, Denis, Vuillard, Bonnard. The only exhibits he praises are those of James Ensor. In one

of the following issues of *La Voce*, he reproduces Cézanne's *Card Players* for the first time. Early in 1910 he himself organised in Florence the first 'Impressionist Exhibition' in Italy. Only a few names were represented, but the choice is significant: Monet, Pissarro, Renoir, Sisley, Degas, Cézanne, Toulouse-Lautrec, Van Gogh, Gauguin, Matisse, and Picasso. For the first time, Matisse and Picasso were now discussed in Italy. Soffici himself reviewed the show. He had the highest praise for the constructive genius of Cézanne and Degas, and by contrast disparaged Van Gogh and Gauguin for their structureless 'Expressionism'. He had made his choice. It favoured Cézanne and the constructive current of modern painting, into which alone the old tradition of Italian painting could flow. Having taken this path, Soffici extolled Henri Rousseau and the archaic grandeur of his conception of the object, and as early as the summer of 1911 he discussed the enlargement of Cézanne's aesthetics by the Cubism of Picasso and Braque, which he analysed very accurately, stressing its attachment to reality. His admiration for this pictorial architecture, which being both constructive and representational seemed so perfectly to meet the requirements of the 'members of a great race of constructive minds' – these young Italians felt they belonged to such a race – left no room for the tradition deriving from Gauguin. Thus the Fauves found themselves condemned as 'a clique of nois parvenu tricksters'. Guided by his *italianità*, he even at that moment scented the great danger involved in the secret undercurrent in Cubism, which was trying to smuggle Fauve and Nabi conceptions into Cézanne's aesthetics: 'Metzinger, Le Fauconnier, Léger, Delaunay?' he wrote; 'blind and hollow swindlers, the whole lot of them!' What it was the Italians found attractive in Cubism, Soffici tells us in his essay *'Il cubismo e oltre'*, published in *Lacerba* in 1913: 'the sober consistency of the bodies and objects, the weight, the gravitation of the masses, the balance of the planes and volumes'. He points out that 'the best Italian art, whose primary merit lies precisely in this soberness, consistency, gravity, and balance, is entirely Cubist in character, and therefore Cubism is in particular conformity with the true Italian tradition'.

At this point we may stop. Following the evolution of aesthetic ideas as reflected by the two leading avant-garde magazines, we have seen how quickly the Young Italians ran through the stages of European modern art, from the Jugendstil to Impressionism and Cézanne, and on to the Cubists, and that by 1910 their pictorial conceptions had attained the general European level.

To the contemporaries who experienced these developments, they seemed rather chaotic. When the new generation opened the sluices, the harmonious world of French art rushed headlong in, with elemental force. The Italians discovered everything at once. Since it is impossible to understand Renoir without going back to Courbet, Neo-Impressionism without Ingres, Picasso without Cézanne, and Cézanne without Poussin, Chardin and Delacroix, French art, precisely because it is so continuous and logical in its development, produced at first a state of confusion. Nor did this confusion lead spontaneously to a new painting. The whole process was purely receptive; each of their discoveries merely added to the violence with which the young Italians condemned their own *ottocento*. But this disorderly demolition of the past was a necessary step before an original Italian conception could emerge. The first articulate conception was Futurism.

### Futurism

Futurism was the Italian expression of the joyous spirit of radicalism which at the time gave wing to the younger generation all over Europe, turning their eyes towards a radiant future that was completely to renovate Europe's ancient culture and outlook. In their pursuit of this goal, the Futurists

felt themselves to be the 'primitives of a completely transformed sensibility'. Their leader, who coined the term '*futurisme*', was a poet – Filippo Tommaso Marinetti. The son of a wealthy Milan industrialist, he was born in Egypt in 1876. He studied at the Sorbonne and for many years lived a worldly life in Paris. In his student days he had come into contact with the decadent and Symbolist milieu, and was an enthusiastic admirer of Verlaine, Rimbaud, Mallarmé, the *poètes maudits*, and their new vehicle of expression, *vers libre*. Like most of the writers gravitating round the *Revue Blanche*, the *Mercure de France*, and *La Plume*, the organs of the Symbolists, he followed the Nabis in his opinions on painting which, it might be added, never went very deep. Marinetti aspired to start a similar movement in Italy, and in 1905 founded in Milan the magazine *Poesia*, which published Verhaeren, Jammes, Mauclair, and virtually all the other Symbolists. He himself translated Mallarmé, and gathered round him a group of young Italian poets, with whom he championed *vers libre*, carrying the new technique to the point where poems consisted of purely associative sequences of words. Amid an atmosphere of grandiloquent polemics which kept literary life in a state of continuous excitement, Marinetti resolved to touch off a new explosion. It was then that Futurism was born. On February 20, 1909, Marinetti's first Futurist manifesto was published in the Paris *Figaro*, then the quasi-official organ for literary manifestoes.

This manifesto dealt almost entirely with the Italian situation; it was ultra-nationalistic and shockingly aggressive. It lashed out at the apathy into which Italy had fallen, at museums, libraries, academies, at culture itself which had grown decrepit with age. In particular, its purpose was to liberate Italy from 'its rotten cancerous tumour of professors, archaeologists, cicerones, and antique dealers'. The rhythm of modern life, speed, the aesthetics of the machine were extolled as heralding a bright new era: 'We maintain that the splendours of the world have been enriched by a new beauty: the beauty of speed. A racing car is more beautiful than the Victory of Samothrace.' The passion for modernity led to an enthusiastic affirmation of modern technology, whose most striking manifestation was the dissolution of the classical concepts of time and space through speed. 'Time and space died yesterday. We are already living in the absolute, for we have already created eternal, omnipresent speed.' This also created a new image of man, who refuses to have anything in common with the sentimental ideal of the turn of the century. The new ideals were: love of danger, fearlessness, rebelliousness, aggressiveness, patriotism, and glorification of war, the strong and healthy injustice of life – and art was conceived as an offensive weapon. 'Beauty exists only in struggle. A work that is not aggressive cannot be a masterpiece. Art must be conceived as a violent assault against the forces of the unknown, designed to subject them to man.' These theses were intended to revolutionise life as a whole.

It proved to be surprisingly easy to propagate them. The Futurist poets and painters developed an original technique of cleverly advertised meetings at cafés. The meetings became mass meetings and put the entire nation into a state of fury and riotousness. The Futurist ideas were expounded all over Italy and, beginning in 1912, throughout Europe, in Madrid, London, Paris, Berlin, and Moscow. They were set forth with so much violence that the meetings generally ended in a free-for-all. According to Theodor Däubler, Futurism roused the popular imagination to such an extent that Italian children played 'Futurists' instead of 'cowboys and Indians'. This was just what the Futurists wanted – to influence life itself. Cultural propaganda was supplemented by political propaganda, which glorified Italy and Italian imperialism, and called for war against Austria. This cultural and political rhetoric proved so effective that, after some polemical scuffles with the Futurists, the two Tuscan hotheads of *La Voce*, Soffici and Papini, went over to their camp and, early in 1913, founded *Lacerba*, a Futurist magazine standing politically for patriotism, imperialism, and interventionism. In it Gio-

vanni Papini wrote: 'Futurism is the proof of our rehabilitation in a progressive, renascent Europe.' One year after the founding manifesto, three painters – Carrà, Boccioni, and Russolo – urged on by Marinetti, drew up the first manifesto of Futurist painting. It was published on February 11, 1910, and was signed by Umberto Boccioni, Carlo Carrà, Luigi Russolo, Giacomo Balla, and Gino Severini. On March 3, 1910, it was read to an audience of three thousand at the Chiarella theatre in Turin.

Giacomo Balla (b. 1871) was the oldest of the group. He had discovered Impressionism and Neo-Impressionism in Paris, and returning to Rome in 1901 brought Divisionism to his two friends, Umberto Boccioni (1882-1916) and Gino Severini (b. 1883). These artists painted in the style of Romantic-Symbolist Divisionism, which was then regarded as daring and modern, and which acquired national Italian characteristics under the influence of Segantini and Previati. Russolo (b. 1885) at first studied music, and then painting at the Milan Academy. He was a friend of Carlo Carrà (b. 1881), a house painter, who in 1900 went to Paris and London where he saw the works of the Impressionists, Gauguin, Cézanne, Turner, and Constable.

The manifesto of Futurist painting, which two months later was followed by the 'Technical Manifesto of Futurist Painting', fully adhered to Marinetti's programme, for it attacked the past, the museums, and the academies, exalted 'every form of originality' and proposed 'to glorify the life of today, violently transformed by victorious science'. Its central theme was universal dynamism. Light and movement destroy the material consistency of things. Objects in motion are multiplied and distorted when we perceive them. 'Our visual energy, which can achieve results comparable to those achieved by X-rays', makes objects transparent; they interpenetrate as they move and vibrate. These new sensations require vibrant visions made of colour and light; the suitable technical devices are Divisionism and Complementarism.

With all their chaotic aggressiveness, these statements add up to a specific conception of painting. As in Impressionism, the point of departure is the optical sensation, but instead of drawing inspiration from landscapes, interiors, and still lifes, the artist finds it in the technological environment, in the great individualities of the machines, and in the civilisation which they have transformed. What the Futurists discovered in modern civilisation was dynamism, 'vehement sensations of movement and speed, the exuberance of action'. They treat subjects such as *Street Noises Invade the House, Rattling Tramcar, Rushing Train,* etc. The method used by the Futurists to treat such subjects consists in representing the objects in motion by a diagram, and in optically linking the object so represented with its environment conceived as a complex whole. The environment physically enters the objects, penetrates it, distorts it, and completes it. The Impressionists had already been aware of some of these things. This is how Strindberg once described to Gauguin the impression made upon him by Impressionist paintings: 'I saw the surging of the crowd on a pier, but I did not see the crowd itself. I saw the speed of an express train, the motion of wheels in the streets, etc.' The Futurists wished to subject these early discoveries of the Impressionists to a discipline, to give them 'the style' that would express our epoch of speed and simultaneity. The Cubists had just developed their method of analytically dissecting the object; but they were less interested in representing movement. On the other hand, the Futurists regarded movement, speed, and the simultaneity of all sensory impressions as the 'new absolute of modernity'. Their goal was to discover the form in which to express sensory experience conceived as an integral dynamic sensation. The catalogue of the Futurist exhibition that toured the European capitals in 1912 contained the following passage: 'To paint a model in repose is absurd and intellectually base. The painter must also express the non-visible that lives and stirs behind the object in repose, the non-visible that

is to the right and left of us and behind us — not merely the little square of life which is artificially enclosed as on the stage of a theatre.' Artists and viewers should take the centre of the picture. (Matisse had formulated similar demands).

The Futurists distinguished two aspects of movement:

(1) *Absolute movement*, i.e., the dynamic lines *(linee-forze=*lines of force) which indicate how the object can be broken up according to its inherent tendencies of movement and form. A sphere placed next to a cone will always give the impression of a dynamic force beside a static force. Their tendencies to movement can be rendered by dynamic abstract forms. But these also create a kind of spatial field of energy. The space between the two objects will be impregnated with the energies they emanate. To express this fact the atmosphere must be given formal consistency. (We can see that here one of Cézanne's ideas is resolutely carried to its consequences.) The tension created by the absolute movement of several things thus sets space itself in motion, and must be expressed by solid dynamic forms. The atmosphere must be given consistency or, as the Futurists put it, 'solidified'.

(2) *Relative movement*, i.e., the actual motion of a given object. 'A horse in motion is not a horse at rest but a horse in motion, that is to say, something entirely different, which must also be rendered as something entirely different.' For instance, it must be given twenty legs! (At that time photographers, in order to illustrate motion, had superimposed pictures of individual phases of motion, obtaining a synthetic picture showing the individual phases in juxtaposition. This influence of photographic technique must not be overlooked.) The simple observation that one cannot depict a rotating wheel with all its spokes, but must find a dynamic formula for it, carries similar implications for the representation of all objects in motion, hence of life itself.

Thus the pictorial dynamism of the Futurists consists in fusing the diagrams of absolute movement with those of the actual motions of an object in its environment, as expressed in the Futurist formula: environment + object.

The most important pictorial device for the realisation of this formula is *simultaneity* — the simultaneous representation of all the sensations contained in a motif. For example, the merely static representation of a woman at a window does not, according to the Futurists, render all the sensations contained in the motif. The painter must also include the street sounds, the rumbling of a passing tramcar, the bustling life that can be seen from the window, the reflections of all this in the woman's mind, and the associations it evokes in her memory. The picture is the artistic formula which must record the complexes of reality. This too was an idea that had been anticipated by the Impressionists. Duranty formulated it quite accurately in his *Nouvelle Peinture*, published in 1876: 'We no longer divorce the figure from the background provided by its environment or the street. In actual life we never see a person against a neutral, empty, and undefined background, but around and behind this person there are things that express his or her position, social status, occupation. The window links us to the outside world. Through the window we see the most unexpected segments of the drama outside, accordingly as we are close to it or far from it, sitting or standing.' The problem involved here could be only very partially solved by illusionistic devices. At this point the Cubists joined in, trying to render the simultaneity of sensations in a complex figure, by synthetically juxtaposing different views of the object. The Futurists adopted this Cubist discovery as a means of representing 'the universal dynamism', and combined the isolated details and data of reality into a new whole, the Futurist picture. The different planes of reality — the inner and the outer, the near and the distant, things seen and things felt — interpenetrate, and are represented simultaneously, that is, juxtaposed on the canvas. Through artistic empathy and pictorial inventiveness they are fused into a new entity: object + environment.

Starting from these premises, the Futurists considerably extended the domain of art. They depicted subjects (such as those announced in their manifestoes) that could not formerly have been rendered in a picture: 'When you open a window, all the street noises, the movement and the material things outside suddenly enter the room', or, more significantly, 'the power of the street, the life, ambition, fear that can be observed in the city the oppressive feeling caused by the noise'. The Futurist painter's task was to construct a new, complex, spiritual reality, for which the objects of external reality provided pictorial analogues. The Futurist was convinced that only by combining all levels of reality could one express the true drama of the object. He did not freely invent abstract forms to serve as his imaginative metaphors; he *developed* his form by sharply analysing his object. He did not rebel against nature, but rather against a so-called art which was confined to fragments of reality and to imitation of old styles and in consequence had lost all sense of style.

Futurism is thus an artistic theory which attempts to render the integral experience of reality by fusing the pictorial signs of things seen with the pictorial signs of things known, felt, and remembered, and by relating them to the universal dynamism with the help of lines of force and diagrams which are derived from the kinetic tendencies of the objects. Historically speaking, Futurism is a logical continuation of late Impressionism. But its purpose was to 'synthesise Impressionism', to 'channelise the Impressionist revolution into the dynamic order of Futurism', to 'discipline it', to give it 'style', a style which expresses our epoch of speed and simultaneity. At first it employed the Neo-Impressionists' method of colour analysis, but at the same time adopted the ideas of Analytical Cubism. This is clearly stated by Boccioni, the theoretical spokesman of the Futurist painters: 'We must combine analysis of colour (the Divisionism of Seurat, Signac, and Cross) with analysis of form (the 'Divisionism' of Picasso and Braque). 'From the Neo-Impressionists, the Futurists learned to dissolve the materiality of thing by means of luminous colour that was made to vibrate by being applied in small brush strokes; from the Cubists, they learned how to break up the object, how to interlock pictorial planes, and how to use simultaneous views. But they employed the two techniques, not to analyse static things, but to express dynamism through kinetic analysis stressing the forms of movement. Their formal inventions consisted, first, in the simultaneous representation of different phases of movement; second, in the development of lines of force which expressed the dynamic features of a given object; third, in the combination of kinetic images with lines of force; fourth, in the interpenetration of the levels of reality. Objects in motion and environment were fused, the inner and the outer were represented as one, simultaneously, without regard for natural appearance. The Futurists developed a common style, so that we may forgo analyses of the individual artists. Roughly speaking, we may say that Carrà was intent upon rigorous form, Boccioni concerned with intellectual content, and Severini with decorative values. Severini lived in Paris and was consequently more influenced by Neo-Impressionism than the others.

Classical Futurism came to an end with the outbreak of the First World War. Carrà and Severini developed in different directions and Boccioni was killed. Under Fascism, Marinetti attempted to impose Futurism as the official style of the regime. But the movement lacked great talents. Only the superficial aspects of Futurism – the portrayal of the sensations of modern industrialised life – lived on. Its last invention was Aeropittura, the painting of sensations of flight (first attempts, 1926; Manifesto of Aeropittura, 1929). Futurism now became identified with this type of painting, but all that was new in it was the subject matter. Moreover, even the subject matter had been anticipated by Nevinson, the English Futurist, who as early as 1918, in his war pictures, had expressed the sensations of flight with the help of the Futurist idiom. With the collapse of Fascism and the death of Marinetti, even this last vestige of Futurism seems to have died out.

However, classical Futurism greatly influenced modern painting. Above all, the idea of universal dynamism proved extremely fertile. It is possible to follow in detail the traces left by the Futurist exhibition which toured Europe's capitals. The change of style observable in the Blaue Reiter artists – Marc, Macke, and Klee – in 1912 is certainly accounted for by the influence of Futurism. In Russia it gave rise to an entire movement – 'Cubo-Futurism'. In England it was the force behind the development of 'Vorticism', whose spokesman, Wyndham Lewis, took Futurism as his starting point. Nevinson adopted Futurist theory *in toto* and adhered to it until the early twenties. Joseph Stella brought Futurism to American painting in 1913 and John Marin was also influenced by it. In Paris, it stimulated the Cubists to pay greater attention to movement and contributed to the emergence of Orphism.

*Orphism*

On February 5, 1912, the Galerie Bernheim inaugurated the first Futurist exhibition in Paris. It was received coolly, even Apollinaire judging it rather severely. But a number of Cubist painters, particularly Delaunay, Metzinger, Picabia, Duchamp, and Léger found in Futurist ideas confirmation of their own conceptions. What interested them most was the representation of movement, the technique of simultaneity. In all fairness, it must be said that the Futurists were the first to attack systematically the problem of movement and the spatio-temporal element in painting, although Toulouse-Lautrec, Seurat and Munch had attempted to give dynamic expression to movement before them. Boccioni correctly pointed this out in an article attacking Delaunay, entitled '*Simultanéité Futuriste*' and published in *Sturm* (1913) and in *Lacerba*. But it is equally correct to say that the problem of simultaneity had been broached in Analytical Cubism; although Picasso and Braque did no more than anticipate it, other painters of their group who liked to theorise about art clearly formulated the problem. These painters secretly rebelled against the static character of Cubism and sought dynamic expression.

Robert Delaunay was certainly the guiding spirit of this movement; he was seconded by a group of young Cubists who had been brought to Cubism by preoccupation not only with Cézanne, but also with Gauguin, Seurat, and the aesthetics of the Nabis.

In 1910/11 a group of painters took to meeting at the studio of the three Duchamp brothers, Gaston, better known by his pseudonym Jacques Villon, the sculptor Duchamp-Villon, and Marcel who later founded Dadaism. Their discussions revolved round certain theories that had previously been expounded at length by Sérusier, Denis, and the painters of Beuron – they spoke of ideal measurement and proportions, and of the Golden Section. But by now this line of thinking had taken a radical turn, and the central question was whether pure number and proportion might not serve as the foundation of an absolute painting that would be as independent of nature as music.

These painters came from Neo-Impressionism and the Nabi tradition. For them the most important element in painting was colour, and they had been greatly influenced by the Fauves' daring approach to it. Thus their preoccupation with number and proportion extended to the laws of colour. These had been analysed by Seurat, but here again the problem was formulated more radically. Seurat had resorted to colour contrasts chiefly in order to find an equivalent for natural light; but these young painters had begun to consider the possibility of painting pictures whose very subject matter would be the spontaneous life of colour, its harmonies and dissonances, and the play of its

proportions. This group included, in addition to Jacques Villon and his two brothers, Delaunay, Léger, Gleizes, Metzinger, Kupka, Le Fauconnier, and Picabia.

Almost all of them looked upon the Cubism of Braque and Picasso as the first definite step towards the realisation of their idea of a form constructed entirely from number and proportion. But their starting points were different from those of Braque and Picasso. These two artists adhered to Cézanne's teaching that 'painting is a theory developed and applied in contact with nature'; they started from the object, developed forms from it, and with these forms constructed their pictures; but the others — the pseudo-Cubists — did almost the exact opposite. They started from a mental conception of measurement, proportions and tones, and tried to embody these in objects. For them, Analytical Cubism, with its free handling of the broken-up forms of the object, was a means of attaining freedom, providing them with a legitimate transition, not to mention a whole arsenal of usable forms.

There was something else that deepened the secret divergence: colour. Braque and Picasso had deliberately foregone richly orchestrated colours, so as to bring out form more clearly; their paintings were subtly animated by modulations of greys, ochres, and subdued greens. The works of the classical Cubists were almost monochrome in effect; in this too they followed Cézanne and his sensitively modulated colours. But the group around Delaunay, Kupka, and Villon had no intention whatsoever of abandoning colour orchestration; rather, they looked on colour and the analytical handling of the colour scale in its full range, as a constructive means of producing pure harmonies based on colour proportions. In a very general way, we may say that this group wished to combine Fauve colour with Cubist form. At the highest level, this would have led to a synthesis of the two lines of pictorial thought, one begun by Gauguin, the other by Cézanne. But none of these painters was gifted enough to carry out this extraordinary task. The most they managed to do was to decorate Cubist elements with colour, or else to negate the Cubist elements completely in favour of a play of pure colours. This secret rift in Cubism led to the formation of a new group only vaguely connected with the parent group. While Braque, Picasso, Gris and their friends, the strictly orthodox Cubists, met at the Bateau Lavoir, the other group gathered for 'dîners', which soon became famous, at a café on the Place de l'Alma. Apollinaire maintained liaison between the two groups. The secessionists around Villon and Delaunay were joined by Marie Laurencin, who at the time cultivated a graceful, restrained Cubism in beautiful colours, and Roger de la Fresnaye, who had come directly from Sérusier and was consequently fully prepared to misunderstand Cubism. It is easy to imagine how eagerly the classical Nabi Sérusier followed the actions of his partisans on the battlefield of Cubism. Early in 1915 he wrote happily to Denis: 'Now that the Cubist fraud is collapsing, I think we shall be able to develop a simple plane geometry, in the spirit of Christian and French clarity and simplicity.' This was a false prognosis. In the spirit of the monks of Beuron, Sérusier over-estimated and misunderstood the new effort to define painting through a canon of proportions. He failed to see that the longed-for canon was already related to abstraction, to an orderly arrangement of pure forms and pure colours. This misunderstanding was natural, considering the hesitation and mediocrity of most of the Cubist heretics. In 1912 they organised an exhibition at the Galerie La Boétie. They baptised their group 'Section d'Or' and founded a periodical bearing the same name. Jacques Villon was the inspirer and organiser of the group, and its name is clearly suggestive of the discussions in his studio, devoted to the Nabi idea of a numerical canon.

Thus an idea of independent origin made its way into Cubism. Instead of analysing the object, this brand of Cubism analysed the pictorial elements; the object was passed over. Braque and Picasso evidently got wind of the schism brewing; at all events they kept aloof from the new group. The

Section d'Or included Villon, Duchamp, Gris, Picabia, Lhote, Herbin, Metzinger, Marcoussis, Gleizes, La Fresnaye, Segonzac and a few others. The exhibition was basically inspired by Cubism and Cézanne; its novelty resided in the strong emphasis on the aesthetic significance of geometry. This attachment to geometry in art, which has played a considerable role ever since, was a very old idea, going back to Plato. The *Philebus* contains the following passage in which the beauty of geometric forms is contrasted with that of the imitative forms: 'They are not beautiful for any special reason or because they serve a given purpose, rather, they are beautiful by virtue of their own nature, and give us entirely of themselves an aesthetic pleasure, which is free from any impulse of desire; and colours of this kind are beautiful too, and arouse a similar pleasure.' This idea of the abstract beauty of geometrical forms and numerical proportions, which, after remaining latent for centuries, had been eagerly taken up by the group around Gauguin, now became the focus of attention. If we compare it with the idea implied in Cézanne's famous dictum about the sphere, cone, and cylinder in nature's method of construction, we see that it is very different. Here we have free intellectual play, aiming at order and law embodied in free forms; Cézanne on the other hand was concerned with forms developed from nature. It seems likely that this subtle, yet sharp distinction was perceived only very dimly by the Section d'Or artists. They confused the two ideas and for this reason they never went beyond a decorative Cubism with an underlying or superimposed pattern of proportions and a tastefully harmonised colour scheme, as exemplified by the works of Marcoussis, Metzinger, or Gleizes.

Jacques Villon was beyond doubt the most sensitive artist of the group. At first he tried to strike a balance between the Fauves and Cézanne. He was unwilling to forego rich and pure colour, but all his attempts to transmute natural forms into pictorial forms led him to Cubism. In breaking up the object and interpreting it he displays great sensitivity and his gentle brush strokes and modulated tones achieve a lyrical effect. He avoids the dramatic, angular, splintered forms favoured by Picasso, polishing the corners to produce musical, slightly curved lineaments. Around these representational arabesques obtained analytically, he builds a grid-like structure with geometrically abstract proportions, which encloses the objects. This abstract crystalline pictorial space is illumined by bright and melodious pastel tints. It gives his pictures a faintly phantasmagorical quality very different from the austerity of classical Cubism. The primary characteristic of Orphist art is the preeminence of colour.

Much the same may be said of a strikingly forceful painter, whose name emerged for the first time in the Section d'Or, Fernand Léger. His reaction against Impressionism did not lead him to Fauvism, not at least for very long. From the outset he aimed at hard, definite, naïvely defining forms. Thus he started out in the manner of Henri Rousseau, and later – in 1910 – joined the Cubists. He adopted the 'facetted Cubism' that Braque had developed in his Estaque landscapes, but handled it with a robust and slightly crude precision. Even his landscapes suggested the forms of machines. At first he showed a predilection for sober blues and greys, but by 1912 his colour acquired a sharply metallic ring, emphasising pure harmonies of reds, blues, and greens. His vigour and robustness contrast strongly with the affected manner of the other fellow travellers of the Section d'Or. All this already bordered on abstract painting.

The outstanding figure, however, was Robert Delaunay. This was his hour of glory. He had come to Cubism from Neo-Impressionism, via Cézanne. This was the usual way. But almost at once he enlarged on the Cubist themes. He did not stop at the analysis of figures, still lifes and landscapes, but became interested in the rhythm and architecture of cities. In 1909 he painted his St. Séverin series. He was fascinated by the spatial imbrications of Gothic architecture, its strange interlaced

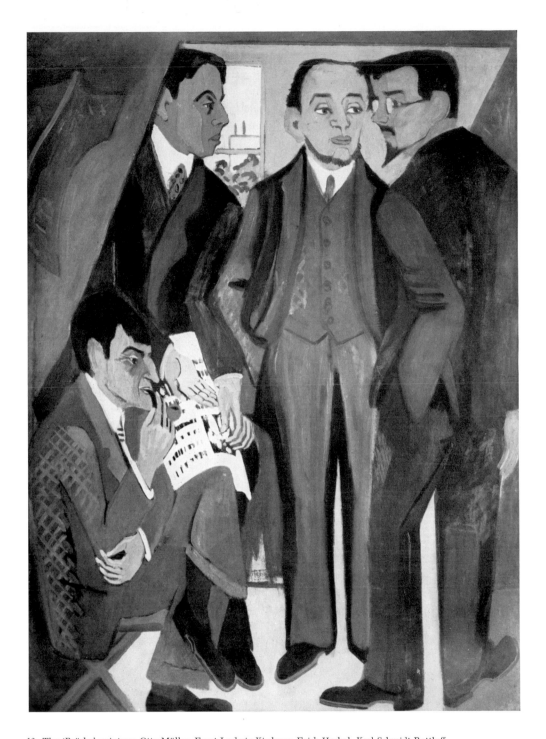

13. The 'Brücke' painters: Otto Müller, Ernst Ludwig Kirchner, Erich Heckel, Karl Schmidt-Rottluff
    (Painting by Ernst Ludwig Kirchner, 1925)

14. Christian Rohlfs (Photo Alexander Graf Brockdorff, supplied by Günther Franke, Munich)

15. Emil Nolde (Photo Helga Fietz, Schlederloh)

16. Franz Marc (Supplied by Günther Franke, Munich)

17. Wassily Kandinsky  (By kind permission of Gabriele Münter, Murnau)

18. A party in the studio of Ernst Ludwig Kirchner — the artist is on the left (Supplied by Otto Stangl, Munich)

19. Oskar Kokoschka (Photo Hugo Erfurth, Cologne; supplied by Günther Franke, Munich)

20. Robert Delaunay  (Photo Florence Henri, Paris)

forms, its restrained rhythms defined by the austere beat of a motif continually repeated. This spatial play was governed by rigorous laws. To disclose them, to render the living rhythm of the whole in visual form: this was the task that tempted Delaunay. For a time he proceeded analytically, keeping close to the motif. But in his efforts to distil the abstract rhythms and to express the dynamic flow of the Gothic piers, he saw himself driven to more abstract distortions – only then did rhythms and circular movement achieve convincing expression. His colours were subdued tones of grey and green.

In 1910 his style changed. He began the Eiffel tower series. This steep, soaring structure held an extraordinary fascination for him. He analysed this technological monster in several variations, bending it, folding it, breaking it into compartments, exploding it into fragments and piecing the splintered forms together into a more and more spectacular structure, adding other forms to it – disjointed houses, rounded cottony clouds – seeking to suggest the dizzy upward movement of the steel scaffolding by shattering some forms and reconstituting others. The explosive anti-gravitational thrust and the precariousness of the formal structure endow the pictures with the dynamic quality which the Futurists at that time extolled as 'the absolute of modernity'. An art based on constructive activity gives rise to a highly expressive vision. At the same time Delaunay's colours become brighter and more varied, and their inherent energies play an increasing part in the dynamic organism of the picture.

The fact that colour, like form, could create rhythm and movement was a new discovery for Delaunay. Not only could colours, by echoing one another and by entering into combinations, indicate the direction of a movement; they could also give the impression of forms turning in space. Delaunay called this 'le sens giratoire' of colours. To test their capacity to produce this effect, he treated (1910/11) a suitable subject – a tower with a Ferris wheel, in a new series of paintings. Here colour was dominant throughout, and the broken-up forms are arranged in clear transparent planes, the Cubist 'plans superposés'. But colour also serves as the equivalent of light. The polyphony of the seven primary colours results in the unison of light; and Delaunay's concern with colour led him from analysis to free synthesis. In 1912 he composed his series of *Windows*. He still takes the visible as his motif and point of departure: an open window in the sunlight and the play of light in the outside world. But the whole is merely a crystalline structure of transparent planes in prismatic colours, an abstract exaltation of light. Like Seurat before him, Delaunay had come across Chevreul's book on simultaneous contrasts, and now interpreted pictorial light 'as a colour organism composed of complementary values, of masses forming pairs, of contrasts on several sides simultaneously'. On the basis of his experience Delaunay was logically led to a conception of abstract painting defined as the orchestration of colours and effects of light. 'Colour alone is form and subject,' he said. 'So long as art does not free itself from the object, it remains descriptive, literature, degrading itself by using defective means of expression, dooming itself to servitude and imitation. This is true even when it emphasises the light playing on an object or the light resulting from relationships among several objects, as long as it fails to give light pictorial independence.' Now, towards the end of 1912, Delaunay began his entirely abstract series of *Circular Rhythms* and *Simultaneous Discs*, showing circular areas of colour which interpenetrate, revolve around one another – colour structures existing in their own right and living their own dramas. 'Everyone has sensitive eyes to see that there are colours, that colours produce modulations, monumental forms, depths, vibrations, playful combinations, that colours breathe... goodbye to Eiffel towers, views of streets, the outside world... We no longer want apples in a fruit bowl, we want the heartbeat of man himself.'

With their deep emotional significance, these pure plays of colour possess rhythm and movement. The eye follows the paths and movements traced for it by the colours. The picture is experienced in time. Next to the spatial form, there appears the temporal form, *forme-temps* next to *forme-espace*, as Gleizes put it, ascribing to Delaunay the invention of *forme-temps*. This is only partly correct, for Picasso and Braque, and the Futurists as well, had been interested in rendering movement. However, Delaunay separated movement from the representational element and produced it by colour alone.

In *Simultaneous Discs,* the colours opposed to each other mean 'nothing more than what is actually seen – colours in contrasts, arranged in circles, and opposed to each other'. They mean nothing representationally, but a great deal in terms of content and expression. In Delaunay's intention they reflect the rhythms that pulsate through the world and Being, for 'nature is pervaded by all manner of rhythms. In this, art should imitate it, in order to become equally pure and sublime, to rise to visions of a complex harmony, a harmony of colours which separate and at the same time join together again to form a whole. This synchronistic action is the sole and specific subject of painting.' This brought Delaunay to abstract painting in pure colours, *'peinture pure'* as Apollinaire put it. And it was Apollinaire who gave the name of Orphism to this offshoot of Cubism.

The name is familiar to us. Referring to Gauguin's orchestration of colours, the Symbolists had spoken of 'Orphic art' and Delaroche had thought that this art 'would clear the way, by resolving the contradiction between the sensory and the spiritual world'. With his keen instinct Apollinaire lit on the term. He had in mind a pictorial equivalent of the pristine poetry invented by Orpheus, but at the same time indicated the genealogy of the group's idea. It is the radical consequence of Gauguin's theories of orchestrated colours. Through it painting enters the 'musical stage', the stage of harmonious colour corresponding to the abstract harmonies of musical sounds. This was essentially the aesthetics of the Nabis, which was now carried to its ultimate consequences within Cubism. And indeed the Section d'Or in its beginnings was shot through with Nabi ideas.

Thus it is not surprising that in 1912, when Delaunay was groping his way towards abstraction, another painter of the group, the Czech Franz Kupka (b. 1871-1957), who had lived in Paris since 1895, arrived at abstract colour music by way of Neo-Impressionism, without going through Cubism. Starting from Seurat's theory, he too studied the reactions of prismatic colours and in 1912 painted his *Newton Discs,* concentric circular forms in pure colours without representational reference. In the same year he exhibited at the Salon d'Automne an entirely abstract painting with a characteristically musical title, *Fugue in Red and Blue,* a figuration of circular and elliptical areas of colour forming a well-balanced pattern.

This abstractionism developed as though by an inner necessity; here again we see the effects of a trend that was making itself felt all over Europe. Kandinsky in Munich and Larionov in Russia had responded to the same urge even earlier. We shall deal with them later.

This was the climax of Delaunay's career. In the years that followed he never asserted himself with equal force. Towards 1915 he went back to natural forms, and not until 1930 did he resume his search for a contrapuntal painting in pure colours. Delaunay enriched painting by the spatio-temporal elements of dynamism, rhythm and movement inherent in colour. He was probably inspired by Futurist ideas: it is certain that the Section d'Or responded eagerly to the Futurists' dynamism and methods of rendering movement. This is attested by two important documents – Jacques Villon's *Marching Soldiers* of 1913, in which the marching groups are dissolved into typically Futurist diagrams of movement and the famous *Nude Descending a Staircase* of Marcel

Duchamp (1912), in which a figure in motion is broken up into several overlapping figures suggesting superimposed photographs of several phases of a single movement, à la Balla. Without its spooky marionette-like quality and its Surrealist grotesqueness, this work would be merely one more example of the Futurist method of rendering movement.

Orphism, which represented itself as a Cubist heresy, actually arrived at abstract painting. The colours and principles of Gauguin and Seurat played a part in the development. Now we shall see how Cubism solved the same problem in its own way. For by 1912 Analytical Cubism had reached its limit and was succeeded by Synthetic Cubism.

*Synthetic Cubism*

'The new painting seeks to represent, not the object, but the new unity; it is a lyricism achieved entirely by pure pictorial means.' That was how Braque formulated the new ideas of the leading orthodox Cubists. This implied a basic shift; analysis of line, tone value and colour, and of their pictorial effects, space, rhythm, movement, balance – took precedence over the object and the formal analysis of its visual appearance. The picture was now conceived as a synthesis of all these elements. In all likelihood the ideas of Delaunay, and other Orphist painters, on the laws and expressive potentialities of colour, exerted a stimulating influence on Analytical Cubism. The change occurred in 1912/13, when the Orphists reached the height of their development. The Cubist studio now gradually assumed the character of a laboratory where the elements of the picture were tested and developed, where art, as Picasso says, was invented by an 'intellectual game'.

The new line was latent in Cubism from the very outset. Cézanne had sought to create the equivalent of the architectonic structure he discovered in nature, and in the process had begun to distort the object: natural appearance had been reduced to a secondary place in the formal hierarchy of the picture. Analytical Cubism radicalised this method. As early as 1910 natural appearance had largely lost its importance as a result of the analytical manipulation of representational forms. The artist's autonomous constructive urge sought to liberate itself from natural data and arrive at a free, autonomous architecture. In 1911 Picasso and Braque achieved independent pictorial space, for the old illusionistic picture space proved incompatible with their formal interpretations of objects. At the same time, representational forms were replaced step by step by purely formal values, and in the course of this development stereometric forms came to serve increasingly as components of these tightly-knit structures. The paintings of 1912/13 can hardly be described as formal interpretations of objects: rather, they are variations on a central motif, which permits of the most complex modulations. Actually, the iconography of mature Cubism is confined to a very small number of subjects – guitar, violin, fruit bowl – which are treated as examples or patterns rather than as things chosen for portrayal from among the inexhaustible treasure of visible nature. An analytical form was isolated from the world of things and used as a leitmotif around which form could be orchestrated in a purely intellectual game. The development led logically to abandonment of the analytical interpretation of the natural object and to the synthetic construction of formal objects, which either had no equivalent in nature or else endowed natural representational forms with an unprecedented effectiveness and reality. Once it was discovered that it was possible, by analysing natural data, to construct an autonomous pictorial organism, the next step was to experiment with the reversal of the process: to develop the picture as a free

115

'abstract' construction, which assumed the features of an object only in the course of its growth, or came to suggest an object only if at the last moment the artist introduced an objective element. This experimentation with the pictorial elements is clearly revealed in the development of the Cubist technique. In its early stage, Cubism had taken over Cézanne's method of building up masses by an accumulation of hatched strokes with a small brush and by leaving parts of the surface unpainted. This technique was gradually enriched. Towards 1910 Braque began to incorporate illusionistic elements such as imitation wood or imitation marble in his pictures, using the techniques of house painters. The unexpected presence of such fragmentary elements of reality produced an effect of shock on the viewer, surprised to discover a completely realistic passage in an otherwise non-naturalistic picture. He was reminded of the world of appearances and at the same time made to realise that natural appearance was ephemeral, acquiring permanent reality only by being in the picture. Moreover, the realistic fragment – a sort of quotation – stood pictorially for the object itself, and provoked a chain of associations which induced the viewer imaginatively to reconstruct it in its entirety. The illusionistic fragment thus served as a kind of emblem, as a clue which helped the viewer to identify the object. Such fragments of reality used simultaneously enable us to reconstruct a complete real object in our minds, even if in the picture it appears only as a fragment or an emblem. The organism eliminates all the dross of natural appearance, which cannot be transmuted into form, retaining only essential, representative elements, which evoke as it were the names of things. This is the meaning of the Cubist 'trompe-l'oeil'.

From here it is only one step to replacing painted, illusionist fragments of reality with real objects or parts of objects, introduced bodily into the picture. In 1912 Picasso and Braque began to use the technique of collage. They pasted strips of paper, wallpaper patterns, newspaper clippings, playing cards, etc. on the canvas and arranged these fragments of real things into an autonomous, balanced order. The first result was an enrichment of the surface. The diversity of the materials used produced tactile values – smoothness and roughness, hardness and softness. Paint alone no longer sufficed to build up the surface, and for this reason Braque was led to add other materials to his paints – sand, sawdust, etc.

This experimental use of actual things marked a new experience in pictorial art. The painter no longer seeks an order in things, but finds an order with the help of things. When he picks up an object that for some reason fascinates him, so isolating it; when he considers it in isolation, and, for example, places it on a surface, the object demands an environment. Now begins an exciting play with fragments of reality, with isolated things which only by dint of a slow constructive process are made to combine into a living organism, in which they lose their absurdity and became part of an order. They enter into communication with one another and with the mind that had arranged them. The artist becomes like Adam giving names to the animals and through this naming, which has no effect whatever on the reality of things, somehow creates an order. In 1913 Picasso, melancholy sorcerer wholly engrossed in the magic of the object, applied this amazing method of continually questioning things to the construction of several reliefs and montages for which he used just about every *thing* imaginable.

The technique of collage, resulting from a logical analysis and enlargement of the pictorial elements, contributed to a crucial change in the foundations of Cubism. For the Cubist no longer analytically extracted forms from objects, but synthetically constructed new formal realities from fragments of objects. The great period of Cubist collage extended from 1912 to 1914.

In these same years the new insights were applied to painting. In 1912 the forms of Analytical Cubism began to grow more abstract and geometric; in 1913 they won complete independence.

Form was no longer to be obtained by analysis and the dissection of objects; form has an existence of its own, and with it the artist, by synthetic construction, makes a picture, which may, if so desired, take a representational name. Whereas Analytical Cubism transmuted a bottle into the abstract form of a cone, Synthetic Cubism transmuted the abstract form of the cone into a bottle. For even Synthetic Cubism never entirely did away with representational references. It would be inexact to say that it stopped short of pure abstraction; rather, its point of departure was just as abstract as Delaunay's, only it felt free to qualify its free forms as objects by bringing them close to forms that evoked associations of material objects. This shuttling between two domains, which were treated as interchangeable at will, lent Cubism an immense freedom and richness, thanks to which it gave important impulses to almost all subsequent developments in art.

Now the Cubists could relax their discipline and let their pictures take on a new richness and brilliance. In 1914 Picasso and Braque employed softer forms which lost their geometrical rigidity. They achieved a new decorative beauty by means of almost precious patterns of lines and dots. Their colours too became richer and more varied. They continued to paint in this style as late as the twenties. Even after Picasso had developed in entirely different directions, his restless mind continued for many years to return to this happy point in his career, when outside world and inner world suddenly, as though of their own accord, achieved full congruity.

In the art of the poster, Synthetic Cubism reigns supreme. Today everyone accepts the simultaneous Cubist structures, such as we can see in a poster showing a wheel of a railway coach (in trompe-l'oeil), a siphon, a bottle and a glass (in overlapping planes) combined into an ornamental picture – provided it bears the caption: Travel by Pullman.

Synthetic Cubism developed quite spontaneously. It had no definite aesthetics. Picasso and Braque freely changed from analytical to synthetic methods and vice versa. They never knew exactly what method they were using. The magnificent aesthetic balance sheet of Synthetic Cubism was drawn up only later by Juan Gris, of whom Picasso said: 'It is wonderful to see the work of a painter who knew what he was doing.'

*The Blaue Reiter*

Before we can take up this last form of Cubism, we must return once more to Germany where related events were taking place.

The Neue Künstlervereinigung of Munich was to be the source of a current wholly new to Germany. Kandinsky had founded this association and provided its ideas. But the membership was heterogeneous, varying greatly both in talent and intelligence. The majority were unable to follow the stormy development of Kandinsky's far-reaching ideas. By 1910 these ideas began to attract a number of unusually gifted artists, and tensions mounted within the organisation. The newcomers were Franz Marc, August Macke, and Paul Klee. Along with Jawlensky they formed round Kandinsky an unofficial, but closely-knit group. They were men of strong individuality, and their thinking was vastly enriched by the exchanges between them. The conceptions developed in this little cell went far beyond the mixture of Fauvism and Jugendstil in which the other members of the Neue Künstlervereinigung would have been glad to settle down for good.

In 1910 Kandinsky began to commit his ideas on painting to writing. His book appeared in 1912 under the title *On the Spiritual in Art*. On the basis of a deeply felt criticism of the materialistic structure of the contemporary world, he strove to ferret out and combat every form of materialism

in art. The modern sciences had transmuted the material substance of things into symbols of energy; in painting, Matisse had liberated colour from its function of signifying objects and given it a spiritual significance. Picasso had done the same for form. For Kandinsky these were 'great signs, pointing to a great goal'. From all this he drew his own conclusion: 'The harmony of colours and forms can be based on only one thing: a purposive contact with the human soul.' The expressive resonance of pure coloured forms provided the painter with a means of making visible the inner resonance of things, their vibration in the human soul. The vibrations of the soul can be raised to the surface and made visible by pure pictorial harmonies unclouded by objective or metaphoric images, just as they are made audible by the pure sounds of music. The artist is free to act as the spirit moves him, free even to abandon the images of nature entirely and entrust himself wholly to the expressive power of pure coloured forms. His only law is 'inner necessity'. Since 1908/09, Kandinsky had been feeling his way to this conclusion in his painting. In 1910 he painted his first abstract improvisation. And up to 1912 he busied himself orchestrating in powerful colour chords the mighty visions, the vast cosmic images that rose up in him.

These were the ideas that moved Kandinsky's friends to cast off their ties with the images of the visible world and to discern the reflections of a higher world in the responsive stirrings of their psyche. For these ideas did not revolve exclusively round 'art', but were embedded in a religious intimation of an encompassing Being, at the centre of which, between the earthly things of nature and the transcendent realities above them, stood man, endowed with antennae that enabled him to enter into communication with the whole. This religious feeling could not be formulated in a creed; it was not even Christian in any literal sense, but was anchored solely in a profound faith in a universal order of being. Notions of theosophy entered in; the group read Steiner and Blawatzky and a Far Eastern pantheism was in the background, but this religious sentiment remained free, unformulated, open to all wonders and prepared to see the wonder of revelation everywhere. One might think of it as a secular form of Franciscanism; behind the shattered images of reality, at any rate, these men were looking for something in the nature of the old Franciscan 'ordo caritatis'. To this extent their idea was Christian in impulse, though without direct reference to the Christian plan of salvation. The goal, said Franz Marc, was to create 'symbols for our time, symbols with which to adorn the altars of the spiritual religion to come'. And to his mind the essence of an image was its power 'to emerge elsewhere'. In these years Marc played with the idea of having the group collaborate on modern illustrations of the Bible, and Kandinsky's visions also included eschatological figures: angels with trumpets, the Last Judgment.

It was a picture of this sort that led to the split in the Neue Künstlervereinigung. For the mediocre hangers-on simply could not face Kandinsky's conclusions. The Fauvism they had reached by way of the Jugendstil already struck them as risky enough and they soon abandoned it. The split came early in December 1911. Within the jury of the third exhibition of the Neue Künstlervereinigung a quarrel arose between the new tendency and Erbslöh and Kanoldt, the spokesmen of the 'conservatives', over Kandinsky's Last Judgment. Kandinsky, Marc, Kubin, and Gabriele Münter left the association. Jawlensky, who supported Kandinsky at heart, could not make up his mind to leave. But Franz Marc and Kandinsky decided to organise an exhibition of their own, a kind of counter-demonstration at the very same Thannhauser Gallery where the regular showing of the Neue Künstlervereinigung was being held. Thus, on December 18, 1911, the 'Blaue Reiter' opened its first exhibition. The artists represented were Kandinsky's immediate group – Franz Marc, August Macke, Heinrich Campendonk, Gabriele Münter, the two Russians David and Wladimir Burljuk, and a few friends, such as Eugen Kahler and Jean Bloé Niestlé; the composer Arnold Schönberg

also contributed a few attempts at painting. France was represented by the two names which Kandinsky regarded as the corner-posts of modern painting, Robert Delaunay – the 'Greater Abstraction' – and Henri Rousseau – 'the Greater Reality'. In March the Blaue Reiter assembled the representatives of the modern art world in a large exhibition of graphic work at the Hans Goltz gallery, clearly intended to show the broad foundations underlying the efforts of Kandinsky and Marc. Here we encounter the French Cubists – Braque, Derain, de la Fresnaye, Picasso, Vlaminck, the German Brücke painters, the Russian avant-garde that had already made ample inroads on abstraction – Larionov, Goncharova, Malevich, the new Swiss artists Hans Arp, Gimmy, Lüthy, and a few isolated Germans such as Wilhelm Morgner and Georg Tappert. In these surroundings, the Blaue Reiter also showed its own work and included the two graphic artists – Alfred Kubin and Paul Klee – who had both been absent from the first exhibition. Beginning in January 1912 the painting exhibit was shown all over Germany: in January it was displayed at the Gereonsklub in Cologne; in March, Herwarth Walden of the Berlin *Sturm* opened his gallery with it, adding Klee, Kubin, and Jawlensky; in July, K. E. Osthaus showed it in his museum at Hagen, and in September it appeared at the Goldschmidt Gallery in Frankfurt. After this the Blaue Reiter exhibited once again as a group at Walden's 'Deutscher Herbstsalon 1913'. Then came the war and the group was scattered.

It was never an official organisation, but a loosely-knit group of like-minded artists. Most important among those who may be identified with it were Kandinsky, Marc, Macke, Klee, and Jawlensky. The name 'der Blaue Reiter' was the title of a picture by Kandinsky, and then of a yearbook edited by Marc and Kandinsky, setting forth the group's ideas on modern art and illustrating them with examples. Begun in 1911, the yearbook appeared in 1912. The point of view of the contributors – Kandinsky, Marc, Burljuk, Macke, Schönberg – is quite homogeneous. They felt themselves to be harbingers of a new spiritual culture, rooted in the manifestations of the naïve soul. Bavarian glass painting, children's drawings, old German wood-cuts were adduced as examples of naïve expression in art. The modern anti-naturalist movement was described in all its ramifications. Franz Marc reported on the 'Fauves' of Germany, on the Brücke, the Berlin New Secession, which had recently walked out of Liebermann's Secession, the Neue Künstlervereinigung and the transformations it had undergone thanks to the liberating influence of the Russians and the young Frenchmen. All this, Marc declared, gives us reason to believe 'that the renewal must not be formal, but rather a rebirth in our thinking'. Burljuk dealt with the Russian avant-garde. One article provided a succinct analysis of Cubism, another described Delaunay's methods of composition. Matisse and Picasso were mentioned repeatedly. Kandinsky treated the question of form. On the basis of his 'principle of inner necessity', he concluded that the art of the future would move between two opposite poles: the 'Greater Abstraction' and the 'Greater Realism'. In reference to the latter, he cited as his star witness Henri Rousseau with his archaic conception of *things*. Arnold Schönberg and T. V. Hartmann reported on the movement of liberation in music. Scriabin's *Prometheus,* in which he attempted to synchronise music and coloured light effects was discussed. This gave Kandinsky an occasion to bring in his pet idea, derived from Wagner, of a 'total work of art' – he even submitted a libretto, entitled 'The Yellow Tone' and providing for a combination of pantomime dance, coloured light orchestration, and music. Franz Marc explained that the entire aesthetic of the Blaue Reiter is dominated by the striving to perceive the 'inner mystical construction' of the world. August Macke seconded him, calling form the 'expression of mysterious forces'.

The *Yearbook* defined the situation in 1911. It marked the beginning of a stormy development

which was to culminate in 1912. Fired by the ideas of Orphism and Futurism, these painters grew more and more free in their work and soon reached the limits of representational art. Their images became metaphors for the 'inner mystical construction' – this was Franz Marc's peculiarly romantic and paradoxical formulation. The Blaue Reiter began as a group personality and remained so even in its growth; but it was facetted like a crystal, each individual refracting the light of the idea in his own particular way. There was the profoundly romantic, pantheistic religiosity of Franz Marc, the visual poetry of August Macke, the Russian mysticism of Jawlensky, the sensibility of Paul Klee, the whole constantly goaded by Kandinsky's mystical passion, but also held in check by his strict intelligence.

### Franz Marc (1880-1916)

It is usually Franz Marc who comes to mind when the Blaue Reiter is mentioned, because he is so close to the German feeling for nature. His pictorial thinking is deeply rooted in German Natur-lyrismus, in the ideas stemming from the heritage of German Romanticism, which exerted so strong an influence in the early years of our century: the spiritualisation of nature, nature mythology culminating in a pantheistic religion of the cosmos.

As a young man, Franz Marc had toyed with the idea of becoming a theologian. Beginning in 1900, he had rather dejectedly absorbed the naturalism of the Munich Academy. In 1903, on a trip to Paris and to Brittany, he had discovered late Impressionism and some of the visionary ideas of the Nabis. He had come into more than his share of the psychological heritage of the nineties, the dread of the world, the loss of any intimate bond with outside reality, the terrible unrest of the *fin de siècle*. Some of the drawings and paintings from his early period are visions of profound, spectral despair. He looked to art to provide relief from the intolerable tension, to help restore the balance of his relation to the world. 'Painting must free me from my terror', he wrote in a letter (1906). At Easter, 1907, he fled to Paris from a marriage he had entered into in a moment of aberration. He sought 'to appease my flagging, terrified soul by contemplating the works of Van Gogh'. He expected Van Gogh to give him peace because he was convinced that by projecting his whole being into nature a man might achieve a *unio mystica* with the cosmos, and so transcend the painful cleavage between the self and the world. In 1907 he noted: 'Art is nothing other than an expression of our dream.' Franz Marc's dream was a harmony with things and this, he was convinced, was the source of images.

And so he began – exactly like Paula Modersohn and Paul Klee – to see things in their bold shapes and to simplify them, to seek the 'runic script' of which Paula Modersohn had spoken, the 'reduction which is the ultimate professional insight', as Paul Klee wrote in 1908. 'Now I paint nothing but the very simplest things,' he wrote in a letter in 1907, 'for in them alone lies the symbolism, the pathos, and the mystery of nature'. In this simplifying he discovered type-signs, through which the particulars of nature are taken up in larger formal contexts. This greater harmony with nature was what he was looking for. It accounts for his interest in animals, in their unconscious life embedded in the totality of Creation. By repetitions of the type-signs he had discovered, and by setting up parallels between them, he sought to produce a pictorial rhythm that would serve as an equivalent to the rhythms he felt in nature and make them visible. He derived a certain amount of help from Hodler's rhythmic parallelism and the arabesque of the Jugendstil. Marc himself formulated his intention rather oddly as an 'animalisation of art', a

formula which may seem obscure at first but is explained by his attitude towards animals. He felt that they were embedded in the great rhythm of nature, participating in the great flow of the universe, in every life impulse, wholly open to the great communicating currents that govern nature. Indivisible being! That is what he aspired to make perceptible in art.

In these years his endeavour to capture types, shapes, rhythms, developed his sense of form and his drawing. He had not yet discovered the possibilities of colour. Here it was August Macke who helped him. They met early in 1910. A native of the Rhineland, Macke was a lover of joyful colour. He had seen the work of Gauguin and Matisse. As early as 1906 he was aflame with his discovery of the strange expressiveness of pure colour, and now he infected Marc with his enthusiasm. In 1910 the two friends exchanged numerous letters: ideas on the laws of colour, on the psychic effect of colour, on analogies with music. They were confronted with the idea which since Gauguin had left painters no rest: the independent expressive power of colour. 'Composition with these elements,' wrote Macke at the end of 1910, 'must take place at an unknown hour, springing from a source which today is still hidden from us, and then it must be joyful and sorrowful, dynamic and pensive.' Marc knew something of this source. He accepted all Macke's ideas about the expressive power of colour, but transposed them in terms of nature symbolism. In his answer to Macke on December 12, 1910, he wrote: 'Blue is the masculine principle, robust and spiritual. Yellow is the feminine principle, gentle, serene, sensual. Red is matter, brutal and heavy. — If, for example, you mix grave spiritual blue with red, you raise the blue to an expression of intolerable grief, and a conciliating yellow, the complementary to violet, becomes indispensable. — And now, if you mix blue and yellow to make green, you bring red, matter, the 'Earth', to life, but here as a painter I always feel a difference: with green you can never entirely appease the eternally material, brutal red. Once again blue (heaven) and yellow (sun) must come to the help of green in order to reduce matter to silence.'

In this year they were joined by a third painter who was already far advanced in thoughts of this kind — Wassily Kandinsky. Marc joined the Neue Künstlervereinigung, became acquainted with Jawlensky, and suddenly found himself in the midst of a group of artists all preoccupied with colour. From France came the message of Matisse and the Fauves. Encouraged by so much solidarity, Marc ventured to take the decisive step. In his great series of animal pictures (1911), of which *Red Horses* is perhaps the best known, he detaches colour from nature, giving it a radiance of its own, and by this 'arbitrary' act transmutes the type form derived from contemplation of nature into a higher symbolic reality.

However, the radiant independent life of colour demanded a new, spiritualised treatment of form. Here Cubism came to his help. By its questioning of things, it achieved a construction that offered a more total image of reality. Marc's interpretation of Cubism aimed at what he significantly called 'inner mystical construction'. He was concerned with content, with an ever more complete expression of the world as he experienced it, of the total structure of being. This fundamental idea, and his concern with colour, led him past classical Cubism directly to Orphism and the ideas of Delaunay. He interpreted Orphism in the spirit of Apollinaire; that is, he took its ideas to mean that coloured forms provided a possibility of expressing the pristine poetry inherent in man's vegetative and psychic embeddedness in universal being. In 1912 he visited Delaunay in Paris and after that the two of them corresponded.

In the same year Marc encountered another impulsion, the Italian Futurist Exhibition at the Thannhauser Gallery in Munich, which he reviewed for the *Sturm*. Here again what aroused his enthusiasm was the greater completeness of the experience of reality, the possibility of giving form to

such themes as 'the power of the street, the life, ambition, anxiety one can observe in the city, the oppressive feeling caused by noise'. Orphic Cubism, Futurism, and the constant presence of Kandinsky – all these helped him to develop and purify his style.

In 1912/13, the years of the *Tower of the Blue Horses*, of *Animal Destinies* and *Deer in the Woods*, the elements of his technique were so enriched and so well fused together that the pictorial signs in which he couched his experience of the world took on pure crystalline form. His pictures became structures of coloured forms characterised by the strict architecture and spiritual fire of cathedral windows, upward striving Gothic shapes, to which broad beams of light gave depth while the magic responses of the radiant colours lent them a facetted transparence. This play of responses between the colours creates a state of sensitive balance, suffused with magic expectation by the spirituality of the colour – one feels as though a miracle might happen. Often strangely luminous, wholly abstract forms hover fragile in the beams of light, sensitively woven into the delicate balance of the construction. Captivated by this gentle harmony, the beholder enters into a remote poetic sphere and notes, hermetically encoded in the sonorous scaffolding of coloured forms, objective indications of what these pictures signify: alertly listening does in warm maternal red, sniffing bucks in cool blue, delicate outlines of fawns in the magical light, majestic horses in harsh masculine blue. Then the abstraction as well takes on its metaphoric meaning, the solemn architectural forms circumscribe a vast space akin to the interior of a cathedral, open to every miracle, and the transparence of the colour becomes a metaphor for the luminous transcendence of the world. The profound accord of living things with their environment finds its equivalent in this magical pictorial space, and the solemn hierarchy of coloured signs creates a place of worship dedicated to man's love and yearning for a universal harmony. These are devotional, spiritual pictures, parables of religious, pantheistic feeling smelted out of utterly transformed images of nature. In March 1913, Marc wrote to Delaunay: '*Je cherche à me mettre dans un état de grand amour.*'

The theme develops from a profound question: Is the world, as we see it conventionally, the only possible form of world? How, for example, does an animal see the world? The question points to the integration of all living beings in a great cosmic whole, and that is what Marc was striving for. In his questioning love of Creation, he strove to find forms and colours offering a metaphoric correspondence to the knowledge, buried deep within us, of a secret order of the world – the Franciscan '*ordo caritatis*'. And so with his colours and forms, Marc, in perfect concentration, composes a legend of the animal, dreaming away his life in unbroken harmony with Creation. Marc's parables are radiant with sublime colour, yet always we discern a soft undertone of lamentation over our human exclusion. In his notes from 1912/1913 all this is clearly stated: 'Yearning for indivisible being, liberation from the sensory illusion of our ephemeral life: this is the state of mind at the bottom of all art. Its great goal is to dissolve the whole system of our partial sensations, to disclose an unearthly being that dwells behind all things, to shatter the mirror of life in order to behold being.'

Kandinsky's cosmic visions of these years encouraged him to abandon objective images entirely and enter into the dimension of pure expression, where nature ceases to be anything more than a reflection of our spiritual relation to it. At the end of 1913, Marc was driven to abstract forms. He held that the 'illusory nature of matter' is confirmed by the ideas of modern science – 'today we dissect nature, which is always illusory, and put it back together again in accordance with our will. We see through matter. Matter is something which man today can tolerate at most; he cannot acknowledge it.' As for pictures – 'must they not be full of wires and tensions, of the wonderful effects of modern light, of the spirit of chemical analysis which breaks forces apart and arbitrarily

joins them together?' He took these developments as a summons to work in the same direction. His pictures became more and more abstract, he began to employ transparent, interpenetrating forms. In 1914 he took the step to abstract painting in the series of 'serene', 'playful', 'battling', and 'broken' forms. Yet even in this final, abstract phase, nature and world were not excluded, but only transposed into the wider dimension to which they had already attained in the whole realm of the modern spirit. 'The subject that formerly aroused our passion now dissolves into vibrations and simple numerical relations. Our passion no longer approaches things sentimentally, no longer shatters against them, but seeks to capture them in form through the profoundly meaningful images that the newly formulated laws of nature set before our astonished eyes.'

At this point in Marc's evolution the war broke out. Marc left for the front and his great visions were compressed into the dimensions of the sketchbook he carried with him in his tunic. In these last sketches from the front – Marc fell on March 4, 1916, at Verdun – the objective element has virtually disappeared. Abstract forms recount the profound meditations of a lonely creative mind, and the poetic titles of these pages only give the barest intimation of what the forms make so clearly visible: 'Magic moment' – here we have the congealed world of the first Creation, in which the crystal begins to stir; 'Plant life coming into being' – the crackling emergence of burgeoning forms in the spring; 'Arsenal for a Creation' – an expectant tissue of pure forms, potential worlds upon worlds. Yet characteristically these 'Projects for a New World' represent a return to the pristine and religious. They illustrate the Biblical story of the Creation in a new way. At the outset Marc had been moved by the idea of illustrating the Bible; now, behind the effective forms of nature, his attentive spirit discerned a religious force that continues to enact the miracle of Creation on every hand. Death prevented Franz Marc from giving pictorial expression to this union of the self and the world in a superordinate metaphysical vision of being. But his idea remains an effective undercurrent in the German art of today, though to discern it we must look beneath the surface.

*August Macke (1887-1914)*

Macke arrived at his personal style in the same years as Franz Marc. The same influences – Kandinsky, Delaunay's Orphism, the Futurists – helped him to produce, from 1912 to 1914, the beautiful series of paintings to which he owes his name in the history of art. But he was of a very different temperament from Marc, lighter and more cheerful, devoted with every fibre of his being to the sensuous beauty of the world. Whereas Marc was intent on 'spiritualising nature', his concern was to suffuse it with joy. His temperament was thoroughly Rhenish. He was born, to be sure, in Westphalia, but his whole youth, spent in Cologne and Bonn, marked him with the keen visual sensibility of the Rhineland, which in its artistic leanings has always looked to France. His training at the Düsseldorf Academy from 1904 to 1906 and a few months spent in Berlin at the studio of Lovis Corinth at the end of 1907 are unimportant. Important were the trips to Paris in 1907, 1908 and 1909. It was then that he discovered colour and encountered the ideas of Gauguin and Matisse. As early as 1907 Matisse and his abstract handling of pure colour were in the forefront of Macke's thoughts. 'When I have all my relations between colour tones,' wrote Matisse in his *Notes d'un peintre*, 'they inevitably give rise to a living chord, a harmony analogous to musical harmony – *toutes mes couleurs chantent ensemble*.' That was fully in keeping with Macke's ideas. But it was only after meeting the Blaue Reiter artists that he was enabled to put

his ideas into effect. Early in 1910 he met Marc and at the end of the year, Kandinsky and Jawlensky. But he did not succumb to the emotional attitudes of Marc and the Russians. He went along with them only to the extent that the new spiritual conception of colour showed him more clearly how to translate visible reality into visual poetry. 1912 was an important year. He went to Paris with Marc and there met Delaunay. Delaunay, who in those years was occupied in combining different and even antithetical movements of colour into a 'synthesis comparable to the polyrhythmics of music', provided him with the means of reflecting in colour his sense of joy at the world that lay open before him. Macke's pictorial ideal had always been something pure, clear, crystalline: you look into it and, refracted by its manifold facets, a lyrically transformed image of the world looks back. Delaunay's Orphist painting, having passed through the strict discipline of Cubism, had this clear, crystalline texture. The spatial energies of colour rest in layers on the fine structures which the Cubists, in order to fixate in form nature's tendency to dispersal, distil from nature or cast over it. Kandinsky, with his passionate nature and Russian 'oceanic' feeling, could not endure such discipline; he worked apart from octaves and regular intervals, his pattern resulting from his drive, not from any attempt to hold it in check. In this early period he had no thought of obtaining density by the arrangement of colour patterns and the coordination of their spatial energies. Russia – but also Stuck and Wagner – cast their shadows on the background of his soul. Macke felt this very clearly and reacted with an unfairness typical of his youth: 'The fact is that Delaunay began with Eiffel Towers in space, while Kandinsky began with gingerbread.'

Macke was influenced by the Futurist idea of fusing perceptions and sensations, separate in space and time, into one picture. A few of his pictures clearly indicate his concern with the young Italians, and it does not seem unlikely that one of his favourite themes – women looking into shop windows – was suggested to him by the Futurists. In any case, the subject appealed to him because of the enlarged frame of reference offered by the window with its reflections of the street life going on behind the woman's back.

However, Macke's was an original talent and all these influences merely helped to determine the direction in which it was to develop. His art can be understood as a synthesis of Fauvism and Cubism, enriched in content by the ideas of the Blaue Reiter painters, but this formula fails to account for the individual character, for the extraordinary poetic and pictorial sensibility of his visual world, which achieves its most personal expression in the radiant 'Thuner See' series of 1913. In the light of his mounting enthusiasm, the beauty of the world became as though transparent, disclosing to him the pictorial metaphor that would make its emergent beauty visible as an independent order. He had achieved a visual poetry, to which a legendary element was soon added. In Spring, 1914, only a few months before his death in battle (September 26, 1914), Macke went for a few weeks to Tunisia with Paul Klee and the Swiss painter Louis Moilliet, who had been close to the Blaue Reiter since 1912. Here the profound emotion inspired in him by the Mediterranean landscape led him to see the whole world as a painted legend, and painting became in his eyes a metaphor for the pure order of beauty in the world. In the marvellous series of water colours from Tunisia, his poetic vision of the African springtime rises up like an enchanted cantilena. In their self-evident beauty the visual world becomes truly a part of the new spiritual image that the Blaue Reiter painters were striving to create. But having come this far, Macke went to his death. It was Paul Klee, his companion on the trip to Tunisia, who gave breadth and depth to the theme struck by Macke. Certain aspects of Klee may be regarded as a fulfilment of Macke's ideas.

*Paul Klee: Early Period*

It was not until the autumn of 1911 that Klee came to the Blaue Reiter. It was then that he met Kandinsky through Moilliet and grasped at once how greatly Kandinsky's ideas, his musical approach to colour and search for the 'inner chord', might benefit the steady growth of his own thinking. He himself, both in his painting and his thinking, had come independently to a point not very far from Kandinsky. He had always been tempted by colour, but despite repeated attempts he had not yet succeeded in transforming his palette into the rainbow bridge by which to attain the realm of the psychic, the second reality that lies behind the world of appearances. To be sure, he had noted as early as 1909 that a painter's attitude towards the contents of his paint box was more important than the study of nature, but sovereign command of colour orchestration was still beyond his grasp.

When he met Kandinsky, he had just completed a series of long-planned drawings for Voltaire's *Candide:* tissues of lines fine as spider-webs, strangely fragile, elongated figures that seem to blow hither and thither like immaterial forms. From the expectant medium of the white ground, the trembling antennae of his line, groping its way forward like a sleepwalker, picks out forms and brings them into being, very much as in waking from a dream we perceive, in the play of shadows, images that interpret our dream. They are improvisations, inspirations of a hand that gladly follows the beckoning line and has become wonderfully sure in feeling its way, communications from the realm which Klee, as early as 1908, described in his notebook as his 'primordial realm of psychic improvisation'.

The development of this script had been slow. Born in 1871 near Berne of a German father and a half Swiss, half French mother, Klee had come to Munich in 1898 and entered into the world of Naturlyrismus and the Jugendstil. Theodor Lipp's experiments on the psychic effects of arrangements of lines, the various investigations of the expressive function and laws of the pure pictorial elements, Van de Velde's seminal ideas – all this lay ready for him. A brief period of study under Stuck, a trip to Italy in 1901, brought him much confusion and here and there a flash of understanding: the palaces of the Italian early Renaissance = formal expressions of a numerical canon which perhaps also underlies the formative activity of nature; the aquarium in Naples = the fantastic formal inventions of nature in a medium that was not assigned to the human species; they challenge man's creative imagination to go and do likewise; the Italian Gothic painting of the early *Quattrocento* = the playful sublimation of the realistic by a highly trained sensibility.

From 1902 to 1906 Klee settled in Berne. This period is marked by a slowly developing series of fantastic etchings in which he attempted to express in figurative metaphors his state of mind, a mixture of sarcastic humour and gentle sadness. At the same time he looked about him in the art world. Hodler and Odilon Redon attracted some interest, but then came Goya and Blake. A brief trip to Paris in 1905 gave him nothing. But soon – in 1906 he returned to Munich – he encountered Ensor's graphic work. Ensor showed him how, quite aside from any representational function, line alone, with its hieroglyphic hooks and bars, can communicate a state of mind. By purifying it still further, by smelting out the 'slag of the world of appearances', it must be possible to transform line into an instrument capable of giving expression to 'psychic improvisation'. In 1908 came the experience of Van Gogh, which confirmed certain of his own insights, particularly his discovery of the enhanced expressiveness of the coloured line.

In 1909 he saw his first Cézannes and clearly understood that the time had come for him to till the field of colour. But Klee was one who developed slowly, waiting for his perceptions to ripen.

Though the idea of a more independent approach to colour had come to him from Cézanne, it was his first meeting with Kandinsky, Marc, and Delaunay in 1911-1912 that first impelled him to act on his own.

During this period of expectant growth, Klee's thinking revolved round a few related ideas. First there was the desire, characteristic of the artistic thinking of the time, to give clearer expression to the feeling aroused by objects. At the time, Klee called this 'transposing things into the transcendent'. The formative process of nature, which shapes all the things that surround us, is obviously based on a subtle all-governing law, a rich variability of basic patterns and ordering rhythms which the productive imagination can recognise and depict. Even in the most detailed of nature's forms we can find analogies to the total law, that 'irrepressible rhythm' of which Delaunay had also spoken. Line and colour provide the painter with an instrument by which to communicate the subjective response of his psyche, as well as his objective insight into the creations of nature in visible structures, and so to create within himself a second reality more complete than that provided by the visual image. The forms of art stem from the same formal root as those of nature, and their products are parallel. This was the very thought that had led Cézanne to his monumental sentence: 'Art is a harmony parallel to nature.' Thus Klee's thinking, though perhaps not in response to direct influences, had arrived at the point whence the whole movement of modern art had taken its departure.

In this situation his meeting with the Blaue Reiter artists was of extreme importance. Their deep Romantic feeling, their feeling for the underlying unity of all being, was wholly in keeping with Klee's cast of mind. Here lay his goal, as his friend Franz Marc brought home to him time and again. But from Kandinsky came the essential impetus to master the expressive power of pure colour.

The graphic field was already in hand. Only slowly, in line with Klee's unhurried, cautious way of letting his ideas ripen, did colour make its way into it. With his graphic line he was able to improvise freely, to express his emotion without difficulty. Colour, on the other hand, required a new means of transposing his visual experience into the pictorial dimension. It was not for nothing that he had come to colour through Cézanne. Thus at first he remained close to the visible world from which he drew his coloured skein, herein more akin to Marc and Macke than to Kandinsky. And there was also a human factor that came between him and Kandinsky. With all his powerful intelligence and clarity, there was an oriental, mystical strain in Kandinsky, an emotional reaching into the limitless, a Wagnerian quality. Klee was drawn to Mozart with his playful joy held in check by fine organisation. This kinship with Mozart and Cézanne kept him away from the full, stormy orchestration of Kandinsky and made him search for a subtle, restrained, unmonumental colour.

Although the encounter with Kandinsky undoubtedly stimulated Klee exceedingly in his thinking, he received more direct help from another direction, from French Orphism and particularly Delaunay. In April 1912 he went to Paris for two weeks, studied the painting of the Cubists, visited Delaunay's studio, and familiarised himself with his work. The importance of Orphist *peinture pure* for the development of Klee's colour cannot be overemphasised. It was here that his attention was drawn to the subtle laws and crystalline structure upon which he was to reflect as long as he lived. At the same time, the Futurists gave him valuable ideas on the significance of simultaneity and the figuration of movement.

Slowly feeling his way, Klee now let colour grow into his graphic texture. But he still needed the great visual experience that would confirm him in his striving to transform colour into an independ-

126

ent organ of expression. This experience came to him in the course of the twelve days spent in Tunisia with his friends Macke and Moilliet. 'Matter and dream at once, and wholly embedded in them a third factor, my self' – this was his almost immediate response to the call of the African landscape. Nature and dream and the self – the three had for him become one. Under the shock of this great visual experience, the various compartments of his thinking – the modulations of Cézanne, the '*plans superposés*' of the Cubists, Delaunay's arrangement of colour planes – fused, as though of their own accord, into a totality that was purely his own. The mere optical experience of the land and the clear light imposed a formal synthesis. From the radiant pattern of colour spots there arose an architectonic structure which required only a few sparse graphic notations to enable it to stand up to nature as a fulfilled, independent, pictorial metaphor. In those few days in Tunis, Klee became a painter and he knew it: 'Colour has me,' he wrote in his Diary. 'That is the meaning of this happy hour: colour and I are one. I am a painter.' This was the beginning of the long series of exemplary pictorial poems whose importance has been fully understood only in the most recent years.

Klee never played a leading role in the Blaue Reiter group. He was the quiet music lover who enchanted his friends with his artistic nature. He remained on the fringe of the group, waiting and slowly maturing. But even in this marginal position he was a moral authority and regarded as such by his fellow painters. Only the keenest sensibility could have suspected the enormous depth that Klee was to contribute to the development of modern art.

*Alexej von Jawlensky (1864-1941)*

As a young man Jawlensky led the life of a Russian officer, dabbled in painting, and attended Ilya Ryepin's class at the St. Petersburg Academy. He moved to Munich in 1896. He was a true Russian. In his nature the sturdy sensuality of the Boyars contrasted with a childlike piety. The disembodied mysticism of Russian legends was at the very heart of his nature as an artist. In Munich he met Kandinsky and remained ever after within the sphere of his artistic influence.

In the course of his extensive travels, Jawlensky had early encountered Cézanne and Van Gogh. But the most important encounter was with Matisse. The organisation of large planes, the expressive power of pure colour – here Jawlensky found the instrument with which to express a poetic experience restricted to the narrow sphere of the objective world – landscapes, still lifes, portraits. By means of simplified contours firmly tied to the surface and clear enhanced colour, he distilled a peculiarly naive décor from the world of things. But his intrinsic eastern nature led him to a characteristic re-interpretation of Matisse's colour. There is a mystical undertone in its colourful peasant brightness suggestive of folk art. He saw Matisse through Russian eyes. At the same time, he came across Gauguin and his 'enigmatic colour'. In 1905 Jawlensky painted in Brittany and became acquainted with the methods and aesthetics of the Pont-Aven painters. It was here that for the first time he succeeded, as he himself tells us, in painting 'what I felt, and not merely what I saw'. In the autumn of 1906 he visited various private collections in Munich in order to see Maurice Denis and Bonnard. In the winter of 1907/1908 Sérusier, the grand master of the Nabis, was in Munich for three months; his student Girieud soon joined the Neue Künstlervereinigung. Jawlensky came to Matisse by way of Gauguin and his pupils. And suggestive colour led him to Van Gogh. Kandinsky, his own Russian nature, Matisse, and Matisse interpreted in terms of Gauguin: these were Jawlensky's points of departure.

Suggestive colour enabled him to weave the indications he found in the visible world into a mystical décor. In 1909, in the atmosphere of comradeship afforded by the Neue Künstlervereinigung, his colour achieved a priceless bloom; soft curves transform the contours of things into decorative arabesques. Yet Jawlensky remained faithful to the object and never followed Kandinsky on the road to abstraction. Landscapes and great heads were his themes. With their powerful colour and strong contours, they transform the motif into naive symbols. From the fervent colour and symbolic power of the heads it was only a step to an exalted mysticism or to religious vision.

This step was taken in the war years which Jawlensky spent in great seclusion in Switzerland. Here he found his way to his 'Variations' – meditative modulations on a single theme: the view from the window of his room at Saint-Prex over the garden with its trees; coloured, almost abstract meditations upon a few unchanging forms distilled from tree shapes. The variations clearly foreshadow the icon-like quality of his later work, with its eternal repetition of meditative signs.

In 1917 Jawlensky finally hit upon the theme which was to bring him fulfilment. From then until the time of his death, he was to let it slip through his fingers like the beads of a rosary: the human face, revealing the distant imprint of a divine power; it is as though he were praying rather than painting. The various series of these heads bear names such as 'Faces of the Saviour', 'Mystical Heads', 'Abstract Heads'. Pure objects of religious meditation, they reduce the image of the human face to a simple geometrical pattern – line of the eyes, line of the nose, line of the mouth – behind which lies hidden the sign of the Slavic double Cross. This reduction is not unrelated to the developments in modern art. With their geometry, the 'Heads' done in the twenties clearly show the influence of Dutch Constructivism. But Jawlensky did on the mystical plane what Mondrian was doing in the intellectual sphere. For Mondrian the horizontal and the vertical were the fundamental symbols of a cosmic equilibrium; for Jawlensky, they were first of all the Cross, that ancient symbol of religious equilibrium. From 1924 to 1929 Jawlensky, who had been living in Wiesbaden since 1921, formed with Kandinsky, Klee, and Feininger, the 'Blue Four' group. These were the neighbours he needed for his meditative painting.

The religious impulses of the Blaue Reiter were brought to full fruition by Jawlensky. His desire was to create pictures that should be religious symbols. Since he was in every way an eastern man, the result was a modern icon. What Rouault derived from his apocalyptic Catholicism, Jawlensky drew from his eastern piety. Fully accepting the new methods, both painters did much to preserve religious meditation in modern painting.

## The Sustaining Environment

The most cursory glance at the cultural life of Germany in this period shows that the opening up of the world of human expression in painting was only part of a general movement. This movement embraced music, whose most revolutionary leader, the diatonalist Arnold Schönberg, was close to the Blaue Reiter, and also took in poetry, in which the principal names associated with the transformation of this art were Rilke, Hofmannsthal, Däubler, Trakl, Heym, Stramm, Lasker-Schüler.

There were close ties between painting and poetry. Rilke's book on the Worpswede school appeared in 1902. Thus his aesthetics begins with the very same Naturlyrismus from which grew North German Expressionism. His profound understanding of Paula Modersohn's artistic achievement shows his keen awareness of the development in painting. Next he turned towards France; his experience

of Cézanne led in turn to his encounter with Picasso, which he interpreted in his fifth *Duino Elegy*. Däubler entered into the thick of the controversy over modern art, and not without pride described his participation in the harlequinades of the Futurists. August Stramm was closely connected with the painters of the Sturm group. And it is to Else Lasker-Schüler that Franz Marc's famous series of postcards was addressed.

Those who took an aesthetic and philosophical interest in art received a salutary shock from a little book which appeared in 1907 and soon became famous: Wilhelm Worringer's *Abstraction and Empathy*. Developing the insights of Konrad Fiedler and Alois Riegl, this twenty-six-year-old university lecturer had arrived at formulations which expressed with astonishing clarity the ideas that were then vaguely in the air. Even his initial assumption 'that the work of art is an independent organism apart from nature, to which it is equal in rank and essentially unrelated', went to the heart of the matter. And his further insight that art, instead of springing from empathy with the world of things, could equally well be engendered by the 'drive to abstraction', seemed to flow directly from the contemporary situation. Worringer held that the tendency to abstraction was always a consequence of a profound disturbance induced in man by the manifestations of the outside world, so that anxiety must be regarded as one of the roots of artistic activity. This theory strikingly reflects the existential situation of the time and by that same token accounts for the generalised drive toward a fundamental transformation in art.

Thus the aesthetic vanguard was well prepared to accept the new trends in painting and did so on a much larger scale than is usually supposed. In the summer of 1912 the big Sonderbund Exhibition in Cologne assembled the entire 'who's who' of European modernism. Van Gogh was the centre of attraction; Munch and Cézanne also had rooms of their own. The anteroom to the exhibition was provided by a little cabinet containing some El Grecos, a notion quite in accordance with the ideas of Franz Marc who wrote in the *Blaue Reiter:* 'Cézanne and El Greco are kindred spirits. Today their works stand at the entrance to a new epoch in painting. In their vision of the world, both of them sensed the inner mystical construction that is the great problem of the present generation.' Round this nucleus the whole of modern European painting was grouped: Picasso, Signac, the new French painters, the Swiss, English, and Dutch painters. From Berlin came the rebels of the New Secession, from Munich the Blaue Reiter and the remnants of the Neue Künstlervereinigung; Kirchner and Heckel decorated the chapel, while Thorn-Prikker did its windows. This in short was the first comprehensive showing of the anti-naturalist movement, an impressive demonstration that the new style covered the whole of Europe. It was no longer possible to speak of the caprice and solipsism of a few individuals. The Sonderbund exhibition made it clear that modern painting was a force to be reckoned with in Germany.

*Rhenish Expressionism*

The fact that the first comprehensive exhibition of modern European painting was held in Cologne indicates the receptivity of the Rhineland to the new painting. It was a region which naturally looked towards Paris. Jan Thorn-Prikker maintained contact with Belgium and Holland. August Macke, his cousin Helmut, and Heinrich Campendonck communicated the ideas of the Munich Blaue Reiter; Heinrich Nauen and Wilhelm Morgner kept in touch with the Berlin Secession. From nearby Hagen the ideas of K. E. Osthaus and Christian Rohlfs made themselves felt.

The Dutchman Jan Thorn-Prikker (1868-1932) played a vital rôle in the creation of a mo-

dern atmosphere in the Rhineland. He had come to Germany in 1904 and had exerted a strong influence on the young Rhenish painters by his teaching in Krefeld, Hagen, Düsseldorf, and Cologne. Through him the Rhenish Catholic painters had become acquainted with the new methods of modern religious art. He himself had learned them from Jan Toorop and Maurice Denis. Thus Thorn-Prikker came from Symbolism and was also strongly influenced by the religious ideas of the Nabis, the Rosicrucians, and the painter monks of Beuron. His Symbolist style acquired a monumental quality through the influence of Hodler. He concentrated for a time on murals and stained-glass windows showing a strong Romanesque and early Christian influence. His leaning towards stylisation, ornament, and abstraction made him receptive to modern anti-naturalism. Beginning in 1912, he cautiously incorporated the elements of Orphist Cubism into his art; the mystical, religious ideas of the Blaue Reiter led him to Franz Marc. With these elements, he built a monumental crystal scaffolding from abstract facettings in which he hermetically encoded religious scenes and symbols.

Through Thorn-Prikker, Heinrich Campendonk (b. 1889-1957) found his way to the Blaue Reiter. He took over Marc's formal elements in his decorative, legendary miniatures, which have a quality of applied art. Through the influence of Chagall, he became increasingly lyrical and illustrative.

The contact with Thorn-Prikker and the Blaue Reiter was also the decisive influence in the colourful, decorative painting of Helmut Macke (1891-1936) and Paul Adolf Seehaus (1891-1919). Walther Ophey (1882-1930) remained closer to Symbolism. Side by side with this Symbolist and Orphist trend, the influences of Neo-Impressionism, Van Gogh, and Matisse were at work. Heinrich Nauen (1880-1941) started under the influence of Van Gogh, but then veered towards Matisse. In his giant murals at Schloss Drove in the Rhineland (1912/13), he strove to lend an atmosphere of 'peace and harmony' to his scenes, with their multitudes of figures, by means of 'strong colours and a powerful rhythm'. But this bold spirit soon flagged and Nauen settled down to a neat, distinguished style that recalls the German followers of Matisse.

The Romantic personality of the Westphalian Wilhelm Morgner (1891-1917) seems somewhat out of place in these surroundings. By way of the Naturlyrismus of the Worpswede school and Van Gogh, he found his way to the ideas of Kandinsky and the Blaue Reiter. A true Expressionist, he looked on painting as a means of expressing cosmic feeling and tended towards abstractionism. He set out, as he wrote in 1913, 'to capture in colour the God who made the world. the force that turns the earth and creates the organisms... to transform existence into a symphony of colours and forms, a vital harmony'. The four years he still had to live (he was killed in the war, in 1917) did not suffice for the execution of this programme. But the few paintings he succeeded in completing are significant examples of the Expressionism which flourished among the younger Germans before the First World War and found its centre in *Der Sturm*.

Rhenish Expressionism is in a class by itself. Its rich colour, sensitive décor, precious patterns, and joyful poetic quality give it a character all its own. It achieved its finest expression in the work of August Macke.

## Der Sturm

A highly congenial rallying point for artists was provided by the magazine *Der Sturm*, founded in Berlin by Herwarth Walden. It soon acquired a gallery of its own.

Herwarth Walden was a typical representative of the Jewish metropolitan intelligentsia. Intensely

curious and receptive to new ideas, he reacted eagerly to all the intellectual and artistic currents of his time. In 1910 he founded his magazine. Presented in newspaper format, it was sold at a low price and achieved a large circulation. Originally conceived as an organ of literary controversy, it became the Berlin counterpart to Karl Kraus' *Die Fackel* (in Vienna) and Papini's *La Voce* (in Florence). Aggressive, polemical, intolerant, it opened its columns to everything that was new and unusual, though offering no constructive position of its own. What brought its various contributors together was essentially the atmosphere of passionate excitement.

*Der Sturm* was of the utmost importance for the development of art. In 1910 Walden met young Oskar Kokoschka in Vienna and persuaded him to move to Berlin. Kokoschka supplied *Der Sturm* with a regular feature, the 'portrait of the week'. The issues for the first year contain this amazing series of portrait sketches, which at one stroke created the Expressionist portrait. Walden had a fine flair. By the second year, the Brücke artists were contributing and by the third those of the Blaue Reiter. Marc and Campendonck contributed woodcuts, Kandinsky's first abstract drawings appeared. In 1913 drawings by Paul Klee appeared on the title pages. But the magazine was also open to the literary effusions of the modern painters. Marc wrote reviews, Kandinsky theoretical articles on abstract form, the *Futurist Manifesto* was reprinted, there were communications from Delaunay and Léger.

In March 1912 Walden associated a picture gallery with his magazine. This was the beginning of the glorious series of exhibitions which month after month spread the gospel of the new painting in the German capital. First Kokoschka and the Blaue Reiter painters were shown; in April, the Italian Futurists; in May, engravings and lithographs by the new French artists, with special emphasis on Picasso. The next exhibition was devoted to the 'German Expressionists' (Kandinsky, Marc, Jawlensky, Campendonk, and others); then came 'French Expressionism' (Braque, Derain, Vlaminck, Friesz, Laurencin, Herbin). And so it went on: Ensor, Kandinsky, Klee, Marc, Delaunay, Soffici, Severini, Archipenko, the Swiss 'Moderner Bund'.

In the autumn of 1913 this activity of the Sturm-Galerie culminated in the 'First German Autumn Salon', which Herwarth Walden organised on the model of the Salon d'Automne. The three hundred and sixty works exhibited represented a first cross section of the achievement in modern art up to that time. A number of artists – Marc was engaged especially for the occasion – helped to organise the exhibition. The place of honour was accorded to Henri Rousseau, more than twenty of whose works were shown. Then came the Blaue Reiter with its whole Russian following; the Brücke group, the German Expressionists – Kokoschka, Kubin, Rohlfs, Nolde, Feininger, and others; the Italian Futurists; the French Orphists – Delaunay, Léger, Gleizes, Metzinger, Picabia, and others; artists from Eastern Europe – Chagall, Archipenko, Brancusi, Epstein, Larionov; Mondrian, Max Ernst, and Hans Arp also made their appearance. With an amazing sureness of touch, Walden had assembled nearly all the leading figures of the modern art world – though many of them were not to achieve fame until years later.

This was the heroic period of *Der Sturm*. In the years before the First World War, this disclosure of a coherent stylistic pattern was of the greatest importance. In the post-war years the Sturm movement, despite far-flung activity – Sturm School, Sturm Theatre, Sturm Bookstore – lost its representative character. The magazine survived until 1932 but was by then out of date. At the end of the twenties, Herwarth Walden went to Russia and was never heard of again. His name will be remembered, not least because it was he who made Kokoschka known in Berlin, the art centre of Germany.

131

*Oskar Kokoschka (b.1886). Early Period*

In 1910 Walden had brought Kokoschka to Berlin from Vienna. The climate of Vienna in the early years of the century was exactly what was needed for the growth of a talent such as Kokoschka's. There were strange contradictions: on the one hand, a comfortable, easy-going philistinism; on the other, elegiac melancholy and an esoteric 'remoteness from life'. An ironic scepticism imposed certain limits on the outpourings of the visionaries. These years saw the beginnings of Siegmund Freud's psychoanalysis, in which an artistic awareness of the most secret human impulses (a cast of mind that would surely have been impossible without the psychic sensibility characteristic of the Symbolist decade) entered into combination with a strictly scientific method. In 1900 Freud published his *Interpretation of Dreams,* in which these most fugitive manifestations of the human mind were treated as scientific realities.

In artistic matters, this exceedingly rich but also exceedingly unstable milieu seems, more than that of any other leading city, to have lived on reflections of foreign movements. The Munich Jugendstil exerted a strong influence on young Vienna, but a morbid note was injected into it by the equally strong influence of English aestheticism. French Symbolism supplied a Romantic, visionary quality. The Secession, founded in 1897, provided a forum for the new currents; in the Vienna Workshops, set up shortly afterward by the architect Josef Hoffmann, the new style was extended to applied art, utensils, and furniture. Both in the good and the bad sense, Gustav Klimt was the typical representative of this Vienna Jugendstil; his unusual gift for subtle colour chords and abstract ornamental forms was counterbalanced by the rank exuberance of his décor and his sticky eroticism.

Oskar Kokoschka entered the Vienna School of Applied Art in 1904 and naturally was caught up in the clutter of the Jugendstil. In 1908 he attracted a certain amount of attention with his first exhibit at the Kunstschau, and the publishing house of the Vienna Workshops put out his *Dreaming Boys,* a series of colour lithographs with an accompanying text. It had been planned as a children's book, but what finally appeared was a dark legend and a series of rather mawkish Symbolist illustrations: against carpet-like, intensely coloured grounds, dreamy sensitive figures are interwoven with a rich décor of arabesques full of dark symbols. The underlying mood is that of Klimt and Beardsley; the angular gestures of the figures show the influence of Hodler. *Dreaming Boys* exemplifies the elegiac view of man, so dear to Symbolist painting, and stems from the same tradition as the melancholy figures of Picasso's 'blue period'. The décor was still that of the Jugendstil. As to the poetic visions it illustrates, they are in the same class as those that Kokoschka poured forth in his plays – the first of which, *Sphinx and Straw Man* and *Murderers, the Hope of Women,* were written in these years. The painter required this compulsive literary flow to free him from the images that bore in on him from all sides. But in the process figures and scenes emerged from the chaos and took on so urgent a presence in his mind that it became necessary for him to illustrate them in his art.

Kokoschka approached the world around him with this same visionary sensibility. His first pictures, dating from 1907, are portraits and still lifes. From the very outset, they are wholly and unmistakably personal. As though hallucinated, the painter palpates objects and faces and gives them the poetic aura called for by the response of his own psyche. Caught up in his own imaginative world, their objective reality ceases to be anything more than a vicarious image. Thus what is essential in the portraits is not any particular outward resemblance nor even the disclosure of a psychological truth. Obviously the portraits of Karl Kraus or Forel do not capture their psycho-

logy or character. The essence of such portraiture is the 'inner face' that Kokoschka projects into them, a poetic *possibility* read into them by the painter, a reflection of his own being. In short, they are *self*-expression. In these pictures it is meaningless to speak of good, let alone new, painting. Kokoschka gives no thought to form, he makes no attempt to organise his feeling. Actually the pictorial means he uses are rather conventional. From this standpoint, we should have to characterise the early portraits as charming and fashionable. What gives them their unmistakable rank and 'novelty' is the hallucinated power that enables the artist to materialise his own state of mind in objects and faces.

One of the great achievements of these years is the *Still Life with Dead Sheep* (c. 1909) : a skinned sheep, a jug, a flowering hyacinth, a fish bowl containing a white salamander. A turtle crawls through the picture and a white mouse darts across the foreground. Thus one cannot speak of a still life first arranged and then painted. The visual experience of the dead sheep summons up a poetic 'echo' that interprets it: the pale salamander, the white mouse, the sickly white of the hyacinth. The whole is pervaded with mould, with the opalescent tones of putrefaction. It is a visionary work, representing the painter's state of mind by means of an hallucinated manipulation of things; there is no concern with the things themselves or with the formal harmony that transforms them.

The same is true of the portraits. Half in trance, the artist looks into human faces, but his pictures tell us more about the painter than about his models. In all of them we discern the same hectic mood, the same frayed nerves, regardless of whether they represent Reinhold, the actor (in the well-known painting *Actor in Trance)*, or Kraus, the sceptical intellectual, or Adolf Loos, the precise, almost pedantic architect, or Forel, the scholar. The models are transformed into metaphorical vehicles of a poetic vision of existence, mere actors in a world of autistic vision. It is this vision that the artist projects into their faces and illustrates by gesture and mimicry. Hence the emphasis on the head and hands. From the standpoint of technique, this 'illustrative' character calls primarily for drawing, and that is why in these portraits the drawing is far more important for the statement of the vision than is the colour, which provides only the background or the tinge of the line. It is the restless line, eating into the object like acid, which gives these visions their expressive power.

In 1909 and again in 1910 Kokoschka went to Switzerland. Here he attacked landscape for the first time, in the famous winter scene of the *Dent du Midi*. In 1910 Walden brought him to Berlin. This was the year of the great crisis of the Berlin Secession. The Expressionist climate fully confirmed Kokoschka in his tendencies. In 1910 the Folkwang Museum and Paul Cassirer organised an exhibition of his painting. His masterly series of portrait sketches appeared in *Der Sturm*.

In his painting the colour texture now becomes gradually more dense, achieving an enamel-like quality. But the hallucinated vision remains the centre from which the pictures emanate. His most concentrated expression was achieved in the graphic series of these years: in 1910 the illustrations to Ehrenstein's *Tubutsch;* in 1913 *The Chained Columbus,* a series of lithographs; in 1914 the illustrations for the *Chinese Wall* of Karl Kraus, and the lithographs illustrating the text of Bach's cantata, *O Ewigkeit – Du Donnerwort.* All these illustrations are related only loosely to the text. The scenic world they create fluctuates strangely between burlesque comedy and apocalypse. Kokoschka was unusually given to suffering combined with an inquisitive self-observation. In these drawings his indefatigable urge to experience the painfulness of life by self-interpretation gives rise to figures of ego and counter-ego, ego and anima – trance-like images of

his own inner self-experience. This is clear from his illustrations for Bach's cantata. One can compare them, of course, to the etchings with which Klinger illustrated Brahm's Fantasias; in a sense they resemble the fantasies that come to persons with a pronounced eidetic faculty while listening to music. But as Kokoschka listens to the music and the words of the Psalm, it is the scenario of his own drama that takes form. Encoded in these scenes is the painter's own shattering experience of the battle of the sexes, the crushing, inexorable character of the Eros, the ego battling with the anima which is angel and devil in one. Many strange elements in Kokoschka's life can be explained by this compulsive vision. His exhibitionism came from his need for self-interpretation.

His drawings show a sovereign indifference to problems of form – nervous writing, tatters of line, sketchiness caused by haste to fixate the rushing flow of images, all manner of deformation when the expressiveness of the mimicry and gesture require it. Lines come together in knots. The nervous tangle throbs with a hectically irregular rhythm. From Kokoschka's experience of his self the medium in him devises a figure; his manic quality excites the line, which carries the figure to the surface of the picture. (With Klee it was quite different; the line itself was the medium giving rise to the figure which interpreted the experience.)

It was the same with Kokoschka's painting. This stage in his development is exemplified by *Bride of the Wind* (1914). Here we see the ego and the anima, driven like Paolo and Francesca by apocalyptic winds. A slippery white shatters the colour ensemble, bearing witness to Kokoschka's graphic leanings and indifference to the laws governing the application of colour. The influence of Van Gogh is clearly discernible – and this is the first time that we can note an encounter with the great masters of modern painting – but all Kokoschka takes from Van Gogh is something of the hectic quality of his script; we find no sign of the pictorial intelligence that Van Gogh preserved through all his madness. Kokoschka's aim – which also determines the quality of his work – is the most expressive form, the most striking illustration of a vision torn from a torrent of images. What matter if the pictorial organism gapes with holes and hangs in tatters!

Kokoschka's visionary gift shows the extreme possibility of Expressionism. Nolde, the Brücke, the Blaue Reiter painters – all were engaged in turning visual experience into painting. Kokoschka came from the 'other side', the world of dreams and visions. Hallucinated images of inner states were projected on the screen of his figurative fantasy, and these he illustrated in painting. With him painting comes close to visionary, prophetic poetry. This freedom to pour forth swarms of images on canvas, to capture trance-like states in an objective, figurative scenario, to achieve self-representation in painting – this was Kokoschka's contribution to German Expressionism. In this respect he represented the culmination of the *Sturm* Expressionism of the pre-war period. It was a tendency beset by the mortal peril of formlessness, to which nearly all the lesser talents who gathered round Kokoschka and the *Sturm* succumbed. A striking example of this was Ludwig Meidner, a visionary and prophet of high stature endowed with keen feeling for the soul of his time, yet utterly unable to draw.

*Kandinsky and the Rise of Abstract Painting*

Beginning in 1905 the great goal was an art that would express human inwardness without recourse to metaphors drawn from the outside world. The essential was no longer to reproduce objects, but to make the picture itself into an object which, through the resonance inherent in

134

its construction, would awaken a feeling similar to that aroused by the things and processes of visible nature. Everywhere we find parallel strivings towards the same goal. In France Analytical Cubism had led to Delaunay's Orphism, and at a certain point that it would be hard to situate exactly in time, analysis had given way to synthesis among the orthodox Cubists.

In Germany everything was ready for a solution. The Jugendstil aesthetics had openly raised the question of abstract art. The ideas of the Nabis and the Fauves had a stimulating effect, and only a resolute push was needed to bring the abstract picture into being. The push was supplied by Wassily Kandinsky.

Kandinsky is generally regarded as the originator of abstract painting. But we must bear in mind that he represents merely the culmination of a process that had long been maturing. Abstract painting can be said to have been born in 1910/11; Kandinsky's first abstract water colour is dated 1910. But only a little later, in 1912, Delaunay and Kupka in Paris arrived at the same solution quite independently of Kandinsky, and at the opposite end of Europe, in Moscow, Larionov found his way to abstract form in 1911. The problem had been so well propounded all over Europe that the solution was inevitably arrived at in many places at once. Essentially Kandinsky's short lead over the others may be attributed to certain favourable circumstances, to his keen pictorial intelligence and to the convincing quality of his artistic formulation. Yet it might easily be shown that one artist or another turned out an abstract picture before Kandinsky and before 1910. As early as 1893 Henry van de Velde had done a few abstract wood-cuts as vignettes for the Dutch magazine *Van Nu en straks*. In 1896 August Endell had decorated the front of a Munich photographer's shop with an immense, radically abstract relief, coloured in violet and turquoise green. Obrist had been striving for abstract sculpture at the beginning of the century. One of his students, Schmidt-Hals, did a series of abstract ornamental paintings as early as 1904. In 1906, Hoelzel experimented with the amplification of abstract ornament to form a self-contained picture. A number of similar cases might be mentioned. Here we shall content ourselves with citing three instances of independent development at widely divergent points on the map. We have seen how, under the impact of Matisse, August Macke, half playing, half experimenting, groped his way towards abstraction. In 1907, at the age of twenty, he relates in a letter how he tried 'to compose colours on a board without thinking of a real object'. Macke's thinking returned again and again to these experiments – which in themselves produced no direct results. His correspondence of 1910 with Franz Marc refers repeatedly to the abstract expressive possibilities of colour and to their psychological effects similar to the chords of music. Macke himself returned only briefly – in 1912, under the influence of Delaunay – to his early abstract experiments. However, not only the abstract experiments of Hoelzel, Obrist and Endell, but, in a profoundly characteristic way, the reactions of the Austrian Alfred Kubin, a painter utterly at the mercy of his psychic impulses, shows that the entire human structure of the decade – the malaise that sprang from an increasing doubt as to the reality and solidity of the visible world – sought a kind of redemption in abstract painting. In 1906 a look through a microscope had suddenly convinced Kubin that the existence of the visible world was by no means as self-evident as is generally supposed. His insight created an 'intense pressure' which he tried to dispel through painting. 'I began to reject all memories of organised nature, and from bundles of veils, from beams of light, from fragments of crystals or shells, from scraps of meat and skin, from leaf ornaments and a thousand other things I made compositions which, even in the midst of my work, surprised me and gave me a deep satisfaction, which, in fact, gave me a happiness I have seldom found in my work either before or since.' In this 'new drunkenness' some twenty abstract pictures

were painted, but when the intoxication was past Kubin was unable to continue. He closed his waking consciousness to the insight that had come to him spontaneously. Only in his novel, *The Other Side*, published in 1909 and, incidentally, read by Kandinsky, did he let his auto-biographical protagonist longingly pursue the same daydreams, creating 'new formal structures in accordance with secret rhythms that had been borne in upon my consciousness' and developing 'a fragmentary, script-like style, which like a sensitive meteorological instrument expressed the slightest fluctuations of my life-feeling'. But Kubin's waking consciousness refused to recognise these ideas engendered by a semi-conscious need, by a restless inner yearning. He never transposed them into conscious artistic activity. It was Kandinsky who first raised these latent yearnings to the brightest light of consciousness.

But we must also mention the case of a man with an extraordinary synaesthetic gift, who tried to draw serious conclusions from the eternal comparison between coloured and musical tones. This was the Lithuanian, M. K. Ciurlionis (1875-1911). A musical infant prodigy, he graduated from the Warsaw Conservatory and devoted himself to composition. Then suddenly – towards 1905 – he turned to painting. His aim was to paint music. His colour compositions were conceived as symphonic movements. They bear such titles as 'Ocean Sonata', 'Sun Sonata', 'Snake Sonata', and contain such musical indications as Andante, Scherzo, etc. At first Curlionis worked with objective analogies, but his method became increasingly abstract – the results were cosmic visions, heavenly bodies moving through worlds upon worlds, traversed by rhythmic gradations and free arabesques suggestive of the Jugendstil. All this is less surprising than it might seem. Eastern Europe was amazingly quick to take up the echoes of Western modernism. It suffices to recall that Odilon Redon had already called himself a *'peintre symphonique'*, that in Munich at the beginning of the century Riemerschmidt, on the basis of the Jugendstil aesthetics, had attempted to express musical tones in lines in a mural frieze for a concert hall, and that the musical element in Klimt is quite obvious. Thus it seems safe to say that Ciurlionis drew his ideas from Odilon Redon and the Vienna Secession and from the mysticism of Sérusier and the Rosicrucians. His case is strangely extreme, yet in a way his work typifies the ornamental, stylised visions peculiar to the Russian offshoot of the Jugendstil, whose representatives in 1910 founded the Moscow 'Blue Rose' association. From the purely pictorial point of view, Ciurlionis's paintings are not so very 'abstract', though the 'objects' he represents are not taken from our natural environment, but from fantastically imagined 'cosmic worlds'. A musical tone is given to these visions of the first days of Creation by means of an abstract ornamental accompaniment. Curlionis' works were well known among the Russian avant-garde. In 1912 Boris Anrep, a Lithuanian painter living in London, had submitted a few of Ciurlionis's pictures to the important 'Second Post-Impressionist Exhibition'. But already in 1911 *Apollon*, organ of the Russian avant-garde, had published a number of his works. Kandinsky became aware of them through this publication if not before. The intention certainly interested him, but he had no use for the formal aspect or the excessive Romantic content. With his profound intuition and keen pictorial intelligence, Kandinsky was able to work out in conscious clarity the ideas of which Ciurlionis, in his musical, mystical visions, was only vaguely aware (he died insane in 1911).

But why should it have been just Kandinsky, a Russian living in Munich in 1910, who succeeded? The answer begins with his nationality. Above all, Kandinsky was a Russian. He tells us on frequent occasions that what aroused his imagination to abstract expression was the vision of Moscow in the evening sun. Then there was the sign language of the Russian icons, the mystical, colour-drenched twilight of the Orthodox churches, and the brightly coloured, abstract ornament

of Russian folk art. But apart from these visual experiences, his Russian nature made it easier for him to depart from the material world and its visible figures. For the Russians with their mystical outlook had never regarded art as a reproduction of the visible world; they had always expressed their emotion in symbols on the abstract ground of the picture surface or used abstract means to create a mystical 'atmosphere' in the interiors of their churches or peasant houses.

This was the source of the freedom with which Kandinsky moved away from the visible world. It is no accident that the echoes of the modern Western movements – Symbolism, Fauvism, Cubism, Futurism – should have taken a more abstract form in Russia. From 1910 to 1914 Moscow witnessed a veritable flood of modern tendencies in painting, but all ended in abstractionism – Larionov's 'Rayonism', 'Cubo-Futurism', Malevich's 'Suprematism'. Pre-war Moscow was the citadel of abstract painting. A note had been struck to which the mysticism, as well as the secret anarchy, of the Russian soul could wholeheartedly respond.

Personal traits had a good deal to do with it. From childhood Kandinsky had been extraordinarily sensitive to colour. As long as he lived, it remained for him a profound and stimulating experience to see a colour, a living thing with its desires and temptations, pouring from the tube on to the palette. At an early age, this feeling for colour combined with a strong synaesthetic gift. Colours lost their materiality and became tones, conjuring up musical associations. Kandinsky first became aware of this at a performance of *Lohengrin* which he attended as a student of political economy in Moscow. 'I could see all my colours; I realised that painting possesses the same power as music.'

The ideas that were in the air helped, of course, to cultivate this sensibility. The association of painting and music was a favourite idea of the Romantics. We find it in Wackenroder, Tieck, Runge, Novalis. Awareness of the intimate relation between sound and colour led Rimington to invent his chromatic organ and Castel his colour piano. At the end of the nineteenth century the idea revived in full force in the German Jugendstil. Endell's remark about an 'art that operates with freely found forms, as music with free tones' merely expressed what was in the mind of every thinking painter in 1900. The French painters were also familiar with the idea. Delacroix noted it in his *Journal*. Odilon Redon and above all Gauguin and Van Gogh tried to put it into effect. Van Gogh, as Kerssenmaker tells us, went so far as to take piano lessons in order to arrive at a better understanding of colour nuances. Van Gogh's prophecy that painting promised to become more subtle – 'more music and less sculpture' – is the leitmotif of the Symbolist decade. Thanks to Symbolist influence, these ideas achieved extraordinary force in Munich in the early years of our century.

This gives us two factors, Kandinsky's Russian origin and his synaesthetic gift. Next we must consider his relation to modern painting and the ideas embodied in it. Kandinsky received his first shock as a young student in Moscow, when he saw one of Monet's 'Haystacks' at an Impressionist exhibition. Accustomed to Russian painting in the style of Ryepin, he did not recognise the motif and it took a look at the catalogue to tell him what it was. His initial irritation soon gave way to the realisation that this was a real 'picture': solely by the use of line and colour, the painter had transferred all interest from the object to his painting. This encounter with late Impressionism led Kandinsky, on the negative side, to doubt the importance of the object and, on the positive side, aroused his faith in the overwhelming, independent power of colour. When Kandinsky, through his move to Munich and his trips to Paris, came into direct contact with the stormy development of contemporary painting, his doubt and faith drove him to those painters, from Gauguin by way of the Nabis and the Neo-Impressionists to the Fauves, who

had argued the pure power of colour in opposition to the reproduction of objects. He joined their ranks. His whole activity from 1905 to 1910 was oriented towards finding an answer to Gauguin's question: 'Why should we not succeed in creating colour harmonies that correspond to our psychic state?' And in the end this striving culminated in abstract painting.

But again, it is no accident that Kandinsky's decisive step should have been taken in Munich. We have repeatedly pointed out that here more than anywhere else the theoretical groundwork for abstract painting had been laid by the reflections of men such as Lipp and Obrist, Endell and Hoelzel, and by the influence of the ideas of the Nabis and Van de Velde. But thus far, when it came to actual pictures, the abstraction had been obscured by a layer of arts-and-crafts ornament. Summoning up all his strength, Kandinsky succeeded in tearing off these decorative veils and in attaining to the pictorial truth that was to provide the foundation of a new development in painting. The subtly logical law of growth underlying the development of modern pictorial thinking stands out with particular clarity in connection with Kandinsky and the genesis of abstract painting.

There is one more idea that should be briefly touched upon. It was inevitable that the painters' increasing doubt in the validity of the visible should have been intensified by the findings of modern science. The intuitive groping of the arts into man's inner world was vastly encouraged by the emergence of Freud's psychoanalysis. But still more important were the changes in the modern scientific view of physical reality. In the first decade of the century two revolutionary discoveries shattered the prevailing conception of the original solidity of things – the discovery of nuclear fission and the new hypothesis of a space-time continuum. In consequence of the first, the concept of matter gave way to that of energy; material, geometrically organised patterns were replaced by fields of force. The second shattered the static, perspective frame of reference into which the data of observation had been inscribed since the Renaissance, and transformed it into a dynamic, non-perspective system. Both these changes implied that henceforth the scientific view of the world would no longer be formulated in terms of representable geometric forms, but in algebraic formulas that cannot be represented. All this did much to confirm painters in their suspicion that the reality of the visible world consisted solely in the human faculty of apperception, that nature had no reality other than the answering image in man – in short that the visible world consisted of imagination. The receptivity of the men of those years to such an experience is illustrated by a few sentences from Kubin's novel: 'I remember that morning when I felt myself to be the centre of an elemental system of numbers. I felt abstract, a point round which energies maintained an unstable equilibrium... The creatures of the dream world were compelled to wrest their imagined world from nothingness and, starting from this imagined world, to conquer nothingness... The primal ground could lie only in the imagination and in nothingness... And then I knew: the world is imagination – the faculty of making images.'

The stimulating effect of the new scientific ideas on the thinking of the painters is easily observed. As early as 1907 Boccioni notes in his diary that to his mind art and artists were in conflict with science, that art must take account of scientific analysis and its view of the universe. Here he had expressed the very idea which in fully developed Futurism led to the conception of space-time. When in 1908 Hermann Minkowsky conceived the idea of the fourth dimension as a unity of space and time, the Cubists were busy working out the simultaneous view of objects, the notion of looking at them and depicting them from several station points at once, thus replacing the old static vanishing-point perspective by a new dynamic conception of space, which would draw the factors of time and movement into the picture. By 1911 Apollinaire consciously recognised this and conceived a relation between the non-perspective space of Cubist and Futurist art and the

scientific concept of the fourth dimension. This notion has been at work in modern aesthetics ever since.

As one might expect, the artists of Eastern Europe were less rational and intellectual in their approach to the insights of modern science. But the shock was just as strong. Kandinsky experienced it to the full. When, as a young painter, he heard of the splitting of the atom, 'the discovery struck me with a terrible power, as though the end of the world had set in. In one moment the mighty pillars of science lay in ruins before me. All things became transparent, without power or certainty.' Kandinsky himself believed that this experience had a good deal to do with his turn away from the images of visible nature, because through it 'one of the gravest obstacles on the way to the fulfilment of my desires collapsed of its own accord and disappeared'. In this moment, the chain broke that had bound him to the visible world, for now to depart from the visible no longer meant to despise or falsify Creation; on the contrary, it became a duty to give pictorial expression to the new and amplified view of Creation. It was this faith in the possibility of embodying in painting the 'inner, mystical construction of the world' that had essentially determined the Blaue Reiter aesthetics. Franz Marc, Kandinsky's friend, stated this clearly: 'The art of the future will be the formal expression of our scientific conviction.' And starting from the conception of matter as pure vibration, he speculated on the appearance of future works: 'Must they not be full of wires and tensions, of the wonderful effects of modern light, of the spirit of chemical analysis, which breaks forces apart and arbitrarily joins them together?' The great task, he declares, is 'the project of a new world'. Such a project, it went without saying, could be formulated only in an 'abstract' idiom. Thus the great revolution in the scientific view of the world lent powerful support to the revolution in art.

Kandinsky's development is so logical that its stages are easily discernible. The development begins in 1900 with Jugendstil and late Impressionism, which helped Kandinsky to cast off the slag of academic Russian realism. The result is sometimes a curious combination of a mediaeval, Romantic fairy-tale world with a luminous surface obtained by means of spots of colour. Kandinsky sought to attain poetic sublimation through the fairy-tale element, but already the bold palette of the late Impressionists was showing him the way to the expressiveness of pure colour and grandiose décor. Up to 1904 he remained close to French late Impressionism with its Nabi aesthetics, particularly to Bonnard and Vuillard. But then his colour became more intense and independent, and he began to make his surfaces vibrate by means of coloured lines and spots. This change was provoked by the influence of Van Gogh and above all Signac. From then on his path led, with inexorable logic, to the late period of Monet (1905) and to the Fauves (1906). In these years Kandinsky – since 1902 he had been taking frequent trips to France and had spent almost the whole of the year of 1906 in the vicinity of Paris – had closely followed the entire contemporary French development and had assimilated the Fauve aesthetics. When in 1908 he returned by way of Berlin to Munich where he was to settle until 1914, older tendencies, that had been submerged for a time, reappeared on a new level. The symbolic element reasserted itself, but now without the old mythological and idyllic trappings; the thematic element receded and Kandinsky sought to express his meaning more and more exclusively through the affective and symbolic values of colour. The experience of Bavarian folk art, which recalled his old memories of the brightly-coloured, abstract ornament of Russian popular art, confirmed him in his striving for independent colour. He began to paint resounding legendary scenes and landscapes which, with their enhanced colour and the radiance of their full chords, lead the viewer more and more to forget the motif. The musical aspect of colour begins to overcome the last elementary thing-

signs. Little experiences, chance occurrences, a picture placed upside down in the evening light of his studio, convinced Kandinsky more and more that what still gave his pictures a certain murkiness was the objective element. In 1910 he finally tried to arrange pure colour chords and arabesques – and nothing else – on his white surface. But it should not be supposed that Kandinsky suddenly banished all objective features from his painting. In 1910 he merely considered pure abstraction as a possible but quite extreme goal. The leading idea of his book *On the Spiritual in Art* (written in 1910), is that a harmony of colours and forms 'can only be based on a purposive contact with the human soul' and that 'composition is a combination of coloured and graphic forms which exist independently, which are summoned up by an inner necessity and, thus living together, come to form a whole that we call a picture'. But this does not preclude the possibility that the inner vibration may be provoked by a represented object. 'To deprive oneself of this possibility of causing a vibration would be to impoverish the arsenal of our means of expression.' In actual fact, the 'Improvisations', the 'Compositions', and of course, the 'Abstractions' – this is Kandinsky's classification of his production – of the period from 1910 to 1912, still contain signs of objective experiences. It was only in 1912 and 1913 that these disappeared entirely and that he came to express himself in pure harmony.

How Kandinsky moved slowly away from object-signs and at the same time fashioned a pictorial organism capable of sustaining the new communicative signs can be clearly discerned in the series of 'Compositions', as his great works are entitled. The three 'Compositions' of 1910 show a whole arsenal of forms which, though extremely abstract, are plainly derived from the world of figures and landscapes. We see signs of hills, meadows and trees, the distant cupolas of Moscow, and, in between, signs of racing horsemen and other moving figures. These pictures produce the effect of dance figures in a mystery play. And here a last vestige of illusionism prevents Kandinsky from discarding perspective. But the colour is perfectly free. It resounds like an orchestra, surges over the surface in great billows of music. The Asiatic, folklore element drowns out the recollection of Gauguin's colour. The two 'Compositions' of 1911 are more restrained and economical. Traces of landscape are barely discernible. On light-coloured grounds the form-producing lines move in free arabesque, a pure expressive script. The illusionistic space is gone. Earthly perspective with its simple movement in depth – foreground, middleground, background – is forsaken for a cosmic space, a more complex, surging, troubled space.

1912 was the year in which Kandinsky came resolutely to grips with Cubism, Orphism, and Futurism and their manner of organising a picture. In *Composition VI* of 1913, his preoccupation with the pictorial structure bore mature fruit. Illusionistic space has given way to the autonomous non-perspective pictorial space worked out by the Cubists, a system of imbricated layers, of superimposed and interpenetrating planes. But Kandinsky introduces an extreme and highly expressive tension into this relatively rational system by means of irrational thrusts reaching out through space, towards the infinite. Kinetic symbols introduce the space-time factor. Thus the orchestration embraces the widest tensions – the rational and the irrational, the limited and the unlimited, the static and the dynamic. In the following *Composition VII* of 1913, and the pictures of 1914, a Dionysian furioso bursts forth in this new independent pictorial cosmos: mightily flowing masses of colour, from which precious, minutely sub-divided jewel-like forms emerge, sweeping arcs that find a response in glittering, vibrant concentrations of graphic detail, a colour ranging from sharpest yellow to fiery purple and spiritual blue and glowing with the inwardness of eastern mysticism. The sound is that of a Russian choir – sharp ethereal sopranos and then the deep organ tones of the basses. Only with the utmost strain does the framework of the picture withstand the

140

stormy incursion of musical, Dionysian, and mystical forces. And this is precisely what distinguishes Kandinsky from the calculating architectonics of the French Cubists. In these pictures the scarcely checked violence of the Northern and Eastern Expressionism bursts into Orphic song. If this kind of art requires a name, perhaps we may call it 'Abstract Expressionism'.

Kandinsky's abstract painting meant not only a radical shift to the images that rise to the eye from the precincts of the soul and not only an artistic turn from the recognition of things to the recognition of the palette and its magic powers of communication; it meant also a complete negation of the fatal tension that had entered into the human mind when it began, for the first time since the Renaissance, to harbour doubts as to the solidity of things. Kandinsky effaced the world of things, denied the confrontation, averted his eyes. For him painting was no longer a dialogue between man and his environment; it was man's dialogue with his inner world, which could now be communicated without recourse to the configured symbols of the outside world. Pictorially speaking, the two worlds existed only as aesthetic expressions of a human attitude towards reality. But the attitude had changed fundamentally and could now find a logical and legitimate expression in abstract painting.

In referring to Kandinsky's painting as 'Abstract Expressionism', we mean to distinguish it from the architectonics and rationality of modern Latin painting. The Latin mind was clearly reluctant to surrender itself to this expressive flow of forms from within. It did not combat or deny; what it sought was balance. Fundamentally Matisse as well as the leading Cubists saw their paintings as symbols of balance. In the play of their arrangements of things and forms, a third term came into being, a spiritual formula which caught up the tension between man and thing and held it in a fragile, suspensive repose. Architecturally the picture was wholly abstract and yet at the same time, through the mastery of form, it captured a piece of the world. By 1912 the French mind had developed an appropriate formula. Synthetic Cubism was its first application. Its strictest and purest, though not artistically its most perfect, expression was the work of Juan Gris. It shows us the response of the Latin mind to the problem of abstract painting.

*Juan Gris (1887-1927)*

The work of Juan Gris once more discloses the old polarities between which the European spirit moves. It is sustained by the classical spirit – the Latin answer to the Romanticism of Kandinsky and the Blaue Reiter painters. Gris followed in the footsteps of the great constructors, Cézanne and Seurat, and held aloof from the mysticism of Gauguin and the expressive pathos of Van Gogh. The profoundly emotional, Romantic experience of the world characteristic of the Blaue Reiter lay outside the scope of his experience. His cool, calculating intelligence viewed experience as merely the initial stimulus, an invitation to the pictorial intellect to embark on its own operations and devise a formula by which to express itself along with the signs and symbols of experience. His whole life was subject to this intellectual control; he was a man who always knew what he was doing.

José Vittoriano Gonzales – this was his real name – came to Paris from Madrid in 1906 and moved into a studio next to Picasso's in the rue Ravignan. At the time Picasso was busy with his large canvas of *Les Demoiselles d'Avignon*, seeking, with the help of archaic Iberian art, Negro art, and Cézanne, to achieve a primordial daemonic quality and, on the formal side, an independent construction of the pictorial elements. In respect of form he was sowing the seeds of Cubism; in respect

content, he was struggling for freedom from the humanistic tradition. All this was of the utmost importance for Gris. Gris himself came from the Madrid Jugendstil; he brought with him the decorative aphoristic style of the German graphic artists of *Simplicissimus* and *Die Jugend* and an appreciation of Toulouse-Lautrec. For a time there was no change. Contributing drawings to French magazines, he clung to this style until 1910. But it is certain that in his mind he was closely following the development of his friends Picasso and Braque.

They had placed the simple object at the centre of their analytic dialogue with the outside world. Towards 1911 Gris turned to the Cubist iconography and formal analysis which were to be the starting point of his own development. He advanced rapidly: in 1910, realistic still lifes in sober perspective; in 1911/12, beginnings of Cubist analysis; by 1913 he had the methods of Braque and Picasso firmly in hand. But what his analysis distilled from objects was the strictest architecture. From visible things he detached architectural, geometrical elements, and from illusionistic space he distilled clearly organised planes, while fortuitous objects shaped themselves into the harmonious crystal of the picture. Gris' controlled intellectuality contrasts sharply with Picasso's dramatic quality and the lyricism of Braque. In the new medium, he reached back to the cool classicism of Ingres and the architectural intimacy of Chardin.

In 1914 Gris achieved the fullest solutions to his formal problems: he employed interlocking planes, minute geometrical forms, and multiple arabesques that circle between the planes. The clearest pictorial formula is achieved in a series begun in 1915 and culminating in 1919. In this work we note the closest intellectual control and a precision which sometimes verges on the mechanical. (It is here that the 'Purists', Ozenfant and Jeanneret, found their starting point.) In these pictures Gris consciously elaborated the tendencies that had been latent in the Synthetic Cubism of Braque and Picasso. No longer do the objective world and its data provide the analytical mind with the material from which it builds up a construction that interprets and transforms the world of things; rather, the mind constructs from within, and on this construction imprints thing-signs that relate it to an objective experience. Emblems of things *emerge from* the construction. The procedure is no longer analytical but synthetic, no longer inductive but deductive. 'It is not a certain picture X,' said Gris, 'which tries to enter into agreement with an object, but an object X, which strives to coincide with my picture.' This insight is the basis of Gris' whole art; it motivates his aesthetics and gives his production an exemplary value. We find it again in the last, highly simplified phase upon which he embarked after abandoning the not wholly successful attempts of 1923/24 to 'humanise' his abstract pictorial architecture by reinstating objective and figurative elements.

This aesthetics, which is the intellectual culmination of Synthetic Cubism, was perfectly clear to Gris. He described it himself in a lecture at the Sorbonne. His paintings, he tells us, sprang exclusively from the inner imaginative faculty and are pure constructions of formal elements. The elements of visible reality that are to be found in them are not the starting point of artistic activity but its outcome. The process begins with the elementary architectonic forms. These are organised by calculation, in accordance with numerical relations and proportions. The abstract figuration that results is the actual picture 'in its universal state'. But now Gris is impelled to make the abstract concrete, to pass from the universal to the particular: 'The pictorial relations between the coloured forms suggest to me certain hidden relations between the elements of an imagined reality... The quality or dimension of a form or of a colour suggests to me the designation or quality of an object.' In a free composition with white and black, for example, the white may be so modified as to become a piece of paper and the black a shadow. 'The painted object is merely a modification of pictorial relations that are already present.' Thus the course taken by Gris was

the exact opposite of that followed by all previous painters, who had derived the elements of their pictures from the elements of visible reality. Cézanne transformed a bottle into a cylinder. Gris begins with the cylinder and through the suggestion exerted by related proportions turns it into a bottle. He *discovers* the object. Consequently he never knows in advance what object is going to turn up in connection with his forms and proportions. 'Only as my own spectator do I draw the object from my picture. Until the picture is finished, I do not know exactly which modification it is that gives the picture its character.'

The object seems to be discovered accidentally. But in reality it is *re*-discovered. For even in his 'synthetic' pictures, Gris holds to his old iconography. The things he 'finds' are the simple, beloved, and thoroughly familiar things of experience. But in the ensemble of the picture they take on a new emblematic character. In the course of the checking and weighing which constitute the artistic act, objects rise of their own accord like symbols deeply engraved in remote strata of the memory. Step by step, artistic activity raises them to the pictorial consciousness as ideas which assert themselves so persistently that in time they become clearly visible. If we reflect on this emblematic character of Gris' thing-signs and the process by which they come into being, we shall realise that. his picture has a twofold function; it is a unique, newly created, independent thing – pure architecture of the mind; but at the same time it 'means' something – it is also an emblematic sign, communicating an emotion aroused by something in the world. The observer can identify the emblems contained in the picture with an object, in his imagination he can re-create the object with an ideal, formal perfection unattainable in a realistic representation. And so Gris' totally abstract conception takes on a representative value. This is what Gris calls 'humanising the mathematics, the abstract aspect of painting'.

If this 'humanisation' is to succeed, the architectural structure must be capable of sustaining the emblems. Only in the last phase of the work are the abstract coloured forms 'qualified' objectively. The germ of this idea was vaguely present in Gauguin as well as Cézanne. With Juan Gris it became fully conscious, and since then it has not been forgotten. His method of 'finding images' has survived; the Surrealists turned it to psychological purposes; for Paul Klee it was a way of achieving a picture that would be a 'metaphor for the totality of the cosmos'. Juan Gris was not the first to conceive the idea, but he was the first to formulate it clearly.

If we think back to Kandinsky and Marc, we see that Jean Gris' classicism is extremely Latin, Cartesian, un-Romantic. His pictorial architecture suggests mathematical formulas; it is not developed from a subjective experience of the world, nor from insight into the formative processes of nature. It is a classical architecture erected in the cool air of the pure spirit. Juan Gris shows the same cast of mind as Paul Valéry. But we have said the same of Matisse. We can only conclude that there is a common bond between two such seemingly different masters as Matisse and Gris. This common bond is what we call style in the broadest sense: the response of contemporary man to the contemporary world. Matisse and Gris – both attain to the tenuous point where the tension between the self and the outside world is transcended and the spirit, through artistic activity, evolves a picture that is a formula of balance. Human expression and visible reality interpenetrate, entering into a relationship which is substantiated in the exact organism – the intellectual formula – of the picture.

This was the French answer. But the Blaue Reiter takes its place in the same stylistic area. Its German members – Franz Marc, Paul Klee – employed a Romantic, cosmic feeling to transform the visible thing into expression, and so achieve a mystical identity with the universe. Freer and less attached to fixed forms, the Russian Kandinsky escaped altogether from this tension by denying the

world of things and built up a world of expression by a kind of musical synthesis. But it becomes clear that even this extreme position is rooted in the idea of a higher identity, for Kandinsky himself speaks of the 'comprehensive synthesis which will ultimately extend far beyond the confines of art to the "unity" of the "human" and the "divine"'. Plainly the Latin mind is motivated by reason, while the northern and eastern mind is driven by feeling and intuition.

## A Review of Developments on the Continent

If we look back over the way travelled thus far, the general direction becomes quite clear. It is the 'road inward'. We have left behind us the years of uncertainty and unrest, the years in which the necessity of departing from the familiar world of things had become painfully clear, but the new goal could be envisaged only in intimations and experiments. Before the astonished and enthusiastic eyes of the ensuing generation of painters a new realm has opened, a counterpart to visible reality: the world of human expression.

Enthusiasm for the new task has radically changed the psychology of the artist. The profound uncertainty of the preceding years had been reflected in the melancholy, elegiac personality of the artist. The new perspective produces a very different attitude on the part of the artist: radicalism, optimism, a sense of belonging to an élite, a joyful anticipation of the future, which seems near and attainable. And where fragments of the old human attitudes still survive, as in the Expressionism of the *Sturm* artists, their manifestations are no longer elegiac, but passionate and dramatic.

But radical as the change may be, its roots in the past cannot be overlooked. As we have said, there was one goal. But there were many paths leading to it. Two of these may be said to predominate. One starts from the position established by the work of Van Gogh, Gauguin, and the aesthetics of the Nabis and the Jugendstil. This is the path of expression, symbolic colour, and suggestive line. Beginning in 1905, great strides were taken along this path, in France by the Fauves, in Germany by the Expressionists. Their method: by a passionate assault upon the world of things to create within themselves an answering image; to sublimate visible reality in an imaginative counter-reality in which the objective forms of the outside world become symbols of the inner world. This expressive answer to outward impressions achieves pictorial form by intensive use of the new expressive elements, pure colour and pure line. With Matisse and the abstract painting of Kandinsky, this path achieves a first culmination. Matisse succeeds in resolving the duality of outside and inside into a harmony by the largely abstract, intellectual formula of his art; Kandinsky transcends visible reality entirely and employs the abstract forms as pure signs for the communications of psychic states. And in penetrating to the core of the personal and individual, he is certain of touching upon the universal, the 'One'.

The other path starts from the monumental art of Cézanne. This is the path of construction and pure form. It is followed – and here 1907 may be taken as the crucial year – by the French Cubists. They too attack the world of things. Their method: by strict formal analysis, to distil from visible things the constructive forms that make it possible to reconstruct the thing in its manifold totality and transform it into a formal element. Since in this transformative process the thing becomes a purely formal element, it now becomes possible and also logical to amplify the analytic method by a synthetic method, that is, to start from pure construction and from it develop formal emblems as signs of things. The organs of expression chiefly cultivated are geometric and algebraic proportions and the communicative values of abstract forms in space. Analytic Cubism culminates in the early

work of Picasso and Braque, Synthetic Cubism in the work of Juan Gris. In Synthetic Cubism, as in Matisse, the pictorial formula achieves an identity between the inner and outer worlds.

These two lines of development created between them a field of force which made possible another new perspective. The influence of the Gauguin tendency upon strict Cubism gave rise to Orphism, represented chiefly by Delaunay; a combination of the two lines resulted in Italian Futurism and the Blaue Reiter aesthetics. Here the expressive and constructive elements were brought equally into play; the underlying hope was that by a combination of the two it would be possible to delve back to the origins of Creation, whence the song of Orpheus arose.

Seen in this light, the words Expressionism, Cubism, and Orphism designate the essential positions achieved in the years between 1905 and 1914.

All arose from the same quest for pictorial expression of man's inner world. The painters of these years make their home in this 'second' reality and acknowledge the outside world only in so far as it is resurrected in the answering image of the mind.

The painter no longer looks outward to the 'motif', but inward to an emotion that strives to manifest itself in the picture. For this reason, the greatest importance is attached to the cultivation of form and colour. Formal invention replaces thematic invention. The picture becomes an independent organism, an architecture of coloured forms in a non-illusionist, non-perspective space that belongs exclusively to the picture. The painter is looked upon as a craftsman, whose trade it is to create an independent organism from pure elements. Only in the course of this work is the spiritual content set free. This active, theoretical cultivation of the pictorial elements led to the revival of an old Romantic notion, the idea of a 'thorough-bass' (that is, a theory of harmony) in painting, an idea which appealed at once to the speculative thinking of the Germans. Adolf Hoelzel spent his whole lifetime working on a theory of the harmony of coloured forms. On the basis of his formulations, Johannes Itten developed a new method of teaching art, no longer oriented towards reproducing things seen but towards representing an experience by means of coloured forms. In their teaching at the Bauhaus, Kandinsky and Klee tried to formulate the laws of form.

In this modified perspective, the picture has gradually become a sort of writing tablet on which the creative mind communicates its own inner experience. The reproduction of a mere visual experience is no longer regarded as a goal. Painting has been redefined as a means of lending visual reality to human expression.

These far-reaching developments were enacted on the European continent, in a dialogue among three countries: France, Germany, and Italy. England and America did not participate. It was only later, after a slow process of assimilation, that they began to put the new ideas into practice.

*England and the New Spirit*

The emergence of a modern artistic attitude in England went hand in hand with the acceptance and assimilation of the ideas which had led to new modes of expression on the European continent and particularly in France.

We have seen how at the end of the nineteenth century in England a small élite had developed, in life as well as art, a frankly exclusive form of aestheticism and a sensibility oriented towards refinement of line and form. This English aestheticism had helped to mould the continental Jugendstil, and even a personality as free and sensitive as Toulouse-Lautrec had been deeply influenced by it. Yet his own exhibition in London in 1898 was a total failure. This gives us an idea of the situation.

The élite which had made so deep an impact on the forward looking young men of Europe was extremely small and isolated. It made hardly a dent in the massive conservatism, puritanism, and moralism which were the dominant values in this hard, practical world of manufacturers, merchants colonisers, and seafarers. Nor had its members any desire to influence the society around them. Conscious of being an élite, they preferred the life-style of the dandy and the splendid isolation of the ivory tower.

In so far as English society was interested in art, it looked to its own tradition. There was the aristocratic painting of the eighteenth century, exemplified by Reynolds and Gainsborough, which now served as a justification for the flat academicism of the Royal Academy. And there was the noble and dreamy ideality of the Pre-Raphaelites, whose idealistic remoteness from the world commended them to Puritan circles. But there were also the sturdy realists who harked back to Hogarth, and on the pretext of moralising painted witty, satirical commentaries on contemporary society or cosy, sentimental scenes. A tradition of marine and landscape painting, unbroken since the eighteenth century, was carried on by a vast number of deft and gifted water-colourists. All this had served to create rigid visual conventions and to surround the image of reality with an elaborate iconography which obstructed new visual experience. Here was a situation that it would be very hard to change.

To be sure, there was Whistler. He had come to London from Paris in 1859 and had been in touch with his continental connections, particularly Manet and his circle. He had brought Fantin-Latour with him and in 1863 had persuaded Alphonse Legros to come to London. In 1876 Legros had been appointed director of the most advanced of the English art schools, the Slade School. These names throw light on Whistler's own development. For this uncommonly talented artist retained a secret penchant for painting in the grand style, for grandiose traditional décor, which he strove to make interesting with the help of ideas drawn from Far Eastern painting. All this prevented him from taking a truly creative attitude towards the new image of reality that was taking form in France. In this sense Whistler was strikingly close to the academic currents that were being superseded in France. He took up a position between Manet and Degas. With a sort of destructive pride, deeply rooted in his personality, he rejected the conclusions drawn by the Impressionists and subsequently by the phalanx of the Post-Impressionists. In England, to be sure, he passed as a champion of Impressionism and, with his supercilious modernism, willingly accepted this role. But what he meant by Impressionism was hardly more than the Degas of the middle period, and he showed a marked tendency towards a Romantic, naturalist murkiness. Be that as it may, Whistler opened the eyes of the English art world to the all-important experiments that were in progress in France. His haughty self-assurance and uncompromising attitude gave him an authority which did much to liberate the minds of English artists. It was he who introduced the new image of the artist to England.

Another important factor was the influence of the great English landscape painters of the early nineteenth century, Constable, Turner, and Bonington. Ever since they had come to the attention of French painters at the Paris Exposition of 1828 and contributed by their example to the development of the Barbizon school, they had been regarded by the French Impressionists as venerable precursors of their own optical experience. But in their own country the Romantic, lyrical atmosphere of their painting prevented people from discerning the novel visual experience it embodied. When the Glasgow school came into being in the eighties, it took up the Romantic component and intensified it to the point of sentimentality. The results were merely an English variant of the Naturlyrismus which, in the last two decades of the century, flourished in provincial circles all

146

over Europe. Here there was no room for the theories of the Impressionists and their direct, unsentimental approach to visual data. Thus it was not the Impressionists who set the tone — but Bastien-Lepage.

Yet further beneath the surface, still another factor was at work: the typically English propensity for literary themes and Romantic metaphors — this strangely surrealist element in English art and literature, which at the beginning of the nineteenth century found its characteristic expression in Blake. Blake was assuredly a great inventor of themes and figures, but from the formal point of view a poor draughtsman and still poorer painter. His work discloses a certain constitutional weakness in the English painting of the nineteenth century, namely, a preponderance of the thematic and literary element, to which the pictorial means employed proved unequal. What English painting lacked in this period when European culture was casting off the conceptions of the Renaissance was a hard, unprejudiced pictorial approach to reality, such as Géricault and Courbet had provided in France. And moreover, there was no one in England to do what Delacroix and Ingres had done in France, to explore the Renaissance and Baroque worlds seriously and constructively in search of serviceable ideas. This was what made it so hard for English artists to recognise the logic and historical necessity of French naturalism and Impressionism. And it was just this that made it so urgent that English art should come to grips with Impressionism.

If not for the commercial aspect of the matter, it would be almost touching to observe the efforts of the French Impressionists and their dealer Durand-Ruel to arouse the interest of the English public. French artists had not forgotten Constable and Turner. They deluded themselves into supposing that a country which had produced such artists must be prepared for their own painting. In July, 1868, Manet visited London and tried — in vain — to obtain an exhibition. During the war of 1870 Monet, Pissarro, and Sisley lived and painted in London. In 1891 Monet revisited London and painted a number of 'impressions of London'. He returned once again in the autumn of 1899. In December 1904 he painted his famous series of views of the Thames. Pissarro visited London in 1890 and in the same year his son Lucien, the painter, moved there for good. Camille Pissarro visited his son in 1892 and 1897. Sisley visited England at least four times between 1871 and 1897. From 1892 to 1898 Toulouse-Lautrec made frequent trips to England, met Oscar Wilde, and in 1895 was privileged to call on the great Whistler.

The exhibitions organised by Durand-Ruel in England might have been more effective than these personal meetings. At the end of 1870 he opened a gallery of his own in New Bond Street. In the next five years he put on no less than ten exhibitions, in which Manet and the Impressionists were represented. But in 1875 he closed his London gallery in discouragement. In 1882 and 1883, he rented galleries and tried, again in vain, to interest the English public in the Impressionists. He did not come back until 1905 when he showed a collection of 315 pictures, including a number of Cézannes, at the Grafton Gallery. But meanwhile people had begun to talk about Impressionism and the exhibition was successful. In 1895 Richard Muther's three-volume *History of Modern Painting*, describing the historical and aesthetic foundations of Impressionism, had appeared in English (the original German edition had been published in 1893). It was followed in 1903 by Camille Mauclair's *The French Impressionists* and in 1904 by Dewhurts's *Impressionist Painting*. The word Impressionism had become a kind of catchword.

Even so, it was still taken pejoratively in many quarters, and the situation was scarcely clarified by the foolish anecdotes related by such people as George Moore, who liked to boast of his personal relations with Manet and the Impressionists and served up a fearful mixture of truth and poetry in his *Reminiscences of the Impressionist Painters* (1906). In general, the English critics contributed

very little to the historical and aesthetic elucidation of Impressionism. It was only with Roger Fry that a creative and energetic critic came on the scene. But up to 1905 even he had no very well-defined attitude towards French Impressionism, though then he began to take in Cézanne.

Actually it was the artists themselves who made the new French ideas at home in England. We have spoken of Whistler. He himself lived between London and Paris and was on terms of friendship with Courbet, Manet and Degas. Though it was only in 1887 that he made up his mind to exhibit two Monets at the Royal Society of British Artists, of which he was president, he seems, in the last years of the century, to have become more and more clearly aware of the significance of the true Impressionists. In any event, he insisted on the inclusion of the French Impressionists and their successors in the annual exhibitions of the International Society of Sculptors, Painters and Graveurs over which he also presided. The first exhibition, held in 1898, included Cézanne as well as the Impressionists. Under Whistler's aegis, Impressionism entered the consciousness of the English art world.

Under his influence two young painters set out for Paris: Wilson Steer in 1882 and Walter Sickert in 1883. There both of them became acquainted with the Impressionists as well as Gauguin, though they themselves remained close to Degas. On their return to England after a long stay abroad they did much to stimulate the younger English artists. Meanwhile in 1884, John Singer Sargent had come to London after ten years of study in Paris, and in 1885, with a group of young painters, had founded the New English Art Club, which represented the most progressive tendencies in the English art world of the time. Actually these 'progressive tendencies' consisted in little more than a superficial adaptation of the new French painting techniques and brilliant colour into the traditional English landscape, portrait and genre painting. The examples looked up to were Manet, Degas, and as usual Bastien-Lepage.

The New English Art Club, which soon attracted a wide membership and consequently, as so often happens, succumbed to conventionalism, included a few rebellious spirits. They formed the group of the 'London Impressionists' who in 1889 put on their own exhibition at the Goupil Gallery. However, in Sickert's programmatic introduction to the catalogue, we find the advanced Impressionists, particularly Monet, treated with great reserve. Whistler and Degas are the great examples. This 'Impressionism' was actually a sketchy, attenuated realism, reminiscent of Constable and the Barbizon painters. And indeed, the personal development of Wilson Steer and Walter Sickert runs in just that direction. Steer started originally from Manet and arrived towards 1888 at an advanced Impressionism. In the early nineties, under the direct influence of the young Paris painters, he was still painting in a lively Impressionist style with Pointillist effects, suggestive of Monet and the later Pissarro. In the late nineties, however, he fell back into a traditional style and even the subject matter of his work of this period recalls Gainsborough and Constable. Only towards 1905 did he return to an Impressionist manner, but even then he retained a Romantic, realistic undertone and the conventional elements of the English school. Sickert for his part had returned as early as 1895 to a dark, heavy style of painting characterised by simple construction and lively brushwork, but the intention remained quite realistic. No doubt the influence of Degas and the contemporary Dutch painters was at work, but the result was a petty bourgeois realism relieved by Impressionist methods.

This then was the situation in 1905 when Durand-Ruel put on his big Impressionist exhibition. It accounts for the satisfactory though not overwhelming reception accorded the French Impressionists on this occasion.

Meanwhile, however, the development on the continent had continued: Neo-Impressionism, Post-Impressionism, Seurat, Cézanne, Van Gogh. This was bound to produce its effects in English circles. As early as 1902 the first faint influence of Gauguin can be noted in Augustus John. In 1894 Robert Bevan had met Gauguin at Pont-Aven and now proceeded, though timidly, to integrate Synthetism into his naturalistic painting. In 1905 Spencer Gore had gone to Paris to study the Gauguin exhibition. At about the same time Charles Ginner and Harold Gilman had independently discovered Gauguin and Van Gogh.

At this time – 1905 – Walter Sickert, who had spent the preceding years in Dieppe and Venice and knew France well, returned to London for good. He was then forty-five years of age. He himself had frequented the circle of Whistler and Degas, knew Impressionism, and had sufficient authority to attract restless young spirits. His studio in Fitzroy Street, Camden Town, became the meeting place of the young men who looked to France. The first to come were the two friends Harold Gilman and Spencer Gore, soon followed by Lucien Pissarro, who of course had the closest connections with French painting. This group of painters with their following of artists and art lovers met each week at Sickert's and introduced a breath of the bohemianism of Paris to the working- and lower middle-class drabness of Camden Town. Soon they were joined by other kindred spirits: Augustus John, Henry Lamb, J. B. Manson, who had just returned from Paris, and a little later by Robert Bevan, Walter Bayes, Charles Ginner, who had also travelled in France. The critic Frank Rutter soon began to attend the meetings of the group, and it was he who thought of organising annual exhibitions of independent progressive painters, on the style of the Paris Salon des Indépendants. For the Royal Academy had long become meaningless for the artistic development of the country and the New English Art Club, founded as a protest against it, had itself become reactionary. Thus there arose the Allied Artists Association, which held the first of its annual exhibitions at the Albert Hall in 1908. The qualities aimed at in these exhibitions were 'simplicity, sincerity, expression', as Frank Rutter put it, words which at that time were in circulation all over Europe and prepared the way not only for the Naturlyrismus of those years but also for Cézanne, Gauguin, and Van Gogh.

But in 1911 in order to express these ideas more clearly than had been possible in an organisation whose sole purpose was to arrange exhibitions, Sickert and his circle formed an association which at Sickert's suggestion called itself the Camden Town Group. Spencer Gore was chosen president. The group consisted of sixteen artists. Aside from those already mentioned it included: Malcolm Drummond, Duncan Grant, James Innes, Wyndham Lewis, M. G. Lightfoot, William Ratcliffe. The oldest (Sickert and Pissarro) were fifty-one and forty-eight years of age; the youngest (Innes and Lightfoot) were twenty-four and twenty-five. Most were in their thirties. In June and December of 1911 the first two exhibitions were held at the Carfax Gallery. A third was held in 1912. Thereafter the Carfax Gallery continued to give some of the group members an occasional one-man show, but declined to put on group exhibitions. Accordingly the Camden Town Group made contact with a number of smaller groups and in November 1913 merged with them to form the London Group, of which Harold Gilman became president. Towards the end of 1913, the new group organised an exhibition in Brighton. The posters still bore the name of the Camden Town Group, but this was the end of its independent existence. The London Group survived for many years as an association of the more advanced artists.

It would be a mistake to regard the members of the Camden Town Group as revolutionaries after the manner of the French Fauves or the German Brücke painters. Their orientation was still towards

realism. Yet they rejected genre painting and anecdote and strove for a spontaneous grasp of reality. Camden Town with its working people and small shopkeepers, its oddities and eccentrics, its hideous architecture, its picturesque cabs and urban bustle – this was the setting they strove to grasp. Thus their very subject matter implied opposition to academic idealism or dreamy Romanticism. From the Impressionists these English painters learned to open their eyes to the world; they adopted the Impressionist technique of direct painting, but the bright colour and the Impressionists' theoretical approach to colour had no appeal for them. Their work tended to murkiness and remained too close to the realistic description of objects. They strove for a firmer, 'more solid' pictorial structure. The freedom of their imagination was often hampered by these considerations of composition, which sometimes led them to adopt old academic recipes. But on the other side, concern with pictorial structure opened their eyes to Cézanne's firm construction and Gauguin's flat décor.

For once these painters had achieved a certain freedom of sensibility, all sorts of influences began gradually to make themselves felt. Their minds opened not only to Gauguin and Cézanne, but also to Van Gogh and the Neo-Impressionists, concerning whom Lucien Pissarro was in a position to supply a good deal of authentic information. Gore looked to Cézanne, Bevan to Gauguin, Gilman to Van Gogh, and each attempted somehow to integrate his new insights with his own naturalist view of reality. The works of the modern Frenchmen began to make their way into some of the private galleries. In 1908 the New Gallery showed Cézanne, Gauguin, and Matisse. Soon – 1912-13 – an attenuated Fauvism and the first attempts at Cubism made their appearance. The artists of the Camden Town Group are quite representative of the situation between 1905 and 1913; their work reflects the incursion – almost simultaneously – of Impressionism and Post-Impressionism and then, in rapid succession, of Fauvism, Cubism and Futurism. To be sure, their reactions were timid and confused, they lacked a precise knowledge of the motivations underlying the events in France. But these artists created a climate favourable to a serious participation in the revolutionary transformation that was taking place in man's consciousness of reality.

Meanwhile the star witnesses to this transformation had been introduced to the English art world in an impressive exhibition. In 1910 Roger Fry conceived the plan of a comprehensive exhibition of the French Post-Impressionists. The leading French dealers – Bernheim Jeune, Drouet, Kahnweiler, Kahn, Sagot, and Vollard – were only too glad to co-operate. The result was an exihibition of some 150 works, many of them masterpieces, which ran from November 8, 1910 to January 15, 1911 at the Crafton Galleries. It bore the title: 'Manet and the Post-Impressionists'.

The keynote was struck by eight Manets, including his most daring masterpiece, *Un bar aux Folies-Bergère*. The Impressionists were absent. The accent was entirely on those masters who, starting from Impressionism, had achieved a break-through in the direction of 'construction' and 'expression', that is, on Cézanne, Gauguin, and Van Gogh. There were no less than 37 Gauguins, including such markedly Symbolist works as *L'esprit veille* and *L'esprit du mal*. This predilection of Gauguin was no doubt characteristic of English taste. Just as Degas had been regarded as the Impressionist *par excellence*, so now Gauguin was held to be the prime representative of Post-Impressionism. Next came 21 Cézannes, including some landscapes of Estaque and Mont Victoire. There were 20 Van Goghs, including *Le Jardin Daubigny* and *La Berceuse*. This impressive foundation, which in itself made up half the exhibition, was followed by the various groups that had flourished in the preceding two decades in France. The Symbolists – Redon, Denis, Sérusier, Girieud – were represented by 16 canvases. The accent was on Denis and Girieud, in other words, on the most Symbolist and naïve interpretation of Gauguin. The Neo-Impressionists – Signac,

Seurat, Cross – had only seven pictures. A prominent position was accorded the Fauves and their following – Matisse, Marquet, Vlaminck, Derain, Rouault, Friesz, Manguin, Puy, Valtat, Laprade, Herbin, Valloton: 39 paintings in all, with the accent on Vlaminck and Rouault. Only two of Matisse's paintings were shown, but no less than seven of his bronzes. There were only two Picassos, the early *Nude with basket of flowers*, loaned by Leo Stein, and the early Cubist *Portrait de Monsieur Sagot*.

When we consider the exhibition as a whole, the 'Expressionist' tendency is quite clear. Indeed, Roger Fry had seriously considered replacing the vague word 'Post-Impressionism' in the title by the more precise 'Expressionism', which was just then gaining wide currency. Gauguin, Van Gogh, and their successors down to the young Fauves set the dominant note with the boldness of their décor and the sharp brilliance of their colour. It was this marked bias that explains why the Cubists were not yet represented and why there were only two, relatively unimportant, canvases by the great Seurat. Fry soon recognised and made good the deficiency. In any event the work of Cézanne stood there like a beacon.

The impact of the exhibition was enormous. True, the artists of the New English Art Club, even Steer and Sickert, were quite critical of the direction taken by the new French art. But the ice was broken and from then on it was no longer possible to ignore the great Post-Impressionist masters. Another factor contributing to this development was the appearance in 1908 of the English edition of Meier-Graefe's epoch-making *History of Modern Art*, which made the historical position and aesthetic ideas of Cézanne, Gauguin, and Van Gogh clear to the English art world. And Roger Fry, in his writings on modern art, disclosed a critical and intellectual stature that had been unequalled by any English writer on art since Ruskin. Fry and Frank Rutter became the spokesmen of the modern movement. The new saints were Cézanne and Gauguin. Some of the independent galleries were caught up in the current. In November, 1911 the Stafford Gallery held an exhibition of Gauguin and Cézanne, and in April, 1912 gave Picasso his first English one-man show, which to be sure was limited to the works of his pre-Cubist period.

From October 5 to December 31, 1912 Roger Fry held his 'Second Post-Impressionist Exhibition' at the Grafton Galleries. Now the accent was placed on the younger contemporaries and an attempt was made to indicate the international range of the modern movement. Clive Bell put together an English group. The painter Boris Anrep assembled a Russian group emphasising Russian folklore, the Byzantine element, and the icon, and including among names now forgotten Larionov, Goncharova, and Ciurlionis. Fry himself selected the French group.

While Manet had set the keynote in the first exhibition, this time it was Cézanne with a group of water-colours. Fauvism and Cubism were the centres of attraction. The two leading masters – Matisse and Picasso – were amply and significantly represented. There were 20 Matisse canvases representing all his periods, and six bronzes; Picasso showed thirteen paintings including important Cubist works. Round this nucleus the younger painters were grouped: the former Fauves Derain, Vlaminck, Friesz, Van Dongen, Puy, Marquet, some of whom had already gone over to Cézannism or Cubism. Bonnard made his appearance. Braque was represented with four Fauvist pictures and one Cubist work, and other Cubist works were contributed by Herbin, Lhote, and Marchand. The tone of the exhibition was in keeping with the keynote set by Cézanne: the 'Expressionist' aspect was somewhat reduced and the 'constructive' accentuated. The conception of self-sufficient, 'significant form', which implicitly included abstraction, was distinctly stressed at the expense of Romantic and Expressionist currents. Accordingly, the Symbolists and even Rouault were excluded.

This exhibition gave rise to a good deal of controversy, which proved fruitful, for it helped to

crystallise out the names that would serve as guides and models in the ensuing period: Cézanne, Gauguin, Matisse, and Picasso. The opposition on the part of the artists in and around the New English Art Club was undiminished, but a kind of secession was clearly in the offing. In the English section which contained over thirty pictures, Clive Bell had included Duncan Grant, Etchells, Roger Fry, Lamb, Lewis, Gore and Spencer. We have encountered most of these artists in the Camden Town Group. They were hardly revolutionaries. Most of them stopped at a cautious Cézannism; some, in respect of composition and colour, were groping their way towards Gauguin and the Fauves. Nevertheless, it is clear that the new pictorial ideas were becoming a ferment in English art.

### Vorticists and Other Rebels

In this group there was a young man, then twenty-eight years of age, who was endowed with a keen intelligence and an aggressive polemical spirit; moreover, he was a brilliant writer. This was Wyndham Lewis. After studying art at the Slade School, he had studied and travelled in Europe from 1902 to 1908. In 1911 he had joined the Camden Town Group where he had created a good deal of disturbance and formed a kind of opposition group. By the end of 1912 he was experimenting in the direction of a Cubo-Futurism with a distinct tendency towards geometrical abstraction. He was not alone. For in the meanwhile Marinetti and his Italian Futurists had been active in England. In 1910 Marinetti had turned up in London for the first time and in March 1912 the Sackville Gallery presented works by the entire troupe of Italian Futurists. Marinetti appeared in person and with a few faithful followers unleashed the whole repertory of Futurist publicity with the usual manifestoes, provocations, etc., obtaining the desired *succès de scandale*. It was inevitable that the rebellious Lewis should turn to Futurism. In April 1913 Gino Severini exhibited at the Marlborough Gallery. In that year Lewis comported himself like a pure Futurist. He found a kindred spirit in C. R. W. Nevinson, five years his junior, who had been in Paris in 1911 and 1912, had met Picasso and been converted to Cubism from his initial Cézannism. After meeting the Futurists he became an orthodox Futurist — more orthodox than Lewis, whose Cubist and abstract experience left him with certain misgivings about the 'naturalism' of the Futurists. In 1913 Nevinson made friends with Severini and also met Lewis. In the same year other artists had established themselves in the field between Cubism and Futurism. There was William Roberts, who in 1913 had visited Italy and Paris and was now practising a curious sort of Cubo-Futurism, clearly influenced by Léger's abstract figure painting. David Bomberg and Edward Wadsworth were working in a similar direction. All were at first associated with Roger Fry, whose criticism set the tone in those years, and worked in the 'Omega Workshops' which Fry, faithful to the tradition inaugurated by William Morris, had organised as modern arts-and-crafts communities. But Fry had no true sympathy for Cubism and Futurism; he held with Cézanne and Matisse. Tensions arose, which were exacerbated by Lewis who, as early as 1913, broke with the Omega Workshops to form the Rebel Art Centre, an enterprise that would hardly be worth mentioning except that it gives an idea of the prevailing spirit of revolt. The critic who took this Cubo-Futurist, abstract movement under his wing was T. E. Hulme in *The New Age*. Frank Rutter also felt impelled to make certain crucial corrections in the aesthetic programme which Roger Fry had laid down with his second Post-Impressionist Exhibition. In the autumn of 1913, he organised at the Doré Gallery an exhibition which he entitled: 'Post-Impressionist and

Futurist Exhibition'. Picasso's Cubism was represented by photographs of his latest works; Orphism was introduced with works by Delaunay; Severini represented Futurism; and German Expressionism made its appearance with Nolde, Pechstein, and Franz Marc. The English group included the most daring painters of the Camden Town Group – Bevan, Gilman, Ginner, Gore, Sickert, and in addition the English Cubo-Futurists, Lewis, Wadsworth, Hamilton, Etchells, and Nevinson. Marinetti himself had come to London, and spoke at a meeting expressly organised for him.

These English painters were now the nucleus of the London Group which in November 1913 had formed round the Camden Town Group. At the above-mentioned exhibition held in Brighton from November 1913 to January 14, 1914, the name of the Camden Town Group figured for one last time in the main title. But the sub-title already disclosed a characteristic broadening: 'An Exhibition of the Work of English Post-Impressionists, Cubists, and Others'. Actually the work of Lewis and his companions was hung separately in a special 'Cubist Room'. In the preface to the catalogue Lewis suggested 'Futurism' as a more suitable overall designation. On this score he was soon to change his mind.

In 1914 Marinetti had made two more trips to England with a view to beating his Futurist drum. On both occasions he had delivered explosive lectures at the Doré Gallery. But that was not enough for him. On his first visit he had sat down with Nevinson and concocted a Futurist manifesto entitled 'Vital English Art'; it appeared in the form of a leaflet which Marinetti, proud of his new English organisation, immediately had reprinted in the Florentine magazine *Lacerba*. The manifesto contained the usual Futurist tirades against tradition, conservatism, academicism, aestheticism, etc., and achieved a certain local colour by striking out also at the Pre-Raphaelites, the New English Art Club, the King and the Government, the English conception of art, and the 'Post-Rossettis with long hair'. It demanded 'an English art that is strong, virile, and anti-sentimental' and insisted on 'desire of adventure, instinct of discovery, worship of strength'. It bore the following signatures: Atkinson, Bomberg, Epstein, Etchells, Hamilton, Nevinson, Roberts, Wadsworth, Lewis. But apparently Marinetti, faithful to his ways, had neglected to consult these signatories and merely assumed their willingness to sign. In any event Lewis and his friends Hulme, Wadsworth, and the important sculptur Gaudier-Brzeska (who not long after was killed in the war) created a disturbance at Marinetti's second lecture. The outcome was a new manifesto, written by Lewis and sharply attacking 'Vital English Art'. This was the 'Vorticist Manifesto'.

The term 'Vorticism' was the invention of Lewis's friend Ezra Pound. The actual aims of Vorticism are hard to define. The word was meant to suggest suction, whirlpool, maelstrom, a state of exaltation, spiritual daring, aggressive intellectual action. All this of course was close to Futurism and Lewis had considerable difficulty in pointing up the distinction between his movement and Futurism. In retrospect he has tried to define Vorticism: 'Vorticism', he wrote in 1956, 'was dogmatically anti-real. It was my ultimate aim to exclude from painting the everyday visual real altogether. The idea was to build up a visual language as abstract as music... Another thing to remember is that I considered the world of machinery as real to us as nature's forms, and that machine-forms had an equal right to exist in our canvases.'

To gain support for these ideas Lewis and Pound decided to issue a magazine. The result was large, sumptuous and flamboyant. There were the usual Futurist typographical inventions but the general effect was harsher and in some way more 'English'. The title page, which would attract attention even today, bore in gigantic letters the word 'BLAST'. The sub-title read: 'Review of the Great English Vortex'. No. 1 appeared on June 20, 1914.

It begins with a manifesto announcing the birth of the new movement. This document has the

usual explosive tone suggestive of the Futurist manifestoes or the Expressionist *Sturm*. But in it we find ideas that were new to the pictorial thinking of the time and extend far beyond painting. For example: 'We need the Unconsciousness of humanity – their stupidity, animalism, and dreams... We do not want to change the appearance of the world, because we are not Naturalists, Impressionists, or Futurists (the latest form of Impressionism), and do not depend on the appearance of the world for our art. We only want the World to live, and to feel its crude energy flowing through us... The Art instinct is permanently primitive... In a chaos of imperfection, discord, etc., it finds the same stimulus as in Nature. The artist of the modern movement is a savage (in no sense an 'advanced', perfected, democratic, Futurist individual of Mr. Marinetti's limited imagination): 'this enormous, jangling, journalistic, fairy desert of modern life serves him as Nature did more technically primitive man.' The manifesto goes on to sing the praises of the Nordic, English spirit: '...a mysticism, madness, and delicacy peculiar to the North... Tragic humour is the birth-right of the North... Any great Northern Art will partake of this insidious and volcanic chaos... In dress, manners, mechanical inventions, LIFE, that is, ENGLAND, has influenced Europe in the same way that France has in Art.' It seems safe to assume that these ideas about strong, primitive, unconscious life as the primal source of art originated with Ezra Pound, for in a contribution entitled 'Vortex-Pound' we find the same exaltation of the primitive and primordial.

We gain an idea of the intellectual appeal of the Vorticist movement from the fact that the three giants of modern English literature – Pound, Joyce, and Eliot – were all connected with it. In 1915 Pound introduced Lewis to T. S. Eliot, and in the second and last number of *BLAST* (July 1915) a number of Eliot's poems appeared. In 1921 Lewis and Eliot, again through Pound, met James Joyce in Paris. Lewis himself, apart from his art criticism and polemics, was a prolific writer of novels and short stories. Here we cannot speak of his significance as a writer. Suffice it to say that Pound and Eliot held him in high esteem.

It is evident that these ideas about the role of the primordial and unconscious in art implied abstraction. And indeed, *BLAST* carried an excerpt from Kandinsky's *On the Spiritual in Art*. At the same time, the editors recognised the urgency of modern technological existence and its new sensations. It was no easy matter to correlate this notion of modern experience with the artistic movements of the time and to classify them on this basis. Lewis attempted to do so in the second number of *BLAST*. He begins by identifying the most important contemporary movements as: Cubism, represented by Picasso; Futurism, represented by Balla, Severini, and Boccioni; Expressionism, represented by Kandinsky. Then he proceeds to criticise these movements. Cubism: he objects to its static quality and concern for 'good taste'; Futurism: he finds fault with its naturalism and preoccupation with propaganda (In the 'Vorticist Manifesto' he had already written: 'The Futurist is a sensational and sentimental mixture of the aesthete of 1890 and the realist of 1870'); as to Kandinsky's Expressionism, he deplores its lyrical, 'cloud-like' quality. Thus he acknowledged the formal accomplishments of Cubism, Futurism, and Abstract Expressionism. But he held that they should be made to express the dynamic sensations of contemporary existence and the answering images arising from the largely unconscious, primordial strata of the *élan vital*. And this, he believed, must be done by means of a direct pictorial language, freed from all a priori rules of taste, stripped of lyricism and description – hence in an abstract idiom.

The 'Vorticist Manifesto' bears the following signatures: Aldington, Arbuthnot, Atkinson, Gaudier-Brzeska, Dismorr, Hamilton, Pound, Roberts, Sanders, Wadsworth, Lewis. Most of these names are forgotten today. The reproductions contained in *BLAST* of drawings by Lewis, Roberts, Etchells,

and Wadsworth are rather disappointing and the surviving paintings of the Vorticists are hardly better. They are rigorously geometrical abstractions with the accent on dynamic contrasts and tensions, Futurist in conception, though farther removed from any objective motif. In any case, they bear witness to a sad lack of artistic genius.

But this applies to the whole situation in England. Let us recapitulate the historical development and the positions attained: towards 1890 Pre-Raphaelite painting achieved a last flowering in Burne-Jones and then, in the course of the nineties, turned into an intense aestheticism whose most characteristic representative was Aubrey Beardsley. This tendency was offset by the widespread 'plein-air' movement and the first influences of French Impressionism as represented by the Glasgow school and the circle of artists round the New English Art Club. Towards 1900 the aesthetes were submerged by the rising Impressionist movement led by Sickert and Steer. Whistler in his late period still maintained a synthesis between aesthetic and Impressionist elements. The years up to 1910 were characterised by the spread of plein-airism. The realistic Impressionism of Sickert and Steer gained steadily in importance. Concomitantly, the influence of French Impressionism grew, bearing the masters of French Post-Impressionism – Cézanne, Gauguin, Van Gogh – in its wake. With the two Post-Impressionist Exhibitions of 1910 and 1912, their hour had struck in England. Now English art underwent a decisive change. The influence of the modern French school became paramount. Cézanne, Gauguin, and Matisse were taken as models and guides. And now – beginning approximately in 1912 – the radical new stylistic movements of the continent began to make their influence felt: Cubism, Futurism, Expressionism. Nevinson became the lone banner bearer of English Futurism. Lewis and his Vorticists attempted to synthetise the formal inventions of Cubism, Fauvism, and Abstract Expressionism and from them develop an autonomous British art. On June 10, 1915 the Vorticists held their one and only exhibition at the Doré Galleries. But then came the War and the various ideas of which we have been speaking were nipped in the bud.

It must be said that English art was lacking in great and significant talents in this period of crucial stylistic change. Yet much was accomplished. England had been drawn into the dialogue concerning the new definition of reality. The result was a new spiritual climate which would favour the future development of the new trends in England.

*The Situation in the U.S.A. and the 'Ash Can School'*

The rise of modern painting in the United States is in many ways comparable to the development in England. In England, as we have seen, Sickert and his circle campaigned against the Academy with a realistic art tempered by Impressionism. In America Robert Henri and his group employed similar methods to break the domination of the academies of New York, Chicago, Boston, and Philadelphia.

The first revolutionary cell formed in Philadelphia. In 1891 Robert Henri had come home from Europe, imbued with ideas of realism and social reform: a painting that sprang directly from life could in turn influence the lives of men. This ethical attitude towards painting had come to Henri in France. As we look back today, it seems obvious that the future belonged to the line running from Courbet by way of the Impressionists to the Post-Impressionist masters. But this could hardly be evident to a young foreigner who visited France in the eighties. Far more conspicuous in the Paris scene of the time was the movement intent on mastering social reality. Its spokesman was Zola. The artists of this tendency looked to the dramatic eloquence of Daumier, Géricault,

and Millet, to the mordant aggressiveness of the early Manet, while surveying the past they redis-covered the achievement of Goya, Velasquez, and Franz Hals. In this atmosphere of social criticism, a number of important graphic artists – Daumier, Gavarni, Guys, Steinlen – had turned to the new media of mass communication, the newspapers, the reviews, the humourous magazines. Their talent and moral earnestness had given their journalistic drawings the ring of great art. Their impact on the public was incomparably greater than that of any picture on exhibition. Beside this art of social reform, the painting of the Impressionists may have struck a good many observers as sheer escapism; from this point of view, their formal investigations could be justified only by the discovery of suitable means of dramatising current events.

These were the ideas that Robert Henri brought home with him to Philadelphia. They were dia-metrically opposed to academic art with its determination to veil and idealise reality, but they coincided with the requirements of the reform movement provoked by the new social realities: headlong industrialisation, mass production, the rise of the trusts and monopolies. In view of this development, extensive reforms were required to protect the working people. It was a time of social tension in which the shaping of public opinion took on an unprecedented importance. News-papers and magazines sprang up on all sides, and with them new methods of reportage and new techniques of reproduction. From this newspaper world with its passion for contemporary reality, came the great realists of American literature – Theodore Dreiser, Sherwood Anderson, Sinclair Lewis – and also the first realistic painters, preoccupied with social reality and its problems. The group that gathered round Henri was made up of reporter-artists.

Their names were William Glackens, George Luks, Everett Shinn, and John Sloan. Young men, just over twenty, they found a kind of spiritual mentor in Robert Henri who was a few years older than themselves. Henri convinced them that the painter was under a moral obligation to give artistic expression to contemporary life; and he provided them with new models, calling their attention to painters who had already found an artistic form in which to express a forthright, unclouded view of contemporary life: Goya and Daumier, Manet and Degas, and most particularly the French graphic artists from Gavarni, Guys, Steinlen and Forain to Toulouse-Lautrec, who were bound to arouse the professional interest of these journalistic artists. By attracting their attention to these models, Henri was able to imbue his friends with a new artistic spirit. From newspaper cartoonists they became artists inspired by conscious artistic intentions.

The few years Henri spent in Philadelphia were only a prologue. New York became the centre of artistic events. In the middle nineties Henri went back to Europe and returned to the U.S.A. in 1899 to settle in New York. Glackens and Luks were already there; Shinn arrived in 1900 and Sloan in 1904. In those years Henri, who had remarkable pedagogic gifts, became the teacher of the younger generation of New York painters. From 1903 to 1907 he taught at the New York School of Art. In 1907 he opened an art school of his own and in 1912 he took over a class at the Art Students League. He and his friends now created a new artistic climate, which provided young painters such as George Bellows and Edward Hopper with their first ideas on art, but was helpful also to artists who were to develop in an entirely different direction, such as Stuart Davis, Arthur Dove, or Joseph Stella. The group of friends from Philadelphia were joined by a few New York painters who had independently arrived at similar views: Jerome Myers, who had found his subject matter in the deeply human scenes he had witnessed in the slums of Manhattan; Eugene Higgins, who in 1904 had returned from Paris and now began, with a heavy, monumental line learned from Daumier and Steinlen, to portray the desperate misery of the urban poor in pictures with faint Symbolist overtones. This interest in the poor and commonplace, in the New York slums where

from the standpoint of academic idealism only ugliness was to be discovered, soon brought these painters the nickname of 'Ash Can School'. But actually they did not accuse; their pictures of misery were without moral intent. Politically, to be sure, they were far to the left; Henri was a humanitarian Anarchist. Sloan a staunch Socialist. With the founding of *The Masses* (1911), an illustrated Socialist magazine, to which Sloan, Bellows, Stuart Davis, etc., contributed drawings, it may have seemed as though the whole group were becoming engulfed in politics. But as painters they were far too much interested in the discovery of the New York scene with its motley human mixtures, too much in love with their subject matter to make use of it for purposes of political agitation.

The artistic bohemians had settled in Greenwich Village in lower Manhattan. In this neighbourhood they made their home, breathing poetry into it, and in large measure creating it. Memories of life in Montmartre played a part. Like the English painters of Camden Town, the Greenwich Village painters modelled their picture of life on bohemian Paris. But there was a fundamental difference. Unlike his French counterpart, the American artist was a foreign body in American society, a kind of outcast. The few isolated members of the upper classes who were interested in art looked entirely to Paris and were quite prepared to accept contemporary French developments. French Impressionism had been taken up far earlier and on a far wider scale by American collectors than was the case in England. But American artists enjoyed small credit. They were obliged to create an environment, a society of their own, and this they did in an impoverished, richly variegated corner of the great New York melting-pot. They became a part of their neighbourhood and there they discovered the poetry of the poor people of New York, of America.

Thus the painters of Greenwich Village accomplished in their own field something similar to what the literary bohemia of Chicago – Dreiser, Anderson, Lewis – had done in the new realistic novel. They made the life and environment of the American common man a fit subject for art. This they were able to do only by identifying themselves with their surroundings, an identification from which they derived a new love and a new pride. The theme of the 'American Scene' called for an 'American' mode of expression. The Ash Can School conceived the desire to feel and to paint not only in a contemporary, but also in an American way. Animated by this sense of purpose, they soon resolved to gain access to the public by arranging art shows on a new basis.

From the formal standpoint, to be sure, this painting did not differ greatly from the Impressionist realism that could be encountered all over Europe in those years. Henri painted his city scenes with dark, smoky colours, but with the succinct, summarising brushstroke of the Impressionists, and in his portraits he was largely inspired by the early Manet. Everett Shinn in his vaudeville scenes followed Degas. George Luks followed Manet but was also influenced to some extent by the Munich school of Leibl, particularly in his figure paintings and representations of street types. William Glackens, in his café scenes, first followed the Impressionist Manet and in 1910 fell wholly under the influence of Renoir. John Sloan, the most powerful of the whole group, used the sharp light effects and the precise abbreviations of the Impressionists in the street scenes and figure motifs in which he brilliantly captured the lower middle-class atmosphere of his surroundings. He never let the joy of painting blind him to the poetic content and mood of his subject. If we compare the production of the Ash Can School with that of the academic genre painters or timid Impressionists who had begun to emerge in America since the great Impressionist Exhibition of 1886, we observe that their determination to master American reality gives their pictures a distinct tone and an unmistakably American accent.

The new American realists now demanded public recognition, agitating against the academies and

their system of exhibitions selected by reactionary juries and – once again following the European tactics – insisting on free exhibitions without juries. In 1907 the Academy rejected the paintings submitted by Luks. The Henri group responded with an exhibition of its own which was held in January 1908 at the National Arts Club. The same year witnessed the famous exhibition of the 'Eight', where for the first time the leading artists of the new school – Arthur Davies, Ernest Lawson, and Maurice Prendergast in addition to the five painters of the Henri group – presented their work to the New York public. Davies was a man of fine sensibility, who followed the modern developments in Europe attentively, but himself painted in a strangely intricate, esoteric style, based on Puvis de Chavannes and Odilon Redon. Later he came for a time to a decorative Cubism. Lawson was a robust Impressionist. Prendergast had spent a few years in France in the middle nineties, and had early discovered Cézanne and the leading Nabis, Denis, Vuillard, Bonnard, who were just then emerging. These were his mentors. Taking city park scenes as his subject matter, he developed a luminous carpet-like décor on a dense coloured surface suggestive of Bonnard.

Thus the first Post-Impressionist ideas were already at work side by side with the realist Impressionism of the Henri group. If in addition we consider the young George Bellows, a pupil of Henri, who was attracting considerable attention with pictures of boxing matches in a dynamic narrative style, we shall have a general idea of the situation in New York at that time. In the first Independent Artists' Exhibition, held in April 1910, these artists appeared before the general public. There was no jury and the artists were free to select their own contributions. The authority of the Academy was at an end. It was these independent artists with a strong sense of their American background who first conceived the idea of an exhibition comprising all the more advanced American artists. The outcome was the famous Armory Show that was to turn out quite differently from what they had expected.

For the Ash Can School was far from representing the whole range of revolutionary ideas that had meanwhile come over from Europe in the wake of Post-Impressionism. In the light of the general development it was a mere beginning, occupying a position comparable to that of the group round Sickert or Steer in England or Slevogt or Corinth in Germany. It was only now that America began to feel the full impact of the new ideas.

*'291' and the Propagation of the New Ideas*

A few of the American painters who had studied in Paris during the crucial years from 1905 to 1910 had already felt the influence of the new ideas. Leo and Gertrude Stein had made friends with Matisse and Picasso and built up a sizeable collection of their works. In their circle it was not difficult to establish personal and artistic contact with the new movements. But in New York there was also a small group that kept in touch with the developments in Paris. This was the group formed by Alfred Stieglitz.

In 1902 Stieglitz, one of the pioneers of modern photography, had with his friend Edward Steichen founded 'Photo Secession', an association of modern photographers. In 1905 he had opened the Photo Secession Gallery at 291 Fifth Avenue with a view to holding exhibitions of modern photography. Stieglitz was a man of lively perception, intensely interested in everything that was new and revolutionary. An extreme individualist, he saw the artist as an aristocrat who looked down on the common herd. And through his circle this image of the 'artist' as the lone visionary, proudly conscious of his mission to combat the sluggish obtuseness of the masses, made its appearance in

democratic America. It was this self-stylisation which gave the modern artist the strength to assert himself and his work against the incomprehension of his contemporaries.

Stieglitz had made the acquaintance of Gertrude Stein in Paris in 1907 and had become enthusiastic over Rodin, Matisse, Toulouse-Lautrec, Cézanne, and Rousseau. He began to show works of art at his gallery. In January, 1908, he held an exhibition of Rodin's drawings, and in April of the following year a small Matisse show. In December, 1909, he showed Toulouse-Lautrec and in 1910, Rodin. In the same year he held a small memorial exhibition of Rousseau and showed some Cézane lithographs. In March 1911 there were Cézanne water-colours and in April some Cubist drawings and water-colours by Picasso. In 1912 he showed Matisse's sculpture. In March 1913, during the Armory Show, he held an exhibition of Picabia. With the Armory Show all the European movements were for the first time set before the American public on a large scale. This vast exhibition showed how much the tiny '291' Gallery had accomplished with its often ridiculed pioneer work. Arthur Davies, one of the guiding spirits of the Armory Show, was an assiduous visitor to the Gallery. '291' and the agitation carried on by Stieglitz's magazine *Camera Work* in connection with the exhibitions had opened the eyes of the American avant-garde to the new developments.

Stieglitz now sought to form a group of those young American painters who were attracted to the new ideas. Nearly all of them had come by their experience in Paris, where many had lived for years. Alfred Maurer had first studied in Paris in 1897; he had lived there from 1902 to 1909 and thereafter divided his time between Paris and New York until 1914. Charles Demuth had gone to Paris in 1904, spent 1907 and 1908 in Paris, London and Berlin, and worked in Paris again from 1912 to 1914. Max Weber lived in Paris from 1905 to 1909, met Delaunay and Rousseau, and entered Matisse's school in 1908. John Marin lived in Paris from 1905 to 1909 and spent 1910 and 1911 in Paris and travelling in Europe. Walkowitz was in Paris from 1906 to 1907; Morgan Russell moved to Paris for good in 1906, followed in 1907 by MacDonald-Wright, who remained there until 1916. Patrick Bruce went to Paris in 1907, studied with Matisse in 1908, and remained there permanently. Arthur Dove was in Paris from 1908 to 1910, Joseph Stella in Paris and in Italy from 1909 to 1912. Marsden Hartley was in Paris, Berlin, and Munich in 1912 and 1913 and from 1914 to 1916; he became associated with the Blaue Reiter artists and exhibited with them in 1913 in Berlin. All the revolutionary events of these years in Paris – 1905, the appearance of the Fauves; 1907, the Cézanne show and the appearance of the Cubists; the great Gauguin and Van Gogh exhibitions – were experienced by these young Americans.

It was from among these artists that Stieglitz assembled his group. In 1909 he exhibited the first of these new names: Alfred Maurer, John Marin, Marsden Hartley. In 1910 he showed Arthur Dove and Max Weber, and in 1912 Abraham Walkowitz. Max Weber, who through Matisse, Delaunay, and Rousseau had gained a keen insight into the new movements, had a good deal to do with moulding Stieglitz's artistic taste; but Stieglitz's closest friend was John Marin, who with his brilliant, sensitive nature came closest to his high-flown notion of the 'artist'.

The development of the taste of the Stieglitz group follows the course of events in Europe quite closely. It began with Fauvism, whose strongest representatives were Alfred Maurer and Max Weber in his early period. Both had been subjected to the influence of the Fauves in Paris in 1906-07; Weber worked in Matisse's school. Now they introduced the sharp explosive colours, the flat décor, and shorthand drawing of the Fauves to the New York art world which was just becoming accustomed to the earth tones of the Ash Can School. Along with Prendergast, who at the exhibition of the 'Eight' had attracted attention by the daring of his carpet-like décor, the Stieglitz group brought the idea of the autonomous action of pure colours to the American art world.

In 1912 Cubism appeared on the scene. With its help, Max Weber aimed at an evocative painting with a firmer, more autonomous formal structure. But characteristically he started from early Cubism and its most expressive phase, beginning with Picasso's *époque nègre*. Weber's works in this style are for the most part figure paintings with the typical Cubist flat space and the Cubist facetting of object volumes. As in early Cubism, there is a distinct note of African art. But with their gestures and mimicry these sensitively stylised figures still seek to express a definite feeling. With all the formal rigour of these paintings, there is always an Expressionist overtone, which seems to spring not only from Weber's own religous feeling and sensitivity to the moods of Jewish folklore, but also from a specific quality in the American spirit.

We find it again in John Marin. Returning from Paris in 1909, he became acquainted in Stieglitz's circle with the modern ideas which do not seem to have touched him in Paris. In 1910 he went back to Europe – Paris, Holland, Belgium, Italy – and it was then that the flame was kindled. When he saw New York again in 1911, it was with new eyes. The city became his theme. The dynamism of metropolitan life, the giant skyscrapers, the heartbeat of the city merged into a shimmering vision of Metropolis. 'Shall we consider the life of a great city,' he wrote in 1913, 'as confined simply to the people and the animals on its streets and in its buildings? Are the buildings in themselves dead? We have been told somewhere that a work of art is a thing alive. You cannot create a work of art unless the things you behold respond to something within you. Therefore if these new buildings move me, they must have life. Thus the whole city is alive; buildings, people, all are alive; and the more they move me, the more I feel them to be alive. It is this "moving of me" that I try to express... I see great forces at work... influences of one mass on another, greater or smaller mass. Feelings are aroused which give me the desire to Express the reaction of these "pull forces"... I can hear the sound of their strife and there is great music being played. And so I try to express graphically what a great city is doing. Within these frames there must be a balance, a controlling of these warring, pushing, pulling forces. This is what I am trying to realise.' Some of the gigantic new buildings provoke a response in his imagination and compel him to define it in an expressive imago. For this work of definition he found some helpful ideas in Delaunay, whose pictorial visions centred round the Eiffel Tower had sprung from a similar poetic emotion at the sight of a modern city; others he took from the Futurists with their method of giving form to motion. But thanks to the original power of his hallucinated vision, all these influences fuse into a crystalline, luminous structure. It is not as though Marin sought by formal arrangement to create an evocative orchestration; he finds it instinctively and with it describes the vision that erupts from his imagination. This expressive passion, this drive to define an experience may sometimes endanger his formal order, but it is what gives Marin's pictures, when they are successful, their great visionary power.

These Expressionist tendencies were carried still further by two other painters of Stieglitz's circle, Marsden Hartley and Arthur Dove. In 1912 Stieglitz had sent Hartley to Europe. But with his strangely mystical temperament, he had not felt at home in Cubist Paris whose ins and outs he had learned at Gertrude Stein's. In the end he came to Munich and fell in with a group who were far closer to his needs, the Blaue Reiter artists. It was Kandinsky and Jawlensky who supplied him with the most important impulses. At first these combined with Cubism and Abstract Expressionism to produce a strangely esoteric, naïve art. The influence of the early Blaue Reiter style was to remain with him down to his late work. Arthur Dove, who shared Hartley's mysticism, arrived at a kind of Abstract Expressionism. His works of 1912 are radical abstractions on figural themes, recalling Hoelzel both with their symbolism and with their eurhythmic décor. Later, Dove, a remarkable man with a very strange life, made his picture surface a background for hallucinated, almost abstract inventions with

a pronounced symbolic content. He was a painter-poet, who on the human side may be likened to Klee. Thus all the new movements that had matured in Europe were reflected in the Stieglitz group: Fauvism, Cubism and Expressionism. Thus far, however, the new ideas reflected by the '291' painters were known only to a small public. They were to become a centre of attention and controversy through an event of the utmost importance for American art: the Armory Show.

## The Armory Show and its Consequences

At the end of 1911 the organisers of the Independent Artists' Exhibition decided to arrange for a new and more comprehensive showing of modern American art. Walt Kuhn, a painter with great organisational gifts, took up the idea and discussed it with the painters concerned at the studio of Jerome Myers. As a result, the 'Association of American Painters and Sculptors' was founded. Arthur Davies, who had far-reaching social connections, was elected president, while Walt Kuhn became executive secretary. Davies was close to Stieglitz and his circle; he was familiar with the European developments and had helped to finance Hartley's trip abroad. Over the understandable opposition of Henri's group, which wished only to show American painting, he decided to include the new European painting in the exhibition. In the summer of 1912 the catalogue of the Cologne Sonderbund Exhibition, in which all the tendencies of modern European art had been assembled, came to the attention of Davies and Kuhn. It supplied Davies with the broad outlines of his plan. Walt Kuhn immediately set sail for Germany, arriving just in time to study the Sonderbund Exhibition, and made the first arrangements with its organisers. Then he went on to Paris, where, with the help of Walter Pach, Alfred Maurer, and Davidson the sculptor, who were living there, and of Davies who had just arrived, he arranged for the French contribution. Then he returned to New York by way of London where Fry's second Post-Impressionist Exhibition was being held.

On February 17, 1913, the 'International Exhibition of Modern Art' was opened with a great fanfare at the 69th Regiment Armory on Lexington Avenue between 25th and 26th Streets. The Armory Show was extraordinarily successful. In four weeks it was attended by almost 100,000 persons.

Over 1000 works by more than 300 artists were shown. The American contribution was the largest. So many American artists submitted pictures that it had been necessary to set up a selection committee headed by Glackens. Even so, the American contribution, of which the painters close to the 'Eight' formed the nucleus, was confused and mediocre. It was the Europeans who gave the exhibition its character.

There was a certain disproportion in the selection, which may be attributed to the Symbolist leanings of Davies and Kuhn. There were 40 works by Odilon Redon, the largest one-man show in the exhibition, 15 by Puvis de Chavannes, and no less than 38 by the English painter Augustus John. More serious was the fact that the Futurists were not represented at all, and the Germans only in the most haphazard manner: there was one Kirchner, an abstract improvisation by Kandinsky — which was promptly purchased — and two Lehmbruch sculptures, including the *Kneeling Woman*. Munch was represented only with a few lithographs; there were two Hodlers. But this does not lessen the achievement. The emphasis was quite rightly on the French painters. A few examples showed the historical development from Ingres and Delacroix by way of Corot and Daumier to Manet. The leading Impressionists were represented by 20 paintings. Great stress was put on the Symbolists Puvis, Redon and Denis. But then followed the Post-Impressionist masters, 18 Van Goghs, 13 Cé-

161

zannes, 12 Gauguins. Rousseau was represented with ten paintings, Toulouse-Lautrec figured less prominently. Next came the Fauves with more than 40 paintings, the lion's share falling to Matisse. The Cubists and Orphists – headed by Picasso and Villon – were strongly represented. There were excellent Delaunays, Duchamps and Picabias. These, particularly Duchamp's *Nude descending a staircase*, enjoyed a brilliant *succès de scandale*.

Picabia himself had come to New York, where Stieglitz was giving him an exhibition at his gallery. The catalogue carried a serious preface by Picabia, explaining the inner motivations of Cubism. Man's conception of reality, Picabia wrote, was undergoing a change from the quantitative to the qualitative. The high-point of his remarks, which attracted considerable attention was as follows: 'The qualitative conception of reality can no longer be expressed in a purely visual or optical manner; and in consequence pictorial expression has to eliminate more objective formulae from its convention in order to relate itself to the qualitative conception... The resulting manifestations of this state of mind which is more and more approaching abstraction can themselves not be anything but abstraction.' In June Picabia published in *Camera Work* an aggressive and ironical satire on abstract art, foreshadowing the shocks and confusion of the Dada techniques. Here wo note the beginnings of the state of mind which in the war years led to the New York Dada movement of which Stieglitz's magazine *291*, founded in 1915, became the organ. With the best of intentions the American critics seemed unable to follow these ideas moving between keen intellectualism and satirical buffoonery. They contented themselves with the usual musical analogies, and in speaking of the Fauves and Cubists stressed the expression of feeling. Thus they too interpreted the new developments in an Expressionist sense.

But the great effect of the Armory Show was on the American public. Coming as a violent shock, it awakened America to the new creative forces. The vague notion of 'modern art', which had come into general circulation between 1905 and 1910, now acquired real content. The word 'abstract' entered into discussions among art lovers in conjunction with the concept of 'significant form', taken over from the English art critics. American society accepted the new art with unexpected enthusiasm. An amazing number of pictures were sold. It need not surprise us that 29 out of the 40 Redons were sold; more astonishing is that all the nine paintings shown by Jacques Villon were purchased and even the whole contribution of the scandalous Marcel Duchamp passed into American hands. It was then that Lillie Bliss, John Quinn, W. C. Arensberg laid the foundations of their famous collections of modern art. With the Armory Show modern art had become an integral part of American cultural life.

The Futurists, as we have seen, were not represented. They were not shown in America until 1915, in San Francisco. But in 1913 an American painter, Joseph Stella, had brought Futurism to New York. After studying art, Stella had spent the years from 1909 to 1912 looking round him in France and Italy. He had come into personal contact with the Futurists and had studied their methods closely. But it was New York that gave him his great experience and the subject matter which justified the Futurist techniques in his eyes. 'Steel and electricity', he wrote in his autobiography, 'had created a new world. A new drama had surged... a new polyphony was ringing all around with the scintillating, highly coloured lights. The steel had leaped to hyperbolic altitudes and expanded to vast latitudes with the skyscrapers and with bridges made for the conjunction of worlds.' This was the same experience that had led John Marin to employ Futurist methods. Stella began with Futurist transpositions of the turbulent play of light and motion in the amusement park at Coney Island: *Battle of Lights*. One recognises Severini's kaleidoscopic shuffling of fragments, but the turbulence of the movement and the dramatic expression of whirling space go far beyond

Severini's charming décor. There is a lack of restraint and a spaciousness which may justly be called American. A few years later Stella found his way to the theme he was to vary in a long series of pictures: *Brooklyn Bridge.* Its iron girders, the dynamic interlocking of weight and bearing-power, the play of lights upon it at night, seen against the background of the giant city – all this struck him as a pictorial symbol for American civilisation. He sought to capture it in an expressive image and arrived at several very convincing solutions. Although this Futurist current had no direct consequences, we shall repeatedly run across its indirect reflections.

Still another line, starting from the Orphism of Delaunay and Villon, was developed in 1912, by two young Americans who had been living in Paris since 1906 – Morgan Russell and Stanton Mac-Donald-Wright. They coined the word 'Synchromism' for their painting. In 1913 they exhibited in Paris and Munich, in March 1914 in New York. Their pictures were purely abstract, pure colour arrangements on simple geometrical forms – cubes and circles. Intricately intertwined chromatic series and complementary contrasts played over the surface, giving it breadth and spatial rhythm, solely through the distance values of the colours. This was the 'colour orchestration' which Gauguin had conceived: feeling expressed entirely by colour and spatial rhythm. The idea had been pretty well worked out by the Orphists, particularly Delaunay. Although the two 'Synchromists' attacked Delaunay bitterly in their manifestoes, their method must be regarded as a variant of international Orphism. But they did call the attention of American art circles to the formative capacities of pure colour and to the possibilities of colour counterpoint contained in the orders of the colour circle. Though Synchromism was short-lived – in 1918 both its adepts turned to objective painting – it left behind it the idea of the autonomous expressive power and abstract possibilities of pure colour.

At the outbreak of the first World War, all the new European ideas had entered upon the American scene: Fauvism, Cubism, Orphism, Expressionism, Futurism, and finally abstract art. They met with steadily increasing interest. What was lacking was a great artist who, working with this material, might have found new and convincing solutions rooted in American experience. None of the artists of this period, not even John Marin, achieved recognition abroad. America was still busy assimilating the new ideas. But in this process of assimilation, the United States became an active participant in modern cultural life. It was inevitable of course that in certain American circles modern art should be condemned as a foreign importation. The clear superiority of the European painting in the Armory Show gave many American painters an unpleasant feeling of inferiority, and the consequence was an attitude of defiance with chauvinistic overtones. This reaction was of considerable importance for subsequent artistic development in America.

BOOK THREE

The Magical Experience of Reality

The Experience of the Absolute

*The Magical Other*

In his early writings Kandinsky refers to two diametrically opposed paths, both of which lead to 'the spiritual in art'. The first, followed by Delaunay and himself, is that of 'the Greater Abstraction'; the other, followed, for example, by the Neo-Primitive Henri Rousseau, is that of 'the Greater Reality'. The second path, like the first, leads beyond visible reality and reveals a new aspect of it, which Kandinsky calls 'the fantastic in the hardest matter'.

This distinction throws a good deal of light on a number of developments in modern art otherwise difficult to explain and helps us to grasp the inner necessity that governed them. For it must be kept in mind that even after art had turned radically away from the world of things, and faith in the reality of this world had been undermined, the inanimate thing was not eliminated from psychological and visual experience. At a deeper level, the thing was encountered again, experienced in a new dimension of reality – in the depths of the mind, whence it sometimes rose to the surface to be perceived as a pure image. This experience, which became particularly intense at a time when the attention of artists was directed more to the isolated 'thing' than to the whole of nature and the atmosphere enveloping it, led to an entirely new conception of the world of things – to the discovery of reality as the magical other. It was discovered that the silent life of things possessed a special aura of strangeness, mystery, magic, which in the contemplating, reflective mind evoked a response expressing fear or irony, or a sense of deep kinship with things. The thing 'of the hardest matter' became a component of human sensibility, and in it the unity of the outer and the inner was once again achieved.

The modern artist found such experiences confirmed by ancient magical art. From 1890 on, modern sensibility responded to naïve art with steadily growing enthusiasm. Since Gauguin's discovery of the intrinsic qualities of primitive art, interest in its various manifestations had never flagged. The naive realism of peasant votive tablets and representations of the saints led Gauguin's disciples to strive for the same simplicity and naïveté in their drawing. The abstract ornaments and daring colours of Bavarian and Russian popular art encouraged Kandinsky on his path towards abstract painting.

This passionate interest in primordial artistic expression spread more and more. In the last decade of the nineteenth century children's drawings were 'discovered': Paul Klee was soon to experiment with their formal characteristics. Ethnologists began to appreciate the artistic value of their pictorial 'documents', and Picasso and Kirchner were soon to draw upon the consequences of this discovery. Archaeologists and classical scholars became aware of the amazing beauty of Greek archaic sculpture, which they came to regard as the purest expression of the Greek mind, more significant than the works of Phidias or Praxiteles. Picasso discovered that the magical sublimity of an Iberian Apollo and the daemonism of so-called Negro art had common formal roots. The primitive, the daemonic, the archaic: behind them the modern mind sensed the old magical unity between man and his environment. A yearning was born to return to this magical world. In terms of the history of ideas, we witness a powerful resurgence of the romantic longings that had been repressed by the positivism of the nineteenth century. But from the standpoint of art, we witness an active search for the symbols and pictorial forms by means of which man secured his hold on the world of things in a bygone age when man and object were still one.

In the course of this fascinating search for the mysterious quality of things, half-forgotten great names came to the surface. The Romantic Symbolists – the Pre-Raphaelites, Sérusier, Denis, the Jugendstil artists, had resurrected Fra Angelico and the Gothic world; now Giotto, Uccello, and Piero della Francesca emerged from the past. These were great constructors whose austere architecture amazed the Cubists; but they were also genuine 'primitives', in whom a sense of purely formal beauty was naturally combined with a feeling for the pristine magical quality of the thing. It was this essential quality of things, not their accidental visual forms, that the masters in question had distilled from the visible: for while seeking to understand what they observed and to give a formal definition of the visible in their paintings, they at the same time defined their idea of the thing. They did not paint the thing in its unique, accidental contexts, but the objective idea they formed of it. They brought the image of the thing into conformity with their definition of it. They demonstrated that in being defined by a primeval form-creating power, reality rose to the level of a 'Greater Reality'.

This visual experience led to a surprising discovery: the existence of a contemporary art that had all the features of primitiveness and spontaneous creation. It had merely been hidden beneath the cultural superstructure, but had survived with undiminished vitality in an anonymous social stratum, in the world of the amateurs, laymen, 'Sunday painters'. Now it was rediscovered by modern painters. In the naïve realism of the Sunday painters they found the contemporary expression of the 'Greater Reality'.

By its very nature, non-professional painting always develops outside and beneath the style-creating forces of history and society. It has nothing in common with folk art, because unlike the latter it is not embedded in a cultural totality which encompasses community, country, and race. The lay painter is on his own, more alone than the professional artist: he is completely isolated, precisely because he is a lay artist. He is a true child of the Romantic movement and did not appear as a stylistic phenomenon until early in the nineteenth century. Up until then, the prevailing style had held all types of art, including folk art, under its sway. It was only with the advent of Romanticism that this homogeneity was destroyed; only then did man confront the world in entire isolation. It was at this moment of cultural history that lay painting was born, as the attempt of the isolated individual to express his vision of the world. It is no accident that the problem of dilettantism was so much analysed at the time, and that the most enlightened spirits of the age, Goethe and Schiller, discussed the nature of dilettantism for weeks on end. It became fashionable to practise some art as an avocation. In such an intellectual climate, isolated individuals of the petty bourgeois class, having no contact with the world of 'Art', were seized with an irresistible urge to paint. In their interpretation of the world these 'lay' artists were inevitably 'primitives'.

In this solitary dialogue between individuals isolated from the secure, convenient formulas of an official culture and the outside world, the magic vision of things achieved a direct expression. The layman who could rely only on his creative instinct – his regular occupation might be that of a schoolmaster, post-office clerk, wrestler, domestic servant, performing a specific sociological function with greater or lesser efficiency – was inevitably a Neo-Primitive in his artistic activity. His own milieu was hostile to his efforts. His silent devotion to art put him into ridiculous situations. All he had was himself, nature as his partner in the dialogue, and his home-grown technique. He had no intellectual conception of his art or of nature. He was still a part of nature, at one with the life of things. And because he approached the world with the directness of a child, his realism was touchingly naïve and his interpretations were characterised by an innocent simplicity. This also accounts for his intense possession of the world, for the Neo-Primitive, like the early Italian

Primitives, brings the visible image of things into conformity with his idea of them. His paintings do not merely reproduce things, but define them. Thus in all simplicity he surrounds his paintings of things with the magical aura of 'the Greater Reality'.

In this anonymous world of petty bourgeois, sailors, shepherds, we find extraordinary artists such as Oluf Braren, a schoolmaster of Föhr (1787-1831). But for a long time they remained unnoticed. It was only when the sensibility of the cultivated classes had begun to approach the magical experience of things and, in its striving for expression, to apprehend the Otherness of nature, that the Sunday painters emerged from their obscurity, and the *style concierge* came to be regarded as art. This too began in 1890. While Gauguin was beginning to note the expressive power of primitive art, while Van Gogh, in his passionate effort to capture the object, was discovering its magical qualities, while Odilon Redon was beginning to deal with the reality of dreams, many artists became gradually aware of the magical vision of the Sunday painters. And it so happened that at that moment an extraordinary genius emerged from the anonymous mass of lay painters — the retired customs official Henri Rousseau.

## Henri Rousseau (1844-1910)

A stroke of chance helped to introduce the works of the Sunday painters to Paris, the centre of the European art world. The Salon des Artistes Indépendants was founded in 1884. Since its professed aim was freedom and tolerance towards all creative expression, it was more or less obliged to show the Sunday painters, whose touchingly naïve and whimsical works provoked hilarious comments by the visitors. From 1886 on, the Salon exhibited works by the Douanier Rousseau. Like others of their kind they were an object of public ridicule, but they arrested the attention of sensitive artists, who, in their search for new ways of expression, sensed that these pictures offered a primitive definition of reality. As early as 1890, Gauguin, Redon, Seurat and Pissarro sought out Rousseau. Even though they joked endlessly about the Douanier's simplicity, naive self-assurance, and grotesque ideas about art, they had great respect for his paintings.

This serene, naïve self-assurance is one of the essential characteristics of the primitive genius. In all simplicity Rousseau, like Séraphine de Senlis, believed himself to be a great master. As he brought his canvases to the Indépendants on his wheelbarrow, it never occurred to him that anyone might think them out of place at a representative exhibition. When he saw his first Cézannes, he at once offered his services to 'finish them'. On one occasion he congratulated Picasso, observing that the two of them were undoubtedly the greatest living painters, Picasso 'in the Egyptian', himself 'in the modern' manner. But this merely shows that this eccentric genius, naïve as a child, had the primitive's solid grip on the world, that could not be shaken by any outside influences. Because he was fully at one with the world of things, his works were self-contained, unaffected by the culture of his time.

In 1895, on learning that a prominent Paris critic was preparing a book on the most important contemporary artists, Rousseau went at once to the publisher's office and handed in a brief essay on himself and his work, taking it for granted that he would be included. In this essay, he says that he studied art on his own, 'with only nature as my teacher, and a few hints from the paintings of Gérôme and Clément'. The latter part of this statement is simply grotesque: the painters he mentions were the popular stars of the Salon. It is characteristic of Rousseau that when he came into contact with the world of 'culture', he reacted exactly like any petty bourgeois to

the recognised dream factory of the time. But he was perfectly right in the first part of his statement – that nature was his only teacher – though this too must be qualified. For the nature he referred to was not the nature that impresses itself on the retina, but a nature he himself defined. It was not until his late period, and then only occasionally, that he did outdoor sketches of landscapes. Some leaves of a plant picked up at random, an enchanted glance at the hothouses of the Jardin des Plantes, sufficed to activate the images stored up in his imagination and evoke a vision of trees, virgin forests, the whole of nature. His ideas and mental images found parallels in visual data, and when necessary the data were sacrificed for the sake of a more accurate definition of the inner image. That was the very method that had been applied by Uccello. For this reason, Rousseau's major works – his *War*, for example – disclose the most amazing stylistic similarities to Uccello. The images of things he thus produced possess magical efficacy because they define the artists's possession of the world. The primitive painter takes possession of the visible world by defining it: he does not distinguish between reality and his vision of reality. Things 'of hardest matter' are the elements of his universal dream of reality.

Henri Rousseau was born on May 20, 1844, at Laval, of poor parents. Between 1862 and 1866 he is believed to have served in the band of a regiment which went to Mexico with the expeditionary force sent by France to support Emperor Maximilian. Demobolised in 1866, he became a clerk in a lawyer's office; in 1871, after the Franco-Prussian war in which he served as a corporal, he entered the customs service in Paris. In 1885 he retired on a small pension, to devote himself to painting. He was about forty when he began to paint, in the belated Romantic idiom of nonprofessional art. His first major work, *Carnival Night* (1886), is a true masterpiece. It is a very romantic picture: a moonlight landscape, bare wintry trees against a background of cloud banks; in the foreground a forlorn park gate and a masked couple. The incomparable poetry of this picture lies in its dream reality. The dark tangle of tree branches carefully outlined against the moonlit sky shows how Rousseau in his imagination re-creates the growth of created nature. Each single tree is treated as an individual instance of the notion his ingenuous love had formed of a tree.

This re-creation of reality from images of things equates dream with visible reality. A reality that strives to rise to the surface from the depths of imagination and dream must be repeatedly re-created and objectivised. In his exotic paintings which begin with *Storm in the Jungle* (1891), he succeeded in endowing his world of dreams with the magic of reality. Because he believed fully in his dream he was able to give it full reality of statement. Rousseau was wholly under the spell of his own magic; he lost himself so completely in his pictorial world that sometimes he had to fling open the window in order to escape the eyes that were staring at him from out of the prehistoric plants of his strange mythical forests. But even the ordinary things he painted acquired the same magical reality, because he freed them from the protective coating put on them by environment, atmosphere, and light. The disguises were shed, what remained was the thing in its purity; the artist's imagination defined its typical features, and asserted it in this new form as reality. One of his paintings, the *Sleeping Gypsy* of 1897, shows a dark-skinned woman in a picturesque costume asleep in a moonlit wilderness; a great mythical lion is sniffing at her. At the lower right we see a pitcher and a mandolin. These objects in their isolation have an archaic material quality, a magic that is the earthly counterpart of the cosmic magic embodied in the moon: a fantastic super-reality in the hardest matter.

Towards 1900 Rousseau began to paint small landscapes out of doors and then, at home, transposed them into paintings that satisfied him. It is of the utmost interest to see how he discards the visual,

accidental elements in defining his vision of reality. The motif is entirely preserved, but the images of things are reduced to simple thing-signs – the houses become cubic blocks, the trees become archetypal plants, the telegraph poles become massive scaffoldings; figures mark off the distances like small ninepins. The universal supplants the particular; from the visual impression the artist extracts an emblem. This transformation of a representational impression into an emblematic image powerfully attracted the new generation – Picasso, Delaunay, Apollinaire. With images of things, the primitive painter constructed a new reality which the more sophisticated painters were still trying to discover. In their formal analyses of objects the Cubists were attempting to arrive at emblems suggesting a more complete reality. When Cubism entered its analytical phase (1906-7), the aesthetic avant-garde discovered Rousseau, because the magic realism of his Neo-Primitive genius corresponded to the new vision of things achieved by modern thinkers. Thus Rousseau, the Sunday painter, came to be regarded as a great 'artist'.

Rousseau's later paintings derive their power both from the vividness with which they embody his imaginary world and from the magical reality with which he endows the things of nature. In *The Snake Charmer* (1907) or in his last major work, *Yadwiga's Dream,* we find both: dream that has become reality, and reality that has become legend. There lies Yadwiga – the anima of the simple-minded Douanier – lulled to sleep by a snake charmer; reclining on a red plush sofa amidst the lush vegetation of a jungle, he is surrounded by beasts of prey and exotic birds. For all the incongruity of the ensemble, its effect is hauntingly realistic because even the solidly material things represented have been transported to a realm of magic. The images of things have become the raw material of an art of expression.

Historically speaking, we cannot call Rousseau a 'modern painter'. He was a primitive who was discovered and appropriated by modern sensibility. To his contemporaries he was a godsend. He cannot be classified with Gauguin, nor with Picasso; he stands outside history, he was a genius of alien origin, the genius of the amateurs, the lay painters. What is baffling about him and what gives food for thought is, first, that he made his appearance at exactly the right moment, and, second, that after modern 'culture' adopted his magical vision, the tide of lay painting began gradually to ebb; for a time its idyllic Romanticism persisted as an element of this modern culture, but today it is obviously sinking back into obscurity.

*Maîtres populaires de la réalité*

In the wake of the enthusiasm aroused by Rousseau, a number of other Neo-Primitives were discovered. Credit for this goes above all to Wilhelm Uhde, thanks to whom several important artists emerged from obscurity. During a brief stay at Senlis before the First World War his good fortune led him directly to a household where one of these painters of genius, Séraphine Louis, worked as a servant. Séraphine Louis (1864-1934) began to paint at the age of forty. She often experienced trance-like states when, guided by 'angels', she beheld paradisiac visions that demanded to be embodied in pictures. She had no idea whatsoever of 'art', hence her obsessive feelings did not suggest traditional structures and figures. But as she sat alone in her small room during her visionary states, her enraptured glance might fall on a bouquet of artificial flowers made of tinsel and glass, such as often added a bit of cheerfulness to the poorest interiors in this period. Starting from these wretched objects, her hallucinated imagination created radiant plants evocative of the Garden of Eden. She painted flowering plants with magical leaves and luscious fruits on which

seraphic eyes would appear, as well as darker signs, symptomatic of her delirious state, erotic symbols which added a Luciferian glitter to the paradise of her dreams. When Uhde had supplied her with paints and the large canvases she had always yearned for, her flowering tree grew to vast dimensions. This tree is her sole subject, which she uses to express her religious meditations and raptures that often stir an erotic cord. In obsessive repetition she paints leaf after leaf; strings and pearly eyes form a supernatural ornament on the surface filled up with restless whirlpools of colour and arabesques. The magical plants she painted from 1920 to 1930 enchanted a public which had learned to appreciate the fascination of the legendary in the works of Chagall. But Séraphine does not belong to this sophisticated world; she belongs to the group of the enraptured simple souls, who paint under an obsessive compulsion. In her paintings she defines the paradisiac dream that obsessed her, transmuting it into visible symbolic objects. In them it becomes real. Once again it is the will to definition that endows with magical reality these imaginary plants, leaves and flowers, painted with extraordinary sureness and precision.

Séraphine was not in the least interested in a realistic rendering of the visible; she revealed things invisible. She was a visionary who saw supernatural, imaginary realities. Most other lay painters were very different, drawing their inspiration from the outside world. At the age of forty Louis Vivin (1861-1936), a minor postal official, recalled his pleasure in painting as a child; when at sixty, he was able to devote himself entirely to his passion, he concentrated on views of Paris. He often based his works on picture postcards showing squares and buildings of the city where he lived. With childlike persistence he drew houses and squares, bridges and towers, brick by brick, stone by stone, re-creating a familiar reality. He is like a child playing with blocks. Absorbed in his meticulous building, he covers the whole picture with a linear web of amazing rhythmic density. Every line defines a material detail with the naïve cartographic accuracy that characterises the drawings of children. This reality, appropriated with the patience of a primitive and pictorially re-created, possesses a highly magical quality — it reflects the magic identification of ideas and images with things actually seen.

Much the same is true of Léon Greffe, a Paris hotel clerk, who in his views of Paris curiously juxtaposes landmarks, monuments, and buildings which are actually situated at large distances from one another, treating them like set pieces, because for him — as for the medieval painters of city views — this was the only way to give Paris its full emblematic reality.

We could mention a long list of other lay painters, from Dietrich in Switzerland to Grandma Moses, an American farmer's wife who began to paint at the age of seventy. The interest of Americans in their own non-professional painters was aroused by the 'Magical Realism' that became an important force in American painting in the late twenties. In 1930 the Newark Museum organised an exhibition of 'American Primitives'. It was here that Joseph Pickett was discovered. Today his masterpiece *Manchester Valley* occupies a place of honour in the Museum of Modern Art. Pickett (b. 1848) was a small shopkeeper at New Hope near Philadelphia. He was the owner of a shooting gallery which he operated at the country fairs in the vicinity. He was about sixty-five when he began to paint seriously. In the last years of his life — he died in 1919 — he did a few entrancingly poetic landscapes, painted in the minute style of the lay painters intent on the clear definition of each separate thing. John Kane (b. 1860) was discovered in 1927 on the occasion of the Carnegie International Exhibition. Kane was from Pittsburgh, of Irish descent. He had worked as a miner, steel worker, road builder, and carpenter. Finally, he took up house painting, which brought him into contact with colour, and he began to paint pictures in his free time. His theme was the city of Pittsburgh. But among the 90-odd pictures he left behind him, there are a few figures in which

the detailed forms seem almost modelled; their hard, precise style remotely suggests the early Florentine mode of definition. In the early thirties, once interest was aroused in these naïve realists, quite a number of them were unearted. There was Patrick Sullivan (b. 1894), a naïve symbolist who painted strange allegories on human life and accompanied his pictures with long explanations of his highly personal symbolism. The most recent discovery was that of the loveable Anna Mary Robertson Moses (b. 1860) — since grown famous as Grandma Moses. In 1937 she remembered her childhood attempts at painting and began to paint scenes of farm life in a charmingly naïve realistic style. Quite a few names might be added to this list of lay painters who described their surroundings, but such an enumeration would add little to what we have said about the magical realism of the modern primitives. However, a few words should be said about those lay painters who, like Sullivan, express themselves in allegories or figural compositions. This is an important aspect of lay painting. These painters attempt to define their life experience in terms of symbols or scenery and in so doing often bring the richly fantastic images of their unconscious to light. Henri Rousseau's most beautiful paintings spring from this store of images. One of the most delightful representatives of this painting is André Bauchant (b. 1873), a gardener and peasant, who became interested in drawing and painting in 1917 while working as a land surveyor in the army. Bauchant was fond of classical themes which came quite naturally to his naive inspiration. His naïve art is reminiscent of the early Florentine *Quattrocento:* it is characterised by plastic hardness and concentration, exact definition of things, and emphatic enlargement of selected representative details. Here again we have a re-created reality; Bauchant's primitive Virgilian fantasy closely integrated his native landscapes into his world of fable.

Bauchant's sturdy earthly poetry reflects his peasant origins. But not infrequently lay painters are transported by their figurative fantasies into an erotic world charged with a peculiar symbolism. Maurice Hirshfield (1872-1946), an American Jewish shoemaker and tailor, is a case in point. He took up painting at the age of sixty-seven and, obsessed by an image of the ideal woman, painted mannequin-like goddesses in a curiously heraldic manner, and friezes peopled by cats with human faces. The amazing thing about these works is their oriental character; their formal features recall Persian miniatures, while the subject matter suggests erotic Hebrew tales. Clearly this old man was inspired in his painting by a dream reflecting old racial memories, which pressed for embodiment in pictures. And once again an imaginary reality defined itself in emblems made of the hardest matter.

This amateur painting provided the 'professional' artists of the time with a solution of the problem of 'the Greater Reality', for it pointed the way to a pristine definition of the visible through representative images of things. The solution was most evident where the non-professional painter came directly to grips with the world of things. This accounts for the fame of Camille Bombois (b. 1883). Workman, wrestler at country fairs, athlete, he had always had a passion for painting and gave up his other occupations for it in 1922 when he found a patron. Bombois is a typical primitive realist. His paintings, which define things in all their massiveness and simplicity, are marked by a great physical vigour. A powerful hand seems to set each object in its proper place and so build up a world of unquestioned solidity. Bombois never tolerates inaccuracy, he discards the surface tinsel and the atmosphere elements that blur the form; having rigorously defined his image of the object, he applies it to visible reality. The mental image corrects nature and becomes representative of reality. In this naïvely defined reality things are transmuted into magical emblems. Another painter in this manner whom we might mention in passing is Dominique Peyronnet (b. 1872).

This lay painting is essentially non-historical. It belongs to the history of modern painting only to the extent that contemporary artists found in its primitive realism an archaic mode of looking at things, and felt that the reality it defined had a 'magical' quality. But in referring to 'magical reality' we have spoken from the point of view of history, culture, and style. The Neo-Primitives themselves did not feel their reality to be magical; they were convinced that their paintings were real images of reality. They never doubted the solidity of things, since the thing became real to them only after they defined it. For them 'definition' and 'nature' were identical.

Not so for the modern 'artist'. He had left the world of things behind him, and from his isolation he saw it as the Other, as something alien, disquieting, something he had lost, which surrounded him on all sides. It stood there as a challenge. To meet the challenge, he had to define the 'magical reality' surrounding him, define it from his own point of view, on the strength of his own human situation. It was necessary for him to invent images of things which made them real to his mind and heart. It was because of this necessity in which he found himself that he was struck, amazed, and deeply touched by the archaic definitions of things in the works of Rousseau and the other Neo-Primitives.

This archaic zone exerted a tremendous subterranean influence on modern culture. When such significant modern painters as Fernand Léger in France, Max Beckmann in Germany and Giorgio Morandi in Italy began once more to replace things with emblems, they were in part following Rousseau. The naïve Romanticism and touching verism of the Neo-Primitives directly inspired the Neo-Romantic painters who were in vogue in the Europe of the nineteen twenties. Some artists, such as Ottone Rosai in Italy or Joachim Ringelnatz in Germany completely assimilated the Neo-Primitive approach to the world and mastered their idiom in the deepest sense. The characteristic ambivalence of this painting that oscillated between dream and reality was of the deepest interest to the Surrealists.

In a joyful advance marked by marvellous discoveries all along the line, modern art was transcending the frontiers of the visible and the natural datum. Seeking to convey messages from the inner world, it had lost all interest in reproducing things. The world of things was left behind. Up until the First World War artists were primarily interested in clearing the path towards 'the Greater Abstraction'. The other domain, that of 'the Greater Reality', was neglected. It was this vacuum that the modern spirit provisionally, as it were, filled with the highest realisations of the naïve painters. For a time Rousseau was able to meet this requirement. But a malaise persisted. On every side man was beset by the silent, inexorable presence of things. When he looked back at them, he felt their mysterious power; he experienced the magical Other, which was fully and solemnly present in his own life – the 'Greater Reality' which clamoured for expression. And it was the very country which in its art and history had given clearest form to the 'old Latin idea of the original solidity of things' (Carrà), Italy, the home of Giotto, Masaccio, Uccello, and Piero della Francesca, that found the first articulate answer to the problem of a modern vision of things. In the Italian Pittura Metafisica of 1917 – for which Giorgio de Chirico had been paving the way since 1912 – things are restored to their rightful place on the new plane of modern sensibility.

*Pittura Metafisica*

Pittura Metafisica did not contribute a new kind of painting, but a new vision of things. This group of painters experienced the world of things as alien and mysterious – reflecting the modern

attitude towards reality. There was something disquieting about the way an inanimate object, seemingly withdrawn into its solemn steadfastness, could affect human emotions. Any old thing forgotten in a corner, if the eye dwelt on it, acquired an eloquence of its own, communicating its lyricism and magic to the kindred soul. If a neglected object of this kind were forcibly isolated, that is, divested of its warmth and of the protective coat of its environment, or even ironically combined with completely unrelated things, it would reassert its dignity in the new context and stand there, incomprehensible, weird, mysterious. The metaphysical painters sought to give pictorial expression to this new experience of things, to their discovery that 'an inexplicable state X can exist both behind and in front of a painted, described, or imagined thing, but above all within the thing itself' (De Chirico). It was precisely the ignored, forgotten, 'ordinary' things to which the new sensibility reacted. 'It is the ordinary things that reveal the simplicity which points to a higher and more hidden state of being and which is the very secret of the splendour of art' (Carrà). The need to define things anew brought these painters into the human situation in which Rousseau and the Neo-Primitives had found themselves at an earlier date. Seen in its broader context, the 'metaphysical' school, which seems to have arisen so spontaneously and, in a formal sense, without the benefit of any real tradition, was merely modern culture's active, articulate response to the new conception of things, which had been passively reflected in the widespread admiration for Rousseau's art.

Unlike the Futurists, the metaphysical painters had no set programme. Nor did they actually form a group. The school came into being as a result of the meeting of two remarkable personalities – Giorgio de Chirico and Carlo Carrà – at a definite place and time, and in a specific human situation. In January 1917, Carlo Carrà was sent to the military hospital at Ferrara to be treated for nervous disorders. There he met Giorgio de Chirico who had been working in the hospital since 1915. The two painters had heard of each other. Carrà, then thirty-six years of age, was one of the leading Futurists, and De Chirico, then twenty-nine, had achieved a reputation in Paris, where Apollinaire regarded him as 'one of the most amazing painters of the young generation'. They quickly became friends, and for several months painted in empty rooms of the monastery where the hospital was housed. De Chirico's brother, the poet Alberto Savinio, was a patient in the same hospital. His phantasmagorical poetry, which reflected the spiritual situation that in German literature had produced Kubin, Meyrink, and Kafka, was a source of stimulation to the two artists. Savinio's poems inspired the figure of the *uomo senza volto* (man without a face), which, later transformed into the *manichino*, haunts the paintings of the metaphysical school. All these circumstances are important: the restlessness and edginess caused by the war and the atmosphere of Ferrara itself, this 'most metaphysical of all cities', as De Chirico calls it, with its vast deserted squares, across which monuments cast their long shadows, the magical symmetry of its layout, its melancholy edifices decorated with *Quattrocento* frescoes representing astral divinities and demons in the most harshly realistic manner. At the same time, the artists' resurgent sense of their own *italianità* conjured up the ghosts of Giotto, Masaccio, Uccello, and their archaic idea of the solidity of things. With their universality, the works of these masters seemed to embody the *principio italiano*, its serene magic forms, its vision of a sublime 'second reality'. Thus De Chirico and Carrà began to feel that they were 'the sons of a great race of constructive minds'. Carrà spoke of Giotto's 'magical serenity of form' and of Uccello's 'brotherly relations with things'. De Chirico was filled with enthusiasm by 'the magnificent sense of solidity and balance which is the hallmark of great Italian painting'.

At this point we become aware of a profound change in the aesthetic thinking of modern Italy.

Until 1914 its leading artists were the Futurists. The archaic grandeur of early Italian painting lay beyond the reach of their declamatory art with its accent on dynamic sensations. Emphasis on sensation did away with the solid simplicity of outline and destroyed the rigorous statics of the pictorial structure. The Futurists regarded not Giotto and the masters of the *Quattrocento* but the Impressionists as their precursors. Although one of the professed aims of the Futurists was to give Impressionism 'style', it was obvious that even Futurist dynamism (object+environment) was still 'a materialistic form of representational description, which by no means transcended the stage of naturalistic reproduction' (Carrà). Moreover Futurism was still tied to the external sensations deriving from the 'motif'. The change reflecting the new attitude towards things occurred towards 1914; it was then that the 'Greater Reality' was discovered in the archaic grandeur of Giotto. At an even earlier date, Ardengo Soffici had pointed out that Cézanne and the Cubists were related in a way to Giotto and Uccello. This was now interpreted as a summons to go back to these masters, and Carrà, the former champion of Futurism, was the first to criticise it. He now felt that *italianità* was the antithesis of Impressionism and that the essential was to make visible the inner image of things, to assert the spirit of order with reference to ordinary things, to replace the blurred vision of Impressionism and the dynamics of Futurism by simple solid volumes and solemn precise form. In 1915 he wrote essays on Giotto and Uccello, and in his *Daughters of Lot*, a painting characterised by the most austere simplicity, he attempted to rediscover Giotto's greatness on a modern plane, which at that time he identified with Rousseau and Derain. In his *Drunken Gentleman* (1916), an amazing still life, painted in an archaic fresco style, in which a few objects are reduced to their simplest plastic forms, he attained to the archaic magic of things and already disclosed the stylistic features of Pittura Metafisica. And now he met De Chirico, from whom he learned to see the fantastic in the real.

De Chirico's background was entirely different. Born and educated in Greece, he absorbed the ancient Greek myths. Later on, he was deeply influenced by the fantastic world of Böcklin and Klinger. Endowed with an unusual poetic sense and a tendency to transmute visual experiences into allegories, he moved closer and closer to the world of things – starting with mythological themes, he shifted to melancholy visions of Italian squares populated only with statues, to magical paintings of things. He had created the vocabulary of Pittura Metafisica when he met Carrà. This and the poetic vision of the object he passed on to Carrà. There is no doubt that Carrà received more than he gave; nevertheless, thanks to him, Chirico acquired a greater feeling for the simplicity of things and the magical beauty inherent in them – for before meeting Carrà he had transported them too quickly to the grandiloquent region of his visual dreams, overemphasising their metaphorical significance. Thus the meeting of these two personalities at this particular time and under these particular circumstances made it possible for Pittura Metafisica to define the world of things as the magical Other.

This school of painting reflects a completely new conception of 'nature'. While the Impressionists sought to express the totality of nature in the atmospheric elements that pervaded the whole surface, the metaphysical painters emphasised the object and its formal and psychological relationships. They defined 'nature' as 'the world of things'; and it was by coming to grips with things that they sought to express the new totality. 'We use painting to construct a new metaphysical psychology of things. The absolute consciousness of the space that an object must occupy in a picture, and of the space that separates objects, is the foundation of a new astronomy of things chained to our planet by the fateful law of gravitation' (De Chirico). By coming to grips with things the imagination gives rise to a new form and psychological reality, the second reality. This artistic reality is not

21. Futurists in Paris. From the left: Russolo, Carrà, Marinetti, Boccioni, Severini (Supplied by the author)

22. Younger Italian Artists. Standing: Birolli, Moreni, Corpora, Vedova, Morlotti.
Seated: the collector Cavellini, Afro, Santomaso. (Supplied by the author)

23. Giorgio de Chirico  (Photo Herbert List, Munich)

24. Georges Rouault (Photo Maywald, Paris)

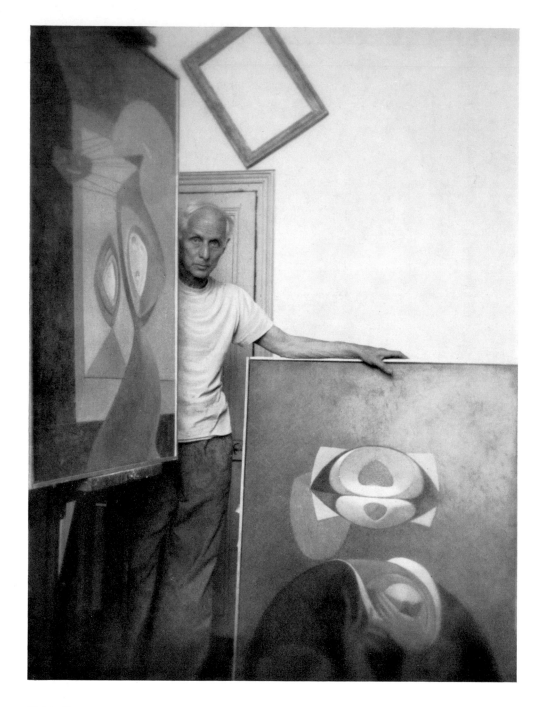

25. Max Ernst (By kind permission of Frau Dr. Lony Pretzell, Celle)

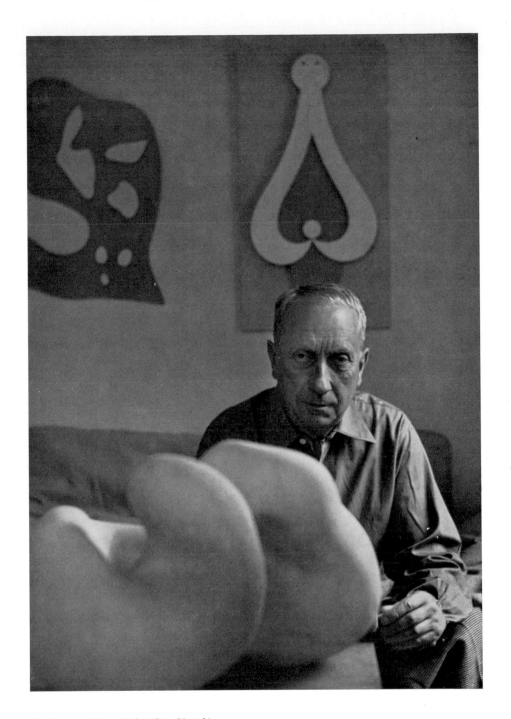

26. Hans Arp (Photo Herbert List, Munich)

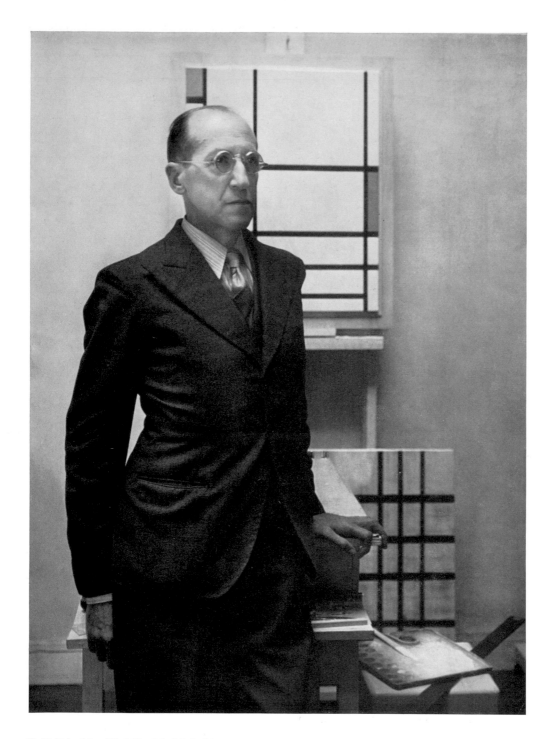

27. Piet Mondrian (Photo Rogi-André, Paris)

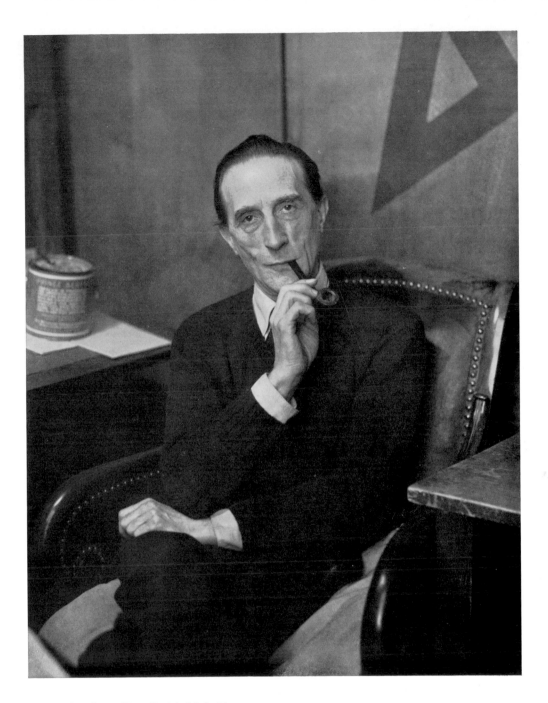

28. Marcel Duchamp (Photo Rogi-André, Paris)

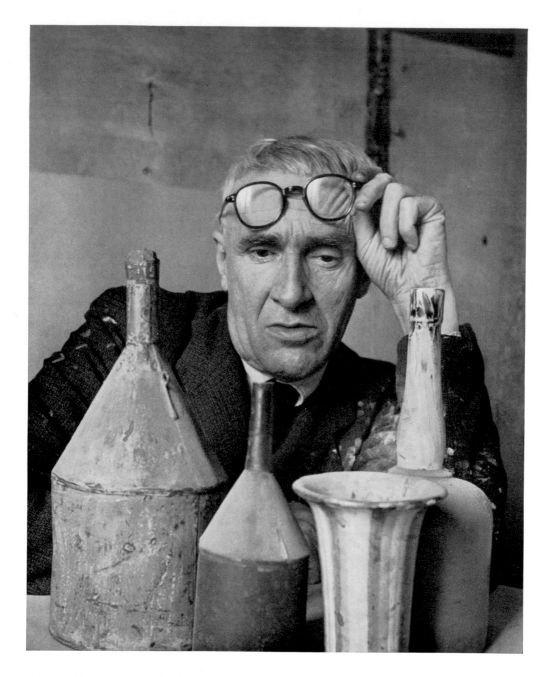

29. Giorgio Morandi (Photo Herbert List, Munich)

'reality at its initial stage, but pictorial representation of the *form* of the object, which possesses so great a radiance that it can capture reality itself. Without this constructive imperative our independence of the physical world remains merely a vain and pretentious word' (Carrà). A higher and more hidden condition of being is discovered precisely in ordinary things and their archaically simple forms. The secret lyricism of the inconspicuous, the magical eloquence of silent and forgotten things are part of our everyday environment; but because we ignore these things, they lead a life of their own. To those of kindred feeling such things appear dangerous or lyrical; it is they that arouse the emotions of the metaphysical painters and provide them with their themes.

The tragic solitude of everyday things results from the fact that the intellect assigns them a place in a logical order governed by utilitarian conventions. But the ignored things live their mysterious lives outside the zone which the intellect with its logical classifications regards as ordinary. 'What constitutes the logic of our normal activities and our normal lives,' says Chirico, 'is an endless rosary made from recollections of our relationships with things.' And he asks what would happen if man were for once to leave the zone of this logic imposed on him by psychological and utilitarian considerations. A man may sit in a room with a bird cage, books, etc., and everything seems ordinary, because everything is logically accounted for by the chain of our recollections. 'But suppose that one link in this chain breaks for a moment, for unexplained reasons independent of our will, and who can tell how this man, this bird cage, these books will appear to me? Terror and amazement... Yet the scene itself remains unchanged, I merely see it from a different angle. And here we have arrived at the metaphysical aspect of things.'

We can provoke such a new angle of vision by placing things in an unusual environment or by combining them with other things with which our intellect or memory does not usually associate them. Then the alogical juxtaposition breaks the chain of recollection, and things appear to man in a new aspect, as magical and autonomous entities. It is for the purpose of provoking this magical experience that the metaphysical painters place the humble objects they represent in unfamiliar surroundings. De Chirico shows a couple of smoked herrings in a setting that suggests the wings of a theatre; in front of them are two building blocks and behind them a candlestick with a starfish; because the realistically rendered fish are shown in a completely new environment, they not only suggest a gigantic super-real dimension, but are also transported into a magical region which entirely justifies the title, *Sacred Fish*. But the chain of recollections can also be broken and things can be experienced as the magical Other if we stare at them fixedly, as though our eyelids had been removed.

The metaphysical painters, who had a predilection for humble objects and their life in forgotten corners, discovered the fascinating stillness which is the aura of things. The space in which the things live becomes rigid and is rendered in geometric perspective; in terms of light, it is defined merely by hard shadows. Within this inexorable stereometry, the fluidity of light and the warmth of the atmosphere coagulate, and are reduced to immobility. Space, too, assumes the character of a magical Other and is defined as such. The rigorously geometric treatment of perspective with its suddenly opening depths removes the picture from the zone of ordinary logic and creates a congealed space that tingles with dramatic tension.

The experience of motionless things cannot tolerate the presence of living beings with their disorderly movements. Living creatures belong to another world, a world of motion and changing interpretations, not to the silent, lofty world of immovable existence. Such a world is populated by beings of a different kind – articulated puppets, statues, figurative trophies made of inanimate objects which are the divinities of this mute world of magical Otherness. This bewitched world

is the home of the *manichino,* puppet and idol, which combines the immobility and silent dignity of ancient statues with the forlornness of humble objects. There is no room here for humans. The figurative mythology that tends to raise man to the rank of a divinity is replaced by the mythology of things. But man and man's experience of the world are convincingly expressed in the symbolism of things. Since man sees the world *outside* himself, he naturally does not find his own image in it; instead, he finds the images of things by means of which he defines his possession of it. Like Giotto, who at the dawn of the modern era left the hieratic world of the Middle Ages to come closer to the world of things and, filled with wonder at them, defined them in his paintings; like Rousseau, the Neo-Primitive, who took possession of the world of things by painting them, modern man, peering out of his world of expression, recognises the world of things as alien and defines it as the magical Other, 'the Greater Reality'. The magical image of the object is the equivalent of the artist's inner image of the world. In it the outer and inner are fused into a new reality. By rendering the magical stillness of these images of things, the metaphysical painters seek to create a second, pictorial reality, which they would like to be as simple and mysterious as that of nature.

The aesthetics which for the first time gave articulate expression to the new conception of 'the Greater Reality', was developed in a few months. Carrà left Ferrara in the summer of 1917. But the new way of thinking, precisely because it so strikingly expressed the modern attitude towards things, had a lasting influence. All modern Italian art is based on the insights won by the metaphysical painters. Cosmopolitan Dadaism, French Surrealism, German Magical Realism, and such individual artists as Max Ernst, Schlemmer, Beckmann – were inspired by this new vision of things to explore the realm of 'the Greater Reality'. Giorgio Morandi, who came to Pittura Metafisica in 1918, gradually infused it with a quiet meditation and lyricism, and in his works the school has survived to this day.

In discussing Pittura Metafisica, we have so far confined ourselves to one of its aspects – its reference to the Greater Reality. But the new conception of things also had another, dramatic aspect. The magical Other was a source of anguish and nightmarish visions, against which the artist defended himself by means of irony. That is how Giorgio de Chirico came to invent his anguished, ironic poetic fables whose protagonist is 'the thing'.

*Giorgio de Chirico (b. 1888)*

It was De Chirico who introduced the term 'metaphysical' into the vocabulary of modern painting. 'It is the stillness and nonsensory beauty of matter that seem to me metaphysical; metaphysical, too, are the objects which by the clarity of their colour and the accuracy of their dimensions negate all confusion and haziness.' He regards as 'metaphysical' all painters who reveal the fantastic quality of the most solid things and raise them to a magnificent realm of visual dreams. He does not hesitate to apply the term *pittore metafisico* to the French nineteenth-century painters who composed in 'the grand manner' – Delacroix, master of the grandiose Romantic gesture, Courbet the virile realist, and Gericault who depicted his heroic horses in dramatic tones of grey and black.

The name De Chirico evokes for us a strangely realistic dream world peopled by ancient statues which throw long shadows across deserted squares, and silent groups of hybrid figures – statues, manikins, trophies – all deriving their gestures from classical rhetoric. This kind of painting recalled to the disturbed modern mind the dark, Dionysian, daemonic aspects of Greek antiquity which

had been forgotten since Winckelmann. In the ghostly figure of the *manichino,* the ancient gods reappeared disguised as demons, replacing the idyllic worlds of Ovid and Virgil with a nightmare whose hermeticism and magic strongly appealed to the modern sensibility. Apollo donned the faceless and soulless garb of the Golem and, god and demon in one, haunted the dreams of men filled with anxiety by the strangeness of things.

From the very outset De Chirico had been at home in the world of antiquity; indeed he was born into it. His Italian parents had settled at Volo in Greece, where he was born in 1888. He spent his entire youth in Greece, and as a child learned the Greek myths which had for him the magic reality that all fairy tales have for children. He received a good classical education. Homer, Socrates, Plato presided over the beginnings of his life. He began to draw and paint at an early date, and took classes in painting at the Athens Polytechnic School. In 1906 when his father died, his mother returned to Italy, sending her two sons, Giorgio and Alberto (Savinio, the composer, poet, and painter), to complete their education in Munich. Here Giorgio entered the academy. But the crucial influence in his career did not come from the academy, although Stuck certainly impressed him, nor from the Secession painters, although he had great respect for Klimt; it came from Böcklin whose paintings he saw at the Neue Pinatkothek and the Schack Gallery. In these paintings antiquity was endowed with the unreal magnificence of legend and transfigured in a Romantic dream of the South. A yearning for the beauty of the South invested the classical scenes with the grandiloquence of dreams. These were the very qualities that most appealed to De Chirico and made him so fond of certain terms – *la nostalgia, la solitudine, il sogno* (dream). And then he discovered Max Klinger, the great Klinger, poetic painter of the *Dream of the Glove,* and Alfred Kubin and his dream landscapes.

He also discovered Nietzsche. In Nietzsche's letters to his sister from Turin, De Chirico saw how the world took on a strange magic for this solitary mind already so far from the world. Nietzsche's letters contain descriptions of Turin's public squares, enormous and spectral, surrounded by symmetrical arcades and inhabited by statues immersed in silence. In his autobiography, De Chirico tells us what moved him so deeply in Nietzsche's vision: 'The strange and deep, infinitely mysterious and solitary poetry, based upon a 'mood', the mood of an autumn afternoon when the weather is clear and the shadows are longer than in summer.' This vision of the deserted Italian squares pursued De Chirico a long time, and he repeatedly tried to define them for himself in his famous *Piazze d'Italia.* But he found still more in Nietzsche: a sense of the void, and a feeling for the inner significance of ordinary things in this void. De Chirico describes it at length: 'Art was liberated by the modern philosophers and poets. Schopenhauer and Nietzsche were the first to teach us the profound meaning of the absurdity of life, and to show us how this absurdity can be transmuted into art... The new painters stop at the rectangles of their canvases, because they have gone beyond contemplation of the infinite. The terrible void that has been discovered is the unchanging, inanimate and calm beauty of matter.' In this contemplation of the void, objects placed before the terrible emptiness of space acquire a magical significance. Nietzsche had had this tormenting experience of the object; it led him to stress the deeper significance of ordinary inanimate things which can be demonstrated experimentally if they are freed from the causal chains of logic. It was from Nietzsche that De Chirico took the idea that the alogical can be used as a new experimental means of knowledge, and he acknowledges his debt: 'It is not we painters who discovered that logical meaning must be eliminated from art.' Under Nietzsche's influence, De Chirico formulated his experience of the mysterious essence of the world of things as a metaphysics of the void, and his magical images of things are the mythological counterpart of this

metaphysics. At the bottom of a self-portrait of 1908, painted in a style very much like Böcklin's, we find the following inscription in De Chirico's hand, *Et quid amabo nisi quod aenigma est?*

In 1909 De Chirico returned to Italy and painted battles of Titans and Centaurs in the style of Böcklin. In 1910 he went through a psychological crisis. Nietzsche took full hold of him: 'The Böcklin period was over, and I began to paint subjects in which I attempted to express the strong mysterious feeling I had discovered in Nietzsche's books – the sadness of fine autumn days, afternoon in Italian cities.' Paintings such as *Enigma of an Autumn Afternoon* were still very Böcklinesque, but they began to convey the fear of the void and the magic vision of things. At this time, he discovered the archaic simplicity that characterises the images of things in Giotto, Uccello, and Piero della Francesca, and he determined to cast off Böcklin's turgid manner in favour of the dry, harsh, fresco-like style of the old masters.

In the summer of 1911 he moved to Paris where he stayed until 1915. He exhibited at the Salon d'Automne and the Indépendants, and met Apollinaire who introduced him to Picasso, Derain, Brancusi, and other French painters, but they did not influence him in any way. Working in isolation, he doggedly persisted in treating the subjects he had begun to treat in Florence. He now painted his famous *Piazze d'Italia,* enchanting evocations of old Italy: deserted squares bordered by towers and arcades and traversed by the long shadows of statues; the clocks have stopped, time stands still, and things frozen into immobility convey a sense of lurking mystery. A spectral subterranean light, terrifying illogical shadows and harsh perspectives produce an effect of magical rigidity and a restlessness full of anxious foreboding. The empty space and the lurking enigmas of the objects dispersed in it are closed off by walls and bars; geometry serves to protect us from them, but it too is grotesque and contaminated by riddles. The last painting of this series dates from 1915.

In studying this series we notice that with each successive work the object and its shadow assume greater importance than the mythical figures and statues. Allegory is less emphasised, things come to the fore. As early as 1913, bananas, artichokes, and fragments of statues – the new protagonists in the drama – occupy the foreplane. De Chirico gives up his wide Italian squares and moves into the interior, closer to things. This brings him to new themes – 'metaphysical still lifes' and 'interiors'. The same year, 1913, marks the appearance of the *manichino,* the mythical idol of the frozen world of things and the void around them. It is a dressmaker's dummy, an automaton, a creature pieced together from objects. Motionless, this cult image of the void contemplates the things and the enigmatic equations of geometric space.

De Chirico returned to Italy in 1915 for his military service. Stationed in Ferrara, he continued to treat these three themes – city landscapes, *manichini,* and interiors – and developed the idiom of Pittura Metafisica. The purpose is to make visible the object in its magical and disquieting reality, but in becoming visible the object unfolds a myth which presents it in a dramatic light. Things are crowded together, enter into abstruse, alogical relationships, and freeze into dramatic constellations. Steep short-cuts completely dislocate space, realistic close-up views and unreal distant views are juxtaposed. In this distorted space dislocated by numerous divergent perspectives, the object assumes the character of the Greater Reality.

By 1920 the classical Pittura Metafisica came to an end. Only Morandi continued calmly to develop its ideas. De Chirico was in fact the first to leave it. Demobilised in 1919, he settled in Rome where he copied Raphael and Michelangelo and preached the return to tradition. By this he meant a striving toward a 'great art' inspired by the Italian Renaissance. But in his famous series of Roman villas with their knights errant, he once again succumbs to the influence of Böck-

lin. He also aimed at more sumptuous colours, which he found in Renoir, as well as in Rubens and Delacroix. The *manichino* still occurs, but it has lost its mythical significance; it has now become a masked actor with melodramatic gestures. In 1925 De Chirico went back to Paris where the Surrealists received him enthusiastically. Encouraged by their applause, he resumed some of his 'metaphysical' themes; but this was only an episode. His art, after a period of Romanticism with pseudo-classical overtones (partly inspired by Picasso), soon lapsed into a declamatory Neo-Baroque style, and he became increasingly hostile to new ideas. For all his great gifts he has failed to develop a significant late style.

It was obviously a passing need created by a specific spiritual situation that had led De Chirico to define his conception of the thing. He must be credited with having succeeded in an enterprise which reflected the urgent needs of the time. Because of his poetic imagination, he was soon diverted to other paths, and instead of aiming at the essential simplicity of the thing, he took his inspiration from its poetic associations and latent dramatic potentialities. The psychological core of his pictures can be summed up in the two highly Romantic and highly modern concepts of anguish and irony. These concepts stand at the centre of contemporary Romanticism, and achieved their most striking expression in Surrealism.

All De Chirico's painting reflects the nightmarish quality that the modern mind perceives in nature and its objects. His figures seem to come straight from Ovid; but his realistically portrayed, petrified gladiators and Dioscuri, mythical horses, Centaurs, taciturn Homeric warriors, and forlorn horsemen on beaches express deep irony, because the setting in which they appear is as incongruous as possible – it is our own modern world.

## Dadaism

While the Italians at Ferrara were inventing their pictorial equivalents of the magical experience of things, artists all over Europe were experimenting with methods of defining the mystery of the real, which was experienced as meaningless or profoundly meaningful.

This experience had risen to consciousness with Nietzsche. It had inspired Rilke's complaint of 1902: 'Man is situated like a thing among things, infinitely alone... everything that links men and things has withdrawn into the common depths which nourish the roots of all growth.' Here Rilke foreshadows the possibility of transcending the contradiction between the inner and the outer by a new method that would penetrate the realm of the unconscious where the two are fused. This idea was now echoed everywhere; it took the form of doubts or probing questions, such as that so brilliantly formulated by Marcel Proust: 'Possibly the immobility of the things around us has merely been imposed on them by our certainty that they are what they are and nothing else, by the immobility of our thinking about them.' But this attempt to set thought and experience in motion meant a complete upheaval, a radical departure from rationality – the replacement of the logical point of view by an alogical one, meaning by absurdity, pre-established order by provoked disorder, etc. And since such a dislocation of our experience can only be the work of a degraded mind, theories were advanced that even madness and absurdity can become organs of knowledge, indeed, that by experimentally shifting our point of view, we must obtain entirely new answers and bring to light inner images which our rigid logic had reduced to obscurity. This experiment was carried out by the Dada movement.

Like metaphysical painting, Dada was not a 'style'; it was the culmination of a state of mind.

On this score, all the 'Fathers' of Dada from Hülsenbeck to Breton are in agreement. The state of mind in question was primarily a consequence of the previously described situation of the modern mind, but it was greatly exacerbated by the oppressive atmosphere of the First World War. To its terrors many European artists reacted with sarcasm, bitter irony, cynicism, and nihilism — a creed of complete anarchy.

Dada was founded in the Spring of 1916 by a group of writers and artists. All were homeless; war refugees, idealistic exiles, conscientious objectors, or anarchists. The movement started in Zurich where intellectuals from all countries gathered during the war. There Hugo Ball, a German philosopher and writer (he died in the Ticino in 1927, worshipped almost as a saint by the local population) had launched the Cabaret Voltaire, which he conceived as an instrument for the re-assessment of moral, cultural, and social values. The method: buffoonery: 'What we call Dada is a harlequinade made of nothing, in which all the higher qualities are called into question.' Hugo Ball was joined by the Rumanian poet Tristan Tzara, the German poet Richard Hülsenbeck, the Alsatian painter Hans Arp, and the Hungarian painter Marcel Janco. Even their way of finding a name for the new movement is highly characteristic. A penknife was inserted between the leaves of a German-French dictionary, and the first word noticed on the page was 'Dada' — French baby-talk for 'rocking horse'. It was unanimously accepted as the name for the new 'style'. This legend embodies the spirit of Dada: immediate acceptance of the accidental, playful irony, childish euphoria often expressed in shouting, screaming, and babbling, and the assertion of obvious absurdities, from which, however, a deeper meaning might unexpectedly emerge — as in the case of the word 'Dada'. For the word has unexpected connotations. In Levinstein's *Children's Drawings* published in 1904, we find the following observation: 'A child who says that its scribble is a "dada" will not hesitate a few minutes later to assure us that it is a "pussy cat".' This tendency to substitute one thing for another without regard for logic, to emphasise the naïve, the absurd, the immediate, the primitive, but also to mystify the public by grotesque paradoxes — all this was inherent in Dadaism, as was the 'law of chance', which the Dada writers and painters held in high respect and to which they often appealed. All these characteristics of Dada reflect a disintegration of logic and a release of the forces of the subconscious; if we add a tendency to buffoonery and grotesquely provocative behaviour, we have summed up the contradictory spirit of Dada. Tristan Tzara's definition seems to me particularly apt: 'Dada is a virginal microbe which, with the insistence of air, penetrates into all places that reason cannot fill up with words or conventions.'

The artistic methods used by the Dadaists in their appearances at the Cabaret Voltaire were primarily inspired by Tzara. Most of them came from the arsenal of Futurism, and the Dada meetings must have been very like those of the Futurists. There were poems made up entirely of vowels as well as the 'simultaneous' poems derived from Marinetti's *Parole in libertà;* the use of background noises in the Dada performances was based on Russolo's theory of 'Bruitism'; and the declamatory Dada manifestoes were modelled on the Futurist manifestoes. But what radically distinguished Dada from Futurism was the absence of optimism, of faith in the future, or militant moralising. Dada ironised and demoralised; its poetry avoids descriptions of situations and impressions; whereas the Futurists used pure vowels to render the rattling of machine guns, speeding machines, simultaneous interpolations, etc., the Dadaists regarded poetry not as a method of describing sensations, but as an automatic activity of the psyche, having nothing to do with logic or description. In this they were no doubt influenced by the French 'alchemists of the world', Apollinaire, Jacob, Jarry, Rimbaud, whose names are often found in Dada publications *(Cabaret Voltaire,* 1916, and from 1917 on, the issues of the magazine *Dada).*

At first the Dadaists developed no distinctive school of painting. In keeping with their general attitude, they championed the schools known as rebellious and modern – Cubism, Futurism, abstract painting. The Cabaret Voltaire was decorated with works by Arp, Picasso, Segal, and Janko. The Dada publications printed contributions by Kandinsky, Klee, and De Chirico. Abstract painting and Cubist montage were most favoured. Hugo Ball knew Kandinsky, Arp was acquainted with Picasso and Braque, and Tzara provided a link with Marinetti and the Futurists. Soon a gallery was founded, in which works of these artists were exhibited along with works by German Expressionists, sent in by Herwarth Walden of *Der Sturm*. All this was a mere cross section of the current avant-garde production. Hans Arp, painter and poet, who as early as 1912 had been in touch with Kandinsky and the Blaue Reiter artists, was the only Dadaist to attempt a pictorial transposition of the Dada experiments. He was drawn to Cubist montage, in which objects and fragments of objects were subjected to the same distortions and rearrangements as words in Dada poems. This clearly suggested the idea of piecing fragments of objects together so as to form a new object. But Arp was an abstract painter; fragments of objects seemed to him to be too descriptive, because they gave rise to associations. Therefore, instead of fragments of real objects, he used so-called 'primeval forms', spontaneous products of the unconscious, amoeba-like, flexible forms reminiscent of the Jugendstil, which he pasted one beside or over the other, obtaining new and surprising 'objects'. The unexpected emergence of these new objects and the shock of surprise they produced led him – as they did Tzara – to experiment with chance combinations. Tzara would draw slips of paper with words inscribed on them from a hat, and present the resulting combination of words as a poem; Arp allowed cut-outs of free or geometric shapes to arrange themselves in a random order, then pasted them on a surface, and presented the result as a picture. This method based on chance led to new psychological discoveries. In the course of such experiments, Arp also used automatic drawing, i.e., irrational, spontaneously traced forms rising from the unconscious. But the results did not go beyond 'abstract painting', even though the execution was marked by the utmost spontaneity.

The Dada methods proved extraordinarily fruitful and liberating in the field of typography. The Dadaists played havoc with the routine make-up of the printed page. Characters were set on a slant, capitals appeared in unexpected places like strange magic emblems; the page was treated as a formal structure, the caption as an aesthetic element, and punctuation and capitalisation were dropped. Futurism with its sense of publicity and Cubism with its sense of artistic values helped the Dadaists to produce a number of startling inventions. These playful experiments inspired many modern printers.

The cinema also benefited from these rebellious games. Starting from abstract painting and the Futurist figuration of movement, the Swedish Dada painter Viking Eggeling, in collaboration with Hans Richter, conceived the idea of the first abstract motion picture.

A Dada school of painting did not develop until Picabia came to Zurich, where he introduced the ideas of Marcel Duchamp. For while the Dadaists were staging their revolt in Zurich, a group of artists in New York was carrying out similar experiments quite independently. Their leaders were Marcel Duchamp and Francis Picabia, and their headquarters was the Gallery of the photographer Alfred Stieglitz, at 291, Fifth Avenue. In Stieglitz's magazine *Camera Work* we find, as early as 1913, poems and drawings which show a remarkable affinity with Dadaism. Later – in 1915 – the Stieglitz group published a magazine called *291*.

Picabia and Duchamp had come to New York from Paris. They had met in Paris in 1910 when they were associated with the Cubists. They were closely connected with the Section d'Or and

the Orphist movements. Duchamp was given to speculation, Picabia was an eccentric. In 1912, when the aggressive dynamism of the Futurists reached Paris, Duchamp's ideas became more sharply defined. A good deal of discussion was devoted at the time – with the eager participation of Apollinaire – to the dissolution of the logical, naturalistic, and humanistic elements in art; and there was even some talk of shattering the classical concept of art itself by means of buffoonery. The products of modern technology – the machine, this new mechanical creature so different from the familiar things of nature – suddenly acquired an extraordinary fascination. The Futurists had welcomed the advent of this mechanised world with enthusiasm, proclaiming that a racing car was 'more beautiful than the Victory of Samothrace'; Delaunay had regarded the Eiffel tower as a fitting subject for a painting, and Léger was moving towards an aesthetics of the machine; but Picabia and Duchamp saw something else in the products of the engineering mind – the 'auto-maton', the inanimate thing endowed with movement, the extra-human creature, the fetish of modern civilisation. They personified these mechanisms in a spirit of irony and animistic Ro-manticism – treating them as strange individualities made of wheels and wires, iron and steel. Whereas the classical imagination of the Italians embodied the thing-fetish in the ironical figure of the *manichino*, here real man-made objects assumed the character of fetishes. Previously men had derived aesthetic delight from books containing illustrations of flowers, plants, and animals. Now catalogues of industrial firms came to be regarded as books of magic, replete with fascinating discoveries.

As early as 1911, in his *Coffee Mill*, which is still completely Cubist, Duchamp had attempted to depict the mechanical apparatus and its movement by a complicated ironical system of cross sections and views from different angles. From 1912 on, he was fascinated by the problem of movement which he tried to solve by using the Futurist kinetic formulas. It was then that he painted his famous *Nude Descending a Staircase*. But already (in his *Bride*, 1912), the living organism is conceived as an abstruse system of pipes, alembics, and compression chambers; the machine, the inanimate apparatus, emerges like a fetish long concealed within the body and now rediscovered. In this way Duchamp opens up an imaginary world of mechanical things, a kind of new and personal mythology whose disquieting features are compensated for by irony. Robbed of its natural qualities, idolised and at the same time ridiculed, the mechanical thing can also acquire the character of a magical fetish without the mediation of 'art', solely by being isolated from its environment. It suffices to take any object, chosen at random from among similar objects that are usually ignored in their corners – a bottle drier, for example – to mount it on a base, and to place it in as incongruous an environ-ment as possible (an art gallery, for instance), and to provide it with an ironical caption and sign-ature identifying it as a work of art – and our object will acquire a disquieting dignity, an adven-turous forlornness so startling that we can only react with fear, rage, or laughter. Thanks to this *'déreglement de tous les sens'* – we recognise the object as a fetish, a fantastic counter-reality in hardest matter. That was exactly what Marcel Duchamp did in 1914 – when he transformed a bottle drier into a 'work of art'. In this way he invented the 'ready-mades', mass-produced objects, speci-mens of which are given the rank of independent entities. In the 'ready-made' the hardest reality is recognised as magical.

In 1914 the outbreak of the war put an end to all these ideas and experiments. Duchamp went to New York where Picabia joined him in 1915. Picabia had in the meantime arrived, by way of Cubism and Orphism, at an extremely dry graphic style, composing geometric and mechanical elements into pictures resembling blueprints. In the refugee world of New York the same restless, erratic, cynical, highly-strung atmosphere prevailed as in Zurich, and the artistic reaction to it was

very similar. Picabia's magazine *291*, which was published by the Stieglitz Gallery and ran from March 1915 to February 1916, carried the radical art and poetry of the time. There were Apollinaire's *'idéogrammes'* – poems printed so as to form a picture, the Eiffel Tower for example – texts by Alberto Savinio, De Zayas, Ribemont-Dessaignes, Max Jacob; ironic glosses by Picabia; and Cubist drawings by Picasso, Braque, and Picabia. The cover design of the December number was a plastic montage by Picasso, the final number bore a Congo mask. Nearly every number included drawings by Picabia, including the first of his ironic, anthropomorphic mechanisms: *Fille née sans mère, Voilà Elle.* There were also a few contributions by young Americans: the June number had an excellent, almost abstract drawing of a skyscraper by John Marin; the May issue had a magnificent wild drawing of a head by Walkowitz, drawn in a startlingly automatistic line suggestive of Jackson Pollock. In 1917, Marcel Duchamp, who took no part in *291*, published a number of literary pamphlets entitled *The Blind Man* or *Wrongwrong*. In the main they provided programmes for Dadaist entertainments. In all these endeavours we find the same preposterous buffoonery and cynical irony as in the Zurich Dada publications.

Duchamp had long since moved away from 'art' in the classical sense of the term. Taking a last fling, he did a large picture entitled *Bride Stripped Bare by her Bachelors*, a mechanomorphic composition painted on a sheet of glass, which he enriched – or spoiled – with all sorts of inventions inspired by his experiments with the 'law of chance' and 'automatism'. Even while working on it, he professed himself an 'anti-artist' and took up chess. Only at intervals did his old fascination with thing-fetishes awaken in him, impelling him to fashion playful mechanical 'objects'. In 1916, he made the first 'mobile' – a bicycle mounted on a kitchen chair; in 1920, *Rotary Glass Plates*, and in 1935 *Rotoreliefs*, forms whose playful movements produced optical illusions. Though all this was not 'art', it opened up new territory. A young American by the name of **Man Ray** had attached himself to Duchamp. Originally a pupil of George Bellows and Robert Henri, he had found his way into the circle of Max Weber, Demuth, and Hartley; in 1913 he had been connected with the Anarchist Group round *The Masses,* and under the impact of the Armory Show had turned to Cubism. An ardent reader of Rimbaud and Lautréamont, he was well prepared to understand Duchamp whom he met in 1915. Under Duchamp's influence he began to make all sorts of technical and manual experiments in addition to his Cubist painting. This was the period of his optical games with unexposed photographic plates – the 'Rayograms'. He also experimented with superimposed exposures with which he achieved highly startling effects and formal arrangements. He was the only American to participate actively in Dadaism. In 1921 he collaborated with Duchamp in publishing an almanac entitled *New York Dada*. In the same year he moved to Paris where we shall meet him again in the circle of the French Dadaists and Surrealists. In one of his last picture cycles, the *Equations shakespeariennes* – inspired by the 'objets mathématiques' in the Institut Poincaré, to which Max Ernst called his attention in 1936 – we still find the old Dadaist fascination with mathematical and mechanical manipulations, accompanied by the purest fantasy. These ideas and games had an enormous influence. The methods of 'Rayography', amplified by Moholy-Nagy's experiments at the Bauhaus, have long become a part of modern photography. The idea of the 'mobile', which Duchamp had inaugurated with his nonsensical montages, fascinated sculptors and led to Calder's dynamic three-dimensional structures. The playful probing of materials and things, which was the true impulse behind the Dadaist techniques, is taken for granted today as a part of the curriculum of every art school.

Tenaciously and with a remarkable freedom from preconception, Duchamp explored three ideas. First, the idea of movement, which had led him from Cubist 'simultaneity' and Futurist kinetic

figuration to the 'mobile'. Through it the poetic, aesthetic, and psychological implications of the machine became an object of possible artistic experience. Second, the idea of irony, which enabled him to accept automatically emerging and accidental elements with their surprising consequences. Buffoonery became part of a technique aimed at provoking and experiencing the unconscious. Third, the treatment of the object, which was first contemplated with irony, then isolated from its natural environment, and finally endowed with a 'personality' of its own. With the 'ready-made', the thing itself, through intellectual and technical manipulation, became the 'Greater Reality'. In 1907 Rilke made the following comment on a Cézanne: 'Before Cézanne artists painted: I like this thing here, instead of painting: Here it is.' Rilke's comment contained in germ Duchamp's way of taking a thing and placing it before us: 'Here it is!'

These three ideas now became part of European Dadaism. Picabia went to Barcelona in 1916, where he met Marie Laurencin and Gleizes and founded the magazine *391*. The first four numbers appeared from January to March in Barcelona and carried texts by Picabia, Max Jacob, Gabrielle Buffet, Ribemont-Dessaignes, Apollinaire, Gleizes, as well as some of Picabia's mechanical drawings. No. 5 appeared in June in New York and No. 8 in February 1919 in Zurich, for Picabia had meanwhile joined the Dadaists in Zurich. This confluence of the two movements that had come into being independently of each other gave new impetus to Dada which spread with surprising rapidity to Germany and France.

In 1917 Hülsenbeck returned from Zurich to Berlin. Here, as the war was entering on its last year, he found a climate of starvation, misery, and seething political unrest. In his *Dadaist Manifesto* he proclaimed: 'With Dada a new reality comes into its own. Life appears as a simultaneous muddle of noises, colours, and spiritual rhythms, which is taken unmodified into Dadaist art, with all the sensational screams and fevers of its reckless everyday psyche and with all its brutal reality ... Dadaism for the first time has ceased to take an aesthetic attitude towards life, and this it accomplished by tearing all the slogans of ethics, culture, and inwardness, which are merely cloaks for weak muscles, into their components.' But in the Berlin climate the Dada artists confined themselves almost exclusively to political satire. The old Futurist techniques were employed to express the mordant irony, the demoralising raillery of the Dada spirit: revolutionary propaganda. The only painter worth mentioning is George Grosz. His harsh corrosive drawings, which combined Cubist and Futurist techniques (montages, fragmentation of objects) with the formal vehemence of the Expressionists, savagely caricatured racketeers, prostitutes, and militarists. Because of its political aims, the Berlin variety of Dada was artistically inferior, in the years 1918-1921 no more than an episode, which came to an end when the general situation had changed. After a period of incisive realism, George Grosz relapsed into a mediocre Romanticism.

The situation in Cologne was more favourable: here a highly talented artist was available – Max Ernst, a former student of philosophy. Wavering between Picasso and Kandinsky, he had become interested in the Expressionist *Sturm* group. But immediately after the war Arp, whom Ernst had known since 1913, went from Zurich to Cologne, bringing along the Dada conceptions he had elaborated under the influence of Picabia. Ernst embraced them wholeheartedly. Along with Baargeld, who emphasised the political-anarchistic aspects of the movement and carried on Dada propaganda in the magazines *Der Ventilator* and *Die Schammade*, he started the Dadaist movement of Cologne. The painters Hoerle and Räderscheidt were loosely associated with it.

What fascinated Ernst was a particular conception of Duchamp's 'Ready-made'. Starting from Picabia's 'blueprints' of humouristic mechanisms, he created a grotesque world from reproductions of technical drawings, in which accidental and unexpected elements played a crucial part. Then he

became intrigued by the fantastic hard reality of engravings in old magazines and scientific books. Like Duchamp, he was struck by the peculiar magic inherent in these pre-fabricated things; he felt impelled to re-arrange these realistic pictures, to transform their hard reality by alogical combinations, to make them more eloquent. By cutting out these illustrations and piecing them together in new ways according to the caprice of the imagination, he was able to produce fantastic images: an optical instrument hung on a tree, a cross section of a beetle was transmuted into the bow of a ship, above which the skeleton of a fish floats in a smoky sky. Such was the origin of Ernst's famous collages – strictly realistic images that were transformed by mere displacement into fantasies, while the things they represented were metamorphosed into magical objects. De Chirico and Duchamp had achieved similar effects in their own ways. In Ernst's collages the magical experience of things was given a new expression which in turn led back to the zones of the unconscious and the 'automatic'.

In 1922 Max Ernst went to Paris where he played an important part in the development of Surrealism.

In Kurt Schwitters the magic of things, which we have seen gripping the imagination of modern man in all countries, assumed the proportions of a manic obsession. He devised a variant of Dada which he called MERZ. It happened in Hanover in 1920. The name explains nothing, it was a pure product of chance: while fitting the word 'kommerz' into a collage, Schwitters cut out the first three letters, so that in the end only MERZ remained. In practice it denoted pictures that were arrangements not of forms but of different materials. Schwitters had started out as an Impressionist; for a time he shifted to Expressionism, but then came across Picasso's relief constructions made of all manner of waste materials, and the collages of the Dadaists. He was fascinated. Gradually succumbing to a kind of deliberate obsession, he collected all sorts of objects – nails, hair, streetcar tickets, etc. – and pieced them together into compositions, out of things he created new things. The juxtaposition of various details which he felt to be magical resulted in a new atmosphere of reality. He regarded the thing as a kind of fetish that would protect him against the void. The objects he collected were densely crowded in their pictorial space. Then he conceived another idea: he undertook to build a 'cathedral' of things and for things. He built his first 'Merzbau' – as he called this gigantic construction – at his home in Hanover in 1924 and spent the rest of his life working on such structures (in 1937 in a farmhouse in Norway: since 1945 at Langdale, England, with the help of the Museum of Modern Art). The intension was for things to create a space of their own, an architectural monument to celebrate their stillness. Of course man could not enter or make use of such a space; it could only be contemplated. It was so crammed with 'litter' that there was no room left in it for 'people'. Here again we encounter the dread of space which uses things as a defence. In 1915 an artist as robust as Beckmann had written: 'Ugh, this infinite space! You have to clutter up the foreground in order to conceal its hideous depths.' In Schwitters' Merzbauten (of which only photographs exist) man's new relation to the thing no doubt achieves its most emphatic expression. In a kind of unconscious piety, man invokes the magic thing to whose spell he has succumbed, creating a visible image by means of which he hopes to exorcise the threats of the magical Other.

In 1919 Tzara and Picabia went to Paris where they resumed their Dada activities. They eventually joined a group of poets gathered round the magazine *Littérature* (founded in 1919), the most important of whom were Breton, Aragon, and Soupault. These writers were far more systematic than Tzara and felt that they represented a specific tradition running from Rimbaud and Lautréamont to Jarry and Apollinaire. They, too, aimed at expressing the unconscious, the world of dreams, the new magical experience of things, and they too experimented with the techniques of deliberately provoked accident, automatic writing, and distorted images and symbols. Thus it was perfectly natural

for them to make common cause with international Dadaism. However, the association lasted only two years, until 1921, when French logic triumphed over the chaotic turbulence of the foreigners. Significantly, the French Dada episode scarcely affected French painting and sculpture: among the Paris Dadaists we find only the names already familiar to us – Duchamp, Picabia, Arp, Ernst, Man Ray. In 1921 Breton sought to organise a congress of all modern intellectuals with a view to formulating a positive doctrine. Tzara was naturally opposed to this idea that was utterly incompatible with the *esprit Dada;* and, as a result, Breton and the other Frenchmen left the Dada movement. In 1922 Breton visited Freud and, with the help of psychoanalytic theories, developed an aesthetics which, taking up an earlier formulation by Apollinaire, he named 'Surrealism'. In this aesthetics the vague ideas of Dada, most of which had been discovered accidentally, were given systematic form.

## *The Aesthetics of Surrealism*

Like Dada and Futurism, Surrealism is a style of life rather than a style in the artistic sense. Like the other movements, it reflected the imperative need of the epoch to discard an image of reality based on logically ordered experiences and memories. The logical order was now felt to be false and superficial. The aim of Surrealism was to cast off the logical view of reality and by certain methods held to have a liberating effect to introduce man into a new, broader domain of experience, in which the artificial boundary between an outside world regarded as real and man's inner world (in process of defining itself) was effaced. It was this domain, which lies beyond the frontiers of the world of things, that Surrealism undertook to explore. Its purpose, in the words of Breton, was 'to resolve the previously contradictory conditions of dream and reality into an absolute reality, a super-reality'.

This conception is expounded in André Breton's first Surrealist Manifesto (1924). Based on the Dada experiments, it finds its literary tradition in the fantastic writers ranging from Gérard de Nerval, Lautréamont, and Rimbaud to Jarry and Apollinaire; it takes ideas from the German Romantics, particularly Novalis, from dialectical philosophy, particularly Hegel, and from Freudian psychoanalysis. Breton starts from the premise that absolute rationalism covers only a comparatively narrow segment of our experience, which, organised and mastered in logical terms, is mistaken for the whole of reality. Opposed to this rational universe, however, is another, no less real world of images rooted in fantasy, imagination and intuition which is striving to come into existence despite the resistance of reason and logic. The task consists in incorporating this broader, more inclusive realm of experience in our conception of the world; such a course is dictated by all the conclusions of modern aesthetics, psychological, and scientific thinking. Freud's psychoanalytic discoveries have defined this frontier zone as a psychic reality and pointed the way to methods of exploring it. Poets and artists, the true administrators of the domains of intuition and the psyche, are summoned to descend into the realm of the unconscious 'and to bring to light genuine *trouvailles* whose concatenation can be described as irrational cognition or poetic objectivity' (Max Ernst). Art conceived as aesthetic manipulation of form is uninteresting; it must be a *méthode de la recherche,* directly concerned with man and his definition of reality. The artist is nothing but a recording apparatus, his role in the mechanism of inspiration is entirely passive. Any attempt at 'active' control through logic, reason, morality, aesthetic would bring this mechanism to a standstill; but if the artist applies the proper liberating methods he can read his inwardness like an open book.

One of the most important ways of access to the dark region of the unconscious and its buried store of images and memories, which is closed to the logical procedures of the intellect, is provided by dreams. According to Breton, the vital impulses that express themselves through dreams and the spontaneous 'caprices of the imagination which *creates* real things' possess 'an immanent value of certainty'. Memory keeps alive such dream experiences and unconscious impulses even when we are awake. The suggestions of the unconscious influence the conscious mind. But since they emerge suddenly and unaccountably within the domain of logic and since we do not know their causes, they are excluded from this domain and relegated to the realm of 'chance', where the most fascinating experiences are doomed to silence, while the great words used to describe them – words such as 'baffling', 'sensational', 'extravagant', 'extraordinary', 'absurd', 'marvellous' – acquire a dubious connotation. However, this realm of the unexpected and 'accidental' provides a bridge to the inner world. When we dream, we do not even ask whether the things we see are possible; everything becomes easy and possible. In the strangest settings we witness the most extraordinary metamorphoses which seem absurd only to the logic that can find no explanation for them. But for the Surrealists the absurd points to the presence of a new reality which seeks to make its way into the reality frozen by our conventions, to enter into harmony with it. Hence Breton's article of faith formulated in his first manifesto: 'I believe in the future resolution of the seeming contradiction between the states of dream and waking in a kind of absolute reality, a super-reality.'

The aesthetic consequences of this doctrine are clear and simple: only the marvellous, whatever it may be, is beautiful. The marvellous alone can fertilise art and give the most pregnant expression to the human sensibility nourished by the unconscious. The artist's task is to make the marvellous manifest itself; in so doing, he may employ many different methods. On the representational level, he may be led to a method which was formulated in almost identical terms by the poet Pierre Reverdy and the painter Max Ernst: the bringing together of two seemingly incongruous things in a context that is alien to both, creates a forceful poetic reality capable of kindling the most intense feeling. The more unrelated the two elements of reality and the more arbitrary their juxtaposition, the more certain the resulting transmutation and the greater the evocative power of the poetic spark they release. Or, on the opposite side, the artist may operate on the psychic level and, in a state of purely passive receptivity, accept the work as an accidental gift, a '*fait gratuit*'. In a half-waking state, letting his pen run on automatically, he will record in his writing the whispering utterances of his uncontrolled thinking. Purely automatic writing brings to the surface images and associations which may be described as a direct '*écriture de la pensée*'. The result of this technique is the spontaneous, the marvellous, '*l'absurdité immédiate*'; in it the communications of the unconscious lay claim to reality. Hence Breton's definition: 'Surrealism = purely psychic automatism through which we undertake to express, in words, writing, or any other activity, the actual functioning of thought, thoughts dictated apart from any control by reason and any aesthetic or moral consideration. Surrealism rests upon belief in the higher reality of specific forms of associations, previously neglected, in the omnipotence of dreams, and in the disinterested play of thinking.'

This belief goes back to an old Romantic idea which had steadily gained ground in the twentieth century, and which is implied in Rilke's saying quoted above, that 'everything that links men and things has withdrawn into the depths' – the idea of the original unity between man and the universe. It was this idea that inspired Novalis when he compared the world to an animal in which we live as parasites, and whose constitution determines our own and vice versa. This intuition of a common original source was confirmed when psychoanalysis demonstrated the existence of a collective unconscious which can determine both the historical and personal expressions of the psyche and

which preserves in its depths a store of images that has defined reality from time immemorial. It was thought that man's unity with things could be restored at this deep level, situated below the level of the personal unconscious. This idea had already been present, in a comparatively mystical form, among the Orphists and in the Blaue Reiter group (particularly in Marc); Klee with his sensitive mind continually brooded over it. Now it became part of the system developed by the Surrealists, and in the Second Surrealist Manifesto of 1929 Breton formulated it exactly: 'there is every reason to suppose that at a certain spiritual level life and death, the real and the imagined, the past and the future, the utterable and the unutterable, the above and the below cease to be perceived as contradictions. It would be pointless to look for a motive for Surrealist activity outside of the desire to attain to that level.'

Surrealism developed a number of techniques and methods for opening the way to the store of images preserved in the unconscious. Their purpose is never to produce 'art'; all of them are conceived merely as instruments for exploring man's potentialities. Somnambulistic, visionary, and mediumistic states, hallucinations, intoxication, dreams, hypnotic sleep, and automatic writing undisturbed by conscious control, serve to provoke a flood of unconscious images which irrupt into the conscious, logical interpretation of reality. Under the compulsion of the artist's inner states, these images are expressed concretely in all their disquieting reality. In states of this kind, needless to say, sensory perception is deranged – we have here the *dérèglement de tous les sens* referred to by Rimbaud. The network of logic which covers our experience of the world is breached to make way for a flood of the fantastic, irrational, extraordinary – the unknown. Such 'derangement' of the senses can be provoked artificially without resort to drugs, hypnosis, etc., through training. 'The poet becomes a seer through long, extraordinary, and consciously practised dislocation of the senses,' says Rimbaud. In addition to deliberately provoked hallucinations, the Surrealists make the most of the baffling effects that result spontaneously from the candid or ironical combination of incongruous things or ideas. Thus the poets resort to puns and word associations suggested by sounds or radicals and engage in truly Cabalistic practices, in so far as it is 'Cabalistic to assume that two words or two vowels that are similar in sound are necessarily matched by two similar images' (Ambelain). The alogical, unique, and marvellous can also be brought to the surface by collective efforts. One man, for example, writes down a succession of words, which suggest a number of words to another man, and so on; the result of such collective automatism is a patchwork that makes no sense logically but spontaneously evokes countless associations and images. This was the technique that produced the collectively written Surrealist novels.

Drawings were composed in a similar manner – one man draws something, folds the page so as to cover it, the next man adds another element, and so on. The result again is patchwork, but composite drawings of this kind exert a peculiar fascination because of their very incongruity and absurdity, and the effect is occasionally quite striking. All such techniques aim solely at fixating strange, enigmatic, spontaneously emerging elements; and it has been established that the flood of images thus released contains unconscious instinctual expressions, impulses originating in the personal libido or in the realm of the pansexual, as well as demonic or idealised images of the anima.

This aesthetics was developed by the poets, above all, Breton, Eluard, and Pierre Reverdy, Breton being the theorist and the leader of the group. In 1924 the first Surrealist manifesto was published and the magazine *La Révolution Surréaliste* was founded. In the second manifesto (1929), the aims of the movement were formulated with greater precision. Important Surrealist exhibitions were held in London in 1936 and in Paris in 1947. The movement has survived to this day.

Several painters joined the movement at an early date. The catalogue of the first Surrealist exhibition (November 1925) includes the following names that are already familiar to us: Picasso, Man Ray, Arp, Klee, Ernst, De Chirico; the only new names are those of André Masson, Joan Miró, and Pierre Roy. In March 1926 the Surrealists founded their own Galerie Surréaliste, where in 1927 a new Surrealist painter was introduced, Yves Tanguy. In 1930 the Spaniard Salvador Dali joined the movement. The poets kept in close touch with the painters; Breton and Eluard wrote many prefaces for the catalogues of the exhibitions. In 1928 Breton published a book entitled *Le Surréalisme et la Peinture*.

Individual artists will be discussed in greater detail later on; here we are concerned only with the aesthetic principles of Surrealist painting. Going over the list of names represented in the first exhibition of 1925, we find that only Max Ernst and Hans Arp can be regarded as the initiators of pictorial Surrealism. These two artists clearly define the range of Surrealist painting: Hans Arp represents the idiom of abstraction, Max Ernst that of magical realism. The abstract branch of the movement – which was emphasised by Arp, Miró, and Masson – naturally resorted to pure automatism: lines and forms expressive of half-consciously perceived, inner impulses, images associatively suggested by the coloured surface. This automatism was sometimes enriched by technical manipulation – collage, the introduction of unusual materials, the inclusion of accidental elements, decalcomania, stamping, and other processes. The results were 'abstract', but sometimes the forms moved spontaneously into figurative and representational patterns producing the effect of an evocative pictorial script that seemed to rise from magical depths.

In this context, however, the other type of Surrealism which aims at bringing out the absurdity of the world of things is more important. This is the type represented by Max Ernst, Tanguy, and Dali. As their materials these artists make use of actual things, creating a chaotic, hallucinated, absurd dream world that is rendered with a meticulous illusionistic realism; fantastic perspectives in which incompatibles are brought together, isolated anatomical fragments composed into grotesque creatures, sinister-looking mechanisms and technological structures, marvellous, monstrous creatures, metamorphoses of organic abstractions – a chaos of hallucinatory evocative power. Here again associations provoked by objects, automatic combinations, artificially provoked accidents, the discoveries of images in amorphous, coloured surfaces, etc., serve to create a dream world. It is a dream about the world of things; as though touched with a magical wand, it becomes the magical 'Other', which is defined as such by its sheer absurdity. This brings us back to the main feature of this brand of Surrealism – its mode of experiencing the world of things. Surrealism is characterised by a special kind of animism: inanimate objects come alive, dead things take on a magic personality, limbs move uncontrolled by the organism to which they belong; in every case we confront things – things which, precisely because their surroundings are absurd and because they are brought together so incongruously, acquire a hard reality and a magical intensity we were never aware of before. And thanks to this new awareness developed from the absurd, we see 'real' things with new eyes; we make selections among them, isolate them and directly perceive – in a root, a mussel, a stone – the 'Other', which responds to us by revealing its true nature, or by a lie and a mystification. A 'found object' of this kind, the *objet trouvé* of the Surrealists, expresses a psychic experience through the immediate concrete reality of the thing. The evocative power of such objects can be enhanced with the help of artificial touches – the *objet trouvé aidé*; a new object can be composed from familiar objects – the *objet surréaliste;* in every case, the object acquires unexpected features by being defined through the absurd, giving rise to a new reality that we recognise as magical. The poets aimed at something very similar in the realm of the word. Hugo

Ball formulated it very exactly: 'We have charged the word with energies which enable us to redis-cover the New Testament notion of the word (logos) as a magical complex.' Like Marinetti, the Sur-realists sacrificed the sentence to the word, which was removed from its context and taken as a magical element. In so doing, they 'awakened and reinforced the deepest layers of memory' (Ball).

In this way Surrealism definitively codified the magical experience of things which, since the dis-covery of Rousseau, the Cubists, De Chirico and the metaphysical painters, and the Dadaists had successively attempted to define. There is no current in modern painting, however naturalistic, that has not been influenced to some extent by this magical vision of the thing, which raises it to the level of 'Greater Reality' and re-defines it artistically. When the definition is successful, the great contradictions between the self and the world are resolved in a higher unity.

The idea that at some point the inner and the outer coincide, we repeat, goes back to German Romanticism. Indeed, Surrealist Verism has a strikingly Romantic character. The dream land-scapes of Dali, Tanguy, and occasionally of Max Ernst are often amazingly reminiscent of Caspar David Friedrich and Carus. However, the animistic, primitive, magical, fetishistic vision of the thing was not developed by German Romantic painting, which is rather feeble, but can be found in Romantic literature, particularly in Novalis, E. T. A. Hoffmann, and Jean Paul.

The foregoing might suggest the question raised by Thornton Wilder in his *Ides of March*. Reflecting on the poetry of Catullus, Cicero remarks: 'If we are to be condemned to a poetry based on buried trains of thought, we shall soon be at the mercy of the unintelligible parading about among us as a superior mode of sensibility.' There can be no doubt that such 'parading' was an element of Surrealism once it became fashionable. But a few pages later, Thornton Wilder has Clodia utter this great truth: 'The world of poets is the creation not of deeper insights but of more urgent longings.' To have redefined in more exact terms these urgent longings whose goal was the Greater Abstraction and the Greater Reality, and a union of the two: this was the great historical achievement of Surrealism.

*The Experience of the Absolute*

While the search for the Greater Reality led, through heightened spontaneity, through a deeper intellectual understanding of the new realms of experience and sensibility, to more exact definition of the world of things as a magical Other, the concept of the 'Greater Abstraction' was similarly clarified and systematised. Kandinsky had interpreted abstract form as a spontaneous expression of human sensibility. In a kind of trance, he combined free coloured forms on his canvases. He described these works as artistic expressions of his states of mind, and justified them solely by 'the principle of inner necessity'. His art was a kind of abstract Expressionism.

Non-objective painting had come to stay. It was clear, however, that its elements – the formal relationships among the colours reflected in their order in the colour circle and spectrum, the contrapuntal use of line, the balancing of volumes, as well as the expressive functions assigned to these taken individually or in combinations – were governed by specific physical and psycho-logical laws. It was necessary to provide a theoretical foundation for the new abstract painting and its elements, which had come into being spontaneously – all the more so, because this painting had eliminated representational, descriptive images of things and relied solely on line and colour to suggest meaning. Increasing awareness of the importance of the abstract aspect of art was parallelled by an effort to create a kind of general canon of painting. The birth of abstract

192

painting was attended by determined attempts to formulate the laws governing line, form, and colour in terms of a theory of harmony and counterpoint. The painters found themselves impelled to go back to the elements, to begin with a theoretical analysis and practical testing of the simplest, most elementary forms, and as a result abstract artists were led to express themselves in more elementary ways, to use line, form, and colour more economically, in short, to subject themselves to the discipline of geometry.

At this point, however, a new idea emerged which proved of far-reaching importance. Abstract painting as embodied in Kandinsky's early works had shifted the emphasis from the outside world to the inner world; but its primary purpose was communication, its forms were pronouncedly expressive and dramatic in character. In other words, they were not conceived as autonomous, as reflecting a harmony subsisting in its own right and valid as such. The new idea was that the picture should be primarily an artistic reality in its own right, an object beautiful in itself, a construction rather than an expression of the artist's emotions; its beauty was conceived as inherent and objective. Cézanne and the Cubists had looked upon the geometrical structures underlying natural forms as an essential element of constructive beauty. They had brought natural forms and artistic forms closer to each other by subjecting them to common laws expressed in subtle harmonies and proportions. Thanks to this geometry, it became possible to construct the picture as an autonomous piece of architecture. It was argued that if the representational references were eliminated, what was left was an elementary geometrical order, whose elements could be used as building blocks in the crystalline construction of the picture. This new abstract art no longer emphasised expression, but construction. The harmony it disclosed – its immanent, self-contained beauty – now became the content of the picture.

Thus it came about that in the period (approximately from 1913 to 1920) in which modern art defined its attitude toward the world of things, it also defined its conception of the Greater Abstraction. During those years, the main emphasis of abstract painting shifted to the most elementary forms, with the result that it became something quite different from the extreme form of Expressionism it had originally been. While one current of modern art was characterised by the object conceived as a magical reality, the other was marked by the ultimate and purest element of pictorial construction: the square. And just as the new conception of reality was developed simultaneously in several countries, so the new abstract treatment of line and colour was developed simultaneously and independently in Russia and in Holland.

*Russian Suprematism and Constructivism*

In the years preceding the First World War, Moscow was chaotically receptive to the new currents in European art. In 1911 Vassily Malishchev, editor of *Novyie Puti* (New Roads), wrote: 'The gods are changing from day to day. Cézanne, Gauguin, Van Gogh, Matisse, Picasso, and even Van Dongen and Le Fauconnier have been exploited ruthlessly, without restraint or discrimination. Everything has been jumbled together in a pandemonium. Everyone tries to scream as loudly as possible, to appear as modern as possible.' Moscow was in close contact with Paris: the younger French painters were better known in Russia than in France. The first Fauve exhibition of 1907 was followed by an uninterrupted succession of ultra-modern shows. Year after year, beginning in 1905, the two great collectors Morozov and Shchukin imported dozens of major paintings from Paris; by 1914 they had collected more than one hundred Picassos and Matisses. Magazines such

as *Apollon* kept abreast of all modern developments in the world of art, and Russian painters repeatedly visited Paris. In 1914 Marinetti went to Russia, and his lectures in St. Petersburg and Moscow left a profound impression. As early as 1911, the first Russian group of Futurists was founded by the Burliuk brothers. From then on Cubism and Futurism enjoyed the greatest popularity in Moscow studios. Many artists also had personal contacts with Kandinsky in Munich, and Kandinsky for his part invited Burljuk, Larionov, Malevich, and Goncharova to send their works to the second exhibition of Blaue Reiter prints (March 1912) in Munich. Among the many schools derived from modern European movements, which thrived in the spiritual climate of Moscow (the city also had an intense political, philosophical, and religious life), three deserve special mention: Larionov's Rayonism, Malevich's Suprematism, and Tatlin's Constructivism. We shall discuss them in the chronological order of their appearance.

Rayonism was developed, beginning in 1910, by Mikhail Larionov (b. 1881) and his wife Natalia Goncharova (b. 1881). Starting from Signac's Luminarism and from Analytical Cubism, Larionov began to break up landscapes and figures into patterns composed of spots and ray-lines. Under the influence of Futurism he interpreted these abstract patterns as lines of force (the Futurists' *forze linee*). In 1912, perhaps inspired by Delaunay, he dropped all representational references, and constructed his abstract works out of sheaves of coloured rays. Except for the experiments of Kupka and Delaunay, Larionov's abstract Luminarism is, with Kandinsky's abstract Expressionism, the earliest variety of purely abstract painting. Moreover, in his Rayonist Manifesto of 1913 Larionov advanced ideas which obviously tended to play down expression in favour of construction, and abstraction in favour of the absolute. Rayonism was short-lived as a school of painting: its ray-lines were more suitable for stage effects. Larionov and his wife began indeed to work for the theatre, contributing designs for Diaghilev's Russian Ballets (from 1914 on, in Paris).

Larionov's anticipation of a constructive abstract art now led to a typically Russian phenomenon, almost Dostoevskian in its extremism. In 1913 Malevich exhibited a canvas showing merely a black square on a white ground. This act was as significant for the Greater Abstraction as Duchamp's ironic act of exhibiting – almost the same year – an object picked at random, a 'ready-made', was for the Greater Reality. Malevich's black square marked the beginning of absolute painting; Malevich with his Suprematism was its precursor.

Malevich's own definition – 'What I call Suprematism is the supremacy of pure emotion in art' – casts no light on the nature of Suprematism. Much more revealing is his account of its origin: 'In 1913, trying desperately to liberate art from the ballast of the representational world, I sought refuge in the form of the square.' In other words, his painting was a spontaneous act, inspired partly by despair and partly by faith, but essentially reflecting a deeper experience.

Casimir Malevich (1878-1935) had come to Cubism via Fauvism; in 1912 he constructed his pictures out of stereometric elements abstracted from natural objects, in a way reminiscent of Léger's explorations. But he felt that as long as he followed this method, the formal construction would inevitably be clouded by representational elements, by small stereometric forms, and by the turbid complexity of a pictorial space that was half geometric and half illusionistic. At this point Malevich, acting on a sudden impulse, proceeded to drop all disturbing elements from the picture, to start from scratch as it were; all that remained was the simplest geometric form – the square on the pure surface. (At about the same time Kupka in Paris began to move in the same direction.) What Malevich painted was not a 'picture', but, as he himself put it, 'the experience of pure non-objectivity'. But this radical negation was a source of development – it turned out to be the *punctum saliens* of an entirely new conception of abstract painting. The expressive and

194

descriptive elements of Abstract Expressionism were eliminated, the constructive elements won the uppper hand; it became possible to conceive of painting as a self-contained architecture of elementary and absolute forms. The square on the pure surface was more than a spontaneous symbol of the 'experience of the non-objective'; it proved to be the first corner-stone of absolute painting.

Malevich's simple geometric figures were followed by richer constellations. He began to use trapezoid and elliptical forms and to include diagonals in his compositions. Not until 1915, however, did he attempt to go beyond the two-dimensional surface, to introduce depth in perspective drawings of solids. By 1917 he had arrived at a kind of abstract linear architecture which discloses great similarities to the works which the Stijl artists were producing quite independently at about the same time.

Malevich attracted a group of young artists, one of whom, Rodchenko, broke away to start a movement of his own. Rodchenko was a fanatic for geometrical aesthetics; his linear figurations are all constructed with the help of compass and ruler, but since they lacked genuine elementary purity they tended to assume the character of decorative patterns. In 1920 Rodchenko declared that painting was dead and turned to typography, advertising, and industrial design.

El Lissitsky (1890-1947) studied at the Darmstadt technical school from 1909 to 1914. In 1919 he joined the Malevich group and, under the influence of Malevich's perspective constructions, drew and painted a number of compositions based on stereometric elements. These works, which he called 'Prouns', steer a middle course between painting and architectural ornament.

By 1922 the Suprematist movement started by Malevich, in conjunction with the theoretically more solid Stijl tendency that had grown up at the same time, began to exert considerable influence on European art. Lissitsky and Moholy-Nagy brought these ideas to the Bauhaus. Kandinsky was to some extent influenced by Suprematism during his stay in Russia after the outbreak of the war in 1914. Malevich visited the Bauhaus in 1926, and his book, *The Non-objective World* (Moscow 1915), was published in German translation by the Bauhaus in 1927. Through the Bauhaus these new ideas fertilised all modern architecture and industrial art.

This unsentimental art with its emphasis on the geometrical architecture of the picture received important impulses from Russian Constructivism, which parallelled the Suprematist explorations in the three-dimensional medium; in other words, it was closer to sculpture. Its roots lie in Cubism and Futurism. In 1913 Picasso had made three-dimensional collages, constructing reliefs of wood, glass, string, and other materials. As early as 1912 Boccioni, in his highly significant manifesto of Futurist sculpture, had declared that sculpture must get away from conventional materials and, instead of confining itself to one material, create works from glass, wood, cardboard, iron, cement, horsehair, leather, fabrics, mirrors, electric light bulbs, etc. The proper task of this art, he said, was to create plastic figurations in space; classical sculpture with its masses disposed around a central axis must be transcended, and sculpture must be defined as the art of 'transposing into material forms the spatial planes that enclose and traverse an object'. Boccioni had interpreted the world of objects and its dynamism in keeping with the Futurist theory (object+environment), and had conceived the idea of introducing movement into sculpture by means of mobile constructions. These ideas, which from 1911 on were shared by the sculptor Archipenko, were now taken up by the Russians, who gave them an abstract slant. As early as 1913, Vladimir Tatlin (b. 1885), a pupil of Larionov, made his first entirely abstract relief construction of glass, metal, and wood. In 1915 he removed his stereometric figures from the ground and hung them on wires. In 1919 he became interested in projects of monumental architecture and drew up plans for the Monument of the Third International, a slanting steel structure which

spiralled to a height of over 1300 feet; inside it three differently shaped stereometric elements were to rotate at different velocities. In 1920 a gigantic wooden model of the project was exhibited in Leningrad.

Tatlin's movement acquired new strength in 1917 when the brothers Naum Gabo and Antoine Pevsner returned to Moscow after the outbreak of the revolution. Pevsner, a painter, had met Archipenko in Paris; Gabo, who studied mathematics in Munich, had constructed mathematical models. At the outbreak of the war, they found themselves stranded in Norway; in 1915, they began to construct reliefs, which were at first representational (in the manner of Boccioni and Archipenko) but grew increasingly more abstract. Tatlin's Constructivist works encouraged them in this direction, and from 1917 on they were the most active and significant among the Russian Constructivists.

Like Suprematism, Constructivism gave rise to a purely abstract art working with stereometric elements. From an aesthetic vision of the world of technology, it sought to derive a modern absolute harmony free from subjective lyrical elements. Its works were not reproductions of things, but were themselves things with an absolute existence of their own; they were 'organised beauty', reflecting the emotions aroused by mathematics and technology.

This Russian modernism became dominant with the Revolution. Up until 1921 Constructivism was regarded as the style of the proletarian revolution. It seemed destined for this role by its exaltation of technology, its dynamism, and the declamatory eloquence with which it adorned the festive rites of the masses. Trotsky and Lunacharsky encouraged it, and it was on the strength of these tendencies that Hitler and his followers later coined the term *Kulturbolschewismus*. In 1921, however, when Lenin promulgated his New Economic Policy, the Russian government began to frown upon all modern art movements as unsuitable for political mass propaganda. Lenin who had witnessed the goings-on of the Dadaists during his Zurich period — he lived next door to the Cabaret Voltaire — described the Russian modernist movements as 'a left-wing infantile disorder'. Socialist Realism was now hailed as the proletarian style. It is the style of all totalitarian regimes. To this day abstraction and stylisation are looked upon in Soviet Russia as 'deviations'. Lenin's pronouncement spelt the end of Constructivism in Russia. In 1922 Kandinsky, Pevsner, Gabo, and Lissitsky left Russia for Berlin. Kandinsky received an appointment at the Bauhaus; Gabo stayed in Berlin until 1933; Pevsner went to Paris; Lissitsky worked in Berlin, Hanover, and Switzerland, and at an early date made contact with Van Doesburg of the Dutch Stijl group. Through these emissaries, Russian Constructivism exerted a considerable influence on architecture and industrial design in Central Europe. This influence was parallelled and reinforced by the Stijl group.

*De Stijl and its Aesthetics*

What took place in Russia had its exact counterpart in the Stijl movement in Holland. Like Moscow, the Dutch cultural centres were in close contact with Paris; here too Cubism provided a powerful impulse, here too the revolutionary spirit that had seized upon intellectual life all over Europe was at work. It influenced many different individuals — painters, architects, sculptors, poets — in many different places, but always in the same direction. Van Doesburg, who himself contributed so crucially to expressing the new sensibility, describes this state of mind very aptly: 'At very different places and in very different forms the new spirit emerged and suddenly rose

196

crystalline to the surface of reality.' But the new spirit was far removed from the theatrical anarchism of the Russians: it was sober, logical, clear and energetic, intent upon a truly engineer-like neatness and attention to detail. It was the spirit of Holland, Puritan, neat and orderly, inclined to geometrical clarity. This was Holland's hour of greatness. Van Doesburg with his keen intellect and Piet Mondrian with his meditative mind were seconded by outstanding architects. Two lines of development joined to form the core of the new style: (1) the internal development of art itself striving to achieve an absolute objective harmony by reducing the formal means to their constitutive elements, and (2) the development of industrial, technological, and architectural design toward clarity and 'functional purity'. It was the painters, however, who by long years of experimentation had given visible form to the new aesthetics and prepared the sensibility of the epoch for the experience of functional purity. For, as Brancusi put it: 'The difficulty lies not in making things, but in creating the conditions under which we can make them.' It was the painters who created these conditions.

In August, 1914, the painter Piet Mondrian who had been living in Paris since 1910 was on a visit to Holland. The outbreak of the war prevented him from returning to Paris. Stimulated by Analytical Cubism, he had been engaged in subtle investigations with a view to reducing the formal geometrical patterns that could be abstracted from nature to their simplest elements set in a framework of horizontals and verticals. By this extreme simplification he hoped to give the clearest pictorial expression to the harmonious relationships governing natural forms. He had now come to the point of picturing the rhythms of a natural phenomenon – the movement of waves towards a jetty, for example – by a geometrical pattern of small strokes and crosses that expressed the natural rhythm in subtle numerical proportions. He soon generalised this procedure: instead of treating special cases and analysing given motifs, he began to investigate elementary pictorial relationships capable of expressing the formal pattern of a more universal rhythm. At this time – 1916/1917 – he met Bart van der Leck and Theo van Doesburg. Van der Leck had just stopped painting his flat rigorous geometrical figurative compositions in the three primary colours (red, blue, yellow); in 1917, he experimented with balanced arrangements of the simplest geometrical figures (rectangles, triangles) in the three primary colours on a plain ground (after 1919, he went back to angular figurative silhouettes, and broke with the Stijl group for good). As for Doesburg, he had begun in 1916 to render natural forms (dancers, cows, etc.) in a rigorously geometrical way, by transposing the representational elements of the natural image into a closely-woven pattern of horizontal and vertical rectangles. The three painters realised that they shared the same aspirations and decided to work together. In 1917, with the architects J. J. P. Oud, Wils, Van 't Hoff, and the sculptor Georges Vantongerloo, they founded De Stijl. In October of the same year, the group published the first issue of its magazine, also entitled *De Stijl*. From then on the development was rapid. Mondrian took over Van der Leck's system of rectangular planes in primary colours on a plain ground and dropped all representational references. Towards 1920 he arrived at his definitive pictorial form: narrow black bands subdivided the surface into rectangular fields in grey and in primary colours. Thus the formal elements of the picture were simplified to the utmost. The flat surface is the ground with which the picture begins and ends. It is subdivided into rectangular compartments in the primary colours alternating with black, white, and grey. The painting is a balanced harmonious structure of irreducible, that is, universal elements.

The elementary law of Neo-Plasticism – as Mondrian named this style of painting in 1920 – can be easily formulated after the fact: harmony is a balance of contrasts (this goes back to an idea

of Seurat's). The most elementary contrast is that inherent in the right angle; constant balance is expressed by straight lines at right angles to one another. Accordingly, only lines meeting at right angles can be employed in elementary art. Since overlapping lines suggest depth, so impairing the elementary flatness of the surface, these lines must appear as narrow bands that are tied as it were to the surface. The bands that give form to the surface constitute a system of rectangular fields, which are articulated and enriched by colour. The realm of colour is reduced to two basic groups: on the one hand, the primary hues, red, blue, and yellow, and on the other hand, the 'non-colours' black, white, and grey. It is only with these elements, arranged according to relations of form and colour, that one can express an elementary and hence universal harmony, entirely free from individual suggestions and representational associations – pure architecture, a pure harmonic art.

For all their seeming simplicity and matter-of-factness, these conclusions gave rise not only to a new aesthetics but to a whole ideology that was to revolutionise architecture and the forms of our technological environment. These painters were in close touch with architects, and as early as 1917 van Doesburg collaborated with Oud in applying the principles of the new school to architecture. Vantongerloo translated them into sculpture, creating formal, well-balanced constructions with the most elementary sculptural element, the cube. But this harmony of well-balanced cubes, based on the most elementary contrasts between horizontals and verticals and between solid bodies and space, is the original principle of architecture – not only in regard to aesthetic forms, but also from the standpoint of the laws of construction. Modern engineering, it was felt, could give these laws their purest expression if only it wanted to. The steel structure of the building engineer was an example of such a harmony of contrasting forces, in which support and weight, thrust and pull, cancelled each other out, giving rise to a simple harmonic balance of elementary tensions. The structure was the visible embodiment of this harmony. To give it the clearest expression by means of proper accents was the *artistic* task of the engineer-architect. In addition he could employ the resources of painting – colour. Elementary colours could provide the balanced structure of interacting elements with visual accents and enrich it with a new contrasting harmony. Thus architecture could become the collective product of artists and technicians – painters, sculptors, architects, and engineers. An easel painting was no more than a guiding example and object of meditation – a kind of mathematical and technological icon – by means of which the creative spirit could repeatedly commune with the universal harmony. But the artists of De Stijl aimed at something far more significant – the highest achievement of architecture, a metropolis, an anti-nature, in which the tyranny of nature would be supplanted by a purely man-made harmony and in which art and life would no longer be divorced from each other.

Once the elementary structure of Mondrian and Doesburg were transferred from the pictorial surface to the three-dimensional medium, architectonic compositions were gradually developed, which served as basic patterns for modern buildings consisting of cubical blocks. All functionless decoration was eliminated, and the contrasting effects of solids and space were stressed. Beginning in 1921, the Stijl architects were enabled to apply their ideas: Oud designed the workers' settlement in Rotterdam, Jan Wils the garden city in the Hague, Ritveld in Utrecht, and Van Easteren in Amsterdam. The most important innovations in the design of furniture, objects of daily use, typography, poster design, and industrial objects originated in this new 'elementary' style. De Stijl exerted an extraordinary influence on European architecture. The ideology of the movement, including its ethical and social implications, guided a whole generation of architects and designers. It gave a decisive impulse to the Bauhaus, to Gropius, Mies van der Rohe, and others.

A number of far-reaching ethical and philosophical ideas associated with 'Neo-Plasticism' recur continually in the manifestoes of De Stijl – truth, definiteness, clarity, simplicity, the constructive, the functional, the collective, objectivity, law. The fundamental concept was that of *Gestaltung* (formation, form-giving, plasticism). Outside nature was regarded as the paradigm of the formless, the vague, the arbitrary, the indefinite. *Gestaltung* on the other hand was synonymous with the order man imposed on nature. Culture in all its aspects was equated with independence from nature. 'By destroying the natural proportions, the artist brings out the elementary plastic proportions' (Doesburg). With these elements he could create a harmony which imposed a spiritual order on the world and life, and expressed this order.

The machine was looked upon as an important formal expression of the modern style, the modern manifestation of spiritual discipline, the means of controlling nature and subordinating it to a human order. The machine revealed a new kind of beauty, whose formal and expressive potentialities could be discovered by the artists and developed into an aesthetics of the constructive and the mechanical. Constructive clarity and mechanical discipline were regarded as the essential imperatives of art.

With the help of the basic elements, discovered by disciplined reduction, it was possible to represent harmony pictorially, as an abstract construction. This construction was objective, not individual. Subordination of the individual to the community was held to be one of the social goals of the modern age. The new art was thus looked upon as concomitant to the social aspirations of the epoch. Accordingly, the task of art could no longer be to create individual and private things – paintings and ornaments requiring private surroundings, but to meet collective and social needs by means of building and city planning. Only when painting, sculpture, and architecture worked collectively to produce an integral form, would the great dream of the artist – to place man within art rather than outside it – come true. Then art and life would be one.

The aim of this new style was to liberate man from the arbitrary and accidental; its content was to produce an elementary harmony based on expressive contrasts, a harmony which would embody an essential balance, a reflection of the universal harmony. Here the human mind would find repose. 'The style of the future will above all be a style of liberation and vital repose.' Nothing superfluous, nothing 'artistic' – 'first and foremost truth, function, construction, no flaws resulting from individual reflection' (Doesburg).

In this new vision of life, the old tragic dualism opposing an imaginary spiritual world to a concrete material world was to be transcended in the knowledge of an indivisible universal reality. Art is discovered and created in matter: this calls for an ethical conception of the raw material of art, for care in the treatment of it and the energies contained in it: 'In embodying aesthetic ideas in matter, a way of life is created, which does away with the separation of the beyond from reality. This transformation of life into a totality ushers in the new culture.' *Gestaltung*, in the last analysis, means 'the supra-rational, the balance between the inner and the outer, the depths rising to the surface, achievement in a creative struggle with ourselves' (Doesburg).

Even though it was painting that created this style and its aesthetics, only architecture, after incorporating the artistic energies of painting, could realise it materially. The painters contributed the idea, but only the needs of the collectivity would produce a style. The breadth of the conception of style here envisaged is indicated by these words of Doesburg: 'I should like to call this style the style of the complete man: that is to say, the style which resolves the great contradictions. To everything we have called magic, spirit, love, etc., it gives reality.'

This inspiring and optimistic ideology and its accomplishments rapidly gained support among

modern artists. In 1920, on a lecture tour in Germany, Van Doesburg met and won over to his side the architects Gropius, Mies van der Rohe, Le Corbusier, Mendelsohn, and Taut. In 1921-1923 he taught at the Bauhaus and in Berlin, spreading the ideas of De Stijl. In 1923 he organised a Stijl exhibition in Paris (whither Mondrian had returned in 1920). He soon found new adherents among painters — Vordemberge-Gildewart in Germany and Domela in France.

But the new adherents and the influence of Russian Constructivism (Lissitsky) and abstract Surrealism (Arp) brought a gradual relaxation of the austere doctrine. In 1925 Mondrian broke away from the movement: a rigorous purist, he disapproved of the new, broader tendencies. Van Doesburg, who had been working with Arp since 1926, published in his magazine the manifesto of a more dynamic conception of the principles of De Stijl, which he called Elementarism. Although the changes he advocated were confined to a freer treatment of coloured rectangles and the introduction of diagonals, they undermined the uncompromising rigour that had been the strength of the movement. By 1931, when Doesburg died and his magazine ceased publication, De Stijl had made its peace with Constructivism and other varieties of abstract painting. The movement survived in the Paris Abstraction-Création group (founded in 1931); here for a time it represented the radical wing of abstract painting and regained some influence after the Second World War thanks to Vordemberge-Gildewart, Domela, and Herbin.

The only painter who clung with ascetic devotion to the original principles of De Stijl was Piet Mondrian.

*Piet Mondrian (1872-1944)*

The genius of Piet Mondrian can be understood only in the light of his personality as a whole. He was a true mystic, yet he admired technology; he was interested in theosophy *and* in jazz; he enthusiastically welcomed everything that was new in modern life, and believed that contradictions of the contemporary world could be resolved in a synthesis which would inevitably bring about a more balanced relationship between man and nature and between man and society. Like the great enthusiasts and optimists of the Age of Reason, like the Utopians Saint-Simon or Proudhon, he believed that human society was moving towards an ideal order, and that the artist's task was to hasten its advent. Man can be happy, Mondrian held, only if his physical and moral needs are gratified. The aesthetic, he believed, is an expression of a collective moral ideal, and once a pure art reflecting the true universal order is created, art will be a convincing illustration of the new state of balance, hence a vital force, transforming life itself; resolving all conflicts, and bringing about a higher state of happiness. Throughout his career, Mondrian was *consciously* opposed to the tragic. He was that rarity, a great religious mind, a secular saint inspired by an unflinching faith that if he could heal the breach even at a single point, the whole world would be redeemed. Thus his paintings, composed of a few coloured squares, are not merely the artistic exercises of an eccentric and highly dogmatic Puritan — they are exercises in the spiritual, almost ecclesiastical sense, products of a mind contemplating and reflecting on the cosmic order, objects of meditation, which make us aware of the existence of a universal harmony. It is this faith that impelled Mondrian to work on his canvases until they became icons of an elementary truth.

Mondrian followed a long path of unremitting austerity and simplification. This path led from the naturalism tempered by the Impressionism of his academic years at Amsterdam, to Jan Toorop's linear stylisations, and finally, in 1908, to Matisse, that is, to emphasis on the surface and on pure

colour. In 1910 Mondrian moved to Paris, where Cubism – Léger and Picasso – attracted him by its rigorous architectonic structures. He now began to develop the formal structure of natural objects by breaking them up analytically, but he soon came to the conclusion that Cubism was 'more or less naturalistic', not enough concerned 'with the logical consequences of its own discoveries'. For several years he laboured to purify the formal geometric patterns taken from nature and bring them into conformity with the requirements of the picture, considered as a flat, bounded surface.

During those first years in Paris Mondrian did his paintings in series, starting out with sketches of trees, landscapes and still lifes, which he then simplified, stylised, and made more abstract in his studio, transforming them into representations of formal relationships and rhythms firmly tied to the surface. In the course of this work, the forms were gradually reduced to their elementary expressions: curves were supplanted by straight lines, diagonal planes were replaced by planes parallel to the frontal plane, and all confused rhythms were disciplined and subordinated to the elementary contrast between verticals and horizontals. The result was a refined geometrical pattern gently modulated with subdued greys and ochres. In Holland, where he was stranded in 1914, he carried his simplifications further, divesting his abstractions of individual and emotional elements. He now incorporated the gentle spatial modulations of the Cubists into the flat surface and reduced the geometrical skeleton to its two basic elements in the form of small horizontal and vertical strokes. But Mondrian still felt that he was 'Impressionistic', dependent on turbid natural appearance. It was during those years in Holland that he hit upon the crucial insight that aesthetic harmony is fundamentally different from natural harmony; that genuine abstraction – 'real abstraction', as Mondrian called it – could never be achieved by stylising natural harmony, by abstracting from it, since natural harmony could be regarded only as a very inadequate embodiment of universal harmony; he decided that the universal harmony was obscured by the forms of objects. 'The emotion of beauty is always obstructed by the appearance of "the object"; therefore the object must be eliminated from the picture.' The universal can be expressed only as pure beauty, as a consonance of pure relationships, as harmony, as balance of contrasts. Pictorially speaking, the composition is reality. However, it is obscured not only by 'the natural', but by the individual as well. The individual elements create a lyricism that mars pure beauty; they produce not universal harmony, but lyrical emotion. Objects and emotions make pure 'plastic' art impossible, because they always call for limited form and particular representation.

Mondrian had reached this point in his thinking when, in 1916, he met Van der Leck and Van Doesburg, from whom he took a number of important ideas concerning colour and the planes. Up until then, Mondrian had only reduced the scale of his colours; he had not reduced them to their constitutive elements. Now, having met Van der Leck, he recalled Seurat and the Divisionist theories of pure colour, and realised that the primary colours – red, blue, and yellow – could serve as the building blocks of the elementary art he was striving for. Now, colour appears in the pictorial organism as a plane. The outline of the plane makes it a coloured form. But elementary form is based on the elementary contrast between the vertical and the horizontal. Consequently, the elementary component of the pure harmonic picture is a rectangle in one of the primary colours, embodiment of the purely horizontal-vertical order. From 1916/17 on, Mondrian's paintings were balanced arrangements of coloured rectangles on a bright ground. However, these rectangles still suggested an illusionistic space, and their effect was still that of isolated limited forms. Associative elements still disturbed the pure 'plastic' form. To eliminate these, Mondrian moved his rectangles together; thick verticals and horizontals divided the entire canvas into rectangles, which were now defined

not as limited forms – rectangles – but as integrated compartments of the surface. 'I brought the rectangles together. The pictorial space became white, black, or grey; the form became red, blue, or yellow. To bring the rectangles together amounted to extending the verticals and horizontals of my earlier period so that they traversed the entire composition. It was clear that rectangles, like any individual forms, influence one another, and must be neutralised by the composition. After all, rectangles are never an end in themselves but a logical consequence of the lines that define them; they are produced spontaneously by the intersection of horizontal and vertical lines. To divest the compartments of their character as rectangles, I later reduced my colours and stressed the intersecting lines that served as their boundaries. Thereby the planes were separated and eliminated and moreover the relationships among them became more active.'

Towards 1920 Mondrian discovered the final solution: a well-balanced harmony, produced by the basic pictorial elements – verticals and primary colours, and, contrasting with these, horizontals and the 'non-colours', blacks, whites, and greys. He had arrived at an elementary art by way of continued reduction. Through its isolation each element achieved its complete, untroubled individuality and disclosed the contrast that constituted its pure being. The elements and their contrasts were related in such a way as to produce an elementary balance, an aesthetic harmony conceived of as an absolute human value, free from natural and individual descriptive features. The ideas of Seurat and Cézanne were thus carried to their ultimate consequences.

This active creation of 'nothingness' proved to be a fundamental creative act. In it 'the abstract' was posited as an *absolute* value. In Kandinsky the form was still the particular symbol of an emotion; now the composition itself was 'plastic' expression, the work was 'plastic' object, the pictorial organism a personality in itself and no longer an analogy to its creator's personality at the time he created it. Abstract form was established as a reality in its own right.

At this point a linguistic problem arose. The term 'abstract' still carried a vague connotation of the activity of 'abstracting' from nature or emotion. Moreover, it served as an antonym for 'real'. But now it was the purely pictorial form that appeared as eminently 'real' and 'concrete'; it existed in its own right, a fully-fledged artistic reality. That is why Mondrian referred to his own style either as 'Neo-Plasticism' (a term which he himself had coined) or as *peinture abstraite réelle*. In 1930 Van Doesburg proposed the designation 'concrete', and since then there have been constant discussions as to the proper name for this style. These terminological discussions provided additional evidence that absolute forms and relationships were now acknowledged as fully real.

In the realm of abstract form modern man found a specifically human reality, opposed to the reality of nature: it offered him the possibility of achieving inner balance. Art was summoned to define the implications of this reality and to embody it in man's life – that is to say, to reshape our environment into a harmonious whole. Painting was merely to show the way. 'In the future, the tangible embodiment of pictorial values will supplant art. Then we shall no longer need paintings, for we shall live in the midst of realised art. As life acquires greater balance, art will disappear. Today art is still of the highest importance, because thanks to it the laws of balance can be directly visualised.' In this vision of universal happiness, Mondrian included the individual. To bring about a universal harmony was to eliminate the tragic, which arises from the imbalance between the individual and the universal. The divorce between the self and the world was responsible for the emergence of a tragic art. This art was individualistic; it thrived on the disproportion between the individual mind and the universal, and expressed this subjective feeling. 'But art should directly express the universal within us, that is, the true appearance of that which is outside ourselves.' The universal is eternal, unconscious, immovable, as opposed to the individual, the conscious, the moving. 'Our whole being

is both unconscious and conscious, permanent and transient... Rising permanently above all suffering and joy is balance... This balance, unconscious and permanent, is the source of art.' The task of art is to render these balanced relationships pictorially, to make the indefinite definite; for this reason, it has always been impelled to define the vague phenomena of nature with ever greater clarity. But Neo-Plasticism does away with this limited form of the natural, individualistic, and tragic, 'and creates a representation in which subject and object, the encompassing and the encompassed, are of equal value – a balanced duality of the individual and the universal; with this "duality-in-multiplicity" the new spirit creates a purely aesthetic balance'.

Such were Mondrian's conclusions; all this entered into his art. Here again we have an attempt to overcome the tragic view of life that we found at the root of modernism, of the turbulent revolutionary movements of the modern mind. It was an attempt to penetrate to the ultimate source of pictorial art and, with the help of its simplest elements, to develop a harmony that would restore the universal and do away with man's tragic isolation.

Art does not create objects of practical use; it creates images for spiritual needs. The images devised by Mondrian reflected a profound spiritual need – witness the profound influence his thinking has exerted on the shaping of our environment, especially on architecture. His images actually become icons in which modern man contemplates the phenomenon of balance as an elementary truth, an intimation of the universal harmony.

Mondrian never looked upon painting as an end in itself, but merely as a beacon pointing the way towards a new human order. His dream was Metropolis, a counter-reality shaped by man in opposition to nature. During the last years of his life which he spent in New York – he left France in 1940 – he modified his vision. The quivering neon lights, the dynamism of New York, the staccato rhythms of American jazz led him to adorn vertical and horizontal bands with a mosaic of colours; his compositions acquired a peculiar throbbing rhythm. Mondrian never regarded his painting as final but merely as the latest stage in the exploration of pure form. He strove to explore the realm of the pictorial means down to its primordial level, to erect the ultimate and most elementary paradigm of formal harmony at the very frontiers of the domain that lies 'beyond painting'.

## Review

Reviewing the period just analysed, which essentially covers the First World War and a few years after it, we find that it was marked by two symbolic acts of profound significance. Both went beyond 'art'; both were spontaneous expressions of a state of mind composed of irony and despair, and in their spontaneity both defined unconscious longings of the epoch. The first act was performed by Duchamp, when he chose an object at random and placed it in a strange environment as an image of the Other, whose accidental but very material presence invested it with the very unrealistic dignity of a magic thing, a fetish. In this act, the modern experience of the object was defined as the experience of the magical Other. The second act was performed by Malevich when, in order to define in the most rigorous manner the opposite of the world of natural appearance, he declared a black square on a white ground to be a painting. In this act, the modern experience of form was defined as the experience of a concrete reality, which belongs to the human mind alone, and in which the mind represents itself. The two acts, as we have just said, have nothing to do with 'art': they were demonstrations, they marked off the frontiers of art at two opposite poles of human experience – the absolute thing and the absolute form, the reality of nature and the reality of man.

Starting from these two positions, a new aesthetics defined the whole field of human expression: Duchamp, the metaphysical painters, and the Dadaists provided the foundations of Surrealism. All of them contributed to defining the aesthetics of the magical experience of the thing. Since then, there has been no painting concerned with images of things, whether naturalist or Impressionist, which does not to some extent reflect this experience. Nor can there be such a painting under the conditions that govern the modern experience of the world.

Cubism, Suprematism, and Constructivism laid the foundations of Neo-Plasticism. Neo-Plasticism formulates the aesthetics of absolute form as a concrete aesthetic reality. Since then there has been no emphatically 'abstract' painting that does not to some extent reflect the experience of absolute form as a concrete reality. These two branches of artistic theory cover the totality of modern man's artistic experience – the experience of the outside world and the experience of the inner world. All the manifestations of the modern spirit in art move between these two poles: the absolute (magical) thing and absolute (magical) form. This accounts for the baffling and frequently noted fact that since Neo-Plasticism and Surrealism there have been no distinctly new movements, no truly new 'isms': they are simply not possible. The vast field of modern aesthetic experience of the world and the self has been marked out in its dimensions; the task is now to take true possession of it, and to make it so rich, interesting, and habitable that it can become the real home of the modern spirit in its countless social aspects.

Does this mean that we are doomed to settle down in a hopelessly divided world, torn between diametrically opposing tendencies, and that the stylistic expression of our epoch must be characterised as 'ambivalent' – an epithet we hear so often? Such a conclusion would be superficial. The very artists who have so uncompromisingly asserted one or the other of the two aspects of art, Breton and Mondrian, have also expressed their aspiration, rooted in a profound experience, towards the unity of man and the world. The Surrealists thought that by reaching into the deepest zone of the unconscious, where the world is defined in images of things, they could effect a union of the individual and the universal. Mondrian thought he could attain to universal harmony by means of his Neo-Plastic art. Both were inspired by the same faith in a higher unity, in which the cleavage between the world and the self could be resolved in a new balance having nothing to do with the mystical stereotypes of the old metaphysics. It is this faith that strives painfully to express itself as the style of the new epoch. It is a style of great range, spanning the vast domain extending between the extremes of the Greater Reality and the Greater Abstraction, but conscious of its essential unity. In it the tragic view of life may be regarded as transcended by a new harmony, whose outlines are beginning to emerge.

BOOK FOUR

Towards a Comprehensive Style

Art between the Wars

*Art between the Wars*

The immense political and social upheavals which followed the First World War had only a marginal effect on the development of art. For in art the basic revolutions had already taken place. But the post-war world offered art and artists a more favourable climate. Not as traditional as their prede-cessors, the new ruling classes were far more amenable to modern art. Almost everywhere 'modern art' came to be recognised – with enthusiasm or distaste – as the legitimate stylistic expression of the day. The passion for novelty was strong in these post-war years, and moreover people were getting used to the modern trends. But there was still another reason for the increased popularity of modern art, namely its own inherent development. The pre-war years had been marked by a headlong advance to extreme positions. The general stylistic pattern had been laid down. Now the artists undertook to settle the realms thus marked out and to give the pattern body, breadth, and depth. As might be expected, the most extreme positions were abandoned or regarded merely as theoretical founda-tions for rich new developments.

Furthermore, a reaction, for which it would be easy to give both a historical and a psychological explanation, set in. In the second decade of the century all the numerous trends in modern painting – even German Expressionism – had veered towards abstraction. Now the pendulum swung back to objective reality and the striving to master it under the new artistic conditions. The dominant trend of the third decade and indeed of the whole period between the wars is a renewed interest in nature, coupled with an endeavour to re-interpret it. The developments in abstract painting received much less attention.

Again, of course, the new ideas and impulses made themselves felt throughout Europe. The artists of the different countries were united by close ties. And yet, though the central problems emerged on a European plane, the national factors stood out more prominently than before. In order to bring out these factors and give a clear picture of the rich achievements of the years in question, we shall take up the main countries *separately*, beginning with Italy.

We have seen in the last book that it was the Italians with their Pittura Metafisica who first gave expression to the new experience of the 'thing'. This is explained by the Italian tradition. As interest now turned to objective reality, it was again the Italians who proposed a plausible way. Immediately after the war, Italian painters, by pursuing the ideas of Pittura Metafisica, found their way to a kind of archaic realism that seemed eminently compatible with the classical Italian tradition. In a post-war world exhausted by the war and thirsting for substantial, reliable values, this tendency for a time gave Italian painting a kind of leadership. All the objective currents that made their appear-ance in the twenties, 'Neue Sachlichkeit' (the New Objectivity), 'Magical Realism', 'Neo-Classicism' owed a considerable debt to the Italian development.

*Italian Ideas*

Perhaps only a devastating war could have put an end to the fanatically theoretical movements of the preceding period; perhaps Carrà was right when he declared in 1919: 'Now that the war is over, we are beginning once more to regard life as a dialogue of man with his own soul.' Amid this

new-found composure, the polemical spirit waned; men became distrustful of theories that claimed to represent the whole truth.

Even Pittura Metafisica had been far less a theory than an attitude embracing a large measure of human and artistic understanding. It had striven for quiet grandeur and clear form; these, it asserted, were the essentially Italian values which accounted for the greatness of early Italian art.

Impressionism, Carrà now declared not without reason, was the very antithesis of *italianità*. By this he meant that the attempt to capture fugitive appearances, begun in Impressionism and intensified by Futurism, was a deviation from the supreme law of art, which called for an *essential* solution. The essential solution, the concentrated ideal figure, could be arrived at only in the silence of the innermost mind. And so he preached a return to the old Italian conception of the ideality of art, invoking Raphael and quoting Baudelaire's eloquent words: *'Tous les bons et vrais dessinateurs dessinent d'après l'image écrite dans leur cerveau, et non d'après la nature.'*

The classical means of expressing the ideal, the flowing line of Ingres, which the Futurists, in rebellion against its classical implications, had broken into bits, became once more the basic element of drawing.

In the area of modern feeling, the Italian artists strove to return 'to the Italian idea of the original solidity of things'. The fugitive mobile forms of Impressionist and Futurist painting gave way to simple, compact bodies, in which the dignity of reality – its second reality – was discovered. The simple things, it was now held, sufficed to summon up the spirit of artistic order.

This new ideality, for which the path had been cleared by Pittura Metafisica, came to be regarded as the true *'principio italiano'*. The Italian painters now recognised their own essential purposes in the universal definition of reality achieved by Giotto, Masaccio, Uccello, and Piero della Francesca: the tranquil sublime form, the simple solemn reality, the clear images of things. Or, as Carrà said of Giotto: 'the terrible plebeian beauty of this Tuscan wonder worker, a beauty constructed on a few cardinal points, round which circles a sensitive arabesque.' This was the style they strove for. The new *italianità* should not be interpreted as provincial nationalism; it was a rediscovery from a modern standpoint, of congenial aspects of classical Italian painting, though it cannot be denied that, in the political climate then prevailing in Italy, it lent itself to a good deal of provincial abuse.

For twenty years, up to the Second World War, these ideas developed from Pittura Metafisica formed the dominant artistic attitude of Italy. The central function of art, it was held, is to distil ideal forms from the objects of nature.

The object, however, was looked upon not as the vehicle of a visual effect but rather as a thing to be dominated by an activity of the mind. The image developed in the mind represents its pictorial, or second, reality. Form as expression of an inner reality is a product of 'distillation' from nature and lays claim to an exemplary value.

In Italy from 1920 to 1940 there was little 'abstract' painting along the lines laid down by Kandinsky or Mondrian. Solitary individuals such as Soldati who subscribed to the Stijl aesthetics, Prampolini, who by way of Futurism arrived at an abstract dynamism, and Magnelli, who living in Paris, took an active part in the constructive tendencies of the French Abstraction-Création group, were well-nigh disregarded. Only in recent years have young Italian painters begun to look upon these men as precursors.

The centre of artistic activity became the object employed as a foundation for static constructions marked by a certain solemnity. Most of the pictures painted in this period were still lifes and landscapes, though behind them one can always discern a nostalgia for the large figure painting.

Even the 'simple object' acquired a poetic 'content'. For unlike the French, the Italians attached great importance to the lyrical associations of objects.

These considerations are reflected in the reaction of the Italians to French painting. Interest was limited to a very few – Cézanne, Seurat, Rousseau, Derain and Braque, all characterised by architectonic structure, static composition, clear, simple form, a spiritual conception of the object, and a certain tendency – '*faire le musée devant la nature*'. Derain and Braque also attracted the Italians by their grave, restrained colour – grey and brown and black, and the resonance of their dark harmonies. The artistic richness that characterises Picasso even in his destructive aspects was something these Italian painters could not quite understand. It was not until many years later that a younger generation of Italians (Guttuso, Birolli, Morlotti) were moved by Picasso's *Guernica* and his apocalyptic, emblematic phase of the thirties. Matisse as well enjoyed little appreciation. Carrà tells us why: 'Matisse's canvases are above all lacking in the constructive dignity and seriousness which we call "*disegno*", a quality that enters into matter itself, giving it the right measure and the indispensable concentration and earnestness of feeling.'

*Classical Realism and Archaism*

The fundamental ethical and aesthetic attitude of the generation which dominated Italian painting between the two world wars was an idealism oriented towards strict, almost archaic form. Defined by Carrà, Morandi and Casorati, the new aesthetics was based on the endeavour, which Cézanne had already formulated in his archaic way, to fashion the heritage of Impressionism into something as solid and enduring 'as the art of the museums'.

Carlo Carrà (b. 1881), more than anyone else, was instrumental in developing this state of mind. More than a leader, he became a moral authority, because he succeeded in combining the constructive ideas of modern French painting with the great traditional values of Italian art, the old masters' solid definitions of the objective world. It was through Carrà that the Italian painting of the years from 1920 to 1940 took on its characteristic classical-archaic realism.

The Futurists – and Carrà, we recall was one of them – had spoken of making Impressionism 'solid'. His interest in the new French ideas began with Seurat, Cézanne and the Cubists, at the point where the painting becomes an autonomous fact distinct from the Impressionist motif Cézanne served Carrà only as a general example. But Seurat, with his broad simplification and flat construction, exerted a direct influence. As for Cubism, it amplified his feeling for the forms that could be abstracted from objects and in the end helped him to recognise Giotto's strict definition of space.

Carrà's Futurist pictures already show the formal gravity that was to mark his entire work. His personal style made itself fully felt only in Pittura Metafisica, which is the true beginning of his art, the enduring element in his slow and difficult development. In his latest pictures with their extreme, solemn simplification he goes back repeatedly to this starting point.

But Carrà's great experience, to which he gained access through the visual lessons of Cézanne, Rousseau, and the Cubists, was that of the early Florentine masters – Giotto and Masaccio. This extends even to his technique which, at its most successful, lends his easel paintings the brilliant enamel to which the '*buon fresco*' owes its magic. Many modern artists, down to Henry Moore, have been influenced by Masaccio, but none has achieved such a profound understanding of his inherent poetry as Carrà. Carrà strips Masaccio's form of all its anecdotal quality, simplifies

it to the point of archaism, carries it back to the basic structures of Giotto, from which Masaccio himself took his departure. Pittura Metafisica was not yet free from poetic and formal invention; but in the twenties Carrà developed his form wholly from the object, with the help of the solemn formal abstractions of the early Florentines. In his own nature there was something of the earnestness and archaic awkwardness which constituted the 'primitive' grandeur of the early Florentines. Thus Carrà's whole art draws its life from a desire to define the essential grandeur of things by archaic simplification. Every object is reduced to its typical form and divested of its anecdotal aspects. In the landscapes the hills merge into great masses, houses reduce themselves to simple cubes, skies become quiet horizons, the landscape takes on a serene composure. The strictly simplified figures become something in the nature of archaic gods while the animals, the dogs or bison, recall the animals of Egypt. All the beauty of things is concentrated in the simplest designation of their form, whence it emerges as another, second reality. The natural existence of things is transmuted into an archaic symbol.

Carrà's most typical contribution is his dense, formal definition of things, which clearly distinguishes his Latin art from that of the North. This is no 'art of expression'. The form is so self-contained, so complete that nothing more can be added to it. It 'eternalises' the things of nature by a formal definition that has nothing to do with 'feeling'. That is why there is so much stillness in Carrà's paintings. In some of them rustic-archaic Italy is resurrected in all its ancient solemnity and melancholy grandeur.

But Carrà was not the only painter to express the second reality enclosed in the solidity of things. There was also Giorgio Morandi (b. 1890) who lived and painted in the quiet, secluded provincial city of Bologna, drawing strength from its native artistic tradition and from his own serene nature. In his person he combined the authentic but little known Italian virtues: modesty, humility towards the work he had undertaken, a sense of brotherhood with things, serene, untiring effort.

Morandi never left Bologna, but he meditated profoundly on modern European art and judged its products in a silent dialogue with the early Florentine and Bolognese masters. He felt himself to be descended from the old masters and took this lineage quite for granted. But his deepest experience was his encounter with Cézanne.

Cézanne opened his eyes to the simple definition of things. And then Morandi perceived the same power of definition in the old Italian masters, and also in Chardin and Corot. He found it again in the achievement or promise of certain modern artists, in Henri Rousseau and the Cubists. It was this repeatedly verified experience which, towards 1918, brought Morandi close to Pittura Metafisica. He never officially joined the movement, but he might have been its purest advocate. Its doctrine of 'italianità', its sudden and intensely modern understanding of Giotto, its profound experience of the magic stillness of form and of the lyricism of the simple object – all that is present in Morandi's art. But he also shared these painters' experience of Cubism and Futurism – their conception of space as an active pictorial element, their inclusion of negative forms in the composition, their interest in the tensions between object forms, their insistence on 'unita dramatica'. However, his art remained free from the half surrealistic, ironic, and literary exaggerations which threatened so much of their work. His poetry flows always from the purely visual. His magic is warmed by a humanist tenderness. Morandi's perspective is neither the mobile, simultaneous perspective of the Cubists, nor is it marked by the magical rigidity of Pittura Metafisica; it is the humanistic 'prospettiva' of Uccello and Piero della Francesca.

Morandi was concerned exclusively with objects. Except for a few early fragmentary figures, direct 'hommages à Cézanne', Morandi excluded man from his choice of subjects. Aside from an

occasional landscape without human inhabitants, his pictures are all still lifes. He constructs them in an atmosphere of solitary, contemplative dialogue between the artist and his object. From the object he cajoles a formal analogy that is its pictorial definition. Thus the object is absolutely indispensable to the picture. Often Morandi spent whole days building up his still lifes from humble objects, moving them together, rearranging them, sometimes even colouring them to suit his fancy. Only then did he proceed, often very slowly, to paint this pre-formed world, and raise it to ultimate pictorial clarity. The same process is at work in his landscapes. These works which appear so universal sprang from a direct contact with his motif. If a mound of earth was removed, a tree felled, or a house repainted, Morandi was unable to finish his picture.

The work thus produced is a rigidly constructed architectonic whole. The objects lie embedded in an ideal cube – frame, surface, and a graduated depth defined by the volumes and colours of the things themselves. In their silent coexistence these humble objects achieve an extraordinary lyrical eloquence. Bottles, goblets, etc., create a solemn, immobile forest of forms, in whose inaccessible seclusion the object takes on a legendary grandeur. Yet the form is pure, unmarred by any literary intrusion. One might call it 'abstract' if it did not spring so directly from the object. It is a spiritual analogy to the object in another sphere, the sphere of pictorial reality. The lyricism of these paintings is wholly encoded in the form. Morandi's quiet restrained art exerted a profound influence on Italian painting.

Felice Casorati (b. 1886) arrived at his figure paintings in a comparable effort to distil the archetypal forms from natural appearance. But he was very different both in his origins and his thinking. His starting point was the Nordic, idealistic figure painting which had maintained a certain classical dignity amid the realism that prevailed in the latter half of the nineteenth century – Puvis de Chavannes, the English pre-Raphaelites, Hans von Marées – and which had dimly survived in the Jugendstil and the various Secession movements. Konrad Fiedler had supplied this current with an aesthetic theory and some of his ideas had reached Italian intellectual circles through Benedetto Croce. The idea was that the filtering power of the mind could develop a purified image of the visual world. Casorati's art partakes of this idealism. He began with the Pre-Raphaelites and the Jugendstil. Once he had started in this direction, it was inevitable that Casorati should come to the modern master who had most eminently devoted himself to figure painting – Gauguin. After a brief contact with Pittura Metafisica, which was not without importance for his development, Casorati attempted, towards 1920, to harmonise Gauguin's experience with his own classical conception of figure painting. The result is an art full of scholastic measure, of intellectual coolness, and a peculiar remoteness from the shifting images of life and its passions. Casorati's style is an application of Gauguin's methods to an Italian type of classicism.

In his figure paintings Casorati aims at large static forms, seeking to strip his figures and ensembles of all accidents and so develop the type and essence of their beauty. The components of his rigorous construction are simple constellations of cubes – generated by his figures and his use of perspective – and masses created through colour and tone value. Casorati's painting has often been branded as academic because of its rigidity and severity. Yet it was Casorati who in the years between the wars strove to restore the dignity of Italian figure painting on a modern plane. The weight of his undertaking and the burden of the resuscitated past gave his art the note of unredeemed melancholy which runs through the painting of this entire Italian generation.

They longed for monumental grandeur and all of them yearned to paint murals. The heroic past was to them an inexorable driving force and a burden that destroyed all gaiety, all love of light-hearted beauty and grace. This heaviness of spirit is particularly typical of Sironi.

211

After a brief contact with Futurism, Mario Sironi (b. 1885) devoted himself to the sombre pathos, the heavy, gigantic beauty of the industrial world. He did not, like the Futurists, celebrate the poetry of the machine, the rise of the masses, the dynamism of modern life, but discerned a primordial spirit lurking beneath the heaviness of deserted landscapes. A world of the damned! With their uncompromising simplification, Sironi's human colossi are of the family of the primordial men who inhabit the paintings of Carrà. But their dramatic passion is more intense and their form less concise; they disclose a yearning for the gigantic that their form is unable to sustain.

Thus Sironi's pictures seem incomplete, fragments of a larger conception. They open up vast visions, but do not achieve rest in the object. Yet for this very reason they are a significant contribution to the striving for monumentality that characterises the Italian painting of our period. For Sironi never ceased to work towards the great composition that would make him a mural painter. Always with this goal in mind, he invented and abstracted, moving farther and farther away from his object and dangerously skirting the perils of scenography.

This tendency towards mural painting, rigorous décor, and the archaic is at work, even in the fanciful playfulness of Massimo Campigli (b. 1895). His painting has its sources deep in the pre-classical Mediterranean past: the hallucinated sensibility of the Etruscans, the elegance of the ancient Greeks, the delicacy of the Minoan art of Crete. Campigli made the discovery of this world in 1928, on a visit to the Etruscan Museum in Rome. With his amiable irony, his sophisticated colour schemes of grey, tender green, and pink, he derived from these venerable sources a curious archaic Rococo. But behind this playful world a rigorous Italian form is discernible.

Campigli was fired with enthusiasm by the ancient murals, by the primitive preciosity of early Mediterranean grave painting. Even his easel paintings have essentially the character of murals. He received commissions for large murals – *Mothers, Working Women, and Peasant Women* for the 1933 Triennale; a mural for the League of Nations Palace in Geneva (1931); and in 1940 a series for the entrance to the University of Padua. These are assuredly remarkable achievements in the field of the modern mural, but the musical, Rococo quality that gives Campigli's art its charm, lacks the power to sustain large surfaces. The essential in his pictures is always the surface. Space is no more than a memory, occasionally evoked by the hieroglyphs of the picture. He does not create human bodies, but scenes peopled by figures which lead a mobile, eurhythmic life on the surface. Man is of interest only as a charmingly archaic puppet, moving about his artificial habitat, the picture surface, to the tune of a meticulous minuet.

Different as the works of Carrà and Campigli may seem, they disclose the same abstract conception of the figure, and archaic gravity in the composition. Carrà has a more serious relation to the object; for him it is the basis of a pictorial analogy, while for Campigli it is merely a sign governed by the ornamental ensemble and subordinated to decorative considerations. But the common element in their painting is an important indication that an Italian style was coming into being.

Throughout Europe the twenties offered a climate favourable for the development of the Neo-Classical style, which was by no means limited to Italy. In those years Picasso developed the formal coldness and linear clarity of a Neo-Classical style marked by recollections of Ovid's mythology. Ingres was held in high esteem. This classicism that had taken hold of Picasso's entourage held a special appeal for the Italians, for it seemed to be guiding modern art back to the grand style.

In 1920 Casorati painted his famous *Eggs*, a brilliant example of suggestive thing-form coupled with intellectual measure. In the following years the Neo-Classicism of Oppi, Funi, Malerba, etc., became the most popular of the pseudo-modern trends in Italy, ushering in the Italian form of international Classicist Verism.

It was Gino Severini (b. 1883) who communicated the French developments to the Italians, and perhaps he was the first Italian to work along these lines. In the war years he had abandoned Futurism for a highly coloured decorative Cubism; then he had moved close to Purism and now – towards 1917 – he followed Picasso to Neo-Classicism. In a dry fresco-like technique he gave a special Italian note to Picasso's classical mannerism. In the ensuing years, still following Picasso, he introduced more and more of the decorative formulas of Cubism into the new style.

Severini never regarded himself as an 'artist' in the Romantic sense, but as an *'onesto fabbricatore'*, an honest craftsman, working to produce a beautiful work. More than any other Italian he participated in the ideas that were in the air in Paris, and made use of them for his own purposes. A sure sense of harmony and proportion, a repertory of serviceable forms, a lucid skill in arranging decorative elements: these were the results of his inquiring intelligence. Above all, he followed the rules of the decorator's craft. He did not hesitate to use certain established forms over and over again as types of beauty – rug patterns, the cubistically deformed fruit bowl, Braque's guitar, etc.

One of the many Italians to espouse Severini's simple, technically proficient Neo-Classicism was Mario Tozzi (b. 1895). Endowed with a pronounced decorative talent, constantly on the look-out for new inventions in the realm of subject matter, some of which he drew from French Surrealism, he developed a monumental, rigidly constructed style and strove in his easel paintings to achieve the effects of murals. But he soon succumbed to the new Italian academicism that poisoned the years between the wars. This was the danger inherent in Carrà's conception of a classical style that would bring out the grandeur of things. Even in Casorati and Campigli, depth of form and content sometimes give way to eclecticism and superficial décor. This weakness is perfectly evident in Severini and above all in Tozzi – whom we have selected here as typical of a whole trend in painting.

*Impression and Instinct*

Side by side with this classical current, we find an almost Impressionist or instinctive type of painting. Here the painter's instinct crowds out all theoretical ideas. So keen is his delight in the pure act of painting that the object itself is drawn into his enthusiasm, becoming a symbol for his enraptured state of mind. Arturo Tosi and Filippo de Pisis are the most significant Italian representatives of this 'instinctive' painting.

Arturo Tosi (1871-1956), the Nestor of twentieth century Italian painting was a direct product of the Lombard *Ottocento*, though in the course of his development he made fruitful contact with the painting of France and Northern Europe. He benefited by the ideas of the Post-Impressionists, Munch, and Cézanne, but the new methods served solely to enrich his strictly personal style. He painted only landscapes and still lifes, in which he sought to enhance visual beauty by lyrical emotion. He was a painter through and through; his whole life lay in the colour and texture of paint, and a fine piece of painting gave him an almost physical pleasure.

In his pictures there is a joyful harmony, a peasant contentment with God's nature. The best of them depict the wide hill country near Bergamo. He saw this landscape in its full lyrical beauty, without the dramatic accent usually favoured by those whose temperament drives them to painting, e. g. Van Gogh or Kokoschka. Quiet colours, a ploughed field, the sun-drenched brightness of a stand of wheat, a pink house –, these were his inspirations. Here we have an Impressionism rendered poetic by the painter's visual emotion, but whose formal gravity clearly reveal its Italian origins.

Lighter, more supple and capricious, but no less inclined to the lyricism of the visual world is the painting of Filippo de Pisis (1896-1956). This poetic personality – an unusual mixture of the sensitive gentleman of the *Settecento* and of a jolly monk – created an expressive idiom of his own from the fugitive brushstrokes of the Impressionists. He wrote his pictures as another might write lyric poems. They are poems without explicit themes. Their subject is a feeling, the sound of a human heart which for a brief moment has given visible solidity to an emotion. This moment of emotion aroused by the sudden appearance of a beautiful trifle passes quickly; it lasts exactly as long as it takes the picture to come into being, and De Pisis worked quickly. The painter does not represent an exact idea; his idea arises spontenously. He cannot go back to it and develop it. Like Kokoschka, he starts from a fleeting moment of sensation, but it develops at once within him to a 'vision' of poetic feeling. His method is descriptive; he narrates his picture as he paints it. And yet every detail of his narrative is merely a quickly noted sign, which attains a poetic value of its own only through the nervous grace of the picture. Drawing plays an important role. De Pisis draws with colour and large parts of the white underpainting are left intact.

Doubtless De Pisis developed his whole conception from French Impressionism, particularly from Manet. This is the source of his penchant for certain noble greys, against which his objects stand out with an elegant verve. But in his painting everything withdraws into a smaller and more intimate world; the sublime aspiration is not felt so directly. Manet's landscapes are transformed into the '*vedute*' in which De Pisis sought to emulate the eighteenth century Venetian masters, particularly Guardi. His whole work is dominated by the poetry of a *Settecento* of his own dreams, an intimate, lyrical, very Italian world. Here and there he strives for the elegant arabesque, the grand design of the French painters, but he is too lyrical at heart. He is too close to his objects to subject them to the requirements of a grandiose décor.

*Classicist Romanticism*

For Italy the problem of a new classicism seemed bound up with the memory of the *Quattrocento*. But in Pittura Metafisica it had already become evident that the ancient world of the Greeks and Romans was present in this recollection, exerting the self-same secret magic that had been at the root of the Renaissance conception of antiquity.

It can be no accident that these nightmares of antiquity and its demonic gods, which characterise Pittura Metafisica, should have been dreamed again at Ferrara, where the painters of the fifteenth century portrayed the ancient gods as astral demons on the walls of the Palazzo Schifanoia, where the strangely ecstatic Ferrarese school of the *Quattrocento* had developed a kind of Verism, based on magic and dreams, where Dosso Dossi had conceived his bewitched visions. These Renaissance painters provided the traditional background for a very Italian variety of Surrealism which introduced the forms of antiquity in the realm of the modern Romantic imagination.

The guiding spirit of this classicist Romanticism was Giorgio de Chirico. This current was also soon to degenerate into academicism. For this Chirico's own development was responsible. He had overhastily concluded that the restorationist trend which was coming into prominence everywhere in the twenties (and which might have been appraised as a necessary by-product of the need to take possession of the field whose most important and most extreme positions had been marked off), was the foundation on which the art of the future would be built. The world of his imagination, which had sensed the sublimity of things and so miraculously spun their legend, soon began to

take on conventional classicist traits. His early recollections of antiquity, springing from his own deep feeling, were submerged by the heroic bombast of Ariosto, and his forms adapted themselves to this ready-made content. Obviously Böcklin and Delacroix provided more suitable idioms than Cézanne for the expression of an eclectic Renaissance. His inclination to the monumental led De Chirico away from the problems of modern painting, beguiling him into an almost abject eclecticism wich drew not only on the Renaissance but also on the great nineteenth century masters of composition. Various factors contributed to this development: De Chirico's training in Munich, an almost Germanic inclination towards a Romanticism in classical garb, and above all the dangerous resolve, underlying his whole art, to create pictures from the figures and symbols of his imagination rather than from a visual and intellectual encounter with the world. De Chirico's bitter polemics against Cézanne clearly reveal the background of his eclecticism.

In the twenties this variety of Romanticism was taken up by Achille Funi (b. 1890). He was himself a native of Ferrara, and from early childhood his imagination had been subjected to the magic of the strange frescoes in the Palazzo Schifanoia. In devising a modern idiom in which to express his vision he drew on De Chirico, on the Paris Neo-Classicism introduced by Picasso, and on Derain's late Italianising period. This was the phase of modern painting to which the Neo-Romantics of the Milan 'Novecento', which he had helped to found, were attracted and it was in this milieu that he developed his style. The influence of Derain enriched his colour, and in regard to form he learned a good deal from the Neo-Romantic version of the formulas of the Renaissance. Like De Chirico in his later years, he was almost entirely preoccupied by the great art of the past. De Chirico's vision is more poetic, more austere and independent, but for this very reason more vulnerable, restless, ironic, while Funi rested confidently in what he regarded as a secure tradition.

In general the period was marked by a decline in creative power and by the flowering of a new provincialism.

## The Novecento and Fascist Reaction

In the current Italian situation, this tendency to provincialism was inevitable. The polemic phraseology inherited from Futurism, the dogmatic fanaticism of De Chirico and Carrà at every stage of their development, provided a whole class of philistine, mediocre painters with a pretext for condemning all modern endeavours and demanding the return to tradition.

*Valori Plastici*, a magazine founded in Rome in 1918 by Mario Broglio, had made its début with articles by Carrà, Savinio, and De Chirico in support of Pittura Metafisica and its aesthetics. Now, exactly a year later, De Chirico published a kind of manifesto entitled '*Il ritorno al mestiere*' (The return to the craft). In this impassioned attack on all modernism, De Chirico accuses the Futurists of giving Italian painting the *coup de grâce* and ridicules Cubism. Only a return to the old academy with its drawing from plaster models, etc., could bring salvation. As for himself, De Chirico concluded, he felt easy in his mind. 'I adorn my vizor with three words: *Pictor classicus sum*.' A few months later Carrà began to publish similar articles in the same magazine; he too sang the praises of tradition and classical art and proceeded to introduce a nationalist note, which was only too eagerly seized upon by the lesser lights among the painters and writers of the day and by Fascist politicians as well. He attacked the 'alchemistic, analytical, and Romantic art' that had come in from the North, from France and Germany, declaring it to be incompatible with true Italianism, and demanded the '*disciplina, serenità e compostezza*' – of Neo-Classicism.

215

One cannot be over-critical of the journalistic rhetoric of De Chirico and Carrà, since it was based on artistic ideas that were in themselves fruitful. The danger lay in the political and cultural level of those who took up their arguments. Ardengo Soffici's 'Periplo dell'Arte', bearing the revealing subtitle 'A Call to Order', degenerates into an unrestrained nationalist attack on the modern schools of northern Europe, and insists on the values of blood and soil and the national tradition. This was the same Soffici who scarcely ten years before had introduced the Italians to modern French art and was soon to cultivate a cautious Cézannism in his own painting.

In the lowest ranks these outpourings surpassed all limits. In *Il Tevere* C. E. Oppo, a fashionable and talentless naturalistic painter, soon to become president of the Fascist 'Sindicati delle Belle Arti', published a series of violent attacks on the 'stylistic poisoning' of Italian painting by trans-Alpine art and invoked the Italian past – by which he meant the most dismal nineteenth century naturalism. The vain and ageing critic Ugo Ojetti came out strongly in the same direction; finally, Vincenzo Constantini published a book on Modern Italian Art in which he indulged in the same sort of nationalist sentiment and glorified painters who at best were fit to decorate provincial town halls. Return to tradition, the great past, idealism, Neo-Classicism, *'naturalismo nostrano'* – such were the slogans. The painting they advertised specialised in Fascist allegory, badly painted groups of mothers and resolute 'muscle-men'. Here was a meeting-place for the reactionary, the resentful bungler, and the opportunist, and soon this trend in art had the power of a totalitarian state behind it.

It was not so much the painting produced in this atmosphere that represented a danger to Italian art as the isolation of the Italian artist cut off from France and the other countries of Europe by the cultural policy of Fascism. Once again modern Italian art was beset by the mortal peril of provincialism.

It was in this climate that an undertaking, which began as a harmless artists' association, achieved a disastrous influence: the 'Novecento Italiano'. At the end of 1922, a group of Neo-Classicists and Semi-Verists, including Funi, Marussig, but also Sironi, met at the Pesaro Gallery in Milan. Their programme called for a return to the great composition and figure painting of the classical past, but in practice their attitude can be situated somewhere between decorative Neo-Classicism, a degenerate secessionism, and traditionalism. In 1923 the group opened its official career with a meeting at the Pesaro Gallery. Mussolini was one of the speakers. In 1924 the Novecento expounded its programme at the Biennale. It strove, Lino Pesaro declared, 'for a pure Italian art, drawing inspiration from the purest sources, determined to cast off all imported "isms" and influences, which have so often falsified the clear essential traits of our race'. The true artists who participated in or observed the founding of the Novecento seem to have looked with misgiving on its eclecticism and provincialism. Inner tensions arose and in the same year the group disintegrated. Oppi, Malerba, Dudreville – typical representatives of the Romantic Verism which in those years was attracting untalented artists all over Europe – seceded. A new group formed at once, which called itself the 'Comitato Direttivo del Novecento Italiano'. It included Funi, Marussig, Sironi, who were joined by Tosi, Salietti, and the sculptor Adolfo Wildt. The shrewd critic Margherita Sarfatti played an important role. The very composition of the 'Comitato' shows that the more obvious aspects of the 'return to the past' and the most vociferous anti-modernism had been left behind. The association was chiefly interested in founding a national forum of artists to organise annual exhibitions supervised by a competent jury. The guiding principle, to be sure, remained *'italianità'* with its classicist and naturalist implications.

The first Novecento exhibition held in Milan in February 1926 actually included all the Italian tendencies down to the Futurists of the second generation who, infected by the national enthusiasm,

had launched a variety of painting devoted to the sensations experienced in flight and known as 'Aeropittura'. In 1929 they issued a manifesto of Aeropittura and in 1931 put on a show of their own, to which Dottori, Fillia, Benedetta Marinetti, Tato and Munaro contributed canvases. But it was inevitable that the Novecento should succemb more and more to the domination of the reactionaries and propagandists, particularly when the command posts of the Fascist art administration — the newly founded 'Sindicati delle Belle Arti' — were entrusted to the Novecento leaders. So it came about that the Novecento, which had originally taken a middle of the road position, was drawn more and more into the official Fascist art machine and it was not long before the name 'Novecento' came to be regarded as a synonym for sentimental propaganda, provincial eclecticism and classicism, and blood-and-soil naturalism. Italian painting had to defend itself against these tendencies and against the whole power of a totalitarian state determined to use art as a means of swaying mass sentiment. It cannot be said that Italian art as a whole submitted to 'co-ordination'. The younger generations in particular reacted violently against the Novecento. But they soon found themselves left to their own resources. The result was an art based on a solitary dialogue with things, a quiet lyricism marked by melancholy and loneliness.

*A Roman School*

Indeed, romantic feeling opened up forms of expression far removed from the Novecento tendencies. This was a lyrical art devoted to the insulted and injured, the inconspicuous poetry that flowers in dark corners. It did not accuse but found consolation in the obscure beauty that managed to survive in the midst of ruin and decay. In this it was akin to the melancholy art of the characteristically Jewish enclave within the Paris school, of the homeless exiles Chagall, Soutine, Pascin, Modigliani. Italian art had remained a stranger to this form of lyricism; Modigliani belonged wholly to the Paris school. These values were brought to the art of Modern Italy by Scipione and his friend Mafai.

Scipione (pseudonym for Gino Bonichi, 1904-1933) died at the age of twenty-nine, of the tuberculosis which had hung over his whole life like a dark fate. His poetic feeling was concentrated and intensified by his sickness. He reached out through reality in visions and dreams that he depicted in his paintings. Even when Scipione took objects as his subject matter, it was not really the objects that he painted but the anguished associations they called forth in his imagination. His Roman views, his still lifes, spring not from a visual sensation, but from an hallucinated imagination. To his apocalyptic eye statues walked like ghosts in the deserted squares of nocturnal Rome. Remotely suggestive of the browns of Baroque gallery-paintings, the smouldering colour of his pictures veils the world in a dream atmosphere. Scipione had developed his conception of painting in the museums and was drawn by a natural kinship to Goya, through whom he came to Soutine and Chagall.

In his fine drawings he also followed the dictates of an imagination inflamed by the objective world. He records his vision and circumscribes it in a nervous, sickly line that gnaws at the forms of things — a line which he may have derived from Pascin. His visionary quality, his obsessive sensuality, his frenzied lyrism make all his pictures poetic events which no doubt owe their dark magic to the proximity of death.

It is with Scipione that the term 'Expressionism' first becomes applicable to Italy. In the fourth decade of the century his art was an important secret force in the direction of the visionary and expressive, though it is hard to appraise its influence on individuals. His friend Mario Mafai has preserved this same type of sensibility to this day.

The art of Mario Mafai (b. 1902) is also essentially visionary but he is closer to the visible world. While in Scipione the picture as a whole is born of an hallucinated Baroque imagination, Mafai takes more account of real objects. His poetic vision discovers rich beauty in poor, forlorn, forgotten things – a bunch of flowers, a deserted house, a desolate landscape. It is a subtle, peculiar beauty – reality is cloaked in precious colour and even a heap of rubble takes its place in a delicate, rich ensemble. It is this precious quality in his colour that gives each of Mafai's visual experiences its melancholy tone, for behind the radiance we discern graphic signs of decay, which lend the ephemeral beauty a moving poetic accent – trees with branches flowing like hair in the wind, bushes like twining snakes, houses which stagger beneath impending ruin.

The restrained ecstasy of his vision determined Mafai's affinity to other painters. He was drawn to Kokoschka, but above all to James Ensor. In the 'Fantasies', a series painted during the Second World War, Mafai conceived a kind of Passion Play, enacted by those who suffer and those who inflict suffering, those who strike and those who are struck, the murderers and the murdered, the tormenters and the tormented, those who bare their faces and those who wear masks. The suffering that coloured his vision enabled him to transcend even the melancholy overtones of James Ensor's magical carnivals.

The ideas of Scipione and Mafai inspired a whole school which is still very much alive in Rome today. It includes such men as Tamburi, Scialoja and Stradone.

## The Younger Generation

The new generation that grew to manhood in the fourth decade of the century reacted strongly against the pseudo-realism and provincial sentimentality of the Novecento, but clung largely to the ideas set forth by the masters of the older generation. Their mentors were Carrà and Morandi, but also Scipione.

A new impulse towards a more profound lyrical conception of the object came from poetry. Such men as Ungharetti, Montale, Quasimodo, drawing to some extent on Mallarmé and Rimbaud, had created a sensitive poetry, rich in imagery, in which the objects of the visual world became metaphors for feeling. These poets were too close to things to give them direct rational names. The consequence was a hermetic quality. The object took on a very personal symbolic content, ceasing to be anything more than a reference point for a state of mind, pure image and pure sound, far removed from all direct analogies. This type of poetry strongly influenced the young painters in the direction of a lyrical hermeticism.

As the painters of the new generation strove to broaden their vision, their eyes turned towards certain French painters who had hitherto been disregarded in Italy. Birolli and Guttuso discovered Van Gogh's colour scale and, by way of Van Gogh, Picasso's expressive phase culminating in *Guernica*. Santomaso became interested in Braque and Lurçat. In Piedmont a lyrical, almost Impressionist school of landscape painters looked to Cézanne and the late period of Derain for help in securing their construction. Rosai, Cesetti, and the graphic artist Viviani drew ideas from the naïve Surrealism of the '*maîtres populaires*'.

In Florence the new lyricism of which we have been speaking found a characteristic expression in the art of Ottone Rosai (b. 1895).

The modern spirit had been brought to Florence early in the twentieth century by Soffici. Then, after the usual transitional phase of Futurism, Florentine painting relapsed – in the wake

of the Novecento tendencies – into an academicism somewhat enriched by the experience of modern art, but not far removed in the main from the bravura painting of the nineteenth century. Such was the work of Primo Conti, Gianni Vagnetti, Giovanni Colacicchi; Carena, then teaching at the Florence Academy, was meanwhile trying to achieve grand composition in the medium of a rather fleecy Impressionism.

Rosai was far removed from all this bravura. One day painting began all over again for him, as though painters had not been at work for thousands of years and the painting of the past had never existed. His relation to his art was that of a child or primitive. Feeling that his poetic purpose could not be attained by the traditional methods, he developed a radically simplified style of naïve, folklore-like realism. The subject matter is working-class Florence; ancient poverty-stricken streets, hillsides covered with grey olive trees, the poor people eking out their existence in the nooks and crannies of the grey city. These simple pictures have the profound, painstaking charm of non-professional art and convey a forlorn note, rendered more poignant by the refusal of poetic effects. Their closest affinity is with the *maîtres populaires*. But the austere ensemble of violet and grey tones, the sophisticated economy of the drawing, disclose a clear ascetic intention.

As to Cesetti, he seems to have been born into 'neo-primitive lyricism'. He was a son of the Maremma, the haunted marshland on the western sea-coast of Tuscany, a desolate country over which the red of the evening sky sometimes spreads a serene beauty. Cesetti is at his best when his naïve emotion conjures up this landscape peopled with buffaloes and horses as in the feverish imagination of a child. But the modern primitive has his characteristic vice, a yearning for 'art' as he understands it. Cesetti soon succumbed to his hankering for grand classical composition and in so doing moved further and further away from his original inspiration. Odd reminiscences, aroused no doubt by reproductions he had run across here and there, cropped up in his pictures: traces of Franz Marc's *Red Horses*, of Edvard Munch's luminous landscapes with their flowing ornamental line, of Bombois's naïvely emphatic realism. His style quickly merged with the neo-romanticism that was current all over Europe in the fourth decade of the century.

The style of the *maîtres populaires* with its naïve realism and sweet, simple Romanticism, responded to the lyrical mood of these years and thus appealed to quite a number of painters. Inspired by the landscapes of Rousseau, Antonio Donghi and Umberto Lilloni found their way to a tender neo-Romanticism that seemed almost Germanic in quality. Preoccupation with the neo-primitives led Gianfilippo Usellini (b. 1903) to the delightful fable paintings on fifteenth century chests, and he borrowed their style for his entertaining, ironically surrealist fables. This melancholy, self-ironising Romanticism was the last refuge of modernism in Fascist Italy.

A similar lyricism made itself felt among those who adhered to the principles set forth by Carrà and Morandi.

Among Carrà's students it was Domenico Cantatore (b. 1905) who most closely emulated his master's archaic simplicity. He did paintings of pathetic models, standing in abashed nakedness in studio corners, quietly melancholy portraits of friends and young girls, unpretentious still lifes of humble objects in a diffuse light, landscapes disclosing the bold outlines of hills, trees, houses in the uniform light of a low hanging sky.

In all this we find an intimate quietness. In the older painters this enchanted, mysterious stillness suggests an attempt to ward off a restless existential anguish. Among their pupils, it turns to a gentle melancholy, a hermetic lyricism with no unrest behind it – as though the repose which Carrà had struggled so hard to achieve in his art had enabled him to found a school whose repose was untainted.

Carrà's circle included Tomea. The heavy painstaking hand of this self-educated artist produces clod-like forms, charged with a dramatic proletarian expressiveness. His earthy still lifes evoke a strangely awkward Surrealist drama, whose protagonists are objects.

Still more withdrawn from the ideas of modern art was the markedly regional school that formed in Turin in 1928, the 'Gruppo dei Sei'. The quality of the Piedmontese landscape and the proximity of France led to a new adaptation of French landscape painting, drawing heavily on the techniques which Segonzac, Vlaminck and Derain in his last period had derived from Cézanne. Dufy as well as Kokoschka, who frequently went to the Riviera to paint, also had their influence. The most important members of the group were Menzio, Spazzapan and Paulucci.

Francesco Menzio (b. 1899) was the most consummate painter of the group. He had started out under the influence of Derain's late period. Then a desire for greater freedom in the handling of colour and line had led him back to the Impressionists. Finally he had been drawn to more subdued colour relations and the way lay open to a deeper understanding of Cézanne. In his pictures there is a very personal poetry which tends to restrain the original brilliance of his brushwork and to simplify his form. Colour becomes a veil, behind which the object recedes to a poetic distance from the beholder.

Taking the Fauves as his starting point, Luigi Spazzapan (b. 1890) went on to a spirited Expressionism marked by a specifically French verve. After the Second World War, his Expressionism took on an ecstatic exuberance bordering on abstraction.

At first an enthusiastic admirer of Dufy and Kokoschka, Enrico Paulucci (b. 1901) soon turned to Cézanne's constructive gravity. In his later development he strove for a more rigorous structure, guided in some measure by Casorati who taught at the Turin academy and gave the local painters a good deal of valuable advice.

There is no doubt that though remaining gratifyingly aloof from the Novecento tendencies, the schools we have been discussing represented a decline. The leading personalities of the fourth decade clung to the solutions worked out by the preceding generation, to which they were inferior in rank. There are only a few names we shall meet again after the war. But here and there we find an isolated spark bearing witness to the latent existence of new ideas.

In Venice, Giuseppe Santomaso (b. 1907) found a fresh point of departure in Braque and Lurçat. He undertook to build up a more abstract art from the 'simple things' that Morandi had found to be 'worthy of painting'. Following Braque, he minimised the individual object for the sake of an abstract figuration based on a simplified architectonics. Then, with the help of an arabesque flowing freely from his subject matter, he set his architecture in motion. He preserved an Italian heaviness, compensating for the absence of the graceful French arabesque by the grave, massive form he had inherited from Pittura Metafisica. His abstract lattice-work gave him a painterly idiom in which to express the hermetic lyricism of the object and helped him to exclude literary elements. Santomaso developed slowly, and it was only in the fifth decade of the century that he achieved full freedom.

In Milan, Renato Birolli (b. 1906) arrived at a new idiom through Picasso's expressive style. He had started out as a follower of Van Gogh, but the Latin element in him was strong enough to ward off any tendency to unrestrained Expressionism. He sought by means of careful construction, to discipline Van Gogh's colour and the grandiloquent forms of Picasso's late period, and only then to give rein to dramatic feeling. Often drawing on the dream world, he encoded the inventions of his rich fantasy in formal structures which became more and more abstract, so that finally the object could scarcely be glimpsed through the abstract prism of the pictorial

organism. Thus he came close to the hermeticism toward which Santomaso was tending by a different path. Shortly before the war Birolli founded an association of artists in Milan: 'La Corrente', as it was called, included, in addition to the above-mentioned artists, such painters as Cassinari and Sassu, and provided the new hermetic Expressionism with a wide, influential forum. In Rome Renato Guttuso (b. 1912), also a member of La Corrente, seemed to be taking a similar path. Guttuso is a Sicilian, characterised by the abstract passions and wild melancholy of his race. His stormy temperament expressed itself in pictorial narratives of battles and murders, wild horses and vicious bulls, gesticulating figures, defined by a hard, passionate line. His abstract passion demanded the most dramatic technique, and this brought him to Van Gogh, from whom he derived his intense colour and the agitated texture of his brushstroke. In 1937 he saw Picasso's *Guernica*, which made a profound impact, politically as well as artistically. The great figures – these emblems of passion – showed him a means of figuring contemporary happenings in a succinct pictorial script. Still he retained the old Latin tendency to hold his forms in check. He seemed to be making his way towards abstract construction and the prismatic hermeticism of Birolli and Santomaso. It was a political decision, his turn to Communism, that diverted Guttuso from his goal and led him to a clumsy 'Socialist Realism' in which all expressive elements are submerged in declamatory propaganda.

*The Italian Contribution*

If we survey the Italian painting of the years between the wars, we cannot fail to note its tendency towards realism, moderation, and reflection on the Italian artistic tradition. The idea of the 'original solidity of things' is its fundamental experience and shaped its whole attitude towards reality. The consequence is an archaic realism which runs through all the Italian painting of the two decades in question. This emphasis on its classical heritage was a source of danger that Italian painting would once more isolate itself and relapse into the provincialism from which it had barely emerged. The danger was not wholly avoided. Nevertheless, distaste for the new academicism led the younger generation to withdraw more and more from the official art world and to pursue its own path towards an hermetic lyricism. None of the new currents aroused much interest beyond the borders of Italy. From the standpoint of the outside world, Italy's only genuine contribution to a new definition of reality was held to be archaic realism. In it the magical experience of things, developed by Pittura Metafisica, had been translated from its original esoteric idiom into more universal and intelligible terms and brought into relation with classical painting. In the early twenties when this idea first made its appearance in Italian painting and found theoretical expression in the aesthetics of *Valori Plastici*, it was a source of inspiration to all European art. The Germans in particular reacted strongly. In considering the German development we shall repeatedly encounter Italian ideas.

*Neo-Realism in Germany*

In the chaotic situation of post-war Germany, the hectic Expressionism of the Sturm painters seemed to offer the most appropriate possibilities. But it soon became evident that their apocalyptic visions contrasted too sharply with the hard reality of the times. Even the masters

of Expressionism – Nolde and the Brücke painters – began to work towards a clear and more realistic contemplation of nature. Those who carried on in the wake of Expressionism included none of the great talents. Looking upon the social and moral misery of the times with eyes of bitter disillusionment, the generation moulded by war and revolution had become realistic to the point of cynicism. Possessed by the dark realities of the social life around them, their cynical vision etched out the 'face of the ruling class' and its counterpart, the misery of the poor. A vision of this sort could be expressed only by the most mordant realism. The familiar figures of the day – profiteers, pimps, prostitutes, war cripples – and the vision of useless slaughter became a leitmotif for bitter moral harangues. The anti-artistic tendencies that had made their appearance among the Futurists and Dadaists were eagerly taken up as a basis for ridiculing the Expressionist conception of the 'enlightened' artist, who, as Grosz now put it, 'lives in a filthy studio, but strives for higher things'. Art was proclaimed to be a 'weapon of offence and defence' and became an instrument of pure proganda.

But this gives us only the outward explanation of German Neo-Verism. It resulted also from developments in art itself. Throughout Europe the trend was towards a new confrontation with objective reality. There was the seductive vision of a Neo-Classicism which for a time aroused the imagination of Picasso; there was the classical realism of Derain and the Italians, backed up theoretically by the aesthetics of *Valori Plastici*. It was the Italian vision of a new classical realism, still warmed in these early years by the poetic power of Pittura Metafisica, that exerted the strongest influence on Germany.

In the early twenties German neo-realism, hitherto a mere reaction against. Expressionism, began to crystallise out as a style. In 1923, in connection with the projected Mannheim exhibition of 'artists who have retained or regained their fidelity to positive, tangible reality' (as we read in the circular), G. F. Hartlaub, former director of the Mannheim Kunsthalle, coined the name 'die Neue Sachlichkeit' (the New Objectivity) for this tendency. Under this banner the exhibition was held in Mannheim in 1925 and afterwards in other German cities. The Neue Sachlichkeit soon became the universally accepted designation for this tendency in the German painting of the twenties. In the same year Franz Roh, in his book on Post-Expressionism, attempted for the first time to define the aesthetics of this current in European arts, which he termed Magical Realism. From the very start, the German development breaks down into two main lines. On the one hand, the radical, social-minded Verism of George Grosz, Otto Dix, and the lesser lights Davringshausen, Georg Scholz and Schlichter; and on the other, the more romantic, naturalistic realism of Kanoldt, Schrimpf and Mense.

The social Verism came first. It was inaugurated by George Grosz (b. 1893), and in its beginnings disclosed marked affinities with Futurism and Dadaism. The psychological background is provided by Dada with its anarchic, destructive tendency and its contempt for tradition, convention, and so-called ART. But whereas Dada spurned all set principles and steered clear of moral or social purposes, this German offshoot, in the midst of the general misery and revolutionary stirrings of the German war years, turned to violent social criticism. In 1915-16 the first of George Grosz's books of drawings appeared. The drawings show the influence of the *Simplicissimus* caricaturists, but also a serious preoccupation with Pascin, Kubin, Kokoschka, and perhaps Klee. The underlying quality is a calculated naïveté, the simple, straightforward approach to reality that George Grosz admired in the Sunday painters and studied in children's drawings and even in the graffiti in public lavatories. From Futurism he took the notion of combining simultaneous views, which enabled him to combine satirical images in such a way as to express the rhythm

of life in the big city. It is a world of whores, swindlers and philistines whose most repulsive aspects he brings out with the naïve force of his mordant line. Increasingly the stylistic elements of Futurism and Dada were set aside in the interests of realistic satire. The paintings of these years – from *The Funeral of the Poet Panizza* (1917-18) to *Germany, a Winter's Tale* (1918) show the same tendency; the framework is still Futuristic, but more and more a satirical Verism takes possession of it.

Soon a new influence crowded out the Futurist style. In 1920 Grosz worked on Dadaist montages with inserted drawings, a number of which appeared in 1922 under the title 'Materialisation'. Here the spirit of Pittura Metafisica is clearly discernible. There is the hard, naked perspective space, into which moves an articulated puppet, the '*manichino*'. But in Grosz this originally mythical figure serves a satirical design: he is the man without a face, the mass-man. Under Italian influence, Neo-Verism was becoming the dominant style. Grosz, too, abandoned his Expressionist, Dadaist, and Futurist forms and what remained was the sharply realistic drawing with which he exposed the shortcomings of his time 'objectively and without mystery'. *Mirror of Philistines, Love above All, The Face of the Ruling Class* – these are the titles of his volumes of drawings, which now appeared in quick succession. His painting, too, is essentially graphic, a penetrating Verist caricature against a ground of mawkish diluted colour. Soon he took Pascin's style of painting as his model, and as his satirical energy waned, he succumbed to a misty Romantic realism.

The career of Otto Dix (b. 1891) the second significant Verist of those years, is quite similar. He too made his appearance amid the wild Expressionism of the post-war period as a bitter, cynical Verist. He had fought at the front and his imagination remained obsessed by the horrors of trench warfare and gas attacks. Sharpened by suffering, his eyes bored into naked reality, intent on discovering as much horror and misery as possible. In the face of this reality, he lost interest in the criteria of art, and indeed it was a kind of anti-art and super-kitsch that seemed best suited to express the obsessive hideousness of his vision. Dada came to his help. On his return from the war, Dix produced Verist montages from coloured paper, glass beads, and pictures from poetry albums, selecting his materials precisely for their ugliness and quality of super-kitsch, feeling that what was most loathsome to look upon would serve best for the definition of reality. He employed these same ideas in his drawing and use of colour, with the same end in view. Like a maniac anatomist he cut through the charming surfaces of things to uncover what was most insane, absurd, and revolting. And then, with the meticulous brush of an old master, he would depict his discovery in his brothel scenes, night fantasies, and portraits. In the trench scenes – lifeless visions of tattered bodies in a lunar landscape, overgrown with the sickly sweet colours of decay – and in his outstanding book of engravings entitled *War* (1924), his Verism begins to touch upon another dimension. The terrible power of memory and the piercing insistence of the skilful, painstaking technique with which Dix defines his realities, give his visions the spectral clarity and silent immobility of a dream. Suffering and dream produce the super-reality which was the goal of the Veristic Surrealists. However, Dix did not pursue this path, but slipped back into the Romanticism that seemed to await all the German neo-realists. In the thirties he derived inspiration from Runge, the German Romantics, and the old German masters. Finally he abandoned his vigorous graphic technique and returned to a crude Expressionism with religious, eschatological overtones.

Such painters as Davringhausen and Georg Scholz popularised this Verist manner; others like Schlichter and Radziwill attempted to combine it with Surrealism but produced no convincing

results. For this radical Verism sprang from a specific historical situation and also ended with it. As regards content, it is a movement of reaction against war, revolution, and Expressionism, while as regards form, it is a reflection of the new realistic tendencies in European art. When these conditions changed, it ceased to be viable.

The Neue Sachlichkeit was tinged with Romanticism from the start and its destinies were similar. It was little more than a direct German response to the classical realism of the Italians and Derain. The tendency had a large following, but it was poor in quality and ideas. It produced no more than two names that are worth remembering.

Towards 1913, Alexander Kanoldt, under the influence of the Cubist school, had achieved a hard geometric construction. Then Derain had shown him the way to a clear view of reality. Next came the ideas of *Valori Plastici*. The result was a brittle graphic technique in the service of a mannered realism that exalted plastic volumes and metallic shapes – a far cry from the powerful thing-definition of Rousseau or Pittura Metafisica.

Georg Schrimpf (b. 1889) came a good deal closer to the powerful definition of the naive painters. Self-taught, he started out experimenting with an awkward decorative Expressionism. Then – towards 1920 – through the influence of Kanoldt and the Italians, his attention was drawn to the clear plastic forms of things. His naïve realism preserves something of the charm of the Sunday painters. He favoured romantic subjects and sacrificed detail to large plastic volumes. In the course of his development he gradually developed an idyllic quality that attenuates the harshness of his realism.

This was the direction taken by the main stream of the Neue Sachlichkeit artists. Such painters as Champion added a naïvely homespun note; others, like Lenk, went in for a cold, affected romanticism. In the end, the whole movement was swept away or swallowed up by the pseudo-naturalism of National Socialist art.

We easily discern the elements that distinguish German neo-realism from the realism of the nineteenth century. There is first of all the Expressionist substructure, which is clearly manifested in the exaggeration of detail. There is the striving for solid, archaic form which relates it to Henri Rousseau and his naïve magical conception of reality. There is the feeling for the simple existence and autonomous magic of things, as defined by Pittura Metafisica. In German neo-realism the magic of things is experienced, but it is flattened and assimilated to a mannered Romanticism, just as among the Italians it was assimilated to the idea of the classical. This is what gives the Neue Sachlichkeit its thin, derivative quality. A painter of far more power and originality was needed to defy the conformism that had settled on the whole of Europe and achieve the concentration necessary for a new realist statement. That painter was Max Beckmann.

*Max Beckmann (1884-1950)*

The great transformation in Beckmann's art began as early as 1915. It was forced on him by the necessity, felt throughout Europe, of redefining man's experience of nature. When Beckmann found himself obliged to abandon his early style, which had been derived from the so-called Impressionism of the Berlin Secession, he first attempted, under the influence of Meidner and the *Sturm*, to clarify his statement by means of Expressionist deformation. Towards 1917 he moved towards a succinct Verism exaggerated in its drawing and plastic form, that brought him close to George Grosz. For Beckmann, like so many others, took the war as a summons to look reality

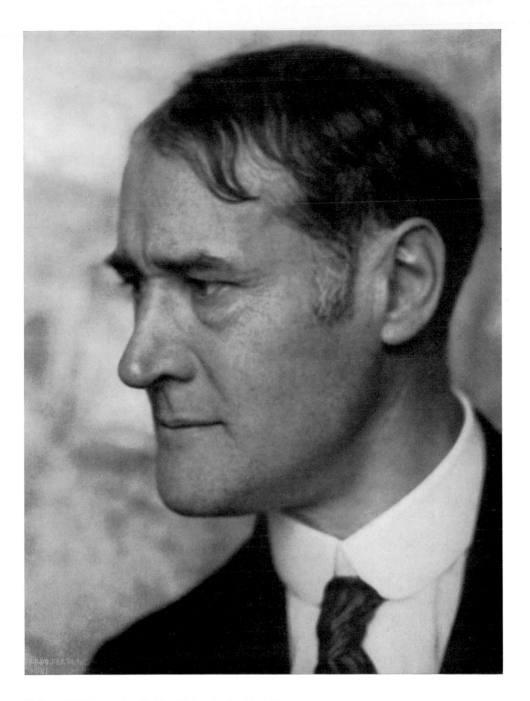

30. Lyonel Feininger (Supplied by Günther Franke, Munich)

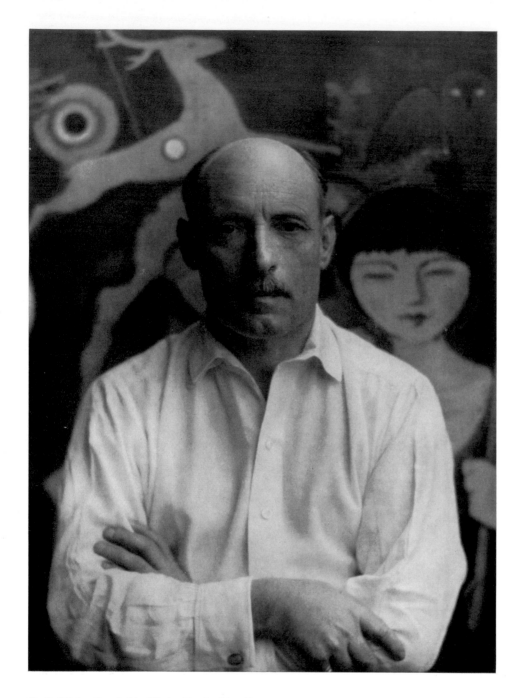

31. Carl Hofer (Supplied by Günther Franke, Munich)

32. Max Beckmann (Photo Helga Fietz, Schlederloh)

33. Figurines from the 'Triadic Ballet' on the balconies of the Bauhaus
    (Photo Lux Feininger)

34. Oskar Schlemmer (climbing ladder) at work on the Bauhaus (Photo Bauhaus)

35. André Derain (Photo Rogi-André, Paris)

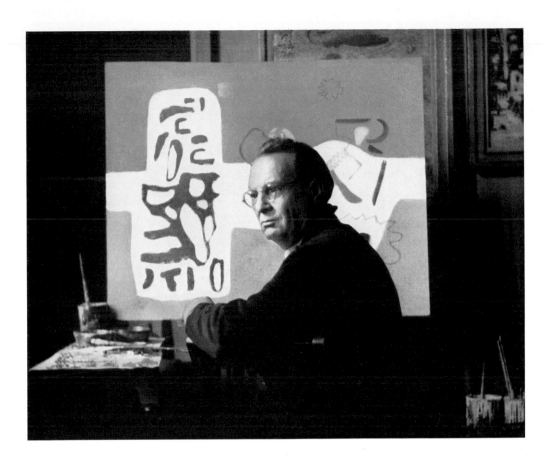

36. Willi Baumeister (Photo Martha Hoepffner, Hofheim)

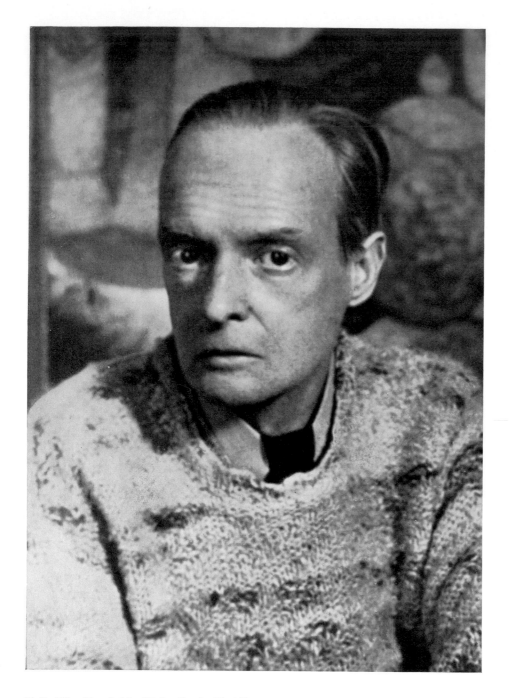

37. Paul Klee (Supplied by Günther Franke, Munich)

in the face. In his circular of 1923 Hartlaub spoke of him in the same breath as Grosz and Dix. And conceivably Beckmann might have been engulfed in the current of neo-realism had he not stubbornly insisted on taking even the contradictions of reality into account.

It was a specific contradiction that wounded him in his artistic nature, and with all his immense energy he tried to overcome it. It was again the thing – object or figure – that provoked his will to state facts. In its volume clearly defined by its dimensions, it was the only tangible part of reality. If you took it as an individual, if you stripped off the veils of its environment and contemplated it as pure, simple form, it became an emblem for the power of existence: the Greater Reality. It was thanks to this emblematic character that you could use it to build up a pictorial reality. You could take it into your mind, learn it by heart, and then employ it as 'the notes of a musical composition' (Beckmann).

But in defining the thing as a volume, you distinguish it from what lies outside it, from space, and that is the beginning of an all-pervading conflict: thing and space. The density, the solidity of the thing as a thing, defines space as the void, the limitless, the initial chaos, the scene of all that is extra-human. It is the silent vacuum, the form of the non-existent, in opposition to which the existent takes on the lonely, forlorn dignity of its existence. For Beckmann space was a metaphysical locality, it was the 'palace of the gods', where dwelt the fear of God and blasphemy as well. He often spoke of the dread of space, which has pre-occupied the modern mind ever since it discovered its own specific relation to the thing, and which we also see at work in De Chirico, Picasso, Léger. Once he explained how, to create a picture surface, he was compelled to transpose the three dimensions to a single plane, and concluded: 'That is how I defend myself against the infinity of space.' Defend himself! Painting becomes a weapon in the struggle for existence. For Beckmann it was a matter of faith. His aim was to understand reality 'within the great spatial void and uncertainty that I call God'.

The proportions which make it possible to encompass this empty uncertainty in a human order can be defined only by a spiritual arithmetic. 'My dream,' says Beckmann, 'is to change the idea of space, the optical impression of the world of objects, through a transcendent arithmetic of my inwardness.' This arithmetic is art which, by perpetually affirming and creating human reality, overcomes its forlornness in the midst of eternity. It is not a question of reproducing reality through real elements, but of *creating* reality with real elements. From this point of view every manifestation of visible reality is felt to be an existential summons to perform an act of ordering. Painting ceases to be an aesthetic concern and becomes an ethical activity necessary to the safeguarding of life itself. In relation to image and thing the moral task is defined by this statement of Beckmann: 'Nature is chaos; it is our duty and our task to order this chaos, to perfect it.'

Things appear in space, the existent in the non-existent, the volume in the void, the certain in the uncertain. Orientation in the uncertain can be gained only through what is certain; orientation in space requires the help of the object. 'If we wish to grasp the invisible, we must penetrate as deeply as possible into the visible.' The contradiction becomes a dialectic. The secret dramatic dialogue in each of Beckmann's pictures springs from the tension between thing and space. In these pictures we see things and figures with imposing volumes and hard contours, each an isolated formal emblem of its own existential power, but strangely weightless as though hovering in air. Each thing attacks space singly, calls another to its help, leans on its neighbour, and thus the painter working with things builds up a fragment of world. Piece by piece things construct a spatial figure that proclaims itself to be representative of reality. Where an empty space remains, bars are set up against it. The frame fits as tightly as possible, but even this does not end the

lurking threat of the space which things have banished from the picture. Things banded together in defence against the onslaught of space – that is the drama of the picture. Order has driven chaos from the picture but it peers in from outside. And within the frame Prometheus the blasphemer battles for human reality. It is an existential action which casts a glaring light on the consciousness of the artist and shows him his possession of the world. Beckmann expresses this experience as follows: 'To transform three dimensions into two is for me a magical experience, during which for a moment I grasp the fourth dimension for which my whole being strives.' From an objective action upon reality and its dimension there emerges what from the beginning was the object of the painter's quest: self-realisation. And in Beckmann we find these astonishing words: 'All objective minds strive for self-representation.'

For Beckmann the portrayal of his barred-in world was self-portrayal of the profoundest sort. On his fenced-in stage things and figures combine into allegories. His brush was not an instrument for the fabrication of 'art'; it was a finger pointed at the world, often at its inadequacies, and at the infamy and meanness of our hearts. These pictures summoned the contemporary to see his position in the world and to chafe at it. Beckmann – though this was only one side of him – was a kind of street singer. Many of his pictures, with their naïve, direct realism, their short cut to reality, look as though they should be lined up in a circus tent: whereupon Beckmann the ringmaster would come in and, using them as illustrations, deliver a sermon on human existence to the sound of a barrel organ. They are experiences of life, clothed in fable and metaphor, often with a moral at the end. And by and large he took a moral view of life and of art: 'Things look black and white to me, like vice and virtue.'

And so for Beckmann nothing is more important than representation and content. His pictures are the very opposite of décor or painting for its own sake. Man, his situation and state of mind are set before us in their full reality. His figures are not pretexts for composition, but actors in a fable, vehicles of meaning. Each one of his pictures is an existential statement. Once we acknowledge the existential conditions, the statement is easily understood, even though its personal cause may remain obscure. Take his *Circus Caravan* of 1940: inside the caravan, under a low ceiling, sits the ringmaster – Beckmann – reading the paper by an oil lamp. Before him lies a questionable Venus, a suitable companion in this atmosphere of fugitive comfort. To the right a heavily barred lion cage, in front of it the trainer. 'Growl, ye passions in the corner!' There is something oppressive about this caged-in well-being. The boy can stand it no longer. He sets the ladder against the wall and shakes at the window in an effort to get out. What a forlorn hope in a hopelessly closed-in world! Immersed in his paper, the ringmaster wastes not so much as a glance on this fool, for he knows there is no escape, not even for himself. This is not merely the interior of a circus wagon, it is a parable of existential experience. Not that Beckmann began with an allegorical intention. He began with a fact and the statement of a fact. His perception of this reality and the formal arrangement that followed aroused his existential feeling. The poetry which resulted was a '*fait gratuit*', a free gift of the hour. Figures and things, even the table and the oil lamp, the colour, the bars erected against space – everything serves to communicate the metaphor. But because it is an authentic '*fait gratuit*', the allegory is not subject to detailed analysis. It remains a hermetic metaphor for an existential experience of a realtiy that remains shrouded in darkness.

Beckmann stood in the middle of reality; he had no desire to cover it over with metaphysical clouds. He was something of a cynic, nothing humble or submissive about him. Before he would take any account of the so-called metaphysical aspect, it had to speak up clearly. It spoke through

his experience of real things, of visible objects in space; reality could not be reproduced, but only created. Beckmann was a producer of reality. He pressed it into shape, constructed a scaffolding with it, and set it up against Creation. No doubt there is something 'blasphemous' in such an attitude. But if we look more sharply, we perceive the same awe of the hopelessly hidden God — the same Old Testament religious feeling as in so much of the art of these years. Living on many different planes of experience, he became one of the great image makers of the epoch; like Picasso. And like Picasso, he strove to shape objects into a grand pictorial script. In a broad sense Beckmann and Picasso — whom incidentally Beckmann thoroughly detested — are not far apart. The Spaniard is more passionate, more serene in his grief; the German more obscure, more profound, but also more barbaric and direct.

Beckmann's road to mastery is quickly described. At first he adhered more closely to the trends of his day than his work as a whole might lead one to suppose. After venturing forth from the safe harbour of Impressionism in the manner of the Berlin Secession, he veered towards Expressionism. Though it was a mere transition, this phase lasted until 1920 — as the lithographs of the 'City Night' series bear witness. As early as 1917 he tried to combine Expressionism with Verism, following the line marked out by George Grosz. The result may be seen in his large painting *Night* (1918-19). The theme — a gang of desperadoes invading a slum dwelling at night — is typical of German post-war Verism with its delight in nightmarish scenes and gruesome detail. But already he was finding his own way. Cubism supplied valuable suggestions. Things and figures began to take on firm, compact volumes and to move back and forth, their compressed energy engendering a barred-in enclosure. The aggressive bulk of things and the piercing counter-thrusts of space introduce a dream-like magic into the Verist reportage.

In this painting Beckmann's development is clearly laid down. For a time he established his volumes by the suggestive use of line, while his colour remained largely accessory. Again he drew help from outside, this time from Rousseau. The douanier taught him how things take on the magical sovereignty of the 'Greater Reality' when they are defined on the strength of a man's grasp of the world and so re-created. In the definition of reality, the important thing is not how a thing looks, but what we know about it. Thus, beginning with the early Frankfurt landscapes of 1920, Beckmann began to re-create the theme of his vision and experience with the help of emblematic thing-signs. In his naïve determination to grasp reality, he defined the forms and volumes of objects piece by piece and fitted them — again piece by piece — into the construction of his picture. Space is built up from the volumes. We discern a far-off reminiscence of Gothic painting, the stone-hard realism of the Pietà of Avignon, which Beckmann — like Derain — had ardently admired at the Louvre.

Towards 1923 he gradually began to abandon this hard naïve realism and to move towards a more classical figure painting. He took a number of important hints from Derain, but the *Valori Plastici* and the general climate of European neo-realism also had a good deal to do with the development of his thinking. His space becomes more restful, his forms grow large and simple, losing their Expressionist or naïve attitudes. Slowly his colour and drawing begin to form an organic whole. The figure paintings of 1925 would be quite comparable to the classical realism of the Italians and Derain if not for their content, the depth and breadth of Beckmann's experience, which produces an extreme formal tension.

Roughly from 1928, Beckmann achieved freedom in his use of colour. Meanwhile he had taken frequent trips to Paris, and no doubt his contact with French painting contributed to this step. He began to define and modulate his objects and his space by means of rich colour. Even black

and white became colours for him. This was the ultimate step from drawing to true painting. Colour casts a supple garment over the particular and the fragmentary; the formal relations become more fluid. Open space makes its appearance. This is the painterly style that was to flower in Beckmann's late work. Now his desperate strivings for contour, space, volume, and colour are appeased. It is a consummate style, in which he is able to set before us his whole experience of reality. His mythical circus folk appear in epic situations. Great triptychs provide a stage for the dark allegories in which Beckmann encodes his experience of existence. The culmination occurs in the great paintings of the classical saga, the mythical legends of human life: the *Perseus Triptych* of 1941, *Odysseus and Calypso*, 1943, and *The Argonauts*, 1950.

Beckmann's greatness lies in the uncompromising insistence with which he translated his position in the world, his hate and love, his anguish and pride, his piety and his blasphemy, into visual terms. He was a realist who could say with perfect truth: 'I have only tried to put down my image of the world as clearly as possible.' But in contrast to the German neo-realists, he saw reality in its widest dimension. 'What matters is real love for the things of appearance outside us and for the deep secrets that are enacted within us.' Reality can be created only on the strength of existential experience. And it is only an artist whose painting is an existential action who can produce a picture of the world which is also a self-representation. In a pictorial script distilled from real things, the inside and the outside come to coincide.

*Carl Hofer (1878-1955)*

In distinct contrast to Beckmann, but sustained by the same general striving to probe the visible world, Carl Hofer appeared on the scene towards 1919. That was the year in which he found his personal style.

His painting springs from an entirely different source. Its outstanding characteristic is a succinct, cool, delicately lyrical classicism. It shows a certain relationship to Gauguin, but there is also an unmistakable suggestion of southern, Mediterranean idealism. The closest stylistic kinship is with Felice Casorati. These remarks enable us to give Hofer his proper place in the vast mosaic of modern European art. His work is the response of a German painter to the conditions and yearnings which in Italy had led back to the classical idealism of the *Valori Plastici* painters. We have seen that the Italians answered the call of their own classical past; Hofer found his traditional roots in the style of the German painters living in Rome in the nineteenth century, of Feuerbach and Von Marées. He had already shown a strong leaning in this direction while studying under Kalckreuth and Hans Thoma at the Karlsruhe Academy (1896-1902). From 1903 to 1908 he lived and worked in Rome, where he encountered the art of Hans von Marées and was strongly influenced by his classical idealism. Then came a new period of study in Paris (1908-1913). The construction of Cézanne's late period was now superimposed on that of Marées. Hofer's pictures – chiefly figure paintings – become flatter and lose their film of pictorial beauty; it is only where the formal framework seems to stand out too nakedly that he hides it beneath the brilliance of Impressionist brush-work. Two trips to India in 1909 and 1911 provided a great human experience and left a permanent mark on his imagery. This was the source of his dreamy, almost vegetative female figures with their angular, timid gestures. This lyrical anima figure was to remain with Hofer as long as he lived. Up to the time of the war he produced lyrical figure painting, characterised by a classicism half concealed behind Cézannian construction.

But now came difficult years. The war surprised Hofer on a visit to France and he spent three years in an internment camp. In 1917 he was freed in an exchange of prisoners and went to Zurich. In 1918, bitterly disillusioned, he returned at last to Berlin and its bitter climate of post-war disillusionment. These experiences helped him to develop a personal style. Contact with hard reality scratched away the coating of idealism and idyllic beauty. What remains is a disenchanted dream. Now his paintings look as if the skin had been stripped away. His grounds – dry colour with a few hectic accents – suggest underpainting. The sparse framework, built up in contrapuntal contrast from a few construction lines and hard contours, stands there in all its nakedness. Like a worried architect, Hofer tries to prop up the house of his dreams. The anima figure is still living in it; but her gestures have grown harsh and no longer idyllic, she has donned the dress of a working-girl. Often a mask replaces the living creature. A few themes recur again and again: girls at the window or quietly busying themselves around the house, a group at table, card players, a boating party. Hofer likes to repeat himself, for then the organisation of the picture can become more sober and deliberate. The figures in these pictures do not directly accuse, but they are angry and joyless. Many of the scenes seem like evil visions. By 1928 he had painted the first version of *Black Rooms*, a bare box full of doors and rooms; a naked man furiously beating a drum, the noise of which sends other figures dashing from room to room. In the landscapes from the Ticino, in restrained still lifes, in groups of girls, Hofer seeks to escape from these dark visions of reality, and here and there in these pictures a startlingly colourful beauty burgeons up from the solemn hardness of his painting. But always his visions overtake him. His obsession allows no change of expression, his style remains always the same. In 1931/32 Hofer tried to escape into non-objective art, and explains this development in the preface to the catalogue of his exhibition of March 1931: 'The traditional forms and ideas no longer suffice me, for I am at the mercy of voices from a new world.' But his attempt failed; reality drew him back again. And it was a bitter reality: the years of tyranny and persecution, the war, the night bombings, one of which destroyed a large part of his work, the second post-war period. This was the reality that set its stamp on his visions: watchmen in ruins under a red moon, criers in snowy wastes, freezing, forlorn couples, masks and grimaces of evil. In some of these pictures the colour becomes more glaring, vehement, desperate, and then falls back into the earth tones. But this legend of his life experience had no influence on his style. The unique emerging moment has no place in the brittle architectonics of this painting.

However, it was precisely the insistent litany of this personal style that gave Hofer his uncontested place in the German painting of the period between the two wars. Here was a man who had begun with a classical vision and a neatly circumscribed dream of beauty; and then his encounter with reality shattered the dream. A disillusioned idealism engendered the bitter images with which he interpreted the life of his time and supplied the succinct form. Hofer was perfectly right in refusing to be called an Expressionist. He was a classical idealist thwarted by reality. If he had gained his experience of life in a more tranquil world, he might have painted like Derain or Carrà or Casorati.

*The Development of the Brücke painters and the Mature Style of E. L. Kirchner (1880-1938)*

Immediately after the war everything seemed to point the way to a revision of Expressionism or at least to a re-appraisal of the Expressionist experience of the visible world. The Brücke painters

did not evade this task. Otto Müller found his way to his great, earnest style. Heckel and Schmidt-Rottluff modified or disciplined their styles.

It was Heckel's resilient mind that reacted most strongly to the impulses of the day. During the war, which he spent in the German medical corps in Flanders, he had attempted to adapt his subjective feeling to objective nature. A meeting with Beckmann, conversations with Ensor, may well have played a part. The whole tenor of his pictures becomes lighter and more relaxed. The bright colour springs from an inner freedom, for now he can accept the gifts of nature with an open heart. In the still lifes and portraits of the mid-twenties he even tended towards a sober realism not too far removed from the endeavours of the Neue Sachlichkeit. He began to paint large panoramic landscapes and city views, for which he gathered material on long summer journeys through Germany and other European countries. All these pictures were painted in his studio after sketches made from nature. They show a careful choice and definition of essentials. From 1925 to 1930 he became somewhat interested in the Sunday painters and took over certain elements of their naïve vision. Later on he borrowed from the painters of the Far East the method of developing decorative hieroglyphs from nature and then re-applying them to it. Heckel has continued to paint landscapes in this lyrical style.

In his robust, frankly aggressive way Schmidt-Rottluff faced up to the same task. At first he clung tenaciously to Expressionism. On his return from the war, he looked upon the objective world as a mere pretext for the eruptive response that he recorded in crude, block-letter abbreviations. But, gradually at first, then towards 1926 more rapidly, he moved closer to natural appearance and developed a highly coloured, lyrical monumentalism which draws its poetic power from a direct communion with nature.

The true genius among the Brücke painters – E. L. Kirchner – took another path, leading to a far deeper knowledge of nature. In 1917 Kirchner had been brought to Davos, desperately ill. Then, after a long stay in various sanatoria, he had made his home in a lonely hut at the entrance to the Sertig Valley. His last important work before coming to Switzerland had been the woodcuts for *Peter Schlemihl* (1916), done in the midst of a grave physical and psychological crisis: distraught visions of anguished unrest, registered in a jagged, uneasy script. Now, on the high plateau near Frauenkirch (1918), a very different life-feeling was born in him, which changed his vision and his forms. Released from the sanatorium with its *Magic Mountain* atmosphere and alone beneath the snug low ceiling of his hut – the sick city-dweller with his exacerbated sensibility acquired a serene, hopeful patience and entered into a new relationship with nature. His surroundings filled him with wonderment. He had only to open the door to find himself face to face with an overpowering, elemental world – the high mountains. Little by little he familiarised himself with the vast, eternal face of nature – gigantic and overwhelming but not hostile. Each step he took into this mountain world gave him a share in its power, its permanence and peace, appeasing the unrest of his soul. He recalled an experience which had affected the whole course of his painting. In 1900 he had attended an exhibition of the Munich Secession, and at the sight of all these stylised or academically emas-culated scenes of nature in the hushed seclusion of the Museum, he had understood how far re-moved all this was from life and reality and it had suddenly come to him that outside 'a tumultuous life resplendent with colour was throbbing in the sun'. Now a mature man in full mastery of his art, he had received the gift of a second life and once again stood face to face with reality – no longer the throbbing dynamic reality of the big city, but solemn, immobile nature and in it the strength of the mountain people, with their terse heavy gestures. Once more he felt the need to take possession of reality. And so he painted this mountain world and its peasants; he saw how the trees

on the mountain slopes shaped themselves into rhythmic signs that punctuated the rhythm of the earth, watched the beasts living and moving, the gently patient cows, the nervous malignant rams, and felt that he had become a part of something vast and strong and simple – the great realm of our old friend Pan. 'It has always been my aim,' he wrote, 'to express emotion and experience in large simple forms and clear colours, and that is still my goal. I want to express the richness and joy of life, to paint men in their work and play, their reactions and counter-reactions, to express both love and hate.'

This simple power could not be expressed by any copying of appearances; it could only be signified by a bold runic script. Things must be replaced by signs and with these signs the epic of reality must be written. Kirchner had always known the hieroglyphic, 'signifying' character of form. But hitherto the agitation of his soul had given his forms a lyrical, dramatic character; they had stood for psychological states. Only now, with his new-found epic vision, was he able to conceive 'objective' forms, capable of signifying *things*.

The years from 1921 to 1925 were the great period for Kirchner's mastery of reality. In constant dialogue with nature, he developed the objective runic spirit which enabled him to record his experience of reality. He produced mountain landscapes and simple, monumental scenes from the life of the mountain peasants. The structure is strict, stressing the scaffolding of verticals and horizontals even in the details. Where circular forms or jagged, pointed forms appear, the rigorous framework lends them rhythmic weight. The colour becomes strong, clear, sonorous. Space – Kirchner's view of space was never predominantly perspective – is organised and disciplined by means of clear superimposed planes. This produces the monumental epigraphic quality of rug designs, and indeed some of Kirchner's designs were used for tapestries. Through harmony with nature, Kirchner penetrated to the formal root of natural objects, whence he distils the signs which stand for reality in his pictorial world.

In 1928 Kirchner's style underwent a new change. Now he concentrated on the formal side of his picture writing, wishing his hieroglyphs to reach back into more remote, more abstract realms and, in the play of their arabesque, to fathom experiences beyond the visible images of nature. He was determined, as he now wrote, 'to accept as stimuli all the riches of the visible and invisible world'. Whereas previously he had been accustomed to paint 'from life', now he painted from imagination and memory. The hieroglyphs become more dense and at the same time more abstract, taking on a free rhythm. 'The hieroglyph, this unnaturalistic formation of the inner image of the visible world, broadens and takes shape according to optical laws that had not hitherto been used in this way in art – the laws, for example, of reflection, interference, polarisation, etc.'

There is no doubt, although Kirchner persistently denied it, that he drew a number of important ideas from Picasso, who since 1925 had been busy working out a pictorial script in which to record his experience. *Colour Dance* (1932), an arabesque formed of three women dancing, is clearly a variant of Picasso's *Three Dancers* (1925). Numerous formal discoveries, which, Kirchner insists, 'all come from nature' give his late work an abstract look. Simultaneous front and side views, distinct object forms joined in a single arabesque, rhythmic reflection, colour planes that enter into cohesive form complexes and break them up – such devices transform the picture into an ornamental structure, in which the runic object-signs join to form arabesques. However, the foundation that sustains the whole remains the original natural experience, and this is what gives the script its power. Kirchner rightly stated that 'everything is in a picture of this kind, not just a part of art as in so-called Impressionism, and there are no fortuitous perspectives or segments of reality'.

At first he insisted on a flat picture surface. But by 1930 superimposed abstract planes begin to create

a space full of magic light and open up mysterious vistas. In this enchanted realm we perceive the thing-signs out of which our imagination reconstitutes the poetic experience at the origin of the work.

Shortly before his death, Kirchner seemed to be entering on a new stage. In his latest canvases he returns to earlier ideas and states his experience of nature more directly. But he had no more time. Frightened by symptoms of his old sickness, filled with despair by the barbarism that was taking possession of Germany – his work had been held up to ridicule, and much of it had been seized and destroyed – Kirchner, whose deepest desire had been the renewal of German art, committed suicide on June 15, 1938.

Kirchner's intuitive insights into the objective world led him to a hieroglyphic script in which he strove to describe his experience of reality more fully than is possible through natural likeness. Starting from similar premises, he had undertaken the same task as Picasso and in a way Beckmann, the very task to which Klee and Mirò had also been drawn, though from a different direction. Kirchner's purpose has nothing to do with naturalism, which he was determined to cast off. His mature style sprang from a compelling desire to recapture reality through forms and signs.

*Kokoschka's Dramatic Impressionism*

At the time of the war, German Expressionism was on the defensive. But then it appeared to acquire an outstanding champion. Oskar Kokoschka had returned to Germany. Demobilised, he spent the spring of 1916 convalescing at Herwarth Walden's home in Berlin, and in April the *Sturm* put on a large exhibition, featuring his *Bride of the Wind*. In 1917 he moved to Dresden and became the centre of an intensely bohemian group of writers and actors.

Kokoschka's hypersensitivity to his environment and penchant for unusual states of mind made him singularly vulnerable in those chaotic times. War, revolution, and the general collapse of morality ended by deranging him completely. The chief symptom of his disorder was a monstrous exhibitionism. In provincial Dresden he clearly enjoyed cutting the figure of the wild genius. Soon he was widely known as 'mad Kokoschka'. A revolting incident that took place in 1918 throws a glaring light on Kokoschka's state of mind, part pose and part real anguish. 'In order to forget the nauseating reality,' he commissioned a Stuttgart dressmaker to make him a female dummy according to the most detailed and indecent specifications. With this manufactured anima, he proposed to live out his dream of the artist's life. Of course his monstrous plan ended in disillusionment, and the whole incident would have passed off quietly as a bit of harmless bad taste if Kokoschka had not subsequently authorised the publication of his correspondence with the dressmaker. For there is no doubt that his exhibitionism and posing led a good many people to question the seriousness of his whole effort. But the literary bohemia of the day applauded his shenanigans. In 1918 Westheim published his enthusiastic biography, and in 1920 Kokoschka was appointed professor at the Dresden Academy.

The pictures of his early Dresden period clearly reflect his state of mind. Construction, line, colour, all show a peculiar lack of poise. The thick, scrambled brushwork is that of *Bride of the Wind*, but over it runs a slimy track that suggests the droppings of a snail. The precise brushstroke of Van Gogh or the Fauves degenerates into a nervous groundless curlicue. And the object matter is as feverish as the script. Nearly all the pictures of this period are figure paintings, groups of friends with frantically deformed poses and gestures, 'psychological' arrangements, often with

232

literary titles, such as *The Emigrants*. They are intended to express 'the struggle of man against man, the contrast of love and hate, and in each picture I look for the dramatic accent'. This is Expressionism of the most undisciplined sort, vision flung on canvas.

Approximately in 1920 – perhaps a vague glimmer of his responsibility as a teacher at the Academy had something to do it – Kokoschka took himself in hand. He began to work hard on the organisation of his pictures. He gave up the sinuous line that had broken his surfaces into tatters, and held the picture together by means of large spots of thick colour. Probably he felt the influence of Cézanne and Bonnard, assuredly that of Nolde. For now his colour becomes strong and luminous, spreading over the surface like a fine carpet. The Expressionist passion is still present, yet it would seem as though the festive colour brought him closer to nature, as though in his joy at discovering the charms of the world he forgot his personal conflicts and attitudes and as though the 'inner drive to worship nature', of which he liked to speak in later years, was beginning to dispel his exhibitionism. His themes become less pretentious: a nude in the open air, still lifes, and here and there a landscape.

No doubt Kokoschka needed a drastic break at this time if he was to escape from the tentacles of the Expressionist milieu. In 1924 he left Dresden for good, without giving notice or saying good-bye, and went to Switzerland to paint landscapes. Then he continued on to Vienna and Paris. This was the decisive experience. In the company of Pascin, he became acquainted with Paris bohemia, its *joie de vivre* uncomplicated by the problems of philosophy or psychology. Attracted by the French passion for reality, he found his way to the art that was the last great expression of this joyful harmony with the world: Impressionism. He was overwhelmed by this gathering of rich personalities, all sharing the same radiant love of nature. He did not single out any one master; what he admired most was the Impressionists' temperament and the way they saw the world.

At this juncture he turned wholly to landscape painting. Gone was the psychological anguish, the torment of the soul. Visual impressions kept his mind too busy, preoccupied with the beauty of the world. His yearning for freedom, wide spaces, nature now sent him on travels through three continents; to Bordeaux, Biarritz and Marseilles, then by way of Toledo and Madrid to Lisbon. In 1926 he was in London. He travelled in fashionable style, for meanwhile Cassirer had undertaken to finance him. Then back to France; in 1928 he visited Tunis, Constantinople, and Jerusalem. In between trips there was always a stay in Paris. In 1929, Ireland and Egypt; in 1930, Algeria and Italy. Only in 1931 did he stop to rest in Vienna, where he remained until 1934. His painting of these years is a complete *orbis pictus*, seen through the eyes of a traveller eager for discovery. Wishing to take home as much of his vision as possible, he sought the widest panoramas, when possible a view from a tower. The manner is thoroughly Impressionist, bright and supple, set down with a dashing brushstroke – but without the secret calculation, the weighing and measuring of the French Impressionists. The theoretical thinking of the Impressionists, on which their whole method is based, was totally alien to Kokoschka. He merely applied their method and was thus closer to the German Impressionists, particularly Corinth and Slevogt, than to the French painters he so admired.

In this period Kokoschka painted with a spontaneity that expressed his whole extraordinary visual sensibility. A magnificent series: the landscapes are poems, records of the experience of a wandering painter-poet, whose vision is alive with dramatic feeling. This is a dramatic Impressionism! It assimilates as much reality as the eye can see; but it is a psychic eye. The impressions of the retina are profoundly affected by the state of the artists's soul. Jerusalem like a glittering ark floats in a

restless surf of hills; the Baroque volutes of Santa Maria della Salute spring like a fountain from the mirror of the Grand Canal. If we compare a series of these landscapes, very different worlds – Paris, Rome, Venice, or Prague — may take on a strikingly similar aspect; the same light, the same colour, the same response. The landscape is assimilated to the dramatic state of the observer. Kokoschka was never to depart from this Impressionist style. But in his late period he used it for other purposes. This had to do with his personal life, cruelly affected by the political events of the day. In 1934, horrified both by the semi-Fascist Dolfuss regime in Austria and the Nazi terror in Germany, he moved to Prague. This experience and the reading of Comenius decided him to enlist his art in the service of his moral conviction. to embody a lesson in his art. This development began in the Prague period, though at the same time he produced a number of magnificent city views. But it was only in 1938, when he fled to London from the approaching German troops, that he painted his first great political allegories. His Impressionist technique, his nervous composition and obscure symbolism were ill-suited to his noble purpose. Again the pictorial organism breaks into fragments, unable to sustain the content. However, a few landscapes and still lifes continued to reflect his old style. After the Second World War he resumed his long trips through Europe and seemed to be going back to his dramatic transpositions of visual experience.

This dramatic Impressionism was Kokoschka's response to the new striving to master visible reality. He did not define it from the standpoint of objective being, nor seek to translate it into signs, but he experienced it as an impression to which he gave the resonance of visual poetry. In the great panorama of European art, he seems closest to such pure instinctive painters as De Pisis or Tosi, Soutine or Pascin. His Impressionism burns with a poetic Expressionism.

*The Transformation of Expressionism*

It has become customary to call the leading German painters of the twenties Expressionists, but the term is scarcely applicable. There is no doubt that a wild undisciplined Expressionism was the dominant movement in Germany in the apocalyptic early twenties. And even in later years Expressionism still had sufficient vitality to sustain a few painters of the younger generation. An example is Werner Scholz (b. 1898). Starting from his admiration for Nolde, Scholz found his way, as late as 1930, to a succinct expressive style: half-length figures of timid children or sorrowful youths, a pathetic bunch of flowers, the massive forms of a landscape. All this was painted without the slightest subtlety in black and white with a few local colours; only later, in the religious triptychs, did he develop a kind of peasant brightness. The almost primitively simple form, modelled out of the shapeless mass of colour, is not intended to define reality but only to sustain the dull, tormented expression; it is merely an emanation of an obscure sorrow, which soon takes on religious overtones.

However, the trend was not towards Expressionism, but towards the definition of reality. Of course the experience of Expressionism could not be ignored, for it had changed man's vision of reality once and for all. The trend, then, was to redefine reality from this standpoint. Even in the crudest Verism of Otto Dix or the cold, smooth hardness of the Neue Sachlichkeit – the most direct statements of objective reality – the Expressionist optics is still at work.

The methods of setting down this newly discovered aspect of reality were as diverse as the individuals who employed them. Dramatic Impressionism served Kokoschka to express his poetic vision of the world. Hofer, with his disillusioned idealism, invented a succinct classical lyricism

as a means of defining his experience of reality. In the dialogue between the positive forms of things and the negative forms of space, Beckmann built up a pictorial reality that formed a bulwark against the emptiness of space. Kirchner took from nature the signs and hieroglyphs in which to state his experience of reality. The ways were many but the goal was one: a kind of realism appropriate to the hour in history, the 'transcendent realism' of which Beckmann once spoke.

This concern for reality affected not only the masters who had gone through Expressionism but the younger painters as well. Towards 1930, in Hamburg Secession circles, a school – Karl Kluth was its strongest representative – seemed to be taking shape. Stimulated by the late, relatively naturalistic style of Munch, these painters strove to transcend Expressionism and to achieve a monumental reality in landscape and figure painting. This desperate struggle for reality is typically reflected by another painter – Xaver Fuhr – who made his appearance in these years. Feverishly intent on reality, like Utrillo unable to look beyond his immediate environment (and like him self-taught), he strove to define it in reductions. His main theme was the clash between the world of technology and retreating nature. With the matter-of-fact simplicity of an engineer, he designates houses, things, implements by the most succinct symbols, draws the connections between them as though with a ruler, but so lacerates the appearance of things in the process that he must bolster them up with new lines. This yields a framework of lines in which there is barely space to hang the signs of reality. The result is a fragmentary reality, wounded on all sides by intersections and points of thrust, face to face with the heartless void.

'Face to face with the void' – this applies to the whole art of the period. The painful breach that separated man from the world about him still lay open. The important thing was to erect a dike against the gaping void, to create the only thing capable of resisting – a man-made reality. Creation by construction – that was the thing. From Expressionism emerged a new and unprecedented realism.

*The Bauhaus Painters*

Now that the system of co-ordinates that had served for five centuries had been abandoned, this new realism rooted in the magical experience of things seemed to provide the main road into the jungle of nature.

But this was only one road. The experience of the absolute as reflected in 'abstract painting' also pressed for exploration. In Germany this tendency even found a centre of action. While Beckmann, Hofer, or Kirchner worked and developed alone, the 'abstract' painters benefited by the companionship of the Bauhaus.

Early in 1919, Walter Gropius, the architect, was appointed head of a new school resulting from a merger of the Weimar Academy of Art and School of Applied Art. From the first it was planned that the central activity would be the teaching of architecture, building, and Gropius called the school *Das Bauhaus*, an allusion to the '*Bauhütten*', the medieval associations of builders in which artists and artisans had worked together under a master builder. The idea was to repair the breach between the artist and the craftsman or technician. The old academic classes were transformed into workshops under the guidance of an artisan and an artist; the latter bore the characteristic title 'master of form'. Theory and production went hand in hand. The beginning of all creative art was held to be the material; the goal was to shape the environment in accordance

with the practical and ideal conditions of contemporary life and the possibilities afforded by industry and technology. The plastic arts were regarded merely as a superstructure, from which, however, new creative impulses should descend into the workshops. In the *Inaugural Manifesto* of April 1919 Gropius formulated the goal: 'Let us create together the new building of the future, which will be everything in one – architecture and sculpture and painting – an edifice built by millions of artisans, which will one day rise heavenward, a crystal symbol of a dawning new faith.' The idea was not without its roots in the past, and it was no accident that the experiment took form at Weimar. In 1902 Van de Velde, commissioned by the Grand Duke, had founded a school of Applied Art; and Van de Velde was later instrumental in the appointment of Gropius as its director. Thus there was a direct tie between the Bauhaus and the arts and crafts movement of Jugendstil days, centred round the famous Werkbund, which had set out to produce articles and fools of daily use, that would be both beautiful and useful. In its beginnings the Bauhaus distinctly reflected the atmosphere of the arts-and-crafts societies and of the Youth Movement with its Romantic enthusiasm and its ideal of co-operation, which had given the artistic currents of pre-war Germany their youthful force. This influence was extremely important, for it made the Bauhaus amenable to the ideas of the Blaue Reiter group, the source of its main contribution to modern European painting. It also determined the selection of teachers.

Gropius was in the fortunate position of being able to build up his faculty from scratch. The first 'council of masters' consisted of the painter Lyonel Feininger, the sculptor Gerhard Marcks, and Johannes Itten, the painter and teacher. Feininger came from the Blaue Reiter circle. Marcks was striving for an expressive plastic construction and hoped to achieve a more concentrated abstract form by way of ceramic bowls and vases. Itten was a disciple of Adolf Hoelzel whose work on an 'harmonics of coloured forms' he carried on, but he had also taken up the ideas of Kandinsky. Itten showed an unmistakable leaning towards Jugendstil Romanticism, which considerably affected the early climate of the Bauhaus.

In 1919 the 'council of masters' called upon the architect Adolf Meyer, in 1920 upon the painter Georg Muche, then aged twenty-five, who in 1917/18 had made his début in *Der Sturm* with a series of abstractions in which one discerns a suggestion of Chagall's colour and of Klee's poetic dimension, and who had recently been working at the Sturm Art School in Berlin. Muche assisted Itten in his preliminary course and served as the 'master of form' in charge of weaving. Paul Klee, invited to join in January, 1921, was first in charge of glass painting, later on of weaving. Oskar Schlemmer, who had been Hoelzel's pupil in Stuttgart, was engaged in April and put in charge of the workshops for sculpture and stage design. At the same time, Lothar Schreyer of the *Sturm-Bühne* became director of the Bauhaus Theatre. Finally, in 1922 after his return from Russia, came Kandinsky, who was given the workshop for mural painting and also taught analytical drawing, from which he developed a kind of theory of composition.

The choice of masters clearly indicates the tendencies and influences at work in the early Bauhaus: Sturm Expressionism, Hoelzel's work on a theory of colour harmony, and above all the influence of the Blaue Reiter, which Kandinsky enriched with ideas drawn from Russian Constructivism. In this period there was still an even balance between Abstract Expressionism and Constructivism. But the Bauhaus was a living organism, extremely alert and open to new ideas. Soon it opened its doors to the related efforts of the Dutch Stijl group and the Russian Constructivists. Beginning in 1921, Van Doesburg made frequent visits to the Bauhaus and lectured on the Stijl movement. The emigré Russian Constructivists were represented by El Lissitsky and Naum Gabo; and in 1926 Malevich also visited the Bauhaus. In 1925 Mondrian's *Neue Gestaltung* and Van

Doesburg's *Grundbegriffe der gestaltenden Kunst* appeared as Bauhaus books; in 1927, Malevich's book *The Non-objective World* was published.

As early as 1923, the appointment of Moholy-Nagy, who reflected the direct influence of Russian Constructivism and Van Doesburg, indicated the beginning of an inner transformation. This was the turn towards the pure functionalism that was to make the Bauhaus the centre of the whole modern development in architecture. Grave tensions arose, for the Constructivist purists did their best to eliminate the Expressionist element. Itten and Schreyer resigned in 1923. When in 1925 the hostile attitude of the government forced the Bauhaus to move to Dessau, Gerhard Marcks also left. By the beginning of the Dessau period, the shift to functionalism was complete.

In 1927 Muche, who had busied himself chiefly with building plans and the arrangement of exhibitions, also left the Bauhaus. Itten had opened an art school of his own in Berlin. Muche joined him as a teacher and remained in Berlin until 1931, when he was called to the Breslau Academy. Later on, after an interim in Berlin, he went to the textile school at Krefeld, of which he is now the head. Towards 1922, Muche had given up abstract painting and had found a metaphorical expression for his feeling in mobile plant forms suggestive of the Jugendstil: *Plants in the Storm, Fading Plants.* Then from the pale colour movements on his canvas faces and figures took form. Slowly there arose a figure painting related to Ensor, a classical lyricism with a Romantic undertone set down in thin, bright colours. But this has nothing to do with the development of the Bauhaus.

The departure of Itten had an important consequence. Itten had organised a preparatory course that was compulsory for all new students. In accordance with the ideas of Hoelzel and Kandinsky, it was based on careful analysis not only of the pictorial elements but of materials as well. On his work bench the student found a bundle containing such things as paper, iron filings, tin, glass, cotton, cellophane. He was expected to analyse each one and consider how it might be utilised in the creation of form. The idea was to teach the student not to start out with ideas of 'art', but to forget his individual self and to develop a rapport with his material. By piecing materials together, arranging them, setting them in motion, he would shape them into a creative medium. Form was held to have its roots in the material. Basically, this was a pedagogic application of the Cubist and Dadaist ideas of 'montage' and 'ready-made'. In Itten's intention, the course was an introduction to expressive form.

After his departure, the preparatory course was taken over by Joseph Albers who had received a good part of his training at the Bauhaus, and experienced and participated in the movement towards functionalism and Constructivism. He retained Itten's method but rigorously excluded all reference to expression as an aim and insisted on rational, elementary forms that could be utilised in functional architecture. Since Albers directed the course until 1933, every new student was indoctrinated from the start with functional, Constructivist ideas. In his own work and as director of the workshop for glass painting, Albers practised a sober 'Elementarism' derived from Malevich and Doesburg.

Thus from 1923 to 1925 the Bauhaus, in the wake of the international Stijl movement, came to be increasingly dominated by a functionalism that regarded art as nothing more than an experimental form of 'industrial design'. The leader in this development was Moholy-Nagy.

Laszlo Moholy-Nagy (1895-1946), a man of keen intelligence with a passion for experiment, had come to Constructivism in 1919 through his encounter with the painting of Malevich and Lissitsky. From clear geometrical forms – triangle, cube, circle, with supporting lines – he built up on the bare picture surface well-constructed architectural forms closely related to the work of Lissitsky

and Naum Gabo. At the Bauhaus he took over the metal workshop where he carried on his magnificent experiments. Every material suggested a suitable formal arrangement. He was fascinated by technology with its transparent, incorporeal, dynamic fields of force. He looked for materials capable of bringing out these ideas, which he also considered in relation to the problems of art. A pile of painted glass discs: here were the '*plans superposés*' of the Cubists embodied in suitable materials. Working with the ideas of Man Ray, he experimented with photography and photograms. Then he took up experiments with coloured light. He examined everything he laid hands on for its artistic possibilities and connected it with the new concepts that pre-occupied him: dynamics, space-time, simultaneity, transparency, fields of force, space modulation. His experiments resulted in a number of discoveries that could be applied in stage design, advertising, industrial design, typography, city planning, and architecture itself. With his intellectual alertness and startling discoveries, he exerted a profound influence on his students. Albers, Herbert Bayer and Marcel Breuer worked in the same direction. Art was overshadowed by industrial design.

This development prepared the way for the third phase of the Bauhaus, which would have brought about its downfall even if political events had not hastened the process. For from the standpoint of the strictest functionalism art was altogether superfluous. In 1928 Gropius left. His successor was the Swiss architect Hannes Meyer, a strict 'dialectical materialist', altogether opposed to free artistic activity. The Bauhaus began to disintegrate. Moholy-Nagy, Herbert Bayer, and Marcel Breuer left with Gropius. Schlemmer went to Breslau in 1929 and Klee to Düsseldorf in 1930. Meanwhile the Bauhaus had become the butt of violent attacks on the part of the rising National Socialist movement. In 1930 Mies van der Rohe became director and attempted to revive the old Bauhaus idea of a co-ordination of the arts. But in the existing political situation he was doomed to failure. In 1932 the Bauhaus was compelled to leave Dessau for Berlin, where in May 1933 it was closed by Goering as a 'breeding ground of cultural Bolshevism'.

Now the ideas and legend of the Bauhaus went into exile. After a period of uncertainty in various parts of Europe many of its leading lights finally settled in the United States. Today Gropius is teaching at Harvard University and Mies van der Rohe in Chicago. Moholy-Nagy, who after leaving the Bauhaus worked as a scene painter, interior decorator, advisor to film producers, and industrial designer in Berlin, Amsterdam and London, founded the 'New Bauhaus' (1937) in Chicago, where he tried to carry on in the old Bauhaus tradition. In his last years he worked on three-dimensional curved objects made of transparent materials, which he called 'space modulators'. Herbert Bayer and Marcel Breuer became extremely successful as architects and industrial designers in America. Since 1933 Albers has been teaching at Black Mountain College in North Carolina. The ideas of the Bauhaus have greatly influenced the teaching of art in America and have played a crucial role in the development of American industrial design.

Yet these ideas were not the whole Bauhaus but only a partial aspect of its second, functionalist phase. Despite the functionalist, Constructivist opposition to 'art', Klee, Kandinsky, Schlemmer, and Feininger remained an undaunted phalanx in the very centre of the school. We may think of them as the 'irrational' component of the Bauhaus spirit. The intelligence and sensibility of Gropius were undoubtedly responsible for their presence at the Bauhaus. Gropius was well aware that independent art fulfils a very special function in modern society. Necessarily individual and experimental, it is free to look beyond the present and, under certain circumstances, to conceive the art style and life style of the future. Gropius knew that an institution such as the Bauhaus would not be able to meet the formal requirements of modern civilisation if the free artists were liquidated as Romantic relics, but that even under the altered conditions they were the very heart of the school, laboratories

of the general creative ideas needed to breathe life into the specialised departments. If over all opposition Gropius kept the painters on at the Bauhaus and honoured them with the title 'masters of form', it was in the conviction that they were indispensable to the dynamic spirit of the school. Standing apart from the Stijl conformists, it was they with their work and teaching who gave the Bauhaus its eminent place in the annals of modern painting.

Klee and Kandinsky acted as guides in the best sense of the word. Standing above the controversy between expression and construction, freedom and function, they assimilated the new ideas, utilised them in their own work, and restored a balance between the conflicting trends. Apart from their activity in the workshops, both of them had their painting classes. Both delivered regular courses of 'orientation in the realm of form', as Klee so aptly put it, consisting of lectures on the nature and genesis of line, form, and colour. They collaborated closely both in their artistic and in their pedagogic activity. Kandinsky was a little more rigid and doctrinaire, Klee more subtle and inquiring. Kandinsky was convinced that a theory of pictorial harmony was quite within the realm of possibility and approached the question scientifically. One of his favourite methods was to set up a group of objects and derive from them an abstract construction of lines and spots; then, on the basis of his construction, he would analyse the formal elements – point, line, surface, space, motion. Klee considered forms more as living organisms; he followed them in their growth and coaxed them to reveal their capacities. Kandinsky proceeded logically, constructively. Klee started with the inner order of things and let them grow in accordance with their inherent rhythm. From the pedagogical point of view Kandinsky's system was more effective; Klee tended to address his remarks to his more exceptional students. In any case the two complemented one another in their diversity and the whole Bauhaus benefited.

In their own creative art, carried on quite independently of the Bauhaus, both Klee and Kandinsky developed the ideas that had sprung up in the Blaue Reiter group. In this Feininger accompanied them for a time. He had taught and directed the Bauhaus print-shop only briefly. The real source of his influence was his studio. Oskar Schlemmer was a good companion, but his art sprang from different sources and he was concerned with different problems. He directed the stage workshop and in his theatre and ballet work attacked the same problems as in his painting. Because the architectonic and constructive aspect, so important for the Bauhaus, plays a dominant role in his work, it may be well to begin with him.

*Oskar Schlemmer (1888-1943)*

But led us make no mistake. The constructive element in Schlemmer has very little to do with the pure harmonic arrangement of free forms as conceived by the absolute Constructivists; rather, it is a formal crystallisation of optical, physical, and psychic experiences. Schlemmer did not reject nature and the soul. He liked to cite a sentence from Runge: 'Particularly in works of art that spring from the the imaginative faculty and the mysticism of our souls, without the help of external subject matter on content, strict regularity is absolutely indispensable.' As early as 1910, Schlemmer declared in his *Journal:* 'It cannot be repeated too often: Dionysian conception and Apollonian form.' Only ordered and controlled form, he held, could enable a picture to sustain transcendent contents, mysticism and nature symbolism.

Schlemmer had a long and logical development behind him when he came to the Bauhaus. In 1910 he had attended the Stuttgart Academy and assimilated Hoelzel's theory of the primacy of the

pictorial elements. In Hoelzel's class he had met Willi Baumeister and Otto Meyer-Amden, a Swiss painter. He had been profoundly influenced by Meyer-Amden (1884-1933), a few years his senior. Otto Meyer, a thorough-going mystic, convinced of man's spiritual mission, regarded artistic production as the reflection of an 'inner movement' in which the human spirit responds to the world with ideas and signs. He believed the numbers and geometries hidden in nature to be mystical signs by means of which such ideas could be represented. In his Stuttgart years, Meyer-Amden painted abstractions from nature as well as meditative exercises in abstract, geometrical forms. His aim was to create a single spiritual order embracing both organic life and the geometrical ideal. Man, in his system, was the point of intersection between the natural and spiritual orders.

These ideas determined Schlemmer's approach to modern painting. In Cézanne and Seurat he found the masters who from their view of nature had distilled a geometry in whose patterns nature's confusion took on order and form. From this point on his path is perfectly consistent.

In his earliest painting he represents nature – landscape, still life, figure – in simple geometrical arrangements after the manner of the early Cubists. Then he followed the path which in France had led from Braque's early Cubism to Gris and Ozenfant. Secretly his whole effort tended towards figure painting. In the human figure Schlemmer found a cypher for the intersection between the rational and the mystical, and here we may discern the same striving to humanise Cubism as in the work of Gris, Braque, and Léger during the same years. But there was also a certain desire to produce the modern icon. Mondrian had conceived it as an elementary reflection of universal harmony. But at the centre of Schlemmer's icon stood the figure of man. Now he organised his pictures with Purist rigour; their proportions should distil a harmony capable of sustaining the human image as a formal idol. Just as ancient Greek art strips the human image of everything individual and particular to create a type, so Schlemmer reduced the natural appearance to a constitutive, stereometric, supra-individual type-sign: 'man', the figurative centre of a geometrical order. Léger's machine men, the 'manichino' of Pittura Metafisica lived in the space of technology or psychology. Schlemmer's sculptural human figure stood as an emblem in the humanistic 'middle', where measure and number – the Apollonian side – hold the passions in check.

At the time of his arrival at the Bauhaus, Schlemmer had begun to experiment with space-construction in plastic reliefs. His position as director of the sculpture workshop kept him at these experiments longer than he had probably intended. He worked on great mural reliefs in which he surrounded his basic figurative theme with constructive forms such as those employed by Archipenko and Belling. But this material introduction of the third dimension did not advance his art, for the plastic element, instead of achieving space and depth, was merely an appendage of the surface. However, he gained a number of ideas about the handling of space from the transparent perspective of modern architecture, with which he became thoroughly familiar in the course of his work at the Bauhaus. And even more important were his experiments on the stage of the Bauhaus Theatre.

Schlemmer was a passionate theatre enthusiast. The stage, which he looked upon as pure artistic space, held a magical fascination for him. He himself was a dancer and had just completed his constructivist 'Triadic Ballet', which was performed in 1922 in Stuttgart and in 1923 at Weimar. In this imaginary 'artistic space' his typified human figurine could take on concrete, visual existence, a creature of pure art. This experience led him to his central theme: *Figure in Space*. Man, represented as a creature not of nature but of art, a supra-individual type, is set in partnership with space. On the basis of this idea, as he noted in 1925, he hoped to arrive at 'metaphysical space, metaphysical perspective, the metaphysical figure'. By this Schlemmer meant that he wished,

by means of benchmarks drawn from human experience, to define space as a responsive magical being.

Schlemmer wished to translate the dancer's experience of space from the fugitive realm of dance movement into the enduring medium of painting. He had learned that the dance is not all gesture and mimicry, rhythm and movement, for with the arabesques of their movements and the immobile figures of their tableaux, the dancers project a fully visible and communicable human tension into the 'artistic space' of the stage. Schlemmer, the dancer-painter, was determined to give visible permanence to this space-figure, defined by man and his conception of space, and in its geometry to capture not the emotions but the existential states of man.

These pre-occupations gave rise to a long series of paintings – strict groupings of human figurines in spatial planes whose imbrications and dislocations create an irrational space reflecting the tensions of man's soul. The figure is static, space is the dynamic factor. In this moving space it becomes possible to figure what Meyer-Amden had called the 'inner movement' in man. 'In abstract spaces of the future, of transparency, of reflection, of optics, the variegated figuration of man.' This was Schlemmer's view of his theme.

After leaving the Bauhaus Schlemmer continued to vary his theme. In 1929 he was in Breslau, in 1932 at the Berlin Academy, then, ostracised by the totalitarian regime, he settled in a village in Baden. His pictures became somewhat more meditative. The form becomes softer and more rounded, embedded in a warm, sonorous colour. The cool precision of his colour and the metallic plasticity of his form give way to a more painterly quality. His last works, little water colours, variations on the view by night from the window of his studio at Wupperthal of the illuminated windows of the house across the way, suggest a desire to record new optical experiences. But for that there was no time.

Schlemmer was a rigorous, simple thinker, not, like Klee and Kandinsky, his comrades at the Bauhaus, an explorer of the most secret realms. On the basis of a single theme he worked out a figurative icon in which the viewer can contemplate the mystical relation between man and space. All Romantic yearning and Dionysian ecstasy make way before his physical and psychic experience of space as man's dialectical partner. And thus the image stands there firm and cool, a crystalline, 'Apollonian' structure, but one in which man remains the measure of all things: 'Dionysian in origin, Apollonian in manifestation, symbol of a unity of nature and spirit' (Schlemmer).

*Lyonel Feininger (1871-1956)*

Feininger, too, was guided by a desire to bring poetry to Cubism. His art is a shade more Romantic. His themes are views of medieval cities and their architecture, preferably Gothic, and seascapes. A strong Romantic feeling puts one in mind of C. D. Friedrich. And it was his Romantic feeling that had led Feininger to Orphic Cubism. Delaunay, whom he met in Paris in 1911, opened his eyes to the poetic possibilities of Cubist formalism, and it was through Delaunay's architectural motifs that Feininger came to his own favourite theme. From Orphism it was only logical that he should find his way to the Blaue Reiter and its central idea: 'inner mystical construction' in nature. In 1913 Franz Marc invited him to show with the Blaue Reiter group at the First German Autumn Salon.

When Feininger came to the Bauhaus in 1919, his original fragmented Cubism dynamised by kinetic symbols in the Futurist manner had given way to a more restful, architectonic style.

Delicately superimposed translucent planes held the spatial crystal in place and gave it transparency. The static framework based on the vertical and horizontal held the asymmetrical forces and diagonals in balance. A clear spatial geometry was defined by constructive guide lines and fine points of support, to which Feininger often, in guise of a signal, attached a human figurine in succinct, bizarre, and sometimes humorous abstraction. Composed in strict counterpoint, these pictures suggest the *Art of the Fugue*, and indeed there is a relation. Feininger was an ardent lover of Bach and himself composed a number of fugues.

A crystalline and convincingly accurate vision of the angular, aspiring architecture of mediaeval German cities now became the content of his well-tempered construction. Through the lattice-work of the abstract structure, the viewer perceives the motif. Transformed by the evocative power of pure formal arrangements, it takes on the character of visual poetry. In the marine views, which Feininger painted on the flat Pomeranian seacoast, the broad vista and its luminous atmosphere also enter into his magic, crystalline order. The free, bright geometry of these seascapes, facetting the infinite with crystal, clearly reveals Feininger's Romantic spirit and the gentle mysticism of the Blaue Reiter. In 1937, after the National Socialists had condemned his art as 'degenerate', Feininger returned to his native America which he had left in 1887 with his German parents. His late work shows a particular interest in atmospheric effects, battles between mist and light. Here and there a reminiscence of Turner is discernible, but Feininger's prismatic optics provides a trustworthy order in which his fugitive atmospheric sensations are held fast.

Feininger found in Cubism the principles compatible with his personal leaning towards harmony, discipline, and order. He never departed from the Cubist framework. But through his deep Romantic feeling for nature he succeeded in giving his Cubism a poetic dimension. In this he was helped, first by Franz Marc and later on by Paul Klee.

*Paul Klee*

When Paul Klee came to the Bauhaus and began to teach, he was compelled to 'take exact note of what he had – for the most part unconsciously – been doing'. This self-examination was an exceedingly productive process, which vastly furthered Klee's vision and his thinking. Through this productive reflection on the conditions which made art possible, he attained to a level of thinking at which the real and imaginary, outside and inside, ceased to be contradictions. These reflections have provided all subsequent modern artists with rich possibilities. Klee had already learned that communication of his 'primordial realm of psychic improvisation' was possible only through a pure orchestration of the pictorial elements. But, on the other hand, the pregnant ground from which images arise – the 'primordial realm' – was already thoroughly prepared and cultivated, a hoard of elaborated visual experiences and impressions, which, once stored in the artist's imagination became a part of his whole being. Immersion of the self in the vast context of nature was a source of rich discoveries which lodged in the soil of the unconscious waiting to burgeon in a creative hour and take form on canvas. The two processes were one and inseparable – the cultivation and amplification of the images stored in the unconscious and the conscious perfecting of the pictorial orchestra, that is, the attempt to make the images visible. This unity of conscious and unconscious gave rise to an art which – as Klee put it – could be construed as a 'metaphor for the totality of the whole'.

In this vision of unity, inside and outside, soul and nature, were felt to be no more than partial expression of a single all-encompassing energy. In Klee's view of the world, the self and the world, man and thing, were united by their common earthly and cosmic roots. If only a suitable idiom could be devised for the expression of experiences of totality, it would ultimately be possible, he wrote, 'to create a formal cosmos so similar to Creation that a breath will suffice to turn an expression of religious feeling into a reality'.

Klee was profoundly convinced that in the pictorial elements the painter possessed a means of erecting a world of expression, parallel to the visual world, reflecting and interpreting the universal unity in which it is grounded. He believed that an exact and honest treatment of the pictorial means provided a sure safeguard against arbitrary acts and that the formal discoveries so arrived at presented a secret correspondence with forms that existed somewhere in the world, though perhaps hidden from human perception. Thus, for a painter, it was all-important to cultivate the pictorial elements, to 'breed them in purity and so make pure use of them'. This was the substance of his lectures at the Bauhaus.

When he stood at the blackboard in his classroom, often drawing with both hands, speaking persuasively of the need for an exact 'orientation on the formal plane', the simplest element became an active personality with its own communication to make. He began with the point and showed what it could do. Set in motion, it engendered a line, a pure cantilena, which might enter into a polyphonic relation with other lines. In the course of its travels the moving line might run back into itself to form a plane figure, square, triangle, circle, etc. In its organic growth the one-dimensional element had entered upon the two-dimensional realm of the plane. The plane, in turn, is articulated and set in motion. Here we have structure and rhythm, which Klee proceeded to develop from the primitive series to the most complicated measures. Once explored in all directions, the plane is moved to produce a volume: we enter upon the third dimension, which can indeed be measured by perspective but still retains its connection with the subject's viewpoint and field of vision, hence, its mobility. The introduction of the third dimension gives us a realm in which to experiment with the higher states of balance. A complex, labile balance of formal impulses offers the painter his possibilities of dramatic expression. Still more subtle states of balance arise when we progress from static to dynamic relations, to the figuration of movement which, with its kinetic or rhythmic signs, introduces the fourth dimension, the space-time continuum.

All these operations have been limited to the realm of measure. With the appearance of tone values (passages from black to white) there is definition in terms not of measure but of weight. From this new standpoint, all our operations have to be effected all over again. Instead of producing the third dimension through perspective, we now obtain it through the space-content of different tone values. The space-time factor can be developed through transitions from black to white or conversely.

With colour the painter enters upon a new realm. Colour is not defined by measure and weight alone, but essentially in terms of quality. Here again we take up our operations from the beginning. Now the third dimension is attained by the distance values of colour. And space-time is developed from the diverse directions of colour movement – by progressive intensification of colour energy and luminosity, by the contrasts between complementaries and the passages from cold to warm or between neighbouring colours. In colour compositions, direction of movement is indicated by intensifications and transitions of this kind.

These three dimensions of measure, weight, and quality define the picture. Each of the elements becomes a living organism which can be induced to make far-reaching communications. In passing

through the pictorial dimensions the artist transposes his whole visual and emotional experience into the world of art. Here nature can be reborn.

For Klee does not forsake the old function of art, the re-creation of the outside world. He merely finds his solution in a wider dimension of observation, a wider conception of the relation between art and nature. For him 'dialogue with nature remains for the artist the *conditio sine qua non*'. But his eye did not stop at the summary natural appearance; it went deeper and from the objects and structures of nature distilled the formal cyphers that make nature transparent and prepare the human spirit for formative acts comparable to those of nature. The essential is to perceive the formative processes of nature and to observe the formal diagrams of its energies – such as flowing, blowing, growing. Through a critical penetration and reconstruction of nature's formative processes, the artist was enabled to confront it actively; it became a 'lesson by which he might learn to do something similar with the formal elements of art'. Whence Klee concludes: 'Just as a child imitates us in his playing, we in our playing imitate the forces which created and create the world.' In Klee the Romantic idea of transcending the cleavage between the self and reality has retained its full intensity. As early as 1916 he noted: 'I am looking for a distant point at the origin of creation. There I anticipate a formula for man, animal, plant, earth, fire, water, air, and all circling energies at once.' Now, in the twenties, the very same idea was being advanced in France by André Breton; it was indeed the central principle of Surrealism, the climactic phase of modern Romanticism. This Romanticism was the area of Klee's art. His pictures are communications of the changing psychic states that sprang from his total experience of self and world. 'The higher the painter rose towards a vision of the world, the better able he became to form free abstract structures which transcend all schematic intent and achieve a new naturalness.'

In order to raise up images from this psychic realm, Klee trusted entirely to the evocative power of the pictorial elements. He began a picture without any intentional object or content, merely setting his pictorial keyboard in motion. He felt only a will to expression. But this self-forgetful manipulation of the elements was 'like a script boring into the visual world'. As he mused and built, setting coloured form upon coloured form, suddenly a cry arose, a memory, an association, something that wanted to be recognised. The pictorial action identified itself with an objective experience or a poetic thought; an unexpected gift, which Klee accepted. His construction, which up to this moment had been meaningless, took on a poetic sense. It could only be adumbrated in poetic metaphors, for this image was not something already present in the visible world, but something which, barely risen to visibility, was looking for a name. The title was only a final poetic metaphor and might be: *Ringing of the Silver Moon, Growth of Night Plants, Dream Birds, Garden of Passions, Saints of the Inner Light*, etc. The picture was an emanation of a psychic state, arrived at by a meditative manipulation of the elements.

Everywhere modern painters were fascinated by this possibility of 'finding' pictures. Juan Gris and the Analytical Cubists had run across it. The object that became visible in this way had a special emblematic quality. It was not a copy of visible things, but a sign filtered through the strata of the psyche, and as such it possessed an evocative power, Mallarmé's '*vertu incantatoire*'. In painting, the emblem could serve as a bridge between abstract form and the objective world.

This system of 'finding pictures' was also the foundation of Surrealist 'automatism'. An automatic flow of colours and forms, uncontrolled by the intellect – this was the technique by which the Surrealist artists established contact with the unconscious, irrational strata of the psyche, whose rich images and symbols they raised to visibility. The Surrealists also looked upon the unconscious as the realm where man is still at one with the universe. Klee himself never belonged to the

Surrealist movement, but the Surrealists claimed him as their own. Breton mentioned him in the first Surrealist Manifesto and invited him to show at the first Surrealist exhibition in Paris (November 1925). But despite definite points of contact with the Surrealists, Klee never regarded himself as a mere sounding board for the unconscious. For his unconscious was that of a painter—a cell in which images grew, a storehouse of sublime experiences and of choice objects that had entered into it in the course of his conscious 'orientation in the things of nature'. Not only is Klee's painting an independent product of the formative mind; it is also an hermetic parable for the Creation —an imago behind which hides a long visual and emotional experience of the outside world.

Klee's art finds its fulfilment in this imago, the formal imprint of the relation between world and man. By looking deeply into the formal development of nature and the higher processes of its imagination, the intuitive judgment discerns the typical, essential forms, the roots of endless formal possibilities in addition to the limited examples provided by nature. Through the eye this natural substrate enters into the human self to become an image in the unconscious. Then in a creative hour, the artist in his unintentional search of forms raises it to the light. It comes to his eye from within. And thus inside and outside are united in the eye. The result is the imago, emblem of a spirit in harmony with the world.

Klee's extraordinary achievement was to have discovered in the ideas of the Orphists and the Blaue Reiter group and in his own meditations on the lofty insights of Romanticism, a way to bridge the gap between man and visible reality. Here was an answer to the yearning of the epoch, the point for which the Post-Expressionists as well as the Surrealists had striven. Of course the terms in which Klee stated his solution are personal. But considering the matter from a universal standpoint we may say that he discovered the conditions under which art can become a central symbol for a total view of the world. Thus Klee, in the most authentic sense, was the 'primitive of the new sensibility', in accordance with which the new generation would define its possession of reality, its grasp of the world.

Klee was well aware of all this. But he was far too humble, far too much a believer in slow growth, to claim that he himself had achieved the style he had in mind. He dreamed of a work 'of vast range, encompassing the whole realm of the elements, of the object, of content, and of style'. But he knew that this was still impossible because the time and environment were not yet ripe for it. And so he cultivated the part of the mission consonant with his personal nature, a pictorial improvisation revolving round his lyrical experiences and states, a visual poem in a fine formal metre. Tucked away in pictures of small format, veiled by Klee's gentle humour and esoteric musings, there developed a quiet Romantic style, which, however, went far beyond the lyrical in its range.

Though homogeneous in origin, Klee's style changed according to the problems he dealt with, and moreover he was sensitive to the currents of contemporary art. His arrival at the Bauhaus was the occasion of a slight Constructivist influence. The structure becomes firmer and often a fine screen is spread over the whole surface. The drawing becomes simpler, the forms larger. An abstract architecture of cubes in colour gradations makes its appearance. Everything is done to turn the pictorial organism into a crystalline, magical prism, in whose refractions the visible world takes on a remote legendary character. But his meditative building with coloured forms does not always 'represent' an objective reality. His fascinating game of disturbing the balance and setting it right again might equally well remain within the realm of the abstract, a musical metaphor, a formal minuet expressive of the artist's feeling.

In 1926 a new phase began. Klee now strove to create a vibration by means of rhythmic series and parallel repetitions. In 1929 – stimulated by the landscape of Egypt, which he visited in this year –

he devised a system of coloured stripes with which, in a series of magnificent paintings, he records the visual adventure of his journey. At first the stripes were flat but then he moved them into a spatial dimension and with the help of luminous super-imposed planes created an airy realm where spirits of the air or wind might well make their home. Towards 1932 Klee extended his hovering airy construction to his use of colour and developed an immaterial realm of coloured light. From a fine mosaic of coloured points, he created an ethereal coloured space which gathers in the light and makes it an object of meditation.

In 1930 Klee left the Bauhaus to teach at the Düsseldorf Academy. The loss of the companionship he had enjoyed at the Bauhaus and the condemnation of his art by the growing cultural reaction drove him more and more to solitary meditation. In 1933 he left Germany for Berne where in the contemplative silence of his studio his art entered its last phase. The format became larger, the subtle emblems grew into heavy, solemn signs, the light transparent grounds became simple and sombre. The picture now becomes a writing tablet on which the objects take their places as simple hieroglyphs, emblems of meditative experience. The tone becomes remote and religious, remote beings and angels appear as though to accompany him on his last journey. When Klee died in 1940 near Locarno, he had done what he set out to do. His work is a complete whole.

Klee's contribution to our modern sensibility was above all the awareness that the objective world surrounding us is 'not the only possible world, that there are other and many more latent truths' discernible in the world of human expression and communicable in art, which make it possible to experience the self and the world, the cosmic and the earthly, as one. In the light of Klee's resolve to figure the totality of the whole, the categories 'objective' or 'abstract' lose their meaning. His method is thoroughly abstract, but with a view to concrete expression he conjures up pictorial signs for objective forms. He is always looking for a bridge to the realm, common to nature and to man, where objective forms become hieroglyphs, a pictorial script in which the human spirit can record its experiences of reality.

This inner bond with the objective world distinguished Klee from the other great master of the Bauhaus, Wassily Kandinsky, though the two them were so close that their works of certain periods can easily be confused by the untrained eye.

### Wassily Kandinsky (1866-1944)

The difference is more quantitative than qualitative. Kandinsky's art is also inspired by a mystical idea of universal unity. Visual experiences might well influence the mood and atmosphere of his pictures, but he never felt impelled to resort to representational references in order to define his subject matter. He tended, rather, to move away from things. His subject matter was the chord, 'the inner tone', evoked by a state of mind or visual perception. He orchestrated it in a purely formal composition, comparable to a musical movement in which representational elements were translated into abstract rhythms.

His teaching at the Bauhaus makes the difference quite clear. Like Klee, Kandinsky gave lectures on the formal elements of art – some of his ideas are contained in his book *From Point and Line to the Plane* (published in 1926) – but he avoided the natural analogies so dear to Klee with his feeling for organic growth. Kandinsky would build up a kind of still life from objects of every conceivable kind and urge his pupils to discover a formal or rhythmic theme in it. Then the theme would be elaborated in innumerable purely abstract variations. The formal theme superseded the

object, which served merely as an initial stimulus and was gradually eliminated as the pictorial construction was developed.

When Kandinsky came to the Bauhaus in 1922, his style had undergone a considerable change. As early as 1913, in his *Composition VI*, a tendency to firmer forms had become perceptible. Under the influence of Cubism and Futurism, Kandinsky had begun to discipline the surging atmospheric effects of his early pictures by a system of planes, gradually eliminating illusionistic depth. Though he stressed the irrational character of his crystalline, latticed space by means of sudden transitions and breaks, and achieved highly expressive dramatic effects by contrasting his well-defined planes with the infinite, it was obvious that he sought to carry his 'Abstract Expressionism' to a new dimension by a more exact arrangement of the planes and a more exact definition of forms in terms of number and proportion. His purpose was to achieve a self-subsisting harmony that would be a concrete reality in its own right even after the expressive, psychological, and personal content had been eliminated. The elements of such a harmony were obviously architectonics, construction, geometry. Kandinsky's development towards a more objective form of Expressionism proceeded slowly, for it involved the sacrifice of essential traits of his personal temperament – his Wagnerianism and oriental exuberance. It was only after his encounter with Russian Constructivism that the pace of this development became more rapid.

In 1915 Kandinsky returned to Moscow via Switzerland. He was now able to study at first hand the works of the Russian Suprematist and Constructivist painters – who had discovered the concrete reality of abstract geometric form. In 1918 he was appointed member of the Art Council at the Commissariat for Public Education, and given a chair at the Moscow Academy. He displayed an extraordinary activity in this new task. He organised museums, founded art institutes and an academy of art and science. At the same time he was in close touch with Russian avant-garde artists, who were strongly supported by Lunacharsky, and who for their part sought to impose Constructivism as the official style of the proletarian revolution. Thus Kandinsky, who was a clear and responsible thinker, was compelled to take a definite attitude towards Constructivism. Still more important was his exchange of ideas with such outstanding artists as Pevsner and Gabo, who eventually became his lifelong friends.

Kandinsky adopted the new ideas very cautiously and gradually. By 1921 his manner had changed perceptibly. The vast turbulent, atmospheric background had given way to a uniform, clear, flat ground. The forms had grown larger and more geometrical, the contrasts between them simpler and more monumental. They were clearly arranged in superimposed planes running parallel to the surface. But still there were jagged zigzag forms and freely curved arabesques of a distinctly Expressionist character. The Constructivist, geometric element did not fully assert itself until Kandinsky joined the Bauhaus where the chief emphasis was on architecture, and where he came into contact with the ideas of De Stijl.

In December 1921, Kandinsky left Moscow for Berlin, and in June 1922, Gropius asked him to join the staff of the Bauhaus. This marked the beginning of the most austere period of his development, which reflected the spirit of the Bauhaus, so uniquely poised between the severest architectonics and the purest poetry, and capable of assimilating simultaneously such diametrically opposed artists as Mondrian and Klee. Here Kandinsky found his bearings. His paintings became sharp, bright, mathematically precise, and yet luminously cheerful. *Composition VIII* (1923) is a magnificent example of this Bauhaus period. The ground is now provided by the pure white surface. On it a sensitively balanced arrangement of geometrical forms in plain luminous colours is loosely and clearly distributed – circles, triangles, squares, bars, circular segments, lines; even

a chequerboard pattern, a serene *'hommage à Mondrian'*, makes its appearance. Every form is standardised on the basis of its geometrical elements and exactly drawn with the help of a ruler, T-square, and compass. The affinity with the tendencies of the Constructivists such as Lissitsky, Gabo and Moholy is obvious, but Kandinsky is incomparably richer. The delicately rhythmical structure with its glittering small ornamental forms, the severe but pleasingly balanced linear forms, the sonorous focal point provided by the large dark circle, and the bright dominant tones, produce the effect of a firmly articulated and richly rhythmical musical composition. The viewer reacts to it as he would to a musical score, when he sees it as a purely formal arrangement and does not look for representational references or emotional associations. That was now Kandinsky's purpose: to create, with elementary coloured forms, subtly arranged, a concrete pictorial reality in its own right, which could justly be called a 'composition'. Here was a fruitful way of transcending Expressionism. Passions and natural data had ceased to be important; the essential, as in music, was to evoke and create a higher state of feeling which would illumine the darkness surrounding us with a reflection of the universal harmony. Kandinsky's Constructivism is not in the least concerned with social applications, decorative effects, or functionalism: it is a sensitive instrument to detect universal orders and as such is at the very centre of art. A series of woodcuts in this cool geometrical style (1922) bears the significant title *Small Worlds*.

Towards 1925 the cosmic implications become more evident – Kandinsky began to show a marked predilection for the circle, which Klee defined in his lectures as 'the dynamic cosmic form, which comes into being when earthly bonds are cast off'. Once again the ground suggests vastness, and the mystical colours evoke the idea of infinite space. The circles put one in mind of hovering stars. Cosmic bodies seem to glow in an infinite space, and for a moment the harmony of the spheres seems to shine through their constellations. At the same time Kandinsky retains the most rigorous formal order, which excludes all associative and descriptive elements and brings out the concrete reality of the picture. There now followed (up to 1933) a long series of pictures in this 'cool Romantic' style, in which Paul Klee, with his alertness to the motive forces of nature, participated in his own way. This was 'the romantic epoch of Kandinsky's concrete art' (Nina Kandinsky).

In 1933 Kandinsky, disgusted by political developments in Germany, went to Paris where, in the stimulating climate of the capital of European art, he developed his rich and majestic late style. He frequented the men who furthered the cause of abstract art in Paris. He became a friend of Miró, Arp, Pevsner and Magnelli, and through the Abstraction-Création group became acquainted with a number of younger artists. Reflections of all this are found in his paintings. The geometrical elements recede, the forms become softer and more flexible, and occasionally we find a distant echo of Jean Arp's biomorphic world. Particularly during Kandinsky's last years, his free figurations scattered over the pictorial surface acquire a cheerful personal character reminiscent of Miró. But these occasional influences are firmly embedded in a style of extraordinary range, which sums up all the phases of Kandinsky's development. Consummate mastery of the resources of Western painting, Byzantine splendour of colour, the richest imagination, coolness of presentation, the freest intuition and clearest intellectual control, are combined to produce a magnificent synthesis which once again enables him to fill concrete forms with intimate human meanings. The steadily growing richness of formal invention eludes description: Kandinsky exploited the full range of his possibilities. And this late style is impregnated throughout with a serene wisdom in which even the burlesque finds its place. In the years immediately preceding his death in December 1944, he painted a number of delightful pictures, in which playful and richly ornamental figurations take on the winged mobility of air spirits or the cheerful gravity of puppets.

In Kandinsky's art abstract painting achieved its richest expression in the two decades between the wars. He covered the whole field situated between Abstract Expressionism and Constructivism. A vast new realm was conquered, and there he held sway. He was not tempted by the enlargement of frontiers towards the realm of nature, which Klee pursued so unremittingly. But between the two of them they created a foundation for the rich development of later years. It is thanks to them above all that the Bauhaus takes its place in the history of painting.

## Willi Baumeister (1889-1955)

Outside the Bauhaus, but sharing many of its ideas, Willi Baumeister contributed to the consolidation and enlargement of the abstract domain. Like Schlemmer, he was a pupil of Adolf Hoelzel and a friend of Meyer-Amden. Using vigorously simplified, elementary Cubist forms, he aimed in his early period at a synthesis of painting and architecture. In 1919/20 he executed the first of his long series of panels which he called *Mauerbilder*. By adding sand, putty, and similar materials to his pigments, he obtained grounds whose texture suggested a wall. Like Schlemmer, Baumeister widened the range of his explorations by introducing plastic elements. He also painted relief-like 'sculptural' murals, in which figures and objects are reduced to rigorously geometrical signs. All this paralleled the contemporaneous tendencies of the French Purists. In 1922 his work attracted their attention, and he soon established personal contact with Léger and Ozenfant.

Towards the end of the twenties his pictorial structure and figurative signs became looser, more curved and flexible, his backgrounds more atmospheric, and his arabesques took on a more 'automatic' character. This development began with his series of pictures on sports themes, and by 1930 it had progressed so far that the representational elements – the human figure and its movements – seemed to turn up accidentally in the course of the artists's explorations. The figurative elements acquired an emblematic character.

In the seclusion of his studio, to which he was confined during the Hitler regime, Baumeister continued unswervingly on this path. Suggestions of actual things, perceived in the outside world, were eliminated. In 1937/38 he painted his series of *Ideograms* – pure signs originating in the depths of the psyche, suggesting prehistoric characters inscribed on ancient walls, whose literal meanings have long been forgotten, but which lure the imagination to roam far and wide. From then on Baumeister relied exclusively on his imagination, and by following the suggestions of his coloured forms was led to ever new 'finds'. This was the method which had been employed by Picasso, Klee, and the Surrealists to gain access to deeply buried stores of images, and which Baumeister himself described in his book *Das Unbekannte in der Kunst* (The Unknown in Art), written in 1943.

The method proved extraordinarily many-sided. The initial stimuli originating in nature, the psyche, or the realm of form suggested the paths to be followed. In 1938 Baumeister began his series of *Eidos* pictures – loose painterly compositions with amoeba-like forms, evocative of primordial life. In 1942 he painted his *African Pictures*, black and grey script-signs on state-like grounds, amazing ethnographic evocations, which also suggest dim prehistoric memories. Then came a series harking back to the most ancient myths and resembling half-legible inscriptions on stone. The titles refer to the epic of Gilgamesh, to Sumerian legends, to the history of Babylon and Israel; the manner is strongly archaic – even figurative elements are composed of hieroglyphic fragments. These paintings suggest prehistoric scenes, rites performed by primitive tribes or

legendary heroes. The style exhibits a mysterious affinity with inscriptions on Sumerian seals. All these groups overlap in many ways. Paintings in dark colours are followed by others in sumptuously joyful tones, mythical subjects by humorous fables, abstract arrangements by series of pictures with figurines. In every case, a thematic content emerges from within, giving the non-representational forms the character of an emblematic pictorial script.

Baumeister's painting must be seen in context with abstract Surrealism; it is related to Max Ernst and Miró, but also to Klee. We have here a pictorial script, a magical alphabet which serves to express and activate deep experiences, distant recollections, long-buried ideas. Baumeister's images are not confined to the purely abstract domain, his explorations often take him to the representational world. Like Klee, Baumeister dwells in an intermediate realm. But unlike Klee, Baumeister does not draw upon a vision of the whole. His images are more narrative in character. His art avoids the dark zones of the tragic and the demonic, but penetrates with amazing success into ancient layers of memory, bringing to light prehistoric and primeval elements, so that quite unexpectedly the oldest images become integral parts of our own modern sensibility.

## The German Contribution

The German contribution to European painting during the two decades between the world wars was rich and varied. It covered the whole new realm of pictorial expression. Kandinsky and the Bauhaus masters achieved a synthesis of the various branches of abstract art, so convincing that it fertilised abstract painting all over Europe. Beckmann arrived at his 'transcendent realism' based on a new pictorial interpretation of reality. At the point of juncture between the 'Real' and the 'Abstract' the prospect of combining the two extremes in a single integral conception became discernible. Kirchner had distilled from reality a hieroglyphic script in which to record his experience. Klee had let his own language of images grow spontaneously from psychic roots. The attempt to build a bridge between the two poles seemed to be successful. In short, the many-sided modern conception of painting found a comprehensive expression in Germany.

As compared with the art of other countries, German painting in those two decades discloses a distinctly Romantic character. The idea of the 'mystical inner construction of the world' seems to be present in all the German masters. The mythical aspect of nature and the belief that man is rooted in the cosmos is the secret theme that runs through all their work. This reacts upon colour and form, which are often heavy with meaning. German painting gave the European stylistic conception its spiritual depth. The needed elements of formal vigour and clarity were provided by the genius of France.

## Purism and the 'objet moderne'

The response of France to the modern ideas about the object was admirably sensitive, temperate, and intelligent. In a critical questioning of Cubism the French mind displayed its subtlest logic. Previously the productive critique of Cubism had followed two lines. On the one hand, Mondrian had completely eliminated the formally disturbing representational references from the Cubist construction and created the model of a meditative and contemplative art expressing itself in purely abstract geometrical and numerical proportions. On the other hand, Juan Gris had transformed

the analytical image of the object into an emblem which reflected a profounder conception of the evocative power of abstract figurations. Formally speaking, Juan Gris also strove for complete clarity of construction and looked upon painting as *'architecture plate colorée'*. But in terms of content, his aim was to endow the picture with a new representational value, inherent in the emblematic object that resulted from the construction, and by thus restoring a link with the world of things, to humanise the mathematical element in painting.

Up until about 1920 there was everywhere a growing interest in geometry, a general fascination with coolly precise and smooth forms, and a striving for greater sharpness in the definition of objects. These ideas were formulated in the aesthetics of Purism, which effectively supported the current initiated by Juan Gris.

This aesthetics also started from a positive and productive critique of Cubism. Amédée Ozenfant (b. 1886), as early as 1916 – i.e., roughly when Gris and Mondrian were proceeding in the same direction – had begun, in his magazine *L'Elan*, to criticise Cubism for indulging in purely decorative effects and relaxing its formal discipline. In 1918, in collaboration with Edouard Jeanneret (b. 1887), who was soon to achieve world fame as an architect under his pseudonym Le Corbusier, he summed up his ideas in a critical essay entitled *Après le Cubisme*. His magazine *L'Esprit Nouveau* (1920-1925) – Juan Gris was one of its contributors – became the organ of the new movement which called itself Purism.

The adherents of this new aesthetics made no attempt to deny that it was directly descended from Cubist theories. Its starting point was the 'heroic' period of Cubism (c. 1912). But the Purists were critical of the subsequent development of Cubism. And it is true that after 1914 not only the Orphists, but Picasso and Braque as well sacrificed structure to rich colour and decorative effects, and that the large number of fellow travellers had gradually relaxed the originally austere style of Cubism. Clouded by the introduction of sensuous elements, the forms became less sharp and precise. Losing their anonymous, hieratic character, they had become intimate and individualistic. Once again individual expression came to the fore, supplanting the comradely anonymity of the early style. Even Impressionist elements slipped in, and the more artists joined the Cubist movement, the more its severity gave way to diffuseness. But it was with its rigorous forms that classical Cubism had created works of crystalline perfection. According to Ozenfant and Le Corbusier, it was those works that met the new needs.

The Purist critique was thus at first a call for discipline. It demanded a clear, precise, rational art in keeping with modern machine civilisation. The precision, smoothness, and hardness of technological form, the Purists believed, called for an equally exact and precise aesthetic counterpart. Impressionist, intimate, accidental, emotional, and personal elements stood in clear contradiction to modern technology.

It was argued in support of this view that aesthetic sensibility was essentially a desire for order. Nature, the argument went on, arouses aesthetic feelings in man when it discloses a striking order. The order thus perceived is man's productive response to nature, reflecting a spiritual need. 'Natural order manifests itself where the visible elements of nature appear to us under the aspect of geometry.' According to the Purists, a straight line runs from Ingres to Cézanne and Seurat and thence to Cubism – and this must be developed and attuned to the conditions of contemporary environment.

Purity and precision of form, these critics maintained, can be achieved only if the elements of art are subjected to strict control. Our basic experience is that of gravitation, which is pictorially expressed by the vertical. The vertical and its opposite, the horizontal, constitute the basic system

of co-ordinates within which our optical sense is organised, and our sensibility responds to any deviation from it. Within this system the elementary geometrical forms yield their purest effects. Through the sensitive mathematics of form and colour relationships, painting can provide itself with a limited but well-ordered and fully adequate keyboard of expression. According to the Purists, this demand was in perfect conformity with the stylistic needs of the epoch: geometrically standardised elements are inseparable from modern civilisation and are the sole basis of its aesthetic expression.

All these arguments of the Purists are in agreement with those advanced by the Neo-Plasticists. But Purism differs from Neo-Plasticism by its emphasis on the world of things. Following Juan Gris, the Purists wanted the pictorial architecture to be qualified and defined by thing-signs. They differed from Juan Gris in defining their objects more systematically. They claimed that only common things could be used in art, for otherwise the anecdotal element would become dominant. Modern civilisation, they argued, created a special category of objects that reflected the modern way of living and thinking – these were the mass-produced 'objets modernes'. These 'modern objects' came into being under the 'law of mechanical selection', i.e., their formal type was determined in accordance with the ideal of maximum utility and the conditions of economical production. This led to the creation of a number of standardised things, which are closely associated with modern man but also genetically inter-related. Purism confined itself to these standardised objects, on the ground that they were the product of the contemporary conception of the object, and as such simple and perfectly intelligible.

The same ready-made, standardised objects had for the first time been discovered by the Dadaists. Le Corbusier called them 'objets à réaction poétique' and in the work of the Purists they preserve some of the personal and magical qualities the Dadaists had seen in them. Indeed, Ozenfant wrote: 'The union between the spirit of Dada and the spirit of Purism begets love for the modern object.'

This conception of the object differs from that of the Cubists, who emphasise its constructive and artistic features, and creates a link between Purism and the poetic conception of the object characteristic of Pittura Metafisica and Dada. The Purist picture rests upon a rigorous, precise Cubist composition, but the normative structure of the object is preserved and the deformations that would detract from its typical form are avoided.

The works of the Purists are less important than their theoretical views which for the most part they merely illustrate. Guided by his experience as an architect, Le Corbusier concentrated his efforts on the abstract aspect of painting, whereas Ozenfant developed his precise, cool constructions from the pure objective forms of his standardised things, and later even included figurative elements in his paintings, on the ground that man holds the highest place in the hierarchy of things.

The Purist emphasis on doctrine and on the investigation of methods and materials gives Purist painting an air of the laboratory. It pointed to a number of new possibilities but failed to realise them. But in the hands of an extraordinary talent the insights of Purism and its aesthetics of the *objet moderne* contributed to the development a more realistic approach to the object. The creator of this special type of realistic painting was Fernand Léger, who called it the 'New Realism'.

*Fernand Léger (1881-1955)*

Towards 1918 Léger achieved a highly monumental synthesis of constructive form and emblematic object. His first large canvas shown at the Salon des Indépendants in 1910 – *Nudes in the Forest* – already reveals a determined effort to combine the doctrines of Cézanne and Rousseau. The figurative composition, the sonorous colours, the magical atmosphere, and the compact volumes are the results of a fruitful study of Rousseau. But in his treatment of the object he takes a different course. Taking literally Cézanne's maxim, as reported by Bernard, that every natural form can be reduced to geometrical solids, Léger transforms his objects into an intricate arrangement of cubes, cylinders, and spheres. Tree trunks and human bodies are composed of tubular forms; with other stereometric abstractions they yield a massive formal structure of almost metallic hardness, so that the representational elements are scarcely identifiable. Nevertheless, the perspective is strictly illusionistic. Nor are the representational forms broken up as they are in Analytical Cubism; they are merely simplified, reduced to stereometric elements. This work does not reflect the strict doctrine of Analytical Cubism. However, it is an attempt in the same direction and was no doubt inspired by the early Cubist experiments. Léger was at that time a friend of Archipenko; in 1909 he met Delaunay and through him Apollinaire and Max Jacob, who may have encouraged him to undertake similar explorations.

Not until 1910 did Léger become acquainted with the theories of Cubism. He did not adopt the classical Cubism of Picasso and Braque, but preferred the more dynamic theory of Orphism. This is clearly revealed by his pure, luminous colours employed in striking contrasts. But his method – until 1914 one of his favourite themes was city landscape – was not yet really analytical. He merely simplified the visual data by the help of a crude energetic line and stylised them by reducing them to their basic forms. The picture is constructed as a sturdy engineering work, almost deliberately lacking in grace. A good deal of it is still loose and imprecise – the colours are applied thinly, the pictorial space and volumes are treated illusionistically: Léger's optics was still relatively Impressionist.

His war experience deepened his human vision and changed his conception of things. He served in an engineering unit, where he came into close contact with men who were at home in the world of technology – workers, mechanics, engineers. He admired their matter-of-factness in dealing with machines, the precision and directness of their movements, their efficiency, and their optimistic view of the machine as a wonderful extension of man's strength and power. This was the source of his optimistic and heroic conception of the machine world and its special kind of realism. He felt that as an artist his task was to discover forms of expression appropriate to modern life. The shining, precise, abstract beauty of the machine provided a visual point of departure. He understood that the mechanical thing possessed a representative value as the truest creation of modern civilisation, and that the images derived from it could become evocative emblems of the modern industrial world.

After Léger was demobilised and resumed painting, he attacked the new task with great determination. He resolutely dropped all loose, Impressionist elements and produced hard, exactly defined, geometrical, rational paintings with inexorably precise forms and planes – cold, unfeeling, machine-like. In this he was certainly encouraged by the style developed at the same time by Juan Gris and the Purists.

The crucial change, however, was one of content, which imposed the change of form. The newly invented objects of modern industrial civilisation, the *objets modernes*, became objects of artistic

contemplation. In Léger's view the *objet moderne* was the legitimate *personnage principal* of modern painting. Later Léger wrote about this period: 'It seemed to me that the neglected, misappraised object was fit to take the place of the motif.' By isolating and over-emphasising chosen representative details, by personifying the object, the artist could make it a symbol of the complex industrial world, its sensations and states of being. 'This way of looking at the object or its details implies an entirely new realism.'

Léger was assuredly stimulated by the Dadaist sensitivity to the 'personality of the mechanical object'. But the Romantic and ironical aspects of the Dadaist view and the idea of the 'automaton' which the Dadaists had taken from Romanticism were alien to Léger's outlook. His vision was far more realistic. He was concerned with the thing itself, not with its lyrical, dramatic, or ironical aspects. He wanted to create an ensemble of evocative images of things, which would define the modern industrial world in human and aesthetic terms.

The sensation of the gleaming machine, the rationality of its cogs and gears, but also the irrational dynamism of moving machine parts, the hard rhythm of continuously repeated operations, the artificial lighting, the flashing signals – in all these expressions the modern industrial world provided a theme for painting. Léger's pictures of those years are like enthusiastic glimpses of vast factory interiors: static scaffoldings merge with the rhythms of moving machine parts to form great geometrical patterns, within which mighty emblems clearly indicate the representational elements in a monumental pictorial script. In the course of his gradual elaboration of this script, Léger discovered that even the fragment of an object, provided it enters into an evocative ensemble, can stand for the whole and like a hieroglyph suggest more complete forms and meanings. This rendering of reality by means of emblems and evocative signs justified Léger in calling his style the 'New Realism'.

Needless to say, the knowledge acquired in handling abstract forms helped Léger to give his thing-signs emblematic force, but he believed that the autonomous easel painting should render an actual experience in representational terms. This requirement could be dropped when painting played a subordinate part in a higher ensemble, a building, for example. Then the painter must come to grips with the substance of the wall itself, he must use the spatial values of colours and their immaterial quality to create movement and space. With the help of colour the wall could become a *rectangle élastique*, and as such a formal element of architecture. In 1920 Léger met Le Corbusier, and in 1925 decorated his pavilion at the Exposition des Arts Décoratifs with murals. These were entirely abstract, because Léger wanted them to be looked upon merely as a supporting and accompanying decorative element. Otherwise he refrained from abstract painting. He once said: 'Abstract painting is dominated by the longing for perfection and liberation, which produces saints, heroes, and fools. This is an extreme state of mind, which only a few creative minds and their admirers can sustain.'

Towards 1920 his forms became large and tranquil. Rhythmical and dynamic elements were less emphasised. A simple architectural structure resulted in a static order and the human figure, which Léger had never lost sight of, was restored to its rightful place. It was to become a determining element in the hieratic order of object forms, and in this order acquire the anonymous dignity of the 'thing'. According to Léger, the human figure must no longer be regarded as a sentimental or expressive value, but must recapture the thing-like anonymity that the Egyptians and early Greeks, but also Piero, Signorelli, and Uccello had known how to give it. It must be treated as an object. Only then, Léger thought, would it be possible to create large figure compositions with the modern industrial world as their background, works that would show the image of man in

relation to his objective environment. Léger's large figure compositions, which are characteristic of his work, always feature gigantic tools and objects at essential points – man defines the thing and vice versa.

The brutal energy with which Léger masters the world of things, transforming them into monumental emblems, discloses, for all the harshness of his manner, an intense love of the visual world. That is the humanistic element in him, which led him gradually to relax the rigid formal structures of his earlier work.

Towards 1928 he began his series of *objets dans l'espace,* which he continued down to his last period. The forms became more flexible, gradually the formal grids were broken up. The hard, unyielding planes admit more air in the intervals between them, sometimes they recede entirely, opening up a free view on grounds suggestive of vast spaces. From the cramped factory interior, one looks out into the vast expanses of nature. Against this contrasting background of wide-open nature, the ordinary mechanical things take on a deeper meaning. Outside their own world of machines and scaffoldings, they no doubt seem strange, but at the same time they are humanised and aquire a lyrical quality. It is a vigorous, archaic lyricism, rejoicing in the light of the sky, that enters into Léger's painting, softening its mood, as though this Norman peasant had rediscovered his old home. There is one painting in which his heavy hand tentatively traces vigorous arabesques outlining clouds against a bright sky; the foreplane is occupied by machine parts and an immense bunch of keys, defined in clear hard lines. As though spontaneously evoked by the rhythmical outlines, a female figure – perhaps a dancer – joins the objects. The result is a kind of mechanical ballet in a cosmic area, where the great bunch of keys takes on a ponderously cheerful personality. Léger's figure paintings also become less rigid and more natural. The machine-like men composed of tubes and cogs give way to a race of gigantic figures characterised by a kind of awkward grace. Their ponderousness in the handling of instruments and other objects – the clumsy way, for example, in which a woman holds a massive spray of flowers – introduces an entirely unexpected lyrical note. Finally, the landscape element makes its appearance. All Impressionism however is gone. Simple emblems signify plants, objects, animals and stand out like powerful signs against the planes that define the space. Once again the power and strength of thing-signs suggest a secure possession of the world, such as we first witnessed in Henri Rousseau.

In Léger's last years this lyricism recorded in monumental hieroglyphs culminated in a series of rural landscapes featuring farm implements. There is little variety in the objects represented – farmyard clutter, ladders, wheels, obstinate weeds – but behind the powerful emblems we find an awareness of the splendour and grandeur of things in the world. In his gigantic *Constructeurs* Léger attempted to find a figurative symbol for his virile faith.

Clearly, Léger's realism has nothing in common with the mawkish nature romanticism, the feeble naturalism camouflaged as humanism, so often substituted for the task of redefining the world of things by artists who, too timid to join in the bold advances of painting, mistook the new interest in the world of things for a return to nature and tradition. Léger's approach to the realities of the world was violent, almost brutally harsh; it was by defining their forms with the utmost sharpness that he succeeded in wresting his interpretative emblems from things. Such violence was indispensable if he was to charge the emblems developed by the Cubists with the full existential power of the object and to create an entirely new 'realism'. Léger's art was a legitimate expression of the new conception of the object. With his emblems he invented a pictorial language capable of describing his visions and feelings, his total experience of the world he saw.

The other realistic current, expressive realism, played a great part in Germany after the First World War. In Belgium it was represented by Constant Permeke's paintings that sought to express important meanings in massive forms and gigantic figures. In Switzerland it influenced René Auberjonois. The school of painting based upon native folklore, which accompanied the political revolution in Mexico, also clearly derives from this European style. In France, however, expressive realism found only feeble echoes. It is not unlikely that its development in France was intercepted by Léger's powerful emblematic art. At all events, the painter who with respect both to form and to content seemed to come closest to this expressive realism – Marcel Gromaire – shows distinct ties with Léger. His search for figure painting with a significant content led him, like Léger, to break away from the iconography of the Cubist still life; like Léger, he was attracted by the world of industry and introduced social elements into his subject matter. But his realistic tendencies were also disciplined by a Cubist rigour of form.

Generally speaking, the return to the natural image, which was quite widespread in France after 1918, expressed a reaction, a tendency to aesthetic compromise rather than a positive assertion. The marginal Cubists were indeed only too willing to transfuse new blood into their decorative paintings by re-introducing elements from visible reality. In so doing, they merely retreated to the position from which Cubism had started, i.e., to Cézanne. 'Cézannism' seemed the most natural solution and did not even require the complete abandonment of the Cubist or Fauve décor. Observations of nature and the feelings aroused by it could easily be fitted into the Cubist and Fauvist forms. These thoroughly tested techniques could be relied on for the décor; the inspiration and the content would be supplied by direct work from nature. In this way Marie Laurencin was able to moderate her graceful Cubism and, with her idyllic *jeunes filles en fleur,* draw a new warmth and tenderness from her contact with nature. Dunoyer de Segonzac softened the austerity of Cézanne and the boldness of the Fauves by introducing late Impressionist elements. Metzinger, followed by André Lhote, devoted himself for a time to a massive Neo-Classicism. Almost all second-line Cubists shifted to nature and the motif. They were joined by such younger artists as Jean Marchand and the consequence was a school of painting which swathed nature in a caressing décor and prudently refrained from crude realism. Picasso's Neo-Classical period and Derain's classical realism seemed to justify the essential ideas of this school.

Classicism and the great tradition: these were the dominant catchwords in France and Italy. In his essays in the *Nouvelle Revue Française,* André Lhote took up the arguments of the Italians and revived the idea of classical realism. An artist who had long been attached to this idea – André Derain (1880-1954), now came into prominence. Even in his Cubist period, Derain's paintings clearly revealed a classical tendency. He tried, by simplification of form, compactness, careful attention to volumes, clear outlines, and distinct colour, to achieve an effect of permanence. This soon brought him into conflict with Cubism and led him back to representational images. These both determined and concealed the construction. Integrated with the representational image, the constructive element was permitted only in exceptional cases to deform it. This led to the conception of a classical art, an art of order and objective simplicity. Even in this early period, between 1912 and 1914, Derain produced still life compositions which fully anticipated German magical realism and the ideas of the Italian *Valori Plastici* group.

However, Derain was still interested in expression. He did not turn to the classical realism of the Italian Renaissance – as Carrà noted with disapproval in his presumptuous little monograph on

256

Derain (1921) – but to the Gothic realism of the French and Netherlands masters of the fifteenth century. In those years Derain took as his model the austere and expressive Pietà of Avignon in the Louvre. Contemplation of this work inspired his vigorous figure paintings of 1914, which French critics classify as those of his 'Gothic' period. Their forms are succinct to the point of austerity; as regards colour, the accent is on stony greys; the construction is marked by a strong tendency to the vertical, which elongates the figures, making the clearly outlined forms hard and sharp. In these paintings Derain employs Gothic elements to achieve a clear, simple, and sober statement of visual experience.

This development was interrupted by the war in which Derain served as a truck driver. In 1918/19 when he resumed painting, the archaic severity was gone. He now strove for a classical realism in conformity with the general tendencies of the period. His forms became more rounded, his colours more pliable and rich in nuances, his optics more conventional, closer to the Renaissance masters. But behind all this a strong will to define forms was still at work. This was the period in which Derain achieved international fame, for his painting now fell into line with the general Neo-Classical and realistic tendencies.

But this style concealed a decline of artistic power. After 1921 the work done in the course of his trips to southern France and Italy shows a slackening of the intellectual energy he had hitherto applied to a personal definition of reality. Elements taken from Corot and Renoir made their appearance in his work – elegant landscapes and charming figure paintings which fascinated the public by their easy accessibility and technical virtuosity and produced a veritable school of Derain. One of its brightest stars was Roland Oudot who flourished in the late thirties.

The fact remains that Derain's work considerably furthered the rise and spread of the new classical realism. He was the only important French painter who gave a native accent to this European current.

### Georges Braque (b. 1882)

Partly under the influence of this trend, Georges Braque developed a supremely balanced style which marks the highest point reached by French artistic sensibility and *juste mesure* in our century. It was a steady, unbroken development; responding thoughtfully to contemporary trends, the artist modulated the form and architecture of his vision without actually changing it. He preserved the refined geometry of Cubism as the basic structure into which the new realist impulses could be integrated. The violence with which Léger took possession of the world of things, as well as Picasso's hallucinated images, lay beyond the range of this art. Where expressive elements made their way into the picture, the subtle rules of Cubist composition soon imposed bounds on them and supplied a corrective to feeling. Even when spontaneous love of the object led him to accept its image as the natural form of its beauty, the resistance of the formal elements transformed the image, which, as Braque put it, could figure in a work of art only after becoming a *fait pictural*. The pictorial organism invariably provided the ultimate standard; the picture was always conceived as a beautiful object in its own right, to be produced in accordance with wise rules. The images of things that defined it in terms of content belonged solely to its poetic world. '*Le peintre pense en formes et en couleurs, l'objet c'est la poétique.*'

Similarly the desire for a significant new content, which had led to the revival of figure painting, was only remotely reflected in his art. His almost exclusive medium has been the still life, so

that even in terms of content he remains within the tradition of a classically temperate lyricism, the tradition of Chardin and Corot. Braque also kept clear of the mounting tide of 'social' themes or of references to modern industrial civilisation. In the rare instances where his imagination plays with the human figure, the figure dwells on a serene existential plane or emerges from the timeless world of classical antiquity, a canephoros or a divinity from Hesiod's *Theogony*.

We left Braque in full possession of the free, rich, chromatic style developed by Cubism in 1913/14. Mobilised at the outbreak of the war, he was severely wounded in 1915. In the autumn of 1916 he was discharged and returned to Paris.

In 1917 he resumed painting but in a different style. Like Juan Gris and the Purists, he became more austere, using larger forms, broader planes, and a more succinct geometry. It is not unlikely that in his new beginning Braque let himself be guided by Gris whom he saw frequently at the time. But this cool Purist bareness was short-lived. By 1919 his colours grew richer and more sonorous, while his brush stroke took on a script-like character. The outlines grew less definite, the rigorous order of the planes was softened, the pictorial space deepened. Elements of natural observation made their way into the picture imperceptibly and persistently, as Juan Gris noted with disapproval: 'I find Braque's latest works soft and lacking in precision. He is moving towards Impressionism.' And it is true that in the early twenties a sensuous note became more and more pronounced. In his greater reliance on natural objects, Braque does not actually aim at reproducing them; nevertheless the visible images of nature play an important part in the creative process. 'To arrive at abstraction, one must start from nature, and to start from nature means to find a motif. To lose contact with nature is inevitably to end up with decoration. – On the other hand, those who begin by setting up objects for a still life and then try to paint them, merely imitate their own arrangements. For them painting is an activity that *follows* something, a lifeless imitation devoid of feeling.'

In this view, the creative process comprises two stages. Braque now approaches the things of his environment with greater love and confidence. Enriched by them, his imagination preserves their lyrical qualities and the constitutive elements of their formal beauty. It is these elements that he calls into play when he begins to paint; he develops them into their most finished and most fruitful forms, brings them into relationship with one another, and composes an ensemble which is a concentrated visual expression of his experience of the beauty and lyricism of the object. Thus Braque does not 'reproduce' a still life, but creates it on the canvas. The apple that appears beside the knife in the picture may, in visible reality, be quite unrelated to it and even situated in an entirely different place; the relation between them arises only in the other reality of the picture. Their objective existence may be of great importance in releasing an aesthetic or lyrical emotion, but their beauty can be actualised only in pictorial terms. And what Braque seeks to preserve is precisely the element of the beautiful, as against Léger's search for powerful emblems and Picasso's emphasis on expressive force. In coming closer to the object, Braque humanises abstract beauty and infuses its aloofness with lyrical warmth. In the glorious series of still lifes that extend over the entire decade until 1930, the summary Cubist optics gradually gives way to a vision intent upon discovering the individuality of objects. This leads to a new poetry extracted from the world of things, an almost classical harmony between objective and pictorial form.

This new way of seeing, which enriched the limited iconographic arsenal of Cubism with flowers and fruits, and all the objects that surround us, occasionally aroused the artist's interest in the human figure. Needless to say, it appeared in terms of an imaginative ideal. He used the classical motif of nudes bearing baskets of fruit, and his forms were also influenced by classical reminis-

258

cences. This is a style of great decorative scope, deep and rich in colour, and since it transposes the abstract Cubist décor into legible objects and figures, it is well suited to large-scale decoration. In 1923/24, Braque was commissioned to design sets for Diaghilev's Russian ballet. This style with its compelling beauty and sumptuous decorative effects brought Braque great fame in the twenties.

In 1929 he returned to barer, sharper forms. The Cubist architecture which had often been almost concealed by painterly elements, is emphasised again, and the sonorous fullness of the colours give way to a hard brightness, marked by occasional shrill contrasts. One might even then have guessed that Picasso's aggressiveness was luring Braque to new adventures.

And in 1930 Braque did actually let himself be carried away by Picasso. Once again his work became more abstract. Long, sinuous, automatically generated curves formed amorphous Jugend-stil-like planes. Combining with geometrical elements, they gave rise to a lively rhythmical ensemble, and a few additional emblems defined them representationally. The method is that of Synthetic Cubism, but the underlying abstract form was made more expressive by its automatic character and Surrealist amorphousness. Often the composition is traversed by free arabesques flowing from the rhythmical movement of the hand, and in no way referring to objects. It is highly significant that in those years Braque used an entirely new medium that he himself had invented – plaster plates coated with graphite; the surprisingly white lines he obtained, by letting his engraving tool run freely over the plate, formed figures reminiscent of early Greek vase paintings or the incised drawings on Etruscan mirrors, to which he gave the names of ancient nymphs and gods. Hesiod's *Theogony* which Vollard commissioned him to illustrate provided him with welcome material for similar works in the graphic medium.

But these cautious experiments with Surrealist methods apparently did not satisfy Braque. He did not share Picasso's gift for spontaneously finding an endless stream of images. Towards 1933/34 he went back to his grand decorative style; reacting against his previous manner, he emphasised illusionist and even Impressionist elements even more strongly than before. He did figure-painting works which now took on the character of intimate interiors. He still resorted to Cubist devices – multiple views, overlapping planes, superimposed forms, and geometrical abstractions – but his treatment of light and space was often almost naturalistic. The decorative element gave way to a quiet intimacy. At the same time Braque was moving closer to the world of things. The works of the last decade disclose the soft, painterly manner, the deep enjoyment of the precious gifts of existence, which so often characterise the late style of great masters. 'In old age art and life become one.'

Braque's development shows the extraordinary inner coherence which Cubism gave French art. His systematic rigour was never imperilled by his recurrent tendency to go back to the visible. The natural elements seeking to enter the picture had to pass through a control zone, in which their pictorial potentialities were tested by the architectonic requirements of the pictorial structure and the needs of the abstract idiom. Looking back at nature from the position he had attained, Braque perceived it as a field in which his Cubist and abstract experiences could be realised through objective elements. The object became a welcome material. Once he overcame its resistance, it would help him to build a picture that would be a pure *fait pictural* enriched with the object's inherent beauty and lyricism. Thus he created an art equally far removed from naturalism and abstraction, which united and embodied both domains in a formula of beauty. By introducing the object, Braque paradoxically achieved a more integrated vision which eliminated the aggressive tension between the self and the world. For all the differences between Braque and Matisse, their

solutions are essentially identical. And since in them the spirit achieves repose Matisse and Braque gave their contemporaries deep gratification. Braque's classicism of *juste mesure* became the supreme example of measure and balance.

## Marc Chagall and the Jewish Strain in the Ecole de Paris

Concern with balance and form certainly characterises the spirit of French art. But Paris was the nerve centre not merely of French, but also of European painting, whose impulses it absorbed and assimilated. In the Paris School the French spirit acted as inspiration and catalyst, at the same time broadening its range through contact with the artistic ideas of other nations. Here we find the drama and fantasy of Spain – Picasso, Miró, Dali – and the expressive Romanticism of the new German art – Max Ernst and (indirectly) Paul Klee. Filtered through the keen intellectualism of the French, these tendencies gave rise to Surrealism.

Within the Paris School there was a kind of enclave – a group of uprooted artists who managed to keep their native folklore alive in the midst of the bustling capital of European art. Here, in this cosmopolitan environment, an art was created which expressed the sadness of the Jewish race, the deep lyricism of its ancient memories and the treasure of its legends. These painters were less concerned with form than with images and meanings implicit in their backgrounds. Their art reflects nostalgia for a lost homeland, but also the sense of solitude, of helplessness in the face of a remote, hopelessly hidden God, which is so uniquely characteristic of the Jewish mentality, and which Kafka so eloquently transposed into modern legends. The gentle sadness of this art, its poetic exploration of the world of objects, bring to mind the Hassidic legend of the world as a vessel that shattered into a million fragments because it was too full of divine love, each fragment becoming a thing which still preserves a spark of God's love. Sometimes it seems as though these painters were looking for the shards of the vessel and the spark of divine love in them. This changed their mode of perception. The eye searched for the legend hidden in reality. The result was a dream about reality, expressed in the metaphoric images of reality. The only source of this art was feeling. It had nothing to do with the *méthode de la recherche* practiced by the Surrealists, and consequently was ignored in Surrealist circles. It was entirely naïve. But because it preserved and interpreted aspects of the visible world, and because it expressed itself in the idiom of the modern Paris School, it found a considerable audience by the early twenties.

These painters who had long lived in Paris now became known, and in 1923, when Chagall returned to Paris, they formed a kind of group. They met every night at the Café du Dôme – the Russians Marc Chagall and Chaim Soutine, the Bulgarian Jules Pascin, the Pole Moïse Kisling and the Italian Amedeo Modigliani. They constituted a special Jewish enclave which enriched painting in Paris with elements of their native folklore. They were often joined by another uprooted artist, the Japanese Foujita. The most important among them was Chagall.

Marc Chagall (b. 1889) was not unknown when he returned to Paris in 1923 – not only because he had lived in Paris before the outbreak of the Great War, but also because, in the eyes of the Parisians, his painting had many points in common with French art. His fantasies and a certain esoteric religious element brought to mind Odilon Redon; the colour and 'analytical' treatment of objects characteristic of his early period related him to Orphic Cubism, the 'Impressionism' of his later years to Vuillard and Bonnard, and his naïve definition of objects to Henri Rousseau. There can be no doubt that all these elements contributed to the development of his style. It was

only thanks to his contact with modern French painting that his legendary vision was able to achieve effective pictorial expression in the first place, and that this Russian-born Jewish lay painter could become a European artist. It is a fact, however, that all these techniques and influences served the sole purpose of giving visual expression to human contents derived from his Jewish origins and Hassidic religious tradition.

Chagall was born of a poor family in the Jewish quarter of Vitebsk. His father was a shopkeeper's assistant. The joys and sorrows of Jewish life in the provincial towns, their tragedies and modest festivities made a profound impression on young Marc's imagination, and he began at an early age to record his experiences in drawings. In 1907 he went, wholly destitute, to St. Petersburg, where he attended a third-rate art school. For a short time he also attended classes at Leon Bakst's studio.

His paintings of those years have all the features of naïve art. He rendered village scenes seen through the half terrified and half amused eyes of a child, trying to bring out their poetic quality by a few representative figures – the fiddler on the roof, the street sweeper, the drunken soldier. In this way he transported his naïve vision into a legendary realm.

In 1910 Chagall found a patron who offered him a small grant to study in Paris. Now this emaciated Russian Jew, suffering from homesickness, had the good fortune to find a corner in the wretched tenement where Modigliani, Soutine and Léger had their studios. He soon began to associate with the avant-garde artists who, thanks to their knowledge of Henri Rousseau's work, recognised the naïve force of Chagall's imagination. He made friends with Blaise Cendrars, met Apollinaire, Max Jacob, became acquainted with Delaunay, and was soon taken up by the Orphic Cubists. It was Orphism that provided him with the formal means to express the dreams and images stored in his memory. The intense abstract colours of Orphism help him to discover his magical, fairy-like colours evocative of Russian folk art. The overlapping transparent planes served him as levels on which to record his nostalgic memories. The method of simultaneity enabled him to render complex images combining elements distinct in point of time. His pictures are magically translucent arrangements of planes, in which representative images from memory are inscribed in a naïve representational style.

'My pictures are not literature,' Chagall once said. 'They are painted arrangements of inner images that obsess me.' He does not break up objects, he breaks up his recollections. Images are juxtaposed as though in a magic kaleidoscope; they are distributed on the surface, each defining an object which touches off a chain of recollections – the domes and houses of a Russian town, a milkmaid, a man with a sickle, a pedlar. The images are words composed to form a poetic sentence. Objects and figures evoked may be shown upside down if the composition demands it, for they are intended only as emblematic suggestions to be recomposed in the viewer's imagination. This method is the exact pictorial equivalent of the 'simultaneous' poems by Cendrars and other Orphist writers. But Chagall uses the methods of Orphism only to give pictorial embodiment to his dream-like reality. He is not even aware of the intellectual – formal and theoretical – aspects of Orphism, but remains an ingenuous soul trying to define as clearly as possible things he had once looked upon with wonder. He is essentially a realist whose narrative enthusiasm makes him a poet – at the deepest level of his personality he is one of the *maîtres populaires de la réalité*.

Even before 1914 the narrative element gradually becomes far more important than the formal construction. In its search for expression, his feeling leads him to curious inventions. A cow suckling a calf and a human child stands like a monument on a village roof-top, while a milkmaid comes flying through the air like an angel; but in her haste her head has separated from the rest

of the body, as though wishing to sing hallelujah all by itself. This is an hallucinated pictorial poem, but it is inspired by an objective emotion, which can only be expressed in representational images – these are the words of the legend.

This art seemed in some way related to German Expressionism. In 1914 Apollinaire took Herwarth Walden to see Chagall, and in June 1914, Walden arranged an exhibition of his work at his Sturm-Galerie in Berlin, which made Chagall's name familiar among German Expressionists. Chagall himself went to Berlin for the opening, and then went on to Vitebsk. Here he was surprised by the war, which prevented him from returning to Paris. In February 1917, when the Revolution broke out, Lunacharsky helped him to found an academy at Vitebsk. In 1919 Chagall went to Moscow and devoted himself with great enthusiasm to the recently founded Yiddish Theatre. In 1922 he decided to leave Russia. He went to Berlin, where he had acquired a great reputation in the interval. There he wrote his autobiography for which he made etchings that were published by Cassirer as a portfolio. Early in 1923 Vollard commissioned him to illustrate Gogol's *Dead Souls*, whereupon he returned to Paris.

During his years in Russia Chagall moved further away from Cubism. The subject matter was provided by his fresh impressions of his native environment, and by his life with Bella, his young wife. In one painting we see him in the outskirts of Vitebsk walking with Bella, whose ecstatic joy lifts her high in the air; in another, he sits on the shoulders of the light-footed Bella, brandishing his wine glass, while an angel hovers over him. With naïve Surrealist metaphors such as these, he tells the story of his feelings, giving himself entirely to the moment of poetic rapture.

On his return to Paris in 1923 his style changed considerably. Until 1939 he was kept busy with the hundreds of prints commissioned by Vollard: the illustrations for the *Dead Souls* (begun in 1923), the etchings for La Fontaine's fables (begun in 1926) and the Bible illustrations (begun in 1931), on which he spent a great deal of time, visiting Syria and Palestine, then Holland (in 1932) to see Rembrandts, and finally Spain (1934) to see El Grecos. He retells the Old Testament stories with a naïve simplicity, cloaking them in a soft, dreamy twilight atmosphere.

His painting discloses a similar change. His colours become more fluid, more fragrant, more richly differentiated, providing an enamel-like ground for the images that expressed his moods in lyrical metaphors: a bunch of lilacs against the background of a river landscape at night with a reclining couple of youthful lovers; a fairy-tale rooster with a cow playing the violin – poetic images and fables that find their way spontaneously from the artist's heart to the canvas. These paintings reflect the artist's moods and the vicissitudes of his life (he left Paris for New York in 1941; and in 1944 Bella died). His art now becomes wholly suffused with the melancholy and gentle lyricism that had always been the dominant traits of his character.

Chagall's position in the Paris School is unique. Surrounded by French artists who devoted themselves entirely to formal researches, he clung to the realm of representation. With a small and constantly recurrent inventory of images and figures, he recorded the memories of his childhood, his longings and feelings. He used them like a small troupe of marionettes to enact the fables or legends that were stored away in his memory or that he perceived in objects. His art partakes of deeply felt legends rather than dreams. This distinguishes him from the Surrealists. His pictorial arrangements seem illogical only at first sight. Each single image in them corresponds to a definite poetic statement; when we see these statements together and re-live the recollections and associations they release, a coherent narrative emerges. The viewer who allows himself to be guided by the poetic images can easily decipher the meaning, exactly as in a realistic picture. Chagall uses abstract elements only in order to give his contents greater poetic precision. He is an

entirely representational painter, and his approach to natural objects is quite direct. What distinguishes him is an original hallucinated vision. He always retains something of the Hassidic conception of nature, according to which every object, however humble, conceals a spark of the divine presence. Just as Chagall's bunch of lilacs blossoms into a tender couple of lovers, so his love of the things of this world blossoms into a legendary image.

## Amedeo Modigliani (1884-1920)

The poetry of the visible was also the goal of Modigliani's art. But he was of the Mediterranean peoples, born at Livorno, and he adhered more closely to the world of things. These were the vehicles of his emotion. The fables, legends, metaphors which provided Chagall with his subject matter are alien to him: he painted only nudes and portraits. Nevertheless, his art expresses the same secret sadness as Chagall's, the same loneliness, the same feeling that man is at the mercy of the incomprehensible paradoxes of life, the same probing lyricism.

Modigliani was fully aware of his Jewishness. He came of a Franco-Italian Jewish family, and was proud of the tradition according to which the blood of Spinoza flowed in his veins. He was not an orthodox Jew, nor was he, in his self-chosen exile, homesick for the East, but always for his 'cara bella Italia'; he was essentially Italian in his physical make-up, his way of thinking, and his generous sensuality. Yet in the innermost core of his being he possessed the specifically Jewish knowledge of man's solitude, which sought for a brotherly or lyrical point of contact with others and for a comforting response. From this core came the melancholy and lyricism which give each one of his paintings its unique aura. But from it, too, came the self-destructive restlessness that quickly consumed his life and made him go down in legend as the last of the bohemians.

Modigliani was a man of radiant beauty, full of wisdom, sensitivity, and an innate appealing tenderness. He sought refuge from his extreme vulnerability in alcohol and drugs. His sensitivity to the sufferings of others, his solitude, and his need for love and kindness were further intensified by his tubercular condition. His eternal quest for a personal response to his own inner need prevented him from participating in the formal explorations of his fellow painters in Paris. Instead, he painted his models and his friends, trying to define what attracted him to them. Like Toulouse-Lautrec, he sketched untiringly and peered deeply into his model's psychic background, but what he was looking for was always the note of helplessness and solitude.

After brief studies at the academy of Venice, Modigliani went to Paris in 1906, and soon established personal relations with the group round Picasso and Max Jacob. His impressions during those first years in Paris were crucial for the development of his art. From Rodin and Matisse he learned the sensitive musical line of his drawings, from Toulouse-Lautrec his trenchant psychology; the early Picasso of the 'Rose period' showed him how, if the proper methods were employed, the human figure could be made to express a peculiar note of lyrical sadness. In fact, Picasso's pre-Cubist style seems to have provided the foundation of Modigliani's figure painting.

Cubism with its analytical deformations had little attraction for him; his deformations derive from different sources. The hieratic expressiveness of Negro sculpture exerted considerable influence. In 1909, urged by Brancusi, he executed a number of sculptures to which he tried to impart a primitive idol-like quality. There was also Cézanne. In 1909 Modigliani saw the great Cézanne exhibition at the Bernheim gallery. From then on, Cézanne's *Young Man with the Red Waistcoat*

was Modigliani's model and guide. It taught him that a painter is free to use any deformation required by his artistic conception or suggested by the depth of his feeling. After a short 'Cézannist' period marked by his first success at the Salon des Indépendants, he quickly found his way to his personal style, which achieved its purest expression in the years from 1914 to 1920.

It is a figurative art of great restraint, and of extraordinary lyricism. Modigliani's sole concern is to give pure expression to the feelings aroused in him by his subject. The greater his sympathy for his subject, the deeper his vision penetrated. His best paintings are the nudes of his beloved *midinettes*, who shared his nights and, warm from sleep and love, posed for him in the morning, and the portraits of his girl friends with their long narrow fragile necks and the melancholy curves of their stooping shoulders. In these works the marvellously lyrical melancholy of the simple human existence, which Modigliani detected everywhere, takes on convincing form. Formally, Modigliani contributed nothing to modern art, but he showed how a strong feeling for the object can raise it to the level of poetry and legend. While Chagall illustrated his legends with pictorial fables, Modigliani extracted his legends from his models. Modigliani's lyrical attachment to his visual statement brought him great fame in the early twenties, when his art fell in with the general tendency of the period. But he did not live to enjoy his fame: he died in 1920, in great poverty, from a fever that his weakened constitution lacked the power to resist.

*Peintres maudits*

In the early 1920s the name of another one of these uprooted artists, whose strange way of life soon earned them the designation of *peintres maudits,* became known in the Paris art world – Chaim Soutine, a friend of Modigliani, who at one time shared Chagall's studio. The son of a Jewish tailor in a village in Russian Lithuania, he came to Paris in 1913, and, living in extreme poverty, studied at the Cormon studio. Van Gogh, the Fauves, and Expressionism provided the formal idiom in which this East European primitive rendered his ecstatic vision. He was also influenced by Tintoretto, El Greco, and Rembrandt's late period. He had no intellectual culture whatever, and he used this idiom, which he acquired without thinking and applied with an hallucinated energy, for the sole purpose of expressing his tragic cast of mind. He attacked the world of things like a man driven by hunger, and beneath his avid frenzy they took on a tragic poetry, which always revolved about the themes of decay and sadness. His works include still lifes with plucked fowl in the livid colours of decay, in the midst of which tomatoes glow like fire; flowers that resist death in an agony of last blossoming; wildly apocalyptic landscapes; the flesh of slaughtered oxen in flamboyant bloody colours. Then there are portraits of choir boys, hotel servants, friends, all of them emphasising the tragic sadness of life. It is a primitive, desperate suffering, a hopeless striving for redemption, which assails the world of things with imprecations and wild questions. Far behind Soutine's tragic personality stand the Hassidim grieving over a world without hope and searching vainly for the God concealed in it. We might say that his sole task as a painter was to clothe this grief in a sumptuous garment of the most precious colour.

From 1917 on Soutine contributed to the development of the Expressionist idiom. This stage of his career culminated in his wild Fauvism of 1919-1922, the three years he spent at Céret. His apocalyptic landscapes date from this period. In a feverish hand he records the visions inspired by the countryside: the houses drop steeply from the vertical, bushes writhe like snakes, the whirlpools of trees form dynamic centres as though the storm of the Last Judgment were raging through

the landscape. In mood and structure these paintings show an amazing affinity with Meidner and the German Expressionism of the Sturm artists. Back in Paris, which up to his death in 1943 he left only in the summer, he gradually restored the unity of the surface which had been torn to shreds in his landscapes. Never losing touch with the object and repeatedly drawing strength from the late works of Rembrandt, he clothed the tragic substance of his paintings in a robe of sumptuous colour.

Formally speaking, Soutine is one of the purely instinctive painters who came to Expressionism by intensifying the Impressionist elements to the point where they acquired an hallucinatory force. He belongs to the tradition represented by Nolde in Germany, Kokoschka in Austria, De Pisis in Italy, and the early Vlaminck in France. But what clearly distinguishes him from the others, is the special 'tonality' of his vision – the unmistakable Jewish strain. His imagination always reaches out to the end of time. Everywhere a secret apocalyptic element breaks through the surface of things. The manifestations of decline and decay disclose a new, strangely melancholy beauty. It seems to be worth noting that Scipione and Mafai in Italy are inspired by a similar vision. We recognise here the special 'tonality' of the Jewish soul which achieved its first pictorial expression in this century, through its encounter with the great tradition of Western painting.

Jules Pascin (1885-1930) and Moïse Kisling (b. 1891) may be considered in the same context. Pascin was a Bulgarian, the son of a Spanish Jew. He studied at the Vienna academy and as a young man was well known in Munich where he contributed drawings to *Simplicissimus*. In 1905 he moved to Paris; subsequently he went on extensive trips to North and South America. Though cosmopolitan and a man of the world – he was the *peintre maudit* of fashionable society – he preserved a core of tragic restlessness. A brilliant draughtsman, he needed a great deal of money and prostituted his art to get it. This he knew, and paid for his betrayal by committing suicide. But his best works – for the most part groups of nude girls, more drawn than painted, on coloured grounds – emanate a kind of questioning melancholy which endows even the most erotic scenes with an aura of the legendary.

Moïse Kisling, son of a Jewish tailor in Cracow, went to Paris in 1910 and associated with the group round Chagall and Modigliani. He is less interesting. In the early twenties he achieved a certain reputation by his harsh realism in the Neue Sachlichkeit style, which at the time was cultivated primarily in Italy and Germany. But despite this hackneyed style, we perceive in his painting an echo of the lyrical sadness which the Jewish masters of the Paris School expressed so effectively.

It is certainly a remarkable phenomenon that the Jewish race, seemingly doomed to live without images, should have achieved specific expression in the idiom of modern culture. For all the differences in their origins, techniques and temperaments, there is no denying the kinship among Chagall, Soutine, Pascin, Scipione and Meidner. It expresses itself in a peculiarly melancholy lyricism, in a bent for the legendary, and formally in the use of Expressionist techniques. It was clearly Expressionism that provided the Jewish soul with its means of pictorial expression. This might be accounted for by the nature of the Jewish attitude towards the world of things. If things are merely the deceptive and misleading disguise of a hidden essence, and at the same time its hiding place, the only way to communicate with the essence is through things, taken as metaphors for it. Expressionism made this possible by an exaggeration and intensification which enabled each thing to take on a legendary and symbolic force.

In the historical situation of modern European painting in the early twenties, this Jewish enclave opened up a special perspective: it called the representational element into play in a new way.

It enlarged the magical experience of the object, adding a new lyrical and legendary dimension. The world was seen as dream and legend, enveloped in warm humanity and clothed in Romanticism. It was received with grateful recognition by a public that was not yet accustomed to the harshness and sharpness of Surrealism.

*Maurice Utrillo (1883-1955)*

The same public brought Maurice Utrillo out of obscurity. In 1923, on the occasion of an exhibition at the Bernheim gallery, his name suddenly became the centre of discussion in the artistic cafés of Paris, and in 1924 Basler referred to him as 'the most popular of all the Paris painters of our time'. The tragic existence of this poor alcoholic from Montmartre was a source of kinship with the other *peintres maudits*. He was a good friend of Modigliani, and there are moving stories about how they would admonish each other to give up drinking. But essentially he was one of those humble painters whose art is an individual expression apart from contemporary currents – the *maîtres populaires de la réalité*.

Utrillo was self-taught or, to be more exact, he was the apprentice of a self-taught painter. He was nineteen when, in 1902, his mother, Suzanne Valadon, after his first internment in an institution for the treatment of alcoholics, made him paint to divert him from liquor. Suzanne Valadon (1867-1938), once a minor circus performer, worked as model for the great masters Toulouse-Lautrec, Renoir, Puvis de Chavannes, and Degas, and eventually began to paint, encouraged by the severe Degas. The little model soon became a well-known artist. Starting with Impressionism, she gradually consolidated her forms and outlines, achieving a vigorous decorative style which preserved the charm of a slightly awkward naïveté. Thus Utrillo's first idea of painting was Impressionist, but his conception of Impressionism was naïvely realistic. He was attracted not by Monet's dissolution of forms, but by the lyrical realism of Pissarro and Sisley. Utrillo's early works look very much like Pissarro's – but they are distinguished by the clumsiness of the layman and a poetic charm that derives from his anxious questioning of reality. Soutine with his ecstatic primitive vision raised Fauvism to the poetic level; Utrillo transformed realistic Impressionism into poetry.

It was the inner compulsion to define his reality – 'wild thirst for reality', as Utrillo once described his state of mind – that peeled away the Impressionist husk from objects. The painter found himself confronted by the simple face of reality. This startling vision has certainly something to do with the alcoholic's hallucinated experiences – the sight of freshly fallen snow on Montmartre as he steps out of the bar; the unseeing eyes of the windows as he totters along the streets, and the crumbling substance of the mouldy walls as his groping hand seeks support on them. Such experiences added up to a vision of Montmartre as a true *paysage intime* into which he injected his poetic experience.

His vision was most intense in recollection, for then his reconstruction of reality was not disturbed by actual observation. The views of Montmartre – Utrillo's favourite subject – were almost all painted from memory in the artist's small room. Even common picture postcards could serve as a basis for his paintings because the reality they evoked was firmly engraved in his mind.

In his famous *période blanche* (c. 1910-1914), Utrillo used a reduced scale of colours from white to grey – the colours of the walls; only occasionally do we perceive the pastel tints of the *faubourgs*. His description of reality consists in a defining reconstruction. Like a mason he builds his walls, like a tiler he covers the houses with roofs, like a carpenter he adds windows and doors,

266

and his 'thirst for reality' sometimes leads him to add lime and plaster to his walls so that they can really be scribbled on and soiled, and to cover them with moss and plants in order to bring out their crumbling. All genuine lay painting is based on a similarly naïve definition of reality. Utrillo, however, uses a different pictorial idiom – one derived from a highly developed Impressionism rather than from an obsolete Romanticism.

After 1914 Utrillo's colours become richer and, particularly after 1927, they are as glaring as on picture postcards. The subject matter and the poetic intention remained the same, but the intensity of the experience and the quality of the exposition declined considerably in the last two decades of his life.

The crucial characteristic of Utrillo's art is the defining force of his realism. The slowly dying world of the *faubourg* with its leprous walls was his reality, and it is this lived reality he knew that is represented in his paintings.

In these painters the art-loving public, weary of the modern aesthetic theories with their intellectual subtleties, welcomed the return to nature it had been longing for. The bourgeoisie chose to forget that these unhappy artists were a pretty disreputable lot. They were hallucinated men, heavy drinkers, wild bohemians whose desperate attempts to record and define their own reality were interpreted with relief by the public as a fulfilment its own dream of a new nature painting. Actually, these painters occupy a special position in the development of art. In them, the magical experience of the world of things acquired a new ecstatic and naïve dimension, it became more vivid and more poetic. They, too, continue the line begun by the *maîtres populaires* and Pittura Metafisica. It is this same line which, by way of dreams and poetic hallucination, leads us to Surrealism.

*The Two Types of Surrealism*

The new treatment of visible reality achieved its most original expression in Surrealism. When Louis Aragon wrote in 1924 that the great modern discovery which created entirely new conditions for art was that the subconscious contained images that could become tangible components of reality, he implicitly recognised the world of things as the medium with the help of which and within which the images of the unconscious could acquire form. This presupposes a new psychological and literary concept of the 'image'. In the vocabulary of Surrealism 'images' are figures and structures stored in the deep layers of memory, which the human imagination brings to the surface in answer to certain stimuli. In hallucinations, visions, and dreams they appear as images 'from the other side', and it is only in relation to the familiar visible reality surrounding us that they seem 'other', dark, ghost-like, magical or absurd. A creature of alien origin appears as something marvellous or absurd among the things familiar to us, under our light, in our space, and it is our ordinary reality that sets off its strangeness. But the ordinary things, by stimulating our associative faculty, can touch off alogical sequences of images. Even if they fully preserve their material reality, they can, by means of substitutions, associations, or by their very isolation, suggest a wealth of entirely unexpected relations. When Lautréamont says a thing is as 'beautiful as the accidental encounter of a sewing machine with an umbrella on an operating table', he defines the absurd by combining images of entirely material things. The Romantics had known this, and Novalis had written: 'When completely unrelated things are brought together by being in one place, at one time, or by some curious similarity, peculiar combinations and strange associations

arise – and one thing brings to mind everything, becomes the symbol of many things, and is itself signified and evoked by many things.' Thus the surrealist 'image' required visible reality as its dialectical partner. Salvador Dali says this very clearly: 'The reality of the outside world is an illustration and argument, dedicated to the service of the reality of our mind.'

If we systematically investigate the classes of images referred to in the theory of Surrealism, we find that they come from three sources: the images of dreams and states of intoxication, which take the form of hallucinations; the images of the deep unconscious, which are brought to light by psychic automatism; the images of the magical experience of things, which are released by associative chains starting from objects. The predominance of one or another of these sources is the basis of a sharp distinction between the currents of Surrealist painting. Because it is directly rooted in pictorial experience, this distinction was significantly overlooked by André Breton in his source book of 1928, *Le surréalisme et la peinture*.

Dreams, states of intoxication, and magical things bring to the surface images which can be defined only in terms of contrast to the natural environment. Presenting all the features of the plausible, they evolve in an illusionistic environment. Their space is illusionistic space. The possible deformations of this space – it can be made to collapse, to expand, or contract – are after all merely modifications of illusionistic space. Among the many paintings produced by surrealism, we find a number in which the most monstrous dream images, treated with extreme 'photographic' accuracy, are situated in a perfectly illusionistic space. This tendency may be called 'Veristic Surrealism'. Its principal representatives are Max Ernst, Yves Tanguy, and Salvador Dali.

The other tendency operates with images obtained by psychic automatism. This tendency is neither reproductive nor illusionistic. The painting is a writing tablet on which the unconscious is materialised in signs which combine into a pictorial script. The surface is the evocative ground. Joan Miró and, occasionally, André Masson belong to this tendency, which we should like to call 'absolute surrealism'.

Though the two tendencies frequently overlap, the distinction is undeniable. Since the first Surrealist exhibition in Paris (1925), the contrast between these two tendencies has often been manifest.

*Max Ernst and Veristic Surrealism*

The origin of Veristic Surrealism can be clearly determined in connection with the first truly Surrealist painter – Max Ernst. In 1922 Max Ernst moved to Paris and worked with Paul Eluard on a cycle entitled *Les Malheurs des Immortels*. Here again we have a series of pictures made of scraps of illustrations cut out from old books and pieced together to form fantastic ensembles. A strange, absurdly realistic world was constructed from ready-made, laterally faithful images of things. Max Ernst retained the fundamental Dada idea that a poetic re-interpretation of things could be achieved by a chance combination of elements of reality. The verist aspect was needed, as Ernst put it, to touch off, 'the strongest poetic sparks by bringing together two seemingly unrelated elements on a plane unrelated to both'. The technique of collage ideally served this purpose, and Max Ernst repeatedly went back to it: in 1929 he published *La Femme 100 Têtes*, in 1934 *Une Semaine de Bonté*, and in 1949 *Paramythes*.

In the series *Les Malheurs des Immortels*, the technological elements receded, and vegetable, animal, and human elements came to the fore. The magical, mysterious quality of the world of

things surrounding us asserted itself as a new theme, disclosing the influence of Pittura Metafisica. Max Ernst's paintings up to about 1926 are also in many ways related to Pittura Metafisica. Dada art and metaphysical painting, and their techniques of expressing unconscious states of mind through the allegorical quality of 'things' are the foundation of Veristic Surrealism.

In Paris, Ernst contributed to *Littérature*, the magazine published by Breton and Soupault, and in association with a number of poets and artists (Picabia, Arp, Man Ray) tested new techniques for extracting images buried in the unconscious. It was in the course of this laboratory work that the exact theory proclaimed in 1924 under the name of Surrealism gradually crystallised.

In August 1925, stimulated by hallucinatory images which he saw in the veined wood of the floor in a hotel room and which imposed themselves on him with obsessive force, and recalling Leonardo's admonition that the images suggested to our fantasy by spots, smouldering coals, or drifting clouds should be taken seriously (they are, says Leonardo, 'like the ringing of bells in which we hear what is in our minds'), Ernst invented a new method, with which he was to experiment for a number of years. At that time he made *frottages* of the floor by placing sheets of paper on it and rubbing them with graphite. 'When I stared intensely at the drawings thus obtained,' he reports, 'I was surprised at the sudden strengthening of my visionary faculties and by the hallucinatory sequence of contrasting and overlapping images.'

This encouraged further experiments. Tracings of materials of every kind – leaves, fabrics, woods, etc. – provided his imagination with an initial stimulus. The various structures entered into unexpected associations and images emerged that called for poetic names: the sea and the rain, the sphinx in its stable, false positions, wefts of ice plants, seismic plants, paired diamonds, garment of leaves, etc. 'In consequence of a series of suggestions and transmutations that imposed themselves spontaneously,' Max Ernst tells us, 'these drawings gradually lost the character of the material from which they derived. They took on the aspect of unexpectedly precise images.'

In 1926 Max Ernst published a whole series of these drawings under the title *Natural History*. The title is by no means misleading. The drawings are actually based on natural materials, copies of structures created by nature, or, to use Duchamp's terminology, tracings of 'ready-mades' produced by nature. In the combination of these natural structures, unconscious associations reach into the realm of nature and enlarge the natural references into visions disclosing the wonders of the cosmos or of the world of animals and plants. By reflectively penetrating into the formal diagrams of nature the contemplating, marvelling mind clears the way to the Orphic sources, and a symbolic message emerges from man's unconscious experience of the world. The structural copies of nature open a view into the forgotten domain in which man himself is still nature, and his unconscious experience of the world is defined in images. These images have the character of the marvellous and can become mythical, if by 'mythical' we mean the intuitive symbols of an experience of the world which lies beyond the world of the senses and the intellect.

The attitude towards nature expressed in *Natural History* is not an isolated phenomenon, although it derives from a very personal experience. It reflects the modern mind's search for a deeper relationship with nature. Paul Klee and Masson rendered similar experiences in a similar way. We shall see later how these experiences eventually were integrated into modern abstract painting, providing a new subject matter that modified its form.

The myths of nature which come spontaneously to the artist's mind when he works on his diagrams of natural objects also (until about 1930) provide a theme for Max Ernst's paintings. The method is similar to that used in the drawings: by a process similar to *frottage*, patterns are transferred to the coloured surface and suggestively worked over. The resulting forms – prehistoric

landscapes with gigantic stars or silent plant worlds against exotic horizons – relate to unconscious zones of experience. The objects that emerge in these symbolic areas of a magical world evoke a primitive nature cult: animal idols make their appearance; tree-gods clad in bark and dryads constructed of lush plant forms crawl back into their tangle of roots when the viewer tries to locate them. In the Greek fauns, nymphs, and centaurs nature was divested of its magical character by the Apollonian spirit, the dark Orphic zones were excluded; now it recovers its original magical character, rooted in the unconscious. The separation between man and nature is done away with. The human spirit returns to the pre-Homeric and pre-Socratic, i.e. Orphic realm. Ernst's 'horde-pictures' are peopled with new hybrid creatures, and only the ironical captions make us forget that a new Orphic mythology of nature has irrupted into the Western imagination. This, too, reflects a general tendency that led to the creation of new idols in Picasso's magical sculptures and Henry Moore's nature idols.

In the years that followed Max Ernst treated the same subject in a harsher, unpleasantly realistic manner. The source of suggestion is no longer the shifting magical background but the play of associative fragments. A malignant fancy develops obscene natural shapes into *objets désagréables*. Nature became an utter jungle. Towards 1936 the magical dream reality of Rousseau's virgin forests provided a new impulse. But Max Ernst's optics is entirely different. He looks at things from a lower region with the evil eye of a beetle surrounded by a threatening, voracious nature. The gigantically magnified microcosm of the swamps becomes the general model of nature. This model too is the result of unconscious associations released by a shock. As the artist looks at a leaf or the machine-like activities of an insect, thus coming into contact with the demonic forces of nature, his startled unconscious releases a tidal wave of images which express the demonology of nature in paintings of luxuriant jungles peopled with monstrous creatures. The ideal beauty of a flower is shown for what it is: an obscene sexual advertisement. Max Ernst's pictures teem with anti-idealistic reversals of this kind. And he describes everything with the meticulous accuracy of an hallucination, investing his works with a diabolical beauty which is part of malicious nature's disguise.

It was the suggestive power of natural things that released the surge of symbols stored in instinctual and unconscious experience; these symbols could then be recorded in images. An inner model could be made visible with the help of the stage props provided by the outside world. This model had demonic features because it developed in the Orphic regions, the realm of forces beyond the control of reason, where the essentially horrible, shock-releasing realities revealed by modern biology lie buried. For there can be no doubt that the mysteries of nature discovered by the optical instruments of modern science spelled the end of an idealised view of nature, disclosing that nature was under the sway of a satanic instinctual mechanism moved by hunger and sex, the scene of a demonic, mysterious, pointless war of all against all. A sensibility which took this experience seriously and emancipated itself from the influence of humanistic conventions by reaching into the unconscious, where man's reactions to this experience are stored, could arrive at an inner model which included all these demonic elements. 'The true interpretation of the material world,' Eluard says, 'cannot exclude the man who reports on it.'

But this world, too, could be raised to the level of a kind of mythology. In the years following 1940 – Max Ernst had escaped to southern France, and in 1941 gone to the United States – he conjures up an ineffably solitary Olympus of coral creatures, tufa dryads, and stalagmite gods in desolate lava-covered Baroque landscapes. His technique changed. With the help of *calcomanie* – a technique in which thin paint is laid on the canvas by means of a kind of stereotype plate –

Ernst produced extraordinarily evocative surfaces that brought to mind layers of sediment, stalagmite formations, and coral growths. From such surfaces, as the artist hearkens to the communications of the unconscious, there emerge creatures in which the unfathomable mutability of all things achieves a unique mythological expression. Treated illusionistically, a magical world in constant metamorphosis irrupts into the natural space of our existence, upon which its mysterious, but infinitely plausible presence casts an insidious doubt. In recent years Max Ernst has worked along less veristic lines and has arrived at large, more abstract figurative signs suggesting fetishes or magic symbols and often fitted into austerely geometrical patterns.

It would certainly be wrong to describe Max Ernst's illusionistic world solely in terms of a dream verism. Though it emerges passively from the unconscious abyss where images are stored, it turns back actively into reality. It is a protest against the claim that the world of appearances is true, against the fixations of this world in intellectual knowledge and in idealist, classical, and humanistic clichés. According to Max Ernst, his art reflects 'the vital need of the intellect for liberation from the deceptive paradise of fixed recollections and for the exploration of a new, incomparably vaster domain of experience, in which the boundaries between the so-called inner world and outer world tend increasingly to disappear'. He introduces veristic settings in order, first, to show the irony of their claim to reality, and second, to use their meanings as an allegory. But at the base of his art there lies a painful awareness of the mystery of nature, which inspires his magical symbols and mythological figures. The nature myth at the centre of his art is no doubt Max Ernst's German heritage. Intellectually he is in the tradition of German Romanticism.

*Yves Tanguy (1900-1955)*

In 1927 a new name emerged among the exhibitors at the Galerie Surréaliste – Yves Tanguy. The very next year Breton devoted a chapter to him in his book.

Tanguy was self-taught. In 1924, after serving for a short time in the merchant marine, he saw in Paris a painting by De Chirico and began to paint without any preparation whatsoever. The encounter with De Chirico's spectral dream world must have had the effect of a violent shock. Tanguy became obsessed with a vision of space as an infinite being – the image had no doubt been latent in his mind. He embodied it as a gigantically vast, grandiosely monotonous landscape, a boundless stage, an infinity in which dispersed objects and the cobwebs of geometrical patterns provided a scant and fragmentary orientation. But this topography of the incomprehensibly boundless panorama required objects of a new kind, objects that could serve as signals. The things produced by nature did not posses this character, because, as components of our conscious idea of space, they imposed fixed forms on it; they would have transformed Tanguy's uncharted, infinite magical space into a conscious, naturalistic space. This meant that it was necessary to devise a new inventory of non-fixed things which, originating in the same source, could assert their right to existence within this vastly extensible space. The space itself became the evocative ground – after the manner of Max Ernst's suggestive coloured grounds – and stimulated the unconscious to produce objects akin to it. Objects that had no connection – or only a vague associative connection – with natural things asserted a full claim to objective existence. They would be meaningless in the world of fixed things, but they were self-sufficient, a species of their own – this is Kafka's definition of his 'Odradeks', self-invented objects. Tanguy's objects – soft, amorphous structures that proliferate like mushrooms and occasionally show an amazing

271

affinity with Jean Arp's plastic objects – are a self-contained species of this kind – a mysterious class of vegetation sprouting from a magical space.

Thus Tanguy's paintings show infinitely vast dream landscapes occupied by Surrealist objects which are the things of this 'other' reality. In this unfamiliar atmosphere, traversed by long shadows cast by a spectral starry light, the objects acquire a peculiar personality. They fill the silent expanse with their calls to each other and their enigmatic drama.

The power with which this alien world of images releases our psychic responses rests upon the implicit identification of its fictions with the realities of the nature surrounding us. Since things that do not exist in the fixed inventory of our knowledge and memory are described sharply, with illusionist realism, a magical super-reality in which everything is possible becomes fully present. Tanguy's realistically descriptive method exerted a lasting influence on Salvador Dali, who transformed Tanguy's vast dream landscape into a playground for startling monstrosities.

### Salvador Dali (b. 1904)

In Salvador Dali, Veristic Surrealism achieved its extreme form. Dali rejected the passive automatic 'finding' of images in favour of a hysterical, enraged, and indefatigable activity of his associative faculty: he transformed objects, interchanged and combined them. He calls his method 'paranoiac-critical activity'. It derives its undeniable power from an amazing hallucinatory energy and a baffingly rich and grotesque associative faculty, which he calls the 'paranoiac' method of thinking. He defines it as a 'spontaneous method of irrational cognition based upon the interpretative-critical associations of the phenomena of delirium.' His raw material was the wildly rushing tide of images, cut loose from the restraining chains of logic and consciousness, that rise to the surface in states of trance, intoxication, hysteria, mania, neurosis, dream, delirium, and in the delusions of madmen. This is 'the passionate use of the image as narcotic', to which Aragon once referred. By splitting his personality, is it were, Dali was able to record the hallucinatory phenomena, to fixate the images of dream and trance in 'hand-painted dream photographs'. Calling into play his extraordinary hallucinatory faculties, a deliberate hysterical exaggeration of his megalomania, and a shameless charlatanism used consciously as a stimulus, Dali abnormalised the very structure of his personality.

Salvador Dali is a Catalan, born at Figueras near Barcelona in 1904. His father was a notary. At the Madrid Academy he came across the Futurist manifestoes. Fascinated by the idea of simultaneity, he interpreted it in his own way. While the Futurists represented the individual phases of an actual movement simultaneously by means of their kinetic signs, Dali saw the possibility of recording, in a similarly simultaneous representation, successive recollections and fantasy or dream images, without concerning himself with the time factor. This provided the possibility of a fusion between the real and its associations, between reality and dream. The rationally existing and the irrationally possible became interchangeable.

Towards 1924 he came into contact with Pittura Metafisica through the magazine *Valori Plastici* which was widely read in Barcelona. The magical dream reality of the metaphysical painters, their sensitivity to the mysteries of the world of things, their animation of the lifeless, gave Dali an important new impulse. Until 1928 he tried to find his own path between magical realism and Futurism. Finally, during his visits to Paris, in 1928/29 he found a milieu that helped him to understand his vague longings. He met Picasso, felt the influence of Joan Miró, and came into

272

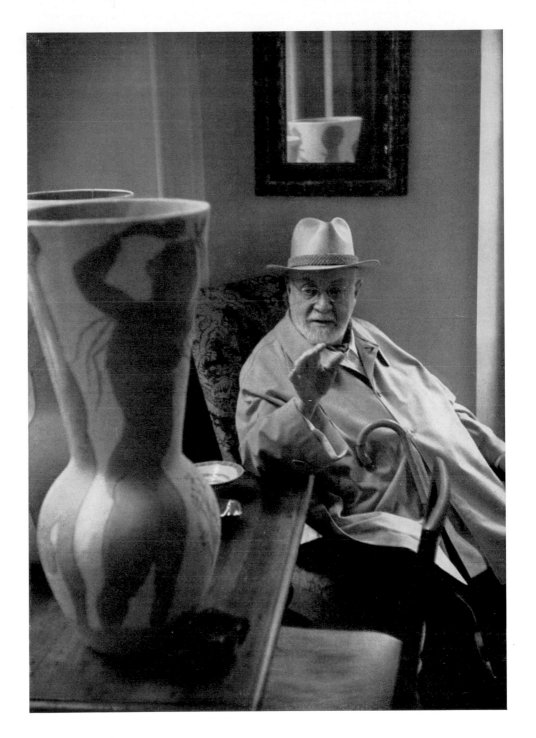

38. Henri Matisse (Photo Henri Cartier-Bresson, Paris)

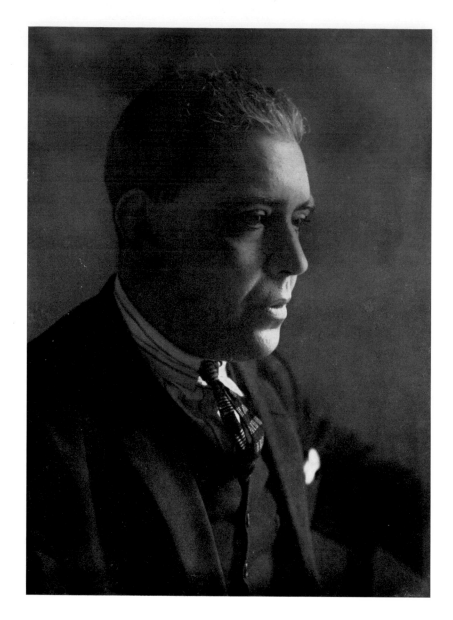

39. Juan Gris (By kind permission of M. Daniel-Henry Kahnweiler, Paris)

40. Pablo Picasso (Photo Herbert List, Munich)

41. Maurice Utrillo (Photo Maywald, Paris)

42. Joan Miró (Photo Herbert List, Munich)

43. Fernand Léger (Photo Maywald, Paris)

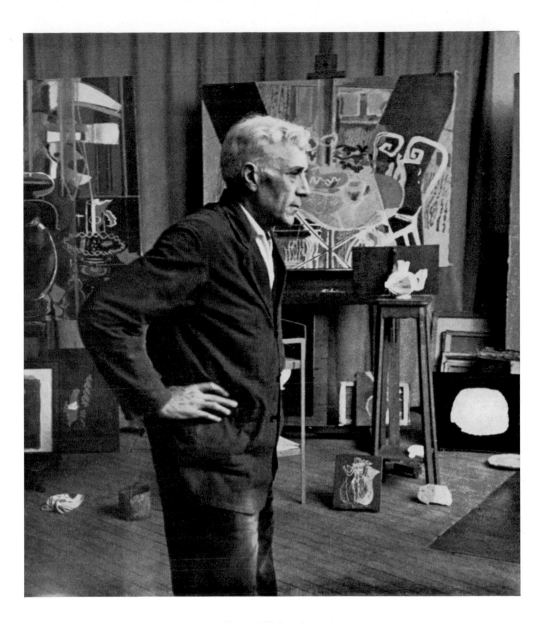

44. Georges Braque (Photo Lothar-Günther Buchheim, Feldafing, Bavaria)

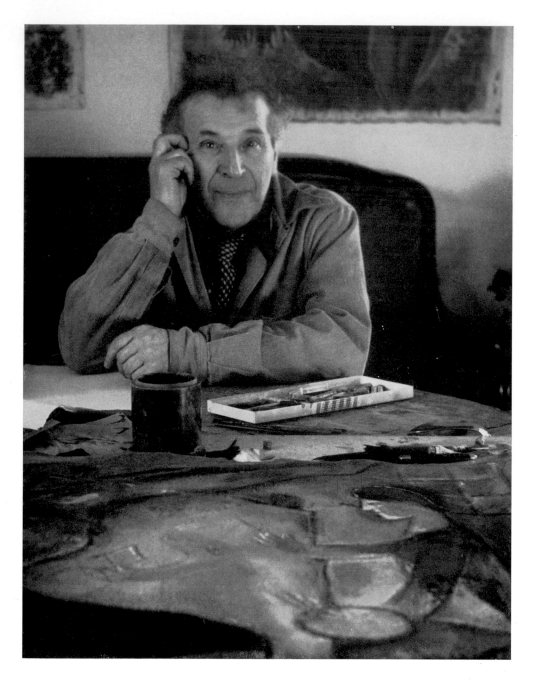

45. Marc Chagall (Photo Herbert List, Munich)

contact with Surrealism through Robert Desnos and Paul Eluard. At first he used Miró's automatic, 'concretising' method of painting, but broke away from it in 1929. His task, he decided, was to record unconscious images as precisely as possible, and as his style he selected an extraordinarily penetrating Verism.

From De Chirico he learned to revere the tragic eloquence of Wagner and Nietzsche. He was captivated by Böcklin's mythology and the convulsive, undulating Spanish Jugendstil. But only after the writings of Freud revealed to him the symbolic world of the unconscious as a buried reality, did he give full rein to his bent for dark inexplicable fantasy. In his enthusiasm for Freud, he came to regard the dark wonder world of dreams and hallucinations as the only subject matter worthy of artistic treatment, and set out to induce in himself, by every possible means, the delirious psychic states which would raise a mystery world to the surface and discredit the real world.

From this point of view, the rectangular canvas was merely a stage for his paranoiac dream. From Tanguy Dali took his setting – the infinitely vast landscape. This is the stage upon which his *dramatis personae* appear – the absurd products of a wild, erotically overheated fantasy. Starting with an absurd situation, actual or remembered, he sets up chains of association, and records the spontaneously emerging combinations of images with extreme realism. Dali feels that the three cardinal images of life are blood, decay, and excrement. The fantastic image-releasing activity of his unconscious searches the whole world of appearances for the threadbare spots where these images will shine through. In Dali's vast landscapes with their alarmingly abrupt perspectives, stand desolate monuments pieced together from decaying limbs, while grotesque 'humanoid' creatures brood suspended like balloons in the congealed air, solid things melt into soft masses, and the dials of watches droop like jellyfish.

These pictures have the terrifying quality of an impassive inhuman apparatus which ticks off the phenomena of the absurd; they suggest a cold intelligent curiosity that matter-of-factly registers and reproduces the images emerging from the darkest instinctual zones. What we call 'art' with its aesthetic values and the laws governing its formal elements is entirely irrelevant to this sort of painting. Painting is taken as an illustrative medium, and the artist's sole ambition is 'to materialise the images of concrete irrationality with the fury of extreme precision'. Dali deliberately continues the process of re-introducing anecdote into art, which the Dadaists – Duchamp, Picabia, Max Ernst – had begun before him. His paintings have descriptive aims, they are genre paintings of the absurd, 'hand-painted photographs'. Thus he was able in his surrealist films, *Un chien andalou* (1929) and *L'Age d'Or* (1931), to make the dissolution of visible reality fascinatingly and tormentingly plausible by substituting one thing for another or letting them merge.

This brings us to the deeper meaning of Dali's Verism. Its function is to decompose the world of real things completely; on the other hand, it seeks to represent the irrational world of dream and imagination with such extreme realism that its truth and reality can no longer be doubted. A destructive force gnaws at the images of the visible, corrodes the curtains of appearance, and calls into play another kind of illusion, which proves to be as stubborn and vital as the first. The two realms of appearance interpenetrate, one conjures up the other. The desired result is a chaotic tangle of images in which the outer and the inner are inseparably mixed but parade before our terrified minds in the guise of a fully existing reality. Again the jungle of nature opens before us. Instinctual forces are set free, evoking a previously unknown mythology which seems to point mysteriously to a hidden place in the Orphic depths of man, the meeting place of the forces underlying all life. This new mythology is essentially unstable, contradictory, and cryptic. It feeds on incompatibility and ambiguity. Dali's art provides us with the best examples: the ambiguous

pictures where one thing stands for another, where a face becomes a landscape and the landscape is again transformed into a human figure. The hidden appearance, revealed only to be hidden again, demonstrates its tormenting contradictions.

During the years preceding the Second World War Dali moved gradually closer to the Parisian neo-Romanticism exemplified by Christian Bérard, and in the course of extensive trips to Italy was also influenced by Raphael, Piero di Cosimo, and the Florentine Mannerists. This inspired him with a desire to become 'classical', as he said in a preface to a catalogue in 1941. But this meant no more than playing his old 'paranoiac game' with borrowed Raphaelesque forms and Renaissance themes – a Surrealism concerned no longer with life, but with history.

*Veristic and Absolute Surrealism*

Veristic Surrealism is an essential aspect of international Surrealism and is still active today. Reflecting the temperaments, personalities, and experiences of the artists practising it, the themes it treats extend from dreamy neo-Romantic idylls to enigmatic myths of constructed objects and dream figures. Dada and Pittura Metafisica provided the fundamental ideas and a great part of the pictorial vocabulary. The method has always been illustrative in the proper sense of the term: images of outer reality have served as illustrations of inner experience. The world of things seen in dreams was transposed into art. With their objective metaphors these painters illustrated a psychological atmosphere compatible with their conception and perception of reality. Individual variations set aside, the content is always the same: all of them aimed at discrediting and undermining the visible world, because all of them suffered from the wound inflicted on the modern mind by doubt about the concept of reality. This was the source of the themes of Veristic Surrealism – the definition of the dissonance, life as a network of demonic and uncontrolled instinctual forces. Veristic Surrealism has concentrated its major forces on illustrating the images flowing from this psychic injury.

To be sure, it also resorts to psychic automatism in order to release the tide of images surging from the unconscious. But its pictorial methods are less direct: it copies the images emerging in the mind, just as naturalism copied the images of outside nature. However, abstract painting and internal developments in Cubism had long cleared the way to a direct method. Both had sufficiently transformed the pictorial organism to make it capable of conveying the silent messages from the unconscious. The essential was to check the constructive tendencies of Cubism and the formal tendencies of abstract painting, and to charge these idioms with the poetic content of the images flowing from the unconscious. André Breton did indeed recognise Cubism and abstract painting as the most important precursors of Surrealist painting. The enrichment of Cubism with the new content – a problem which greatly preoccupied Picasso in those years – would provide a synthesis capable of absorbing the new elements without loss of the pictorial autonomy that was the most important conquest of Cubism. Through Cubist construction and the methods of abstract painting, the psychic automatism was able to achieve a more direct expression. Thus there emerged a new Surrealist current, rooted more in Cubism and abstract painting than in Dada and Pittura Metafisica. Inadequate as the name may be, we shall call it 'absolute Surrealism'. Picasso contributed essential elements. But within the Surrealist movement itself, it is represented by André Masson and Joan Miró.

274

*André Masson (b. 1896)*

In 1924 Masson, who had briefly attended art schools in Brussels and Paris and later studied on his own, exhibited a number of paintings and drawings at the Galerie Simon in Paris. They attracted the attention of the Surrealists who that year gathered around Breton to form a distinct group. He took part in the first Surrealist exhibition and his name occurs in the very first issue of *La Révolution Surréaliste*. He remained closely associated with the movement until 1928 when he left it after a quarrel with Breton.

The paintings he showed in 1924 – views of woods, graveyards, a tomb by the sea, etc. – seemed to follow the Cubist method. They were rigorously abstract constructions with firmly embodied representational references. But within and over the flat planes the curved outlines formed a mobile, sinuous arabesque which imparted an ecstatic motion to the whole composition – 'rage de mouvement'. The trance-like, mysterious curves communicated their desperate restlessness to the composition. What seemed to set these animated curves in motion was a dark, tormented emotion, a painful, unredeemed injury, a nocturnal obsession, the feeling that the world was suffering from a hidden wound. All this was expressed in dark, recurrent pictorial symbols – stone tombs, knives buried in flesh, ropes, etc. – images of an almost masochistic attitude towards life. These convulsive symbols emerging from the unconscious were what particularly attracted the Surrealists. Moreover, the Surrealist methods, taken from Dada and Pittura Metafisica, were here unexpectedly enlarged by a similar offshoot from Cubism.

In the two years that followed, Masson further consolidated his pictorial structure. He was influenced by Juan Gris with his rich, interlocking, loose, planar order and his 'synthetic' method of image finding. But Masson's forms remained splintered and restless, and his pictures are still eloquent of pain. An example is *A Bird Hit by Arrows*. The sign of a bird is formed by clashing diagonals; it soars up, and in its flight encounters the contrast of two sharp downward thrusting forms. As the painter worked with his coloured forms, a metaphor for his disquiet came to him. Painting becomes a method of searching for images that provide concrete symbols of psychic states. Masson's images always point to a theme of suffering reflecting his human outlook – 'la discorde', the world's open wound.

In 1926/27, influenced perhaps by the related explorations of his friend Joan Miró, Masson did a series of magnificent paintings in which the forms are almost exclusively produced by probing, wavy lineaments which wind their way through relief-like spots of colour. As in the cantilena of a long epic chant, whole stories take shape: fighting fishes or travelling knights with their heads between floating stars, gigantic figures often assuming a mythical stature – 'finds' released by an inner movement, which appear before us as the figurative symbols of a previously unknown, spontaneously emerging mythology.

This automatic writing in conjunction with a simplified basic structure distilled from Cubism leads to the series done shortly before and after 1930, which is the culminating point of Masson's art. Large abstract forms provide a thorough-bass over which the arabesque spins its melody. In perfect freedom the line, writing automatically, dances over the planes, in the course of its movement suddenly discovers analogies to objective reality, dwells for a moment on the recollection and then fixates it as a metaphor. Once again the metaphors of fighting fishes and wounded animals evoke the painful experience of a dissonant world.

From 1934 to 1936 Masson lived in Spain, where he painted a number of pictures relating to the life of the earth – harvest scenes, wheatfields, and figures suggestive of nature mythology. Here

he does not depict his direct observation, but his experience of nature's bounty. The experience suggested simple hieroglyphs which describe his psychic and visual adventures with the 'interior' of a wheatfield. In this way it became possible to see the field literally 'from the inside'; and one of these paintings is actually entitled *Interior of a Wheat Field*. But even here Masson does not forget the sorrowful drama of all life. Prickly thistles spring up, like demons armed with pincers, and the stalks of wheat begin to crack, bend, break; the whole composition trembles and only with great effort maintains a balance between peace and war.

His bent for dramatic subject matter led to an unexpected crisis after 1937. Masson suddenly began to produce paintings of a shrill verism – desolate, often perverse dream scenes, as though trying to find a direct and obscene outlet for an abstract fury. Masson had been greatly captivated by Spain, that blood-drenched land exalted by subterranean cruelties. It was also the land of Picasso, Miró and Dali. In his Spanish paintings Masson began to be influenced by the art of these modern Spaniards and to diverge from his own line. It was then that the Spanish Civil War broke out. European artists reacted violently to this open assault on human freedom. There are situations in which art ceases to be important and all that matters is to proclaim your feelings. When disgust leads a man to stop singing, he begins to curse. Masson's painting became vituperative, cruel, bloody. He fled from Spain. But free Spain had hardly been drowned in blood, when the German tyrant set the entire world on fire. When France fell, Masson escaped to America. In view of Masson's nature, all this may explain why, in striving to master this cruel world, he dropped the aesthetic elements of his art and began to illustrate his despair at the world's open wound directly, brutally, and realistically. In terms of the history of art, we may say that he took up the Verist Surrealism of Salvador Dali.

It was only in America, and in France during the years that followed – Masson returned to Paris in 1946 and soon moved to Aix – that Masson went back to his original style. The period of violent emotion had been marked by many advances. In particular the paintings done in America are more vigorous, more monumental, more dramatic, and display some of the sublime symbolic energy of ancient mythical art. More recently, Masson has been led by his experience of light to a style which comes closer to nature and owes many impulses to Turner and the late Monet. In 1953 Masson wrote: 'From the object which has now stopped oppressing me, there comes a tension that grows gradually more luminous and continues in all directions up to the edges of the pictorial surface. The lofty doctrine of Turner and the spiritual message of Zen painting have reached me.' The result is an almost Impressionistically fluid painting, conveying a tender, sensitive lyricism with its luminous veils of colour.

André Masson's art is the image of a tremendously restless nature, which expresses itself only when artistic passion reaches fever heat. His pictorial vocabulary is composed of extremely sensitive linear figures, which have the psychographic flexibility of Far Eastern ink drawings – long, dance-like, singing lines and short angular commas, set down by an automatically tracing hand, but arranged to form a coherent ornament. The themes 'found' by means of this writing are often wild and cruel, as though born of an abstract fury – a wounded man thrusting a knife into his eye, an infernal battle of animals and men, furiously dynamic scenes of erotic pursuit – a convulsed world full of catastrophes, marked with the cruelly bared wound of eternal dissonance. This world of Masson's emblems is the direct reflection of his inner world, the anatomy of his own universe. He tries frantically to grasp at something, but in the end he can never grasp anything but the reflection of himself.

In the history of modern painting Masson is important to the extent that he helped to prevent the

pictorial form developed by Cubism from becoming a prison, to cut it loose from the domain of the still life within which it had been elaborated, and to fill it with a new, humanly more meaningful content, 'the poetry of the heart' as he once wrote. This content he found in zones of the psyche where images are born, and he strove to combine the formal insights won by Cubism and abstract painting with the new Surrealist themes. In a more general sense, Masson stands in the same line of thinking as Paul Klee and Joan Miró, and faced the same problems. But here and there his inner instability clouded his perception of his goal.

*Joan Miró (b. 1893)*

Joan Miró's art is a direct expression of his wonderfully candid heart. Even in works disclosing the most intellectual subtleties, he preserves his childlike gaiety and primitive imagery. Because he is so deeply rooted in the Orphic depths, primeval memories such as those reflected in the magical cultures of Peru and Mexico, in the ritual sand paintings of the Indians, are alive in his work.

Miró is a Catalan, heir to an ancient race of expressive artists and full of the ecstatic fantasy of medieval Catalan painting. His studies at the Barcelona art school seemed at first to overlay his primeval sources. In 1917/18 he felt the influence of Fauvism, and then of Cubism. Early in 1919 he went to Paris where Picasso befriended him. Until 1925 he shuttled back and forth between Paris and his farm near Barcelona.

During those years, while he was cautiously assimilating Cubism, Miró laid the foundations of his personal art in a number of marvellous landscapes which show his native farm and its familiar surroundings in the glassy stillness of the southern mid-day light, in which all things acquire a magical sharpness. Miró renders these enchanting scenes with extraordinary delicacy; his concise, meticulously accurate script defines the linear structures of trees, plants, and animals. The subtly articulated filigree of the signs weave an ethereal rhythm over the entire composition; some of the summarily indicated plants or earth formations even constitute rhythmic sequences, so that the objects portrayed – flower beds, orchards, or cattle pens – derive a cheerful, childlike force from the repetition that so often accounts for the charm of lay painting. These are highly poetic images of the life of the earth. Without Romanticism or timidity, they are eloquent of the strange beauty of Miró's beloved earth, expressing a deep emotion which restores the simplicity of the viewer's heart. To this innocent vision the landscape recounts its legend; everything in it acquires a personality of its own and takes part in the story of life. The rhythmical filigree of a tree reaches gracefully upward, yearning for the warmth of the sun; the rich earth brings forth rustling plants and swarming insects, which take on fabulous, joyously eccentric forms. Every detail becomes the emanation of a strange and marvellous power which, remote as it may be from man, is always kindly.

Miró's poetic sense of nature, his delight in the bright playfulness of her inventions, led to a decisive change in his art, which took place in 1923/24. Too lyrical to find full expression for his emotion in the existing, ready-made forms of nature, too richly imaginative to resist the temptations of poetic association, Miró moved away from natural appearance, eagerly pursuing the fables that the deeply loved familiar things whispered to him. To render these things he invented new emblems of a loving, playful humour. *The Tilled Field* (1923/24) marks the transition to the new manner. The theme is still rustic, and the delicately drawn objects still paraphrase the familiar images of nature. But the poetry of things now stirs his fancy to free fabulation. A gigantic ear protrudes

277

from the trunk of a great prickly tree and listens diffidently to the restless life around it. Other personified trees – suggesting a cross between a cactus and a trigonometric scaffolding – stand there with flapping arms or rigidly erect with serrated aloe leaves. A horse drawn in curlicues rattles off a dance in the midst of its tree companions doomed to immobility. Under the big tree the lower animals scramble and squirm busily about; a rooster, a snail, and a dachshund admire each other's buffoonish figures. All this adds up to a loving burlesque of animated rustic nature. A new vocabulary is required to picture this poem of nature: the representational elements must be transformed into emphatic type-signs, precise emblems. The proud presence of a mighty aloe plant conjures up the image of a signal mast with a large triangular sign as its head, and to flatter its pride, it is decorated with flags. The transparency of the air releases daintily floating forms which stress the luminous lightness of the atmosphere. Miró was to retain the basic lyrical mood of a man in brotherly communion with the earth, the firmament, and all living creatures. But as he let himself be guided more and more by Orphic inspiration, his painting took on the character of a free script with which he recorded the fantasies of his heart in a largely abstract style.

Miró began to develop this script in 1924. His line becomes wholly free, no longer checked by recollections of natural forms. He allows it to find forms of its own accord – geometrical frames, figurines, abstract creatures of an amazing vitality. Each of these beings produced by his inexhaustible fantasy possesses its own active personality, and down to the last fibre of its form acts out the role assigned it in the artist's fabulation. The result is a wonderfully playful world revealing the poet's delight in narrating. The poetic first cause is always discernibly a childlike, marvelling insight into the secret mythology of nature. Miró's pictures now begin to look like writing tablets covered by a naïvely meticulous pictorial script. Space is reduced to a single, but very transparent and very spacious ground. On this tablet, a poetic record of the artist's deep experience of the world seems to inscribe itself.

This change in Miró's art was furthered by his encounter with the works of certain artists and the ideas of Surrealism. From Kandinsky's abstract style and the suggestive power of his abstract signs, Miró derived many lessons of a general nature. In 1924 he saw works by Jean Arp, from whom he learned to accept and develop accidental finds. A short time later he saw paintings by Paul Klee. It was particularly Klee's sensitively playful world with the deep meanings it concealed that confirmed Miró on his path.

All these impulses were strengthened by the aesthetics of Surrealism. André Masson, who had become Miró's friend in 1924, introduced him to the Surrealist group. Veristic Surrealism with its substitutions and its method of piecing together fragments of reality, with its spirit of irony and contradiction did not attract Miró. What did attract him was the Surrealists' determination to make visible the treasury of images stored in the unconscious, to embody profound psychic experience in painting, their recognition of the poetic dream and its hermetic metaphors. Surrealism provided theoretical justification for automatic writing, reliance on spontaneity, the provocation of the accidental. It was Miró's Cubist background that kept him, like Masson, from adopting the illustrative method of Verist Surrealism. His intention was to go beyond the Cubist conception of plastic bodies and to achieve once again 'the poetry of the heart', or, as he himself put it, 'dépasser la plastique cubiste pour atteindre la poésie'.

In 1928 Miró was led back to Cubist discipline – by way of Vermeer whose cool precise organisation of space he had admired in the course of a visit to Holland. It was then that he painted the series of his 'Dutch Interiors' which disclose, with unexpected sharpness, his return to the Cubist construction of space. In representational terms we should describe them as still lifes, but here again

objects are endowed with a fantastic personality and animation: we see a guitar hopping about in the embrace of a comical figure which only a moment ago was a tablecloth. The other inanimate things join in the dance. Light abstract forms trace the choreography or beat out the time. They, too, act like living persons and are quite capable of engendering bird-like or fish-like creatures, while conversely a melancholy reclining dog in the midst of the dancers is drawn with a daintiness that gives him a hugely comical fairy-tale quality. The bare construction of space sets off the grotesque, imaginative fable by contrast. There is no better example than these Dutch Interiors to show how Miró went 'beyond Cubist plasticity to attain to poetry'.

This was only a passing episode. After a time his forms grew larger and more lapidary, taking on a simpler, emblematic character. Once again the planes in depth were reduced to a single flat ground, which suggests space by its deep, mysterious colours. Now black plays an important part in the definition of forms, introducing a note of gravity. A slightly spooky quality enters into the burlesque. The mythical strain, always present in Miró, stands out more clearly: supernatural beings quite at home in unfamiliar atmospheres, fabulous animals, signs of celestial bodies, are the actors that emerge from the 'other' world of the coloured grounds. The dreaming fantasy, listening to the murmurs of the unconscious, spins a wonderfully sensitive line, as though putting forth feelers, following the automatic movement of the hand that gropes its way forward, recognises a figuration in sudden amazement, and, guided by association, defines it more exactly. As in Klee, forms are spontaneously 'found' and gain the character of the 'marvellous'.

Between 1929 and 1931 Miró's forms were largely abstract, and he seemed to be moving towards purely non-objective painting of the kind championed by the Abstraction-Création group (founded in the early thirties). He was asked to join the group but declined on the ground that he was pursuing different aims. In giving pictorial expression to the complex creatures of his imagination he was unwilling to dispense with the suggestive power of figures and representational signs.

In 1931/32 Miró developed the style which, with slight modifications, sums up his whole previous experience and has characterised his art ever since. It is a style of psychic improvisation with a certain affinity to Klee, but more monumental. On sonorous, intensely coloured grounds Miró inscribes large emblematic forms, whose supple contours are often remotely reminiscent of Jean Arp. Sensitive, precise outlines traced with supreme skill define the forms. These are always figurative in character – fantastic beings and magical shapes resulting from amazing metamorphoses of human, animal, and vegetable elements. In contrast to the burlesque playfulness of the earlier works, this style is dramatic, expressive of many anxieties. Although Miró was able, in spite of his highly trained sensibility, to achieve the spontaneous naïveté of children and primitives, his creative experience of the world testifies to a mature outlook. At the core of it there is always a poetic vision of nature, a wholehearted participation in all the aspects of life – the joyful, the Dionysian, but also the horrifying. In a figurative hieroglyphic script recalling primitive cultures, the artist transposes his feeling and experience into mythical tales.

It is a pictorial script capable of communicating an experience that leaves traces in the unconscious. Its communications are not always pleasant. Severe human tensions, merciless instinctual drives, the fragility of our existence, our revulsion at the cruelty of nature – all these called for expression. As early as 1932/33 prickly, slimy, bristling, loathsomely obscene forms – the repulsive, offensive, infuriating, sinister things which the surrealists call 'objets désagréables,' occur frequently in Miró's paintings. Man in his function as zoon politikon provided sufficient horrors. Spain was soon to be full of them. The Surrealists must be given credit for having been almost the only group who in their artistic expression held up a mirror to the baseness of the political and social world.

Masson, Dali, Max Ernst were aware of the terrible dissonance and expressed it in metaphorical images. Late in 1936 Miró fled from the Civil War to Paris. In 1940 the Second World War drove him back to Spain. During this period gruesome, monstrous creatures entered his mythical world. Not until 1942 – in the peace of his farm near Barcelona – did these references to the epoch gradually recede. The mythology of nature reappeared – stars, nights, and the secret beings which, in Miró's poetic world, dwell between the stars and the night.

From his early poetic and humorous visions of nature, Miró, playfully yet profoundly exploring the dangerous, the mysterious, and the absurd, developed a spontaneous pictorial script which enables him to record his poetic experiences and psychic states with the utmost precision. In this he is comparable to Klee, who beyond a doubt played an important part in Miró's development. However, not only did Miró paint gigantic works (while Klee limited himself to small formats); but moreover he achieved a monumental form and expressed meanings far removed from Klee's Romantic lyricism. In his works, whole strata of archaic human experiences and symbols long buried in forgotten zones come to the surface. His art as a whole burns with an intensely sensuous power. Absolute Surrealism, and particularly Miró's art, point the way which is most likely to lead to the point where the inner and the outer coincide and which Breton described as the true and ultimate goal of Surrealism. In actually communicating the deepest psychic experiences, Miró's pictorial handwriting, sustained by the abstract formal idiom, penetrates to the 'Orphic' point where our grasp of the world and our position in it can be fundamentally defined. Painting is not merely an 'art', it is also a *méthode de la recherche*, and as such it helps to illumine the original obscurity in which the world lies concealed from us.

## The Great Style of Pablo Picasso

All the impulses and counter-impulses which kept painting in motion in the two decades between the wars are mirrored in Picasso's art. He, more than anyone, is the man whose painting reflects all the yearning of the modern mind. The greatness of his genius is measured by the fact that he absorbed the human experience of an entire epoch, its certainties as well as its anxieties. He believed that art is valid only to the extent that it reflects our entire human experience and our existence in the world. Picasso has said this repeatedly and as clearly as possible: 'No, painting is not made to decorate apartments. It is a weapon of attack and defence against the enemy' (1945). 'Of course you can paint pictures by assembling parts that will be perfectly matched, but such paintings will exclude any kind of drama' (1945). 'What matters is not what the artist does, but what he is. Cézanne would not have interested me in the least if he had lived and thought like Jacques Emile Blanche, even had the apples he painted been ten times as beautiful. What is of interest to us is Cézanne's restless striving – that is what he teaches us; what is of interest to us in Van Gogh is his emotion and his torment – there you have the human drama!' (1935).

This accounts for the versatility of his art and the multiple paths along which his pictorial thinking moves during those two decades. To explore in all directions the whole area between the sensory and spiritual experience was the artistic objective of the epoch as a whole. On one point only was there general agreement and certainty: namely, that a purely descriptive, naturalistic art could not do justice to the modern experience of the world. But how the longed-for 'spiritualisation' of art could be achieved, to what extent the artist should move away from the natural image, the relation between experience of things and experience of the absolute – all these questions

were answered by the individual artist in accordance with his personal beliefs. Picasso took this gigantic conflict upon himself, and within him it has never ceased to be a conflict. The issues remained open; he has never accepted a unilateral solution without at the same time discerning the possibility of an opposite solution. He has never glossed over contradictions and he has never been a conformist. It was this tremendous conflict that provided the dramatic theme of his art, the source of his images and emblems.

We left Picasso towards 1914, at the point when he had raised Cubism to its richest pictorial and decorative development. But then his restless spirit drove him away from the realm he had mastered. One side of his being urged him to move closer to the visible world. In 1915, while continuing to produce Cubist paintings, he began to make naturalistic brush drawings, quite reminiscent of Ingres both in line and in conception. In the years that followed he kept on in this direction; employing a classical continuous line, he painted not only portraits and still lifes but also classical figure compositions, which clearly disclose echoes of Pompeii, Roman art, and Raphael. This was Picasso's first response to the state of mind which at about the same time led the metaphysical painters to contemplate and question the classics. In the spring of 1917 he went to Rome to design the sets for Cocteau's ballet *Parade,* and remained there for several weeks. He took a lively interest in the staging of the ballet, and seems to have breathed his spirit into the whole performance. He set up three gigantic Cubist montages, the 'Managers'. The appearance of these inhuman automatons on the stage transported the living dancers into an unreal and absurd atmosphere. The result was a strange mixture of reality and unreality, a peculiar confusion between realism and abstract fantasy, which Apollinaire in the preface to the programme termed '*sur-réalisme*'. Picasso's 'Managers' are clearly related in conception to the *manichini* of Pittura Metafisica, which made their appearance at about the same time. This combination of playful realism and absurdity, intended to produce a shock, reveals the same spirit that gave rise to Dada. Picasso also designed the backcloth in which we find the childishly descriptive, realistic elements characteristic of lay painting. One cannot speak of direct influence; Picasso simply responded to stimuli that were making themselves felt among the most diverse personalities all over Europe.

The same is true of the experience of the absolute. Picasso carried on his investigations in the same direction and at the same time as Juan Gris, Piet Mondrian, and the Purists. He flattened the space in his Cubist paintings, his forms became sparse and geometrical. The Cubist paintings done from 1918 and 1920 are his contribution to purely geometrical abstract art, the 'absolute form' that preoccupied so many artists in those years.

It would be a mistake to interpret the variety and supposed contradictions in Picasso as manifestations of a split personality, virtuosity, or charlatanism. Picasso as an individual was steeped in the forces that were to mould the great style to come and faced up to the tensions between them. He defined in his own way the magical-ironical experience of the world of things communicated by Pittura Metafisica and Dada; he reacted in his own personal way to the new, classicist idealism which led to the archaic realism of *Valori Plastici;* he himself tried out the experiments with absolute form, which culminated in the Stijl aesthetics. In short, he combined a wide range of artistic responses to the tensions inherent in the epoch.

In the early twenties Picasso developed two antithetical styles. On the one hand he disciplined and monumentalised the classical, realistic tendency. He painted classical themes and immense sculptural figures presenting frequent reminiscences of Roman statues. This new classicism is characterised by archaic space-creating volumes. It might be interpreted as an expression of the

desire, general in those years, to reconstruct outward reality with the help of classical art. It must be remembered, however, that the new view of antiquity was fraught with anguish and irony. The mysterious statues, the 'trophies' of the Metaphysical painters had disclosed this 'disquieting antiquity' – a vastly important phenomenon in the history of the survival and interpretation of classical antiquity and one that has also exerted a profound influence on modern literature. This anguished interpretation of antiquity is clearly a component of Picasso's neo-classicism. On this basis we may interpret certain curious elements in his classical paintings as an ironic mannerism: the figures are often grotesquely elongated in the style of the sixteenth century mannerists, the limbs monstrously thick, and the grotesqueness is further enhanced by absurd foreshortenings. This is a classicism expressive of dream and longing, but without faith, which tries to hide its anguish in irony.

Parallel to this neo-classicism, Picasso produced a series of Cubist paintings, brilliantly austere still lifes and figures of harlequins – the most magnificent of the series are the two versions of the *Three Musicians* (1921). The composition is classically severe. The pictorial space is clear and simple, like a theatrical stage. The forms are large, almost solemn. They are almost exclusively geometrical forms, and they are pieced together in the 'synthetic' manner to suggest representational elements. Picasso plays the whole keyboard of Cubist inventions, down to the *trompe-l'oeil* effects. This is Picasso's most consummate period; and yet the content and mood point to a deep change in his personality. To be sure, the *Three Musicians* has all the features of a musical ornament; but the choreographic rhythms it has captured seem peculiarly melancholy against the dark stony background. The players – Harlequin, Pierrot, and a monk – are seated with their backs to the void. The corbel communicates a classical quality to the background forms and defines the mood with great precision; uneasiness, emptiness against the stony ground of unfathomable history. It is a work full of grave meaning, full of the sadness that has never left Picasso.

The early twenties were marked by a profound change in the outlook of modern man, a general tendency towards restlessness and anxiety. In those years philosophy and theology developed the ideas which gave rise to the existentialist philosophy of freedom and anguish. In 1925 André Breton declared that the distinguishing features of the modern mind were its 'restlessness' and 'convulsiveness' and demanded in his Surrealist Manifesto that these should be taken into account. This shift in the psychological structure of modern man was inevitably reflected in the domain of art. Towards 1925 Picasso's style underwent a radical change. His paintings acquired a new dramatic expressiveness, a violent, turbulent, convulsive quality which brought him close to Surrealism. The human drama required the strongest expression, which could no longer exclude the horrible and the monstrous.

The turning point is marked by the *Three Dancers* of 1925. The serenely beautiful décor of the Cubist paintings has suddenly vanished. The mood has become ecstatic and hysterical. The choreographic figure traced by the three dancers is not in the least eurhythmic, but suggests, rather, a dance of flagellants, punctuated by the blows of a whip. Associations are handled in a new way – invariably they point to pain, torment. A mask-like grimace pervades the whole composition, the clash of serrated and pointed forms produces an effect of shrillness. The absurd is called into play by ambivalent elements: a shadow becomes a classical profile, a spectral moon-face emerges from the flowing hair of one of the dancers. Picasso eagerly follows every association suggested by a form or an object. The method is that of automatic writing. The whole is Picasso's reaction to the situation noted by the Surrealists. The human drama in its extreme situations is reflected in the release of form from its usual ties. Divorced from the beautiful, it becomes '*forme désagréable*'.

The idea underlying this type of painting is unmistakable: the more offensive and monstrous the form, the greater becomes its dramatic impact, the more powerfully it assails the viewer. The repulsive with its shock action breaks through the barrier which beauty sets up round the human drama. Where the drama strives for expression, 'the loathsome form' has legitimate uses. It had been doomed to silence by the Apollonian pose of a culture moulded by classical Greece. But in epochs bent upon expression, it has often risen to the surface. Whenever the Orphic element asserts itself against the Apollonian element, the expressive impact of ugliness is recognised as a legitimate artistic form. Thus not only Picasso but the whole Surrealist movement tried to define certain emotional states by means of 'abominable forms'. The Surrealist *objet désagréable* or *objet à jeter* (object to be thrown away) is an experimental form of this expressive effort. Its purpose is to define the dark states in man by the expressive power of the repulsive.

In the summer of 1927, which Picasso spent at Cannes, he began to imagine such objects in the three-dimensional medium. They were grotesque deformations of bathing women. His experiments culminated in a series of projects for sculptural monuments – fetish figures composed of sticks and bone-shaped forms. By investigating the grotesque and repulsive potentialities of form Picasso succeeded in lending his strange '*personnages*' a fantastic mimicry. Like the Dadaists and the Metaphysical painters before him, Picasso arrived at a strange mythology of fetishistic sculptural forms.

The same year this disquieting mythology made its appearance in figure paintings. One of these is the *Seated Woman* of 1927. The austere emblem has a hieratic magical expressiveness. The painting is comparable to an icon, in which an emblematic sign permanently records a certain conception of life and existential expression. The stage-like pictorial space is almost classical. The hieratic figure whose distorted features enhance the dramatic effect, is shown in the pose of an exotic, magical idol against the concave form of its niche-like space. The painting carries the universal, sublime connotation of the word 'imago'. Picasso now enters the world of pictorial emblems and invents a pictorial script suitable for his dramatic purposes, similar to those devised by Miró and Klee in those years. His new preoccupation was the invention of '*imagines*' to express psychic states.

He does not eliminate the representational element, but merely transposes it into the emblematic dimension. The representational form, like all forms, takes on a psychic animation. A pitcher, an apple, and a fruit bowl can enact a real drama. Translated into an animated arabesque, inanimate nature provides the written characters for an unusual drama. The drama that interests Picasso arises from the tension between the self and the 'otherness' of objects and can be made intelligible only by representational analogies. This is the basic reason why he kept clear of abstract painting and why he said in 1935: 'Abstract art is nothing but painting. But what happens to the drama? There is no abstract art. One must always begin with something. Then all traces of reality can be removed. There is no danger then, because the idea of the object has left an indelible mark. It is this idea that stimulates the artist, inspires his ideas, arouses his emotions. Ideas and emotions are definitively captured in his work; they cannot be divorced from his painting.' Thus the artist's mirror is always turned to life and the world and reflects the emotions they arouse in him. He projects it back as a true reflected image, which is composed of both object and mirror, an image that reflects the variability of the relationship between the self and the world, and that records this relationship in the permanent visual form of an emblem. He projects it back as an imago!

This type of emblematic art found its most magnificent realisation in Picasso's *Guernica*. *Guernica*

is a topical painting, but by transposing the event it depicts into emblems and symbols, it raises

it to the realm of universal legend. On April 26, 1937 the Basque town of Guernica was raided by the bombers of the German Condor Legion, which was under the orders of the rebel general Franco. The news reached Picasso when he was planning a large mural commissioned by the Spanish democratic government for the Spanish pavilion at the Paris World Fair. It was this commission and the indignation aroused throughout the democratic world by Franco's brutal act that gave rise to *Guernica*. This gigantic mural (11 ft. 6 ins. × 25 ft. 8 ins.) is in the truest sense the picture of an event.

Picasso heard the shocking news just as his art had developed to the point where he could deal with a theme of this kind. Since 1934 his paintings had been growing steadily more expressive. His curving arabesques had been broken up into pointed angular forms that produced the most powerful dramatic effects. His subject had often been the drama of destruction, rendered in symbols derived from the bullfight, in scenes revolving about horses and bulls.

It is these ancient animal symbols of Spain that provide the allegorical forms for *Guernica*. At the centre of the equilateral triangle built into the composition – it suggests the pediment of a temple – we see a disembowelled horse, its mouth gaping wide, a hieroglyph of strident pain. On the extreme left, the bull stands motionless, the new conqueror in the sinister immobility of his pride. In between are symbols of human suffering: summarily drawn human figures fleeing in panic, screaming, a falling woman, and the body of a dead warrior torn to shreds. At the top a woman races into the picture like a cry, convulsed with astonishment and horror. She holds a lamp that illumines the scene. The unrealistic, convulsive character of the setting is emphasised by the structure of the pictorial space, which suggests at once an interior and an outdoor view. A splintered light moves over the composition which is painted austerely in black, white and grey. These decipherable signs constitute a metaphor of the world drama which began with the bombing of Guernica, a symbolic, impersonal, universal legend of the terrible human predicament. The sudden horror experienced by the artist concentrated his inventory of images, which had been filled with symbols derived from the bullfight, into an imago of terror, in which form and content are expressively united. For this is not a symbolic portrayal of an event, but a pictorial legend based on it, a visual imago which discloses in a coherent vision the whole landscape of terror that the news of the bombing opened up in the artist's mind. To this extent the painting is 'topical'. But it raises the single event to the universal, symbol-charged plane of legends and signs. By means of pictorial signs the event has been made mythical.

This transformation of personal emotions into pictorial signs, and of form into myth now became Picasso's self-chosen task. Everything he has done since *Guernica* reflects this desire to transform what he has seen and experienced into a visual imago. His subjects may be elegiac or bucolic, as in his lithographs of the post-war years; they may be scenes observed accidentally, and endowed with a legendary aura as in the case of his views of Paris in 1945; they may even be topical and political allegories as in his *Massacre in Korea* or *War and Peace* (1953). But in every case Picasso aimed at concentrating a deeply felt experience in a visual sign, through which the fortuitous inspiration was raised to the realm of the legendary.

Thus Picasso became the great image-creator of the last three decades, as Munch had been at the turn the century. The pictorial script he invented did two things: it recorded the emotion aroused by the outside world and it communicated the profound Orphic insights of the innermost psyche. Through Picasso modern art found a way to express the simultaneity of the inner and outward worlds. But Picasso was not alone – Beckmann and Kirchner worked in the same direction. And in the same period, Paul Klee, in his own lyrical, romantic way, developed the imago, which he

too conceived as part of a more comprehensive pictorial script. What distinguishes Picasso is the directness of his experience. Paradoxical as it may seem, it is his Mediterranean realism, the dramatic spontaneity of his responses to the realities of contemporary life, that enabled him to paint the legend of our existence in the here and now – the drama of contemporary man. The name of Picasso does not stand merely for painting, it stands for the epoch and its many images of itself.

## Abstraction-Création

It might seem as though the new interest in visible reality and the determination to distil an emblematic script from representational signs had diverted the Paris School from abstract exploration, as though Picasso's verdict had been more than the expression of a purely personal point of view. To be sure, Jean Arp and Joan Miró painted free abstract forms suggestive of a psychic flora, but since these forms were closely related to those 'discovered' by automatic writing, one might regard them as a special type of Surrealist art. Mondrian, on the outer fringes of the Paris School, was almost unnoticed; Kandinsky was for the present unknown; and even Delaunay, the first French master to arrive at abstract art, went back to a more representational painting. The same is true of all the Orphists who had occasionally come into contact with abstraction, from Villon through Gleizes to Herbin. The fact is that the creative forces of abstract painting were outside the Latin countries – in Holland, Russia and Germany.

The psychological influence of Paris had a good deal to do with this. Paris was beyond doubt the capital of painting and sculpture, but it made no new contribution to architecture. No buildings reflecting the spirit of modern technology were erected; the idea of the modern metropolis was felt in Paris only on the aesthetic level. The new abstract art – the Constructivism of the Russians, the Neo-plasticism of the Dutch, and the synthesis of the two achieved in the Bauhaus – was inspired by a very different, revolutionary, ideology, which made a frontal assault on the romantic concept of 'art' and aspired to inject art into the very centre of contemporary life. According to this ideology, a picture is merely a product of contemplation on the forces whose practical embodiment is technology. In close co-operation with architecture and engineering, art should endeavour to give form to life itself. Thus the distinction between 'pure art' and 'applied art' became meaningless. Industrial design, architecture, interior decoration, advertising – these were included in the tasks of the new art; they provided new sources of inspiration as well as new materials – steel, aluminum, glass, synthetic materials, etc. Montage became more important than painting. To all this Paris, the ancient city which stubbornly resisted even the most timid attempts at modern architecture, was certainly ill suited. In the artistic climate of Paris, which had been shaped by Impressionism, abstract painting with its machine-like impersonal script and new materials was inevitably regarded as sheer anti-art.

Thus we should have been justified in disregarding abstract painting in Paris between 1920 and 1940, if the seeds planted there in those years had not borne rich fruit after the Second World War. For, needless to say, the new ideas found their way into the international milieu of Paris and even seemed to gain strength in the thirties. In 1924 Van Doesburg put on an exhibition providing welcome illustrations of the theoretical articles that he and Mondrian had published in *De Stijl*. In 1929, the Galerie Zak held the first one-man show of Kandinsky. In 1930 Van Doesburg launched the magazine *Art Concret* and in the same year the Galerie 23 held an international

exhibition of abstract art. In the years that followed, the unfavourable political conditions in Germany drove many modern artists to emigrate. In 1932 Naum Gabo moved from Berlin to Paris, rejoining his brother Antoine Pevsner with whom he had collaborated in 1927 on the much noted Constructivist settings for Diaghilev's ballet *La Chatte*. The abstract artists living in Paris gathered round them and on February 15, 1931 founded the Abstraction-Création group. In 1933 Kandinsky also settled in Paris. He and Piet Mondrian, with whom he was on the best of terms, were now among the pillars of the abstract school in Paris. With the collapse of art in Germany in 1933, Paris became the haven and home of abstract art. Abstraction-Création which at times numbered up to 400 members, published a yearly almanac and organised frequent exhibitions. It served as an organisational centre for abstract painters and enabled them to exert a certain influence.

It also served as a reservoir which gathered together the various currents of abstract painting – Kandinsky's Abstract Expressionism, the absolute painting of the Stijl group, the biomorphic concretisations of Arp and his Surrealist followers, the romantic Constructivism of the Russians. All these tendencies interacted, learned from one another, and moved closer to one another, giving rise to a style in which the mysticism and Romanticism of the East were united with the Cartesian spirit of the West to form a harmonious whole.

The various currents had gradually abandoned their extreme positions. Under the influence of Russian Constructivism Kandinsky had disciplined the Abstract Expressionism of his earlier years; he had thoroughly studied the 'harmonic' ideas of De Stijl and with their help developed the majestic art of his late Paris period. The Russians – Gabo, Pevsner, and El Lissitsky – had subjected their initial anarchism to an arithmetical discipline. Through the versatile Moholy-Nagy new contacts were established with the technological world and its forms. On the other hand, the Stijl artists, guardians of the severest and purest form, had gradually, under the influence of Constructivism and of Jean Arp, relaxed their ascetic system based on strict horizontals and verticals. After the death of Van Doesburg in 1931, the younger artists who succeeded him as leaders of Stijl quickly moved closer to international Constructivism, within which they formed what might be called an 'absolute' wing.

A few of the Abstraction-Création artists achieved prominence at this time. Del Marle (b. 1889) joined the Stijl movement in 1922. Later, influenced by the three-dimensional constructions of the Russians, he applied Mondrian's harmonic theories to plastic construction and his work gradually took on the character of Constructivist decoration. In 1928 César Domela (b. 1900), who joined the Stijl group in 1925, created relief paintings with various materials in the style of Van Doesburg's elementarism; strongly influenced by Jean Arp, he gradually drifted into a pretentious Jugendstil décor.

The purest representative of the Stijl discipline in this period was the German artist Vordemberge-Gildewart (b. 1899). In 1919, as a student of the technical college in Hanover, he began to work towards an art based on a small number of primary elements. Always aiming at extreme purity, he experimented with and developed the ideas of Russian Suprematism. This soon brought him close to El Lissitsky and in 1924 led him to the Stijl group, although he did not completely fall under the spell of Mondrian's rigorous form. By adopting Van Doesburg's elementarism, Vordemberge-Gildewart went back to his own point of departure. A member of the Abstraction-Création group since its foundation, he developed a style of his own, characterised by purity and clarity. He dropped the grid lines and formed sensitively balanced ensembles with simple geometrical forms and lines on grounds of brilliant, sonorous colour. Free from rhetoric and subtly lyrical, these

compositions preserve the original purity, austere beauty, and formal harmony which were the contribution of the Stijl aesthetics to modern sensibility.

It should be noted that none of the artists mentioned thus far is a native Frenchman. As we have seen, the abstract school of Paris was distinctly international in character. Even so, it is surprising to see how few Latin artists it included. Indeed, there were only two Frenchmen – Auguste Herbin and Jean Hélion. From 1917 to 1921 Auguste Herbin (b. 1882) experimented with geometric forms based on Orphic Cubism. Then he took up representational painting, but in 1926 went back to abstraction. His works took on a Constructivist character: he arranged geometrical forms – triangles, circles, circular segments, and rectangular figures – into regular patterns whose sonorous colours evoked magical or symbolic meanings. After 1931 Jean Hélion, who at first wavered between Cubism and De Stijl, painted a number of superior abstract works – ponderous, robustly modelled, almost machine-like forms arranged rhythmically on grounds suggesting depth. Later he shifted to Surrealism and an unpleasant mannered realism.

The most important contribution was that of the Florentine artist Alberto Magnelli (b. 1888). In 1913 he joined the Cubist movement in Paris. Returning to Florence in 1915, he developed a strangely ponderous abstract style which he soon abandoned. From then until 1933 he painted landscapes in which the representational elements were reduced to large forms. In 1933 he was back in Paris, and in 1936 he began the magnificent series of abstract paintings that has been in progress up to this day. He has retained the geometrical forms of the Constructivists, but his massive constellations of forms are endowed with a solemn dignity. His art breathes the spirit of archaic Italy and its muralists. The form is ponderous and solemn, the colours restrained and sonorous, each form possesses its own weight. In the dialogues between the forms and in the overall rhythm the painter's human outlook achieves clear expression. The rich human experience embodied in his work has given Magnelli a prominent position in the realm of modern art.

Thus we note that the various abstract schools merged during the thirties in Paris. The originally rigorous positions of abstract painting were gradually relaxed and broadened. The constructive element was still preponderant, but new contents tend to be included everywhere. The manipulation of new materials seems to have become increasingly important, but even in this domain expression tended to eclipse the functional and utilitarian. The climate of Paris seems to have favoured human and artistic considerations. This school cannot be said to have contributed essentially new insights or amazing new qualities. But it presided over a slow organic development. The panorama grew broader, a new growth developed in the field staked out in the preceding decade. Surrealist currents, including the secret but persistent influence of Jean Arp, relaxed the Constructivist rigour. And the entire picture is dominated by the serene majesty of Kandinsky's late style. Thus in a decade of largely anonymous endeavour the ground was prepared for the new flowering of painting in our own day.

## The Situation in England

In the period between the two wars, English art largely followed the stylistic trends that were at work on the continent, though somewhat less emphatically, in the sense that no large group movements arose in this period.

When such painters as Nevinson, Lewis and Paul Nash came home from the war, it seemed for a time as though they would carry on from the revolutionary positions already attained. In 1918

Nevinson showed his Futurist war pictures which, with their simultaneous overlap, convincingly expressed the dynamism of technological war. He had already drawn into his art the new optical sensations connected with aerial warfare and may thus be regarded as one of the founders of the 'aeropittura' that provided the second wave of Italian Futurists with one of their favourite themes. His paintings were well received by the public; they were widely shown and reproduced in specialised publications. If despite this reception Futurism had no further consequences in England, it was because of a change of spirit among the artists themselves. All over Europe the need was felt for a new confrontation with nature, reflected in such slogans as 'Back to nature'. Nevinson did not escape this general trend. Soon after 1920 he went 'back to nature' and began to paint in a hard, precise, descriptive style which may be regarded as an English parallel to the endeavours of the Neue Sachlichkeit.

At first Wyndham Lewis thought he would be able to develop his Vorticist ideas. He even tried to reassemble his old phalanx and founded a new circle, 'Group X', which put on an exhibition at the Mansard Gallery in March 1920 but soon collapsed. In 1921 he brought out a magazine, *The Tyro*, which survived for only two numbers. In it he proclaimed the ideas of abstract art in his usual belligerent tone. As the illustrations show, he still had in mind the 'mechanical' geometrical abstractions of Vorticism. But by 1922 he too shifted to an expressive realism, in which he tried to combine Expressionist distortions and abstract geometrical detail in a kind of Neue Sachlichkeit. He wrote vast quantities of fiction and criticism and in 1927 founded *The Enemy*, a magazine devoted largely to the problems of art, which he wrote almost single-handed. He alone in the England of the twenties tried to maintain the polemical effervescence that had been so fruitful in the years before the war. Though he flailed about him in all directions and did not spare even the artistic trends he had formerly defended, his writings of this period often show a kind of nostalgia for the bold clear thinking which in earlier years had produced the freedom and freshness of Cubism and abstract painting. In the early thirties, when it seemed as though these ideas might regain their former appeal, Lewis was prepared and even in his painting found his way back to his abstract and Cubo-Futurist ideas. He is a typical case of the modern painter whose intelligence is greater than his creative power and who is confused by his own militancy and critical propensities.

Try as he might to stir up excitement in London art circles, their inertia was well-nigh insuperable. Meanwhile the London Group, which had formed in 1913, suffered the same fate as the New English Art Club before it; it became 'official', cultivating a moderate modernism half-way between Cézanne and a cautious Expressionism. It eagerly welcomed the idea of a 'return to nature'. The result was a poetic, interpretative Expressionism characterised by a vigorous, naïve delight in brushwork. Even the elderly Sickert, like Corinth or Slevogt in Germany, was caught up in this moderate Expressionist current.

In this subdued atmosphere a few individuals distinguished themselves by the boldness of their colour and the personal content of their work. There was Matthew Smith. In 1910 he had studied with Matisse in Paris and in 1920, on his return from the war, had joined the London Group, which regularly showed his pictures though he lived chiefly in Paris from 1920 to 1926. He attracted attention by his bold colour, for his starting point had been Matisse's most flamboyant Fauvism, that of 1905-06. In the excitement of the first post-war years, Smith had given an Expressionist wildness to Matisse's bright and sharp, but also cool and controlled colour décor. Then as the twenties wore on, he gradually abandoned this bold style in favour of a highly coloured expressive Impressionism.

288

John Piper and David Bomberg also belong to this Expressionist movement. Bomberg's Jewish feeling gave his work an ecstatic note that was the exception in the London Group to which he had belonged since 1913. Expressionist methods enabled him to give his motifs a visionary quality. As a young painter before the war, he had learned a good deal from Fauvism and Cubism, and had belonged for a time to Lewis's circle. But now, setting formal problems aside, he began to question the visible world for the poetic legend it concealed. Here again we find the 'Hassidic' mood we have noted in the Jewish painters of the Paris school. In 1923 Bomberg went to Palestine and returned with ecstatically Expressionist landscapes that introduced a new note into English painting. His art can most readily be compared with that of Soutine whom he resembled in temperament. In the course of the thirties – in 1935 he returned to London for good after long travels in Palestine, Spain, Greece, and Morocco – his forms became larger, his paintings more massive and solemn. A dark gravity which sometimes recalls Permeke replaced the ecstatic gesture of Soutine.

This visionary mood was to take an entirely different form in Stanley Spencer, a strangely complex character. Returning from the war after several fantastic, hallucinated years in Macedonia, he conceived the idea of painting large religious cycles in a setting provided by his immediate surroundings. Temperamentally close to the lay painters, whose naïveté he often shared, he attacked the great religious themes – *Last Supper, Resurrection, Entry of Christ into Jerusalem, Christ in the Desert* – which like a naïve visionary he projects into his everyday world, often adorning them with grotesque and absurd thematic inventions. His style is marked by a dry, primitive realism with suggestions of Surrealism as well as of the Neue Sachlichkeit. In his fantastic religious figure paintings, he strangely combines the magical transfiguration of reality with an expressive 'primitivism' and a realism sometimes verging on crudeness. Occasionally his scenic fantasy and the dryness of his style remind one of Bauchant – this is the most naïve aspect of his art. But in contrast with this we note a high degree of technical ability, a thorough knowledge of contemporary techniques, and an abundance of literary metaphor. In all these pictures there is a powerful force of hallucination. We are often reminded of the deep current of fantasy that was at work in so much of the English art of the past, in Blake or Samuel Palmer for example.

Paul Nash, an unusually intelligent painter, who combined this profound metaphorical art – the Romantic component in the realism of the English – with the 'thing-experience' that had found its expression in De Chirico and the Romantic ideas of Rossetti, had shown Romantic landscapes with a markedly literary flavour. On the French battlefields which he had known first as a soldier and then, after he had been gravely wounded, as an Official War Artist, he had conceived terrifying images of a scarred, deadly silent landscape, in which the charred skeletons of trees figure a tragic narrative. This experience of the metaphorical quality of thing-images held him fast. After the war he sought at first to enhance their eloquence by Expressionist procedures, by distortion and intensified colour, and ultimately worked the magical prismatics of the Orphists into his interpretation of naure. But it was clearly the encounter with De Chirico's art, to which Lewis had called attention in 1927 in *The Enemy*, that led him to a free, metaphorical play with the thing-images. However, his metaphorical style is far from the intentional, absurd and ironic coupling of incongruities practised by the Surrealists. It is purely Romantic, showing a direct kinship with Blake. In the midst of the landscape, spectral box-like forms seem to stir strangely in the breeze, evoking the mood which the title describes in literary terms: *The Soul Visiting the Mansions of the Dead*. The literary content of these pictures is reflected in a certain scenographic, illusionist quality, suggestive of the stage. Often a motif in the landscape – a group of archaic

dolmens for example – stirs the fantasy to spin a poetic image, and then the landscape with the dolmens becomes a *Stone Forest*. Their metaphorical character lends these Romantic scenes a Surrealist note.

## *'Unit 1' and English Romanticism*

In the early thirties a few younger painters began to attract notice. Nash, who in the course of his own experiments had given some thought to abstraction and Constructivism, sought contact with these rising new forces. The result was 'Unit 1', a new group which formed round Nash in 1933 and found an outstanding literary spokesman in Herbert Read. Its composition was extremely heterogeneous. First there was a small group of Romantic Surrealists who, like Nash, were concerned with the metaphorical aspect of things and drew their ideas from De Chirico, Lurçat and Surrealist Verism: Edward Burra and Tristram Hillier. Then there was a group of abstract Constructivist painters – John Armstrong, John Bigge, Edward Wadsworth – whose interest had been aroused by the abstract forms they found in the works of Nash or Hélion or Arp. As a whole these painters were none too talented or inventive, but in their midst we find three names which were to give English art a new weight. These were the sculptors Henry Moore and Barbara Hepworth and the painter Ben Nicholson. In these years Moore and Hepworth, starting from eloquently simplified figural sculpture, had gone on to produce anthropomorphic constructions in which the natural shapes of things were resolutely deformed, and in the end arrived at purely abstract forms. Ben Nicholson, who had not yet wholly freed himself from the influence of Braque, was working with the ideas underlying the Synthetic Cubism of Juan Gris, in which the world of things is defined by pure formal arrangement. He had also begun to experiment with a free formal geometry in the manner of strict Constructivism. This group of artists, which came into being so unexpectedly, is an almost exact reflection of the avant-garde which some years earlier on the continent had rallied to the veristic and abstract variants of Surrealism and the abstract Constructivist tendencies of Abstraction-Création. Thus this relatively small cell reinforced the connecting threads, which had slackened so noticeably during the twenties, between England and the basic trends of European art.

In order to set the new developments before the English art world the group decided to hold a comprehensive international exhibition. Herbert Read played a prominent part in organising it. In June 1936 the great International Surrealist Exhibition was opened at the New Burlington Gallery. In retrospect we note that it produced the same liberating effect as the two Post-Impressionist exhibitions of 1910 and 1912. Breton, Eluard and Dali served on the international committee. Herbert Read, Roland Penrose, Paul Nash and Henry Moore made up the English committee.

The exhibition was retrospective in character. It began with the early De Chirico, showing 12 of his pictures painted between 1913 and 1917; there were three Marcel Duchamps from the period between 1911 and 1914, six Picabias done between 1914 and 1925, and a group of Man Rays. These represented the initial position of Pittura Metafisica and Dada. Next came the early Surrealists: Masson with 14 pictures from 1924-28, Miró with 22 paintings dating from 1920-35, Picasso with 11 pictures and Tanguy with 12. The Verist Surrealists were strongly represented, with Dali (12), Max Ernst (16), Magritte (14), Leonor Fini and Oelzen. Abstract Surrealism – with Arp, Taeuber-Arp, Brancusi, Calder – received somewhat less attention. The qualitative em-

phasis was on the imaginative Surrealism of Picasso and Miró. This category included Wolfgang Paalen, Victor Brauner and Dominguez. Paul Klee was represented by 15 works.

Of the English artists who participated, Nash and Burra were relatively Veristic; Penrose showed a few 'objects'; Moore and young Sutherland contributed works situated between abstraction and an imaginative interpretation of nature. The Romantic tone of the English group was characteristic. With this exhibition the whole store of Surrealist ideas – automatism, the images of the unconscious, alogical playing with associations, the coupling of incongruous things, the alienation of the object, the magical experience of things, the system of 'finding' images through the free use of the pictorial means, the total liberation of the fantasy, etc. – all this burst in upon the English art world. Yet only a few of these ideas bore fruit, and these were at once assimilated to the English Romantic tradition. In his introduction to the catalogue, Herbert Read says next to nothing about the actual Surrealist aesthetics; he stresses the 'primacy of the imagination' and proceeds to put the whole accent on the word 'Romantic': 'Super-realism in general is the Romantic principle in art'. In *Surrealism,* an album issued in connection with the exhibition, Read expressly contrasts Romanticism with Classicism ('the intellectual counterpart of political tyranny'), the creative impulse with a priori principles, introversion with extraversion. All these antitheses tell us about Surrealism is that it is a contemporary variant of the old Romantic ideas. This was a Surrealism wholly in the tradition of Blake and the English Romantics.

And indeed the actual ideas of the Surrealists made little headway in England. Graham Sutherland, a young English painter whom Nash had drawn into the exhibition and who was to be much talked of in the future, was quite in the tradition of the Romantic painting which clothes the feelings aroused by nature in pictorial analogies. This was the direction favoured by English sensibility. And yet the liberating influence of the Surrealist exhibition is not to be denied. It made for a new freedom whose effects reached far into the future.

New ideas were also at work in other circles. In the early thirties Roger Fry had occasionally championed non-objective art, and in 1933 a small group of painters had formed – Pasmore, Moynihan, Coldstream, Graham Bell – who experimented with abstract techniques as a means of expressing the feelings aroused in them by nature. They derived some of their ideas from the phantasmagorical transformations of Turner's late period. In 1934 an exhibition of 'Objective Abstractions' was held at the Zwemmer Gallery. 'Objective Abstraction' meant the transformation of a natural motif into an answering ensemble of abstract forms. This was the first appearance of Ivon Hitchens, whose painting is still characterised by this abstract interpretation of nature. Impelled by his feeling, he transposes his landscape motif into broad planes and coloured spots in a flowing style. The result is an almost abstract composition through which one barely glimpses the motif.

With all these isolated efforts, the decade did not achieve coherent stylistic expression. Cautious beginnings in this direction were offset by influences from different quarters. There was the persistent call for a 'return to nature', emanating from the conservative members of the London Group, but there was also the political influence of Communist doctrine, particularly among the 'Objective Abstractionists': Graham Bell, William Coldstream, Victor Pasmore. Stirred by the Spanish Civil War and the rising tide of Fascist totalitarianism, they had been drawn to Communism and accepted its naturalist aesthetics. However, this political undercurrent should not be taken too seriously, for actually the work of these painters cannot be identified with a militant, 'party-line' Socialist Realism. Dissatisfied with their abstract experiments, they merely turned to a lyrical nature painting. Of course they wrote manifestoes, condemning the work of Matisse as mere

decoration, but they themselves, strange to say, remained in the shadow of Cézanne. Their work may best be compared to the quiet, somewhat enchanted nature painting, in love with the world of simple things, which had arisen in the Italy of the thirties in the circle of Morandi, Mafai, and the young Roman landscape painters, and which also embodied a protest against Fascist heroics and the declamatory hollowness of Fascist art. The new English school, which took the name of 'Euston Road Group' in 1937, when Coldstream, Pasmore and Claude Rogers opened a school of painting in the Euston Road, cultivated a lyrical, restrained naturalism with the accent on simplicity, and in its paintings of commonplace subjects – landscapes, still lifes, figures and nudes – discovered an abundance of subtle *'valeurs'*. Cézanne, Corot, and to a lesser extent Bonnard were the models, though more in a poetic than in a pictorial sense. The subdued polemics carried on by these painters were directed against French modernist 'mannerism', against Surrealism and abstract painting. As one would expect, this new intimate nature painting was extremely popular among the English public, which was glad to escape from the confusing aesthetic theories and 'metaphysics' of modern art. At the outbreak of the War, the Euston Road School closed. At that time the general public believed that England was finished with modern movements for good. But very different forces were in the making and the experience of total war with all its terrors was to change the perspective completely.

Looking back over the two decades between the wars, we find neither a homogeneous pattern nor outstanding individual talents. The beginning was characterised by echoes of the pre-war revolutionary movements, soon submerged by a tempered, mildly Expressionist modernism, by the cult of pure form, and a retreat to the Golden Mean. The hesitant experiments in the direction of abstraction and Surrealism that we meet with here and there merely reinforce the general impression of lack of direction. In the early thirties there were new signs of movement. Abstraction and Surrealism reappeared on the scene; communication with the continent was restored; among the younger artists some powerful, disconcerting personalities were beginning to emerge. But all this was submerged by a lyrical naturalism which seemed to imply a retreat all along the line. Nevertheless, a few names had already risen to the surface: the sculptors Henry Moore and Barbara Hepworth, the painters Ben Nicholson and Graham Sutherland. Under the radically changed conditions created by the Second World War, they would achieve greatness and become the first modern English artists to exert an international influence.

*The Situation in the United States*

In the United States as in Europe, there was an increasing tendency after the First World War to suspend formal investigations and return to nature. But here, too, international modernism, in its most radical forms, seemed at first to be gaining ground. In 1920, Katherine Dreier, seconded by Duchamp and Man Ray, had founded the 'Société Anonyme', designed to promote the developments connected with Cubism, Dadaism, and abstract painting – such names as Kandinsky, Klee, and even Schwitters were already mentioned. In 1921 an exhibition of these extreme trends organised by the Société, visited a number of American cities.

Buyers began to commit themselves to modern art. In the twenties it was taken up by collectors, and in the thirties it acquired a privileged position. It was in these years that Walter Arensberg built up his collection of Cubists, Dadaists, and abstract Surrealists. In 1922 A. E. Gallatin became converted to modern art. In 1923 Duncan Phillips, who had turned his collection into a public

foundation three years before, began to include modern painters. Chester Dale, Conger Goodyear, Mrs. John D. Rockefeller built up their collections; in 1925 Albert C. Barnes incorporated his museum in Merion, Pennsylvania, with its large collection of Picassos and Matisses, as an 'Educational Institution'. In 1924 Mrs. Lillie P. Bliss converted her collection into a foundation. It formed the nucleus of the New York Museum of Modern Art, founded in 1929, which soon became the centre and guiding star of American artistic life. But the American collectors were interested almost exclusively in European art; American artists were largely excluded.

They found themselves in a strange situation. These were the famous 'roaring twenties' – a period of unprecedented economic boom, followed by the great crash of 1929 which shook the economic structure of the whole world. In this world of ruthless business enterprise, of frantic speculation, the intellectual and the artist were hopelessly isolated. Their response was a profound pessimism, which in literature found its expression in the strange mixture of nihilistic defiance, vitalist individualism, and self-pity that came to be identified with the 'lost generation'. Nearly all the younger painters had been moulded to a very great extent by the Ash Can School, by Henri and Sloan, and had absorbed their ideas of social reform, Anarchism and Socialism. It was inevitable that these ideas should be reinforced by the social conditions prevailing in the twenties, particularly after the crash, when the whole social edifice built on the profit motive, on individual greed, seemed to be collapsing. The consequence was an art of social commitment, that is to say, a hard realism concerned with the events of the day.

In 1918 a new illustrated magazine appeared, *The Liberator*. It carried on the militant reformist current of *The Masses*, to which the Ash Can Painters had contributed and which had ceased publication during the War. And 1926 saw the founding of *The New Masses*, a militant organ of social struggle, edited at first by John Dos Passos. Its contributors included many of the country's leading intellectuals. The artists who drew for it developed a mordant satirical style. They found their stylistic models in the French political caricaturists, in George Grosz and the German *Simplicissimus* artists. This was the starting point of such artists as Adolf Dehn and Peggy Bacon.

In the course of the depression the reformist Socialism of the intellectuals soon blossomed into revolutionary Communism. This brought with it a demand for 'Socialist Realism'. In America as elsewhere, the Communist critics and cultural commissars fabricated a whipping boy, which became the butt of all their attacks. This was formalistic 'art for art's sake' – a notion which took in all modern art.

Those artists who stood aloof from political struggle became infected with a dangerous resentment. Bitterness over the preference of most collectors and galleries for the new European painters encouraged pleas for an American art and attacks on 'decadent Europe'. Though at first this current expressed a more or less healthy American nationalism, it took on definitely chauvinistic traits in the thirties among the painters of the 'American Scene' grouped round Thomas Benton. Rejection of Europe as a mentor was combined with anti-modernist arguments that suspiciously resembled the artistic polemics of European Fascists and other totalitarians.

The spirit of the Armory Show was forgotten. American artists began to form exhibition groups of their own, a tendency reinforced by the isolation of the war years. In March 1916 the 'Forum Exhibition' of the Anderson Galleries in New York had tried to assemble 'the very best examples of modern American art'. The sixteen painters shown did indeed offer a convincing cross section of modern American art, extending from Benton and Bluemner to Marin, Dove, Hartley, MacDonald-Wright and Man Ray. In the catalogue and in the publicity for the exhibition great weight was placed on the 'American' aspect. In 1917 American artists finally succeeded in organising their

293

first exhibition without a jury, the 'Independent Artists' Exhibition', which, it was hoped, would become the forum of American art. On this occasion the committee quarrelled with Marcel Duchamp over one of his daring Dadaist 'objets', and he withdrew. Regardless of the special circumstances, the incident was symptomatic of the growing isolationist trend in American art. Even Alfred Stieglitz, who had done everything in his power to introduce the new European ideas into the American art world, was caught up in the nationalist current. After the war he ceased to show European painting. In 1925, when he again opened a gallery of his own, 'The Intimate Place' at 489 Park Avenue, he showed only the American artists of his own circle: Marin, Hartley, Dove, O'Keeffe, Demuth. In 1929 he moved to 509 Madison Avenue and, significantly, called the new gallery 'An American Place'.

The accent on Americanism naturally encouraged efforts to depict the 'American scene', the countryside as well as the cities. This was the heyday of a regionalism which as usual made for a naturalist style. Yet despite its isolationism American art was not unaffected by contemporary European trends.

With Classical Realism, Magical Realism, and Neue Sachlichkeit, European art had also arrived at new forms of realistic description. Even such radical regionalists as Thomas H. Benton or Grant Wood were definitely influenced by the Neue Sachlichkeit, while Ivan Albright's painting no less unmistakably reflects the expressive realism of Dix and Grosz. Contact with the ideas of *Valori Plastici* led Maurice Sterne, who lived in Italy for a time after the war, to exchange his fashionable, decorative Expressionism, based on Gauguin and Pechstein, for a Classical Realism in which he imitated the styles of the Renaissance. Niles Spencer, who spent the season of 1921-22 in Italy, was won over to Carrà's large classical forms. No American who visited Europe in this period could fail to note the dominance of these new varieties of realism.

Realist ideas poured in from still another direction – from Mexico. Since 1921 the Social Realism born of the victorious revolution had produced the expressive style of the new Mexican fresco painters. Diego Rivera and Orozco achieved an enormous influence, extending to the United States. In the early years of the depression, when the government included artists in its public works programmes and the WPA (Works Progress Administration) Federal Art Project was commissioned to decorate a number of public buildings, the Mexican fresco style found many imitators. In 1930, Orozco and Benton were both at work simultaneously on frescoes at the New School for Social Research. In 1933 when Rivera did his murals for Rockefeller Center, Ben Shahn was one of his helpers. Thus many factors contributed to the rise of the new realism.

*Romantic Aspects and American Cubo-Realism*

Of course many of the artists who had worked with anti-naturalist and Expressionist ideas before the war remained faithful to these trends. But they too sought to fill in the constructive framework of their pictures with elements that were closer to nature than before. Abstraction was clearly on the retreat. Joseph Stella forsook his turbulent Futurist style for a firm, rigorous pictorial architecture, through whose lattice-work the buildings of Manhattan could be glimpsed as in a vision. He still employed the Cubist system of screens, but now his intention was thematic: an apotheosis of the metropolis. In the five large canvases of the *New York Interpreted* series (1920-22), his last important work, we discern the Purists' hard, cold, machine-like formulas of object definition. And working along similar lines Charles Sheeler, in the same period, was

beginning to develop a smooth, precise style in which Cubist geometrical abstractions were adapted to naturalist purposes.

In 1915 John Marin had gone to the coast of Maine and discovered new subjects for his pictures. Sea and rocks, trees and sky became the interpreters of the poetic emotion that nature aroused in him. He still retained the Cubist *'plans superposés'*, the crystalline planes reflecting the luminous transparency of the atmosphere; he still used the kinetic ray-lines of the Orphists and Futurists to express the dynamics of the play of light he discerned in nature; he used the pure colour and ornamental arrangement of the Fauves to transform his image of nature into a vision suffused with colour – but all these operations aimed at making a pure, natural experience clearly visible. The Expressionist intention had become dominant.

As early as 1917 Max Weber, who only two years before had found his way to Synthetic Cubism, turned back to an expressive Fauvism and in the ensuing period, with the help of Cézanne and Matisse, sought to come still closer to natural forms. But his emotional approach to nature accentuated the expressive note in his painting. Partly under the influence of Soutine and the early Rouault, he developed an ecstatic, descriptive Expressionism with which in the late thirties he began to combine more abstract forms. Alfred Maurer was caught up in the same Expressionist trend. After the war Marsden Hartley also gave up his abstractions and moved closer to nature. He now recorded his experience of nature in simplified landscapes and figure paintings in strong simple colour, still clearly reminiscent of the early Munich Expressionism of the Neue Künstlervereinigung. An intentional formal awkwardness, the expressive *'gaucherie'* which had been discovered by the Nabis and much used by the German Expressionists, helped him to express strong, simple feeling. Even the strange painter-poet, Arthur Dove, who had been living since 1918 in a houseboat on the Hudson, abandoned the geometrical structure of his early abstractions towards 1920. In fluid colour he now shaped symbolic signs that seemed to stand half-way between things and abstract evocative forms – poetic paraphrases of his experience of Panic nature.

From this general current there emerged a new tendency: the direct definition of reality in forms of extreme precision. Here again the starting point was advanced Cubism, the clear, cool, precise formal architecture of Juan Gris and of Léger's paintings of machines, from which the Purist aesthetic had developed. The beginnings of this new trend may indeed be regarded as an American variant of Purism. Its chief proponent was Charles Sheeler. For a time he was followed by Charles Demuth. In 1915 Sheeler's experiments had brought him to Cubism, which, however, he – like Demuth – understood as a means of defining reality through abstraction. Demuth preserved the flat space of Cubism, the crystalline grid enclosing object signs, and the dynamic ordering of the surface by a system of constructive lines and ray lines. Sheeler, however, reduced the objective element to basic stereometric forms whose cubic three-dimensionality he accentuated. Actually this was no more than a simplified realism, a description of reality with the help of Cubist forms. As subjects he chose modern buildings, the industrial landscape, machines, and mass-produced objects, whose functional, mathematically determined forms lent themselves readily to his smooth, cool stereometry. This delight in the abstract forms of mechanical things had been aroused in New York circles by Duchamp and Picabia with their often playfully ironic mythology of the machine. Demuth was a friend of Duchamp but Sheeler too had been influenced by this current. These experiences and ideas soon aroused interest in Léger's aesthetics of the machine and Ozenfant's Purism.

Startling new discoveries were provided by the camera and the optical manipulations it made possible. These came to Sheeler's attention in 1917 and from then on, side by side with his

painting, he practised photography, specialising in pictures of architecture and machinery. By approaching a subject from an unusual angle, by the use of steep upward or downward views, unusual lighting, close-ups, and careful selection of detail, it was possible, with this purely mechanical instrument, to bring out the formal structure and stereometry of the machine world. The forms that resulted seemed purely abstract and showed an astonishing resemblance to the paintings of the Cubists and Purists. The most striking of these photographs were taken by Paul Strand, a member of the Stieglitz circle.

Sheeler applied his photographic experience to his painting, basing his pictorial optics wholly on the camera. At first his views of the industrial world followed the formal models of Juan Gris and the Purists, but later on he moved increasingly towards sober realistic description. In the late twenties he was doing industrial landscapes which outdid the camera in precision: lines drawn with a ruler, a cold light that sharply defines the cube-like shapes of factory architecture, an obstinately rigid perspective. With their stony stillness that suffers no life or motion, the glassy hardness of their atmosphere, the spotless smoothness of their colour, the mechanical precision of their forms, these pictures are a kind of hymn to the industrial age, a definition of the omnipresent world of technology. In a society which worshipped at the altar of industry they were much admired as a realistic, and at the same time romantically transfigured, apotheosis of the American 'industrial scene'. And the suggestion of Cubism that still clung to them gave them an exciting aura of modernity.

This trend, to which American art critics gave the name of Cubo-Realism, had a wide influence. Niles Spencer, Stefan Hirsch, George Ault took it up, but tended to moderate and romanticise Sheeler's photographic hardness and precision. This gave rise to a style that may be regarded as the American variant of the German Neue Sachlichkeit or the Italian *Valori Plastici*. Here too Romantic impulses were at work, and even a pure Romantic such as Peter Blume, who in the thirties was to awaken the element of fantasy latent in this congealed Verism, was able to take Cubo-Realism as his starting point.

But even in Sheeler's photographic super-realism there was a strong Romantic feeling at work. With the help of selective observation and memory, it distilled a 'mental image' which was then reproduced with the hardest realism. Sheeler describes his method as follows: 'Something keeps recurring in memory with an insistence increasingly vivid and with attributes added which escape observation on first acquaintance. Gradually a mental image is built up which takes on a personal identity. The picture takes on a mental existence that is complete within the limits of my capacities, before the actual work of putting it down begins.' The 'mental image' is a poetic translation of reality, its Romantic aspect.

This Romantic aspect achieved interesting expression in the work of Georgia O'Keeffe, an artist remarkably sensitive to psychological states and the symbol world of the unconscious. Finding in nature symbolic forms which could be related to the human psyche, she isolated them and gave them a poetic accent. Georgia O'Keeffe, who later became Alfred Stieglitz's wife, belonged to his circle from 1916 on. Thus she lived and developed among artists who had remembered the anti-naturalist function of art. Among them Arthur Dove was closest to her. As early as 1916 she had attempted largely abstract transpositions of natural impressions and moods, and Dove had encouraged her use of abstract metaphor. In connection with an exhibition at the Anderson Galleries in 1923 she wrote: 'I found that I could say things with colour and shapes that I couldn't say in any other way — things that I have no words for.' But towards 1925 she discovered that by a simple change in 'optical attitude' we can discern, in the formal hieroglyphs of nature, arran-

gements of coloured forms which supply a highly evocative material for the expression of the feelings aroused by nature and make a powerful impression on the human psyche.

Again the impulsion seems to have come from photography. In 1925 Stieglitz had held an exhibition of 'Seven Americans', consisting of the work of his five artists – Demuth, Dove, Hartley, Marin, O'Keeffe – and of photographs by himself and Paul Strand. It was Strand with his camera who had brought about the change in 'optical attitude'. By close-up views of leaves, flowers, and other objects of organic nature he had discovered abstract forms and structures which not only surprised and satisfied the aesthetic feeling, but also translated the aims and purposes of formative nature into expressive form. These forms offered an adequate expression for the feelings aroused in us by nature – feelings 'that there were no words for'. They communicated a shock which released rich chains of poetic association.

Georgia O'Keeffe experienced this shock at the sight of the lush forms of flowers: the iris, the orchid, the calla lily, etc. A magnified view of the inner structure of a flower released a shock which raised a physical fact of nature to the productive plane of poetic insight, the fact, namely, that these intricate forms are nothing other than nature's fantastically luxurious sexual advertisement – formal signs of the Eros that governs all nature. The details released by the magnifying lens exerted a strong power of suggestion. Brought out by enlargement, suggestive elimination, and the accentuation of expressive detail, the reproduced natural form became an evocative form. Transferred to painting, this vastly enlarged detail of a flower disclosed a form and colour world of dark enigmatic beauty, which seemed quite abstract. Its mysterious lure stirred the unconscious realm of the erotic and pan-sexual. Nature itself with its formal signs and colour arrangements provided the means with which to express the responses of the human Eros to nature's driving forces. Here again we find recognition of the evocative power of natural things, a perception of the 'psychology of things', their 'metaphysical aspect', of which De Chirico spoke, their 'fantasy in the hardest matter', as Kandinsky put it. Once started in this direction, Georgia O'Keeffe made use of the suggestive power of unusual things in unusual contexts and, sustained by the general development, arrived at a cool magical realism, which transposes the hard existence of things into the realm of the super-real.

*Painters of the American Scene*

In the same period we encounter a more interpretative naturalism directly concerned with American life and the native landscape. It grew quite spontaneously from the American naturalism of the pre-war period, from the tradition of the Ash Can School, whence also it derived its pronounced Americanism and preoccupation with the 'American scene', with the American common man, and the provincial aspects of American life. Its leading representative was Edward Hopper, a pupil of Robert Henri. Towards 1910 he had begun to paint in a sober naturalistic style, in which a cool Romanticism was already implicit. To find his own personal mode of expression he had only to develop this Romantic note, and this he succeeded in doing towards 1923. Magical Realism gave him some hints. It taught him to simplify his form, to breathe poetry into his motif by accentuating evocative forms, to enhance the cubic quality of his object forms by means of a cold light, and to employ intense, exaggeratedly sharp colour. With these means he described poetic impressions of the American scene: a solitary house in the absurd style of 1900 beside a railway embankment; a filling station in the evening light; white wooden houses and churches in the

New England colonial style; factories, deserted suburban streets in the cold light of an early morning; or a brightly lit bar in a New York street at night. Often the cool hard light which defines the forms falls from one side, casting long shadows. Sometimes these scenes include isolated human figures, but, like supernumeraries on a deserted stage, they merely accentuate the lifeless silence in which things stand out so sharply. The underlying mood is one we encounter in the Europe of those years, which made its first appearance in Pittura Metafisica. Here it allies itself with certain aspects of the American scene: the loneliness of the big city, the Romantic magic of motionless things in the clear light of the wide American sky. A hard realistic Romanticism!

This current gained wide support. In New York, at the end of the twenties, it gave rise to a whole school of painters, centred round K. H. Miller, which combined the old Ash Can tradition with the cold, manneristic, inventory style of the Neue Sachlichkeit. It even influenced the surviving painters of the Ash Can School, Sloan, Luks, and Glackens, and confirmed them in their old tendencies. It provided a background for the fame of George Bellows and justification for new academic trends. It assumed a moderate, sensitive form in the nudes and interiors painted under the influence of Pascin, who lived in America from 1914 to 1924. And with the regional painters it degenerated into photographic realism and provincial chauvinism.

Towards 1930 this regional painting flowered and achieved recognition. Its success was due to its theme: the discovery of an unknown America which for more than half a century had not been regarded as a fit subject for art: the small towns, the countryside, and backwoods of the South, West, and Middle West, an America that was primitive and puritanical, stodgy and old-fashioned, but still mindful of the brave, generous frontier days whence a rich folklore had grown. The life of American farmers and backwoodsmen, of rural districts and shanty towns – this was the subject matter of the regional painters.

The best known was Thomas H. Benton. In the thirties he was even regarded as the founder of a new movement in art. Benton had been in Paris from 1908 to 1911 and had tried his hand at Synchromism. After the war he had thrown all his modern ideas overboard and had returned to a classical realism with an eye to the Renaissance. He may have been influenced to some extent by the modern Italians. Then for many years he travelled about rural America, the Middle Western and Southern states, sketching and finding his subject matter. At the end of the twenties he produced from this material a large number of pictures illustrating life in the American back waters. Painted in a hard, slightly caricaturing style which exaggerated the plastic quality of things, these pictures have all the hallmarks of the Neue Sachlichkeit. He continued to paint in this manner until the late forties. His later painting, devoted to life on the farm, is richer in colour and distinctly Romantic.

It was also Benton who in his first murals, done in the early thirties, applied the style and technique of the Mexican fresco painters to great panoramas of American life, but also to symbolic social satires on the evils of American capitalism.

Though regionalism dominated American painting in the thirties, it produced few memorable names. Grant Wood, who hailed from Iowa, may be regarded as its leading Middle Western representative. In Munich, where he studied in 1928, his attention had been drawn to the clear, precise realism of the Dutch and German painters of the fifteenth and sixteenth centuries with its magnificent formal definition. He applied this strict, forthright realism to the figures and faces of his provincial environment. But because Grant Wood was intent on the clearest formal definition and because the sovereign form of the late Gothic masters shone through his realism, his figure paintings and portraits, even when they are faintly satirical, achieve a kind of universality; reaching

out beyond any individual characterisation, they stand there as symbols of the American small town and its homespun, unpretentious people.

This regional realism reflected the isolationist and nationalist tendencies of the thirties, but also fell in with the demand for 'Social Realism' created by the political developments of these depression years. It was supported by the intellectuals in charge of the WPA art projects who, under the pressure of social events, stirred by the growing power of Nazism and by the bitter conflict unleashed by the Fascists in Spain, had moved gradually closer to Communist ideology and its aesthetics of 'Socialist Realism'. This influence on the part of left-wing totalitarianism, which we have also met with in England, was very considerable. In its American workings, however, it was flexible enough to leave room even for such independent personalities as Ben Shahn, Arshile Gorky and Jackson Pollock, who worked on the WPA projects.

*Surrealism and New Tendencies*

For side by side with this surface naturalism, the ideas that had set modern art in motion were still at work and even influenced the naturalist painters. According to the personality of the individual artist, an Expressionist, primitivist, or fantastic aspect might emerge in his work. Charles Burchfield, who shortly before 1920 had made his appearance with a number of Expressionist water-colours embodying a strangely fantastic nature poetry, never, even in his adaptation to the prevailing realism, relinquished the Expressionist and Baroque character of his vision. In his Middle Western street scenes, he singles out weird private houses and expressively enhances the grotesque absurdity of their architecture. Yasuo Kuniyoshi, who began to paint in the early twenties with Chagall and Campendonk as his models, retained fantastic, Surrealist elements even in his more realistic phase that began in 1928. It was in the thirties that Edwin Dickinson painted his mysterious hallucinations in a classical, Baroque style: objects, nudes, figures that emerge quite realistically from the Baroque chiaroscuro, but remain fragmentary because a mysterious shadow falls over them. This highly Romantic, enigmatic world points once again to the realm of the super-real. Since his return from Spain in 1931, Philip Evergood had wholly identified himself with the struggle against social injustice, exploitation, racial persecution and Fascism. But his work of these years shows a satirical exaggeration, a mixture of cold realism and Expressionist deformation, of realistic reportage and visionary elements. After the war this penchant for dark allegory led him close to Max Beckmann, who taught in the U.S.A. from 1947. But reality itself offered enough fantastic aspects. Keenly attentive to the transience of all things, Ivan Albright, viewing the world with a microscopic myopia, isolated the symptoms of decay. Like Otto Dix in his early period, he painstakingly probed living bodies for indications of death's corrosive action. Inanimate things – masses of litter described in precious detail – took on a macabre personality. The iridescent colours of decay stressed their character as symbols of transience, justifying the symbolic titles in which Albright gave linguistic expression to his sense of the frailty and corruption of all living things, of the eternal presence of death.

The painter who most clearly expressed the life-feeling of this period in America was Ben Shahn. He was deeply aware of the ethical and social responsibilities with which these years of crisis confronted the artist. But in his social protest he did not content himself with proclaiming a dogma of political salvation or with exposing corruption; he let things – men, their living conditions – speak for themselves. With a profound sense of humanity and a melancholy love, he allied himself

with all that was poor and humble – even to the lifeless things. With an insight rooted in his Russian-Jewish background, he looked beyond the surface aspect of things to perceive their secret lamentation. Even when he deals with burning political or social themes, he may in a sense be counted among the '*peintres juifs*' who are able to describe the melancholy poetry of things with such penetration. In the early thirties he painted a famous series of gouaches dedicated to the executed Anarchists Sacco and Vanzetti – they have the poignant, deeply moving quality of peasant paintings. His paintings based on current events of this kind, his murals or posters dealing with social problems, his records of plain people – for instance, a group of young workers playing handball in an empty lot – all convey the same note of unmonumental solemnity and quietness, of simple direct feeling, of compassion for man in his solitude. To express this feeling, he used the simple, powerful means of naïve realism. The naïve precision of George Grosz's early line drawing, but also the painstaking object definition of the '*peintres naifs*' enter into his work. This naïve quality went hand in hand with an almost photographic precision of selected details. The naïvely displaced or exaggerated perspective disorders our perception but guides the eye to the evocative details which awaken our emotional response. The colour is dry and oddly sweet, often forming, at the focal points of the formal construction, bright flat patterns which introduce an unexpected abstract element into the pictorial organisation and intensify the fantasy latent in the realistic motif. Once again the super-real looks out from behind the images of reality.

It became the determining factor in the fantastic visions of Louis Guglielmi and Peter Blume, who entered into direct contact with Veristic Surrealism. Peter Blume, the most interesting of these fantastic Verists, had become acquainted with Charles Sheeler in the middle twenties and had been fired with enthusiasm by the fantastic aspects of his starkly realistic representations of the machine world. He now enriched these elements of fantasy, discovered in the realities of the technical and natural worlds, to produce amazing allegorical scenes. In 1932, on a visit to Italy, he had become familiar with the meticulous style of the early Italian Renaissance and developed a remarkably faithful and accurate technique which he proceeded to apply to his fantastic scenes. He took over some of the inventions of classical Surrealism: a certain animism, the coupling of things not normally found together, the combination of incongruous scenes into a coherent image. But the result is less Surrealist than fantastically Romantic and relates always to a definite and real situation or scene.

It is characteristic of the artistic aims of those years that only certain elements of Verist Surrealism were taken up although the abstract aspects of Surrealism must surely have been known to American artists. In 1927 the Valentin Gallery in New York exhibited De Chirico, and in 1928 Miró. In 1930 the great Klee exhibition was held at the Museum of Modern Art and in the same year the fantastic Surrealists of the Paris School formed part of the 'Painting in Paris' exhibition. In 1931 the first well-rounded exhibition of Surrealism in the U.S.A. was held at the Wadsworth Athenaeum in Hartford, Connecticut. In the early thirties there were frequent Surrealist shows in the New York galleries: in 1933, Dali, Miró, Masson; in 1934, Giacometti, Dali, Arp; in 1935, Dali, Miró, Masson. In 1936 the Museum of Modern Art put on a comprehensive exhibition of 'Fantastic Art, Dada, Surrealism'. But despite all this, only the ideas of Verist Surrealism, the ideas that could be utilised in the poetic interpretation of reality, were taken up in American art, which was too exclusively concerned with describing the contemporary scene to take an interest in the abstract aspects of Surrealism. Such central preoccupations of Surrealism as automatism, the finding of an imago by the manipulation of coloured forms, the hallucinated projection of images into evocative coloured grounds, and such masterly works and insights as those of Miró or Klee, were for the present ignored.

However, these ideas did not disappear entirely. Here and there abstract elements re-emerged. In the thirties the Bauhaus painters Joseph Albers, Lyonel Feininger, Herbert Bayer and Moholy-Nagy had emigrated to the U.S.A.; Albers and Moholy-Nagy had entered upon their fruitful teaching careers at American art schools. And during this whole period Stuart Davis clung to his personal, largely abstract, Constructivist style of painting. He had taken up the ideas of Cubism and Dada before 1920 and held Duchamp and Léger in high esteem. In 1929 after a long stay in Paris, he had returned to New York and begun to introduce the evocative signs of metropolitan life into his sharply coloured constructions: the giant hieroglyphs of advertising posters, the convulsive movement and glaring colours of electric signs, the throbbing jazz music, the dynamic rhythm of the big city. All this provided him with expressive material. The result was a dynamic texture of letters, numbers, kinetic forms, outlines of things, which stand like quotations in the abstract ensemble and convincingly evoke definite aspects of New York. In the late thirties these abstract figurations with their marked personality and capacity for arousing associations, showed a certain kinship with Miró and something of his influence as well.

But the ideas of abstract Surrealism were also at work on more secret levels and found confirmation in quite unexpected quarters. On a trip to China and Japan Mark Tobey had been impressed by the fine brush script of the Chinese; he had studied their calligraphy, and taken up the ideas of Zen philosophy. In 1935 he developed a meticulous, sensitive linear script, his 'white writing'. In those years, to be sure, he still applied his calligraphic method to objective motifs, but the Surrealist idea of automatic writing was already implicit in his meditative, immaterial script. Morris Graves had also taken up Far Eastern philosophy, but by nature far more religious and mystical than Tobey, he had begun to practise Zen Buddhism. Formally, he had drawn inspiration from Tobey. In 1937 he found his personal style. With a fine, vibrant tissue of lines and forms on coloured grounds, he built up a magic crystalline space in which fantastic images emerged like visions – images of distant landscapes, animals, and birds, which fully justified the appendage '...of the inner Eye' that he often added to the titles of his pictures. Quite independently he moved close to the work of Paul Klee. And in those years Arshile Gorky was already busy developing his personal style by a process of restless searching in the area delimited by Picasso's Surrealism of the late twenties, Miró's mature style, and abstract Constructivism. Though all this was taking place beneath the surface of artistic life, nevertheless these beginnings of a confrontation with imaginative, non-Verist Surrealism and abstract painting may be regarded as the germ cell from which, during and after the Second World War, a new force in American painting was to erupt and grow impetuously, finding its way to an expression entirely its own, which, for the first time in the history of American painting, was profoundly to affect European art.

If we look back over the American painting of the two decades between the wars, national and regional peculiarities are indeed discernible here and there, but the general development is a fairly faithful reflection of European currents. There is even a tendency to blunt and moderate the European trends – partly explained no doubt by the fact that in this period American painting had no great talents comparable to Picasso or Klee, Miró or Kandinsky. Even in the early twenties there was a general tendency to divest Cubism, Fauvism, and abstract painting of their radical ideas, and harness them to a more realistic kind of painting. From Cubism there developed Cubo-Realism, which soon moved very close to the Neue Sachlichkeit and Magical Realism; from Fauvism sprang a more naturalist Expressionism. At the same time there was a vigorous realism rooted in the American tradition, which soon however took on the qualities of Magical Realism. Choosing as their theme the rural American scene and the American social situation, the painters

of this trend commended themselves to an isolationist society, intent on shutting itself off from the unrest that was taking hold of Europe. With the crash of 1929 realism in its regional and social aspects became increasingly dominant. The idea of art for art's sake gave way to the ideology of social commitment, and inevitably the aesthetics of Communist totalitarianism gained a considerable influence. The depression provided the conditions for social realism. As a result of the government aid programmes necessitated by the situation, art was accredited with a social function which quite naturally implied a descriptive realism. The thirties in the United States were years of social-minded, realistic art. But under the surface the ideas of expression and form lived on, made contact with the European developments centred round Surrealism, and laid the groundwork from which an art of a very different character was unexpectedly to emerge.

## The Assault of Totalitarianism

Though we have done our best to limit the present chronicle to the inner problems of painting, we have been compelled to note, again and again, how factors from outside the realm of art — considerations of humanism, Christianity, and in particular of politics — have affected the internal development of modern art. Not only on the European continent, where in the thirties the art world became a veritable battlefield between modern, progressive forces and conservative or reactionary movements, but in England and the United States as well, we have encountered traditionalist, nationalist, Fascist, and Communist forces intent on discrediting modern art or destroying its freedom and bending it to their purposes.

In the third decade of this century, art was advancing vigorously towards the visual expression of our contemporary sense of reality. A new style of tremendous range, embracing the many positions conquered by individual artists and reflecting the combined effort of all social forces, was at last in sight. The spiritual élite was equal to the task in hand. Modern art was penetrating the life of society, influencing the theatre, ballet, film, publicity, and all other fields of pictorial expression. The museums opened their doors to it. To enlist popular support, to give the people the feeling that the development of a new style directly concerned them, the first public galleries devoted to modern art were created. Berlin led the way with the new section of the Nationalgalerie, inaugurated at the Kronprinzpalais in August, 1919. The new trends began to play a dominant role in the large, representative exhibitions; and, as has always been the case in periods of artistic flowering, modern works were sent abroad to represent national achievement. A fruitful exchange began among the European nations. The Venice Biennale became an important place of encounter. Other countries also organised international exhibitions — a particularly memorable one was that held in Dresden in 1926. The public at large came to realise that modern art reflected a stylistic movement of European, indeed, universal scope.

Inevitably the widespread acceptance of modern art aroused opposition on the part of artistic cliques which felt slighted, of honest traditionalists, diehard nationalists, preachers of humanism, etc. All this was quite normal, and since the situation of art was essentially fluid, this sort of opposition produced a good deal of justifiable criticism and counteracted the danger of a modernist conformism. There was no real threat to modern art from this direction.

The brutal assault came from an entirely different quarter. It was political. It exerted little or no influence on the development of modern art, but it did block and very much delay the organic integration of modern art with the life of modern societies. The source of the attack was a political

perversion of the idea of socialism. After the old ruling classes were removed by revolutions in Russia, Germany, and Italy, the more or less democratic governments that took over proved short-lived, unable to cope with the chaotic conditions of the post-war period. In these three nations, which were not ripe for democracy, the logic of events led to the development of political totalitarianism. Totalitarianism is the concept which subsumes three such seemingly different movements as the Leninist-Stalinist stage of Bolshevism, Mussolini's Fascism, and Hitler's National Socialism. The clearest and most striking expression of the inner affinity of these three movements, all of which were directed against human freedom, is that they all produced identical conceptions of art and the same brand of official art.

It all began in Russia. Lenin's directive to his cultural apparatus, which had been re-organised and subjected to political control, was to transform art into an instrument of 'monumental propaganda'. According to the doctrine of historical materialism, ideologies have no independent histories; the form of social organisation in each period is determined by the level of productive forces, which is the only subject of historical development, and everything else, including art, merely reflects this indivisible history. On the basis of this theory, the Bolshevist dialecticians maintained that art must take sides, that it must serve the goal of history as defined and prescribed by the Bolshevik party. Accordingly, the main thing in art was content; form served solely to illustrate the content as clearly as possible and to make it easily accessible. The function of art, as defined by the Bolshevists, was to glorify the party, its leaders and accomplishments, to sing the praises of the heroic working class, to communicate optimism, and when necessary to struggle against the remnants of the past and the enemies of the party. To this recipe Stalin added the ingredient of nationalism, so reviving the notorious 'blood and soil' theme. The final upshot of a long period of discussion, criticism, and self-criticism was the distinction made between 'formalism' and 'Socialist Realism', which the bureaucrats of all Soviet-influenced countries from East Germany to China have been echoing with crushing monotony in their speeches and writings for the last fifteen years. 'Formalism' is condemned as individualistic, regressive, and disintegrating; 'Socialist Realism' is championed as accessible to the masses, affirmative of life, and conducive to the fulfillment of the economic Plans. Needless to say, this 'Socialist Realism' has nothing in common with true realism: it is actually an illustrative sugar-coated stereotype, cut to size for the 'needs of the popular masses', and utilised in accordance with 'the present stage in the class struggle'. Its aim is not 'to raise the level of the masses', but 'to create a popular art', whose main theme is 'the bright side of Socialist construction'. The above quotations are from a speech by Mao-Tse-Tung addressed to the artists of the new China. Identical passages can be found in the speeches of Mao's western-most colleague, Grotewohl, whose declaration that 'in judging our artistic production political criticism is primary and artistic criticism is secondary' is quite typical of the attitude of totalitarian politicians. Goebbels, who made similar pronouncements, may be considered in the same class.

The method of translating these ideas into action has been strikingly illustrated in East Germany. First the regime welcomed artists and intellectuals with open arms. In 1945 a liberal-minded 'Cultural Union' was founded. As party functionaries infiltrated the 'Union', the line became somewhat more severe and membership began to be compulsory. Then the Union was absorbed by the Communist trade unions. The debate on formalism was opened; in 1951 the central committee of the party passed a resolution 'against formalism in art and for a progressive German culture'. Finally came the appointment of a 'State Commission for Art', which – depending on the public it addresses – invokes the old masters or Soviet art as the models to be followed but in the

last analysis imposes 'Socialist Realism' with the help of an all-powerful government machine. This is the tested recipe. It is invariably effective.

In Italy the methods employed were considerably milder. This had something to do with Mussolini's personal make-up, for he was not without a certain *bonhomie*. The Italian artists were fortunate in that Mussolini had no understanding of painting and was thoroughly bored by it. Moreover, Marinetti, the leader of the Futurists, happened to be one of Mussolini's earliest followers and was able to exert a certain influence through his position as senator and member of the Academy. But Futurism in its second stage favoured themes dealing with the glorification of Fascism, the Nation, and war. The foundation of the Novecento paved the way for a gradual shift to a stereotyped heroic realism, an extremely dangerous development because all artists were compelled to participate in the Fascist 'Sindicati delle Belle Arti'. It was only thanks to the influence of certain groups of Fascist intellectuals, above all the group around the critic Margherita Sarfatti, that the attempt to regiment Italian art was not quite successful. Under Fascism the 'representative' exhibitions were primarily devoted to a turgid illustrative realism glorifying the new national values: the Duce, Fascist construction, blood and soil, mother and child; some space was given to the declamations of the late period of Futurism; and last came the few artists engaged in a serious quest for a contemporary approach to reality. Almost all the artists we have mentioned were at least represented in these exhibitions; often the most prominent – Carrà, Morandi, Casorati, etc. – were even given places of honour. There was no abstract art; only among the Futurists a few artists – particularly Enrico Prampolini – came close to abstraction in their 'cosmic visions'. However, the situation was very uncertain, there was always a possibility that the government apparatus would one day decree Fascist realism as the national style. This would certainly have come to pass if history had not liquidated Fascism first. Italian artists were always aware of this latent pressure, and all of them, with the exception of Carrà and a few others, belonged to the anti-Fascist camp.

However, the most vicious and ignoble attack on the freedom of creative man was perpetrated in totalitarian Germany. It was inaugurated by fanatical crackpots drunk on Nordic mythology who equated the true German spirit with the 'aristocracy of the sword'. Günther, the proponent of 'racial science', supplied pseudo-scientific arguments in support of the grandeur of the 'Aryan' principle: Schultze-Naumburg proclaimed the beauty of the native soil. All this finally led to the foundation by Rosenberg of the 'Kampfbund für deutsche Kultur'. Racial foundations were proclaimed the first prerequisite for a German culture. The Nordic superman, that monstrous emanation of Wagner, the misunderstood theories of Nietzsche, and the Jugendstil, was exalted by Rosenberg, the official myth maker. The 'sub-man' was invented as his antithesis. The task of art was to represent the Nordic man in his warlike glory, with his Nordic homeland in the background. Since modern art did nothing of the kind, it was branded as sub-human, a Jewish invention aiming at the disintegration of the Nordic spirit – although none of the leading modern German painters was a Jew.

The National Socialist theory of art was the product of all this obscurantism. Early in 1934 Rosenberg was entrusted with the 'supervision of the entire spiritual and philosophical education and training of the Party'. From the first, these Nazis had made life hard for modern artists and organisations (the Bauhaus had been particularly persecuted); after Hitler's seizure of power, the attack on modern art became systematic. In 1933 modern-minded artists and museum curators were dismissed from government service, and the first exhibitions of 'Kulturbolschewismus' or 'Art in the Service of Disintegration' were held. In September, 1934, Hitler made his first Nuremberg speech against 'degenerate art'. A decree promulgated in 1935 required all exhibitions to be ap-

proved by the Reichskunstkammer. In another speech in Nuremberg, Hitler denounced 'the spoilers of art who belong in an insane asylum or a prison'. In 1936 the Kronprinzenpalais was closed. In 1937 all works of 'degenerate art' owned by public institutions were confiscated. July 1937 saw the opening, in Munich, of the 'Degenerate Art' exhibition, in which the most insidious devices were used to misrepresent modern art and hold it up to public ridicule. In 1938 a specially appointed commission sold the confiscated works of art and some were destroyed. In 1939 masterpieces collected over many years and ranging from Van Gogh and Gauguin to Braque, Picasso and Matisse, including German masters such as Barlach, Marc, Lehmbruck, Nolde, Kirchner and Klee, were auctioned off at Lucerne. Artists were persecuted even in the seclusion of their studios: the most important of them were forbidden to paint, the prohibition being enforced by police inspection. Modern art went underground, but remained faithful to its mission.

Above ground, the ghastly vacuum, the sound and fury of totalitarian art reigned supreme. In October, 1933, Munich observed a Day of German Art, and the corner-stone of the 'House of German Art' was laid. The Reichskulturkammer was founded in November of the same year. In June 1934 the Reichskunstkammer held its first meeting, presided over by two wretched and totally unknown painters. In April 1935 Goebbels issued a decree regimenting all artists and placing them under direct Party orders. No one was permitted to practise art outside the jurisdiction of the Kammer; the police were authorised to keep recalcitrants in line. Artists were told to produce a 'racially conscious' and 'popular' art, which would be understood even by 'the lowliest storm-trooper'. Exactly as under Russian Bolshevism, art was made the servant of politics: on November 15, 1935, Goebbels declared at the opening of the Reichskultursenat: 'The freedom of artistic creation must keep within the limits prescribed, not by any artistic idea, but by the political idea.' This government-controlled art was presented to a public full of foreboding at the monstrous exhibition held in the monstrous, newly-opened 'House of German Art' in Munich on July 18, 1937. Shortly before the opening, Hitler in person stormed through the exhibition halls, ordering the removal of eighty paintings – 'I will not tolerate unfinished pictures' – dismissing the jury members, and finally appointing his court photographer to administer the show. The result was – totalitarian, differing from Bolshevik art only in the uniforms; a glib, mendacious, stereotype realism, glorifying the Führer, the Party, War, Blood and Soil, Mother and Child, the Hero. There was even an assortment of muscle-bound nudes – both male and female – in illustration of the slogan 'Strength through Joy'. Such was the art of German totalitarianism!

Totalitarian art is the uniform style of all dictatorships. Just as every dictatorship mobilises the masses and destroys the freedom of the individual in order to consolidate its power, so totalitarian art recognises the average, mass mind as its absolute standard and excludes all individuality. A propaganda message is illustrated by a stereotype realism attuned to the visual habits of the masses, and the advocates of this style, like all sterile academicians and with as little justification, invoke 'the classics' or 'the great past'. Free inquiry is suppressed. Immediate utilitarian application is required. The innermost purpose is to destroy all faith in personal values and the individual mind, which is condemned as immoral, asocial, and destructive.

Art and style, however, are never static; they must always be discovered anew, and this task of discovery is always performed by the isolated mind and the spiritual community of individuals. That is why, as history has made perfectly clear, totalitarianism is incapable of producing art. In thirty years Russian 'Socialist Realism' has not produced a single artist or work of lasting value, although a considerable section of Western intellectuals looked towards Russia with hope and sympathy. Nor was German totalitarianism more successful, even though the artists of the Third

Reich were entrusted with 'the greatest commissions of all time'. It produced not a single memorable artist or work. The effects of the totalitarian onslaught were purely negative. It had no effect on art, because the pictorial expressions of totalitarianism were dead even before they were born. Art itself remained alive in the catacombs. Although more than half of Europe fell under totalitarian domination, European art remained essentially intact and advanced unswervingly on its path.

*Retrospect*

In the course of our survey of painting in the two decades between the world wars, we may have seemed to lose ourselves in a chaos of conflicting currents. But if we look back from a higher vantage point, a pattern emerges, and we observe that what seemed to be chaos was actually richness. Generally speaking, the period was marked by the occupation, cultivation, expansion, and unification of the domain whose two provinces Kandinsky termed 'the Greater Reality' and 'the Greater Abstraction'. The exploration started from two extreme positions – the magical 'thing' and absolute form – but in the course of it the extreme formulations were tempered and the possibility of a compromise was envisaged. This in turn helped the public, which, in the nature of things, is baffled by the isolated work, to understand the general direction of the movement. The cultivated classes began to accept the new art. In the early twenties, modern art came to be regarded as possessing real value and was discussed by a wide public.

A new orientation towards reality can be observed throughout Europe in the early twenties. It followed different, and frequently overlapping paths. At first the most important of them seemed to lead via Rousseau's magical experience of the thing and Pittura Metafisica back to old archaic and classical ideas. This current gave rise to the archaic realism and classical idealism represented in Italy by Carrà and Casorati, in France by Derain and the Picasso of this period, and in Germany by the Neue Sachlichkeit artists and Hofer. Since this movement drew on Mediterranean art – Greek and Roman antiquity, Giotto, Masaccio, Uccello, Piero – the Italians played a leading part in it. Their aesthetics, developed by the *Valori Plastici* group, was predominant. These artists sought to enrich Rousseau's means of expression by studying the old Italian masters whose art, like Rousseau's, reflected a primitive appropriation of the world, and to apply the insights thus gained to a new definition of reality. They broadened the initial positions of Pittura Metafisica. The result of their efforts was an archaic, classical, magical realism.

Starting from an entirely different position, Expressionism pursued the same objective. What inspired the creative artist was no longer an inner vision but things themselves and the emotion they aroused. This led to three types of painting. First, there was a dramatic and lyrical Impressionism of the kind practised by Kokoschka and De Pisis, who transformed the emotions aroused in them by things seen into visual poems and recorded them instinctively. Second, there was an expressive lyricism whose representatives – Chagall, Soutine, Modigliani, Scipione, Utrillo – listened to the music of things, brooded on the story they told, and fused thing and story into a poetic reality. Third, there was an expressive realism which isolated characteristic elements of nature and from them reconstructed reality: this tendency is illustrated by Beckmann and a good deal of Picasso. All these paths radiated from the centre of the Greater Reality, from the magical experience of the thing. Their goal was not to describe or reproduce reality, but to define and construct it. They marked a first approximation to an art expressing the contemporary conception of reality and proved that such an art was possible.

In seemingly diametrical contrast to this current, the other current flows from the centre of the Greater Abstraction. By inexorably eradicating all representational elements, it was possible to define form as the ultimate concrete reality. In working his way through Cubism, Mondrian traced the frontiers of his art. Similarly Kandinsky, after a period of Abstract Expressionism, arrived at the conception of the concrete reality of form.

Once the entire domain had been surveyed, the next step was to take full possession of it. Russian and Bauhaus Constructivism, De Stijl, and the currents merging in the Abstraction-Création group marked the way leading from the most rigorous geometric discipline to free form. Art stood on the threshold of an immensely rich domain. The principal aim was to produce an equivalent, not of reality but of universal harmony.

Thus the boundaries and the general topographical features of the two provinces were well defined. However, they were not isolated, but adjoined; in fact, the greatest artists were those who explored both sides of the boundary, simply ignoring the doctrinaire signposts of 'abstract' or 'representational' art.

This happened quite naturally and at the elementary level in the development of Cubism. The truth is that both in its analytical and in its synthetic stage Cubism was always close to the boundary line, since it extracted its harmonic structure from representational elements and its representational elements from the harmonic structure. At this point we find a reinforcement and accentuation of the intermediate position. It is reflected in the humanisation and 'poetisation' of Cubism by such painters as Léger and Braque or Schlemmer and Feininger. An intimate correspondence between representational and absolute form was achieved, and its end result was the object-signifying emblem, which may be said to occupy a central position, defining the outside world, but also relating to man's inwardness.

We have seen that in the case of some masters who were concerned with the construction of reality, emblematic signs emerged directly from the ground of their objective experience. From visible forms they evolved a pictorial script in which objects served as hieroglyphs of inner messages. Such masters were Picasso in France, Beckmann and Kirchner in Germany. They cleared a path which led from the heart of reality to the domain beyond reality. At the same time another path was opened, starting in the realm of inner experience. The Surrealists, particularly Miró, evolved a pictorial script in which pure forms and harmonies emerging from the ground of unconscious experience entered into formal relationships with objective shapes. Thus, at the heart of the psyche, they found a signpost pointing to the domain of reality.

Here at the point of intersection, a conception of totality and identity begins to take shape, a striving to encompass the two provinces in a single realm. It was here that the subtle mind of Paul Klee made itself at home. With an equally deep understanding of the form-creating forces of both regions, the natural as well as the psychic, he gained an intimation of the common ground in which all forms have their roots. It was he who came closest to the point where outside and inside cease to conflict. And this was the very point that art was looking for when, thrown back on visible reality, it began to have doubts when it found itself confronted with the task of giving pictorial form to the new, complex, post-Renaissance idea of reality characteristic of our own post-Renaissance epoch.

In those two decades we note the beginnings of a style of great range, spanning 'the entire domain of the pictorial elements, of representation, content, and style' – the style of which Klee dreamed – but only dreamed. For let there be no mistake: this style was not yet a reality. However, the threads of many individual efforts were gradually beginning to outline a recognisable pattern that would serve as a basis for future developments. The new generation of artists has been working indefatigably in this very direction.

BOOK V

The Contemporary Scene

Art since 1945

When hostilities ended in the spring of 1945, those who reflected on the European situation from the social, political, and philosophical points of view could not help wondering whether the deeper community of the creative forces which make culture and art possible in the first place, had not been destroyed in the general collapse. All they could see was the chaotic panorama: a vast army of refugees, of defeated and persecuted beings; wrecked social structures; two stubbornly contending doctrines of mass happiness, both of which seemed hopelessly compromised; conventions and beliefs that had become so threadbare through misuse that they had lost all capacity for regeneration. The three nations at the heart of Europe, which had created its art, seemed like burned-out organisms whose only remaining vital impulse was hatred. Germany in particular, its mind and soul undermined by the totalitarian virus, physically exhausted by war and famine, seemed incapable of any creative effort. But Italy and France were also gravely weakened by the infiltration of totalitarianism, the regimes of occupation and the underground struggle against the invaders.

The desperate post-war situation, in conjunction with the widespread mood engendered by the undermining of modern man's sense of reality, reinforced the escapist tendencies that have always been present in the European mind. A whole literature of cultural criticism came into being, which recommended – on the basis of strong religious, political, and humanitarian arguments – withdrawal to the secure old positions of European culture, and, by implication, the complete abandonment of all modernist efforts, in art as in everything else. The secure values were held to be: Christianity, humanism, democracy. Among the Germans – whose brooding mind easily falls prey to an extravagant romanticism and – as Clémenceau, inspired by his clear-sighted hatred, put it – 'a satanic longing for death', this negative attitude became particularly strong. Modern art was one of its main targets. In sharp and comprehensive analyses, Sedlmayr diagnosed 'the loss of a centre' – to his mind the salient characteristic of modern art – as the deadly disease of modern European culture. Hausenstein deplored the absence of a religious humanism. The kindly and circumspect Guardini asked whether the deep disquiet of the modern mind could not, after all, be overcome by a return to the Christian doctrine of redemption. In England this attack on modern art was carried on by Wyndham Lewis, in France by Weidlé. All this amounted to a condemnation of 'the rootless freedom' of modern culture, and a plea for a return to the tested ideas of Christianity, humanism, and democratic socialism.

The danger of these views should not be under-estimated, for when bandied about by crude thinkers they implied an identification of modern art with Hitler's 'degenerate art'. Almost automatically the inference was drawn that it was necessary to return to the great old traditions. The artist was faced with a difficult dilemma. Christianity, humanism – he recognised their claims in their own domain, but in his own field they could not serve as a basis for activity; at best, if he was lucky, they could result from it. The same was true of the democratic ideal. Politically, it goes without saying, the artist could fully support it, but the essential postulates of democracy – majority rule, determination of issues by the ballot – could not be transferred to the domain of art. A clear decision with respect to democracy involved complex and painful problems for the artist. Gottfried Benn in Germany and Alfred Camus in France pointed this out in no uncertain terms. The

position of the contemporary artist in the face of these demands was highly ambivalent.

Such demands derive from a false methodological approach. They are concerned not with what art is but with what it should be. They do not reflect a concern with existing works of art, with artistic expression as such: they do not spring from a serious inquiry into the ideas at work in modern art. Instead, it was decided in advance what direction art *should* take and works were judged according to this ready-made criterion. It is easy to see that a 'therapeutic' approach of this sort – however well-intentioned – would make for an unhealthy public attitude towards art.

But what was the reaction of art to all this? The fact is that it was not in the least affected by these extraneous ideas. The war itself and its aftermath had little or no influence upon art, but merely produced, in the vast majority of artists, a markedly negative attitude towards society and the manifestations of public life. Comparing the present with the period after the First World War, we are amazed at the persistent lack of response shown by the creative artists of our generation to world-shattering historical events – and their lack of response can only be interpreted as a withering comment on the spiritual significance of such events. The Spanish Civil War aroused tremendous indignation among Western artists, who saw that it involved an organised attack on human freedom; the Second World War aroused no response at all. The creative artist had long left war behind him. Now he cut himself off from the outside world, concerned only with his art.

During the First World War artists still tried to discover a meaning in the war, which they hoped would pave the way to a brighter future. Franz Marc who fell in the siege of Verdun regarded the war as a process of purification; he believed that 'a springtime of culture must follow this monstrous catastrophe'. The letters of this entire war generation are full of visions of the future – 'there will be fulfilment, some time in the future, in a new world' (Marc). The generation following the Second World War was very different – disillusioned, sceptical, lonely, it judged reality severely and attached value only to the present and in it to human life.

When we recall the conditions under which many artists worked during the Second World War, we cannot help being deeply stirred by the perseverance with which they pursued the work that alone interested them. This is most strikingly shown by the careers of the German artists who suffered, in hopeless isolation, the full weight of the National Socialist persecution of art. To take a few examples: while serving as a private in a unit stationed in France, E. W. Nay employed his few hours of leisure in developing a sumptuous colour scale and in transforming figurative elements into formal themes. On the Russian front and later during years of misery in Russian captivity, Fritz Winter developed his ideas; it was during a brief convalescent leave in the spring of 1944 that he produced his series *Driving Forces of the Earth* in which he gave abstract expression to his conception of man's accord with universal Being. Hans Hartung escaped from Germany in 1935 and was later imprisoned in Spain. After years of an underground existence he enlisted in the French Foreign Legion. Throughout his hardships he never lost sight of his objective, which was to record spontaneous psychic impulses in pictorial patterns. There was Wols, the tragic wanderer, who availed himself of the avenue of flight that still remained open to free spirits. In the fourteen wretched months spent in French internment camps at the outbreak of the war and then in hiding at Cassis and Dieulefit, he worked unremittingly to elaborate a pictorial script that would enable him to record his inner responses to existence.

The imperturbable faith of these men in the higher necessity of their work, which they carried on under the most desperate conditions, is one of the best proofs of the vitality of the ideas inspiring modern art. Drawing their strength from the innermost essence of art, these men stood fast against all official prohibitions or doctrines of salvation.

The true artist continued to assert the dignity and value of the isolated individual, fearlessly facing

up to his own existence and the new realities of the world and freely expressing his experience in his works.

This faith in freedom united the creative energies of Europe despite all physical and moral barriers. It alone accounts for the scarcely believable fact that after the end of hostilities, when it became possible once more to take stock of the artistic situation in European countries, a single common pattern stood out clearly. Far more strikingly than before the war, indeed, more than ever before, the work done in different countries seemed to form a European whole. Moreover, this unified pattern was vastly enriched by the unexpected developments which during the war had got under way in the United States. Thanks to the contribution of such artists as Gorky, Pollock, Motherwell, and Matta, the United States had become an independent and highly productive participant in the dialogue of international art. Everywhere, regardless of frontiers, art obeyed the same impulses, and what in the dark years had looked like desperately isolated achievements proved to be parts of a general organic growth. For the freedom asserted by art was not rootless; as the fundamental impulse of human existence, it had its roots in the spiritual conditions of artistic life itself, which in turn had experienced a growth of their own, in the long sequence of artistic ideas and works that began with Cézanne. The new generation took up the heritage in an unbroken line.

Needless to say, the external conditions varied according to the country. The situation was clearest in France. The German occupation had not affected the spiritual structure of the nation. The exhibitions of the leading masters held at the end of the war – Picasso, Braque, Léger, etc. – sufficed to mark the positions thus far attained. The younger men who had come to the fore shortly before and during the war, had all gone through roughly the same development – from a representational to an almost non-objective form of expression. They formed a group round Bissière, Bazaine, and Manessier. Joining forces with the advanced tendencies of the pre-war Abstraction-Création group, they now began to play a more and more important part in the French artistic scene. The idea of 'concrete art' was further developed by Vasarély, Mortensen, and Dewasne, while Hartung and Soulage, Wols and Fautrier worked in the direction of 'psychic improvisation'. In 1947, when the various modern tendencies demonstrated their unity at the first Salon des Réalités Nouvelles, it became clear that a far-reaching reappraisal had taken place in French art. Abstract painting, which had hitherto led an obscure existence in France, had become the dominant stylistic expression. It has preserved this preponderance to this day.

German art was a completely unknown quantity. The spiritual and social structure of the country had been destroyed; its cultural continuity and communication with its neighbours had been broken by totalitarian fiat. And the masters who might have been regarded as its moral authorities – Klee, Kandinsky, Kirchner, Beckmann – were dead or in exile. In this desperate situation, the underground unity of the spiritual impulses of the European nations asserted itself with the most amazing force. Although outwardly cut off from other countries, the new German art was oriented by the same energies as that of other countries. It was helped, of course, by those artists – Baumeister, Nay, Winter, Gilles, Werner, to mention only a few – who during the years of persecution had persevered unswervingly in their task, and whose work, still in process of development, was now once more on exhibition. In painting, ties with the pre-totalitarian past were quickly restored. When Ludwig Grote arranged the unforgettable Blaue Reiter and Bauhaus exhibitions in Munich in 1949 and 1950, he was motivated by the same impulse as the new artists. This was confirmed as soon as it became possible to survey the artistic scene. It could not be doubted that German art, including that of the younger generation, had its place in the unbroken development of modern art, and that here too the most significant forces were in the abstract camp.

The situation was no different in Italy. The threat of provincialism and nationalist traditionalism that had hung over the Italian art world in the period between the two wars was quickly dispelled by a vociferous revolt of the younger generation. The sense of reconquered freedom found an outlet in an unrestrained 'Storm and Stress' period. In 1947 the leading young artists gathered in the Fronto Nuovo delle Arti. At that moment they still followed a path intermediate between representational Expressionism and pure abstraction. But scarcely a year later a new split occurred. Such painters as Guttuso and Pizzinato followed the call of 'Socialist Realism'. The majority, however, including such men as Afro, Birolli, Santomaso, and Vedova, set out resolutely to elaborate abstract means of expression for their sensations and emotions. And at first the ideas connected with geometrical Constructivism and 'Concrete Painting', which such painters as Magnelli and Soldati had already taken up in the thirties, seemed to be gathering strength. In 1948 the Movimento Arte Concreta was founded; its exhibitions were an exuberant counterpart to the Paris Salon des Réalités Nouvelles. Thus the new Italian art also turned to abstraction – a highly unexpected development in view of its antecedents. Soon after the war England began to make a highly original contribution to Western art. Combining their own original developments of Surrealist ideas with the ornamental fantasy of early English art, a number of artists, including the sculptor and graphic artist Henry Moore and the painters Sutherland, Bacon, and Alan Davie, arrived at a style of their own, characterised by mythical figures and strange metamorphoses of objective forms. These artists transposed their experience of the magical element in nature into thing-like or anthropomorphic forms which functioned as metaphors for their Panic animism. They were enabled to achieve these results by intensifying their abstract idiom and making use of Surrealist automatism. This mythical, metaphorical transmutation of reality, which we shall describe in greater detail later on, is England's central contribution to the painting of the present day. It is complemented by developments originating in Cubism. Ben Nicholson, with his rigorous, masterful style, carried on the leading ideas of Synthetic Cubism and Purism and demonstrated the richness of their pictorial possibilities. Immediately after the war, young painters such as Colquhoun, MacBryde, Le Brocquy, and Craxton took the expressive Cubism developed in the thirties by Picasso and Miró as a basis for their personal expression. In the early fifties the trend towards abstraction became increasingly pronounced. Pasmore turned to 'concrete art'. Hilton and Lanyon transposed experiences of the landscape into abstract forms. Bryan Wynter, Heron, Turnbull aimed at a meditative mode of abstract expression, emphasising psychic impulses. Here the liberating influence of American painting, and in particular of Pollock, De Kooning, Rothko, and Tobey, is clearly discernible.

For at the end of the war the United States had also made its appearance with a powerful and highly original contribution. During the war a group of New York painters, fascinated by Surrealist automatism, had turned to abstract painting as a means of recording their psychic impulses directly. Their pictorial thinking revolved around the idea of 'psychic improvisation', conceived by Klee and Kandinsky before the First World War. Robert Motherwell supplied ties with the liberating ideas of Dada and abstract Surrealism, which showed Gorky the way to his mythical figure improvisations and enabled De Kooning and above all Pollock to devise their powerful techniques of instinctual expression. The result was the monumental, spontaneous variety of abstract painting which we know today as Abstract Expressionism or Action Painting. A complementary tendency, starting from the same presuppositions, was provided by the meditative art of Tobey, Rothko, and Gottlieb. Towards 1950, the new American painting began to be known in Europe, and proved enormously inspiring to many of the younger European artists. American

conceptions merged with the ideas of Wols, Hartung, and Fautrier, whose 'Art Informel' was also based on psychic improvisation, to form one of the fundamental positions of contemporary modern art. New abstract painters made their appearance everywhere. In 1949 the 'Cobra' group gave its first exhibition in Amsterdam. Its leading lights were Karel Appel and Corneille, both Dutchmen, and the Dane Asger Jorn. They too trusted in the evocative force of pure coloured forms; they too tried to make their materials speak, and sought, by automatist procedures, to release the images stored up in the unconscious, though they sometimes made use of objective elements. In Spain too — in Madrid and Barcelona — an expressive painting of great dramatic power, based on abstract forms and the evocative possibilities of the materials, has developed in the last decade; its leading representatives are Tapiès, Saura, and Millarès. Even in the Communist countries where the official doctrine of 'Socialist Realism' has impeded the free development of art, abstract painting has risen to the surface. This has been evident in Yugoslavia, and in the last few years the movement has gained amazing power in Poland.

From a purely objective point of view, it is undeniable that the predominant trend in the Western art of today is abstraction. But it still remains for us to discover exactly what is meant today by 'abstraction' in art.

The conspicuous predominance of abstract painting has been matched by a no less conspicuous shift in aesthetic evaluations. The new saints were to be Kandinsky and Mondrian, and the name of Klee was suddenly on everyone's lips — a particularly surprising phenomenon in the case of Italy and France where very few of Klee's paintings were to be seen. The Surrealist idea of automatism played a part. Miró's figurative pictorial script and Léger's massive emblems of things became extremely important, and, needless to say, Picasso but, significantly, only the Picasso of the expressive period, culminating in *Guernica*, in which he made use of large ideograms.

This reshuffling of aesthetic values clearly reveals the nature of the new task facing contemporary art. It was a task implicit in the continuity of the modern development. Between 1920 and 1940 everything implied by such names as Mondrian, Kandinsky, and Klee — abstract painting in all its varieties, even the variety that found formal analogies to the objective world — had remained in obscurity. The centre of attention was an art that sought to define reality with the help of images drawn from reality. Now the situation was reversed. It was not that any less importance was attached to the definition of reality, but that abstract painters began to take a deeper interest in this very problem. They began to formulate clearly what in the past they had only dimly suspected, namely that abstract painting was also concerned with the creation of realities; harmonic realities existing in their own right, and expressed by structures of form and colour; psychic realities expressive of man's inner world; and realities relating to the outside world, reflecting modern scientific insights. For this reason, artists now sought to avoid the epithet 'abstract' in describing their works; they preferred and stressed the term 'concrete' and spoke of *realités nouvelles*.

This insistence on theoretical clarity is highly characteristic of the artist's new image of himself. He feels that his task is to translate his actual existence into pictorial realities, and instead of merely accepting the visible world confronting him, to interpret it in the light of modern knowledge. He regards his activity and its result, the work of art, as a highly speculative phenomenon. Intuition is the beginning of the creative act; it sets in motion a controlled formal mechanism which can be verified at any moment. At the end of the operation every intuitive impulse has been converted into visible finished form. Intuition and clear-minded speculation form a synthesis which can also be found in modern poetry (Benn), in modern music (Schönberg, Von Webern, Messiaen), and even in systematic thinking (Heidegger).

315

Visible reality is probed speculatively with the same intensity as the genetic processes. Nature, too, becomes a speculative phenomenon, conceived in purely abstract terms. The new scientific view of the world, in which substance is identified with energy, space with time, and finitude with infinity has profoundly influenced the modern artist. He believes that new scientific concepts, such as sub-atomic structures, the field of energy which has taken the place of matter, and dynamic energy which has taken the place of things, require that he should contemplate not the finished outside forms of nature, but its dynamic energies, its active essence. It is in these that he finds his creative stimuli. Where the energies of nature are harnessed to serve society, in the world of technology and the machine, the imagination is now less stimulated by the cool precision and economical strength of the visible technological forms than by the invisible dynamic processes. Purism and Léger conceived of the machine as a thing and used its visible forms to signify this alien individuality; the painter of today has a better understanding of the energies and circuits concealed in the machine, and seeks to express these in pictorial form. But if in a romantic mood he goes outdoors, he soon discovers in the images of nature subtle diagrams picturing organic and motor processes. In the veins of a tree he sees a diagram of growth, in the cracks of a rock a diagram of disintegration. The grooves in sand dunes are nature's own way of transposing the wind's action into a drawing, and the delicate patterns in the sand of a river-bed are a precise translation of the process of flowing. The painter who wishes not to represent the finished forms of nature – tree, river, sand dune – but to understand and express the dynamic energies that generate them – the processes of growing, blowing, flowing – will pick these diagrams from the confusion of natural data and take nature's productive activity as the basis for his conceptions and formal ideas. He understands the productive activity of nature in terms not of things but of actions.

The new realities that the painter perceives in science, technology, and nature encourage him to abandon the 'biological' domain which no longer seems the only real and possible field of action, and to base his formal meditations on these new abstract realities. But there is – and to give full weight to this idea I should like to borrow Guardini's apt formulation – there is 'a kind of indirect feeling which makes elements that can be conceived only abstractly a real part of our own life'. For these abstract realities can become so much a part of our own existential zone that we 'possess' them, and they manifest themselves as activity and gesture on the canvas, giving us a sensation of truth, of sudden recognition. But we must not put undue emphasis on impulses stemming from the contemporary environment. The painter has his own inner world, he is in direct communication with the ground of reality, which is also the object of scientific investigation, of our quest for knowledge. The painter does not discover, he re-discovers. 'When we move from this contemplation (of the pure world within us) to nature, we find that everything in it is quite familiar to us, and we have sure knowledge of every form.' These profound words of Novalis are eminently applicable to the modern painter and bear witness to his link with the ideas of the Romantics. The style that is emerging today is the 'cool romanticism' of which Klee spoke. The old Romantic problem – the problem of the relation between subject and object – is raised anew in more urgent terms by contemporary realities. And again the solution is sought in a unity of the two. Today abstract painting is the favoured method of achieving this identity by artistic meditation.

However, the emphasis on abstraction in modern art must not make us forget that this method is only one among others, and that one reason why it has attracted so many artists in recent years is that its possibilities have not yet been fully explored. The visible world will always be

with us. Although today its power to generate new ideas and forms seems greatly diminished, it still exists and occasionally provides unexpected new impulses. These cannot be ignored in an analysis of the present situation, a situation still characterised by the basic dialectical tension between object and form.

*Visual Reality in the Service of Ideology. L'art engagé – L'art dirigé*

We have just seen how society has confronted the modern artist with moral, religious, and social demands, urging him to define his attitude towards them. The implication, in such a dialogue with 'society', is that he must formulate his position in terms intelligible to the public at large – in the case of painting, in familiar symbols and legible images of reality. Since painters are not only artists but also members of society, they have not on the whole shut their eyes to this question. The more deeply social life became entangled in guilt, hypocrisy, and misery, the more urgent it became for the artist to express his beliefs, or even to employ his art as a weapon. The idea of art for art's sake began to lose ground at the very dawn of the modern movement, and modern art as a whole has actually been opposed to it. In the first years after the war, when Europe was hovering on the brink of extinction, the question of '*art engagé*', of commitment in art, was passionately discussed. Since then it has been on the wane.

In the field of literature, where content plays a more significant part than in painting, it was relatively easy to take a position. Here too, of course, form played a part, but the question that essentially concerned the writer was whether his action should be based on inner freedom or on convictions concerning human welfare. It was chiefly on two fronts that the positions were crystallised. The first was religious and humanitarian. Catholic writers such as Paul Claudel, Bloy, Péguy, and Bernanos opposed the camp of Paul Valéry and André Gide. The conflicting attitudes were clearly defined in the correspondence between Claudel and Gide, which has recently become so famous. One party asserted that the deepest moral and religious 'commitment' was the prerequisite for significant literature; the other insisted on creative freedom. In his last work, *Mon Faust*, Paul Valéry once again drew the portrait of the man who creates his work in the serenity of his own equations, beyond all dualism between God and the devil.

The second front was political and social. Here Left-wing intellectuals, grouped around men like Aragon and J. P. Sartre, were opposed by writers such as Albert Camus, who 'in the name of the human passion for everything specific and unique in man' advocated 'rejection along the entire line. The first decision of an artist is to be an artist; it is based upon the idea of what he himself is, and upon a specific conception of the essence of art. By its very existence, the work of art negates all the conquests of the ideologies.' Needless to say, these controversies about 'commitment' were not confined to France but were carried on independently in other countries. In Italy, Elio Vittorini, an outstanding young poet, and a thinker as astute as Felice Balbo were partisans of 'commitment', one in the social, the other in the religious sense. In Germany, Gottfried Benn hit back with cynical sharpness at the champions of political, Christian or humanitarian ideologies, and denied the regenerative value of their ideas. This debate on the artist's commitment is of the utmost importance, for it has set in motion a dialectical process that is sure to continue for many years to come.

Painting was also drawn into the debate. Here the situation was far more complicated, for not only the content, but also, and in greater measure, the formal idiom itself was at stake. To what

extent, for example, could abstract painting communicate religious, moral, or political meanings? Is not such painting a mere playing with form, that cannot commit anyone to anything? Does not communication demand a more or less realistic idiom? Well – 'commitment' was not new in modern art, and I am not referring only to social criticism such as we find in the German Verism of the twenties. The icons of Rouault and Jawlensky had their source in the deepest religious 'commitment', Picasso's *Guernica* and Kokoschka's political paintings sprang from a moral and social 'commitment', and Mondrian's meditative art from a vision of the society of the future. Official Surrealism had 'committed' itself politically as early as 1930. Thus the possible styles of *art engagé* ranged from Verism, through Expressionism and Surrealism, to absolute painting. Nevertheless the desire of young painters to give a universally valid content to their art complicated their search for form.

Furthermore there was a growing resistance to the absolute school of abstract painting with its increasingly emphatic rejection of all 'content'. Even before the war a movement expressing spiritual values and emphasising content had been launched by a group of young French painters. The group around Bissière, including Manessier and Le Moal, and the short-lived 'Témoignage' group, advanced ideas that had remained alive under the surface since the days of Sérusier – ideas derived from Christian mysticism, Neo-Platonism, and Thomism, which naturally turned the artists' attention to mediaeval painting and its lofty symbolism. For a time it seemed as though 'commitment' actually led back to tradition and to representational signs. An exhibition held in 1941 entitled 'Young Painters in the French Tradition' presented a group of young painters who seemed to be working in this direction. It included Bazaine, Estève, Gischia, Lapicque, Le Moal, Manessier, Marchand, Pignon, Singier, and Tal-Coat. Their works were emphatically modern in appearance: the conception of space was Cubist, the colour was Fauvist, and the deformations were Expressionist. But they manifested an almost programmatic tendency to the representational, drawing inspiration from Romanesque painting and sculpture. Was, then, representation the only way to a more deeply meaningful art?

The opposite turned out to be the case. The most deeply 'committed' painters – in particular, Manessier, a practising Catholic, as well as Bazaine, Singier, and Le Moal, who were more inclined to pantheism – were driven increasingly to the use of abstract signs. The development was almost inescapable, because abstract conceptions simply could not be illustrated by representational methods. All these painters ended up with abstract emblems in which man could not recognise things or scenes, but only his own thoughts. The idea that 'commitment' implied the use of representational forms proved false.

The same development took place in Italy, where the debate centred round the human content of art. In 1945 a *Manifesto del Realismo* was issued; its signatories included such artists as Morlotti, whose ideas had nothing in common with the usual conception of realism. It is highly significant that these artists regarded as realists the masters who had struggled for a definition of reality in the period between 1920 and 1940, Picasso and Léger, for example. In 1946 the Fronto Nuovo delle Arti was founded. It included Guttuso, Turcato, Birolli, Cassinari, Santomaso, Vedova, Morlotti, and Pizzinato. Although this group tended towards abstraction, references to human and social realities played an important part in their manifesto. As late as 1947 such painters as Corpora and Turcato signed a statement calling for resistance to abstraction and for preservation of human and objective values. But here again the subsequent development showed that the expression of human meanings did not necessarily call for representational painting. Corpora, Vedova, Turcato, Santomaso were all driven by an internal necessity to adopt an abstract

idiom. As for Germany, we shall mention only Georg Meistermann. A practising Catholic and hence 'committed', he can only express his faith and the tension between faith and life by resorting to abstract form.

We have seen, then, that the trend towards a representational art that seemed to have been initiated by the debate on *art engagé* was short-lived. The assertion that abstract painting fled from reality, that it was 'escapist' – a term that cropped up frequently in the course of the debate – was not borne out by the facts. Abstract painting was quite able to assimilate all the great ideas of mankind, so proving that it was not art for art's sake but art for the sake of man, *l'art pour l'homme*. On the other hand, the realistic efforts of 'committed' artists have so far failed to produce results worth mentioning. This is particularly and painfully true of religious art.

So far we have dealt with *art engagé* that drew its content from universal ideas and beliefs. But then we come to politics, the world of political totalitarianism. The Leninist-Stalinist state had seized control of art as of everything else, and on the assumption that one of the state's tasks was to educate artists, had decreed 'Socialist Realism'. This resulted in a new variety of 'committed' art, *'art dirigé'*, an art controlled by the state. Speeches by Communist leaders and their cultural aides-de-camp monotonously echoed the demand for 'an art understandable to the working population, which gives it pleasure and educates it ideologically'. The result was totalitarian pseudo-realism. Wherever Communist power penetrated – and this includes East Germany – art was quickly regimented under the terrible pressure of the state machine. Where it did not penetrate, as in Western Europe, the Communist Party ideologists attempted to win over the artists by appealing to their love of the people, country, family, tradition, and sense of human fellowship. If this primitive demand for realism found a certain audience among Western artists, it was no doubt thanks to the undeniable merits of Communism in combatting its brother enemy, Fascism. The modern artist was by his very constitution anti-Fascist. In the Italian *Brigate Garibaldi* and in the French *maquis*, many artists admired Communist militancy. After the war a not inconsiderable section of French and Italian artists sympathised politically with Communism. The West German artists, who because of their experience of state-controlled art and their proximity to the East had become sceptical towards the aesthetics of Communism, remained relatively immune, and took virtually no part in the debate on 'Socialist Realism'. Most French and Italian artists were sufficiently sure of themselves to dismiss the cultural and political demands of the Party as bureaucratic nonsense, and while continuing to sympathise with Communism, to ridicule the stereotype praises of Soviet art, published by the Communist press. Indeed they could point to better models than the proffered 'tradition': a derivative Western realism in the style of Ryepin. In this attitude they were encouraged by Picasso and Léger, who professed Communism but had no intention whatever of accepting party control. Nevertheless, a number of young artists certainly succumbed to an ideologically inspired realism, particularly in the first post-war years. In every case the results were inferior, and this applies not only to the younger artists, but also to the Picasso of *Massacre in Korea*, and the Léger of *Constructors*. It was only when, in the last years of Stalinism, the party increased its pressure and made an all-out effort to impose its 'realism', that one artist after another refused to follow. It was then (towards 1950) that the term 'homeless Left' became a byword in Western studios.

Only a few genuine artists complied with the party doctrine. In Italy, there was the small group led by Renato Guttuso. This passionate Sicilian, a genuine descendant of Verga, fanatically devoted to all the oppressed and persecuted, had played a leading role in the anti-Fascist underground in Rome. His art had always been inspired by a passionate human commitment, which had led him

to Van Gogh and to Picasso's late period. Obsessed by the horrors of war, he was impelled to describe them in a wildly tragic style. His scenes of war, murder, and struggle suggested the simple belief of the Sicilian peasant that the persecuted are always right because they are always more human than their persecutors. His descriptive, moralising tendency made it possible for Guttuso to accept the doctrine of 'Socialist Realism', though at the expense of his artistic insight. But his monumental, ponderously realistic propaganda paintings still carry a legendary power which has its source in Sicilian folklore, and in unconscious recollections of Sicilian peasant art. Where this archaic power was absent, the result was a mediocre pseudo-realistic descriptive art. This is what happened to the talented Venetian Armando Pizzinato, who started from Picasso, then shifted to an abstract Futurism, and finally adhered to the party line.

In France the example of Picasso kept most of the Communist sympathisers among painters from falling into the party's aesthetic line. Even when Edouard Pignon treats Socialist subjects, he paints in a vigorous Expressionist style, moulded by Picasso. In his eyes this is realism. 'To my mind,' he says, 'art is *bound* in the literal sense of the term to life, to reality, and to the public, and I regard everything that tends to separate art from reality as a kind of negation of life, as death.' And at the same time he goes on painting in the style developed between the two wars by the masters who sought to conquer reality. Only André Fougeron and his followers accepted 'Socialist Realism' in the literal sense. Like Pignon and Marchand, Fougeron took Picasso's forms and Matisse's colour as his starting point. Then he became involved in the revolutionary movement while working as a coal miner in northern France, and when the party ordered him to paint in the style of 'Socialist Realism', he complied. At present he favours large historical works in the style of nineteenth-century patriotic art, but his unmistakable affinity with the naïve painters and their deep grasp of reality is revealed in many details.

All in all, the realist trend originating in *art dirigé* was not too strong. Art could not survive in the straitjacket of political concepts and plainly ridiculous equations ('formalism' and abstract painting = bourgeois decadence and capitalist imperialism; realistic painting = regeneration and socialism). However, the example of Guttuso suggests that when such realism is combined with an authentic traditional substance, a vigorous reaction is possible.

This is what had happened in Mexico. In that country, shot through with archaic and primitive energies, the conjunction of ideas about freedom, and the discovery of modern Western art, led to the sudden flowering of a popular and realistic Mexican art. The movement was begun by Rivera and continued by Orozco, Siquieros, and Tamayo. The European and American art world holds this Neo-Mexican school in high esteem. We cannot say whether this process will be repeated in other nations that are still close to primitive and archaic sources, and to what extent these impulses will eventually influence world culture. It is not unlikely that in the world culture of the future, realism will be the domain of the more primitive extra-European peoples. However — and with this we return to a basic idea we have long been pursuing — the realism that comes to the surface from primitive strata reflects the very same will to define and reconstruct reality as inspired the modern European masters we have discussed above. This seems to be proved almost irrefutably by the fact that Orozco and Tamayo were able to make use of forms created by Picasso, and that Siquieros drew on the Surrealist idiom. Their realism has nothing in common with the Soviet realism contrived by the political simplifiers, but it has a great deal in common with the mastery of reality achieved by modern European painters, with what Beckmann called 'transcendent realism'.

The term 'transcendent realism' is useful because it denotes the traditional foundation with which Picasso and Léger, Beckmann and Kirchner provided the new generation of artists who, on this basis have been able to transform, transpose, and interpret visual reality in the light of their own experience. Here we have a vast field in which a great number of talented artists have been active. Nevertheless their contribution must in general be characterised as a consolidation and broadening of previously conquered positions, as a process of assimilation often accompanied by mannerist repetition. The great artists who initiated the new 'mastering of reality' have exerted a lasting influence.

In French painting this style of realistic Expressionism is clearly revealed, especially in the years immediately after the war. It was Matisse, and above all the overwhelming genius of Picasso, with his Expressionism of the mid-thirties, who pointed the way. In order to preserve a measure of independence in the face of this fully-formed style, many talented artists looked to nature for support. Even before the war François Gruber, a pupil of Friesz and Waroquier, and André Marchand followed this line – Gruber in a sensitive and expressive naturalism, which deformed visual appearance as little as possible and sometimes resorted to Surrealist metaphors, and Marchand in a Constructivist style that broke up the forms of objects and rebuilt them from elementary signs. The range defined by these two painters is approximately that of a group of young artists who in 1937 presented their works in a collective showing labelled 'Forces Nouvelles' and attracted some attention by their proximity to nature. But only for a short time, because immediately after the war these naturalist impulses began to dwindle, crowded out by decorative, expressive, and abstract elements. This led to an attempt to extend the monumentalism of Picasso and Matisse in an abstract direction, an attempt which revealed the tragic inadequacy of this whole school. Every deviation from the magnificent synthesis of Picasso and Matisse brought a loss of power and richness and led inevitably to mannerism. None of these highly talented painters who practised realistic Expressionism – Marchand, Clavé, Pignon, the early Fougeron, Léon Gischia – avoided this danger. They held a position previously attained, but they were unable to advance. Representational art proved inadequate as a vehicle for new forms.

A similar constellation is found in Italy. Here too it was Picasso whose vision of reality encouraged a few painters to employ representational signs in a personal way. This had deeper effects in Italy, because the Italians with their bent for archaic construction and their feeling for solemn forms, were better able to avoid the pitfalls of decoration and superficial painting. Birolli, Cassinari, Morlotti, and Zigaina have been working in this direction. In fact they were the first to introduce into Italian pictorial thinking the idea of an Expressionist mastery of reality in the tradition of Cubism. But the disintegration of the Fronte Nuovo in 1948 showed clearly that this was a transitional position on the way to an abstract, hermetic art.

In Germany the traditional foundation of this current in contemporary painting has been provided by Expressionism and its transformations. Some artists have been influenced by Picasso, but the main line has been a development of German Expressionism. Powerful new formulations have been rare. Even before 1933 a group of Hamburg artists led by Rudolf Nesch and Karl Kluth had worked in this direction, finding their tradition in Kirchner and Munch. Nesch, who has lived in Norway since 1933, continued along the path shown by Kirchner towards the expressive hieroglyph; later he found an evocative medium in the technique of the metal colour print and derived his subject matter from the Norse world of dreams and ghosts. Accidents and Sur-

realist use of material lured his imagination along unknown paths. He has developed a highly original representational script for his legendary contents. His method of making forms and signs emerge from his material points is in a direction similar to that taken by Jean Dubuffet and Asger Jorn. Similar phenomena might be listed from all countries. But they would merely show the same trend towards abstraction from the natural forms of Expressionism, Cubism, and their combinations. This was the predominant development among the younger painters in the first years after the war.

Thus representational art in the post-war period managed to develop as far as Expressionism. But no further. From an historical point of view, this representational Neo-Expressionism has performed a useful function by preserving past conquests. Even though it inevitably involved manneristic elements and many of its products were shallow and conformist, it firmly held the positions attained on behalf of visible reality in the preceding two decades and so kept alive the dialectic play between object and form that maintains modern art in a state of tension. But so far it has failed to produce a new vision of reality.

Surrealism has also proved unable to develop its Veristic aspects. In 1947 when the International Surrealist Exhibition was held in Paris, and in 1954 when Veristic Surrealism was once again fully represented at the Venice Biennale, it was only too apparent that its substance had been consumed by the developments in Expressionist and abstract painting. It had scattered seeds in all directions and all that was left of it was the convulsive, eccentric tone created by a deranged sense of reality. Dali who devoted himself increasingly to religious subjects, Delvaux, and Magritte continued, in ever renewed metaphors, to revolve around the old Surrealist obsessions, unable to escape from the magic circle. There were new names and powerful statements, such as the wild mythical totemism of the Cuban Wilfredo Lam or the Chilean Matta, but these two painters drew on other, more primordial sources. Similarly the French painter Victor Brauner, with his mythological figure paintings so clearly reminiscent of Maya miniatures, was not a true Surrealist; it would be more accurate to say that his art reflected his exotic and archaic interests. The astonishing mythical figures of Moore, Sutherland and Bacon are genetically related to the basic ideas of Surrealism, but the actual work is so far from Surrealist Verism that it must be regarded as a distinct phenomenon.

Often the example of the masters proved too overpowering and the result was repetition. In Italy Leonor Fini did variations on Max Ernst's jungles, and Minassian painted Surrealistically deformed objects in the tradition of Pittura Metafisica. In Belgium Octave Landuyt took up the Surrealist anxiety metaphors from the insect world. In Austria Rudolf Hausner combined elements of De Chirico's Pittura Metafisica with Surrealist Verism. With the help of Max Ernst's evocative techniques Christian d'Orgeix in France and Richard Oelze in Germany developed their otherworldly landscapes in which anthropomorphic sharpes sometimes emerge. In Germany, in particular, where Surrealism had never really prospered, the younger generation turned to it in the years following the war. A group of young Berlin painters – Zimmermann, Frankenstein, Thiemann, and Trökes – have employed the Surrealist stock-in-trade: alogical fragments of reality and dreams. But the group kept curiously clear of the trenchant Verism and pure automatism of classical Surrealism, for the secret proximity of Paul Klee continually recalled them to a more conscious attitude towards form. Today they are all far closer to Klee than to Surrealism, which seems to have exhausted itself distributing ideas and insights in all directions. Its least fertile aspect proved to be the Veristic one, the most fruitful the abstract tendency represented by Miró. For there can be no doubt that the Surrealist techniques of automatism and psychic improvisation, designed to set free

the images of the unconscious, have been of the utmost importance. They saved the new abstract trends in painting from degenerating into decoration and gave them a new expressive power.

Here and there, all over Europe, a representational art, immature in style, has made its appearance, not too emphatically, but sounding a note never heard before. It is as though a few individuals had broken away from the general current, trying, entirely on their own and on the basis of their own human experience, to recollect the solace of nature. In the simple existence and formal succinctness of the thing their sensibility discovered a melancholy analogy vibrant with the tears and sorrows of the European soul. Harking fraternally to the messages of silent things, Morandi had struck this note in Italian painting. Mafai had confided his sorrow to nature. This was not forgotten by the young Italian painters. At Italian exhibitions immediately after the war, one often encountered a quiet, lyrical vision of reality, exemplified more particularly by Tamburi, Scialoja, and the group of young Roman painters around them.

In France, this poetic representational art, affected by the mood of existentialist philosophy, took on an almost programmatic character not quite in keeping with its spirit. Gruber and Lorjou were the first to express man's solitude in the midst of things by a concise realism. An exhibition of painters under thirty held in Paris in 1948 showed that young artists had again become sensitive to the lyricism of things. A group was formed including Rebeyrolle, Minaux, Mottet, Venard, and Bernard Buffet and calling itself 'L'homme témoin'. But what these painters bore witness to was the emptiness of the world, the desolation of things deserted in the ghost-like barrenness of space, man's vulnerability. This pictorial equivalent of existentialism had a peculiar affinity with the figures of the sculptor Giacometti, which are completely eroded by the power of space. Young Buffet found the strongest expression for this mood of disappointment, renunciation, disillusionment. In murky, livid tones he paints sober emblems of cheap objects in desolate interiors: a broken chair, a kitchen table, and, on top of them, faded, tired things which have lost all cohesion and are kept from falling apart only by a network of dry lines. Drawn figures as lonely as the things occasionally form a scene – a Pietà, a Crucifixion – evoking the wretchedness of man's estate.

This concern with the image of visible reality made itself felt intermittently but persistently. In England a realistic counter-movement seemed in the mid-fifties to halt the general trend towards abstract painting. In 1953 and 1954 a group of young painters – Edward Middleditch, John Bratby, Jack Smith, and Derrick Greaves – showed their paintings at the Beaux Arts Gallery and in 1956 at the Biennale. There is no doubt that they were encouraged by the example of the young French Neo-Realists. A more important influence however, was the surprising element of Verist realism that can be discerned here and there in Sutherland's painting, especially in the portraits. For the realism of this English group started from Surrealist assumptions. In Middleditch's well-known *Pigeons in Trafalgar Square*, the square takes on a strangely unstable, theatrical quality and the displaced flagstones on which puddles have formed, give one the feeling that the base of the monument has begun to crumble and will soon give way completely. In 1956 Jack Smith painted a series featuring shirts hung out to dry and various items of underwear. These objects take on a weird, haunting personality, like victims of some weird Kafkaesque crime. In Bacon as well we find this same sense of a twilight reality. And even in the crude Expressionist realism of John Bratby, the most robust of the group, we find these strange dislocations of figures and space. In general we may say that with all their 'realism' these painters do not so much describe reality as question it. Their reality takes on a metaphorical quality. But this means that their recognition of reality, without which there can be no true realism, was itself subject to doubt. In point of fact this English romantic Neo-Realism, like its French counterpart, was a mere episode.

This commiseration with things afflicted found its most moving expression in the late work of the American painter Ben Shahn. After the war he moved steadily away from the serene optimistic faith of his earlier pictures. The colour becomes dry and hectic, the line thin and spare, and we find the succinct, naive definition characteristic of children's drawings. The space becomes flat and strangely unstable. In this scant, unstable space are enacted scenes full of profound melancholy, which in representational metaphors, express human suffering in a disintegrating world. The protagonists are timid, forsaken children, or jugglers and acrobats, or members of the lonely crowd disguised as middle-class citizens. And the role of things is no less important. Simple, every-day objects dangle like marionettes from thread-like lines, playing out a sorrowful fable of the instability and fragility of all existence.

A strange feature of this 'existentialist' realism is that the sober image of the object itself illustrates man's hesitation in the face of things and the uneasiness they cause. Things carry the artist's feeling, but they carry it away from the world of things. They allow the artist to sound them, but the sound they give off is hollow. His sensibility withdraws with a shudder from their alien coldness and, offended, confused, and anxious, seeks refuge in poetry. These objects do not suffer direct contact, one can approach them only by way of poetic metaphors.

*Anglo-American Voices – The Myth of Reality*

This uneasiness in the presence of reality found an original expression in England. Cut off from the continent by the war, English artists had been thrown back on themselves. The younger generation's feeling of despair at having been hurled into the absurd, paradoxical, anachronistic situation that had arisen in Europe, made for an unprecedented freedom. Shorn of all traditional presuppositions, each man found himself privileged and condemned to face up to the tragedy of human existence as an individual. The young artist was driven to work out his relation to his own reality and express it as directly a possible. English artists became more conscious than ever before of the dark side of life, of the spectral, terrifying, crepuscular aspects of the world.

This went hand in hand with an intensification of the specifically English qualities in English art, the hallucinated romantic animism and ornamental fantasy characteristic of the English tradition in art. One is reminded of Ezra Pound's remarks in the Vorticist *BLAST* of 1914, about the 'primitive and primordial', the 'mysticism, madness and delicacy peculiar to the North', about the 'tragic humour', the 'insidious and volcanic chaos', which, he believed, are present in all great Nordic art.

All this now achieved a new formal expression, which was most successful in English sculpture. We must say something of this sculpture, for in this period it profoundly affected the whole artistic climate and ushered in new formal conceptions. The outstanding figure was Henry Moore (b. 1898). He showed the way to a whole group of younger sculptors – Kenneth Armitage (b. 1916), Reg Butler (b. 1913), Lynn Chadwick (b. 1914) and Eduardo Paolozzi (b. 1924) – and encouraged them to find their own personal expression.

During the war Henry Moore had been appointed 'official war artist' and had had little time for sculpture. This was the period of his famous 'Shelter Drawings' – scenes in the London tube during the bombing. In them stark reality takes on a mythical dimension – we perceive a mythical race of chthonian beings who seem to have been living in these caverns since the beginning of time. The half-light engenders a strangely oppressive feeling, compounded of the fear in which these people

live and of our own fear of what will happen when these subterranean beings emerge to the surface to do what man can do to man. The immediate situation becomes a transparency, through which we discern the universal element in the mythical ground of modern man, his terror and pent-up demonic fury. The unmistakably antique note in the stone statuary of the figures recalls the tragic metaphor of Greek drama. We see the modern Ulysses who once again, like the classical Odysseus on the Cimmerian shore, conjures up the shades of the underworld, among which contemporary figures move with a strange familiarity. Moore had long been preoccupied with this mythology of the modern scene. It had grown within him since his first encounter with Surrealism in the early thirties. After the war it found expression in a number of drawings and sculptures in which the existential feeling of our time is embodied in mythical figures which seem to come from some distant realm but are defined as contemporary by their 'technoid' forms. Through the modern mask we distinguish an antique idol, a classical statue, eerie and lost in these strange surroundings. This fantastic, spectral interpretation of antiquity recalls De Chirico and certain modern poets. But here there is no irony. Features of the landscape undergo metamorphosis into gigantic idols moulded of deepest earth, polished and hollowed out by the wind. Natural forms engender abstract monumental structures with anthropomorphic overtones which, like the menhirs and dolmens of prehistoric times, take on the character of mythical symbols. In all these formal inventions we sense the hallucinated ornamental fantasy of the Celts, which has been at work in all the great periods of English art. Here it combines with a profound experience of modern existence to invent powerful new metaphors.

Graham Sutherland in his painting applied this super-real metaphor to the landscape, lending it an animistic, Panic quality. Sutherland's encounter with Surrealism and with Picasso's late style in the mid-thirties had intensified his innate animism and his feeling for the metaphorical value of things. To him nature was a living creature, whose forms offered him trenchant analogies to his own inner experience. Individual things, representative details, acquired the value of 'figures' expressing the poetic shock released in the painter by his contact with the mythical. Such was the genesis of his pre-war pictures: fantastic tree forms, shattered roots which, like strange, monstrously sexual animals fill the picture with their aggressiveness; spiny shells or juniper bushes on a rocky coast, personified stone forms. Sutherland has explained what he was trying to do: '. . . it is a question of bringing out the anonymous personality of things; at the same time they must bear the mould of their ancestry. There is a duality: they can be themselves and something else at the same time. They are formal metaphors.'

Under the impact of the war the metaphors became increasingly terrifying, monstrous, aggressive. In 1944 Sutherland painted his 'Horned Shapes' series – horny, thorny forms which are natural in character but do not imitate nature. Shortly after the war, came the 'Thorn' series – thorn-trees, thorn-heads, thorn loggias – which first made him known in Europe. In these pictures, sharp and hectic in colour, fantastic, malignant animal and vegetable forms sprout from the thorn motif. The metaphorical quality of these realistically painted demonic plants is quite evident. Sutherland described his intention: '. . . my thorn pictures came into being in a curious way. I had been asked by the Vicar of St. Matthew's, Northampton, to paint a crucifixion. In the autumn of that year I had been thinking of the form the work was to take; in the spring of the following year this subject was still very much in my mind. So far I had made no drawings – and I went into the country. For the first time I started to notice thorn bushes and the structure of thorns as they pierced the air. I made some drawings, and as I made them, a curious change developed. As the thorns rearranged themselves, they became, whilst still retaining their own prickly, space, en-

compassing life, something else — a kind of 'stand-in' for a crucifixion and crucified head . . . The thorns sprang from the idea of potential cruelty — to me they *were* the cruelty . . .'

This poetic symbolism of formally transmuted thing-images marked all his ensuing work. On his frequent visits to southern France, beginning in 1947, Sutherland's painting became more cheerful — vine bowers, palisades of palm-leaves, but behind their seeming Mediterranean serenity, we still discern an uncanny note. Towards 1949 this 'secret presence' took shape in a long series of paintings, the 'Standing Forms'. These are illusionistically painted, pillar-like shapes, almost anthropomorphic in character; it seems as though a breath would suffice to bring forth a human figure. They stand in open spaces and gardens, surrounded by an atmosphere of solemn solitude. 'The "Standing Forms",' writes Sutherland, 'are based on the principle of organic growth with which I have always been preoccupied. To me they are monuments and presences. But why use these forms instead of human figures? Because, at the moment, I find it necessary to catch the taste, the quality, the essence of the presence of the human figure — the mysterious immediacy of a figure standing in a room or against a hedge in its shadow, its awareness, its regard, as if one had never seen it before — by a substitution.'

Thus they are poetic paraphrases of a feeling inspired by reality, which can only be expressed in pictorial metaphors. Sutherland wished to 'enlarge the field of painting by setting the emotional paraphrases of reality within the ambience of optical reality'. To him natural forms and natural space were the scene into which the 'vision' erupted; he clung to them as a means of showing the remoteness of the surface from the essence of reality. This disclosure transforms the image of nature into a mythical metaphor embodying the artist's unconscious feeling of the world. For Sutherland is essentially a painter of nature, whose animistic feeling seeks answering images to make visible his feeling for the mysterious, puzzling, unknown aspect of reality. In recent years, he has been giving greater weight to the idea of the Surrealist '*personnage*'. Figures take a more prominent place, and with them the demonic aspect. Increasingly, his Panic nature idols are replaced by restless, spectral, malignant hybrid creatures; his metaphors point directly towards the state of man.

In this last development, which began towards 1954, Sutherland was influenced by another horror-stricken visionary, Francis Bacon. Bacon comes from Dublin; he is a man of wide culture and a great reader of Nietzsche. Self-taught in art, he began to paint at the age of twenty. But from the start he was familiar with the methods of modern painting, and from the start he has been guided by the memory of Fuessli, Blake, Bosch, the '*terribilità*' of the Mannerists, and the enigmatic quality of the Romantics. He has always been a great traveller. What attracted him was not nature but the life of the cities. As his raw material he took the pictorial records of this modern urban life: cheap photographs, culled from newspapers and magazines, of bellowing politicians, grinning celebrities, and the fantastic catastrophes of our mechanised age; scenes in crude photographic detail, depicting products of the dream-factory of the cinema, with its sudden irruptions of terrifying reality (the screaming woman in *Potemkin*); the cover pages of *Time* . . . But side by side with these strident images of reality Bacon's mind also registered the hothouse plants of culture, segregated in the museums: the chuckling Rembrandt of the self-portrait, Velasquez's gloomy Pope Innocent X, Van Gogh going to work in the unshaded heat of the Midi. With these pictorial sources behind him, Bacon aspired to paint 'the history of the last thirty years'.

He paints in series, which are variations and studies on a theme. It is interesting to note that like Sutherland, he began in 1945 with studies for a crucifixion. In 1951 he painted variations on Velasquez's Innocent X, in 1952 studies of a mongrel, in 1957 the variations on Van Gogh's tragic

*Vincent goes to Work.* With manic insistence he circles round his theme, until what was at first plain and simple enters upon a second level of desperate twilight metaphor. The *Crucifixion* becomes the screaming Mary Magdalen, an ungainly female figure cowering as before an executioner, her face concealed by the shadow of an umbrella, so that only her screaming mouth is visible. In 'Studies of a Dog', the mongrel, standing on a sewer grating as though paralysed by a terrible blow, symbolises the dull suffering of the creature. In 'Studies for a portrait of Van Gogh', Vincent, like a grotesque maniac, dashes back and forth across the road under the sun's glare, as though hopelessly imprisoned in the boundaries of the famous picture he left behind. All this is painted in an elegant fluid colour, which takes on a rich resonance in the dark zones where the form loses itself. Then suddenly a fierce light picks out a gruesome detail – the screaming mouth for example. Only the Van Gogh series has the furrowed impasto and hallucinated glow that we associate with Vincent himself.

In 1954 a group of these strange pictures was exhibited at the Biennale. The most terrifying were the variations on Velasquez's famous portrait of Innocent X. A hideous mockery of a masterpiece, so it seemed: the Pope is seated as Velasquez painted him, but within a glass case and bathed in a vague nocturnal light; the face is still cold and forbidding, but the mouth is wide open, roaring with laughter like the mouths of the politicians in the magazines. The shock and indignation of the viewer were legitimate. But the sudden shock ignited a slow-burning poetic fuse that made the gruesome metaphor intelligible. What Bacon had painted was the scream of the picture in which the Pope sits captive. It is as though we ourselves, with the roaring of the daytime world still in our ears, should suddenly find ourselves in the museum at night, face to face with this portrait, illumined for a moment by the passing beam of a searchlight, and as though suddenly an association with the noises of the day were projected on the Pope's forbidding features. We should never be able to look at Velasquez's picture without recalling this hallucination, this snapshot of a terrible unconscious fear. Yet this romantic conception does not capture the whole meaning of Bacon's metaphor. For one thing, there is an ethical protest, as though the angry Pope were crying out from the stillness of his prison against the noisy nightmare of our day; but there is also a kind of cruel candour and a bitter irony, as though this head of a venerable institution revealed for one moment with his roaring laughter that had he been alive today he too would be one of our politicians. This ambiguity also governs the relation between the picture and its model. The original painting, whose desecration creates the shock, remains a work of art transfigured by the golden light of history; but at the same time it is a spook, an animistic thing, which is at it is but might equally well be different, according to our psychic attitude to it.

This takes us to the heart of Bacon's metaphor. Like Sutherland's, it is animistic; however it is concerned not with the things of nature but with the pictorial symbols of man's being. These may be works of art, monuments of culture, or the documentary images of reality poured forth by the modern media of mass communication. In each case the painter's emotion at such a document stirs his pictorial fantasy and releases a psychic shock that has the effect of a revelation. He is compelled to modify his documentary material, to lay bare its essence, until it takes on the character of his hallucinated image. The result is these 'documentary metaphors' on contemporary existence, which hammer away at one point. In view of the hallucinated insistence with which Bacon lays bare the nightmares in the soul of the individual member of the lonely masses, it seems a trifle too innocent (though it is correct as far as it goes) when Bacon says: 'A picture should be a recreation of an event rather than an illustration of an object' or 'Art is a method of opening up areas of feeling'. The 'event' for Bacon is the spectral quality of contemporary reality; life moves as behind a pane

of glass – often indicated in Bacon's pictures – which gives reality a character of mystification and hallucination. The 'area of feeling' he opens up is the horror with which this mystification fills him as he views the documents of our existence.

In Moore and in Sutherland we have noted an obsessive, recurrent rhythm, the hallucinated ornamental fantasy characteristic of Celtic and early English art. This old heritage has found a strange expression in the work of the young English painter Allan Davie. In his pictures, however, the representational element does not play a central role, although the figures born of his restless associative faculty often assume a decidedly personal character. The art of Klee, which he encountered in 1945 at an exhibition in the London National Gallery, Picasso and the Surrealist '*personnage*', Sutherland's Panic nature mythology, the sculpture of Africa and Oceania, and the mythical imagery of pre-Columbian gold ornaments: these provided the foundation on which he was to build his pictorial expression of a very personal mythology rising up from his unconscious. Davie looked upon the emanations of the unconscious as direct embodiments of demonic or mythical forces, which *pass through* the painter and, without any intervention on his part, take form on the canvas. He found philosophical and religious justification of this attitude in Zen-Buddhism; as for his pictorial expression, his encounter with Jackson Pollock in 1948 was decisive. At the time Davie was working as a jazz musician; he had abandoned painting more than a year before, after seeking his way between Gauguin, Picasso's Expressionism, and Klee's abstract painting. Then, in the course of a trip through Spain, France and Italy, he came across some of Pollock's paintings – from the 'totemic' period of 1943-45 – in Peggy Guggenheim's collection in Venice. They showed him the way. What he discovered in them was the possibility of regarding the picture surface as an arena where mysterious forms lead their own spontaneous lives, reaching down, by way of endless imaginative associations, into those primordial strata whence the artists of 'primitive' peoples derived their magical ornaments and mythical figures. The insight which sustained Alan Davie's whole art was that these mythical figures could still, or once again, be reached on the plane of modern existence.

The method is pure hallucination. A sign inscribed spontaneously on the canvas calls forth another, and so on. The outcome is a cluster of associative forms reaching out in all directions, forming totemic signs and other-worldly beings. Yet one cannot actually distinguish any objects or figures. Great ornamental signs against a confused tangle of lines suggest the presence of a numinous power and justify such titles as *Image of the Fish God*. A fantastic animism embodied in totemic monuments, in forms that partake of psychic vegetation, in flying and crawling forms, permeates these pictures, creating an atmosphere of dark terror.

The content is rather similar to that of Sutherland's late work. But Davie couches his feeling for reality in mythological metaphors, more removed from the images of nature. In Davie too, however, we discern the English voice that made itself heard in Moore, Sutherland and Bacon, the same striving to exorcise the mystification of modern existence, to sublimate fear by means of mythological figures. He finds his medium of expression in an ornamental fantasy springing from old sources of English art. His purpose is to make visible the unfathomable myth of reality, even if it cannot be made intelligible.

A tendency complementary to this mythical and metaphorical vision of reality developed in New York during the war. It was inaugurated by the gifted young painter Matta, a Chilean of Spanish and French extraction, then thirty years of age. A favourable spiritual climate had been created by the small but highly active group of European Surrealists who had fled to New York at the beginning of the war, and by a group of young American painters who took up their ideas and gave them a very personal turn.

A number of leading European artists had taken refuge from the war in New York. Chagall, Léger Mondrian, Ozenfant, Lipschitz and Zadkine were living there, all in relative isolation. The Surrealists, however, succeeded in reconstituting their group, including André Breton, Max Ernst, Marcel Duchamp, André Masson, Yves Tanguy and Wolfgang Paalen. (Salvador Dali, who had moved to the United States in 1938, was living on the West coast.) In March 1942 Pierre Matisse put on an exhibition of these 'Artists in Exile'. In the same year Breton organised a Surrealist exhibition at Reid Mansion in New York, with Marcel Duchamp in charge of the *mise en scène*. It attracted wide attention and made a profound impression on the younger American artists. The Surrealists were extremely active. In June 1942, Breton and Max Ernst founded a new magazine *VVV*, which between then and 1944 ran to four issues. In the first number Breton published his 'Prolegomena to a third manifesto of Surrealism or Else', illustrated with drawings by Matta. In this declaration of principles the accent is on psychic automatism and the finding of new myths and personal mythologies arising from the unconscious. Breton also tried to explain the origin and development of Surrealism to the American art public. In December 1942 he delivered a lecture, at Yale University, on the '*Situation du Surréalisme entre les deux guerres*', published in *VVV* for March 1943. In 1942 Peggy Guggenheim opened her 'Art of this Century' gallery, which became a centre for the new tendencies. She showed not only the well-known Surrealists but also some of the young American painters who were to usher in the new movement in American art. Marcel Duchamp exerted a great influence.

What attracted the young painters was not so much a ready-made pictorial vocabulary or any definite techniques, as Duchamp's ironical attitude that made him accessible to every conceivable mode of self-expression, and Breton's insistence on the mythical ground of the unconscious. The enthusiasm of the Americans was kindled by two fundamental ideas – automatism, which made possible free psychic improvisation as a means of expressing man's innermost psychic impulses, and the idea that our experience of reality builds up a mythical substrate in the unconscious, which by releasing mythical images responds to related experience. It was these two ideas that set contemporary American painting in motion. Pollock, Motherwell, De Kooning on the expressive side, Tobey, Rothko, Gottlieb on the meditative side, took up the idea of psychic improvisation; Matta and Gorky concentrated on the mythical image of reality.

Matta, a student of Le Corbusier, who had begun to paint in 1938 under the influence of the Surrealists, had come to New York in 1939 and soon joined the Surrealist group. In 1941 he went to Mexico for a few months and immersed himself in ancient Mexican art with its mythical, demonic signs. This was an important lead, though at first inapplicable to the contemporary world. At the time he painted pictures that he called 'inscapes'. From fluid colour, which served as the medium for his trance-like, semi-automatic expression, other-worldly landscapes took form, atmospheric areas in which psychic vegetation and strange, unknown objects made their home. In 1942 he did his first large canvases: *The Earth is a Man* and *Here Sir Fire Eat*. They suggest an indeterminate astral space in which hurtling meteors and geometrical perspective figurations provide an occasional benchmark. Evidently Matta's imagination is beset by cosmogonic conceptions aroused by the alarming perspectives of modern science. And indeed he expressed the opinion in 1943 that just as modern psychology had given rise to Surrealism, so modern physics would call forth a new kind of painting. By this he meant to say that the contemplation of these scientific conceptions of reality and of the images released by their shock could build up in the unconscious a mythical ground that would enable the artist to transpose our new scientific reality into a mythical dimension. In his famous *Le Vertige d'Eros* of 1944 he still adhered to the forms

of his inscapes: constellations of small bodies floating over vertiginous figurations of space, set in rotary motion by circling lines and light effects. The starting point, to be sure, was Freud's statement that all realisation takes place between Eros and death, but in his pictorial embodiment of the metaphor Matta made use of images which clearly originated in his preoccupation with modern physics. In 1945 he suddenly turned to a new kind of demonology. If his earlier pictures may be regarded as a remarkable anticipation of the dawning atomic age, the new pictures reflect the terrifying demonic aspect of the new forces released by man. Matta himself explains this turn: 'My main preoccupation through the period of *Le Vertige d'Eros* was looking within myself. Suddenly I realised that while trying to do this I was *being with* a horrible crisis in society.' This shock, produced by the terrifying aspects of reality and by man's utter helplessness and bewilderment in their presence, gave birth to a complete demonology whose protagonists are fantastic technological creatures. Duchamp's animistic machines in *Le Roi et la Reine entourés de nus vites* (1912) and the 'bachelors' of the *Mariée mise à nue . . .*, now took on an exemplary meaning for Matta. In those years he was on terms of close friendship with Marcel Duchamp and had closely studied his work and his thinking. But Breton also offered him an important lead. In the third *Surrealist Manifesto* of 1942 Breton had spoken of transhuman beings and figures – he called them the 'Great Invisibles' – who might serve as the protagonists of new myths. But important as these ideas may have been for Matta, the decisive impetus was the personal shock induced by an uncanny, terrifying, undefined reality. It impelled him to people his indeterminate world of dread with mythical beings – 'The Great Invisibles'. In *The Heart Players* (1945) these beings make their appearance, anthropomorphic mechanisms, fantastic 'technoid' figurations, whose mechanical gestures produce an interlocking spatial constellation, as though playing a cryptic game of chess with unstable spatial figures. The formats now become very large in order to encompass the painter's movement. For these hallucinations are created by a semi-automatic use of the painter's motor energies; the painter himself physically enacts the spatial tensions and gestures of his mythical beings.

He himself as an active being was drawn into his pictures. In 1946 he painted the gigantic *Being with* ('being with a horrible crisis in society', as Matta himself explained), in which his whole demonology is repeated. An absurdly intricate, floorless room, half torture chamber, half engineer's office, where the laws of gravity are no longer in effect, is peopled by strange hybrid creatures, part insect, part machine, equipped with tongs and hooks. Some are active, some passive, some employ their terrifying equipment to torture others. The shock is intensified by an affectation of human indifference; the painter is merely supplying a statistical record like an engineer drawing up a report about a space ship in outer space and its astral inhabitants. This attitude of remoteness lends an extraordinary, psychological weight and a mythical dimension to Matta's metaphorical expression of the splendour and misery, the power and torment of man, frantically utilising the uncontrolled forces of technology he has unleashed and living beneath their unfathomable menace. It is not unjust to compare this picture with 'science fiction'. For in science fiction the imagination of modern man tries to free itself from fear by inventing and creating a new mythology. Matta's pictures evoke the myth that responds to the shock produced in the unconscious by the unfathomable reality that is unfolding before us. Matta's purpose in painting is to make this myth visible.

These ideas of Matta were a source of inspiration to his friend Arshile Gorky, also a member of Breton's New York circle. Gorky was an Armenian. He had been living in the United States since 1920; he had studied painting in Rhode Island, Boston, and New York, but still thought of himself as a Caucasian, a descendant of Armenian peasants and priests. This heritage accounts, no doubt, for his deep interest in metaphysics, dreams and myths. His attention had been drawn

to Surrealism by exhibitions at New York galleries in the thirties, and he had attempted to combine Cubist construction with Surrealist poetics. This had led him to Picasso and Miró, and certain of the ideas of Klee and Kandinsky had also played a part. But it was his friendship with Breton and Max Ernst and Matta's example that showed him the way to his personal style. He was far less complex than Matta. The driving force in his art was not 'scientific anguish' but nature and his own inner life. His relation to the world around him was still dominated by a poetic nature mythology, and he looked upon his painting as a means of expressing this mythology. His style is painterly and soft, and at first his colour showed the influenc of the early Kandinsky. After his encounter with Matta's mythical figurations he too began to people his pictures with other-worldly forms and beings, but they are lyrical in character and the myth they enact is a nature myth. The anguish that entered into them (and there was no lack of it in his tragic life; he committed suicide in 1948) was of a very personal kind. On fluid coloured grounds, which always evoke landscapes, a fine trance-like line gropes its way forward, creating vegetable forms and biomorphic shapes. And this vegetation sprouting from the unconscious reflects the artist's deepest feelings of tenderness and shock in the presence of nature. The erotic element dominant in nature pervades the pictures like a recurrent nightmare. Gorky's feeling for the inscrutable myth of reality found its most lyrical expression in his late work.

### The Lyrical and Hermetic Possibilities of Visual Reality

From such an interpretation of reality it is only one step to an art which takes things no longer as components of actual reality, but as hermetic vocables for the communication of the lyrical potentialities hidden in the world of objects.

As early as 1912 Apollinaire, speaking of Delaunay's transparent colour planes, used the term 'Orphic' to denote the transformation of the artist's experience of the world into musical harmonies. Luminous colours and a crystalline weft of forms enabled the painter to transport the visible into a magic sphere. Crystalline elements were super-imposed on natural appearance, distilled light transformed into colour was captured in transparent patterns, and nature shone through them like an image from behind the canvas. The picture was like a window opening out on another, poetic reality infused with coloured light. Delaunay and the long chain of Orphic Cubists in France, and Marc, Macke and Klee in Germany invented and tested a method of inter-weaving representational references and abstract colours and forms to express an emotion tied to objects. Hermetically encoded in a coloured structure, conjured up by a few signs defining objects, an image shone forth from the ground, an image that did not belong directly to the world of objects, but was sufficiently close to it for the viewer to establish a connection. The artist could choose one of two methods to arrive at this sort of image. He could start from nature and the emotion aroused by it and achieve the desired harmony through the transformative power of form. Or he could start from the meditative, abstract aspect, and by way of his formal discipline find the representational reference as he painted. No doubt the two methods are related, but they are nevertheless distinct. They have in common both the Orphic ground of experience and the hermetic encoding of the evocative representational sign. They differ only in their point of departure, which is reflected in their greater or lesser distance from the familiar visible world. So far these two schools have not been given names; they might be called 'representational hermeticism' and 'abstract hermeticism'.

Representational hermeticism now seemed to be the only remaining possibility of demonstrating the vitality of the represenional element. It turned out to have retained a good deal of strength, and a great many artists can be said to have passed through a stage of representational hermeticism on their way to abstraction – Manessier and Bazaine in France, Meistermann and Nay in Germany, Santomaso and Corpora in Italy, to mention only a few. However, it was not merely a passing phase; it also provided a vantage point for the poetic contemplation of nature. Today this represent-ational hermeticism is to be met with everywhere.

In France this style of painting has been unexpectedly revived by a direct descendant of Orphism, Jacques Villon. For many years Villon had completely abandoned painting, then shortly before and during the war he went quietly back to his original manner, which he fashioned into an instrument for the lyrical and musical interpretation of the world of objects. His new work, shown after the war, appealed greatly to many young painters by its poetic hermeticism, which corresponded to their own aims, and soon his name was on everyone's lips. Villon's method consists in transforming natural light into a hovering, somewhat honey-coloured light, and then in con-solidating the luminous structure by means of a delicate geometrical pattern, so that the coloured light forms crystals. The natural motif is refracted in this rigorously geometrical structure as in a prism, and within the subtly regulated pattern takes on a magical transparency which enables it to shine forth from the pictorial ground as a lyrical reflection of reality. In this subtle play with visible realities the natural data are taken into account, but at the same time the free forms appearing on the canvas and striving for visual expression are given full scope. Paul Klee had carried on the same sort of activity with marvellous results; Villon is less profound, more French and decorative. For this very reason the French public understood him more readily. Immediately after the war a group of French painters tried to express the poetic qualities of nature by the evocative power of abstract painting. Actually this group, consisting of Bazaine, Estève, Lapicque, Le Moal, Manessier, and Singier, had formed in 1941 under the cover name 'Peintres de tradition française'. All these painters took Orphism as their starting point and strove to lend a poetic quality to the strict construction of Cubism by enriching the colour and intensifying the expressive quality of abstract form. With regard to content, they strove to transcend modern man's alienation from visible nature and to attain, through poetic feeling, to a new harmony with the environmental world. Pantheist and religious ideas admonished them to reinforce their ties with Creation. Their religious bias guided them to the symbolic art of the Middle Ages, in particular to the spirituality of Romanesque and Gothic stained-glass windows, in which they rediscovered the formal charact-eristics of Orphic Cubism – the flatness, the luminous suggestive colour, the strict hierarchy of forms, the designation of object forms by evocative signs. For the transformation of visible motifs into visual poetry Paul Klee offered important hints. The leading painters of the group were Bazaine and Manessier, who were joined by their old friend Bissière when he resumed painting after the war. Manessier, with his religious commitment, sought to recapture the abstract spirituality of mediaeval stained-glass windows, while Bazaine, who was more of a pantheist, held fast to the images of nature. He started from objective motifs and from them distilled a coloured pattern. In the course of his development the pattern became increasingly autonomous, but never wholly abandoned its representational starting point. Man, to Bazaine's way of thinking, is an integral part of nature, and this is what enables him to draw nature into the world of human feeling. As we wrote in his 'Notes sur la peinture d'aujourd'hui', his aim is 'to embody this interpenetration, this great common structure, this profound kinship between man and world'. Thus he holds fast to the motif. In a deeper sense his pictures are all landscapes, and indeed they

bear representational titles such as *Midi, Arbres et rochers*. Nevertheless, they are quite abstract in character. They are not merely colour chords derived from nature or nature transformed through the medium of colour. They are a kind of musical paraphrase whose theme is the feeling aroused in the artist by nature, by his memories of the French landscape and the happiness that invaded him as he contemplated it. In the development of the colour-theme every representational memory is extinguished; the experience is echoed only in feeling. The colour theme was at first simple, based on broad lines and firmly defined geometrical figures. Latin discipline and restraint were still at work.

Only towards 1953 did the graphic framework, reminiscent of stained-glass windows, become more relaxed; now the colour, organised in broad spots, gave the surface greater spatial and atmospheric depth. The poetic mood was sustained by the coloured light. The natural motif which underlies all these seemingly abstract pictures is transformed into an orchestrated colour chord which captures the feeling it aroused in the artist. Monet in his late period (the *Nymphaeas)* had already dissolved the objective motif in a play of light and colour; Bazaine – not without a glance in the direction of Monet – transformed it into orchestrated chords. The painting is an 'incarnation' of the emotion aroused in the painter by the view of nature – a metaphor which still suggests the original motif by the *'puissance d'évocation'* of the orchestrated coloured surface.

This method of transforming the feeling aroused by nature into coloured forms was also the basis for the extraordinary late work of Roger Bissière. In 1947, after almost ten years of complete retirement, Bissière, already in his sixtieth year, showed a series of new paintings at the Galerie Drouin. His reputation was restored at one stroke, because the profound poetic feeling that permeated these canvases was exactly what the group around Bazaine and Manessier were striving for. They seemed quite abstract: delicately modulated coloured spots, orchestrated in dark tones of purple, brown, golden ochre, emerald-green, and sonorous blue, illumined the surface with their warm, magic light and formed a carpet-like pattern articulated by a fine network of dark lines. But here and there, through this enchanting colour mosaic, we discern simple, abbreviated signs indicating figures and objects – the façade of a church, angels, birds, stars, suns, trees, or branches. They provided 'coloured images upon which each viewer can hang his fantasy'. Since 1920 Bissière had been close to the lyrical Cubism of Braque. From 1924 to 1937, while teaching at the Académie Ranson in Paris, he had called the attention of his students (who included Manessier) to the poetic possibilities of Cubism and had acquainted them with the art and ideas of Paul Klee. But he himself had achieved no satisfactory expression. In 1939 he retired to his farm in the Dordogne, where the shadow of the war and an eye ailment which threatened him with total blindness, led him to abandon painting for a number of years. But thus thrown back on himself, he achieved an inner harmony with nature which engendered wonderful dreams and visions. Projected upon his closed eye-lids, his visual experiences of nature were transformed into magical chords of light and colour. 'The outside world vanished,' Bissière tells us, 'making way for a miraculous world inhabited by angels and birds and flags in the wind.' In 1945 these images finally took shape on canvas, and they are still the source of Bissière's serene inspiration. These quiet pictures are full of feelings inspired by nature, but Bissière does not record them directly, he seeks to recreate the causes underlying them. From visible nature he distils the colour chord or arrangement whose *'puissance d'évocation'* provoked his poetic feeling. Abstract in structure, these chords are nevertheless filled with experiences of nature and life. They inhabit the intermediate realm between nature and pure poetry, so dear to Paul Klee to whom Bissière owes so much.

This persistent endeavour through the evocative power of abstract forms to restore the ties of painting with visible reality lies at the very centre of the work of Nicolas de Staël, a young French painter of Baltic extraction. In 1942, at the age of twenty-eight, De Staël turned to abstract painting, convinced that he could not adequately express his poetic feeling by reproducing natural forms. He started with the geometrical constructions of Synthetic Cubism, but after 1946 his forms became increasingly freer and more expressive. Soon exquisite colour gave his flat Cubist surface greater depth and suffused the picture with a mysterious, darkly resonant light. Coloured blocks and cubes give the colour chords and sequences a rhythmic beat. But increasingly the rhythmic structures take on a value of their own, a 'figurative' character. They form coloured architectures against the radiant grounds, giving them an atmospheric depth that evokes the free space of nature, and seems in some strange way to seek contact with the images of nature. Such is the associative resonance of these forms that often we have the impression that landscapes and coasts and figures are on the point of emerging from the colour fabric. In 1952 a football game in a Paris stadium at night provided a decisive visual shock which suddenly led De Staël to identify his freely found coloured forms with visible reality. From then on he fully accepted the associations that were already implicit in his abstract paintings. This was the beginning of the pictures, inspired by long stays in Provence and on the Mediterranean coast of France, which are today associated with De Staël's name: great landscapes and figure paintings – football players, musicians, nudes – built up of large coloured spots and transformed into colour chords. Isolated, imprecise objective indications of the natural motif are developed into colour movements of exquisite beauty. In these evocative figurations the distance between the natural image and the poetic response rising from within is annulled. But then De Staël sought to capture the natural appearance more directly, and this was impossible. His attempt to come closer to natural appearance only made the distance between it and his own contemplative responses painfully evident. The impossibility of resolving this conflict may have been the cause of De Staël's tragic suicide in March, 1955. However, the striving, which preoccupied his whole generation, to transform poetic impressions of nature into a symphony of colour chords and cantilenas, found its most perfect expression in his nature work.

These methods developed from the prismatic pictorial structure of Orphic Cubism were not the only ones employed in French objective hermeticism. Charles Lapicque for example tried to reconcile the representational and the abstract by a contrapuntal structure of coloured planes and arabesques. Matisse was his prototype, but he went further in the direction of the abstract. Colour planes and arabesques determined the abstract décor and orchestration, but from this formal structure representational images emerged: figures, mounted knights, race horses. A number of other names might be mentioned in connection with this objective hermeticism. Perhaps the most important are Estève, Le Moal, Lanskoy. All these painters began with a certain attachment to the visible and developed towards fuller abstraction.

Italian painting followed the same path. Soon after the war this same method of transforming natural motifs into corresponding figurations of coloured forms became the dominant mode of expression in the artists grouped round the Fronte Nuovo delle Arti. Orphic Cubism, which in Italy had been overshadowed by Futurism and the developments following from Pittura Metafisica, began to attract the attention of the young painters – all the more so because it showed a natural kinship with Picasso's dramatic figure painting of the late thirties – *Guernica* and *Fishing by Night at Antibes*, which had made a lasting impression on them. With astonishing rapidity the young Italians took up the suggestions of Orphism and developed an objective hermeticism attuned

to the Italian feeling for the beauties of nature. Then under the influence of such French painters as Bazaine, Manessier, and Hartung, they moved increasingly towards abstraction.

Thus Renato Birolli, who founded the Fronte Nuovo and who before and during the war had exerted a stimulating influence on the painters of the Milan Corrente group, turned resolutely to Orphic Cubism after the war, giving up his initial Expressionism based on Van Gogh and Picasso. He encoded the objective motif in an almost abstract texture of evocative colours and forms, which clearly expressed the sensations and feelings associated with the motif. In the last years of his life – Birolli died in 1959 – new insights into the abstract possibilities of colour orchestration, a deeper experience of the landscape (in Italy, France, and the Netherlands), and the influence of Bazaine and Manessier led him to reduce the representational element more and more. A dynamic play of coloured forms provided him with sufficiently expressive equivalents of his feeling. Immediately after the war, Bruno Cassinari and Ennio Morlotti also came to grips with Orphic Cubism and with Picasso. While Cassinari still employs the prismatic methods of the Orphists to give poetic intensity to his vision of nature, Morlotti has been seeking in the last few years to develop from the motifs of nature a dense colour harmony based on a few earthen tones. After a brief Cubist period, Antonio Corpora adopted for a time a style closely related to that of Bazaine and his group, but then moved away from the motif and is today close to Art Informel. Among the painters of the Fronte Nuovo it is the Venetian Giuseppe Santomaso whose development seems to be of most consequence. During the war he had been preoccupied with Braque and had closely studied the Byzantine mosaics of San Marco, attracted by the spiritual radiance of their colour. Up until 1950 he strove, quite consistently, to combine Cubist composition with this spiritual colour as a means towards the poetic transfiguration of natural objects. In the process the Cubist patterns and spatial geometry dissolved more and more in the radiance and light of his colour. The surface developed into a free luminous field traversed by beautiful colour resonances. By working with certain simple motifs – the old shipyards of Venice and their strange machines, agricultural implements in the barns of the peasants on the mainland – he learned to designate objects by abbreviated evocative emblems. These coloured signs enabled him to give his orchestrated surface an objective definition in line with his original experience. The light over the Venetian lagoon, the play of colours on a wall, a night of song during the wine harvest – such experiences were represented through the metaphor of coloured forms and the evocative power of coloured light. The more the literal image of reality vanished behind these evocative structures, the more purely and fully could the inner poetic response released by the motif (or by the memory of the motif) be expressed. What appears in the painting – and this is true of this whole group of painters – was no longer the actual motif, the landscape, the boats and houses in the little ports, the sea and the lagoon, but a pictorial expression of the happiness and excitement that pass through the eyes of the painter as he contemplates the colours and forms of the outside world, and which afterwards, recollecting and meditating, he hermetically encoded in corresponding formal structures.

In England also, during the first years after the war, Picasso's expressive, emblematic art and with it Cubism, the formal foundation of this style, were taken as a model by certain of the young painters. In those years the two Scotsmen Robert Colquhoun and Robert MacBryde applied Cubist discipline to their conceptions of figure and thing, and with the help of ideas from various sources – Van Gogh's colour, the décor of pre-Columbian Mexico – sought to make the Cubist interpretation of objects more expressive. Drawing on Picasso's late figural style, the Irish painter Louis Le Brocquy introduced fantastic, intensely expressive figures into a surface articulated in the Cubist

manner. By way of Picasso, John Craxton found his way to the early Cubist style of Miró. In those years he returned home from Greece with landscapes and figure paintings in the prismatic, transparent style with which Miró in 1921 and 1922 had transposed the Mediterranean scene into a legendary dimension. Some of these pictures seem literally to have emanated from the Greek islands and their light. In the main, however, these Cubist exercises led nowhere. Some of these painters continued to repeat themselves, while others, such as Le Brocquy, sought more abstract equivalents for the motif.

In the early fifties the movement towards abstraction became increasingly pronounced in England. The predominant tendency was now a lyrical interpretation of the landscape, sustained chiefly by colour. Ivon Hitchens had begun before the war to transpose landscape motifs into a pattern of broad coloured spots. After the war, under the impact of his experience of the Sussex country-side, where he has been living since the war, these answering images became increasingly abstract – lyrical paraphrases on the colour resonance and mood of the surrounding landscape. This method of transforming an experience of the landscape into an answering image that isolates the formal and poetic values underlying the experience, of passing beyond the motif to an expression of the feeling it releases, found wide acceptance. Roger Hilton, who shortly before the war may have acquired similar ideas from Bissière in Paris, now pursued them resolutely. The motif is more and more overlaid by a bold fabric of broad spots and arabesques on the space-encompassing surface. In the last few years, as the structure of spots and signs became more independent and expressive, Hilton moved close to the Abstract Expressionism of the Americans. Comparable in intention is the painting of Peter Lanyon. His basic experience is the landscape of St. Ives where he was born and still lives. Influenced at first by Nicholson, his painting became towards 1950 more dynamic, more painterly, and more abstract, and he developed a dramatic script. But underlying the abstract gesture there is always a definite objective experience. Such titles as *Tide Race, Night-boat Passing, Coast Line*, or *Rising Wind* were not invented afterwards by association; they designate a concrete experience which found expression in the abstract ensemble and the stormy gesture of the forms. Thus it was inevitable that Lanyon should in some measure be influenced by the American Action Painters – in intent he comes closest to De Kooning. Since the comprehensive exhibition of modern American painters at the Tate Gallery in 1956, their influence on the younger English painters may be noted on every hand.

The transformation of natural appearance into formal equivalents from which a poetic colour paraphrase can be composed is the foundation of the work of William Scott, a painter who stands aloof from all groups. In female nudes and above all in still lifes, he has effected this process of transformation step by step. Images of simple things – collections of ordinary kitchen implements – provide the building stones for his rhythmic colour constructions. Up to 1950 he remained close to the object form, which he defined simply and rather drily, and it was precisely this succinctness that brought out the poetic mood, the pathetic, forsaken beauty of simple things. But since then he has gained in freedom. The thing-images have been simplified into lapidary signs which, combined with other forms, constitute a rhythmic pattern which captures the beauty or special character of the motif and transforms it into an abstract equivalent. This is the method which De Staël, who was shown in London in 1952, applied to landscapes and figures. As in De Staël's work, the warmth of an emotion experienced in the presence of things seen shines through the abstract coloured surface of these pictures. But Scott's hermetic imago is far removed from De Staël's classical Mediterranean beauty. Often erotic symbols emerge through the objective abstractions. In this art we find the restless rhythm, the hallucinated ornament from

336

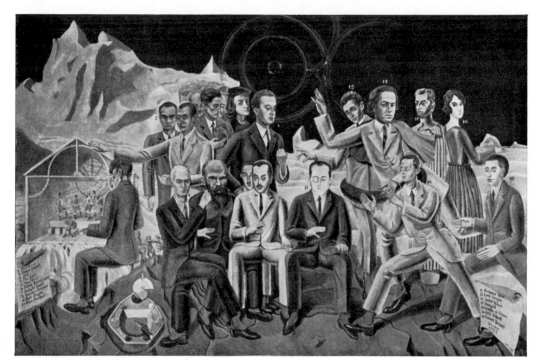

46. Reunion of Friends
(Painting by Max Ernst, 1922)

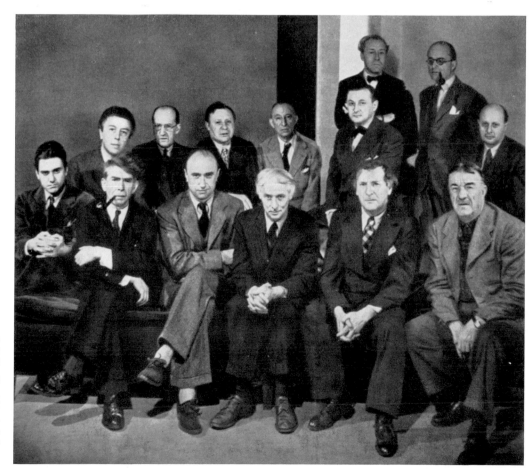

47. Artists in Exile
(Exhibition at the Pierre Matisse
Gallery, March 1942)

From left to right:

First row: Matta, Zadkine, Tanguy,
Max Ernst, Chagall, Léger

Second row: Breton, Mondrian,
Masson, Ozenfant, Lipschitz,
Tchelitchew, Seligmann, Bermann

(Photo Soichi Sunami, New York)

48. Ernst Wilhelm Nay (Photo Johanna Schmitz-Fabri, Cologne)

49. Alfred Manessier (Photo Rogi-André, Paris)

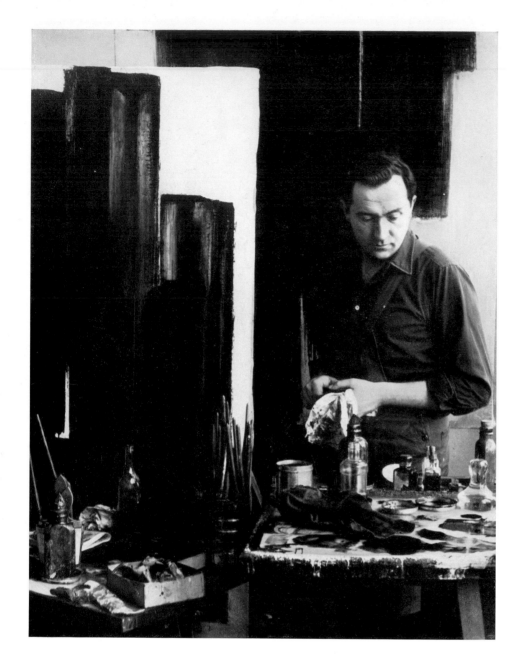

50. Pierre Soulages (Photo Denise Colomb, Paris)

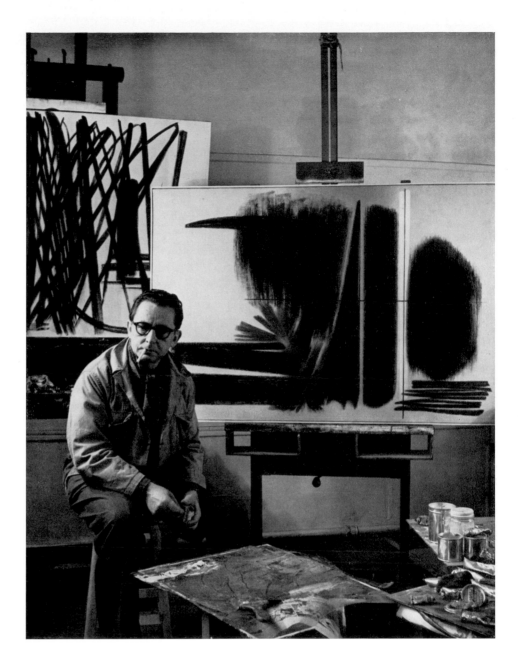

51. Hans Hartung (Photo Denise Colomb, Paris)

52. Graham Sutherland (Photo John Hedgecoe, London)

53. Wols (Photo Wols)

54. Jackson Pollock (Photo Hans Namuth, New York)

Celtic sources that we have frequently discerned in English painting. In Germany we find several examples of this art which composes lyrical poems with representational signs. Werner Heldt has invented a simple vocabulary of signs for houses and churches, streets and squares to describe his sensations in the empty, resounding streets of Berlin, the dead metropolis, and with the help of this language he keeps composing lyrical *ritornelli* on his theme. Camaro conceals the void of reality by a dream proscenium. Thin posts support gently fluttering canvas walls before which are suspended *loges* and parapets and boards – a fragile backdrop filled with shadows which turn into figures or objects; a scene of expectation. Then a sign calls forth a thing, its echo carries across the pictorial stage and conjures up a figurine. Thus the artist sets in motion a hushed drama that ends in a lyrical parable. Richer and more luminous in colour and far more comprehensive in content are the pictorial poems of Werner Gilles. Always lyrical in mood, he is inspired by lyrical poets, Hölderlin, Baudelaire, Rimbaud, and like them he expresses the impulses of his inner life in representational metaphors or allegories. A beloved landscape or a lyrical moment is transfigured into dreams which evoke scenes, figures, and objects. The dreams are what he paints; the representational setting retains a symbolic significance, and the lyrical emotion is captured in abstract forms and colours. From the mysterious inverweaving of signs and tones there emerges a little fairy tale full of deep feeling or, when he is particularly successful, an Orphic song.

The technique of representational hermeticism consists in deriving from the representational motif a formal pattern which transposes the motif into its own hermetic idiom and interprets it formally and poetically. Yet this hermetic Orphic art possesses not only the freedom to move away from the object, but also the freedom to raise it to a higher and more permanent reality. This art lies in the border zone of abstract painting, where it encounters a different kind of contemplation of nature which transcends the representational image.

In the light of the foregoing survey of the methods of mastering the object in contemporary painting, we cannot but register a striking diminution in the vitality of representational art. The impulses to realism originating in philosophy and politics have had little effect on art. The bond with objective reality that seemed so urgent in the twenties and thirties was so weakened that the only realistic position capable of being defended seemed to be 'transcendent realism' as Beckmann called it. Nature attracted interest only in so far as it yielded images and metaphors in which to express man's existential feeling. But soon the existential experience of reality moved to more abstract regions. The visual data were encoded in a hermetic idiom; the painting became a product of meditation which transposed them into the dimension of pictorial poetry, where they fused with the stream of messages pressing to the surface from the inner depths. By a curious detour, abstract painting was once again to come into contact with the Orphic ground of reality. But what is 'abstract painting' today?

### Concrete Form

The term 'abstract painting' is today violently rejected by the very artists who have dropped all reference to natural forms. And indeed it is merely a crude designation for an art which moves in the realm of the non-representational. The impulses underlying this art are extraordinarily varied. To describe them we must make a number of fine distinctions.

As we have pointed out, contemporary non-objective painters persist in regarding form as a

concrete reality; their purpose is no longer to transpose natural appearance into purely formal structures by the method of abstraction, but to give concrete visual form to abstract ideas and experiences. The painter no longer works with the finished forms to be found in nature; the formal elements constitute his field of action. From this point of view it is true that, as Doesburg put it, 'nothing is more concrete and real than a line, a colour, a plane'. The term most often heard today in discussions on abstract painting is 'concrete art'.

The term is not new. In 1930 van Doesburg published in Paris a little pamphlet bearing the imprint *A C* and entitled *Numéro d'Introduction du Groupe et de la Revue Art Concret*. It includes an uncompromising manifesto which declares that art is universal, its task being to create a universal language. Every link with the formal data of nature or the claims of sensory or emotional life amounts to a disturbance of the universal by the particular and individual; the presence of lyrical, dramatic, or symbolic elements troubles the vision of a pure self-subsisting harmony. The means of giving concrete form to the creative spirit cannot be *'forme-nature'* nor its variant *'forme-art'*. It can only be rigorous absolute form, *'forme-esprit'*. Thus, the artist's goal is not abstract interpretative art, but concrete constructive art. Form and imago do not point to something else but signify only themselves. If the artist is to eliminate all possibility of association, he must employ only clear, simple forms which the mind can fully control and verify. Such forms are the geometrically measurable elementary forms. Consequently a painting must be constructed exclusively from clearly defined flat planes, exact lines, and pure colours. Its order must be set forth with a technique as impersonal and mechanical as possible – without 'interesting surface' or 'handwriting'. Such a technique gives rise to a concrete harmonic structure which is absolutely clear and carries an inherent, logically verifiable certainty. Just as mathematical insights into geometrical and numerical orders are expressed in formulas, so pictorial insights into proportion and harmony are expressed in a formula of forms and colours. 'In painting,' Doesburg concludes, 'there is nothing to be read, but only things to be seen.'

This 'Concrete Art' based on the aesthetics of the Stijl group was no longer rigorously confined to the static horizontal-vertical system that characterised the early productions of the Stijl painters; it now made use of dynamic diagonal forms and a freer geometry. This relaxation of the original doctrine paved the way for a closer association with the other free schools of abstract painting. A fusion of this kind resulted, in February 1931, in the foundation of the 'Abstraction-Création' group through which the idea of concrete form greatly influenced all abstract art. If we leaf through the first few annual fascicles (which the group began to publish in 1932) under the title *'abstraction-création, art non figuratif'*, we come across nearly all the names representative of abstract painting today – Arp, Albers, Baumeister, Bill, Delaunay, Domela, Gleizes, Herbin, Kandinsky, Kupka, Moholy, Mondrian, Nicholson, Prampolini, Schwitters, Taeuber-Arp, Doesburg, Vantongerloo, Vordemberge-Gildewart, etc. All of them had become convinced of the value and scope of concrete form, though some stated their opinions more dogmatically than others.

During the thirties all these developments remained very much in the shadows. Not until the end of the Second World War – 1945 may be taken as the crucial date – did abstract painting come into its own. At the same time the idea of Concrete Art gained ground. It has found its sharpest expression in the geometrical-constructivist schools of contemporary European painting.

In the Ecole de Paris the geometric current of concrete painting gained great importance immediately after the war. Paris provided favourable conditions for its growth. As early as the thirties all the artists who regarded concrete form as the vehicle of pictorial harmony – from Mondrian and Doesburg to Magnelli and Arp – had met in the free atmosphere of the French capital. The movement was broadened by men of the Cubist generation (Herbin and Kupka), and younger members of the Stijl group (Del Marle and Domela). Constructivist sculptors (Pevsner, Jacobsen, Lardera) contributed vigorously to the movement. Public interest was aroused by special exhibitions and lectures. The newly founded Salon des réalités nouvelles and the Salon de Mai also provided a forum for 'Concrete Art'. It was not long before the new Constructivism gained so large a following in Paris that the danger of a new abstract academicism was seriously discussed in some quarters.

The danger would have been real enough, particularly in view of the long history of Concrete Art, going back to Russian Constructivism and De Stijl, if specific spiritual and visual experiences of modern life had not provided the painters with sufficient stimulation to save them from mannerism and repetition. The functionalism of modern architecture, the purposeful structures in which technology and industry find their formal consummation, are but a few symptoms of the irresistible transformation of our visual environment. A new, less natural reality has taken the place of nature and modified even its very own domain – fields, forests, sea-coasts, and rivers – bringing them into conformity with a human order. 'The picturesque has been pretty much supplanted by the mathematical', as Mondrian put it. Geometrical equations trace the patterns of this emerging reality and serve as visual facts which influence the painters's eye and imagination. And behind all this is the profound fascination of algebraic numbers, in whose immaterial filigree the modern mind has been able to express its entire view of the cosmos. They have provided the painter with a stimulus to devise, in his own domain of form, new patterns evoking that new, immaterial reality.

The art thus produced is one of pure harmonics. It operates on the surface with measurable geometrical forms, it is divorced from all illustrative and sentimental elements, and is devoted only to the beauty and harmony of a non-utilitarian formal order. The Constructivists and the Stijl artists had already found the subtle beauty of geometry purer and more stimulating than forms copied from visible nature. Plato had been moved by the geometrical beauty that appears to us distinct from its logical causes and – because it had to be contemplated disinterestedly and without sensuous desire – it struck him almost as a moral value. This moralistic Platonism provided the foundation for the aesthetics of the new Concrete Art. The first assumption is that – as Jean Arp says – 'in this world the high and the low, the light and the dark, the eternal and the transient are in perfect balance'. The painter's task is to give visible expression to this balance by means of formal arrangements, according to the degree and modality of his experience. His work is like the swing of a pendulum around an imaginary harmonic axis; the amplitude of the swing records both the painter's individuality and his state of mind. The painter is always in search of balance, but at the same time he is always obliged to disturb the balance in order to restore it on a new plane. All this implies a new image of the artist, who feels close to the theoretical mathematican and, like him, expresses harmony in a formal order made of numerical proportions and geometrical patterns. Thus the rigorously constructed, geometrical paintings of Concrete Art are genuine products of meditation and contemplation. They must be experienced meditatively, too, as icons in which intelligence contemplates the transparent structures of mathematical filigrees.

Such is the force of conviction carried by this art that today many painters all over the world are actively engaged in the constructive definition of our sense of universal harmony. Vasarely and Dewasne among the many younger French painters of this school, and the Danish painter Mortensen, have particularly asserted their originality. They had all studied science before taking up painting, and their work is characterised by a certain scientific precision. They create harmonies with clearly defined geometrical forms arranged in a strictly flat order. Vasarely who became acquainted with Bauhaus functionalism through Moholy-Nagy, has been trying with the help of flat forms cut out sharply as though with scissors, to achieve an order that will be the formal equivalent of the material world around him. Dewasne is richer and more complicated, his forms more closely interwoven. This gives his paintings a dramatic accent. Although the aims pursued by these painters are closely related, they offer striking proof that personal factors can play an important role in an art which at first sight seems so impersonal.

For the first time Italy has responded enthusiastically to the idea of concrete form. No less than seventy qualified painters showed at an exhibition held in 1951 at the National Gallery in Rome under the title 'Arte astratta e concreta in Italia'. This seemed all the more surprising because Italy had been extremely reserved towards abstract art in the previous decades. It is true that in 1934 the Galleria del Millione in Milan exhibited some abstract painters one of whom, Mauro Reggiani, is still well known today. In 1935 Magnelli, Licini, and Soldati were represented at the Second Roman Quadriennale, and abstract groups had formed in Turin around Fontana and Veronesi, and in Milan around Rho and Radice. But such groups remained obscure. Only after the war did young Italian painters shift to abstraction on a broad front. The Bauhaus ideas were discussed everywhere, and Kandinsky and Klee, who had been virtually unknown in Italy, became leading masters. The developments once again confirmed the essential features of the Italian spirit in painting, which for all its occasional outbursts of declamation and rhetoric, insists on formal discipline, simplification, and consolidation of pictorial structure. Soldati and Magnelli possessed this rigorous gravity from the outset, and it was further developed by the constructive ideas of Concrete Art. The 'Movimento Arte Concreta', founded in 1948, became the principal forum of Concrete Art in Italy.

This movement attracted numerous adherents but produced few significant personalities. Its foremost Italian exponent is still Alberto Magnelli — who lives in Paris. The Roman Giuseppe Capogrossi was the only painter of this tendency to achieve a new personal quality. In 1949, after critical years of experiment with various forms of representational expressive painting, he developed a new, elementary style. He gave his surface rhythmic articulation with the help of a single basic form, rather resembling a comb, which varied but little. When, as in his best pictures, he succeeds in going beyond a purely decorative pattern, the comb-signs, by their distribution and the directions of their movement, give rise to a field of tensions comprising a spatio-temporal dynamic. In this field divergent pictorial forces are composed into a higher harmonic balance. Capogrossi's ideas seem to have been taken up and extended by 'Spazialismo', the Milanese movement whose ideas Lucio Fontana began to disseminate in 1947. In Spatialism, ideas of concrete painting were combined with the experimental, provocative procedures of Dadaism. Ultimately it became a variant of the 'Art Autre' or 'Art Informel' which in the last decade has asserted itself in the painting of all the Western countries. In the course of this development strict Concrete Art has disappeared almost entirely in Italy.

In Germany the ideas of the Bauhaus were revived after the war. Kandinsky and Klee, in particular, exerted an extraordinary influence on the younger generation. However, the ideas of Concrete Art,

which Albers and Moholy-Nagy had developed at the Bauhaus, met with little response among artists, though they played a vital rôle in architecture, industrial design, interior decoration, and related crafts devoted to the shaping of our everyday environment. The leader in this field was the Swiss architect, sculptor, painter, and designer Max Bill, who had himself studied at the Bauhaus and belonged to Abstraction-Création, and whose work embodied the ideas of the Stijl movement. Under the influence of Vantongerloo, he based his painting – which was only a part of his many-sided creative work – on the numbers and mathematical proportions with which the modern spirit defines its world; from them he developed an aesthetic counterpart, a *forme-esprit* in which the non-sensory beauty of numerical relations can be contemplated. By way of creating a forum and workshop devoted to the formal problems raised by modern society, he helped to found the Hoch-schule für Gestaltung at Ulm, whose director he became in 1951. As teachers of painting he appointed Vordemberge-Gildewart, who came directly from the Stijl movement, and the young Argentinian Maldonado who had familiarised himself with Concrete Art in South America and in Paris. But beneficial as this revival of the old Bauhaus ideas of functionalism may have been for architecture and industrial design, it had no influence on painting as an independent art.

There is no doubt that many of the younger German artists have assimilated the ideas of Concrete Art, which are easily detected in the products of the new German abstract painting, but Concrete Art has not developed there as an independent trend – for that the Germans are basically too romantic. In Hamburg however we find a group of younger painters whose work reflects the style and theory of the young Frenchmen grouped round Vasarély and Dewasne. And the same ideas take on a more personal form in the work of the Munich painter Rupprecht Geiger who, with the help of a strangely magical colour, has been able to weave fragments of highly romantic experience into his strict geometrical arrangements of the simplest forms. Though fully consonant with the modern view of the world, these paintings surprise us with their initimation of the Romantic experience of infinity.

This unexpected turn, combining the cool harmonies of Concrete Art with a Romantic experience of infinite space, can also be observed in the American painter Barnett Newman. With their intense, suggestive colour, giant monochrome surfaces, whose monotonous expanse is broken into rhythmic intervals by a very few vertical lines, evoke infinite worlds, a field of meditation on infinity. One might have expected the teaching of Albers and Moholy-Nagy and the example of Mondrian, who worked in New York from 1940 up to the time of his death in 1944, to promote a flowering of Concrete Art in the United States. But this was not the case. Aside from Albers, Fritz Glarner, who emigrated to the United States in 1936 after ten years in Paris, was the only painter in America to carry on Concrete Art in the tradition of Mondrian and Doesburg. Those of the younger American painters who were interested in the ideas of De Stijl – Barnett Newman for example – strove to combine Concrete Art with the kind of formal meditation that has reached its culmination in the recent work of Mark Rothko.

In England Concrete Art has had little influence on the younger painters. In general they have started with Cubism and then gone on towards a more spontaneous and abstract form of expression. Only Victor Pasmore, one of the leading exponents of the sensitive naturalism of the Euston Road School, took up Concrete Art. In 1948 he went through a severe crisis, feeling his lyrical nature painting to be incompatible with the contemporary sense of reality. He sought a solution in abstract painting, which he had approached for a time in 1934. After a period of geometrical collages he attempted, in 1949 and 1950, to transform his surface, by means of dynamic spiral motifs, into a sounding board for psychic impulses. Finally, towards 1952, under the influence of Naum Gabo

and the Stijl aesthetics, he produced rectangular harmonic arrangements of strips of metal and plexiglass on a pure surface, quite in the spirit of international Concrete Art.

Yet it was in England that, in the years after the war, an outstanding artist arrived at a synthesis of all the currents underlying Concrete Art — Analytical and Synthetic Cubism, Purism, the Stijl aesthetics, and Constructivism — and so created a work of great richness and freedom. This was Ben Nicholson. He had started working towards this synthesis fully ten years before the war, taking Juan Gris as his starting point. But what stimulated him in Gris was not so much any particular painting as the idea underlying his work as a whole. This was the idea of a visible order reflecting the equation '*forme = esprit*'. In the harmony provided by such an order, Gris had believed, the spirit could find contentment. But Gris had also taken account of the possibility that the abstract equation might, as he put it, 'take on objective qualification', that is, coincide with the harmony concealed in the things and images of the outside world. In the course of his methodical investigations Nicholson amplified these ideas with similar ideas that he found embodied in contemporary painting and attuned them to his own poetic feeling. His path led from Juan Gris, Synthetic Cubism, and Purism to the abstract Constructivist endeavours of the Stijl group and Abstraction-Création, touching on the poetic realm of Paul Klee. Naum Gabo's transparent mathematical constructions were also taken into account. All the while searching the human mind and the images of nature for manifestations of a superordinate harmony, Nicholson finally developed a personal style of strict clarity and well-proportioned harmony, reflecting the cool romanticism of his apperception of the world. Nicholson's arrangements are purely geometrical and abstract. Geometrical forms — chiefly squares and circles — produce a tense balance responding to the artist's clearly defined idea of harmony. But quite in accordance with Gris' ideas, these purely abstract arrangements are capable of entering into other contexts of amazing richness; quite unexpectedly a bond is established with the harmonic order in nature, and thus the picture, begun abstractly, takes on 'objective qualification'. From the abstract arrangement emerge signs for visible things, formal emblems objectively embodying the superordinate harmony. Sometimes nature provides the impetus. Nicholson's work includes numerous still lifes, landscapes, city-scapes, set down in a fine, arabesque-like, immaculately precise line on a surface of cool bright colour articulated in flat spatial planes. In these pictures Nicholson starts from the objective motif and goes on to construct a self-contained architectonic order which may preserve a representational quality in so far as the forms presented by nature fit in with the formal requirements of the picture. In many of his paintings Nicholson draws a distinct architectural or landscape motif into the harmonic scaffolding of the picture. But the objective motif is transformed in the process, stripped of its confusing detail; the universal order concealed in it is isolated and made visible By these methods Nicholson has achieved great freedom: he has learned to find a harmony that satisfies him in the things of the outside world and to draw it forth; to employ a pure formal order as a paradigm of a pure abstract harmony, or, by discovering formal analogies, to establish a relation between this abstract harmony and the harmony hidden in the images of nature. Personal expression and even national traits may make their appearance. What seems characteristically English in his work is a certain atonal quality in the colour, a tendency to inject staccato rhythms and bright sharp accents into balanced earthy colour chords, the minute 'Gothic' articulation of his composition, and the ornamental fantasy that emerges from beneath the clear drawing. Even in Nicholson's strict style these factors provide a romantic note. But the picture is always a self-sufficient architectonic structure, a pictorial equivalent for a universal harmony which the artist feels in himself or discovers in the things of the outside world.

With Concrete Art, which aims at harmony through geometry and construction, contemporary pictorial thinking has enlarged and greatly enriched the domain whose boundaries were traced by Piet Mondrian. Its basic premise is that the artist's authentic material is absolute, clearly defined form and that his task is to treat the picture as an autonomous field, from which he eliminates all disturbing elements in order to achieve a harmony which is the ultimate and self-sufficient formula of the spirit and hence a visual equivalent of the balance achieved by man in the universe. Despite its greater formal richness, the painting is always conceived as an absolute, as the harmonic end formula in which all personal emotions have been reduced to silence and repose. In the geometrical architecture of the painting, human existence and its expression give way to pure harmony and its formal order. This is the most radical position held by abstract painting.

*The Concrete and the Expressive*

Concrete Art conceives of the picture as a distillation, an harmonic end formula which transcends all natural or artificial formal or psychic tensions, a product of keen intelligence and clear application of the laws governing the pictorial elements. According to the basic theory of Concrete Art, everything essential in art has always rested upon end formulas of this kind: the proportions of Egyptian reliefs or of the archaic Apollo, the rigorous constructions of the great frescoes of the Renaissance, the hidden geometries of Chardin or Poussin. Thus the elimination of representational images and the overt use of pure geometry do not imply a radical and definitive rejection of the great art of the past, but rather a reassertion of its eternal values stripped of their historical and social disguises, and an application of these purified eternal values within the framework of a new society that is seeking, in every sphere, to re-interpret the world of objects in terms of abstract relationships. This most rigorous current of contemporary abstract painting is therefore able to identify itself with, or at least to invoke, the Apollonian or Platonic conception of art. This classicism leads it to shun the expression of human passions.

However, classicism is only one of the possible human attitudes. Its balance rests upon the neutralisations of conflicts in a mid-point. It takes the shortest roads to achieve this balance, and the result conceals these roads as well as the tensions that determine their direction. But the longer the roads, and the greater the tensions, the more vigorous, direct, and humanly stirring the expression of the work will be. If the genesis of the work is not concealed, the roads will be perceived as the traces of inner movements, and the human drama, directly, spontaneously and concretely recorded, will remain decipherable even in the balance finally achieved.

Contemporary abstract painting has provided many new methods of expressing what is most personal in man. Aspects of human existence spontaneously set in motion the handwriting of coloured forms, so conjuring up a pictorial structure which is a record of momentary states of mind and also of the dynamic process by which the picture itself came into being. The picture is a junction of many energic currents; in it their antagonisms achieve a tingling balance. Geometrical concrete painting presented itself chiefly as a movement. The new current, however, was elaborated by a number of strong personalities. The most important of these made their appearance at the very beginning: Hartung, Wols, Pollock.

Since 1922, when he began to paint, Hans Hartung has been working to make art into an instrument capable of directly recording his inner experiences. His undeviating purpose has been direct psychic improvisation undisturbed by objects whether recollected or observed. He has never taken

any existing modern painting as his model but has been guided solely by general theoretical considerations. One of these was Kandinsky's idea, expressed in his early improvisations, that states of mind can be transmuted spontaneously and directly into forms and colours. Ultimately Hartung's art goes back to Van de Velde's principle that line is a force which borrows its energy from the man who traces it. Line conceived of as the trajectory of kinetic energy provided Hartung with his first means of producing spontaneous images of his emotions. In pursuing this new idea, which was almost an obsession with him, Hartung soon came to look upon the entire field of formal elements as an arsenal of psychographic characters. On this basis he developed his meditative technique.

The act of creation begins even before the artist picks up his brush, with the primary field of the waiting white canvas. His meditation on it releases the first productive movement – the colours are summoned to action. The loosely applied paint lays the general foundation. Spots of colour scattered on the ground create a spacious atmosphere, which is at first quite indefinite. Its mood sets the feelings of the moment in motion. But still the whole is pure tonality, diffuse, vague – an arena open to all possibilities. Into this gravid atmosphere an intense energy is released. It records itself spontaneously in linear diagrams. In their various constellations the trajectories of energy in search of form are disclosed and contrasted; an endless sensitive line gropes its way forward, sending out feelers and repeatedly turning back; a swirling bundle of crackling lines of force conveys the emergence of a conflict; a network of furiously intersecting lines rejects a possible solution. Sheaves of lines resembling steel springs pressed together, and massive heavy lines, produce a new, frantically resolute assertion. This linear network of energies defines and consolidates the evocative ground. But the lines themselves are independent formal entities with a dynamic expressiveness of their own, directly associated with the kinaesthetic sense. They may be thin as cobwebs, produced by a twisting movement of the lightly dancing hand; they may plough through the paint slowly or by fits and starts. They capture the rhythms of the artist's hand: the strokes may be swift or slow, hurried or hesitant. This movement in time, in conjunction with the graphological aspects of the pictorial script, makes it possible to record psycho-motor energies directly.

Thus the drama – the search, the excitement, the rejections, the assertions – is encoded in the simultaneous texture of the processes at work. The network of lines and bars traces paths for the eye. If we follow these paths, the handwriting becomes eloquent, and its successive stages tell us of lively events – moments of slowing down, of frustration, when comfortingly luminous or dangerous grounds are fenced in. Thrown into all this is an energy which inexorably asserts itself and in the end subjugates the forms. For if a painting emerges from these psychographic communication signs, it is because the motor energy reacts not only to inner impulses but also to the appeals of the pictorial organism. In this dialogue a taut balance is created. Behind it we find always the same theme – man and his states of mind. A restless, highly-strung temperament disciplines itself and controls its anxiety by an extreme effort of artistic creation. In happier moments simple signs, as concentrated as Far Eastern ideograms, make their appearance.

The method which Hartung has perfected is the automatic writing slowly developed in modern art – a seismographic technique, which records every tremor of the psyche. The painting is a concrete imprint of a moment of human life. The painter's situation is made visible by his creative action. This art of psychic improvisation was developed under the most difficult living conditions and bears their mark. In 1935 Hartung fled from Nazi Germany to Paris, where the sculptor Gonzales encouraged him in the direction he had taken. Interned at the beginning of the war, he fled to the Spanish border from the approaching German armies and finally ended up in the Foreign Legion. In 1944 he was seriously wounded during the fighting in France and lost a leg.

Despite these hardships he pursued his artistic goal unflaggingly. When his work was shown at Paris exhibitions shortly after the war, he was immediately recognised as a leading light of the Paris school and as one of the outstanding representatives of Western painting.

Hans Hartung is today one of the important representatives of the Ecole de Paris. Nevertheless, his search for greater freedom of expression points to his German origins and his early experience of German Expressionism. The stubbornness with which graphic elements assert themselves in his art, dissolving and keeping open the forms, may also have something to do with his German origins. When French painters apply a similar psycho-motor technique, the form tends to become more finished and static. The signs that Gerard Schneider sets down as equivalents of his emotions suggest not so much paths and movements as forms confronted in a dialogue. Although the dialogue is also characterised by spontaneous expression, the character of the script and the dynamism of the movements result in firmer forms. In Pierre Soulages, the violence of the energies employed is disciplined by a large austere construction. The powerful buttresses made of heavy bars are reduced to simple elementary gestures: a rectangular scaffolding, over which black strokes mark ponderous movements. Thematically these paintings suggest a solid achievement of archaic strength against a threatening background. Because the basic structure of these nocturnal icons of black, grey and ochre is unchanging, even a slight modification of the contrasting movements produce a change of meaning.

In Hartung as in Soulages the ultimate aim of psychic improvisation was a complete, self-contained monumental icon which would embody in its clearly defined image, the impulses and passions of life. But in 1945 René Drouin exhibited at his gallery in the Place Vendôme a number of small works — water-colours and drawings — by a hitherto unknown painter. There was nothing monumental about them and there was no attempt to achieve the fully formed picture that painters had aimed at since Cubism. Employing only the evocative qualities of colour and line, these pictures were free improvisations, directly recording moments of human existence. This painter, whose name was Otto Wolfgang Schulze, called himself Wols. He was the primitive of the new sensibility, of the trend which we now call 'Art Informel'. Since this first exhibition at the Galerie Drouin his very personal work has exerted an ever-increasing influence on younger painters and has been an essential factor in producing the stylistic expression which, under names such as 'Tachisme', 'Art Informel', 'Art autre', has dominated the painting of the whole Western world in the last few years. The human attitude embodied in this work accounts in part for its influence. What gives the life and work of Wols their value as contemporary documents is Wols' exemplary acceptance of the destiny which man meted out to man in the chaotic years before and after the war: persecution, poverty, homelessness, and perpetual flight. Gently submissive to his fate, he recorded what befell him: not the facts, but the images provoked by the wounds that life inflicted on his psyche.

Son of a well-to-do family of civil servants, Wols grew up in Berlin and Dresden. In 1932, after a brief period of study at the Frobenius-Institut in Frankfurt and a four month course at the Bauhaus in Berlin, he left Germany for Paris. At that time he painted a little, wrote haphazardly, and photographed a great deal. Then came a long stay in Spain — Barcelona and the Balearic Islands — until the Civil War drove him out of the country. In 1936 he worked as a photographer in Paris and held a successful exhibition of his photographic work, continuing to paint in his spare time. His painting at the time retained something of the objective metaphor of Surrealism, but was strangely 'antique' in tone, as though carrying on a dialogue with Hieronymus Bosch. Then came war, internment, flight, and a long period of hiding in Vichy France.

Wols had no thought of painting as a profession. At the dictation of life, he painted a record

which concerned him alone. The images that rose up in him were parables for his inner dreams – he jotted them down in a spontaneous improvised script: lines as fine as spider-webs on sheets of notepaper, so small that his hand in its gentle, trance-like movements could explore the whole pictorial field. He once wrote: '…the movements of the hand and fingers suffice to express everything… The arm movements necessary in painting a canvas involve too much ambitious purpose and gymnastics. That is not what I want.'

He improvised strange dreams full of poetic meaning. 'All my dreams', he noted, 'take place in a very large and beautiful unknown city.' His water-coloured dream cities have a Mediterranean aura; streets, squares, inns, and harbours are set down in the finest lines in such a way that the eye can explore them for hours. One is reminded of the strange, mysterious places that Kafka or Kubin conceived of as the scenes of their dream episodes. Devoid of human inhabitants, they are subtle autonomous organisms which grow like corals into their own structure and provide a home only for the painter himself. There are also ships, Flying Dutchmen with the wind in their sails and antennae at their bows and sterns, laden with delicate, diminutive structures born of nature's formative fancy. And there are remote spent stars or hovering crystalline creatures of the air against twilight horizons, while sometimes we encounter anthropomorphic shapes which beneath our eyes fall into the sleep of putrefaction; for, in Wols, wherever life appears, the aura of death is also present. His psychic vegetation often defies objective definition – increasingly so as Wols penetrated deeper into his dream world. But his state of mind is defined with the sharpest precision by the antennae of his sensitive line and the radiations and refractions of his coloured light. Dark images emerge: *Les Chants de Maldoror*, phallic flowers, hatred of sex, abstract fury, and over and over again the bleeding wound of the world. Patiently attentive to the communications of his inner psyche, Wols untiringly recorded the surging images projected on the screen of his closed eyelids. This series of visual poetic dreams was painted in the fourteen months spent in French interment camps in 1939 and 1940 and in his hiding places at Cassis and Dieulefit.

It was these improvisations that René Drouin showed in December 1945. Returning to Paris, Wols soon began – in January 1946 – to paint larger pictures. The larger format and the transformation of the surface into a sounding board for inner impulses demanded total commitment. The metaphorical capacity of objective intimations no longer sufficed. Painting became direct action from the heart of existence: the trace of its gestures, the choreography of its rhythm, the heartbeat of the painter himself. Just as nature records its processes of development in geological structures, in 'diagrams' of growth and decline, just as a wall preserves the record of its history, of the injuries inflicted upon it by time and chance, so the picture surface became for Wols a writing tablet on which his fate inscribed its chronicle in a script of lines, coloured light, and spots which directly register the tingling of his nerves. Only the tensions of existence are worth recording. This attitude required an extreme concentration, obtained through intensification of the life process itself – and here alcohol played a part. Such self-provocation meant self-destruction, for every picture absorbed a part of the painter's psychic vitality; the pictorial texture devoured his living tissue. For five years Wols endured this process of self-destruction. He died on September 1, 1951. His work comprises a hundred oil paintings and several thousand water-colours and drawings.

Wols' art is not without its history. It begins with the fabulising narrative line of Ensor and Kubin and the statistical, naïvely descriptive line of the early Grosz. Hieronymus Bosch and the Surrealists helped him to the freedom of his thematic invention, and the latter gave him the idea of automatism. He learned from Paul Klee his techniques of psychic improvisation and also from the free graphic style of the early Kandinsky. Certain technical elements of Wols' later work, in

particular his use of plastic paint – 'haute pâte' – may have been suggested to him by Jean Fautrier, who first in 1942 and then in his 'Otages' series of 1944-45 employed this technique originally deriving from Klee. Thus the elaboration of Wols' style closely follows the artistic development of the present period, and that is one reason why his work did not remain isolated but became the pictorial expression of a contemporary situation. At the same time, but quite independently, Pollock and Tobey in America responded to similar impulses. It was because Wols took this definite situation upon himself and transformed it into pictures that his work achieved its extraordinary resonance in the present-day world.

### Psychic Improvisation in American Painting

At first these developments in the Paris School were overshadowed by post-Cubist and hermetic painting. But in the late forties they gained appreciably in importance because they were reinforced by tendencies in the same direction that had meanwhile asserted themselves in the United States and were beginning to enter into the European art world.

In the United States – and pre-eminently in New York – the isolation of the war years had produced a constellation which offered American painting new points of departure. We have seen how the group of Surrealists who emigrated to America during the war familiarised the younger American painters with ideas such as the unconscious as a source of images, the mythical ground of reality, and psychic improvisation through automatism. Above all the idea of psychic improvisation became the starting point for astounding developments. Though the formal ideas of those masters whose work may be identified with abstract Surrealism – Miró, Max Ernst, Masson, Kandinsky, and Klee – were not without influence, the kindling spark was provided by the fundamental idea of freedom as a way to self-expression. An attitude was born in which the most secret impulses in man were taken seriously and painting was felt to be a direct expression of life itself.

It was an alluring, though anarchic, field of freedom that opened out before the younger painters. True, this freedom was not without its tragic aspects. In 1954 Robert Motherwell, who had belonged to this avant-garde, recalled the situation at the time: 'When my generation of "abstract" painters began exhibiting ten years ago, we never expected a general audience... it would have been unreasonable for us to expect one, no matter what we did... ten years ago it seemed that we were embarked upon a solitary voyage undertaken in the belief that the essence of life is to be found in the frustrations of the established order.'

In this isolation from, and antagonism to, society, raised to the point of paroxysm by the tragic background of the war and the prevailing despair in human nature which seemed capable of the most unconscionable crimes, a painter could feel free to do anything. His freedom was a vacuum in which he was no longer responsible to anyone but himself. His unlimited self-responsibility dertermined not only his ethical attitude but his way of painting as well. Cut off from a society utterly unconcerned with what they did, these painters were free to paint pictures that seemed to be no pictures at all, to employ techniques that defied every classical notion of painting, to choose enormous formats that well-nigh precluded the possibility of a private purchaser, to express states of intoxication condemned by the prevailing morality. They found their only justification in the inner necessity of their self-expression. We must bear in mind the absolute character of this human attitude, and the tragic note in it, if we wish to understand the depths of feeling involved in the crass indiscipline of this new American painting.

Names for the new trends began to emerge: in 1946 the term 'Abstract Expressionism' became current. Distinct groups formed. The most radical group, who interpreted psychic improvisation in the Abstract Expressionist sense, gathered round Pollock, and included Motherwell and De Kooning. Matta and Gorky remained on the fringe. The central figure was Pollock. By a degree of self-destruction that seems almost inhuman, he gave psychic improvisation a monumental dimension.

In 1943 Pollock held his first one-man show at Peggy Guggenheim's 'Art of this Century' gallery. The pictures bore strange titles: *The Guardians of the Secret, The She-Wolf, The Mad Moon-Woman, The Moon-Woman Cuts the Circle.* The very titles are evocative of myth. These pictures, all of them large, have a strange formal restlessness about them – a flat space overgrown with an unruly baroque vegetation. Amid these turbulent forms disquieting signs, rhythmically repeated, inscribe cryptic messages. Here and there the form begins to gesticulate wildly and from the gesture an evocative sign emerges: a hand, a face, a human body, a figure, and mythical beings take up their dwelling in the surface ploughed through with pictorial energies. Two pillar-like anthropomorphic figures keep vigil beside a tablet inscribed with cryptic signs, beneath which lies a wolf-like animal: *The Guardians of the Secret;* four standing figures surround a monstrous, many-breasted, convulsively gesticulating figure: *Pasiphae,* the mythical queen who took a bull for her lover. If we analyse the formal structure of these figures emerging from the convulsions of Pollock's pictorial organism, we find intimations of Picasso, Masson, Miró, and the Mexican Siqueiros – the masters with whom Pollock was most concerned in his student years before the war. But in his impetuous spontaneous script, these associations merge into a very personal style. The liberating idea to which these pictures owe their power is the spontaneous, automatic projection of the painter's psychic states. It had been a ferment in the minds of the younger painters since 1940. Matta had communicated it to Motherwell; one day they suggested to Pollock that the three of them should work together in investigating the pictorial possibilities of automatism. Although Pollock declined, he agreed with their point of view, saying: '...the Surrealists are right: all painting comes out of the unconscious'. In those days Pollock was still searching for the mythical images that surge up in the unconscious in the course of a man's encounter with reality. The canvas was a field on which to project a personal mythology arising from the unknown.

But he soon abandoned this approach. For a number of years after 1946, the figurative associations disappear. Now his method was pure psychic improvisation, set down in a completely abstract script, the direct recording of his expressive gesture. In order to perfect this script and to eliminate the associations with bodies, gravitation, and perspective that are present in all traditional methods of painting, he turned to highly unusual methods and media. He employed thin house paint and lacquers, silver and aluminum emulsions, and took up the technique of 'drip-painting' with which Hans Hofmann had experimented in the war years. The canvas is placed on the ground. Casting off all intellectual control, the painter moves over it with complete spontaneity; the liquid paint dripping from his brush or from a tin with holes in it weaves the trace of his gestures into a dense filigree. The work so produced is a direct record of the psyche charged with the painter's *élan vital*. Pollock came to regard painting as pure action, an intricate trance-like choreography fixated in colour traces on the picture surface. The choreographic trace registers the artist's inner life. Often it suggests the hallucinated ecstasy of a whirling dervish, and always it betokens a passionate, desperate search, sometimes favoured with discoveries of a heart-rejoicing lyrical beauty. To make room for his sweeping gestures, to permit him to be literally 'in the painting', Pollock often chose gigantic formats. The canvas becomes a field of forces that draws the painter's whole

348

being into it. 'When I am in my painting', Pollock wrote, 'I am not aware of what I am doing. It is only after a sort of 'get acquainted' period that I see what I have been about. I have no fears about making changes, destroying the image, etc., because the painting has a life of its own. I try to let it come through. It is only when I lose contact with the painting that the result is a mess. Otherwise there is pure harmony, an easy give and take, and the painting comes out well.' What emerges here through the vitality of the line and its coloured filigree is not really a picture in the classical sense; it is a psychic event, recorded in a psychographic network of expressive traces. In the classical sense it is formless – 'informel' – for these pictures are peopled not by forms but by motor energies. They even go beyond psychography. In them we discern a new system of gravity, in which above and below lose all significance, a rhythmic vibration which seems to come from, and to move towards, infinity, a non-perspective, spherical space evoking the infinite, curved space of modern macrophysics. Painting is the imprint of a moment in human existence, but as such it also reflects the responses which science, with its alarming blue-prints of reality, calls forth in the unconscious of modern man. This too is a proof of its authenticity.

Occasionally figural signs, shadows of figurines, emerge in the whirling filigrees of these 'all-over paintings'. Pollock, who had no use for the word 'abstract', never rejected these associations when they seemed to intensify the expressiveness of his pictures. In 1950 his inner view of the world seems to have been invaded by figural images, often of a monstrous character. Apparently the shimmer of colour and the light emanating from it were a barrier to these disquieting visions, for Pollock, began to make use of harsh contrasts between black and white and of a violent dark line. He attacked the canvas with desperate aggressive gestures, as though to compel the Adversary hidden behind it to appear. Sweeping brushstrokes, whirling tatters of form, a frag-mented light are the means employed in this automatic calligraphy. Monstrous figures emerge, faces, spectral hybrid beings brought forth by the cruel line that cuts like a knife into the psychic tissues. These pictures flow from psychic wounds. They show mounting unrest, self-torment, and self-doubt. They write finis to the fantastic drama of this life which came to a tragic end in a car accident on August 11, 1956.

With Pollock the drama of contemporary existence – the tragic element which Mondrian set out to overcome – became once more the central theme of modern art. Intense tragic feeling became the sole justification of painting. Since psychographic expression could be sustained only by the most intense life-feeling, the authentic artist was constrained to live at the highest emotional pitch. Painting became a tragic action, and act of self-destruction, for in it a part of the painter's life energy is consumed. Pollock and Wols paid the price. In their work as in their lives, they set an example that enjoins every painter who employs their methods to commit himself in the same way.

From the historical point of view Pollock's work occupies the realm which Klee called the 'primordial domain of psychic improvisation'. His barbarous rejection of culture and history, his desperate energy and self-destructive pride were needed to develop this idea on a monumental level. Seen in this light, Pollock's art is a further logical step towards that work 'of vast range, encompassing the whole realm of the elements, of the object, of content, and of style', which Klee had designated as the distant goal of painting.

But what was the artistic environment in which this work developed? The young painters with whom Pollock was in contact were by no means the backward provincials that Europeans like to imagine. They were thoroughly familiar with the developments in modern art. All of them

had felt the impact of Picasso's late work and had taken mature Cubism as their point of departure. Miró and Klee were well known to them from exhibitions at the Museum of Modern Art and at private galleries; excellent examples of Kandinsky's early work could be studied at Solomon Guggenheim's Museum. Here they derived their first hints of a way to advance beyond late Cubism, to achieve greater freedom of expression and more profound content.

The teaching of Hans Hofmann at the art school he had been directing since 1932 was highly beneficial to the general climate. This was the meeting place of the younger New York artists, where they discussed the problems of contemporary painting under Hofmann's guidance. Hans Hofmann knew these problems from personal experience. Before the First World War he had belonged to the circle of young German painters round Matisse. He had lived in Paris from 1904 to 1914; in personal contact with Matisse, Picasso, Braque, Gris, and Delaunay, he had experienced the heroic beginnings of modern art. His great love was Matisse, but he was also deeply affected by German Expressionism and Kandinsky's Abstract Expressionism. In the still lifes and landscapes he had painted since his arrival in America in 1932, he had introduced more and more Expressionist and abstract elements into Matisse's restful colour décor. By 1940 he was carrying his transpositions of the objective motif so far that his painting was almost abstract. Through his school, the theory of the evocative function, of colour, form, line, space, and rhythm, entered into the general discussion of art. An educational role was also played by the small 'American Abstract Artists' group which had taken up the ideas of Abstraction-Création during the thirties without significant results.

In this climate the Surrealist ideas of the pictorial function of the unconscious and of automatism acted as catalysts. The war years produced a new constellation, characterised chiefly by psychic improvisation and the dissolution of the Cubist pictorial structure. This was the period of Matta's mythical 'inscapes'. With the help of Miró, Kandinsky, and Matta, Gorky freed himself from Picasso and Cubism. Hans Hofmann, already over sixty, tried out a number of automatic methods, including drip-painting, and experimented with an Abstract Expressionism which already had all the hallmarks of 'Action Painting', a term suggested in 1952 by the critic Harold Rosenberg. Baziotes began to record his romantic legends of magical animals and nature sprites. Gottlieb did his first 'pictographs' — panels inspired by the magical designs of the Indians — in which magical signs, eyes, hands, heads, snakes, etc., are combined into a cryptic script in separate compartments of the surface. Rothko shrouded his picture surface in a dim magical light, through which one discerns a fantastic submarine flora. De Kooning slowly freed himself from Cubism and laid the groundwork for his Abstract Expressionism.

Young Robert Motherwell played an important part in the development of pictorial thinking in this period. He began to paint in 1940, under Matta's influence, thus starting off with automatism. At first attracted by the possibility of making his material speak, he found a satisfactory means of self-expression in the collage. He studied the theory of Surrealism, the methods and ideas of Dadaism, and Duchamp's seemingly paradoxical notions of 'anti-art', so helping his friends to clarify their thinking. Once again Marcel Duchamp became a stimulating force in American art. He was 'a one-man movement', De Kooning recalls, '...for me a truly modern movement because it implies that each artist can do what he thinks he ought to — a movement for each person and open for everybody'. Motherwell also brought Kierkegaard's Existentialism to bear and related abstract painting to the Romantic view of a human existence embedded in a universal context. Abstract painting for him was a spiritual striving to achieve the universal and so to become one again with the world: 'Abstract Art is an effort to close the void that modern men feel... a form

of mysticism.' Thus the new painting acquired a philosophical background and intellectual depth. It was stimulated by the ideas of Freud and the discoveries of psychoanalysis and sustained by the conviction that since all great art is grounded in myth, the central task of a new art is to create a personal mythology. Accordingly the younger artists proceeded to explore the mythical expression of primitive American art, that of the Indians, and of the pre-Columbian art of South and Central America.

Although it was agreed that the new painting should be autobiographical in character, two basic points of view can be distinguished from the start. The one was meditative; its proponents sought to attain the mythical images provoked in the unconscious through apperception of the world. These included Matta, Gorky, Baziotes, Gottlieb and Rothko. The other was expressive, intent on the spontaneous expression of inner impulses, on direct psychic improvisation. Its leading representatives were Pollock, Motherwell and De Kooning. Though at first the accent was on the 'finding' of mythical images – and we have seen that Pollock tended in this direction up to 1945 – they gradually moved towards psychographic Abstract Expressionism.

Some of the new painting was already shown in the war years. In 1942 Baziotes and Motherwell were represented at the International Surrealist Exhibition in New York. Beginning in 1943, Peggy Guggenheim put on one-man shows of Pollock, Baziotes, Motherwell, Hofmann, and Rothko. In 1945 Julien Lévy gave Gorky his first important one-man show. And the work of some of the West Coast artists also made its way to New York. In 1944 the first examples of Tobey's 'White Writing' were shown, and in 1946 Peggy Guggenheim exhibited some pictures by Clifford Still, who was still painting in a Surrealist style. After 1946 the new painting was consolidated, and gained in influence. In 1948 Baziotes, Motherwell, Newman, and Rothko founded an art school which they named 'Subjects of the Artist'. Out of it grew 'The Club', where avant-garde artists met each week. In 1947-48 Motherwell helped to edit the avant-garde periodical *Possibilities;* from 1944 to 1951 he edited a series known as 'The Documents of Modern Art'.

Both the terms Abstract Expressionism and Action Painting show that the main accent was now on free expression. Pollock's work set the example. In 1948 Motherwell arrived at a free and personal mode of expression. Simple, ponderous, melancholy forms – circles, squares, stars, ovals, bars – became his medium. On the bare surface they acquire a dark concentrated power. Despite the compact heaviness of the individual forms, there is a strangely explosive quality in his way of arranging them. This basic tone builds up to a climax in the long series of 'Elegies for the Spanish Republic', which has occupied the entire decade since 1950. The means are now very much simplified: a few black bars and ovals against a white ground emanating a muffled light. A violent restless calligraphy is at work in the compactness of the forms. With these means he achieves an expression of dark pathos which quite justifies the melancholy title.

In the same year Willem De Kooning, a painter of Dutch origin who came to the United States in 1926 at the age of twenty-two, achieved prominence with his first one-man show at the Egan Gallery. He too now reduced his colour to the contrast between black and white. Elements of Cubism are still discernible but they are charged with a psychographic expression quite in keeping with the personal interpretation of Cubism formulated by De Kooning in 1951: 'Cubism has that wonderful unsure atmosphere of reflection – a poetic frame where something could be possible, where an artist could practise his intuition.' On an almost black ground to which spots and streaks of white light lend a spatial motion, the white traces of his brush writing draw a violent psychogram. These pictures are wholly abstract, pure psychography, but as the artist worked they evoked in him associations with things seen and experienced, which account for such objective titles as

*Night Square,* one of the most daring pictures of this series, and suggest that figurative conceptions always held a considerable place in his imagination.

And indeed he was soon, in 1951, to begin his series of 'Women', a theme round which he circled with manic persistence until 1955. He resumed the use of colour, which took on expressive force. From its contrasting movements, to which a violent gesture gives their direction, the figure of a woman takes form — demon and erotic anima figure in one. Thomas Hess aptly described these female idols as: '... Queens, rulers of a country that names its hurricanes "Hattie" or "Connie"'. No definite woman served as a model; the imago emerged of its own accord in the course of the painting. Its presence was pervasive. This lady demon, this obsessive fantasy of the unconscious, this wish dream and enemy, was everywhere: in the cinema, on the street, in the painter's dreams, and finally on his canvas, where he met her time and again. This is what gives these pictures their hallucinated power and their script its desperate unrest, as of one pursued by a secret terror. Once again the mythical came to the fore. In the same years, we recall, Pollock too was pursued by figural visions of this kind. For once the unconscious was tapped by free psychic improvisation, its demonic images rose stormily to the surface. Where these methods are used, the terms 'abstract' and 'figurative' lose their meaning. This was already true for Paul Klee.

The series of 'Women' broke off of its own accord in 1955. The figure became less scuptural, its contours merged with the dramatic movement of the coloured masses, the woman's body became a kind of landscape. In 1955 De Kooning's pictures were again completely abstract — figurations of dynamic forces which in their clash transform the surface into an apocalyptic field of spatial and coloured tensions. But here and there, to an increasing extent in the last few years, an objective motif seeks to shine through the powerful colour planes: a landscape. Here again the Panic vision of the landscape is not the starting point but the result of pictorial action, a materialisation of an inner image released by the artist's work, which can, however, encompass precise optical impressions and memories. As in Orphist abstraction the ground emanates the 'hermetic' image; but now the image is produced by the associative power of abstractly related coloured forms.

During the black and white period of De Kooning and Pollock a new name made its appearance. In 1950 the Egan Gallery gave Franz Kline a one-man show. The paintings were large canvases characterised by heavy black signs. There is a suggestion of Soulages, of the cryptic black signs of Klee's late work, of Far Eastern hieroglyphics; but in these powerful spontaneous signs a very personal striving for expression makes itself felt. Nothing seemed to have prepared the way for these pictures. Before 1950 Kline had painted in a Cubist style relatively close to nature. Then he attempted, in small Indian ink drawings, to transpose visual motifs into ideograms. These became increasingly abstract and took on a psychographic character, a gesture springing directly from the artist's own vital dynamism and body movements. This created a need for larger dimensions. When Kline attempted to transfer his symbols to larger formats, his body movements enhanced the power of his line, which acquired an amazing expressiveness. The cosmic existence, a vast oppressive space, seems to invade the pictorial field; the framework of heavy signs seeks to withstand it, to resist its weight or to strike back against the crushing power of the void. The basic form is a great black jagged bar embodying forces that are supporting and collapsing, pushing and pulling. The pictorial gesture itself expresses a specific relation to the cosmos. This same gesture pervades the pictures Kline has done since then. It is clearly significant of contemporary man's relation to cosmic space, his terror and struggle to defend himself. It has been widely recognised as an appropriate symbol and has been taken over by many other painters. It may be discerned also in De Kooning's latest works.

By 1950 the overall style of the new American painting had been convincingly consolidated. On this groundwork a considerable number of painters developed along individual lines. In 1951 Philip Guston found his way to free psychic improvisation, adding a lyrical note of his own. He introduced a more sensitive quality into the violent script of Action Painting by means of rhythmic sequences of lines and spots, and moderated its apocalyptic space by a gentler vibration of the surface. In 1950 Clifford Still moved from the West Coast to New York and continued to develop this new lyrical, meditative note in Abstract Expressionism with his broad, gently modulated coloured surfaces across which coloured spots move like shadows. Jack Tworkov's pictures, built up of restless linear forms that seem to be stirred by the wind, also belong to this trend. In these paintings there is always a suggestion of a specific atmosphere or even of a natural reality, that is often reflected in the titles. James Brooks, on the other hand, strives to attenuate the tragic violence of De Kooning and Kline by a more careful and pondered treatment of colour, skilfully tied to the surface. This well-prepared and, in some respects, already tilled field has been quickly occupied by the younger generation. Michael Goldberg, Norman Bluhm, Grace Hartigan, Helen Frankenthaler, Theodor Stamos – these are some of the new names. The decade since 1950 has witnessed a striking development of this style of free improvisation. Generally recognised as America's very own stylistic expression, it has begun to exert a strong influence on the art of other countries. Yet, as usual, it is the 'primitives of the new sensibility' who have produced the most important, excellent, and humanly significant work. Pollock, De Kooning, Motherwell and Kline represent the atittude and vision which we associate today with the general terms Abstract Expressionism or Action Painting.

*European Trends in Psychic Improvisation*

The new American painting has been known to the European art world roughly since 1950. In 1947 Peggy Guggenheim returned to Europe and in 1948 and 1949 showed her collection, which included a number of important Pollocks, in Venice, Florence, Milan, Amsterdam, Brussels, and Zurich. In 1950 she organised a one-man show for Pollock in Venice and Milan, and in the same year he was represented at the Venice Biennale along with Gorky and De Kooning. In Paris the Galerie Maeght had shown a few American artists including Gottlieb and Baziotes as early as 1947, and in 1949 had given Hans Hofmann a one-man show. In 1952 the Galerie de France in Paris put on a large exhibition of the American avant-garde and in the same year the Galerie Fachetti gave Pollock a one-man show. In 1951 a selection of the new Americans was shown in Berlin, for the first time in Germany. Thanks to the American pavilion at the Venice Biennale, to small travelling exhibitions, and to the efforts of some of the private galleries and art clubs, the new American painting came to be much discussed in Western Europe. More recently it has been shown at the 'New American Painting' exhibit organised by the New York Museum of Modern Art, which travelled throughout Europe in 1958 and 1959, in the unforgettable Pollock show which was put on in several European cities in 1958, and in the American section of the 'Documenta II' exhibition held in Cassel in 1959, where the new American painting, shown side by side with other representative contemporary art, fully demonstrated its value and quality. This rapid recognition and acceptance of American achievement was possible only because similar trends had developed independently in the European centres. Thanks to the example of Hartung and Wols, to certain aspects of the work of Jean Fautrier, who had suddenly made his appearance

in 1945 with his 'Otages' – little studies on the theme of a tragic face which emerged, strangely devoid of contours, from a surface treated with plastic materials – the basic theme of psychic improvisation was struck authoritatively in the Paris School.

It exerted an extraordinary attraction on the younger generation and here again the tendency was towards monumentality. Beginning about 1948, Georges Mathieu, inspired chiefly by Wols, began to develop his spontaneous 'écriture', a refined form of Action Painting, influenced also by Far Eastern models. With the grace of a ballet dancer, the artist's line inscribes the traces of a capricious fantasy on the white surface and succeeds in transforming even gigantic surfaces into an enchanting harmony of swift, ebullient arabesques. Jean-Paul Riopelle, a Canadian who came to Paris in 1947, began in 1950 to combine the idea of painting as pure psychic action with a rich treatment of colour. Spots of colour worked with a knife form a dense vibrant membrane which covers the whole surface. As in Pollock's 'all-over painting', the rhythm, once achieved, seems susceptible to infinite repetition. Within the pictorial field a universal rhythm, rising up within the painter, is captured in a visible diagram of colour developments. In the *Nymphéas* of Monet's late period such a rhythm had been sounded; Monet had detected it in the vibration of natural light. Riopelle following his inner feeling, disengages the rhythm from its immediate natural context. In a series of paintings which he entitled *Nymphéas*, Riopelle expressed his admiration for Monet. Jaroslaw Serpan articulates his paintings in rhythmic developments produced by groups and series of comma-like strokes and graphic whirls. Serpan's concern with biology and mathematics led him to feel the presence of a common rhythm in man and nature, and in his painting he expresses this feeling that could be expressed in no other way. All these painters have relied on psychic improvisation as a means of recording their inner states. The poet Henri Michaux, who took up abstract drawing as a means of capturing vibrations of the spirit inaccessible to language, has accurately defined the most extreme attitude towards psychic registration. He draws, he says, 'in order to act as blotting paper for the innumerable cross currents that are incessantly converging within me... in order to bring out the most vital rhythms, the vibrations of the spirit itself'.

Large number of younger painters were attracted by this method of free self-expression, which gradually became the dominant style of the day. In 1948 the Galerie Allendy in Paris put on a first programmatic exhibition of the new painters working in Paris, including Hartung, Wols, Mathieu, and Bryen. And in April 1951 Michel Tapié, with his exhibit of 'Véhémences confrontées' at the Galerie Dausset, drew attention to the international range of the new stylistic expression. Side by side with the works of the Frenchmen Hartung, Wols, Mathieu, and Bryen hung those of De Kooning and Pollock, of Riopelle, and of the Italian Capogrossi. In 1952 Tapié published his book *Un Art autre*, in which he sums up the new tendencies, analyses their style, and proposes the designation 'informel'. These first pointers, barely noticed by the public, exerted an extraordinary influence on painters. Today the devotees of this general trend have swollen to a multitude, grouped under the catchwords 'Art autre', 'Art Informel', 'Tachisme', and 'Abstract Expressionism'. A critical inquiry into this mass phenomenon of 'informal art' is beyond the powers of any one writer. For the present it is even impossible for a historian to describe the chronological order and stages of this tumultuous development, for the polemical and apologetic character of the criticism accompanying the various groupings has so muddled the facts and dates that it is scarcely possible to disentangle them.

Amid the confusion, however, we can distinguish a few groups and individuals who not only demonstrate the European range of expressive psychic improvisation but also give it a recognisable

personal note. From 1948 to 1950 a number of painters from the Netherlands and Scandinavia formed a group which they named 'Cobra' from the initials of its members' home cities: *Co*penhagen, *Br*ussels, and *A*msterdam. The first members met in 1948 in a Paris café. Cobra made its first public appearance in the municipal museum of Amsterdam. The leading lights were the Dutchman Karel Appel, the Belgian Corneille, and the Dane Asger Jorn; other members were Atlan, Alechinsky, and Constant. What brought these painters together was their desire for direct expression unguided by the intellect. With its fantastic, largely automatic Expressionism, its unrestrained brushstroke, and wild gestures, their work may be regarded as a European parallel to American Action Painting. But in their spontaneous self-expression strange visions emerged – fabulous beings and animals, masks and fetishes. There is a definite tie with Nordic folklore: with the dark, mysterious goblins which had peered through the surface of Dutch and Flemish painting from Bosch and Rembrandt to Ensor, with the ornamental fantasy of the Vikings, and the grimacing demons of mediaeval Danish frescoes. They did not look for objective images to begin with but found them in the purely spontaneous act of painting. The dense colour and networks of lines gave rise to an association which set the mechanism of the unconscious in motion and so produced images. They carried on in this direction. Karel Appel, somewhat akin to his compatriot De Kooning, developed a violent, robust Expressionism: vestiges of human heads and bodies tossed up by great waves of colour. More lyrical, Corneille let legends rise from the rhythmic scaffolding of his colour groups and form into scenes and landscapes. Emotions and experiences gathered in the course of his travels in Africa and South America emerged from his unconscious to form a complex image. For the Dane Asger Jorn, passionately interested in the history of religions, in strange cults, magic lore, secret societies and their symbols, the canvas is a scene of magical actions. In the course of his spontaneous manipulation of his materials, objective signals emerge, indicating the presence of a vision that alarms him. Here a magical process is at work; a moment of individual existence is transformed into a mythical presence evoked in objective signals. The form of the whole is inseparable from these deeply meaningful signals. They are interdependent. If the viewer attempts to isolate the objective scene, the apparition vanishes at once behind the turbulent movement of the form; but if, concentrating on the aesthetic and psychographic element, he wishes merely to follow the formal movements, the hidden spectre from the world of magical, demonic legend peers out everywhere. The formal gesture has a character of conjuration. It is conceivable that in this border zone between evocation and pure psychic improvisation, towards which the Cobra painters and in particular Asger Jorn are striving, painting may recover its objective content, that here painters may find a road leading away from the private worlds in which the innumerable camp-followers of Art Informel seem to be stifling.

In Germany the expressive trend of psychic improvisation found wide-spread resonance, as seems only natural when we consider that the two leading masters of this tendency in the Ecole de Paris – Hartung and Wols – had grown from the German tradition created by Klee, Kandinsky, and Expressionism. Hartung's art, which despite the unfavourable conditions of the German post-war period gained an audience in Germany as early as 1948, exerted a great liberating influence on German abstract painting, hitherto limited to the Bauhaus discipline and a kind of Blaue Reiter Romanticism. Even so self-sufficient a personality as Fritz Winter was unable to resist this influence. The broad sweeping gesture freed him from his preoccupation with minute forms; the spontaneous power of self-expression provided a counter-weight to the sentimental Naturlyrismus and Romantic metaphor which tradition and inclination had so deeply engrained in German art. A new expressive element had made its appearance.

The influence of Wols was felt only later, towards 1950. Early in 1952 four painters – Goetz, Greis, Kreutz, and Schultze – formed a group in Frankfurt which they named 'Quadriga' and in December of the same year gave their first exhibition, entitled 'Neo-Expressionists', at the Galerie Franck in that city. Elements of Abstract Expressionism were unmistakably present. Pollock as well as the Cobra group, with whom Goetz maintained contact, already exerted a powerful influence. But the general tone was a rather lyrical Tachisme drawing its main impulses from Wols. Only Karl Otto Goetz sought for a more dynamic and graphically more precise mode of expression, taking in certain features of Action Painting. The other Quadriga painters, whose style was shared from 1953 by the Westphalian Emil Schumacher, followed the lyrical trend in psychic impro-visation, to which Wols had shown the way. Today they represent the German variant of inter-national Art Informel.

A number of new paths opened up in those decisive years. The young Rhenish painter Hann Trier, who in 1948, somewhat under Hartung's influence, had arrived at a free expressive script, even took a surprising illustrative turn. In a splashing arabesque-like script he improvised, from the tension of the moment, dynamic whirlpools of forms, expressive of momentary tensions. He recognised their illustrative quality which, as though by sleight-of-hand, could conjure up an unexpected relation to an idea or an object. A minor, often humorous accent might suffice to evoke a scene from a fable by Lessing, an irritating noise, or some other direct association.

In the last decade this expressive, psychographic technique has been steadily gaining ground in German art; it seems to provide a means of reviving Expressionism on the abstract level. K. R. H. Sonderborg may be regarded as the most important of the younger German painters. He has been living in Paris for some years and has achieved an important position in the Paris School. His development is strikingly similar to that of Franz Kline. Thirteen years younger than Kline, he too started out in 1950 with Indian ink drawings in which the automatic movements of the hand are converted into dynamic traces. Slowly the format expanded and the script took on an explosive character. But Sonderborg's signs, unlike Kline's heavy bars and dark scaffoldings, tended towards an electric dynamism. His basic form became the diagonal drawn across the surface with a swift gesture, creating an impression of wild speed. Whorls took up the movement, jagged little kinetic signs beat out a swift rhythm which with its violent repetition evokes the sound of motors. The pace and rhythm of the pictorial figure and the resultant spatial dynamic reflected an unconscious reaction to the facts of modern life – speed, the domination of new spaces, the fantastic perspectives of technology. And suddenly, by way of confirmation, technological forms entered into the auto-matic script. For what Sonderborg's automatic improvisations make visible are not lyrical impulses from within but harshly aggressive answers to the new technological realities of which we are gradually becoming aware. This spontaneous and thoroughly unromantic expression of a direct response to the environment gave many of the younger German painters a salutary shock. For example, it led a painter as deeply anchored in the modern German tradition as Fred Thieler, to break up the Romantic pattern he had inherited from the Blaue Reiter with dynamic and psycho-motor forms.

The new ideas also made themselves felt in Spain and Italy. Here, as one would expect, the accent was on the human element, and an attempt was made to connect the new methods with aspects of the native tradition: the dark, hallucinated expressiveness of Spanish art, the dramatic quality of Tintoretto, the dynamics of Futurism. Beginning in 1950, a number of new painters in Madrid and Barcelona took up the techniques and ideas of Art Informel and Abstract Expressionism. With his passionate Spanish temperament the young Madrid painter Antonio Saura set himself to

developing the new expressive possibilities. A man of extreme intelligence and sensibility, Saura had begun to paint in 1947, stimulated by Matta. The psychic automatism of the Surrealists was his starting point, leading at first to landscapes peopled by strange vegetative shapes, suggestive of Matta's 'inscapes'. Then came a long period in which he worked with the ideas of Art Informel, of Hartung and Wols, that is with the expressive possibilities of the pure pictorial means dissociated from their illustrative function. Finally in 1954, under the impact of his encounter with the work of Emilio Vedova, Saura found his way to the violent Abstract Expressionism that has characterised his work ever since. His colour reduced itself to a harsh contrast between black and white. An impetuous automatic brushstroke registers his grave inner tensions. The emphasis is always on the tragic, the unredeemed. Sometimes objective signals emerge from the impassioned formal gesture, erecting a bridge to the ancient images of human suffering such as the Crucifixion, or to the demonic stimuli of modern mass society, the sexual idols which the cinema, that modern dream factory, holds up to the fantasy of contemporary man. As documents of man's inward terror at the suffering and error of human existence, these pictures may be said to perform a moral function.

This same moral aspect distinguishes the work of the Italian Emilio Vedova, which was so important for Saura. In Italy the ideas of Abstract Expressionism and Art Informel were taken up only hesitantly. In the last decade an Italian variant has grown up in Milan, round the Spatialist movement inaugurated by Fontana; it includes Crippa, Scanavino and others. Mattia Moreni, working in Paris, has definitely turned to Abstract Expressionism. But many of the Italian artists have copied the idiom of international informalism so slavishly that the inner necessity of their work seems in many cases open to doubt. This does not apply to Vedova. He is one of the few modern painters who look upon their work solely as a means of recording the impulses with which they respond to present-day experience. His purpose is not aesthetic but purely expressive. His painting comes into being as an active response to the *'astratti furori'*, the furious abstract sensations that rise up in us in the course of our battle with life. *Clash of Situations, Picture of the Times, Page from my Diary, Everything Noted, Open Letter*, these are his themes. Vedova started out in 1936 with the impetus of genius. His first works were drawings of the intricate interiors of Venetian buildings, which already reveal the same expressive, passion-charged line structures and the same dialectic tension between assertive, aggressive, slashing brush strokes and searching, meditative forms that are still the essential features of his pictorial graphology. The fantastic line drawing of Rembrandt's late period, the dark tensions in Goya's black and white work, the ecstatic calligraphy of Tintoretto – these were his groundwork. Thence he went on to study the problems of contemporary art. Expressionism held a natural appeal for his turbulent, passionate nature. He was attracted to Permeke, Rouault, Soutine, Kokoschka, the German Expressionists, and of course to Picasso, the Picasso of *Guernica*. It was at this point that Vedova resumed his work after the war, still under the impact of the last terrible years that he had lived through as a partisan. The powerful expressive language of Picasso's *Guernica* had a solid foundation in the Cubist formal idiom. In 1946, Vedova, subjecting himself to strict discipline, set out to acquire the organisation of evocative Cubist painting. In so doing he resumed contact with Italian Futurism, by then almost forgotten, and with Boccioni's theories. Within the strict Cubist structure his striving for a direct expression of contemporary experience asserted itself. The object signs vanish more and more. Abstract dynamic forms take over the narrative. It was then that he began to concern himself with the *Scontro di situazioni*, the clash of contradictory situations in man. Having thoroughly prepared his pictorial means, Vedova was able, in the course of a perfectly consequent development, to become increasingly free. In 1950 he began

to break up his geometrical scaffolding. The dramatic element innate in him demanded an uninhibited script, flowing from direct action and impetuous dialogue with the picture surface. In 1953, in the 'Ciclo delle protesta' series, he achieved great expressive force. This is an impetuous dialogue, a clash of intense formal contrasts. The colour is dominated by the harshest contrast between black and white, which represent light and darkness, good and evil. Here and there a violent yellow or red flashes out with sharp suggestive force and seems, amid the tumult of black and white, like an outcry in the night or a wound which the battling forms have inflicted on the pictorial organism. Crossing and interpenetrating, the contrasts of black and white open up vistas, evoke dynamic spatial relations, a barred-off, apocalyptic, disintegrating space. In this field in motion, filled with colour contrasts, the brush, brandished like a sabre, sets down its signs. The painter's movements are the slash and the thrust. There is great spontaneity in the script forms: assertive bars answered by aggressive wedges; splintered fragments which in clashing are hurled out of position; fleeing, questing, restless lines which rush wildly away or gather defensively into knots. The dominant forms are the breaking beam, the acute angle, and the whorl. Every sign is a psychic movement translated into a pictorial trace. Working together, they become a field of human tensions, made outwardly visible. This brings Vedova close to the dramatic expression of Wols and Pollock. In a direct sense they taught Vedova nothing, but they confirmed him in his conviction that art – beyond narration and illustration – is concerned above all with man's being, his heartbeat and innermost emotion.

There can be no doubt that psychic automatism has provided the main foundation for the various tendencies we have just described. In spontaneous, impulsive action pure expressive gesture leaves its trace on the surface. In extreme cases, we have an almost uncontrolled trance-like action, submissive to every accident and governed by no rule; lines are scribbled, paint is dripped on the surface, and formlessness is looked upon as the measure of spontaneity. The surface becomes an area of action; painting becomes a kind of choreography, a meditative moment whose trace, held fast, yields information about the painter's psychic state. The picture is taken as the arena of a passionate will to expression. To what degree the painter is able to charge the gestures traced on the surface with the power to express his inner impulses – that depends solely on his inner strength and commitment. Hartung, Pollock, and Wols committed themselves to the full. The commitment of Pollock and Wols led them to self-destruction. The profound conviction made visible in their work is the source of their world-wide revolutionary influence.

The technique of concrete expression brings to its maturity Delaunay's idea that the central concern of painting is no longer its themes or objects but the very heartbeat of man. Through spontaneous action the inner dynamic of man is made directly visible. The picture is a concrete, self-contained reality, no less than in the art ordinarily called 'concrete'. But the freedom of its methods, its emphasis on effective inner impulses give this art an expressive character.

*The Evocative Possibilities of the Materials*

The various methods of concrete expression in which communication depended entirely on the evocative power of line, form, and colour, had awakened modern artistic sensibility to visual stimuli which, because they did not penetrate to consciousness, were obscured from normal pragmatic vision. Apparent accidents on the surface of the most commonplace natural objects were capable of releasing whole chains of association leading to a kind of poetic, irrational insight.

The grain of a tree, the fine veins of a leaf, the structure of a clod of earth, the cracks and abrasions on old walls, the scribblings of children on the pavement – might relate a legend of growth and decay or of the land of childhood. In the eyes of a sympathetic beholder, all manner of nondescript materials that seemed far removed from any possible artistic use – charred wood, a scrap of cloth on a rubbish heap, a piece of lace in a dustbin – took on a strange evocative power.

Artists became aware of this at an early date, particularly while investigating the expressive quality of the pure pictorial means. In the last years of the First World War Paul Klee had striven to embody irrational poetic insights of this kind in his painting and to create surfaces that would stimulate the imagination in the same way as the mysteriously meaningful things that the eye discovers half unconsciously in the world around us. With gauze, glue, and plaster he created a mysterious ground, suggesting a wall, drenched it with luminous colour, groped his way over it with the thoughtful antennae of his fine line, scratched it here and smoothed it out there, and so created conditions suggesting poetic insights such as those mentioned above. Keenly attentive to the evocative structures and diagrams that his untiring eye discovered in nature, he had found a way of taking them over into his own meditative figurations and so giving his scenery a natural plausibility. Later on Kurt Schwitters had discovered in the technique of Cubist collage the possibility of introducing commonplace everyday materials. Match boxes, nails, corks, railway tickets, all sorts of litter that could stimulate a responsive sensibility through surprising chance associations became material for expression. By mounting such materials on his surface, by combining them in such a way as to bring out the individuality of the particular tatter of reality, an artist could greatly enhance their poetic quality. The more remote these scraps of reality seemed to our practical, utilitarian perception, the more useless, rejected, forlorn they were, the more evocative they became when held up as objects of contemplation. The individual fragment became something new and startling, something never seen before and, as such, a goad to the imagination. But in addition the artist's personality expressed itself in his arrangement of these materials. Just as a scholar's desk, an editor's wastepaper basket, the contents of a lady's handbag, tell us all we wish to know about the owner, so the contemplative field the artist sets up with materials chosen seemingly at random, provides an exact record of his inner nature. In short, artistic manipulation can turn these humble evocative materials into eloquent means of expression, media of psychic improvisation. Finally, Max Ernst had devised a number of techniques by which to utilise, for purposes of artistic expression, the suggestive quality of structures found in nature. By stamping, rubbing, and calquing, he transferred the 'diagrams' of formative nature – wood grains, bark, leaves, insect wings, etc. – to his picture surface, so obtaining the most hallucinatory effects. Each of these isolated 'ready-made' drawings of nature opened up the way to a hidden realm of poetic possibilities; pursuing the chain of association, he would find himself face to face with a dazzling irrational insight. In his *Histoire Naturelle* Max Ernst assembled a whole collection of poetic images, figures, landscapes, plants and animals born of the evocative power of natural structures and expressing a profoundly romantic insight into nature.

These ideas and techniques were reflected in the theories of Futurism (Boccioni), Dadaism, and Surrealism, but relatively little importance was attached to them at the time. It was only in the forties, when the ideas of Surrealism took on a new intensity and Dada was rediscovered, that they came to the fore. Nearly all the artists who turned to hermetic painting and psychic improvisation derived important impulses from the rich and many-sided work of Paul Klee. His method of 'making the material speak' came in for renewed attention. Cubist collage, Surrealist montage were rediscovered and many of the painters who were trying to develop a personal idiom

through abstract painting were attracted to them at one time or another. Though for most artists this was no more than an occasional exercise, a few important painters concentrated on these possibilities and produced works which are numbered among the important achievements of contemporary art.

In 1945 Jean Fautrier had made his appearance in Paris with his 'Otages'. Following Klee, he had transformed his surface into an evocative field by working it with a palette knife, applying plastic materials which emerged like islands from the liquid paint. Out of this field arose strange apparitions, 'diagrams' of tragic heads and faces. There was nothing new about the technique as such. Fritz Winter, Paul Klee's student and friend, had used it in 1932 and 1933 for his beautiful little dark panels with their cryptic signs; Baumeister had taken it up again during the war years, in his 'African Images'. However, it seemed new and unexpected in Paris in 1945 and the mood prevailing at the end of the holocaust made the public receptive to the note of lyrical grief that Fautrier's work evoked. The 'Otages' awakened the sensibility of the Paris School to the evocative capacities of the materials themselves and to the conception of the picture surface as an evocative field of irrational insight. Fautrier's work helped to break the domination of rigorous late Cubism and geometrical abstraction. Wols was also moved by it. Fautrier himself never succeeded in going beyond his original theme or in expanding his sensitive *ritornello* into a fuller chord.

Jean Dubuffet set out to explore the possibilities of Fautrier's technique more fully. Having resumed painting in 1942 after several interruptions of varying length, he showed a group of his new work at the Galerie Drouin in 1944: pictures of old houses, still lifes, scenes with figures scrawled as by a child, in a '*faux naïf*' style clearly influenced by Paul Klee. In 1946 there was a second exhibition. Its title, 'Mirobolus, Macadam & Cie., Hautes Pâtes', suggested the playbill of a magician at a small town fair. And indeed the paintings disclosed a remarkable combination of magical tricks and disarming naïveté. The surface had been treated with a plastic mixture of glue, sand, and asphalt. This '*haute pâte*' was obviously taken from Fautrier, but Dubuffet used it for other purposes. It gave his surfaces a highly unusual character. With their modelled forms, their haphazard scratches and blemishes, their spots of colour seemingly applied without aim or purpose, they gave the impression of those aged weather-beaten walls into whose cracks and discolorations our fancy likes to read images. Here it is the *material* of the surface that releases images. Under its spell the painter began to scribble on the wall. Heads, masks, figurines, droll landscapes with droll inhabitants emerged from the mould and mud, little scribbled men roamed over the wall, or picture ground, transforming it into a smiling land of childhood. In his scribbling, the artist employed the direct ingenuous line of children, laymen, madmen, or mediums, whose art Dubuffet, like Klee, had studied attentively. In this 'art brut', as he called it, he found the basis of a direct, compulsive expression, consonant with the method of bringing up images from the pictorial ground. In addition, however, his odd figures and scenes had a special quality of their own. They belonged to a category of images with which every individual is endowed but which seldom passes the threshold of consciousness. Our active eye is always communicating an abundance of observations and sensations which, because they are utterly useless and banal, are condemned to silence by our waking consciousness. Yet they touch a chord in the irrational, poetic depths of our psyche, and are transformed in the unconscious into poetic metaphors which seem to convey a compelling, clairvoyant truth. Our eye passes swiftly over a wall, dwelling for a brief moment on its spots and crevices, and within us there arises an illuminating metaphor for the passage of time and the transience of things. A few steps further on the eye discovers a little man that a child has scribbled on the wall and a poetic image from our childhood responds in us. From a dried-up mud puddle, from

a clod of earth on our path, the aged face of the earth peers out at us, and in a fragment of stone we read the sorrowful tale of our cooling planet. Sudden insight discloses all manner of sensations which clamour to become poetic images but are lost a moment later when consciousness intervenes. In order to activate this strange and wonderful store of images, to regain possession of these fugitive poetic insights and to give them permanence, Dubuffet sought to create, on his pictorial field, conditions that would produce similar sensations in the eye and release a flash of poetic response. He moulded, kneaded, and scraped his ground, he scribbled on it, until it took on the evocative character of a wall once seen and long since forgotten, which had called forth his image of the passage of time. He kneaded his materials, smeared them, dried them, until the wrinkled face of the earth, a chthonian goblin, or a pre-human landscape emerged from the mud. Once the direction of his associations became clear, he was able to elaborate them consciously, with the help of refined techniques; the poetic insight would not be lost.

On this evocative field rich cycles of poetic images took form. From 1947 to 1949 Dubuffet travelled extensively in the Sahara and his experience of a primordial landscape shaped by the forces of the earth, the wind, and the sun, entered into his imagination. The droll magical figurines disappeared. A cycle devoted to the poetry of the lonely earth took form on friable surfaces worked with sand, putty, and glue. In 1950 he began the 'Corps de Dames' séries; ponderous female bodies that emerge from the earthen grounds like embodiments of the fruitful earth, comparable to prehistoric fertility idols. In 1951 began the long series of the 'Sols et Terrains' and 'Terres radieuses'. The grounds are skilfully worked into geological structures, fossil forms, cross sections of the earth. On this terrain appropriate creatures – little men, friendly animals make their home. The poetic evocation is nearly always related to the chthonian element – a dark praise of the earth. The themes suggest memories of Max Ernst's *Histoire Naturelle,* and most of the techniques employed also go back to Max Ernst. Printing, rubbing, decalcomania are the means employed to create a ground pregnant with images. In 1956 Dubuffet devised a new technique. He cut suggestively coloured canvas into little star shapes, circles, rhomboids, etc., and, automatically following their suggestions, pasted them mosaic-like on the surface. The result was starry meadows, gardens of stars, luxuriant dream landscapes. The purest nature poetry!

But whatever was evoked, whatever technique was employed, the poetic metaphor was in every case released by the evocative power of the material. This was what transformed the surface into a field pregnant with poetic images and lured to the surface sensations ordinarily wasted by disinterested vision. Unrelated to reproduction, this force emanating from the material set free the productive fantasy, leading the way to images such as have never been seen – to the utterly Other. In viewing thes pictures of Dubuffet, Michel Tapié conceived his idea of an 'Art autre', a 'completely different' kind of painting, free from all classical rules, concerned only with the startling, the unexpected, the miraculous. This is the conception underlying all Art Informel and accounts for Dubuffet's enormous influence. Among the younger painters – and sculptors – he is regarded as one of the most stimulating artists of the post-war years.

In line with this development a young Spanish painter, Antonio Tapiès of Barcelona, began in 1954 to attract attention with paintings whose strangely wall-like surfaces somewhat resemble Dubuffet. But while Dubuffet's naïve narrative fantasy links the poetic metaphors in praise of the good earth with fragments of landscape and with burlesque figures, Tapiès pictures remain strictly within a domain of their own. They are strict, taciturn, solemn, and display a certain 'Spanish' grandeur. By means of plaster, glue, and sand mixed in varying proportions, the surface is given a stratified relief. Its hollows and elevations lend it a special tactile quality. In places the painter removes the mortar,

scrapes the underpainting free, bores holes in it, scratches in cryptic signs, lines, rhythmic sequences, and often sets a coloured signet on the dry ground with wet paint. All this makes his surface intensely evocative. But it never acts as a provocation like Dubuffet's 'art brut'; it has a restrained beauty, a lofty charm conducive to meditation. The solid ground suggests a wall that conceals something mysterious and wonderful, a solemn, infinite, magical space which sometimes peers through. The signs inscribed on the wall, the injuries inflicted on it seem like signals for the hidden wonder or like violent attempts to penetrate to it. The pictures exert a suggestive power upon the meditative mind. Like fragments of anonymous reality, they evoke in us the same sensations that our vision, once freed from aims and purposes, discovers in reality. In an almost literal sense they are walls of meditation. They release a poetic message 'when dull, inert matter begins to speak with incomparable expressive force': this is how Tapiès himself defines the miracle of painting.

To make the material itself speak! Once training or special psychological circumstances had opened up sensibility to the evocative power of inherently dead materials, seemingly remote from the sphere of art, their lure became so strong that the materials themselves came to be regarded as means of expression. In 1952 an Italian painter, Alberto Burri, showed works consisting merely of old rags and scraps of sacking. They recalled Picasso's collages, the work of Schwitters, and the montages of the Dadaists and Cubists, but they carried a new note of intimate expression. With their diverse structures the crumbling, spotted scraps of sacking formed a desolate field; the heterogeneous fragments were fastened together with thread and string and arranged into an unstable melancholy geometry. Here and there the fragile seams tore open and then a liquid red trickled like blood from the picture body. Where fire or rot had made holes in the sacking, a nocturnal ground shone through, or a golden glow or an eloquent colour appeared. Here again the textile surface seemed to conceal something which nevertheless – despite the attempt to create a comforting beauty, a kind of order, from these tragic remnants and their colour modulations – peered through everywhere. The tatters seemed to conceal a mortal wound. an intangible threat. This becomes evident in a picture done in 1954. Over the centre of a large dark surface a fragile scrap of sacking is drawn taut; a few taut thin threads fasten the sacking to the edges of the picture, as though the tearing fabric were still seeking to hide what was pressing so inexorably to the surface: dark, formless space, empty nothingness.

The power of scraps of rubbish to evoke the world's wounds and the threat of the void can no doubt be explained by the psychological mood of our time, by our cruel experience of life, and by the metaphysical anguish of contemporary man, as defined by Existentialism. And these indeed were the factors that brought them into being. Burri had studied surgery and had served in the war as an army doctor. Taken prisoner, in 1944 he began, in a prison camp in Texas, to paint, or rather to seek expression for feelings that disturbed him. In 1945, on his return to Rome, he gave up medicine in order to master his anxiety through painting. In the course of a long, compulsive process of work, the monotonous image of blood-soaked bandages rose up within him as a universal metaphor. In decaying sacks and tatters he found the appropriate material in which to express, in terms of the crudest reality, this pictorial metaphor for the world's wounds and man's terror of the void. He went on to develop this basic theme. In 1956 he worked on the 'Legni' series – charred wooden planks forming a fragile palisade against the invading empty ground. Then came a series of pictures in which a kind of plastic foil, burned, pierced, and melted by a blow-lamp, takes over the evocative function of the covering screen. Finally, in 1959, came the cycle of the 'Ferri'. Here the ground is entirely closed in by tin plates, battered from within, and welded and riveted

together. A firm geometrical pattern emerges from the separate fields, condensing into a formula for the menace of the space lying behind; its surging force remains perceptible only in the bumps battered in the tin. The anguish is still all-pervasive, but now it is held in check by solidity, order, and form.

In conjunction with the rediscovery of Dadaism, the original expression which Burri had achieved through the evocative power of everyday scraps of reality stimulated many young painters to pursue similar investigations. Among these the Spaniard Manuel Millarès (b. 1926) and the American Robert Rauschenberg (b. 1925) have already distinguished themselves by the personal force of their communication.

## The Concrete Function of Colour

In the recent painting we have been discussing so far, the accent has been on form. The rôle of colour has been secondary.

In concrete painting, geometrically defined form was the main element of construction; colour was its qualitative garment. In Abstract Expressionism colour served primarily to supply the qualitative mood of the ground. Since the early colour improvisations of Kandinsky and since Delaunay's Orphist constructions, colour had lost ground as a plastic value in its own right. One reason for this was that the evocative painting had been developed on the basis of form. The 'pure colour' tendency, beginning with Gauguin and culminating in the Abstract Expressionism of Kandinsky's early period, failed to achieve the harmonious structure of the autonomous painting because it over-emphasised the expressive values and the symbolic meanings of colour. It was soon obliged to ally itself with Cubism, for here – through the development fro Cézanne to Juan Gris – the autonomous pictorial organism was given a firm foundation. Abstract painting, beginning with the Stijl movement and Constructivism and ending with various schools represented in the Abstraction-Création group, was concerned not with autonomous colour, but with autonomous form. Even Kandinsky, after 1920, accepted the discipline of clearly defined form as a restraint to the Orphic flow of colour.

The consequence of all this was that a problem of eminent importance for painting remained essentially unsolved. Hoelzel, who was fully aware of the problem, lacked the necessary creative power to embody his theoretical solution in convincing works. Abstract painters were reluctant to bring the full colour keyboard into play. Their reluctance was not unjustified. The sumptuous polyphony of free colour arrangements tempted the visual imagination to indulge in dreams, to find flowers and landscapes where no such thing was intended. This associative power interfered with the pure manifestation of colour, tempting the artist to modify his construction so as to suggest the forms of the objective world. A slight exaggeration, an arbitrary detail sufficed to transpose a visual reality into a magical dimension. Animistic, magical, mythical, lyrical, expressive suggestions – everything man can perceive in things – easily found their way into the picture by means of colour. This dangerously Protean element eluded control, slipping quickly from representation to abstraction and vice versa. Even Delaunay, who in his late period experimented with chromatic arrangements, saw himself compelled to restrain these elusive elements by geometrical structures and circles. The problem of using pure colour as a concrete plastic value remained open. However, it took on extreme urgency with the idea of the concrete reality of the

picture and its formal elements. Only recently has the problem been solved. Bazaine, De Staël, and Riopelle had indeed striven for an independent colour orchestration, but their colour melodies had been prevented from developing freely by their ties with Cubist formal patterns, with representational or expressive intentions.

We cannot emphasise strongly enough how important this solution was for the new abstract art. The new solution was not found by way of abstract painting, but was developed within a school which, originally representational, influenced by Fauvism, was led closer to abstraction by Nolde and Kirchner. The first comprehensive solution was achieved in 1950/51 by one of the most gifted colourists in modern painting – the German E. W. Nay. In France the American painter Sam Francis has been working quite independently of Nay in the same direction. Nay's long and consequent development best shows the process leading up to the realisation of colour as concrete form.

'To paint is to form the picture from colour.' This principle, formulated by Nay, made him receptive to the way in which Munch, Nolde, and Kirchner had made use of colour. Omitting Nay's early development, which led him to Surrealism in the early thirties, we find that his 'Lofoten paintings' (done during a prolonged stay in Norway in 1936) mark the first step towards a solution. These paintings show human figures by the sea, fishermen with boats, fjord landscapes. The colours flow convulsively in restless streaks, forming crashing contrasts, harmonies, whirlpools, but in their movement outlining representational elements, hieroglyphic signs of landscapes and human figures. The intention and the form are still quite close to Kirchner. Colour and form still find support in representational elements. The pictorial structure, décor and space are still developed within representational constellations and references. But the festive clamour of the brilliant colours is developed into a dialogue which even at that early date left the motif far behind and took on an independent value.

The dialogue among the autonomous colours tended towards increasing purity of expression. In the sumptuous series of paintings which Nay did in 1943 while serving in an army unit in France, he began to organise his colours in accordance with their autonomous impulses. The figurative element is still present, but it merely supplies the main theme for musical developments and paraphrases. The colours are ordered in complementary harmonies and chromatic passages, which are contrasted or interwoven so that the surface décor acquires an autonomous tension. Space is created solely by colour relationships, and appears as an animated surface relief. In these paintings Nay gradually adapts the Cubist principles of autonomous pictorial structure to the requirements of colour. The formal insights of Juan Gris are now applied in the realm of colour. This leads to the development of the non-perspective painting, animated by the movement of colour.

These works posses an extraordinary evocative power which, in the years that followed, Nay developed to the full. From an orchestration of radiant colours, he conjures up figures, scenes, legends, visual memories, all related to the primordial experience of the Orphic, mythical strata of the psyche. The images spring from an extraordinary mental state: a heightened consciousness which even in extreme passion carefully observe the laws of colour arrangement, yet preserves its ties with the Orphic stratum. Luminous, clearly defined ensembles of blues, yellows, and bright Dionysian greens, pounding rhythms, and glittering mobile figures produce a magical space, from which representational emblems emerge to link coloured form with objective meanings. The dance rhythm and the bright, coloured forms serve to express a bucolic, pastoral, Dionysian sense of life, deeply embedded in mythical recollections.

After 1946 Nay may be said to have cast off one husk after another. His ecstatic colour is subjected to an ever stricter discipline, and the more he stresses the absolute values of colour, the less use he

364

makes of representational references. This resulted no doubt from a kind of intuitive calculation responding to the necessity of saving his sweeping flow of Nordic and Eastern images from a contourless Expressionism. It was then that Nay accentuated his Western character to the utmost. The independent colour architecture grows steadily clearer, firmer, more precise. An unexpected rigour becomes apparent. The figure of colour is buttressed and anchored until it can fully withstand the Dionysian tide of images. What makes these paintings so moving is the acrobatic skill with which a balance is maintained between logical rigour and passion. Every painting is a balancing act involving a great human peril. In an effect involving the whole man the tonal substance of colour was progressively emancipated from representational or metaphorical elements until, by 1951, it became a perfectly tuned instrument. The mythological, bucolic, legendary elements have vanished; no longer is there any room for the creations of nature, or by the same token, for darkness and anguish. The paintings are clear, luminous, and beautiful; pure pictorial events in their own right. They bear titles such as *With a Red Strip, Triumph of Yellow, Blue with White Pendulums*. The content is made visible solely on the concrete plane as a pure arrangement of colours, and permits only of musical associations – *Vowel Sounds, Silvery Melody, In Black Measures*. This art has moved beyond the realm of the transformation and trans-illumination of the visible. All graphic, geometrical, and figurative elements have been eliminated. The colour is free, supple, sensuous, and rich. The precisely outlined emblems and abbreviated signs made of loops, dots, and circles, by means of which Nay previously gave his paintings objective definition have disappeared. The colours modulate a fully consonant harmony, and in the consonance of luminous tones often achieve the silvery shimmer which has always been regarded as the mark of perfection in painting. The carefully worked out relief structure of the pictorial space is more concealed than before and more naturally woven into the formal ensemble. Rhythmical spots of colour now mark the planes which were formerly sharply defined. The spatial order is also rhythmically richer and more musical. Subtler arithmetical proportions supplant formal geometry. And now, as we might logically expect, the Western horizons of the constructors Poussin and Gris are gradually eclipsed and there emerges a Northern and Eastern realm where such painters as Munch, Nolde, and Kandinsky have their place. If these paintings make the viewer think of the early works of Kandinsky or Nolde or of Expressionism, the grain of truth contained in such a comparison lies in the fact that the Nordic world of expression has here achieved a new birth. Colour alone sustains the picture. As in music the colour orchestration is regulated by a sensitively elaborated method. In working out his method, Nay reduced the formal and rhythmic elements to a basic form in which all directions of movement – horizontal, vertical, diagonal – are combined: in fact, to the disc. Since 1956 it has been the foundation of his colour rhythm and melody.

However, these new paintings no longer express anything but themselves. The thematic, humanistic, mythical elements have fallen away. The painting is a purely artistic affair, a concrete event based upon calculations similar to those involved in a musical composition. As in music, the result cannot be described, but only seen. 'But these feelings rest on a universal human foundation.' In the sonorous organism of colour, man's entire emotional world – with its primitive and refined, sensuous and esoteric, human and artistic aspects – is set down in configurations of pure colour. 'The act of will that sets off the artist's work implies no statement or expression. It carries no philosophical, speculative, romantic associations. Colour is not a vehicle, it does not stand for something else, it is form in itself.' Colour conceived of as a concrete plastic value opens up a vast new field to absolute painting. The scores written in the medium of colour with their concrete harmonies, rhythms, and developments re-echo in our feeling like a musical composition. As in

music, a subtly devised arithmetical method regulates the arrangement of coloured forms. Here the eternal metaphor – 'music of colours' – finds its concrete embodiment.

One of the painters to make this advance into the field of pure colour in the last decade has been the American Sam Francis. After studying art in California, he moved to Paris in 1950 and there joined the little group of American painters around Riopelle. He was assuredly attracted to Riopelle's dense colour rhythms, but he was still more interested in the great French colourists, the later Monet, and above all Bonnard and Matisse. Yet the pictures of his early years in Paris, from 1951 to 1954, are almost monochrome – sensitive modulations on white and grey or red and pink, which cover the whole surface and set it in gentle vibration. In 1954 his colour became more intense. The whole surface is still covered with little plaques of colour, suggesting the irregular stones of a mosaic. A dialogue of darkly shimmering colour begins: between black and blue, between dark orange and black. Little secondary voices, a radiant yellow, a spot of red, join in. The colour developments become more and more free and dynamic; often fine threads of thin, liquid paint traverse the surface, connecting the various colour voices in a delicate filigree responsive to all accidents, all occurrences. But the colour still has the character of a dark substance, unfolding its fantasies against the white ground that shines through. In 1956 the colour becomes lighter and richer. The dense colour décor breaks up, the spatial quality of the white ground is drawn into the ensemble. In 1957 and 1958 a trip around the world brought Sam Francis rich new impressions; a long stay in Tokyo gave him an insight into the meditative expression of old Japanese art. Now at last he achieved his full chords. A tissue of luminous colour cells, which carry the separate voices and connect them, moves freely over the white ground, drawing it into the picture, giving it mobility and suffusing it with atmosphere and space. The white represents a wide free space which often requires gigantic formats to sustain the rhythms of its breathing. In it the colour voices sound like a melody from afar. Often the colour movement begins with a motif broken by the edges of the picture, develops on the surface in a free and luminous counterpoint, and then once more turns outward across the edge, into infinity. The rhythm comes from outside and returns whence it came, but one of its variations is fixed in the well-tempered colour field of the picture. The titles – *Blue and Red*, or *Violet, Yellow, and White* – designate only the colour voices orchestrated in the picture. The paintings themselves are pure colour movements, symphonies of colour, in which a joyful harmony with the world is transformed into a colour melody.

This fortunate possibility of instrumenting colour compositions on the keyboard of the palette, rests upon the recognition of the plastic value of colour as a concrete material. The interplay between law and invention must be governed by a specific method if the chords and melodic lines are to be accurately ordered and effective. The method will vary from painter to painter but in every case the painter, if he is to succeed, must arrive at an orderly, limited, but adequate theory of composition, comparable to the theories evolved in music.

*Meditations and Figurations*

The idea of painting as a spiritual activity which – like music – employs its own means to transform an area of spiritual experience into an independent organism of sound and colour implies close interaction between conscious methodology and hallucinatory power. Such interaction reflects an essential feature of the spirit of our age. The modern mind, both in its intellectual conceptions

and in its practical outlook, combines the coolest and most exact manipulation of numbers and materials with the most amazing intuitive insights. The more effectively method and pure poetry are fused, the more compelling will be the form of the work and its expression of the essential ground in which it is rooted. In mastering the antagonism between the two elements personal feeling finds objective embodiment in a concrete order and humanises the law imposed on them both.

Many painters could not accept the discipline of this art, feeling that it disturbed their meditative response to lyrical emotions and visual experiences. They left themselves open to all impulses, even to a lyrical perception of the world. It is no doubt in this less clearly defined world that most Western abstract painters make their home today. It is to them that the term 'abstract painting' properly refers. Abstract painting shuns definitions, and seeks to elude clear demarcation lines. It covers the area where individual meditation is given full scope, and where the artist reserves all rights, including the right to find his way back to visible things. The human and artistic attitude involved may be gathered from the following statement in which the French painter Bissière defines his own art: 'I did not aim at paintings in the pretentious sense of the word, but only at coloured pictorial signs in which everyone might encounter his own dreams. When I set down on the canvas these signs in which I should like to recognise myself, when many persons feel touched by them and are tempted to hold out a fraternal hand, it seems to me that I have been successful, and I don't ask for more. In the last analysis, I am convinced that the quality of a work of art is measured by the sum of humanity it contains and liberates.' The conception of the picture as a documentary tablet on which the artist records his profound experience of the cosmos and so builds a bridge between man and his outside world, is again coming to the fore. In the United States particularly this meditative form of painting developed parallel to Action Painting. The initial inspiration came from the East, from the philosophies and meditative techniques of China and Japan, and perhaps for this reason the first steps were taken in the western United States. Subsequently these oriental ideas merged in New York with Surrealist ideas.

It was Mark Tobey whose attention was first drawn to the Eastern conception of painting as a technique of meditation. He had started to paint under the impact of his encounter with French Cubism at the Armory Show and then, in 1922, after a brief period of art study in Chicago, had settled in Seattle. There he became acquainted with the Persian Bahai philosophy, one of those mystical, esoteric forms of oriental thought, which strive to recapture man's original unity with the universe through contemplation of nature. It was then that he began to concern himself with the meditative brush techniques of the Far East. From 1931 to 1938 he lived in England, where he taught at Dartington Hall School. During this time he took several trips to China and Japan for purposes of study. While staying at a Japanese monastery, he became converted to Zen Buddhism and studied the Chinese calligraphers. Their meditative script, which was at once psychic improvisation and sign writing, expressive of contemplative experience, inspired him to find a similar mode of expression for his own Western vision and experience. By 1935 he had devised the technique that he called 'white writing'. Little white script-like signs covered the coloured ground with a fine filigree of lines, transforming the surface into a vibrant medium compounded of light and space. In this intricate network he captured visible images of the outside world, of countrysides, cities, and streets, which shone through the mobile filigree like immaterial apparitions, defining the thematic direction of his esoteric script. So powerful was the psychic movement embodied in his lines and signs that they may well be regarded as a preparation for Pollock's free expressive script. And this indeed was the direction in which Tobey developed. Moving farther and farther away from the visible world, the fine filigree became a formal

equivalent for an inner expressive movement. However, Tobey reserved his freedom to accept the signs of the objective world when they seemed appropriate to the direction of his meditation. For his aim was always to achieve through pictorial meditation a harmony between inside and outside, between the individual in man and the universal of the world surrounding him.

Soon Tobey was followed by Morris Graves, a former seaman, who had begun in 1931 to draw animals in the Los Angeles zoo and in 1934 had moved to Seattle and become a painter. He adopted the technique of 'white writing'; he too was converted to Zen Buddhism and studied the art of the Far Eastern calligraphers. But from the start animals were the main theme of his work. Their unconscious life, embedded in the universal harmony of nature, became for him a symbol of his own feeling about life. Like Franz Marc and Paul Klee he looked upon the unconscious existence of animals as the form of life preceding the fall from grace brought about by human consciousness. And his pictures, like those of Marc and Klee, are full of a gentle sorrow over man's dereliction from his unconscious dream life. In 1942 the Museum of Modern Art in New York exhibited the highly poetic 'Inner Eye Series' that is his main contribution to modern art. It made him famous overnight. The pictures show animals, other-worldly creatures, a bird singing in the moonlight. These images came to him from within; he painted them as though with closed eyes. As he harkened in patient self-forgetfulness to a rhythm rising up from within him, his hand, groping half-automatically over the ground, formed a network of fine lines which built up an immaterial space from coloured light. Into this magically evocative fabric of lines the painter's hallucinated fantasy projected his animals which, in an other-worldly pictorial space, recounted the nostalgic fable of a life embedded in universal Being – metaphors and parables for a life of contemplation.

While these Western American artists came to meditative painting by way of the philosophies and expressive techniques of the Far East, the related New York trends took Freudian psycho-analysis and Surrealist automatism as their starting points. Consequently the pictures are entirely different in technique and general appearance although the purpose is similar. The two New York artists who strove for a meditative art as though to complement the Abstract Expressionism of the artists round Pollock, were Adolph Gottlieb and Mark Rothko. They had become close friends in the crucial war years and were united in the conviction that all art is based on myth, that the central theme of contemporary art is the mythical zone of the unconscious to which Freud had drawn attention. In those years Gottlieb, also stimulated by Klee and Torres-Garcia, took up the mythical signs from the ritual art of the Indians. It was then that he began his series of 'Pictographs'. The pictorial field was divided into a chequerboard on which were inscribed magical signs and motifs – eyes, snakes, hands, masks, etc. Taken together, the signs produced a cryptic script with a mythical undertone. Towards 1950 the surface was unified, the writing became more spontaneous, but the orientation was still towards symbolic signs. In 1951 came the series of 'stratified landscapes' – other-worldly landscapes formed of broad horizontal stripes in which symbols and cryptic signs were inscribed. In 1954 these changed to the 'Grandscapes' in which great circular forms appeared, evoking cosmic and primeval landscapes. Finally, in 1956, the formal repertory was reduced to two basic forms, a disc and a shapeless blot. The circle, symbol of the cosmos, is above, radiating colour like a halo; below, with its jagged contour, the formless, lightless black spot symbolising chaos. In the dialogue between these two elementary forms the great conflicts in which world and man move find their expression: cosmos and chaos, heaven and earth, light and darkness, form and the formless, repose and passion. The picture becomes a meditative field of these balanced elementary contrasts which govern human existence.

368

Towards 1950 Mark Rothko arrived at his meditative image by a similar process of radical reduction. As a student of Max Weber, he had painted before the war in the Expressionist style of Weber and Soutine; then, during the war, he had come through Surrealism to psychic improvisation. To him, however, psychic improvisation was not the expressive psychography underlying Action Painting; it meant the possibility of making visible in a pictorial analogy the idea at work within the individual and its mythical background. He too, stimulated by Matta and Masson, started with 'inscapes'. Imaginary creatures and plants grew like a kind of submarine flora from dim, fluid coloured grounds. In the immaterial medium of colour these beings created another world that seemed utterly incompatible with the natural space of human experience. In the following years the psychic vegetation became increasingly dim and spectral, its formal detail completely absorbed by the immaterial coloured light. From the coloured light emerged irregular coloured spots which towards 1948 began to take on simple geometrical forms arranged in a rectangle; they set the surface in gentle motion and as they emerged derived a strange hypnotic power from the monochrome ground. Finally, towards 1950, the formal and linear quality vanished entirely from the flat coloured surface. The picture became a screen, illumined by dark light, articulated only by a very few coloured fields which rise from the ground and sink back into it. These screens of light have nothing more in common with framed pictures; they symbolise the great, unlimited, universal space surrounding us, in which the numen has its place. Only the suggestive, hypnotic power of colour determines the idea and content. Rothko avoids the great complementary contrasts and employs colours close together in the colour circle: passages from brown to red, from grey to blue, from orange to red... These give rise to a magically uniform light, which is nowhere directly present, but which emanates from chords of neighbouring colours. The colour modulation appears to give the luminous screen a rhythmic breathing, as though some mysterious Divinity were moving behind it. It would be difficult to assign a proper place in the modern art world to these screens of meditation, for they are in no way related to the usual pictures to be seen at our exhibitions. However, one cannot deny their power to provoke intense meditation.

The meditative aspect has played an important role among those of the younger English painters who became interested in American art in the middle fifties. In 1955 a Tobey exhibition was held in London; in 1956 Rothko was represented in a comprehensive exhibit of modern American painting at the Tate Gallery. Patrick Heron, who had started out with a decorative Cubism, took up Rothko's meditative colour movement; Turnbull, following the lead of Barnett Newman and Rothko, experimented with the tensions between large, simply sub-divided coloured surfaces; Bryan Wynter drew inspiration from the minutely articulated rhythms in the meditative panels of Tobey and Tomlin. Today the influence of this aspect of American painting may be noted all over Europe.

In Germany the meditative method found fertile soil at an early date, because it fell in with the prevailing Romantic mood and feeling for the world and nature. A special place must be accorded to Julius Bissier. A grave personal crisis and a timely encounter with certain ideas of Brancusi and Baumeister led him in the early thirties to abandon his poetic nature painting in the style of the old masters and to express himself in a script inspired from within. Ever since he had begun to paint, he had studied Chinese drawing and brush techniques and had recognised his own attitude towards nature and life in Chinese poetry and philosophy. This influence now came to the fore. In 1930 he did his first 'psychogrammes'; executed in a state of meditative trance, they resemble Chinese Indian ink drawings. They were written down as though under dictation from

within and then, after the manner of the oriental masters, repeated and clarified until they acquired the character of meaningful though cryptic signs. These signs forming under the trance-like movements of the hand tended always to apprehend an elementary contrast and raise it to a higher harmony. Bissier called them 'signs of bipolar life'. They connote the tension between male and female, active and passive, fluid and rigid, etc. Symbolic forms emerge – fruit, flowers, or bowls and vases. The painter's activity was a concentrated meditation, comparable to that of the Chinese philosophers, in which the spirit rises above all earthly desire and finds its way back to its inborn cosmic freedom, that is to say, harmony with the whole of creation. Thus Bissier, in patient meditation, developed a highly esoteric calligraphy, modelled on Far Eastern proto-types, from a few elementary characters which suggest, among other things, analogies to vege-tative and organic processes. Free psychographic forms enter into a natural proximity with natural forms; rigid hieroglyphic signs and the most personal expressive script maintain a balance. In 1947 Bissier had attempted, with the help of the coloured monotype technique, to introduce colour into his Indian ink signs. Again a long period of patient work set in, which finally achieved fulfilment in the series of 'Miniatures' begun in 1956. These are small improvisations in tempera on small irregular pieces of canvas. A miniature world of simple forms – crosses, lines, ovals, graceful concave forms suggesting vessels, plant forms – stand in a free rhythmic arrangement on a ground glazed with colour. The colour accentuates and modifies this rhythm, creating a strange hovering effect and, punctuated by the little rhythmic signs, giving forth a strange tender melody, which seems to accompany the paths laid out for the meditative eye. These paintings offer a direct expression of man's moods and poetic experience. Content and causality are taken very seriously, often more seriously than the strict pictorial organisation.

This lyrical probing of the domain of human sensibility wavers between passive acceptance of emergent pictorial impulses and active creation of forms. The content found by this method is by its very nature non-aggressive. Form is passively submitted to, not actively produced. Here form lacks the dramatic representative value of an autonomous figure which sustains the pictorial action and sets it in motion. But where importance is attached to such action, where artistic creation is seen as an aggressive action rooted in human existence, form as an autonomous figure reappears. In this context, the form-figure is not representational; it is an abstract sign which, however, is endowed with essential personality and can consequently come into emblematic proximity to the world of objects. An abstraction of this kind always has an exact meaning.

Among contemporary European abstract painters, the Italian Afro and the German Meistermann occupy a crucial position. Both are concerned at the disappearance of great human meanings, and both seek to give the abstract picture greater expressive force through the evocative power of emblems. Afro remains entirely within the domain of his human experience. In his paintings, a searching script traces forms which take on concrete existence as the painting proceeds. But each of them is inspired by an experience, an idea, a recollection that is encoded in the forms and demands to be released. Afro insists on demanding from his figurations a meaning consonant with his own intentions and personal experience, and seeks to give this meaning its most effective expression by aggressive treatment. The statement may turn out to be quite precise, though not actually visible – *Fear of the Dark* or *Repression*. But a visual experience may also emerge from the arsenal of memory – for example, *Bull Baiting with Lassos*. Thus the abstract figuration, the pure form, takes on an emblematic character that makes it a vehicle of objective communication. These paintings maintain a direct poetic correspondence with the essential aspects of reality that memory preserves. 'The painter's memory is synthetic,' says Afro, 'it rejects everything that

belongs to practical life and direct experience. I should like to paint the true idea of things rather than their appearance.'

This conception of reality has still deeper implications for Meistermann. His religious faith has something to do with it. Behind the visible world he senses the workings of a great formative power, and he tries to penetrate to it. His art reflects the discrepancy and tension between this ground of reality that he knows through his faith and the approximations to it which are possible in man's dynamic experience of life. This art is less contemplative than aggressive. It calls into play an extraordinarily hard and sharp intelligence which does its utmost to encompass the discrepancy and to keep it open. Using a hard, almost illustrative technique, Meistermann captures these painful tensions in a rigidly emblematic script. As early as the thirties he had begun, encouraged by Klee and Mataré, to condense his observations of nature into formal emblems, seeking to record his ephemeral visions of landscapes, figures, or things in formal signs that would give them greater completeness. By persistent study of the origin and evocative force of these emblems, and of their capacity to convey wider meanings, he soon discovered that, as representational signs, they are only part of the total 'inner handwriting', and that this handwriting, once freed from representational fetters, can express 'finds' still more remote from consciousness, messages originating in a deeper experience of the world and life. He drew new ideas from Léger's emblems of things and Miró's hieroglyphics. More and more he entrusted his statement to the eloquence of independent figurative signs, and so created an emblematic art of great dramatic force, which, in a script not without hardness, and in colours not without heaviness, expresses man's painful failure to come close to the ultimate ground of reality and thus falls back on the artist's psychic state as the last secure ground of experience. Occasionally, in response to a call from without, the dramatic figurations may cluster accidentally together to form an hermetic emblem, a kind of archetype in which vast areas of vision and faith stand condensed. For a moment man's remoteness from the ground of reality is transcended and the painter's 'world' is given to him as a charisma.

For the essential feature of these meditations and forms is that they do not give up the aim of possessing reality. Their goal is the 'imago', the comprehensive sign encompassing all man's inner being, and hence also the world and nature, for existentially he is also these. The concrete, harmonic work of art can be unfolded and then there shines forth from the ground the 'second reality' which our intuitive cognition may discover even in things of nature but which here is raised to objective existence by the evocative power of emblems.

Here abstract art has given rise to a tendency that we called 'hermetic' when it still contained references to objects. In it the outer and the inner begin to coincide: the gap between the real and the abstract is bridged.

### The Hermetic and the Real

Just as the realities of the encompassing world may assume the burdens of man, that is to say, just as they can be made into vehicles of spiritual expression, so the absolute forms created by the spirit and sensibility can carry the burdens of reality, that is to say, they can give a spiritual insight into the ground of reality. Today this proposition may be regarded as a certainty, confirmed by experience. Since the 'experiential ground of reality' includes the idea of the 'divine', it would be more accurate to speak of 'the experiential ground of creation'.

This subtle idea, whose roots once again go back to Romanticism, has become an object of great concern in contemporary painting. Perhaps it was already discernible in the dark icons of Soulages. It is clearly disclosed in some of Meistermann's works, where it points to the fountainhead of all Creation ('God' for the believer who thereby regains access to the store of symbols contained in theology). Among the younger painters, this idea has been most clearly expressed by Alfred Manessier: 'We must reconquer the full weight of lost reality. We must re-fashion for ourselves, to the measure of man, a heart, a mind, a soul. The real, the painter's reality, lies neither in realism nor in abstraction, but in the reconquest of his human value. Non-objective art seems to me to provide the contemporary painter with his best chance of gaining access to his inner reality and of grasping the awareness of his essence, indeed, of his Being. I believe that only by starting from this reconquered position will the painter be gradually able to find himself, to rediscover his powers, and to strengthen them to the point where he can reach the reality of the outside world.'

Manessier, Le Moal, and Singier – who are close friends – have been actively pursuing this task within the Ecole de Paris. They are strongly influenced by Klee. However, what they are trying to integrate into French painting is not Klee's forms and techniques, but his basic aim: to go back to the 'primal point of creation', to resolve partial observations and fragmentary sensations into a total vision, and thereby to gain a more comprehensive idea of an all-encompassing Being, which will then become a source of images.

The very tone of the idea is religious, and Manessier actually carried it into the domain of religion. As a practising Catholic he feels at one with his ground of Being. He can define it as a specific object, drawing, in his act of definition, on the ready-made symbols of the sacred – the Cross, the Crown of thorns, the images of the liturgy – as well as the existential symbols of creation itself. Originating in meditation on the sacred symbols and metaphors and on the words of creation embodied in natural forms, an art is born whose structure recalls the hieratic but love-warmed austerity of religious images. With their large relief-like networks of signs, these abstract, warmly luminous, flat architectures erected in tribute to a superior being, evoke sacred names: *Turris Davidica, Pour la fête du Christ-Roi.* Thus they cannot be regarded as the votive gifts of a pious painter; they are, in a very concrete and general sense, attempts to chart the domain of religious existence by means of invocations comparable to the invocations of the liturgy, which are after all often quite strange, indeed, 'absurd'. These works are complete symbols.

However, symbols can also denote experiences and perceptions of nature after these have been stripped of details. They emerge from the inner depths, and describe not objective realities but only their human reflections. Manessier's winter scenes, Le Moal's dark pantheistic landscapes, or Singier's meditations are results of a strange dialogue between vision and reflective meditation. It is not particular cases, but insights into the organisation of natural phenomena, symbolically distilled by recollection and meditation, that lead to more complete images. Singier's *Dutch Landscape* or his *Coaling Station* are conceived as landscapes, but the finished works are more complete symbols which raise the poetic suggestions of the object and the initial perception to a more comprehensive vision. Here too the representational references are not the starting point, but the result of the creative process. This is Klee's method. The extraordinary exemplary value of Klee's art makes it clear that this was no special, personal case. From Klee's improvisations and small canvases there slowly develops an art of great formal and thematic breadth, because these enormously fruitful seeds are contained in the total conception of Klee's art.

Thus it is not surprising that in Germany this new mode of responding to the world as a whole has

been taken up by two of the most outstanding artistic personalities – Theodor Werner and Fritz Winter. They have enlarged the old German Romantic idea of the 'image of the life of the earth' *(Erdlebenbild)* into a new dimension, which might be called 'the image of the inner depths of the world' *(Weltinnenbild)*.

Theodor Werner developed slowly; starting from Cézanne, he found his own path which led him by way of Cubism to abstract painting. During a five-year stay in Paris (1930-1935) he came close to the currents represented by Abstraction-Création and assimilated the ideas of concrete art that were latent in that group. But another long process of maturation was required before Werner produced the wholly abstract paintings that he showed at the first exhibition of his works held in Berlin in 1947. It is only since then that his name has been known in Germany.

His surfaces show painterly, space-modulating, sumptuously coloured grounds, marked irregularly with spots; in them are embedded jagged, angular forms and sharply outlined, curved figurations; over them is traced an arabesque sometimes sensitive and nervous, sometimes cutting explosively through the paint. Beyond a doubt these are abstract paintings, products of colour, without identifiable representational elements. And yet we sense clearly that this painter conceives of the pictorial ground as an existential ground. It is an existential ground well prepared by intelligence, experience, and study; it has absorbed the amazing and terrifying discoveries of modern physics and mathematics and the resultant view of the world. Under these new conditions, the 'metaphorical factor in objects' counts no longer. Three-dimensional things have lost their metaphorical power amid the new conception of space and have been supplanted by structures of a more algebraic character – oscillations, movements, tensions. Man who is 'a stranger in the new space' has the existential task of adjusting himself to it. If he is a painter, he must discover forms that imaginatively reflect this modern existential space, he must chart its terrible formlessness by visually charting its salient points. The temporary impossibility of expressing this new world in metaphors exacts from man's inwardness forms to take the place of the things which can no longer serve the purpose. These are replaced by the painting conceived of as a concrete reality, vehicle of a new metaphor, which is created out of nothingness and human freedom acting in nothingness, and is found in a meditative 'imitation of the creation of the world'. This is the content that is suggested by Werner's paintings which cannot be described in detail or interpreted literally, but which can be fully perceived.

Fritz Winter follows a similar path. He is simpler, more earthbound, more direct, and often more warmly communicative. He comes directly from the Bauhaus teachings of Klee and Kandinsky, and through them continues the tradition of the Blaue Reiter with its nature mythology. He was remarkably mature as early as 1930, when he embarked on a steady, industrious, and extremely fruitful development. The work done in 1943 during a short leave from the army still carries a fraternal reminiscence of the last period of Franz Marc. In 1949 – when he returned from Russian captivity – his art burgeoned into greatness. He was encouraged from afar by his fellow artists of the Paris School – Hartung and Manessier, and the knowledge that he had many comrades was reflected in the joyous freedom of his work.

In connection with Winter's paintings, the concepts of 'representational' and 'abstract' begin to be inadequate. We see diagrams of energies, structures, fields of forces, delicate crystalline patterns, which we seem to recognise because their inherent naturalness and necessity suggest that these are the forms in which nature records the living consummation of her vital impulses and which in turn summon the painter to transform his experience of animated nature into similarly animated diagrams. He leaves behind him the finished, ready-made elements of the

natural image, he makes himself as dynamic as nature, and with his art gives visible form to experiences that are inaccessible to representational art – the growth processes of living creatures, the driving forces of the earth, the rising of the sap, the blowing of the wind, the flowing of rivers. Everything – the spontaneous impulses of the psyche, the equipoise of pure harmony, insights into nature – all find their pictorial equivalent. These paintings which seem to hearken to their own thoughts, breathe an intimate human warmth and suggest a profound bond between this personal world of expression and the universal within and around us. This is no solipsistic introspection. They reflect the same love for the Greater Creation which Fritz Winter, heeding the lesson of Franz Marc and Paul Klee, has preserved within himself, the love which Marc defined as the goal of art and which leads the artist 'to dissolve the entire system of our partial sensations and disclose the unearthly being that dwells behind all things'. Winter's paintings thus may be described as carrying on the great Romantic tradition – in so far as it is Romantic to believe that there is an immaterial point where the inside and outside, the near and the far, the animate and inanimate coincide, and that by attaining to that point it is possible to restore unity with the world of things on a universal plane. This idea runs through the artistic thinking of our century like a powerful leitmotif and is in the truest sense its motivating principle.

In this abstract art pregnant with content – we might call it 'abstract hermeticism' – the circle begins to close. We suddenly perceive that abstract painting can also be a method for appropriating and mastering the world. It has become abstract in consequence of the change in our picture of the world as a whole. This hermetic art faces a task whose solution is of vital importance for our generation's peace of mind, for its freedom from fear. Our modern thinking, obeying an inexorable logic undismayed by paradox, has found itself in realms that cannot be visualised. Visible nature, no longer sufficient, has been transcended on all sides. At this point the human mind has called abstract logic into play, and, by manipulating numbers and symbols of energy, has been able to explore a field of reality which is inaccessible to our sensory imagination. Nature has lost its visual substance. Our entire world picture is expressed in numbers and concepts that cannot be visualised. We can no longer form mental 'images' of it. And yet we must make such images if we are not to be overcome by fear, by the terrible impotence of our imagination, by the void that we can no longer arbitrarily fill with traditional images. This may be what Theodor Werner had in mind when he said that 'Art is the plank of salvation in an epoch when man is a stranger in a new space'. We must step into this world that has become abstract, establish ourselves in it, and endure it. For this we need painters with a modern consciousness, image-makers whose artistic intelligence and intuition move forward with the same keenness, daring, and sureness as logic, but who remain with us while logic hurries away.

*A Glance Forward*

Our path has led us to the present day, but it is not ended. Everything in the art of today points to an unknown future.

Post-war painting as a whole has a peculiarly fragmentary character. To be sure, it takes its place within the great stylistic pattern that has been shaping itself since the turn of the century. But within the general pattern it has concentrated overwhelmingly on abstraction. Contemporary artists have greatly enlarged and defined the abstract domain. The discoveries and ideas, the concepts and theories of individual artists have been gathered together and transformed into a style, the ab-

stract style of our time. The entire range of communication accessible to abstract painting has been clearly defined – from pure harmonic balance to the hermetic picture of the inner depths of the world.

Western realism seems to be a thing of the past. Nevertheless the overall stylistic pattern has its realistic aspect which clearly retains its validity for us. How else can we explain the fascination exerted on modern Europeans by all primitive definitions of reality, by the realism of the Negroes, Mexicans, etc.? It is easily accounted for, if we give serious thought to the fragmentary character of contemporary European art. It does not suffice to suppose that the preponderance of abstract art today is merely a reaction to the 'transcendent realism' of the years between the wars, that the pendulum of history will swing cosily back again and realism will once again have its day. We must bear in mind that Europe today is merely a part of the greater whole, for which Europe itself has paved the way.

This realisation is forced upon us by a fact unparallelled in history, namely that the European outlook, developed in the last half century and reflected in modern art and architecture, has today been accepted all over the world. In Europe and America, Canada and Brazil, Persia and Japan, it has overwhelmed the bastions of folk culture, many of which have been built up and preserved over thousands of years, and destroyed them at any rate on the surface. A world culture is beginning to be discernible. Today Klee, Kandinsky, Picasso are recognised the world over. Today everything has entered into our consciousness – the millions of years of biological evolution, the thousands of years of human expression, the ways of life of all peoples.

It is this very simultaneity that now excludes European folklore; the 'great stylistic pattern' which bridges the gap between 'the Greater Reality' and 'the Greater Abstraction' has already assumed a global character. Thus it is quite possible that the fundamental point of view expressed in this book reflects a historical situation that has already begun to change. I have written it as a European historian, about modern Western art. In a few decades such an undertaking may be inconceivable and it may only be possible to write as a world historian about world painting. But because I have merely described something and invented nothing, and because I believe that the history of the human race is governed by the laws of life, I am convinced that the future historian in question will still encounter our fundamental stylistic pattern. But he will encounter it at a global, not at a local level. He will see primitive peoples and coloured races moving forward by unexpected stages in their definition of 'the Greater Reality'. He will see 'the Greater Abstraction' taking form among the dynamic nations intent upon unravelling the mystery of the Universe. He will see the two together as a style encompassing the world. Indeed, he will no longer speak of nations, but of human levels, though without passing value judgments upon them. We must therefore envisage the possibility that in the coming world culture 'the Greater Reality' will be the domain of the 'primitive' peoples outside Europe. Although we have with our life-style destroyed the ancient cultures scattered over the world, the dead lives on in the tissue of the living. All this can be sensed even today in the midst of the contemporary artistic bustle. Time and again we have observed how the magical and totemistic invocations of reality known to primitive cultures are being integrated into our intelligent Western pictorial techniques, and how the voices of the dead make themselves heard among the living.

We might conclude with a glorious dream about the future happiness of a great new community of all mankind! ... But such dreams are inevitably tinged with irony, because when we mortals think of the generations yet unborn, we know that those living are always in a miraculous way the last, and because this 'miracle' is the true and irretrievable substance of our existence in the world – the pure present.

AFRO (BASALDELLA, AFRO). Born March 4, 1912 in Udine. Studied in Venice and Florence. After a brief stay in Paris, moved to Rome in 1937. 1941-44, taught at the Venice Academy. Has been living in Rome since 1948.
*Reference:* L. Venturi, *Afro*, Rome 1954.

AHLERS-HESTERMANN, FRIEDRICH. Born July 17, 1883 in Hamburg. Studied in Hamburg and from 1907 to 1914 in Paris, in 1910 with Matisse. Returned to Hamburg in 1918. 1928-1933, taught at the Werkkunstschule in Cologne. 1938-45, Berlin, 1945-1951, director of the Landeskunstschule in Hamburg. Lives in Berlin.
*Publications:* For contributions to periodicals see particularly *Kunst and Künstler.* — *Stilwende*, Berlin, 1941 (expanded edition, 1956). — *Pause vor dem dritten Akt*, 1949 (Memoirs).
*Reference: Der Cicerone* XV, 1923, p. 329.

ALBERS, JOSEF. Born March 19, 1888 at Bottrop, Westphalia. After preparatory studies in Berlin, Essen, Munich, studied at the Bauhaus in Weimar. From 1923 to 1933 master at the Bauhaus. From 1933 to 1948 taught at Black Mountain College, North Carolina. Has been teaching at Yale University since 1950. Visiting lecturer at Ulm in 1954.
*Publications:* Articles in *Bauhaus* II and IV.
*Reference:* Catalogue of Exhibition at K. E. Osthaus Museum, Hagen 1957.

ALBRIGHT, IVAN. Born February 20, 1897 in Chicago. Father a portrait painter. Studied architecture at University of Illinois; spare-time painter. 1918, in France where he did medical drawings in an army hospital. Studied briefly at Ecole des Beaux-Arts in Nantes. After the war returned to America and continued his studies at Art Institute of Chicago, in 1923 at Pennsylvania Academy, and in 1924 at National Academy, New York. In 1925 moved to Warrenville, Illinois.
*References:* Daniel C. Rich, 'Ivan Le Lorraine Albright' in *Magazine of Art*, February 1943, pp. 48-51. — *New Art in America*, ed. J. H. Baur, New York 1957, pp. 198-202.

AMIET, CUNO. Born March 28, 1868 at Solothurn. Studied with Buchser from 1884 to 1886. 1887-1888, studied in Munich and 1889-1891 in Paris during which time visited Pont-Aven and met Gauguin and his group. After his return to Switzerland (1892) friendship with Hodler. In 1906 brief membership of the Brücke. Regular visits to Paris up to 1939. Lives in the Emmenthal, Switzerland.
*Publication:* 'In eigener Sache' in *Werk*, March 1943.
*References:* A. Baur, *Cuno Amiet*, Basle 1943. — C. v. Mandach, *Cuno Amiet*, Berne 1939 (Catalogue of Prints).

ANGRAND, CHARLES. Born April 29, 1854 at Criquetot-sur-Ouville. First exhibited at the Indépendants in 1884 and belonged to first Neo-Impressionist group. Died April 1, 1926 in Paris.
*Reference:* J. Rewald, *Post-Impressionism from Van Gogh to Gauguin*, New York 1956.

ANQUETIN, LOUIS. Born January 26, 1861 at Etrepagny (Eure). First influenced by Monet, later by the Neo-Impressionists. Through Bernard became acquainted with the style of Van Gogh and Gauguin and developed a decorative, mobile style of figure composition. Died 1932 in Paris.
*Reference:* H. Vollmer, *Künstler-Lexikon*, Leipzig 1953.

APPEL, KAREL. Born 1921 in Amsterdam. 1940-43, studied at Rijksacademie, Amsterdam. 1948, founder member of Cobra group with which he exhibited from 1949 to 1951. 1952, showed at Michel Tapié's 'Un Art Autre' exhibition in Paris. 1954, represented at Venice Biennale. 1955, one-man show at Stedelijk Museum, Amsterdam. Lives in Paris.
*References: Quadrum* III, pp. 41-48, and VI, pp. 32-34.

ARCHIPENKO, ALEXANDER. Born May 30, 1887 in Kiev. 1902-05 studied in Kiev, 1905-08 in Moscow. In 1908 moved to Paris. After 1910 attempted to introduce the elements of Cubist style into sculpture. Towards 1914 'Sculpto-Peinture'. Beginning in 1916, slow return to more traditional forms. 1920-23, Berlin. Since 1923 in the U.S.A. where he opened an art school in New York. Lives in Hollywood.
*References:* H. Hildebrandt, *Alexander Archipenko*, Berlin 1923. — Catalogue of Exhibition, 'Alexander Archipenko, Plastik, Malerei, Druckgraphik', Darmstadt 1955. (Text by E. Wiese.)

ARP, JEAN (HANS). Born September 16, 1887 in Strasbourg. Painter, sculptor, poet. Studied in Strasbourg, Weimar, Paris. 1904, first stay in Paris. 1911-12, in Munich and connection with the Blaue Reiter. 1914, Paris, where he was connected with Apollinaire and his circle. 1916, co-founder of Dada in Zurich. 1919-1920, worked with Max Ernst in Cologne. 1922, moved to Paris. 1926-40, lived at Meudon near Paris. Since 1930 active as a sculptor. 1931, co-founder of Abstraction-Création. 1940, flight to Grasse. 1942-45 in Switzerland. Has been living at Meudon since 1945.
*Publications: On my way. Poetry and Essays* 1912-47, New York 1948. — *Le Siège de l'air, poèmes* 1915-45 Paris, no date.
*References:* G. Giedion-Welcker, *Hans Arp*, Stuttgart 1957. — J. T. Soby, *Arp*, Museum of Modern Art, New York 1958.

AUBERJONOIS, RENÉ. Born August 12, 1872 at Yverdon, Switzerland. Preparatory studies in Dresden.

1898, further study in London, continued after 1901 in Paris. Lived in Paris from 1901 to 1914. Association with Cubists. 1914, moved to Lausanne, taking occasional trips to Paris and Rome. 1948, one-man show at Venice Biennale. Died in Lausanne, October 11, 1957.

*References:* C. F. Ramuz, *René Auberjonois*, Lausanne 1943. — *René Auberjonois, Dessins, textes, photographies*, Lausanne 1958.

BACON, FRANCIS. Born October 28, 1909 in Dublin. Self-taught. Began to paint in the early thirties. 1945, *Studies for a Crucifixion.* Since 1949 has regularly held one-man shows in London. Spends summers in southern France. 1950 and 1952 in Tangiers. 1951, studies of Velasquez' paintings of Pope Innocent X. 1952, *Studies of a Dog.* 1953, first exhibition in New York. 1954, showed at Venice Biennale. 1955, represented in 'The New Decade' Exhibition in the Museum of Modern Art, New York. 1956-7, *Studies for a Portrait of Van Gogh.* Lives in London.

*Publication:* 'Notes' in Catalogue of 'The New Decade' Exhibition, Mus. Mod. Art, New York 1955.

*References:* R. Melville in *Horizon*, December 1949, pp. 419-423; *World Review*, January 1951, pp. 63-64 and February 1952, pp. 31-32.

BAKST, LÉON (ROSENBERG, LEV). Born May 10, 1866 in St. Petersburg. Studied at Moscow and Paris academies. His name is identified with the beginnings of Russian modernism and the sets for the Russian Ballet. Died December 28, 1924 in Paris.

*Reference:* A. Levinson, *Léon Bakst*, Berlin 1925.

BALLA, GIACOMO. Born July 24, 1871 in Turin. Studied in Paris at the turn of the century. Handed on the theory of Neo-Impressionism to Boccioni and Severini. 1910, one of the founders of Futurism in art. Lives in Rome.

*Reference: Archivi del Futurismo*, Rome 1958.

BARLACH, ERNST. Born January 2, 1870 at Wedel, Holstein. 1888-91, vocational school in Hamburg. 1891-95, Dresden Academy. 1895-6, Paris. 1897, long stay in Paris. 1898-99, Hamburg and Wedel. 1899-1901, Berlin. 1901-04 Wedel. 1905-06, Berlin. 1906, trip to Russia. 1907-09 Berlin. 1909, Florence. In 1910 moved to Güstrow in Mecklenburg. 1915-16, served in Army. 1919, appointed member of the German Academy of Arts. Died October 24, 1938 in Rostock.

*Publications: Der tote Tag* (1912); *Der arme Vetter* (1918); *Der Findling* (1922); *Die Sintflut* (1923); *Der Graf von Ratzeburg* (1927); *Ein selbsterzähltes Leben* (1928 and 1948).

*References:* F. Schult, *Ernst Barlach*, Berlin 1950. — F. Dross, *Ernst Barlach. Leben und Werk in seinen Briefen*, Munich 1952. — Wolf Stubbe, *Ernst Barlach*, Munich 1959.

BASTIEN-LEPAGE, JULES. Born November 1, 1848 at Damvillers, (Meuse). Studied with Cabanel at the Paris Academy. Exhibited at the Salon beginning in 1870. Was regarded as one of the leading representatives of social realism in art. Died December 10, 1884 in Paris.

*Reference:* A. Theuriet, *Jules Bastien-Lepage*, Paris 1885.

BAUCHANT, ANDRÉ. Born April 24, 1873 at Chateaurenault near Tours. Non-professional painter. Trained as gardener. During his military service as surveyor began to draw. In 1920 he came to the attention of Le Corbusier and Ozenfant. 1921, first showing at Salon d'Automne. 1927, commissioned by Diaghilev to do sets for a Stravinsky ballet. Worked as a gardener in Touraine. Died in August 1958.

*Reference:* W. Uhde, *Fünf primitive Meister*, Zurich 1947.

BAUMEISTER, WILLI. Born January 22, 1889 in Stuttgart. 1906, studied under Hoelzel at the Stuttgart Academy. Friendship with Schlemmer and Meyer-Amden. 1912, first trip to Paris, where he first saw the work of Toulouse-Lautrec and Gauguin. 1914, second trip to Paris with Schlemmer, impact of Cézanne. 1914-18, served in Army. 1919, the first Constructivist paintings for murals. 1924, trip to Paris, contact with Ozenfant, Le Corbusier, and Léger. 1928-33, taught at Frankfurt Art School. 1933, dismissed as 'degenerate artist' and returned to Stuttgart. 1939-44, industrial design at Wuppertal. Beginning in 1946, teacher at the Stuttgart Academy. Died August 31, 1955 in Stuttgart.

*Publication: Das Unbekannte in der Kunst*, Stuttgart, 1947 (written in 1943-44).

*Reference:* W. Grohmann, *Willi Baumeister*, Stuttgart 1952.

BAYER, HERBERT. Born April 5, 1900 at Haag, Austria. 1919, studied architecture in Linz. 1921, student at the Bauhaus. 1925-28, master at the Bauhaus. 1928-38, advertising business in Berlin. Has been in the U.S.A. since 1938, working as an industrial designer and architect. Lives at Aspen, Colorado.

*Reference:* A. Dorner, *The Way Beyond Art. The work of Herbert Bayer*, New York 1947.

BAZAINE, JEAN. Born in December 24, 1904 in Paris. Studied sculpture at the Ecole des Beaux-Arts in Paris. Has painted since 1924. 1941, organised the Exhibition 'Peintres de tradition française' in Gal. Braun, Paris. 1953-4 visit to Spain. Lives in Paris.

*Publication: Notes sur la peinture d'aujourd'hui.* Paris 1948.

*Reference:* A. Maeght, *Jean Bazaine*, Paris 1953.

BAZIOTES, WILLIAM. Born 1912 in Pittsburgh, Pa. 1933, moved to New York, studied at National Academy of Design. 1936-41, WPA Art Project. During the war became friends with the New York group of abstract painters. 1948, founded an art school with Motherwell, Newman and Rothko. 1949-52, taught at Brooklyn Museum Art School and New York University. Since 1952 has been teaching at Hunter College in New York. Lives in New York.

*Publications:* See *Possibilities* I, Winter 1947-48; *The Tiger's Eye*, October 1948; *Right Angle*, June 1949.

*Reference: The New American Painting*, Museum of Modern Art, New York 1959, p. 20 ff.

BEARDSLEY, AUBREY. Born August 24, 1872 at Brighton. Worked briefly in architect's office but left for reasons of health. Met William Morris in the winter of 1891. 1892, first illustrations commissioned. 1893, began his career as graphic artist with drawings for *The Studio*. 1893-94, drawings for Mallory's *Morte d'Arthur* (appeared in 1894). Friendship with Rossetti, Burne-Jones, Crane, Morris, Whistler. 1894, drawings for Wilde's *Salome*. Beginning in 1894, art editor of *Yellow Book*. 1896, illustrations for *Lysistrata*. 1896, became art editor of *Savoy* magazine. 1897, first symptoms of illness. Converted to Catholicism, visited Paris and Dieppe. Went to Mentone to convalesce and died there on March 18, 1898.

*Publication: Under the Hill. An unfinished short story.*

*Reference:* E. Hölscher, *Aubrey Beardsley*, Hamburg, 1949.

BECHTEJEFF, VLADIMIR. Born in 1878 in Moscow. Started out as an officer. Taught himself to paint in Munich. Friend of Jawlensky and member of the Neue Künstler-Vereinigung in Munich.

*Reference:* O. Fischer, *Das Neue Bild*, Munich, 1912.

BECKMANN, MAX. Born February 12, 1884 in Leipzig. 1899, art school in Weimar. 1903-04, visit to Paris. 1906, Exhibition at 'Berliner Sezession', Villa Romana Prize. 1907-14, Berlin. 1908, trip to Paris. Member of the 'Berliner Sezession'. Resigned in 1911. 1914-15, Army Medical Corps, served in Belgium and Holland. 1915-33, lived in Frankfurt. Beginning in 1925, taught at the Frankfurt Art School. 1929-1932, several stays in Paris. From 1933, when he was dismissed from his post in Frankfurt, to 1937, lived in Berlin. 1937, Paris. 1938-47, Amsterdam. 1947-1949, taught at Washington University, St. Louis, Missouri. Moved to New York and taught at the Brooklyn Museum. 1950, Carnegie award and Prize at Venice Biennale. Died December 27, 1950 in New York.

*Publications: Briefe im Kriege,* Berlin 1918. — Lecture at New Burlington Gallery, London July 21, 1938 in *Werk 36* (1949), p. 92 — *Tagebücher 1940-1950*, Munich 1955.

*References:* B. Reifenberg and W. Hausenstein, *Max Beckmann*, Munich, 1949. — L. G. Buchheim, *Max Beckmann*, Feldafing 1959.

BEHRENS, PETER. Primarily an architect. Born April 14, 1868, in Hamburg. Studied painting in Karlsruhe, Düsseldorf, and Munich. In 1893, co-founder of 'Münchner Sezession'. 1900, appointed teacher at Darmstadt; first architectural activity. 1903-07, director of the School of Applied Art in Düsseldorf and art adviser to the A.E.G. in Berlin. 1922-36, director of the architecture department of the Vienna Academy. 1936, teacher at the Berlin Academy. Died February 27, 1940 in Berlin.

*Reference:* P. J. Cremers, *Peter Behrens*, Essen 1928.

BELL, GRAHAM. Born November 21, 1910 in the Transvaal. 1931, moved to England. Attended Durban Art School. Student of Duncan Grant. Friendship with Coldstream. 1934, exhibited with 'Objective Abstraction'. Active as an art critic. 1937, beginning of a new lyrical naturalism. Worked with the painters of the Euston Road School. 1939, entered Army. Killed on August 9, 1943.

*Publication: The Artist and his Public*, London 1939.

*Reference:* K. Clark, *Paintings of Graham Bell*, London 1947.

BELLOWS, GEORGE. Born August 12, 1882 in Columbus, Ohio. 1901-04, attended Ohio State University; 1904, studied with Henri at New York School of Art. 1909, Associate Member of the National Academy of Design in New York. 1910-11, taught at Art Students' League. 1912-18, taught at Ferrer School with Henri. 1913, Full Member of the National Academy. Died January 8, 1925 in New York. 1946, Retrospective at Art Institute of Chicago.

*Reference:* P. Boswell Jr., *George Bellows*, New York 1942.

BENTON, THOMAS H. Born 1889 at Neosho, Missouri. 1908, went to Paris for three years. Friendship with Stanton MacDonald-Wright. Settled in New York in 1912. From 1924 travelled through the Southern and Middle Western States, drawing scenes from the life of America. Benton was the leading painter of the American regionalist school. Beginning in 1930, several large murals. During the second World War worked as draughtsman for the U. S. Navy.

*References: Thomas H. Benton,* American Artists Group, New York 1945; *Thomas H. Benton, An Artist in America*, 1951.

BERNARD, EMILE. Born April 28, 1868. After studying at Atelier Cormon went to Brittany in 1886. Friendship with Gauguin, Van Gogh and Cézanne. Regarded himself as the latter's pupil. 1893-1900, Egypt and Spain. 1900, Venice and after 1904, Paris. Died April 16, 1941, in Paris.

*Publications:* Correspondence with Van Gogh and Conversations with Cézanne. Editor of the periodical *La Rénovation esthétique.*

*Reference:* P. Mornand, *Emile Bernard et ses amis*, Geneva 1957. — J. Rewald, *Post-Impressionism from Van Gogh to Gauguin*, New York, 1956.

BILL, MAX. Born December 22, 1908 at Winterthur. Active as architect, painter, sculptor, writer. After studying at School of Applied Art, Zurich, taught architecture at Bauhaus from 1927 to 1929. Settled in Zurich in 1929. 1931, member of Abstraction-Création group. 1944-45, appointed teacher at the Zurich School of Applied Art. 1951, plans for the Swiss pavilion at the Milan Triennale. 1951-58,

director of the Hochschule für Gestaltung in Ulm. Lives in Zurich.

*Publications:* In addition to numerous works of art criticism: *Quinze variations sur un même thème.* Lithographs with text, Paris 1938. — *X=X.* Drawings with introduction, Zurich 1942. — 'Die mathematische Denkweise in der Kunst unserer Zeit' in *Katalog Ausstellung Kunsthaus Zürich*, October/November 1949. — *Wassily Kandinsky*, Basle 1949.

*Reference:* T. Maldonado, *Max Bill*, Buenos Aires, 1955.

BIROLLI, RENATO. Born December 10, 1906 in Verona. After studies at the Verona Academy moved to Milan in 1928. Belonged at first to the Novecento. 1938, founded the Corrente group in Milan. 1947, became a member of the Fronte Nuovo. Starting with an Expressionism influenced by Picasso, he arrived at an almost abstract hermeticism. Died May 3, 1959 in Milan.

*Publication: D'Arena.* Gall. Schettini, Milan 1956.

*References:* A. Tullier, *Renato Birolli*, Milan 1951. — *Renato Birolli* with texts by Russoli, Valsecchi, Birolli, Milan (undated but after 1958).

BISSIER, JULIUS. Born December 3, 1893 in Freiburg, Germany. Studied at Karlsruhe Academy. 1914-1918, served in Army. 1929, turned away from representational painting. Began in 1930 to do free compositions in Chinese ink contrasting formal elements signified as masculine and feminine. Friendship with Baumeister and Schlemmer. Beginning in 1946, coloured monotypes. Lives at Hagnau (Lake Constance). Member of the Zen group of artists.

*Reference:* 'Julius Bissier', *Kat. Kestner-Ges.*, Hanover 1958.

BISSIÈRE, ROGER. Born 1888 at Villeréal (Lot-et-Garonne). After studying in Bordeaux moved to Paris in 1910. 1926-30 taught at Académie Ranson. His pupils include Manessier, Bertholle, Le Moal. Influenced by Klee. Lives in Paris.

*Publications:* Georges Braque, ed. *l'Effort Moderne.* Nr. 3, 1924.

*Reference:* Max-Pol Fouchet, *Bissière*, Paris 1955.

BLUME, PETER. Born 1906 in Russia. Moved to the U.S.A. in 1911. Studied in New York. 1932 and 1936 in Italy on Guggenheim grant. Lives at Gaylordsville, Conn.

*Publication:* 'After Surrealism' in *New Republic* LXXX, October 3, 1934, pp. 338-340.

*References:* J. T. Soby, *Contemporary American painters*, 1948, p. 51-55. — *New Art in America,* ed. J. T. H. Baur, New York 1957, p. 203-208.

BOCCIONI, UMBERTO. Born October 19, 1882 in Reggio, Calabria. 1898, moved to Rome and met Balla who made him acquainted with Neo-Impressionism. Friendship with Severini. 1902-04, Paris and Berlin. From 1907 lived in Milan. 1909, met Marinetti and joined the Futurist movement. February 11, 1910 signed the Manifesto of Futurist Painting. In 1911, met Apollinaire and the Cubists in Paris.

1912, showed at the International Futurist exhibition. 1913, exhibited his sculptures in Paris. 1915, volunteered for the Italian Army. Died August 16, 1916 on the North Italian front.

*Publications: Pittura, Scultura Futurista,* Milan 1914. — F. T. Marinetti, *Umberto Boccioni, Opera completa.* Foligno 1927.

*References:* Marinetti, *Umberto Boccioni*, Milan 1924. — G. C. Argan, *Umberto Boccioni*, Rome 1953. — *Archivi del Futurismo*, Rome 1958.

BOMBERG, DAVID. Born December 5, 1890 in Birmingham. Son of a Polish leather worker. 1895, family moved to London. 1905, training in lithography. 1908-10 night classes with Sickert. 1911-13, attended Slade School. 1913, short trip to Paris where he met Picasso, Modigliani, and Kisling. Influence of Cubism and Futurism. Member of the London Group. 1914-15, member of Vorticist Group. 1915-18, in Army. 1923-27, in Palestine. Autumn 1927, return to London. Beginning in 1929, visits to Spain, Morocco, Greece, and Russia. Nov. 1935, return to London. 1945-53, taught at Borough Polytechnic School at Dagenham. 1947, with some of his students founded the Borough Group which broke up in 1949. 1948, trip to Cyprus. 1953, trip to Paris, Chartres, Vézelay. 1954, trip to Spain. Founded the Borough Bottega where three group exhibitions were held from 1953 to 1955. Died August 19, 1957 in London.

*Publications:* Catalogue of exhibition held in 1914 at Chenil Gallery, Chelsea; Preface to Borough Bottega catalogue, 1953-54.

BOMBOIS, CAMILLE. Born February 3, 1883 at Venareyles-Laumes (Côte d'Or), son of a river boatman. Non-professional painter. Passed his childhood on a barge and worked as herdsman. 1903, wrestler with provincial circus troupes. 1907, worked on Paris Métro. 1914-18 fought in War. 1922, a street exhibition in Montmartre made him famous overnight. His success enabled him to devote himself entirely to painting. Lives in Paris.

*References:* W. Uhde, *Fünf primitive Meister*, Zurich 1947. — H. Bing Bodmer, *Camille Bombois*, Paris, 1951.

BONNARD, PIERRE. Born October 13, 1867 at Fontenay-aux-Roses (Seine). 1885-1888, studied law in Paris. 1888, studied at Académie Julian. Friendship with Denis, Sérusier, Vuillard. 1889, helped to found the Nabis. 1891, shared a studio with Denis and Vuillard. Exhibited with the Nabis at Le Barc de Boutteville gallery. Met Toulouse-Lautrec. 1893, lithographs for *Revue Blanche.* 1900, illustrations for Verlaine's *Parallèlement.* 1903, exhibition at Salon d'Automne. 1907-11, travels in Holland, England, Italy, Spain. 1923, Carnegie Award. Spent summers at Le Cannet near Cannes, and at Deauville and Trouville. From 1940 lived in retirement at Le Cannet where he died on January 23, 1947.

*Publication: Correspondances,* Paris 1944.

*References:* J. Rewald, *Pierre Bonnard*, Museum of Modern Art, New York 1948 (with detailed bibliography). — Natanson, *Le Bonnard que je propose,* Geneva.

BRANCUSI, CONSTANTIN. Sculptor. Born February 21, 1876 at Pestisani Gorj (Rumania). Studied at the academies of Cracow, Bucharest, and Munich and after 1904 in Paris. 1906, association with Rodin. Beginning in 1907 strove for elementary abstract form in sculpture. 1908, *Sleeping Muse*. 1915, *Nouveau-Né*. Died March 16, 1957 in Paris.

*Reference:* C. Giedion-Welcker, *Constantin Brancusi*, Basle-Stuttgart 1958.

BRAQUE, GEORGES. Born May 13, 1882 at Argenteuil (near Paris). Youth at Le Havre where he was trained as a decorator. From 1900 studied painting in Paris. 1906, in Antwerp with Friesz, autumn at L'Estaque. Moved towards the Fauves and Cézanne. Spring of 1908 at Estaque, the first Cubist pictures. When these were rejected at the Salon d'Automne, exhibited with Kahnweiler. 1908, friendship with Picasso. Analytic Cubism. 1911-12, Papiers collés and transition to Synthetic Cubism. 1914-15, fought in war, severely wounded, and discharged in 1917. Slight naturalistic modification of his Cubist form. 1923-24, stage sets for Diaghilev. 1932, illustrations for Hesiod's *Theogony*. 1939, sculpture. 1940-44, in the Pyrenees. Autumn 1944, return to Paris. 1948, Grand Prize at the Venice Biennale. 1953, decorated ceiling in the Salle Henri II in the Louvre.

*Publication: Cahier de Georges Braque*, 1917-47, Paris 1948.

*References:* J. Grenier, *Braque—peintures*, 1909-47, Paris 1948. — H. R. Hope, *Georges Braque*, Museum of Modern Art, New York 1949 (with complete bibliography). M. Gieure, *Georges Braque*, Paris 1956. — J. Russell, *Georges Braque*, London 1959.

BRATBY, JOHN R. Born July 19, 1928 in London. 1951-54, studied at Royal College of Art, London. 1954, grant to travel in Italy. First exhibition at Beaux Arts Gallery in London. 1956, showed at Venice Biennale. National Guggenheim Prize. 1958, co-operated on a film, *The Horse's Mouth*. First exhibition in U.S.A. Since 1955 has been teaching at Carlisle School of Art, Cumberland. 1959, became a member of the Royal Academy. Lives in Greenwich, London.

*Publication:* 'A Painter's Credo' in *Art News and Review*, III, No. 6, 1956.

BRAUNER, VICTOR. Born June 15, 1903 at Piatra, Rumania. After brief study in Bucharest moved to Paris. Joined the Surrealists in 1929. Lives in Paris.

*References:* Cat. of Exhibition at Leicester Galleries, London 1959. — A. Jouffroy, *Victor Brauner*, Musée de Poche, Paris 1959.

BREUER, MARCEL, Architect specialising in interiors, and industrial designer. Born in 1902 in Hungary. Studied at Bauhaus and taught there from 1926 to 1928. 1928-31, Berlin. 1931-35, extensive travels in the Mediterranean countries. 1935-37, London. 1938, renewed his close collaboration with Gropius. Has been teaching at Harvard University since 1937. Lives at Cambridge, Mass.

*References:* Peter Blake, *Marcel Breuer, Architect and Designer*, Museum of Modern Art, New York 1949 (with bibliography). — G. C. Argan, *Marcel Breuer*, Milan 1957.

BROOKS, JAMES. Born 1906 in St. Louis, Mo. 1923-25, studied at University of Dallas, Texas. 1926, moved to New York. 1927-30, studied at Art Students' League. 1938-42, worked on WPA Art Project. 1942-45, served in Army in the Middle East. 1946-48, taught at Columbia University, New York. Since 1948 has been teaching at Pratt Institute in Brooklyn. Lives in New York.

BUFFET, BERNARD. Born July 10, 1928 in Paris. 1944 entered Ecole des Beaux-Arts. 1948, won the Prix de la Critique. Lives in Paris.

*Reference:* P. Bergé, *Bernard Buffet*, Geneva 1958.

BURCHFIELD, CHARLES. Born April 9, 1893 at Ashtabula Harbor, Ohio. 1912-16, studied at Cleveland Museum School of Art. 1916, moved to New York. 1918-19, served in Army. 1921, moved to Buffalo, N.Y. 1921-29, worked as designer. 1925, moved to Gardenville, N.Y. 1930, exhibition of early watercolours at Museum of Modern Art, New York. 1944, retrospective at Albright Art Gallery, Buffalo. 1949-52, taught at Art Institute of Buffalo. Lives at Gardenville, N.Y.

*Publication:* 'On the Middle Border' in *Creative Art* III, September 1928, pp. 25-32.

*Reference:* J.T.H. Baur, *Charles Burchfield*, New York 1956.

BURLJUK, DAVID. Born July 22, 1882 in Moscow. Studied in Munich and Paris. 1910, founded the Futurist group in Moscow and met Kandinsky in Odessa. Member of Blaue Reiter. Now living in New York.

*Publication:* 'Die Wilden Russlands', in *Blaue Reiter*, Munich 1912.

*Reference:* K. S. Dreier, *David Burljuk*, New York 1944.

BURRI, ALBERTO. Born 1915 at Città di Castello, Italy. Studied medicine. Taken prisoner by Americans during the war and began to paint in 1944 in a prison camp in Texas. 1945, settled in Rome, gave up his medical practice in order to paint. 1947, first exhibition in Rome. 1954, first exhibition in New York. 1960, showed at Venice Biennale and received International Critics' Prize. Lives in Rome.

*References:* J. J. Sweeney, *Burri*, Rome 1955; 'Alberto Burri' in *Quadrum*, VII, 1959, pp. 79-90.

CAILLEBOTTE, GUSTAVE. Born August 19, 1848 in Paris. 1873 studied at the Ecole des Beaux-Arts, Atelier Bonnat. 1875, association with the Impressionists, with whom he exhibited. Built up an important collection of Impressionist works. 1887, moved to Argenteuil. Died February 21, 1894. In 1897 his collection passed into the hands of the national administration of French museums.

*Reference:* M. Bérhaut, *Gustave Caillebotte*, Paris 1951, with provisional catalogue of works.

CALDER, ALEXANDER. Born August 22, 1898 in Philadelphia. 1919-22, worked as a mechanical engineer. 1923, studied painting in New York. 1926, Paris.

Association with Arp, Mondrian, Miró. 1928, first show of his wire plastics in New York. 1930, meeting with Léger. 1931, member of Abstraction-Création, the first mobiles. Lives at Roxbury, Conn.

*Publication:* See *Témoignages pour l'art abstrait*, Paris 1952.

*References:* Sartre and Sweeney, *Alexander Calder, Mobiles, Stabiles, Constellations*, Paris 1946. — J. J. Sweeney, *Alexander Calder*, Museum of Modern Art, New York 1951 (bibliography).

CAMARO, ALEXANDER. Born September 27, 1901 in Breslau. 1920-25, studied with Otto Müller in Breslau. 1928-30, studied dancing with Mary Wigman. From 1930, painted in Berlin. 1933-45, extensive travels in France and Greece. 1951 Art Prize of the City of Berlin, appointed teacher at Berlin Academy. Lives in Berlin.

*Reference:* Katalog Kestner-Gesellschaft, Hanover 1952.

CAMOIN, CHARLES. Born 1879 in Marseilles. Belonged to the first Fauve group. Close association with Cézanne. Lives in Paris.

*References:* Duthuit, *Les Fauves*, Geneva 1949, English translation, New York 1950; *The Fauvist Painters Charles Camoin* (Art-Documents), Geneva 1958.

CAMPENDONK, HEINRICH. Born November 3, 1889 in Krefeld. Studied in Krefeld and Munich. His first teacher was Thorn-Prikker. In 1911, Marc and Kandinsky invited him to Sindelsdorf. Member of Blaue Reiter. After discharge from Army in 1916 settled at Seeshaupt (Upper Bavaria). 1926, appointed teacher at Düsseldorf Academy. 1933, dismissed as 'degenerate'. Appointed teacher at Amsterdam Academy. Died June 9, 1957 in Amsterdam.

*Reference:* M. T. Engels, *Campendonk*, Recklinghausen 1958.

CAMPIGLI, MASSIMO. Born July 4, 1895 in Florence. Self-taught. 1907-15 worked as journalist in Milan. Began to paint in 1919. 1919-39 in Paris, influence of Picasso and Léger, of Etruscan and Cretan art. Extensive travels in Europe. 1939-49, Milan. 1948, one-man show at Biennale. Since 1949 has been living in Paris.

*References:* R. Carrieri, *Massimo Campigli*, Milan 1941 (Bibliography). — M. Raynal, *Campigli*, Paris 1949.

CAPOGROSSI, GIUSEPPE. Born March 7, 1900 in Rome. Studied law. Turned to painting in 1930. 1927-32, Paris. Lives in Rome.

*Reference: Cahiers d'Art* 25 (1950), p. 245.

CARRÀ, CARLO. Born February 11, 1881 at Quargnento (Piedmont). After brief study at the Brera, first visit to Paris and London in 1900. 1909, meeting with Marinetti and Boccioni. 1910, signed the Manifesto of Futurist Painting. 1911, trip to Paris and meeting with Apollinaire and the Cubists. 1915, beginning of a primitive, archaic style which in 1917, after his meeting with De Chirico, culminated

in Pittura Metafisica. Beginning in 1919, in close contact with the *Valori Plastici* tendencies, he developed his archaic realism based on Masaccio. As a teacher at the Milan Academy, Carrà exerted a leading influence on the generations of Italian painters between the two wars.

*Publications:* Extensive activity as a publicist and critic for *Lacerba, Valori Plastici, Popolo d'Italia, La Voce.* — *Pittura Metafisica*, Rome 1919. — *Giotto*, Rome 1924. — *La mia vita*, Milan 1943.

*References: Archivi del Futurismo*, Rome 1958. — G. Pacchioni, *Carlo Carrà*, Milan 1959.

CARRIÈRE, EUGÈNE. Born January 17, 1849 at Gournay (Seine-Maritime). 1870-76, studied in Paris with Cabanel. 1890, founding member of the Société Nationale. 1896, one-man show at the Galerie Art Nouveau. Died March 27, 1906 in Paris.

*Publications: L'éducation de l'art par la vie* (1900). — *L'homme visionnaire de la réalité* (1903). — *Schriften und ausgewählte Briefe*, ed. J. Delvolvé, Strasbourg, 1911.

*Reference:* C. Morice, *Eugène Carrière*, Paris 1906.

CASORATI, FELICE. Born December 4, 1886 in Novara. Studied law, then attended Academies of Padua, Naples (1908-11), Verona (1911-15). 1915-18, fought in war. 1919, settled in Turin. After beginnings influenced by Jugendstil and Pre-Raphaelites, he turned, towards 1920, to the ideas of Pittura Metafisica as they survived in *Valori Plastici*. As a teacher at the Turin Academy exerted a decisive influence on the Turin school. Lives in Turin.

*Reference:* A. Galvano, *Felice Casorati*, Milan 1947.

CASSINARI, BRUNO. Born September 29, 1912 in Piacenza. Studied at Milan Academy. 1938, member of Corrente. Frequent stays in France. 1946, founder member of Fronte Nuovo delle Arti. Lives in Milan.

*References:* M. Ràmous, *Contributo per Cassinari*, Modena 1951. — F. Russoli, Bruno Cassinari, *Disegni*, Bologna (undated, after 1954).

CESETTI, GIUSEPPE. Born March 10, 1902 at Tuscania near Viterbo. Self-taught. Now living in Venice, teaches painting at the Academy.

*Reference:* C. Cardazzo, *Giuseppe Cesetti*, Venice 1934.

CÉZANNE, PAUL. Born January 19, 1839 in Aix-en-Provence. Classical schooling and early friendship with Zola. 1859, studied law in Aix. 1861, moved to Paris to study painting. Met Pissarro. In the autumn, returned to Aix where he went to work in his father's bank. 1862-64, second stay in Paris. Friendship with the Impressionists. 1864-70, moved back and forth between Paris and Aix. 1865, met Manet. 1870, worked at L'Estaque. 1871, return to Paris. 1873, stay at Auvers-sur-Oise, influence of Pissarro. 1874 showed at first Impressionist exhibition. In the following years, painted at L'Estaque, Pontoise, Aix, and Auvers. 1877, showed at third Impressionist exhibition. From 1882, lived chiefly in Aix. 1886, break with Zola. 1887, exhibited with Groupe des XX in Brussels. 1895, first showing at Vollard gallery. Meeting with the young poet Joachim Gas-

quet. 1904-05 one-man shows at the Salon d'Automne and the Indépendants. Died October 22, 1906.

*Publications: Correspondance*, Paris 1937. — E. Bernard, *Souvenirs sur Paul Cézanne*, Paris 1912. — J. Gasquet, *Cézanne* (second part: 'Ce qu'il m'a dit'), Paris 1921.

*References:* L. Venturi, *Cézanne, son art, son œuvre*, 2 vols. Paris 1936. — F. Novotny, *Paul Cézanne*, Vienna 1938. — K. Badt, *Die Kunst Cézannes*, Munich 1956. — Meyer-Schapiro, *Paul Cézanne*, New York 1956.

CHAGALL, MARC. Born July 7, 1889 in Vitebsk. 1907, studied painting at the St. Petersburg Academy. 1910-14, in Paris, friendship with Apollinaire. 1914, exhibition at the Berlin 'Sturm'. 1914-22 in Russia. 1917, founded an art school in Vitebsk. 1919, helped to decorate Yiddish theatre in Moscow. 1922, moved to Berlin. 1923, commissioned by Vollard to illustrate Gogol's *Dead Souls* and moved to Paris. 1927-30, illustrations of La Fontaine's *Fables* (1952). 1931, trip to the Middle East. 1935, trip to Poland. 1941, emigrated to U.S.A. 1947, return to Paris 1949, moved to Vence and took up ceramics. 1951, trip to Israel. Lives at Vence.

*Publication: Ma vie*, Paris 1931.

*References:* J. J. Sweeney, *Marc Chagall*, Museum of Modern Art, New York 1946 (with extensive bibliography). — Franz Meyer, *Marc Chagall, Das graphische Werk*, Stuttgart 1957. — Franz Meyer, *Marc Chagall* (in preparation).

CHIRICO, GIORGIO DE. Born July 10, 1888 in Volo, Greece. Studied engineering, then painting in Athens and Munich. 1911-1915 in Paris, frequented Apollinaire and his circle. 1915, return to Italy where he joined the army. 1917, met Carrà in Ferrara. Founding of Pittura Metafisica. 1918-19, lived in Rome and Florence, associated with *Valori Plastici* group. Return to a Romantic Neo-Classicism. 1924, moved to Paris. Worked with the Surrealists and showed at the first Surrealist exhibition. 1929, publication of *Hebdomeros*. 1930, sets for Krenek's *Orest* at the Kroll-Oper in Berlin. 1935-38, Paris. Since then by turns in Milan, Florence, and Rome. Lives in Rome.

*Publications:* Extensive publicist activity. — A Novel, *Hebdomeros*, Paris 1929 (Milan 1942); *Memorie della mia vita*, Rome 1945.

*References:* R. Carrieri, *Giorgio de Chirico*, Milan 1942. — J. Faldi, *Giorgio de Chirico*, Venice 1949. — J. T. Soby, *Giorgio de Chirico*, Museum of Modern Art, New York 1955.

CIURLIONIS, MYKOLAS KONSTANTAS. Born September 10, 1875 at Varena, Lithuania. Studied music at the Warsaw Conservatory. 1905, began to paint and for a short time attended Warsaw Academy of Art. Died March 28, 1911 near Warsaw.

*Reference:* A. Rannit, 'Mykolas K. Ciurlionis,' in *Das goldene Tor* VI (1951). p. 57.

CLAVÉ, ANTONI. Born April 5, 1913 in Barcelona. Studied in Barcelona. In 1939, after Civil War, fled to France. From 1942, Paris. Paints chiefly for the theatre. Lives in Paris.

*References: Graphis* IV (1948); V (1949); VIII (1952).

COLDSTREAM, WILLIAM M. Born February 28, 1908 at Belford, Northumberland. 1926-29, attended Slade School. 1933, joined the London Group. 1934, gave up painting to work on documentary films. 1937-39, taught at Euston Road School which he helped to found. 1943-45, Official War Artist in Italy and the Near East. 1949, taught at Slade School. Knighted in 1956. Now director of the Slade School and chairman of the National Advisory Council on Art Education, London.

CONTI, PRIMO. Born October 16, 1900 in Florence. Self-taught. 1917-19, association with Futurism, then shift to the ideas of the Novecento. Lives in Florence.

*Reference:* G. Papini, *Primo Conti*, Florence 1946. — *Archivi del Futurismo*, Rome 1958.

CORINTH, LOVIS. Born July 21, 1858 at Tapiau, East Prussia. 1876-80, studied at Königsberg Academy. 1880-84, Munich Academy. 1884, trip to Antwerp and Paris. 1884-87, Paris. 1887-91, Königsberg. 1891-1902, Munich. 1902, moved to Berlin. From 1918, summers at Urfeld on the Walchensee. Died July 17 1925 at Zandvoort, Holland.

*Publications: Gesammelte Schriften*, Berlin 1920. — *Selbstbiographie*, Leipzig 1926.

*References:* K. Schwarz, *Das graphische Werk von Lovis Corinth*, Berlin 1922. — A. Kuhn, *Lovis Corinth*, Berlin 1925. — C. Berend-Corinth, *Die Gemälde von Lovis Corinth* (Catalogue of Works), Munich 1958.

CORNEILLE (CORNELIS VAN BEVERLOO). Born 1922 in Liège, Belgium, of Dutch parents. 1940-43, studied drawing spasmodically at Académie des Beaux Arts in Amsterdam. Self-taught in painting. 1948, founder member of Cobra group. Travels and exhibitions in Denmark, Sweden and North Africa. 1949, trip to southern Tunisia. 1950, moved to Paris. Has shown at Salon de Mai since 1950. 1954, represented at Venice Biennale. 1956, showed at Stedelijk Museum in Amsterdam. Guggenheim Award for the Netherlands. 1957, travels in Africa. 1958, travels in South America and the West Indies. Visit to New York. 1959, showed at Biennale in Sâo Paulo, Brazil. Lives in Paris.

*Publications:* 'Journal de Voyage' in *Cahiers du Musée de Poche*, No. 1, Paris.

*Reference:* J.-C. Lambert, *Corneille*, Le Musée de Poche, Paris 1960.

CORPORA, ANTONIO. Born August 15, 1909 in Tunis. Studied at Tunis Academy. 1929, Florence, 1930-37 Paris, Tunis, Italy. From 1939, Rome. Founding member of the Fronte Nuovo delle Arti.

*Publications:* Extensive critical writings.

*References:* L. Venturi, *Otto Pitturi Italiani*. Rome 1952. — *Cahiers d'Art* 1950 and 1952.

CROSS, HENRI EDMOND (HENRI DELACROIX). Born May 20, 1856 in Douai. Studied at the Lille Academy. 1876, moved to Paris. 1883, met Monet and the Im-

pressionists. 1884, friendship with Seurat and Signac. 1909, exhibition at Berlin Secession. In his last years close ties with Denis. Died May 16, 1910 in St. Clair.

*References:* P. Signac, *De E. Delacroix au Neo-impressionisme*, 1911. — J. Rewald, *Post-Impressionism from Van Gogh to Gauguin*, New York 1956.

DALI, SALVADOR. Born May 11, 1904 at Figueras near Barcelona. From 1921, studied painting in Madrid. 1924, influence of Pittura Metafisica. 1928, trip to Paris. Met Picasso and the Surrealists. 1929, work on his film *Un chien andalou*. 1931, collaborated on the film *L'Age d'or*. 1934, illustrations for Lautréamont's *Chants de Maldoror*. First trip to U.S.A. 1937, trip to Italy, influence of Raphael and Baroque art. 1940, moved to the U.S.A. 1950, stay in Rome.

*Publications: La Femme Visible*, 1930. — 'The Stinking Ass' in *This Quarter* V (1932). — *Conquest of the Irrational*, New York, 1935. — *La vie secrète de Salvador Dali*, Paris 1942.

*References:* J. T. Soby, Salvador Dali Museum of Modern Art, New York 1946 (with extensive bibliography). — R. Morse, *Salvador Dali*, New York 1958.

DAVIE, ALAN. Born September 28, 1920 at Grangemouth, Scotland. Father a painter. Began to paint in 1936. 1938-40, studied at Edinburgh College of Art. 1941-46, served in Army. 1945, profoundly impressed by Klee and Picasso. Turned to abstract art. 1947-48, jazz musician. 1948, trips to France, Italy, Spain. Attended Biennale. Saw Pollock's paintings at the Guggenheim Collection in Venice. 1949, London. Worked as a goldsmith. From 1950, regular exhibitions in London. 1953, became a teacher at the Central School of Arts and Crafts in London, where he taught the goldsmith's craft. 1955, turned to Zen-Buddhism. 1956, first exhibition in New York, which he visited. 1957, Gregory Fellowship at Leeds University. Since 1959 at Central School in London.

*Publications:* 'Statement' in Catalogue of exhibition at ICA gallery, January 16—February 23, 1957. 'Notes' in catalogue listed below.

*Reference:* Catalogue of Whitechapel Art Gallery, London, June-August 1958.

DAVIS, STUART. Born December 7, 1894 in Philadelphia. 1910-13, studied under Henri in New York. 1913, exhibited at Armory Show. 1913-16 did illustrations and title pages for *The Masses*. 1918, Army cartographer. Trip to Havana. Towards 1919 turned to non-objective art. 1923, summer in New Mexico. 1928-29, Paris. 1931, teacher at Art Students' League. 1933, WPA Art Project. 1934-39, took leading part in Artists' Congress. Editor of *Art Front*. Since 1940 has been teaching at New York School of Social Research. 1945, retrospective at Museum of Modern Art, New York. Lives in New York.

*Publications:* 'Art and the Masses' in *Art Digest,* October 1, 1939; 'The Artist Today' in *American Magazine of Art*, 28, August 1935, pp. 476-478; 'Self-Interview' in *Creative Art* 9 1931, pp. 208-11.

*Reference:* J. J. Sweeney, *Stuart Davis*, Museum of Modern Art, New York 1945.

DEGAS, EDGAR. Born July 19, 1834 in Paris. Deeply impressed by Ingres at an early age. 1855, took up studies at Ecole des Beaux-Arts. 1856, journey to Italy and study of the old masters. On return, intensive study at the Louvre. 1865, association with Manet and his circle; beginning of his 'race course' series. 1872, beginning of the ballet scenes. 1873, trip to America. 1874, participated in the first Impressionist exhibition. Died September 27, 1917 in Paris.

*Publication:* M. Guérin, *Lettres de Degas*, Paris 1931.

*References:* P. A. Lemoisne, *Degas et son œuvre*, Paris 1946 (4 vols). — Catalogue of graphic work in L. Delteil, *Edgar Degas*, Paris 1919. — Catalogue of sculpture: J. Rewald, *Degas' Works in Sculpture*, New York, no date.

DELAUNAY, ROBERT. Born April 12, 1885 in Paris. 1902, apprenticeship at a decorator's studio and beginning of art study. 1904, stay in Brittany. Influence of Pont-Aven school. 1905, Neo-Impressionism. 1909, first Cubist phase. 1910, exhibition at Indépendants. 1911, association with Blaue Reiter at Kandinsky's invitation. 1912, Orphic Cubism. 1913, abstract 'Formes Circulaires', trip to Berlin with Apollinaire and opening of his exhibition at the 'Sturm' Gallery. 1914-20, Spain. 1921, return to Paris. 1930, reliefs. 1937, decoration of the Palais des Chemins de Fer at the Paris World Fair. 1939, organised first exhibition of 'Réalités nouvelles' at the Galerie Charpentier. 1940-41, at Mougins. Died October 25, 1941 in Montpellier.

*Publications:* Colour theory printed as MS by the Association des amis de Robert Delaunay. See W. Hess, *Problem der Farbe*, Munich 1953.

*References: Robert Delaunay. Du Cubisme à l'art abstrait. Documents inédits et Catalogue de l'Oeuvre* (Introduction by P. Francastel), Paris 1957.

DELVAUX, PAUL. Born 1897 at Antheit-Lez-Huy, Belgium. Son of a lawyer. Studied architecture, then painting at Académie des Beaux-Arts in Brussels. Influenced by Permeke. 1924, joined Le Sillon group. Influenced by Magritte and De Chirico's Pittura Metafisica. Since 1935 has been painting in a Verist Surrealist style. Lives in Brussels, teaches at the Institut National Supérieur d'Architecture et des Arts décoratifs.

*References:* C. Spaak, *Paul Delvaux*, Monographies de l'Art Belge, Antwerp 1948; E. M. Langui in *Quadrum* I, May 1956, pp. 133-142.

DEMUTH, CHARLES. Born November 8, 1883, in Lancaster, Pa. Studied at Pennsylvania Academy in Philadelphia. 1907-08 trip to Paris, London, Berlin. Contact with '291' and close friendship with Stieglitz. 1912-14, Paris. Studied at Académie Colarossi and Académie Julian. 1921, another stay in Paris. 1926, one-man show at Stieglitz's 'Intimate Place'. Died 1935 in Lancaster, Pa. 1950, Retrospective at Museum of Modern Art, New York.

*Publication:* 'Confessions' in *The Little Review,* New York, No. 2, May 1929, pp. 30-31.

*Reference:* A. C. Ritchie in catalogue of Demuth exhibition, Museum of Modern Art, New York 1950.

DENIS, MAURICE. Born November 25, 1870 at Grandville (Manche). 1888, Académie Julian in Paris with Bonnard, Vuillard, Sérusier. Co-founder of the Nabis. 1891, shared studio with Bonnard and Vuillard. 1893, decorations for the Théâtre de l'Oeuvre. From 1894, commissions to decorate churches. 1895, first trip to Italy. 1897, trip to Rome with Gide. 1903, with Sérusier visited Verkade at Beuron monastery. Vollard published woodcuts for *L'imitation de Jésus-Christ*. 1906, with Bernard visited Cézanne. 1907-08, Italy. 1908, taught at Académie Ranson. 1912, decorations for the Théâtre des Champs-Elysées. 1914, painted apse of Saint-Paul in Geneva. 1919, founded Ateliers d'Art Sacré in Paris. 1927-28, U.S.A. Died November 3, 1943 in Paris.

*Publications: Théories* (1890-1910) 2nd. ed., Paris 1920. — *Nouvelles théories*, Paris 1922. — *Histoire de l'Art religieux*, Paris 1939. — *Sérusier, sa vie, son œuvre*, Paris 1943.

*References:* S. Barazetti, *Maurice Denis*, Paris 1945 (with extensive bibliography). — P. Jamot, *Maurice Denis*, Paris 1945. — A. Humbert, *Les Nabis et leur époque 1888-1900*, Geneva 1954.

DERAIN, ANDRÉ. Born June 10, 1880 at Chatou near Paris. 1898-99 attended Académie Carrière and made the acquaintance of Matisse and Vlaminck. 1901, influence of Van Gogh. 1901-02, worked with Vlaminck at Chatou. 1904, studied at Académie Julian. 1905, worked with Matisse and showed with the Fauves at the Salon d'Automne. 1908, influence of Cézanne and Cubism. 1910, trip to Spain where he worked with Picasso at Cadaquès. 1912, beginning of the 'Gothic' period. 1914-18, served in Army. 1919, sets for the Ballets Russes. 1920-30, protracted trips in south of France and in Italy. Died September 8, 1954.

*Publication:* See Westheim, Künstlerbekenntnisse, p. 151.

*References:* J. Leymarie, *André Derain*, Geneva 1948. — D. Sutton, *André Derain*, London 1959.

DEWASNE, JEAN. Born May 21, 1921 in Lille. Studied art, science, and music. Active also as an architect. Beginning in 1943, turn towards abstract painting. 1946, Kandinsky Prize. Since 1951, teaching at the Atelier d'Art Abstrait. Living in Paris.

*References:* P. Descargues, *Jean Dewasne*, Paris 1952. — Interview in *Art d'Aujourd'hui*, January 1953.

DICKINSON, EDWIN. Born 1891 at Seneca Falls, New York. 1910, moved to New York. Studied at Pratt Institute and Art Students' League. 1912-17, lived in Provincetown, Mass. 1917-18, served in Navy. 1919-20, travels in Italy, Spain and France. 1937-38 and 1952, travels in Europe. Since 1944 has been teaching in New York and spending summers on Cape Cod.

*Reference: New Art in America*, ed. J. H. Baur, New York 1957, pps. 214-17.

DIETRICH, ADOLF. Born November 9, 1877 at Berlingen am Untersee, Switzerland. Non-professional painter. Small peasant and artisan. Began to paint in 1905. 1909, showed some of his paintings at an exhibition in Zurich. 1922, one-man show at the Kunsthalle in Mannheim. 1938, exhibition at Museum of Modern Art, New York. 1953, exhibition at Kunstmuseum, Winterthur. Died June 1952.

*Reference:* K. Hoenn, *Adolf Dietrich*, Frauenfeld 1942.

DIX, OTTO. Born December 2, 1891 at Untermhausen near Gera (Thuringia). After apprenticeship to painter, studied in Dresden under Richard Müller. 1914-18, served in Army. 1919-21, studied at Academies of Dresden and Düsseldorf. 1921-25, painted in Düsseldorf. 1925-27, in Berlin. 1927, appointed teacher at Dresden Academy. 1933, dismissed. 1935, settled at Hemmenhofen on Lake Constance. 1945, fought in war. 1945-46 a prisoner in France. Lives at Hemmenhofen.

*Reference:* Catalogue of Otto Dix Exhibition 'Gemälde und Graphik 1912-1957', Deutsche Akad. der Künste, Berlin 1957. — O. Conzelmann, *Otto Dix*, Hanover 1959.

DOESBURG, THEO VAN (C. E. M. KÜPPER). Born August 30, 1883 in Utrecht. 1916, collaborated with the architects Wils and Oud. October 1917, with Mondrian founded the magazine *De Stijl*. 1918, contact with the European artists of similar tendencies. Propaganda trips through Italy, Belgium, and Germany. 1921, visit to the Bauhaus. Meeting with Mies van der Rohe and Le Corbusier. 1922, friendship with Schwitters. Participation in the Dada movement in Holland. Under a pseudonym edited the magazine *Mecano*. 1923, organisation of the Stijl exhibition at the Rosenberg Gallery in Paris. 1924, beginning of Elementarism. 1926-28, collaboration with Arp on alterations to l'Aubette, a restaurant in Strasbourg. 1926, Manifesto of Elementarism in *De Stijl*. 1930, publication of the magazine *Art concret*. Died March 7, 1931 at Davos.

*Publications:* Extensive activity as a publicist. — *Le mouvement nouveau dans la peinture*, Delft 1917. *Grundbegriffe der neuen gestaltenden Kunst*, Bauhausbuch, 1925.

*Reference:* H. L. C. Jaffé, *De Stijl 1917-31*, Amsterdam 1956.

DOMELA, CESAR. Born January 15, 1900 in Amsterdam. Left Holland in 1919 to become a painter. Lived in Switzerland and in Berlin. 1923, exhibited abstract paintings at the Berlin 'November Group'. 1924, Paris. Association with Doesburg. Membership of Stijl movement. 1927-33, in Berlin. Influence of Gabo. From 1928, relief-like decorative montages in various materials. From 1933, in contact with Abstraction-Création, Paris. Lives in Paris.

*References:* L. Degand, *Témoignages pour l'art abstrait*, Paris 1952. — Cat. of Exhibition at Stedelijk Museum, Amsterdam 1955. — H. L. C. Jaffé, *De Stijl 1917-31*, Amsterdam 1956.

385

DONGEN, KEES VAN. Born January 26, 1877 at Delfshaven near Rotterdam. 1897, moved to Paris. 1905, member of the Fauve movement, which gave him the ideas for his fashionable style. Lives in Paris.

*Reference:* P. Fierens, *Van Dongen*, Paris 1927.

DOVE, ARTHUR. Born 1880 at Canandaigua, N. Y. Studied at Hobart College, Geneva, N. Y. and Cornell University, Ithaca, N.Y. up to 1903. 1903-07, successful illustrator and cartoonist. 1907, met Alfred Stieglitz. 1908-10, travels in France and Italy. Towards 1910, turned to abstract art. 1912, first one-man show at '291'. 1912-18, painted and farmed at Westport, Conn. 1920-29, lived and painted on houseboat on Harlem River. From 1926, regular exhibition at Stieglitz's galleries. Died 1946 on Long Island, N.Y. 1952, Retrospective at Downtown Gallery, N. Y.

*Reference:* D. Phillips, 'Arthur Dove' in *Magazine of Art* XL, 1947, pps. 192-197.

DUBOIS-PILLET, ALBERT. Born October 28, 1845 in Paris. Member of Impressionist group and co-founder of the *Société des Indépendants*. Died in 1890 at Le Puy.

DUBUFFET, JEAN. Born 1901 in Le Havre. 1918, studied art for a few months in Paris. Interested in literature, music, and languages. 1924, temporarily gave up painting. Lived in Buenos Aires, worked as salesman. 1930, founded wholesale wine business. 1934-37, resumed painting, then went back to the wine business. Since 1942 has devoted himself exclusively to painting. 1944, first exhibition at René Drouin gallery in Paris. 1947-49, several trips to the Sahara, where he did a number of drawings and gouaches. 1955, moved to Vence. Spends his time between Vence and Paris.

*References:* J. Fitzsimmons in *Quadrum* IV, 1957, pp.27-50; G. Limbourg, *Tableau bon levain à vous de cuire la pâte. L'Art brut de Jean Dubuffet*, Paris 1953.

DUCHAMP, MARCEL. Born July 28, 1887 at Blainville near Rouen. Trained as librarian and attended Académie Julian. 1911, member of Section d'Or. 1912, *Nude descending a staircase* shown at Section d'Or. 1914, the first 'ready-mades'. 1915, visit to U.S.A., where he became the leading spirit of the group, which worked along the same lines as Dada. 1915-23, work on the monumental glass picture *The Bride Stripped Bare by her Bachelors, Even.* 1917, edited the magazines *The Blind Man* and *Wrong-Wrong.* 1920, experiments with abstract films. 1926, organised large exhibition of modern art in New York. 1934, publication of the portfolio *La Mariée mise à nu.* Rotoreliefs, 1942, organised Surrealist show in New York. Collaborated with Breton and Ernst, on the magazine *VVV* in New York. 1947, helped to organise the international Surrealist exhibition in Paris. Lives in New York.

*Publications:* Extensive publicist activity. *La Mariée mise à nu*, Paris 1934.

*References:* K. S. Dreier, *Duchamp's glass*, New York 1944. — R. Lebel, *Marcel Duchamp*, London 1959.

DUCHAMP-VILLON, RAYMOND. Born November 5, 1876 at Damville (Eure). Sculptor. Originally in the tradition of Rodin, took up Cubism in 1912. 1914, *Le petit cheval.* 1916, gassed at front. Died October 7, 1918 at military hospital in Cannes.

*Reference:* W. Pach, *Raymond Duchamp-Villon*, Paris 1924.

DUFY, RAOUL. Born June 3, 1877 in Le Havre. Studied painting first in Le Havre, and in 1900 at Ecole des Beaux-Arts in Paris. 1901, impact of Van Gogh. 1905, influence of Matisse. 1906, participation in Fauve movement. From 1907, influence of Cézanne and the Cubists. 1908, work with Braque at L'Estaque. 1909, trip to Munich with Friesz. 1911, met Poiret the couturier, who encouraged him to do textile prints. 1921, tapestries. 1922, trip to Sicily. 1925, trip to Morocco, 1937, decoration for the Palais de l'Electricité at the World Fair. 1940, moved to Perpignan. 1950, stay in Boston. 1951, return to France. 1952, moved to Forcalquier (Basses-Alpes). Grand Prize at the Biennale. Died March 23, 1953 at Forcalquier.

*References:* P. Courthion, *Raoul Dufy*, Geneva 1951. — G. Besson, *Raoul Dufy*, Paris 1953.

ECKMANN, OTTO. Born November 19, 1865 in Hamburg. Studied in Hamburg and Munich. 1894, took up decorative art. Justus Brinckmann called his attention to coloured Japanese woodcuts. From 1895, contributed to *Pan* and *Jugend.* 1897 became a teacher at the Berlin School of Applied Art. Died June 11, 1902 at Badenweiler.

*Reference:* Special number of *Deutsche Kunst und Dekoration*, April 1900.

EGGELING, VIKING. Born October 12, 1880 at Lund, Sweden. 1908, taught drawing in Switzerland. 1911, Paris. Meeting with Arp. 1915-16, Ascona. Friendship with Tzara. Member of Dada. 1919, worked with Hans Richter. The first scroll-paintings. 1920, meeting with Doesburg. 1921, move to Berlin and work on the first abstract film, *Diagonal Symphony.* 1922, first performance in Berlin. Died May 19, 1925 in Berlin.

*References:* *Art d'Aujourd'hui*, October 1953. — Catalogue of show at National Museum of Stockholm, October/November 1950.

ENDELL, AUGUST. Born April 12, 1871 in Berlin. Architect, applied art. From 1891, scientific study in Tübingen and Munich. 1896, trip to Italy and friendship with Obrist. Applied art in the circle of Obrist, F. Fischer, Riemerschmied, Pankok. 1896, Foto-Atelier Elvira in Munich. 1901, Berlin, worked as architect and for Wolzogen Theatre. 1918, appointed director of Breslau Academy. Died April 13, 1925 in Breslau.

*Publications:* 'Architektonische Erstlinge' in *Dekorative Kunst*, III, No. 8. — *Zauberland des Sichtbaren*, Berlin 1928.

ENSOR, JAMES. Born April 13, 1860 at Ostend. Early instruction in drawing. 1877-79, Brussels Academy. 1879, return to Ostend where he spent the rest of his life. 1883, joined Groupe des XX. 1886, first

engravings. 1888, *Entry of Christ into Brussels*. 1899, Special Ensor number of *La Plume*. 1930, ennobled by King of Belgium. Died November 19, 1949.

*References:* P. Colin, *James Ensor*, Leipzig 1931. — F. Fels, *James Ensor*, Geneva 1947. — A. Croquez, *L'Oeuvre gravé de James Ensor*, Geneva 1947. — L. Tannenbaum, *James Ensor*, Mus. of Mod. Art, New York 1951. — Paul Haesarts, *James Ensor*, Brussels 1957.

EPSTEIN, JACOB. Born November 10, 1880 in New York of Polish parents. Sculptor. Studied in Paris. After influence of Rodin, Cubist period. After superficial contact with Surrealism, a hard realism influenced by Donatello. Died in 1959.

*Publication: Jacob Epstein, An Autobiography*, London 1955.

*References:* B. van Diesen, *Epstein*, 1920. — Cat. of Exhibition at Tate Gallery, London 1952.

ERBSLÖH, ADOLF. Born May 27, 1881 in New York. 1888, moved to Barmen. Karlsruhe Academy. 1904, Munich Academy. Settled in Munich. 1909, cofounder of Neue Künstler-Vereinigung. 1916-20, member of 'Neue Sezession' in Munich. 1916-18, served in Army. 1926, trip to South America. Died 1947 at Irschenhausen (Upper Bavaria).

*Publication:* 'Phantasie und Form' in *Die Kunst*, April 1929.

*References: Kat. Ausstellung Kunstverein* Barmen, May 1931. *Die Kunst und das schöne Heim*, No. 54, 1950, pp. 161-163.

ERNST, MAX. Born April 2, 1891 at Brühl (Rhineland). 1898-1914, school at Brühl, then studied history of art in Bonn. Self-taught painter. 1913, showed at Deutscher Herbstsalon in Berlin and first stay in Paris. 1914-18, served in Army. 1919, formed Dada group in Cologne with Arp and Baargeld. Edited *Schammade*. From 1922, in Paris. Contributed to *Littérature;* co-founder of Surrealist movement. 1925, showed at first Surrealist exhibition in Paris. 1926, *Histoire Naturelle*. 1929, *La femme 100 Têtes*. 1930, *Rêve d'une petite fille*. 1934, *Une semaine de Bonté*. 1939-40, interned in southern France. 1941-45 New York. 1946, settled at Sedona (Arizona). 1949, *Paramyths*. 1950 and 1953, long stays in Paris. 1954, Grand Prize at Biennale. Lives at Huismes (Loire).

*Publication: Beyond Painting*, New York 1948. —

*References:* L. Pretzell, *Max Ernst*, Brühl 1951 (extensive catalogue). — P. Waldberg, *Max Ernst*, Paris 1958.

ESTÈVE, MAURICE. Born May 2, 1904 at Culan (Cher). Studied at Académie Colarossi in Paris. 1923, textile design in Barcelona. From 1931 showed at Surindépendants and from 1941 at Salon d'Automne. Abstract painting since 1945. Lives in Paris.

*Reference:* P. Francastel, *Maurice Estève*, Paris 1958.

EVERGOOD, PHILIP. Born 1901 in New York. Spent childhood and youth in England. Educated at Eton and Cambridge. 1921, studied sculpture at Slade School in London. 1923, moved to New York, stud-

ied at Art Students' League. 1924, lived in Paris and travelled through Italy and southern France. 1926, return to New York. 1927, first one-man show in New York. 1929-31, trip to France and Spain. Deeply affected by El Greco. 1931, return to New York. Turned to social themes. Active in left-wing anti-Fascist movements such as Artists' Union, American Artists' Congress, etc. Lives in New York.

*Reference: New Art in America*, ed. J. H. Baur, New York 1957, p. 113 ff.

FAUTRIER, JEAN. Born May 16, 1898 in Paris. 1908, moved to London. Attended Royal Academy of Arts and Slade School. Returned to France at outbreak of the First World War. Settled in Paris. 1928, first abstract paintings. 1945, exhibition of the 'Otages' at Gal. Drouin, Paris. 1957, exhibition at Gal. Rive Droite, Paris. 'Fautrier, 30 Années de Figuration Informelle'. 1960, Grand Prize at Venice Biennale. Lives at Chatenay-Malabry near Paris.

*References:* A. Malraux, *Les Otages*, Paris 1945. — *M. Ragon Fautrier*, Paris, Le Musée de Poche, 1957.

FEININGER, LYONEL. Born July 17, 1871 in New York of German parents. 1887 moved to Germany. Study in Hamburg and Berlin. 1892-93, Paris. 1894-1906, in Berlin where he did drawings for American and German magazines. 1906-08, Paris. 1908-19, Berlin. 1911, on visit to Paris, became acquainted with Delaunay and Cubism. 1913, showed at Blaue Reiter Exhibition at Deutscher Herbstsalon in Berlin. 1919-33, master at the Bauhaus in Weimar and Dessau. 1924, co-founder of Die Blauen Vier group. 1933-36, Berlin. From 1937, in New York. Died January 11, 1956 in New York.

*References:* D. Miller, *Lyonel Feininger*, Museum of Modern Art, New York 1944 (Bibliography). — Hans Hess, *Lyonel Feininger*, Stuttgart 1959.

FIETZ, GERHARD. Born July 25, 1910 in Breslau. 1930-32, Breslau Academy under Kanoldt and Schlemmer. 1932-33, Düsseldorf Academy with Nauen. 1937-38, studied with Kanoldt at Berlin Academy. Served in war. 1946-47, turned to abstract painting. Founder member of the Zen group. Now teaching in Berlin.

FINI, LEONOR. Born August 3, 1908 in Buenos Aires of Italian parents. Self-taught. Worked in Trieste, Milan, Monte Carlo and from 1933 in Paris, where she first showed with the Surindépendants. Represent a romantic, veristic Surrealism. Lives chiefly in Paris.

FONTANA, LUCIO. Born 1899 at Rosario de Santa Fe, Argentine, of Italian parents. 1905, moved to Milan. Studied sculpture under Wildt at Brera Academy. 1930, first exhibition of abstract sculpture at the Galleria del Milione in Milan. 1934, membership of Abstraction-Création, Paris. 1937, exhibition at Jeanne Bucher gallery, Paris. 1939-46, in Argentine. 1946, published 'Manifesto Blanco' in Buenos Aires. 1947, return to Milan. Founded Spazialismo and issued first 'Manifesto spaziale'. From 1949 regular exhibitions at Gall. del Naviglio, Milan. 1954, one-man show at Venice Biennale. Lives in Milan.

*References:* A. Pica, *Fontana e 20 Spazialismo*, Ed. del. Cavallino, Venice 1953; G. C. Argan, *Studi e note*, 1955, pp. 211-216.

FORAIN, JEAN-LOUIS. Born October 23, 1852 in Reims. Studied at Ecole des Beaux-Arts. Friendship with Monet and Degas. Active chiefly as graphic artist. Died July 11, 1931 in Paris.

*References:* M. Guérin, *Jean-Louis Forain lithographe*, Paris 1910. — M. Guérin, *Forain aquafortiste*, Paris 1912.

FOUGERON, ANDRÉ. Born October 1, 1912 in Paris. Self-taught. Started as Expressionist. Worked for many years in coal mines of northern France. Today regarded as leader of Socialist Realism in France. Lives in Paris.

*Reference:* J. A. Cartier, *André Faugeron*, Paris 1955.

FOUJITA, TSUGOUHARU. Born November 27, 1886 in Tokyo. Studied at Tokyo Academy. 1912, London. 1913, moved to Paris. 1917, first exhibition in Paris. From 1918, showed regularly at Salon d'Automne and Indépendants. Has illustrated numerous books. Lives in Paris.

*References:* Paul Morand, *Foujita*, Paris undated. — M. Vaucaire, *Foujita*, Paris undated.

FRANCIS, SAM. Born 1923 at San Mateo, California. 1941-43, studied medicine at University of California. 1943, served in U.S. Air Force. Hurt in a crash, began to paint in hospital. Studied at California School of Arts. 1948-50, studied history of art at University of California. 1950, moved to Paris. Joined the group of American painters around Riopelle. 1952, first one-man show at Galerie du Dragon in Paris. 1957-58, trip round the world; visited U.S.A., Mexico, Tokyo (where he was commissioned to paint a number of murals), Hong Kong, Siam, India, Rome. 1958, return to Paris. Triptych for the Kunsthalle in Basle. 1958, New York and Paris. 1959, trip around the world, visited India and Japan. Spends his time between New York and Paris.

*References:* Catalogue of exhibition at Berne Kunsthalle, 1960; H. Read in *Quadrum* I, May 1956, pp. 7-22; K. Kuh in *Art in America*, Vol. 44, 1956, No 1, p. 10 ff.

FRESNAYE, ROGER DE LA. Born July 11, 1885 at Le Mans. 1903-08, studied at Académies Julian and Ranson. Influence of Denis. 1911, friendship with Villon and Gleizes. Joined Section d'Or. 1912-13, influence of Braque and Picasso. 1914-17, served in Army. After the war gave up Cubism for a realistic traditionalism. Died November 27, 1925 at Grasse.

*References:* W. George, *Roger de la Fresnaye, Dessins et gouaches*, Paris 1928. — R. Cogniat and W. George, *Oeuvre complet*, Paris 1950.

FRIESZ, OTHON. Born February 6, 1879 in Le Havre. Early friendship with Dufy with whom he studied painting in Le Havre. 1897, moved to Paris and studied at Beaux-Arts, Atelier Bonnat, and later at Atelier Moreau, where he met Matisse. 1904, showed at Salon d'Automne with the group around Matisse and in 1905 contributed to the famous exhibition of the 'Fauves'. 1906, stay at La Ciotat with Braque. 1909, trip to Munich and Italy. 1911, trip to Portugal. 1913, exhibition at Cassirer Gallery in Berlin. 1935, tapestry designs. 1937, collaborated with Dufy in decorating Palais de Chaillot. 1938, trip to U.S.A. Died January 10, 1949, in Paris.

*Reference:* M. Gauthier, *Othon Friesz*, Geneva 1957.

FRY, ROGER. Born December 14, 1866 in London. Father a judge. 1885-88, studied science at King's College, Cambridge. 1891, studied art in Italy. 1892, Paris, Académie Julian. 1893, studied under W. R. Sickert. 1893-1908, member of the New English Art Club. 1901, art critic for *The Athenaeum*. 1905-10, director of the Metropolitan Museum of Art in New York. 1910-19, editor of *The Burlington Magazine*. 1910 and 1912, organised the first and second Post-Impressionist Exhibitions. 1913-19, founded and directed Omega Workshops. 1918, joined the London Group. 1933, professor at Cambridge University. Died September 9, 1934, in London.

*Publications:* Extensive literary and editorial activity. — *Transformations*. Critical and speculative essays on art, London, New York 1926. — *Vision and Design*, London 1920. — *Last Lectures*, 1939.

*Reference:* Virginia Woolf, *Roger Fry*, London 1940.

FUHR, XAVER. Born September 23, 1898 at Neckarau near Mannheim. Self-taught. 1930, short stay in Florence. 1943-50, at Nabburg (Upper Palatinate). From 1946, teacher at Munich Academy. Lives in Regensburg.

*References:* F. Roh, *Xaver Fuhr*, Munich 1946. — C. Linfert, *Xaver Fuhr*, Potsdam 1949.

FUNI, ACHILLE. Born February 28, 1890 in Ferrara. After long association with Futurism, c. 1920, shift to Derain and the Neo-Classicism of the Paris school. Member of Novecento. Lives in Milan.

*Reference:* Giorgio de Chirico, *Achille Funi*, Milan 1940 (bibliography).

GABO, NAUM (NAHUM PEVSNER). Born August 5, 1890 at Briansk, Russia. 1909, studied engineering at Technische Hochschule in Munich. 1912, meeting with Kandinsky. 1913-14, visited his brother Antoine Pevsner in Paris. Meeting with Archipenko. 1914, continued his studies in Oslo, where he did his first plastic work in a geometrical Cubist style. 1917, moved to Russia. Association with Kandinsky, Malevich, Tatlin. 1921, return to Germany. Up to 1933, lived in Berlin with frequent trips to Paris. 1932, collaboration with Abstraction-Création. 1933, moved to London and in 1946 to the U.S.A. Lives in Connecticut.

*Publications:* 'Realist Manifesto' of 1920. Excerpts in *Kat. Ausstellung Kestner-Gesellschaft, Hanover*, November, 1930. — In collaboration with B. Nicholson: *Circle. International Survey of Constructive Art*, 1937. — See also *Témoignages pour l'art abstrait*, Paris, 1952 and H. Read, *The philosophy of modern art*, London 1952, p. 238.

*References:* H. Read, *Naum Gabo and Antoine Pevsner*, Museum of Modern Art, New York 1948.

— Herbert Read and Leslie Martin, *Naum Gabo*, London 1957.

GAUGUIN, PAUL. Born June 7, 1848, in Paris. Started out as a sailor and merchant. Began to paint in 1874. Friendship with Pissarro. Showed with Impressionists. 1883, gave up his business activities. Worked at Osny with Pissarro. 1884, trip to Denmark with his family. 1885, divorce and return to Paris. 1886, first stay at Pont-Aven. Meeting with Van Gogh. 1887, journey to Martinique. Summer 1888, stay in Pont-Aven. Meeting with Bernard. Late autumn, visited Van Gogh at Arles. 1889, exhibition at Café Volpini. 1889-90, stay at Pont-Aven and Le Pouldu. End of 1890, return to Paris. 1891, departure for Tahiti. Autumn 1893, return to France. Summer 1895, Tahiti. 1900 moved to the Marquesas Islands. Died May 8, 1903 at Hiva-hoa.

*Publications: Noa-Noa*, 1891-93, Paris 1924. — *L'ancien culte Mahorie*, Paris 1951. — *Avant et Après*, Paris 1923. — Letters to: de Monfreid (1919, 1930), Fontainas (1921), Bernard (1926, 1942), Vollard (1943), his family (1946).

*References:* J. de Routonchamp, *Paul Gauguin*, Paris 1925, (basic). — M. Guérin, *L'œuvre gravé de Paul Gauguin*, Paris 1927 (2 vols). — C. Morice, *Paul Gauguin*, Paris 1919. — E. Bernard, *Paul Gauguin*, Lorient 1941. — J. Rewald, *Gauguin's Drawings*, New York, London 1958.

GEIGER, RUPPRECHT. Born June 26, 1908 in Munich. Studied architecture in Munich and practised architecture. Painted since the war. Member of Zen group. Lives in Munich.

GIACOMETTI, ALBERTO. Born 1901 at Stampa, Switzerland. Sculptor. 1919-20, School of Applied Art in Geneva. 1920-22, in Italy. 1922-25, Paris Academy and study with Bourdelle. 1930, joined Surrealist movement. Also paints. Lives in Paris.

*References:* Important exhibition catalogue, Pierre Matisse Gallery, New York, February 1948. — *Alberto Giacometti, Schriften Fotos Zeichnungen* (text also in French), ed. Ernst Scheidegger, Zurich 1958. J. P. Sartre, Les Peintures de Giacometti (lettre à Matisse de Novembre 1950 in *Derrière le Miroir* (Cat. Gal. Maeght) No. 65, Paris, May 1954. — Jean Genet, *L'Atelier d'Alberto Giacometti*, Décines (Isère) 1958.

GILLES, WERNER. Born August 29, 1894 at Rheydt. 1914, Kassel Academy. Served in army during war. 1918-24, Weimar School of Applied Art and Bauhaus. Student of Klemm and Feininger. Study in France (2 years) and in Italy (10 years). 1930, Prix de Rome. 1933-1936, Berlin. Up to 1941, with interruptions, southern Italy. 1941, Berlin until drafted. After war at Schwarzenbach (Saale). Now lives alternately in Munich and on Ischia.

*Reference: Kat. Ausstlg. Kestner-Ges.* Hanover 1949.

GILMAN, HAROLD. Born February 11, 1876. Son of a clergyman. 1896, attended Hastings Art School. 1897, Slade School and friendship with Spencer Gore. 1904-05, travels to Spain and the U.S.A. 1906, friendship with W. R. Sickert. 1910, trip to Paris. 1911, founder member of the Camden Town Group. 1912, stay in Sweden and Norway. 1913, president of London Group. 1915, taught at Westminster School of Art. Died February 12, 1919, in London.

*References: Harold Gilman, An appreciation* by W. Lewis and L. F. Ferguson, London 1919. — J. Wood Palmer, 'Harold Gilman', Arts Council Exh. Catal. 1954.

GINNER, CHARLES. Born March 4, 1878 in Cannes. Son of an English physician. 1899, studied architecture in Paris. 1904-08, studied painting at Ecole des Beaux-Arts. Influence of Van Gogh. 1909, trip to Buenos Aires. 1911, founder member of Camden Town Group. 1913, founder member of the London Group. 1916-18, took part in the war. 1920, member of the New English Art Club. 1942, Associate of the Royal Academy. 1939-45, Official War Artist. Died January 6, 1952 in London. 1953, memorial exhibition at Tate Gallery.

*Publication:* 'Neo-Realism' in Catalogue of Ginner-Gilman; Exhibition, Goupil Gallery, London 1914.

*References:* 'Charles Ginner, The Camden Town Group', in *The Studio*, November 1945. — H. Wellington, 'Charles Ginner', Arts Council Exh. Catal. 1953.

GIMMI, WILHELM. Born August 7, 1886 in Zurich. 1908-40, Paris. 1911, trip to Rome. Studied at Académic Julian. 1919, first show at Gal. Berthe Weill. 1940, return to Switzerland. Lives at Chexbres.

*References:* N. Jacomelli, *Wilhelm Gimmi*, Geneva 1943. *Catalogue de l'œuvre lithographié*, Aigle 1956.

GIRIEUD, PIERRE. Born 1874 in Marseilles. Studied under Sérusier. Deeply influenced by Siennese painting. Member of Neue Künstler-Vereinigung in Munich. One-man shows in Munich, 1911 and 1913. Lives in Paris.

*Reference:* Edouard-Joseph, *Dict. biogr. des artistes contemporains*, II, Paris 1931.

GISCHIA, LÉON. Born 1903 in Landes. 1923 studied painting under Friesz and then Léger. Travels in Spain and Italy. 1927-30, in the U.S.A., Since 1937 represented at all important exhibitions. Numerous stage-sets and illustrations.

GLACKENS, WILLIAM. Born March 13, 1870 in Philadelphia. Studied in Philadelphia. Started out as a cartoonist. Belonged to Henri's circle, which later developed into the Ash Can School. 1896, moved to New York. 1906, trip to Paris and Spain. Member of National Academy of Design. 1913, co-organiser of Armory Show. For a time, president of the Society of Independent Artists. Died 1938.

*Reference:* Catalogue of William Glackens Memorial Exhibition, Whitney Museum of American Art, New York 1938.

GLARNER, FRITZ. Born July 20, 1899 in Zurich. 1905, moved to Naples where from 1914 to 1920 he studied at R. Istituto delle Belle Arti. 1909-13, Paris and Chartres. 1923-35, Paris. 1935-36, Zurich. 1936, emigrated to U.S.A. Since then has been living in New York.

GLEIZES, ALBERT. Born December 8, 1881 in Paris. 1910, influence of Cubism. 1911, met Picasso. 1912, founder member of Section d'Or. With Metzinger published *Du Cubisme*. 1913, showed at Deutscher Herbstsalon in Berlin. 1915, went to New York. 1919, return to Paris. 1937, murals. 1939, moved to Saint-Rémy (Provence). 1941, return to Catholicism. 1950, showed at Sacred Art exhibition in Vatican. Died June 24, 1953.

*Publications: Du Cubisme*, Paris 1912. — 1920; contributed to Barbusse's magazine *Clarté*. — *Vers une conscience plastique*, Paris 1932.

*References:* Schoener, *Albert Gleizes*, Cincinnati Art Museum 1956. — J. Golding, *Cubism*, London 1959.

GOETZ, KARL OTTO. Born February 22, 1914 in Aix-la-Chapelle. 1931-34, School of Applied Art in Aix-la-Chapelle. 1935-36, Switzerland and Italy. 1936-38, military service. 1938-39, Dresden Academy. 1939-45 served in War. Since 1948 has been editing the magazine *Meta*. Since 1950 has been living in Frankfurt and Paris.

GOGH, VINCENT VAN. Born March 30, 1853 at Groot-Zundert, Holland. Art dealer in Brussels, London, Paris. After unsuccessful theological studies, lay preacher in Belgian coal mining district. Began to paint and draw in 1880. 1880-81, private instruction in perspective and anatomy in Brussels. 1882-83, The Hague, first attempts at oil painting. From December 1883, lived with parents at Nuenen. November 1885, left for Antwerp where he studied at Academy. February 1886, moved to Paris. Studied at Atelier Cormon. Meeting with Toulouse-Lautrec, influence of Impressionists. Met Seurat, Signac, Gauguin. 1887, friendship with Bernard. February 1888, went to Arles. In October visit from Gauguin. December 23, first breakdown. February 1889, again taken to sanatorium. March, visit from Signac. May, sanatorium at Saint-Rémy. May 1890, trip to Paris and move to Clinique du Dr. Gachet at Auvers. Shot himself July 27. Died July 29, 1890 at Auvers.

*Publication: Verzamelde brieven van Vincent van Gogh*, ed. J. van Gogh-Bouger, Amsterdam-Antwerp 1952-54.

*References:* J. B. de la Faille, *L'Oeuvre de Vincent van Gogh*, Catalogue raisonné, 4 vols. Paris-Brussels 1928. — J. Meier-Graefe, *Vincent van Gogh*, Munich 1910. — C. Nordenfalk, *The Life and Work of Van Gogh*, London 1953.

GONCHAROVA, NATALYA. Born June 2, 1881 in Moscow. 1898, studied sculpture at Moscow Academy. 1904, turned to painting. 1910, collaborated with her husband Larionov in foundation of Rayonism. 1912-13, sets for theatre and ballet. 1914, moved to Paris. Sets for Diaghilev's ballets. Lives in Paris.

*References:* Seuphor, *L'Art abstrait*, Paris 1949. — *Burlington Magazine* 97 (1955), p. 170.

GORE, SPENCER F. Born May 26, 1878 at Epsom. 1896-99, attended Slade School. 1904-06, Dieppe and Paris. 1906, attended Gauguin exhibition. 1905, became acquainted with Sickert. 1909, member of New English Art Club. 1911, founder member and president of Camden Town Group. Died March 26, 1914 in Richmond.

*Reference:* J. Wood Palmer, 'Spencer Gore' in Arts Council Exh. Cat. 1955.

GORKY, ARSHILE (Pseudonym for Vosdanig Adoian). Took the name of Gorky at the age of 16 on his arrival in the U.S.A. Born in 1905 at Khorkom Vari in Turkish Armenia. 1909, moved to Aykestan. Fled from Turkish persecution to Russian Trans-Caucasia. Lived in Erivan, the capital of Soviet Armenia, working as a bookbinder and printer. Began to study art. 1920, emigrated to the U.S.A., where he lived in Watertown, Mass. at the house of an older sister. Studied art at Rhode Island School of Design, and in 1923 in Boston. 1925, moved to New York and studied at Grand Central School of Art, where he taught from 1926 to 1930. From 1935 worked on WPA Federal Art Project. During the war, friendship with Breton, Tanguy, Matta and the younger abstract painters of the New York School. 1945, one-man show at the Levy Gallery in New York; Breton wrote the introduction to the catalogue. 1946, operated on for cancer. June 26, 1948, broke his neck in car accident. Committed suicide on July 21, 1948.

*Reference:* E. K. Schwabacher, *Arshile Gorky*, Whitney Museum, New York 1957.

GOTTLIEB, ADOLPH. Born 1903 in New York. Studied at Art Students' League. 1921-22, Paris, Berlin, and Munich. 1935, founded 'The Ten' group in New York. 1937-39, lived in Arizona. 1939, return to New York. Commissions for murals and stained-glass windows. 1940, beginning of the 'Pictographs'. 1945, first one-man show at the Nierendorf Gallery. Since 1947, regular one-man shows at the Kootz Gallery. Since 1955 has been teaching at the Pratt Institute. Lives in New York.

*Publications:* See *The Tiger's Eye*, December 1947 and June 1949.

*Reference:* W. Rubin in *Art International* III, 1959, p. 44 ff.

GRANDMA MOSES (ANNA MARIE ROBERTSON). Born 1860 near Greenwich, U.S.A. 1878, married a farmer at Staunton, Virginia. Began to paint at the age of 77. Was discovered in 1939 and made famous by the 'Unknown American Painters' exhibition.

*Reference:* Sidney Janis, *They Taught Themselves*, New York 1942.

GRANT, DUNCAN J. C. Born January 21, 1885 at Rothiemurchus, Inverness-shire. Son of an army officer. 1885-93, in India. 1894, return to London. 1902, attended Westminster School of Art. 1902-03, travels in Italy. 1906, Paris, studied with J. E. Blanche. 1907, Slade School. Regular trips to France. Met Matisse. 1910, trip to Greece and Constantinople. 1911, trip to Tunisia and Sicily. Member of Camden Town Group. 1913-19, connected with Fry's Omega Workshops. 1915, showed at Vorticist Exhibition. 1919, member of London Group. 1926, 1932, and 1940, represented at Biennale. Since 1927 regular visits to France. 1959, Retrospective at Tate Gallery.

*References:* Raymond Mortimer, *Duncan Grant*, Penguin Books, Harmondsworth 1948. — Alan Clutton-Brock, Tate Gallery Exh. Catalogue, 1959.

GRAVES, MORRIS. Born August 28, 1910 at Fox Valley, Oregon. Grew up in Seattle. 1929-31, worked on a freighter, visited the Orient and spent a part of 1931 in Japan. 1931, moved to Los Angeles, then in 1934 back to Seattle where he began to paint. 1936, first one-man show at Seattle Art Museum. WPA Art Project. Spent the autumn of 1939 in New York and Puerto Rico. Friendship with Mark Tobey. 1940, return to Seattle. 1941, beginning of the 'Inner Eye' Series. 1942, represented in an exhibition at the Museum of Modern Art that made him known. 1945, took up Zen-Buddhism. 1946-47, Guggenheim Fellowship, and protracted stay in Honolulu. 1948-49, trip to Europe, stay in Chartres. 1950, stay in Mexico. In the autumn of 1954 took a trip to Japan and then to Ireland where he remained until 1956. Lives in Seattle.

*Reference:* F. Wight, J. T. H. Baur, D. Phillips, *Morris Graves*, University of California Press, Berkely 1956.

GREAVES, DERRICK. Born June 5, 1927 in Sheffield. Father a metal worker. 1948-52, studied at Royal College of Art in London. 1952-53, lived in Italy. 1953, first show at Beaux Arts Gallery in London. 1956, represented at Venice Biennale. Teaches at St. Martin's School of Art in London.

GRIS, JUAN (JOSE VICTORIANO GONZALEZ). Born March 23, 1887 in Madrid. 1902 attended School of Applied Art in Madrid. Jugendstil influence. Drawings for magazines. 1906, moved to Paris. Friendship with Picasso. 1910, began to paint, under Cubist influence. 1912, first showed at Indépendants and Section d'Or. 1913, stay at Céret with Picasso. 1914, summer at Collioure. 1920, showed at last Cubist exhibition at Indépendants. 1922-23 ballet sets for Diaghilev. Died May 11, 1927.

*Publications: Sur la possibilité de la peinture.* Lecture at Sorbonne 1924 (see Kahnweiler). — *Letters of Juan Gris*, ed. D. H. Kahnweiler, London 1956.

*References:* D. H. Kahnweiler, *Juan Gris*, Paris 1946, New York 1947, London (basic). — J. T. Soby, *Juan Gris*, Mus. Modern Art, New York 1958.

GROMAIRE, MARCEL. Born July 24, 1892 at Noyelles-sur-Sambre (Nord). Self-taught. Before the war influenced by Matisse and Cézanne. 1914, called to Army, 1916, wounded. After the war, under the influence of Léger, found his way to an expressive style based on large forms. 1937, decoration of Sèvres pavilion at World Fair. Designs for Gobelins. 1939, worked with Lurçat in Aubusson factory, developing modern art of tapestry. 1952, won Carnegie Award. Lives in Paris.

*Publication:* De l'abstrait au concret, in '*Beaux Arts*', June 29, 1934, p. 8.

*Reference:* G. Besson, *Marcel Gromaire*, Paris undated.

GROPIUS, WALTER. Born May 18, 1883 in Berlin. Architect. 1903-07, study in Berlin and Munich. 1907-10, assistant to Peter Behrens in Berlin. 1911-12 built Fagus-Werke at Alfeld. 1914, office building and factory at Werkbund Exhibition in Cologne. 1914-18 served in Army. 1918, director of the State Art School in Weimar; co-founder of the Bauhaus. 1919-28 director of the Bauhaus. 1927, Weissenhof housing development in Stuttgart. 1925-27, Dessau-Toerten housing development. 1928, Berlin. 1934, emigrated to England. 1937, appointment at Harvard University. 1937-40, co-operation with Marcel Breuer in Cambridge.

*Publications:* Extensive publicist activity, bibliography in Argan. — S. Giedion, *Walter Gropius, Mensch und Werk*, Frankfurt 1954.

*Reference:* G. C. Argan, *Walter Gropius e la Bauhaus*, Rome 1951.

GROSZ, GEORGE. Born July 26, 1893 in Berlin. Studied in Dresden and Berlin. Began as caricaturist for satirical magazines. Towards end of First World War association with Dadaists. c. 1925, brief connection with Neue Sachlichkeit. 1932, trip to America, where he settled in 1933. Returned in 1959 to Germany where he died on July 6, 1959.

*Publications: Die Kunst in Gefahr*, Berlin 1925. — Brief autobiography in *Spiesserspiegel*, Dresden 1932. — *Ein kleines Ja und ein grosses Nein*, Hamburg 1955.

*References:* W. Wolfradt, *George Grosz*, Leipzig 1921. — J. I. H. Baur, *George Grosz*, New York 1954.

GRUBER, FRANÇOIS. Born March 15, 1912 in Nancy. Studied in Paris under Friesz, Dufresne, and Waroquier. Influence of Bissière and Braque. Died December 1, 1948.

*Reference: Le Point*, December 1947 (Mulhouse). — Catal. of Show at Tate Gallery, London 1959.

GUGLIELMI, LOUIS. Born in 1906 in Cairo, Egypt, of Italian parents. 1914, moved to U.S.A. Studied at National Academy of Design. 1932, began to paint in earnest. Influence of Verist Surrealism. 1943, represented at 'American Realists and Magic Realists' exhibition at Museum of Modern Art, New York.

*Reference:* D. Miller, A. Barr, *American Realists and Magic Realists*, The Museum of Modern Art, New York, 1943.

GUILLAUMIN, ARMAND. Born February 16, 1841 in Paris. Self-taught. Friend of Pissarro and one of the earliest members of the Impressionist group. 1874, showed at first Impressionist exhibition. Only in 1892 able to devote himself wholly to painting. 1894, first one-man show at Durand-Ruel gallery. Died June 26, 1927 in Paris.

*Reference:* T. Duret, *Histoire des Peintres Impressionistes*, Paris 1906.

GUSTON, PHILIP. Born 1912 in Montreal, Canada. 1916, moved to Los Angeles. Brief art study in Los Angeles. 1934-35, Mexico. From 1935, WPA Art Project. 1941-45, taught at University of Iowa and at Washington University in St. Louis, Mo. 1947-49, received Guggenheim Fellowship, travelled in Italy, Spain and France. Since 1950 has been teaching at New York University. Lives in New York.

*Reference: The New American Painting,* Museum of Modern Art, New York 1959, p. 40.

GUTTUSO, RENATO. Born January 2, 1912 in Palermo. Studied law. Turned to painting in 1931. 1946, founder member of Fronte nuovo delle arti. Chief representative of Socialist Realism in Italy. Lives in Rome.

*References: Renato Guttuso, Gott mit uns.* Rome 1945. — Giuseppe Marchiori, *Renato Guttuso,* Milan 1952.

HARTIGAN, GRACE. Born 1922 in Newark, N. J. Lived in California from 1941 to 1942. 1942-47, worked as mechanical draughtsman and studied painting in Newark. 1945, moved to New York. 1948-49, Mexico. Lives in New York.

*Reference: The New American Painting.* The Museum of Modern Art, New York 1959.

HARTLEY, MARSDEN. Born 1877 in Lewiston, Maine. 1892, studied at Cleveland School of Art. 1898, moved to New York where he studied at Chase School and National Academy of Design. 1901-08, summers in Maine. 1909, first one-man show at '291'. For many years a member of Stieglitz circle. 1912-13, Paris and Germany. Meeting with Kandinsky and Marc at Sindelsdorf (Bavaria), showed at Blaue Reiter Exhibition and 'Erste deutsche Herbstsalon' in Berlin. Turned to abstract painting. 1913, return to U.S.A. and exhibited at Armory Show. 1914-16, trip to London, Paris, Berlin and Munich. 1916, return to the U.S.A. 1919, abandoned abstract painting for a figurative Expressionism. 1921-36, long stays in France, Italy, Germany, and New Mexico. Up to the time of this death spent summers in Maine, winters in New York. Died in 1943 at Ellsworth, Maine.

*Publications: Adventures in the Arts,* New York 1921; *Androscoggin,* Portland 1940; *Sea Burial,* Portland 1941; *Selected Poems,* New York 1945.

*References:* E. McCausland, *Marsden Hartley,* University of Minnesota Press, Minneapolis 1952; Catalogue of 'Lyonel Feininger - Marsden Hartley' exhibition, Museum of Modern Art, New York 1944.

HARTUNG, HANS. Born September 21, 1904 in Leipzig. Began to paint abtractly in 1922. 1924-28, attended Academies of Leipzig, Dresden, Munich. 1925, became acquainted with Kandinsky's work. Numerous visits to Paris. 1933-34, Minorca. 1935, return to Berlin and flight to Paris. During war served in Foreign Legion and was severely wounded. 1945, naturalised Frenchman. Lives in Paris.

*References:* Domnick, *Hans Hartung,* Stuttgart, undated. — R. Gindertael, *Hans Hartung* (in preparation).

HECKEL, ERICH. Born July 31, 1883 at Döbeln (Saxony). Self-taught. 1904, studied architecture at Technische Hochschule, Dresden. Meeting with Kirchner. 1905, co-founder of Brücke. 1907-10, Dresden and Dangast (Oldenburg). 1909, trip to Rome. 1911, moved to Berlin. 1915-18 medical corps in Flanders. Meeting with Ensor and Beckmann. From November 1918, in Berlin. Travels in Germany, Italy, and France. From 1944, Lake Constance. 1949, appointment at Karlsruhe Academy. Lives at Hemmenhofen am Untersee.

*References:* H. Köhn, *Erich Heckel,* Berlin 1948. — P. O. Rave, *Erich Heckel,* Berlin 1948. — Graphic work: *Erich Heckel, Graphik der Gegenwart,* Vol. 1, Berlin 1931. — Sculpture: M. Sauerlandt in *Museum der Gegenwart,* Berlin 1930.

HELDT, WERNER. Born November 17, 1904 in Berlin. Study at Berlin Academy. 1930, Paris. 1933-36, Majorca. 1936-40, Berlin. Fought in War. Since end of War in Berlin. Died October 3, 1955 at Sant'Angelo, Ischia.

*References:* Gert. H. Theunissen: *Werner Heldt Zeichnungen,* Berlin 1948. — *Kat. Kestner Ges.,* Hanover 1957.

HELION, JEAN. Born April 21, 1904 at Couterne in Normandy. Started out as engineer and architect. From 1926, associated with Mondrian and 1930, collaboration with Doesburg. 1931, joined Abstraction-Création. 1937-39, in U.S.A. Lives in Paris.

*Reference: Cahiers d'Art* (1949) 24; p. 281; — 25 (1950), p. 171.

HENRI, ROBERT. Born June 24, 1865 in Cincinnati, Ohio. 1886-88, studied at Academy of Art in Philadelphia. 1889-90, attended Académie Julian and Ecole des Beaux-Arts in Paris. 1891, returned to Philadelphia. Friendship with Luks, Glackens, Sloan, and Shinn, the future members of the Ash Can Group. 1895-99, lived in Europe. 1899, moved to New York. 1903-07, taught at Chase School. 1907, founded his own art school. From 1912, taught at Art Students' League and Ferrer School. 1926, contributed to *The New Masses.* Died in 1929 in New York.

*Publications:* See *Craftsman* XV, January 1909, pp. 386-401; XVIII, May 1910, pp. 160-172; XXVII, February 1915, pp. 459-469; *The Art Spirit,* Compiled by M. Ryerson, Philadelphia - London, 1923.

*Reference:* W. F. Paris, 'Robert Henri, Pioneer of Modernism in American Art', *The Hall of American Artists* IV, New York University 1949.

HERBIN, AUGUSTE. Born April 29, 1882 at Quiery near Cambrai. 1900-01, Art School in Lille. 1903, moved to Paris and came under influence of Impressionists. From 1910, influence of Cubists. 1922-25, representational painting; since 1926, abstract. Connection with Abstraction-Création. Lives in Paris.

*Publication: L'Art non figuratif non objectif,* Paris 1949.

*Reference:* Massat, *Auguste Herbin,* Paris 1953.

HERON, PATRICK. Born January 20, 1920 at Headingley, Leeds. Father an industrialist. Grew up at St. Ives. 1937-39, Slade School of Art. Since 1947, regular exhibitor in London. Cubist influence. Since 1947 has been active as a critic and writer on art. Abstract painting since 1956.

*Publications:* Extensive literary activity. *The Changing Forms of Art,* London 1955; *Braque,* Faber Gallery, London 1956.

HILTON, ROGER. Born March 23, 1911 at Northwood, Middlesex. Father a physician. 1929-31, attended Slade School. 1931-39, frequent stays in Paris. Studied under Bissière at Académie Ranson. 1939-42, served in War. 1942-45, a prisoner of war. Since 1946, frequent stays in Paris. Since 1950 has exhibited regularly in London. Has been teaching at the Central School of Arts and Crafts in London since 1950.

*Publication:* 'Statement' in L. Alloway, *Nine Abstract Artists*, London 1954.

HIRSHFIELD, MAURICE. Born 1872 in Poland. 1890, came to the U.S.A. Worked in a garment factory and became an independent manufacturer, first of clothing, then of slippers. Began to paint in 1937. Died in 1946.

*Reference:* Sidney Janis, *They Taught Themselves*, New York 1942, Chap. 2 (autobiography on pp. 17-18).

HITCHENS, IVON. Born March 3, 1893 in London. Father a painter. Studied at Royal Academy Schools. 1925, first exhibition in London. 1934, member of Objective Abstraction Group. Moved to Sussex during the war. From 1931, member of London Group. 1956, showed at Venice Biennale.

*Reference:* P. Heron, *Ivon Hitchens*, London 1955.

HODLER, FERDINAND. Born March 14, 1853 in Berne. 1867, apprenticed to a landscape painter at Thun. 1871, Geneva, studied with Menn, a landscape painter. Autumn 1878, trip to Madrid. 1889, showed at World Fair. 1890-91, *Die Nacht*. 1891, trip to Paris, joined Rose-Croix Esthétique. 1892, showed at Salon de la Rose-Croix, Durand-Ruel gallery. 1894, six weeks in Antwerp. 1896, beginning of *Battle of Marignano* in Landesmuseum, Zurich. 1904, exhibition at Wiener Sezession. 1905, trip to Italy. 1907, commission for *The Students March Off*, in University of Jena. 1910, *Oath of Reformation* commissioned by city of Hanover for City Hall. Died May 20, 1918.

*Reference:* W. Hugelshofer, *Ferdinand Hodler*, Zurich 1952.

HOELZEL, ADOLF. Born May 13, 1853 in Olmütz. Studied in Vienna and Munich. 1882, trip to Paris with Langhammer. 1888, moved to Dachau. Beginning in 1893, directed school of painting at Dachau. 1904, first article on elements of artistic expression in *Die Kunst für Alle*. 1906, post at Stuttgart Academy. 1917-18 compositions on the theme: 'Coloured Sounds'. 1923, beginning of pastel series. Died October 17, 1934 in Stuttgart.

*Publications: Gedanken und Lehren*, Stuttgart 1933. — 'Aufzeichnungen zusammengestellt von W. Hess' in *Kat. der Gedächtnisausstellung* 1953.

*References:* H. Hildebrandt, *Adolf Hoelzel als Zeichner*, Stuttgart 1913. — *Kat. der Gedächtnisausstellung*, Introduction by H. Hildebrandt, Stuttgart 1953.

HOFER, CARL. Born October 11, 1878 in Karlsruhe. Studied in Karlsruhe. 1900, long stay in Paris. 1900-02 studied with Hans Thoma. 1902, Stuttgart Academy. 1903-08, Rome. 1908-13, Paris. 1909-1911, travels in India. 1913, moved to Berlin. 1914, first large one-man show at Cassirer gallery in Berlin. 1914-17, interned in France. 1917, exchanged and sent to Zurich. 1918, return to Berlin. Appointed teacher to Berlin Academy. 1925, the first Ticino landscapes. 1930-31 abstract period. 1932, return to old style. 1933, dismissed as 'degenerate'. March 1943, studio destroyed by bombs. 1945, appointed director of Hochschule für bildende Künste in Berlin. Died April 3, 1955 in Berlin.

*Publications: Aus Leben und Kunst*, Berlin 1952 (Autobiography). — *Erinnerungen eines Malers*, Berlin 1953. — *Über das Gesetzliche in der bildenden Kunst*, Berlin 1956.

*References:* A. Jannasch, *Carl Hofer*, Potsdam 1948. — *Festgabe an Carl Hofer zum 70. Geburtstag*, Berlin 1948.

HOFMANN, HANS. Born March 21, 1880 at Weissenberg (Bavaria). From 1898, studied art in Munich. Lived in Paris from 1904 to 1914. 1915, opened a school of painting in Munich. Numerous trips to France and Italy. 1930 and 1931, gave summer courses in Berkeley and Los Angeles. 1932-33, taught at Art Students' League in New York. 1934, founded a summer art school at Provincetown, Mass. 1941, acquired American citizenship. In close contact with the young abstract painters of the New York School. 1944, first exhibition in New York at 'Art of this Century' (Peggy Guggenheim) gallery. Lives and teaches in New York and Provincetown.

*Reference:* F. S. Wight, *Hans Hofmann*, University of California Press, Berkeley 1957, includes bibliography of Hofmann's extensive writings.

HOPPER, EDWARD. Born 1882 at Nyack, N.Y. 1900-06, studied under Henri at New York School of Art. 1906-10, three trips to Europe, which however had little influence on his art. 1908-19, designer in an advertising agency and illustrator. 1920, first one-man show at Whitney Studio Club. 1933, retrospective at Museum of Modern Art, New York. Spends winters in New York, summers in New England.

*Publication:* see *Reality*, Spring 1953, p. 8.

*Reference:* L. Goodrich, *Edward Hopper*, The Penguin Modern Painters, 1950.

ITTEN, JOHANNES. Born November 11, 1888 at Südern-Linden (Thun). 1913-14, studied with Hoelzel in Stuttgart. 1915, geometrical Constructivism. 1919-23, taught at Bauhaus. From 1923, directed art school of his own in Berlin. Now directs the School of Applied Art in Zurich.

*Reference:* Cat. of one-man show at Stedelijk Museum, Amsterdam 1957.

JANCO, MARCEL. Born 1895 in Bucharest. Originally an architect. Came to painting through interest in Cubism and Futurism. Member of the first Dada group in Zurich, where he decorated the Cabaret Voltaire. After the war returned to Bucharest where he was active as an architect. Lives in Tel Aviv.

*Reference:* R. Motherwell ed., *Dada, The Dadaist Painters and Poets*, New York 1951.

JAWLENSKY, ALEXEJ VON. Born March 26, 1864 at Kuslovo. Cadet School in Moscow. 1889, St. Petersburg Academy. 1896, moved to Munich and studied at Anton Azbe's art school, where Kandinsky soon became a student. From 1902, worked independently. 1905, visits to Brittany and Provence. Influence of Cézanne, Van Gogh, Matisse. 1909, joined Neue Künstler-Vereinigung in Munich. 1914, moved to Switzerland. 1917, beginning of 'mystical faces'. 1921, moved to Wiesbaden. 1924, joined Die Blauen Vier group. 1929, contracted arthritis deformans. From 1934, the 'Little Abstract Heads'. Died March 15, 1941.

*Reference:* C. Weiler, *Jawlensky*, Cologne 1959.

JEANNERET, CHARLES-EDOUARD. See Le Corbusier.

JOHN, AUGUSTUS E. Born January 4, 1878 at Tenby, Wales. Father a lawyer. 1894-98, attended Slade School. 1900, first stay in Paris. 1903, member of New English Art Club. 1911-14, painted in Ireland and Wales. 1921, Associate of Royal Academy. 1928, Member of Royal Academy. 1940, Retrospective at Tate Gallery; 1954, Retrospective at Royal Academy.

*Publication: Chiaroscuro, Fragments of Autobiography*, London 1952.

*Reference:* John Rothenstein, *Augustus John*, London New York 1944.

JORN, ASGER. Born 1914 at Vejrun, Denmark. 1936, moved to Paris where he worked under Léger and Le Corbusier. 1949, co-founder of Cobra group. Long visit to Italy and Tunisia. 1951, took part in Cobra exhibition at Gal. Pierre, Paris. Wrote on aesthetics of modern art and popular art. Lives in Paris and Albisola Mare, Italy.

*Publications: Guldhorn og Lykkenhjul — Les Cornes d'or et la roue de la Fortune*, Copenhagen, no date; *Pour la Forme*, collected articles (Internationale situationiste), Paris 1958.

*References:* Catalogue of Exhibition at Arthur Tooth Gallery, London 1958; C. Dotremont, *Asger Jorn*, Copenhagen 1950.

KAHLER, EUGEN VON. Born January 6, 1882 in Prague. 1901-1905, studied in Munich with Knirr and Stuck. 1906-07 Paris. Winter 1907-08, Egypt. 1909-10, Spain and North Africa. Associated with Neue Künstler-Vereinigung, Munich. Died December 13, 1911 in Prague.

*Publications: Sinnen und Gesang*, privately printed 1914. — Letters from Egypt, in *Ganymed* V (1921), p. 29.

*Reference:* J. Peregrin in *Genius* III (1921), p. 29.

KANDINSKY, WASSILY. Born December 5, 1866 in Moscow. Studied law and only took up painting at age of thirty. 1896, moved to Munich, attended Azbe's school of painting and studied under Stuck at the Academy. 1900-03, worked independently and taught at private art school of Phalanx association, whose president he was. From 1902, member of Berliner Sezession. 1903-08, travels in France, Tunisia, Italy. From 1908, Munich and Murnau. 1911, Blaue Reiter exhibition. 1914, return to Moscow. 1918, appointed teacher at Moscow Academy. 1921, moved to Berlin. 1922-1933, teacher at Bauhaus. From December 1933, in Neuilly-sur-Seine, where he died on December 13, 1944.

*Publications: Über das Geistige in der Kunst*, Munich 1912. (English: *On the spiritual in Art.*) — *Der Blaue Reiter*, edited in collaboration with Marc, Munich 1912. — *Rückblicke*, Berlin, Sturm 1913. — *Klänge*, Munich 1913. — *Punkt und Linie zu Fläche*, Bauhausbuch, 1926. — *Essays über Kunst und Künstler*, ed. M. Bill, Stuttgart 1955. — Bibl. of Articles in Bill.

*References:* M. Bill, *Wassily Kandinsky*, Paris 1951. — W. Grohmann, *Kandinsky*, London 1958.

KANE, JOHN. Born 1860 at West Calder near Edinburgh. Worked as a miner. 1880, emigrated to the U.S.A. and settled in Pittsburgh. Worked in steel mill, also as a road builder and house-painter. Began to paint and draw in his free time. Discovered in 1927 by Andrew Dasburg. Died in 1934 in Pittsburgh.

*Publication: Sky Hooks. The Autobiography of John Kane as told to Mary McSwigan*, 1938.

*Reference:* Sidney Janis, *They Taught Themselves*, New York 1942, pps. 76-98.

KANOLDT, ALEXANDER. Born September 29, 1881 in Karlsruhe. 1899, attended Karlsruhe Academy. 1908, continued study in Munich. Joined Neue Künstler-Vereinigung. 1914-18 served in war. After war, friendship with Mense and Schrimpf. Active in developing Neue Sachlichkeit. 1925, appointed teacher at Breslau Academy. 1932, Berlin Academy. Died 1939 in Berlin.

*Reference:* F. Roh, *Nach-Expressionismus*, Leipzig 1925.

KIRCHNER, ERNST LUDWIG. Born May 6, 1880, at Aschaffenburg. 1901-05, architectural studies at Dresden Technical School, interrupted in 1903-04 by study of painting in Munich. Co-founder of Brücke. 1907-09, summers at Moritzburger Lakes near Dresden. 1911-1916, in Berlin. Association with Sturm. 1913, murals at Sonderbund Exhibition in Cologne. 1914, volunteered for Army. Collapse; sanatorium in the Taunus. 1917, moved to Davos. c. 1926, beginning of 'abstract' period. 1922-38, collaboration with weaver Lise Gujer. Committed suicide June 15, 1938 at Davos.

*Publications:* Prefaces to catalogues. — *Chronik der Brücke*, 1913. — 'Glaubensbekenntnisse eines Malers' in *Die Literatur-Gesellschaft* V (1919). — 'Anfänge und Ziel' in *Kronik van hedendaagsche Kunst en Kultur*, Bussum. I. June 1935. — Letter of 1929 to F. Winter in Catalogue of Bauer Collection, Nuremberg 1952. — Letter of 1937 to Valentin in Catalogue of Exhibition at Valentin Gallery, New York 1952. — Kirchner wrote a number of articles under the pen-name Louis de Marsalle.

*References:* W. Grohmann, *Das Werk Ernst Ludwig Kirchners*, Munich 1926. — W. Grohmann, *Kirchner, Zeichnungen*, Dresden 1925. — G. Schiefler, *Das graphische Werk Ernst Ludwig Kirchners*, Vol. I, Berlin 1920, Vol. II, Berlin 1926. — W. Grohmann, *Ernst Ludwig Kirchner*, Stuttgart, 1958.

KISLING, MOISE. Born January 22, 1891 in Cracow. Study at Cracow Art School. Lived in Paris from 1910. 1915, served in Foreign Legion. Numerous trips to southern France and Spain. Died April 29, 1953 near Lyons.

*Reference:* K. Einstein, *Moise Kisling,* Leipzig 1922.

KLEE, PAUL. Born December 18, 1879 at München-Buchsee near Berne. 1898-1901, Munich. Studied under Knirr and Stuck. 1901, trip to Italy. 1902-06, Berne. 1906, moved to Munich. 1911, friendship with Blaue Reiter artists. 1912, trip to Paris. Spring 1914, trip to Tunis with Macke and Moilliet. 1916-18, served in Army. 1922, appointment at Bauhaus. 1925, showed at first Surrealist Exhibition in Paris. From 1926, showed with Kandinsky, Feininger, Jawlensky under the group title 'Die Blauen Vier'. 1929, trip to Egypt. 1930, appointed to Düsseldorf Academy, where he remained until 1933. 1931, trip to Sicily. 1933, dismissed from Academy and moved to Berne. Died June 29, 1940 at Muralto near Locarno.

*Publications: Wege des Naturstudiums im Staatl. Bauhaus,* Weimar 1919-23, Munich 1923. — *Über die moderne Kunst* (lecture at Jena, 1924), Berne, 1945. — *The Thinking Eye,* ed. Spiller, London (in preparation) — *Tagebücher,* ed. Felix Klee, Cologne 1956.

*References:* W. Haftmann, *Paul Klee,* London 1954. — W. Grohmann, *Paul Klee,* London 1954. — Graphic work: J. T. Soby, *The Prints of Paul Klee,* New York 1945.

KLIMT, GUSTAV. Born, July 14, 1862 at Baumgarten near Vienna. Studied at Vienna School of Applied Art. 1898, founder member of Vienna Secession. Resigned 1903. Helped to organise Vienna Workshops. Died February 6, 1918, in Vienna.

*Reference:* M. Eisler, *Gustav Klimt,* Vienna 1920.

KLINE, FRANZ. Born in 1910 in Wilkes-Barre, Pa. Grew up in Philadelphia. Studied art in Boston from 1931 to 1935 and in London from 1937 to 1938. 1939, returned to New York. 1950, beginning of his personal style and first one-man show in New York. 1952-54, taught at various colleges. 1956, showed at Venice Biennale. Lives in New York.

*Reference:* E. de Kooning in *Art News Annual,* No. 27, November 1957, pps. 86-97, 174-179.

KLINGER, MAX. Born February 18, 1857 in Leipzig. Studied in Karlsruhe and Berlin. 1883-86, Paris. 1886-88, Berlin. 1888-93, Rome. 1893, return to Leipzig. 1902, completion of the *Beethoven.* Extensive activity as painter and graphic artist, including 1881, *Paraphrase on the Finding of a Glove,* 1894, *Brahms Fantasia.* Died July 5, 1920 at Grossjena near Naumburg.

*Publications: Malerei und Zeichnung,* Leipzig 1895. — *Briefe,* ed. H. W. Singer, Leipzig 1924.

*Reference: Klinger-Album,* Leipzig 1925.

KLUTH, KARL. Born January 21, 1898 in Halle. Studied in Karlsruhe. Founder member of Hamburger Sezession. 1939-49 fought in war and taken prisoner. Since 1952, teacher at Hamburg Landeskunstschule.

KOKOSCHKA, OSKAR. Born March 1, 1886 at Pöchlarn (Lower Austria). 1904-07 studied at School of Applied Art in Vienna. Influence of Klimt. 1908-14, lived in Vienna, Switzerland, and Berlin where he belonged to Sturm group. During first World War, wounded on Russian front (1916). Thereafter lived in Vienna and Berlin. 1918, moved to Dresden. 1920-24, taught at Dresden Academy. 1924, gave up teaching and went on extensive travels through Europe and Mediterranean countries. 1931, moved to Vienna. 1934, emigrated to Prague. 1938, fled to London. 1948-49, Italy. Thereafter lived at Salzburg and in Switzerland. — Series of Illustrations: 1908, *The Dreaming Boys;* 1913, *The Chained Columbus;* 1914, *The Great Wall of China* by Karl Kraus; 1915, *Bach Cantata;* 1918, *Job.*

*Publication: Oskar Kokoschka Schriften, 1947-55,* Munich 1956.

*References:* E. Hoffmann, *Oskar Kokoschka,* London 1947. — Hans Maria Wingler, *Oskar Kokoschka,* Salzburg 1956.

KOONING, WILLEM DE. Born April 24, 1904 in Rotterdam. Apprenticed as house painter and attended Rotterdam Academy. 1924, attended Academies at Brussels and Antwerp. 1926, moved to U.S.A. and worked as house painter. Friendship with Gorky, with whom he shared a studio for several years. 1935, WPA Art Project. During the war, belonged to the group of young abstract painters in New York. 1948, first one-man show in New York. Taught at Black Mountain College, North Carolina. 1950-51, taught at Yale Art School, New Haven, Conn. Showed at Biennale in 1948, 1950, 1954, and 1956. Lives in New York.

*Reference:* T. B. Hess, *Willem de Kooning,* New York 1959.

KROGH, CHRISTIAN. Born August 13, 1852 at Aker near Oslo. Studied in Karlsruhe and Berlin. 1878, return to Norway. Championed Impressionism in Norway. 1881, trip to Paris. 1901-09, taught at Académie Colarossi in Paris. 1909, appointed director of Oslo Academy. Died October 16, 1925 in Oslo.

*Publications:* Editor of the *Impressionist.* — *Albertine* (a novel) 1886. — *A Duel* (novel) 1888. — A selection of his writings appeared in 1920/21 under the title *Kampen for Tilvaerelsen,* 4 vols.

*Reference:* A. Aubert, *Die norwegische Malerei im 19. Jahrhundert,* Leipzig 1910.

KUBIN, ALFRED. Born April 10, 1877 at Leitmeritz (Bohemia). From 1898, study in Munich. 1903, first portfolio of drawings published by H. v. Weber. 1905, trips to Paris and Italy. 1906, acquired Castle of Zwickledt near Wernstein on the Inn. 1910, association with Blaue Reiter artists. In post-war years travelled widely in the Balkans Died August 24, 1959.

*Publications: Die andere Seite,* Munich 1909. — *Dämonen und Nachtgesichte,* Dresden 1926. — *Mein Werk,* Dresden 1931. — 'Dämmerungswelten' in *Die Kunst* XXXIV (1933), p. 304.

*Reference:* P. Raabe, *Alfred Kubin, Leben, Werk, Wirkung,* Hamburg 1957 (Index of works).

KUNIYOSHI, YASUO. Born in 1893 in Okayama, Japan. 1906, emigrated to U.S.A. Lived in Los Angeles and attended Los Angeles School of Art. 1910, moved to New York, studied at National Academy and Henri School. 1914-16, attended Independent School in New York and Art Students' League. 1917, showed at exhibition of Society of Independent Artists. 1922, first one-man show at Daniel Gallery in New York. 1925 and 1928, protracted visits to France. 1935, Guggenheim Fellowship. Trip to Texas and Taos. Co-founder of American Artists' Congress. Died 1953 in New York.

*Publications:* See: '*Magazine of Art*'. Febr. 1940, pp. 72-83. — '*Arts Weekly*', April 23, 1932, p. 150.
*Reference:* L. Goodrich, *Yasuo Kuniyoshi,* New York, 1948.

KUPKA, FRANK. Born September 23, 1871 at Opocno (Bohemia). Studied in Prague and Vienna. 1895, moved to Paris. Friendship with Jacques Villon. Contributed to satirical magazines. 1911, took up abstract painting along Orphist lines. 1914-18 served in French Army. In the twenties influenced by aesthetic of the machine. From 1931, connected with Abstraction-Création. Died 1957 at Puteaux near Paris.

*Publication: La Création dans l'Art plastique.* Prague, no date.
*References:* A. Barr, *Cubism and Abstract Art,* Museum of Modern Art, New York, 1936. — Catalogue of one-man show at Musée Nat. d'Art Moderne, Paris 1958. — Seuphor, *L'Art abstrait,* Paris 1949.

LAM, WILFREDO. Born December 8, 1902 at Sagua, Cuba. Studied in Havana, Madrid, and Paris. 1937, moved to Paris. Joined Surrealist group. 1940, fled to U.S.A. Lives in Paris.

*References: Cahiers d'Art* 26 (1951), p. 181. — P. Waldberg, 'Wilfredo Lam' in *Quadrum* III, p. 31-40.

LANSKOY, ANDRÉ. Born March 31, 1902 in Moscow. 1919 fled to Kiev and served in White Army. 1921, moved to Paris and began to study painting. From 1937 moved gradually away from representation. Influence of Klee and Kandinsky. Since 1941 largely abstract. Lives in Paris.

*References: Art d'Aujourd'hui,* October 1951. — L. Degand *Témoignages pour l'art abstrait,* Paris 1952. — Grenier, 'Lanskoy' in *L'Oeil,* Paris, May 1956.

LANYON, PETER. Born February 8, 1918 at St. Ives, Cornwall. Father a musician. 1938, studied art at Euston Road Art School. Friendship with Nicholson and Naum Gabo. 1940-46, military duties in Italy and the Near East. 1947, studied with Nicholson at St. Ives. Since 1949 has shown regularly in London. Founder member of the St. Ives Group and of the Penwith Society of Arts. 1950-56, taught at Bath Academy of Art. 1953, grant to travel in Italy. 1959, first showing in New York. Lives at St. Ives.
*Reference:* P. Heron, 'Peter Lanyon' in *Arts,* February 1956, pp. 33-37.

LAPICQUE, CHARLES. Born October 6, 1898 at Theize (Rhône). Painting in Paris since 1910. Has been exhibiting at Galerie Jeanne Bucher since 1925. 1937, decorations for Palais de la Découverte. Association with Villon, Bazaine, Manessier. Belongs to Salon de Mai group.
*Reference:* Lescure, *Lacpique,* Paris 1956.

LARIONOV, MICHAEL. Born May 22, 1881 at Teraspol (Ukraine). Studied at Moscow Academy. 1906, stay in Paris. Founder of Russian Fauvism and Rayonism. 1912, Rayonist Manifesto. 1914, moved to Paris. 1915-29, sets for Ballet Russe. Lives in Paris.
*References:* A. Barr, *Cubism and Abstract Art,* Museum of Modern Art, New York 1936. — Seuphor, *L'Art abstrait,* Paris 1949. — *Burlington Magazine* 97 (1955), p. 170.

LAURENCIN, MARIE. Born October 31, 1885 in Paris. Friendship with Apollinaire and the Cubists. From 1911 connection with Cubists. In Spain during First World War. Thereafter in Paris. Died 1956.
*Reference:* H. v. Wedderkop, *Marie Laurencin,* Leipzig 1921.

LECK, BART VAN DER. Born November 26, 1876 in Utrecht. Studied in Amsterdam. 1916, with Mondrian. 1917, co-founder of *De Stijl* movement. Lives in Amsterdam.
*References:* M. Seuphor, in *Werk,* November 1951. — H. L. C. Jaffé, *De Stijl 1917-1931,* Amsterdam 1956.

LE CORBUSIER (CHARLES EDOUARD JEANNERET). Born October 6, 1887 at La Chaux-de-Fonds, Switzerland. After studying graphic techniques, worked as architect under Perret in Paris and Behrens in Berlin 1906-10). 1918 moved to Paris. With Ozenfant founded Purism. 1920-25, associate editor of *L'Esprit Nouveau.* 1922, returned to architecture. Since then has painted only occasionally.

*Publications: Etude sur le mouvement d'art décoratif en Allemagne,* 1912. — In collaboration with Ozenfant, *La peinture moderne,* Paris 1925 and *Après le Cubisme,* 1918. — *The Modulor,* Cambridge 1954.

*Reference:* E. Boesinger, *Le Corbusier und Pierre Jeanneret, Oeuvre Complète,* 5 vols: 1910-29; 1929-34; 1934-38; 1938-46; 1946-52. Zurich, beginning 1930. — In connection with his painting, see S. Giedion, *Space, Time and Architecture,* p. 407.

LE FAUCONNIER, HENRI. Born July 1881 at Hesdin (Pas-de-Calais). 1901, moved to Paris. 1909, in circle of Gleizes and Delaunay. 1910, member of Neue Künstler-Vereinigung, Munich. 1911, trip to Italy. 1912, one-man show in Folkwang Museum, Hagen. 1914-19, Holland. Thereafter in Paris. Died in Paris, January 1946.
*Reference:* J. Romain, *Le Fauconnier,* Paris 1922.

LÉGER, FERNAND. Born February 4, 1881 at Argentan in Normandy. Began as architectural draughtsman. 1900, study in Paris, from 1903 at Ecole des Beaux-Arts. Influence of Cézanne, Matisse, friendship with Rousseau. 1910, association with Cubism. 1911-12,

Section d'Or. 1913, showed at Deutscher Herbstsalon in Berlin. 1914-16, fought in war. Gassed. 1920, meeting with Le Corbussier. 1923-24, worked on film *Ballet Mécanique*. 1924, trip to Ravenna. Association with Stijl painters. From 1931, extensive travels in U.S.A. and Greece. 1940-45, U.S.A. 1945, return to Paris. 1946, mosaic for the façade of church at Assy. 1951, ceramics. Died August 17, 1955 at Gife-sur-Yvette near Paris.

*Publication:* Autobiography in Catalogue of exhibition in Paris, Musée des arts décoratifs, 1956, pp. 25-39.

*Reference:* D. Cooper, *Fernand Léger*, Geneva 1949 (Bibliography).

LEHMBRUCK, WILHELM. Born January 4, 1881 at Duisburg-Meiderich. Sculptor. 1895-99, School of Applied Art in Düsseldorf. 1901-06, Düsseldorf Academy. 1910-14, Paris. 1914-17, Berlin. 1917-18, Zurich. Then Berlin. Committed suicide on March 25, 1919 in Berlin.

*References:* A. Hoff, *Wilhelm Lehmbruck*, Berlin 1936. — *Ausstlgs.-Kat. Mannheim* 1949 (Bibliography).

LE MOAL, JEAN. Born October 30, 1909 at Authon-du-Perche (Eure-et-Loir). Studied at Lyons Academy. Student of Bissière at Académie Ranson in Paris. Also painted for theatre. With Singier and Manessier forms a group that shows in Gal. de France. 1950, Prix de la critique. Lives in Paris.

*Reference:* Lassaigne, 'Le Moal', in *XXe Siècle*, No. 6, Paris 1956.

LENZ (PATER DESIDERIUS). Born March 12, 1832 at Haigerloch. 1850-57 studied in Munich. 1858-62, taught at School of Applied Art in Nuremberg. 1862-65, Rome. 1865-68, Stuttgart, working on the 'canon of the human figure'. 1868-70, decorated the Mauruskapelle near Beuron. 1874-78, painted several rooms at Monte Cassino. Entered Benedictine Order. Died January 28, 1928 at Beuron (Württemberg).

*Publication: Zur Aesthetik der Beuroner Schule*, Vienna and Leipzig, 1912.

*Reference:* J. Kreitmaier, *Beuroner Kunst*, Freiburg 1914.

LEVY, RUDOLF. Born July 15, 1875 in Stettin. Studied in Karlsruhe and Munich. 1903-14, Paris. 1909, studied with Matisse and belonged to Purrmann's circle. 1919, Munich. 1920, Düsseldorf. 1921, Berlin; then alternately Berlin and Paris. 1933, emigrated. From 1937, Italy, mainly Florence. 1943, deported by the SS and disappeared.

*Reference:* C. Scheffler, *Rudolf Levy*, Werkkunst-Verlag 1927.

LEWIS, P. WYNDHAM. Born November 18, 1882 in Nova Scotia. Brought up in England. 1898-1901, attended Slade School. 1902-1908, travels in Europe. 1911, member of Camden Town Group. 1912-13, showed at Second Post-Impressionist Exhibition. Encounter with Futurism and Cubism. Friendship with Ezra Pound. Founded the Rebel Art Centre. 1914, Founded the Vorticist Group. Editor of *BLAST*

1915, organised Vorticist Exhibition in London. Meeting with T. S. Eliot. 1915-17, served in Army. 1917-19, Official War Artist. 1918, published *Tarr*. 1919, exhibition of his war pictures in London. 1920, founded the 'Group X'. 1921, met James Joyce in Paris. Published *The Tyro* magazine. 1927, edited *The Enemy* magazine. 1928-39, extensive publicist and literary activity. 1940-48 travels in Canada and the U.S.A. Beginning in 1950, critic for *The Listener*. 1953, blindness. 1956, Retrospective at Tate Gallery. Died March 17, 1957 in London.

*Publication: Autobiography, Rude Assignment,* 1950. — Complete bibliography of his writings in Geoffrey Wagner, *Wyndham Lewis*, London 1957 (pps. 315-348).

*Reference:* C. Handley-Read, *The Art of Wyndham Lewis*, London 1951.

LHOTE, ANDRÉ. Born July 5, 1885 in Bordeaux. Studied sculpture at Bordeaux Academy. 1908, moved to Paris. From 1911, association with Cubists and Section d'Or. Since 1918 has taught at his own school of painting. Active also as an author and critic. Lives in Paris.

*Publications:* Beginning in 1919, critic for *Nouvelle Revue Française.* — *La Peinture, le cœur et l'esprit.* Paris 1933. — *Traité du Paysage,* Paris 1941.

*Reference:* P. Courthion, *André Lhote*, Paris 1926.

LICINI, OSVALDO. Born March 22, 1894 at Monte Vidon Corrado (Ascoli Piceno). In his youth, friendship with Morandi. Long stay in Paris. Took up abstract painting in 1931. Style characterised by a Surrealistic automatism leaning towards animism. Died October 1958 at Monte Vidon.

*Reference:* G. Marchiori, *Licini*, con 21 lettere del pittore, Rome 1960.

LIEBERMANN, MAX. Born July 20, 1847 in Berlin. Studied in Berlin under Steffeck and in Weimar. Meeting with Munkaczy. 1872, first trip to Paris and period of study in Holland. 1873-78, Paris. From 1875, spent most summers in Holland. 1879-84, in Munich. From 1884, Berlin. At the beginning of the nineties, contact with French Impressionism. 1898, member of Berlin Academy. 1899, President of Berliner Sezession. Died February 8, 1935 in Berlin.

*Publications: Max Liebermann als Schriftsteller,* Cassirer, Berlin 1922.

*Reference:* K. Scheffler, *Max Liebermann*, Munich (4th edition) 1923.

LISSITSKY, EL. Born November 10, 1890 in Smolensk. 1909-14, studied at Darmstadt Technical School. 1919, association with Russian Constructivism. 1921, teacher at Moscow Academy. 1922-23, moved to Germany, worked with Doesburg and Mies van der Rohe. 1923-25, Switzerland. Died 1947 in Moscow.

*Publication: Les Ismes de l'Art*, 1925 (in collaboration with Arp).

*References:* Seuphor, *L'Art abstrait*, Paris 1949. — 'El Lissitsky, Typographer' in *Typographica* 16, London 1960.

LORJOU, BERNARD. Born September 9, 1908, in Blois, France. Studied briefly at Academy and started out in Paris as textile designer. Influence of Grosz and Permeke. Founder member of *L'Homme Témoin* group, from which Buffet and Minaux have emerged.

*Reference:* Catal. of one-man show at Wildenstein Gal. London 1958.

LUCE, MAXIMILIEN. Born March 13, 1858 in Paris. Neo-Impressionist. Friendship with Signac and Cross. From 1887, showed at Indépendants. Died February 6, 1941 in Paris.

*Reference:* A. Tabarant, *Maximilien Luce*, Paris 1928.

LURÇAT, JEAN. Born July 1, 1892 at Bruyères (Vosges). Studied in Nancy. Belonged to the Paris circle of the poets Vildrac and Elie Faure. From 1920, exhibited at Indépendants. Brief association with Surrealism. In the last twenty years active chiefly as tapestry designer. Lives at Saint-Céré (Lot).

*Publications: Tapisserie française*, ed. Bordas 1947. — *Le Travail dans la Tapisserie du Moyen-Age*, Geneva 1947. — *Designing Tapestry*, London 1950.

*References:* P. Soupault, *Jean Lurçat*, Paris undated. — Jean Marcenac, *L'exemple de Jean Lurçat*, Zurich 1952.

MacDONALD-WRIGHT, STANTON. Born in 1890 in Charlottesville, Va. 1907, went to France, studied at Ecole des Beaux-Arts and Académie Julian. 1912, in Paris, founded Synchronism in collaboration with Morgan Russell. First Synchromism exhibition at Carroll Gallery in New York. 1913, represented at Armory Show. Showed at Galerie Bernheim Jeune and Salon des Indépendants in Paris and in Munich along with M. Russell. 1916, returned to the U.S.A. 1917, one-man show at '291'. 1919-20, return to representational painting. 1937, stay in Japan. For many years taught oriental and modern art at the University of California and in Los Angeles. 1952-53, stay in Japan. 1954, return to abstract painting. 1956, large Retrospective at Country Museum, Los Angeles. Lives in Santa Monica, Calif.

*Reference:* Catalogue of one-man show, Los Angeles 1956.

MACKE, AUGUST. Born January 3, 1887 at Meschede (Sauerland). 1904-06, Düsseldorf Academy. 1905, first trip to Italy. 1906, trip to Holland, Belgium, and London. 1907, first trip to Paris. Winter 1907/08, studied with L. Corinth in Berlin. 1908, second trip to Paris and Italy. 1908-09, military service. 1909, trip to Paris. 1909-10, stay at Tegernsee and meeting with Marc. Association with Neue Künstler-Vereinigung, Munich. 1911, visited Moilliet at Thun and Marc at Sindelsdorf. Association with Blaue Reiter. 1912, in Bonn. Showed at Sonderbund Exhibition in Cologne. September, Paris with Marc. Meeting with Delaunay. Winter 1913-14 on Thuner See with Moilliet. April 1914, trip to Tunisia with Moilliet and Klee. August 1914, entered Army. Killed in Champagne, September 26, 1914.

*Publications:* Articles in *Der Blaue Reiter*, Munich 1912; *Kunst und Künstler* XII (1914); *Sturm,*

1915. — Letters in *Die Kunst* XXXI (1930), p. 244 and in P. Westheim, *Künstlerbekenntnisse*, Berlin.

*Reference:* G. Vriesen, *August Macke*, Stuttgart 1953 and 1957.

MACKE, HELMUT. Born June 29, 1891 in Krefeld. 1906-08, Krefeld School of Applied Art under Thorn-Prikker. Friendship with Campendonk, Nauen, and August Macke. 1910-11, Munich, association with Blaue Reiter. 1912, Berlin, friendship with Heckel. 1913-1918, served in Army. 1923, Leipzig. 1925-29, Krefeld. 1929, Prix de Rome and stay in Italy. 1933, moved to Hemmenhofen on Lake Constance. September 8, 1936 drowned in Lake Constance. 1943, the greater part of his work burned in Krefeld.

*Reference:* Catalogue of exhibition in Krefeld, 1950. Includes a number of letters.

MAFAI, MARIO. Born February 15, 1902 in Rome. With Scipione founded new Roman school based on the Expressionism of Soutine and the French painters of like tendency. Lives in Rome.

*References:* J. T. Soby, *Twentieth Century Italian Art*, Museum of Modern Art, New York 1949. — L. Venturi, *Pittori italiani d'oggi*, Rome 1958, p. 30 ff.

MAGNELLI, ABERTO. Born July 1, 1888 in Florence. Self-taught. c. 1910, several trips to Paris and friendship with Futurists and Cubists. 1914, long stay in Paris and friendship with Picasso and Léger. 1915, Florence. First wholly abstract paintings. 1918, representational painting with Expressionist transpositions. 1920-30, representational painting with extreme formal rigour. 1931, moved to Paris. Association with Abstraction-Création. 1933, return to total abstraction. 1950, one-man show at Venice Biennale. Lives in Paris.

*References:* Arp, *Onze peintres vus par Arp*. Zurich 1949. — Seuphor, *L'Art abstrait*, Paris 1949. — Alberto Magnelli, *Collages*, Paris 1957.

MAGRITTE, RENÉ. Born 1898 at Lessines, Belgium. Grew up near Charleroi. 1916, moved to Brussels, where he attended the Académie des Beaux Arts. From 1922, began to paint in Surrealist style. 1922-25, designer in a rug factory. Trips to France, England, Germany, Holland. Influence of De Chirico. 1927-30, lived near Paris. Associated with Breton, Eluard, and the French Surrealist movement. 1930, returned to Brussels, where he lives.

*Publications:* 'La pensée et les images' in *Les art plastiques*, No. spécial, June 1954, pp. 39-43.

*References:* E. L. T. Mesens, *Peintres Belges Contemporains: Magritte*, Brussels 1947; L. Scutenaire, *Magritte*, Antwerp 1948.

MAILLOL, ARISTIDE. Born December 8, 1861 at Banyuls-sur-Mer (Pyrénées Orientales). Sculptor. Started out as painter. 1882-86, Academy in Paris. c. 1890, influence of Gauguin. 1893, association with Nabis. 1894, tapestries and beginning of sculptural activity. 1902, exhibition of tapestries and small plastic works at Vollard gallery. 1908, trip to Greece with Count Kessler, who commissioned him to illu-

strate Virgil's *Eclogues* (appeared 1926). Died September 28, 1944 at Banyuls.

*References:* J. Rewald, *Maillol*, Paris 1939 (Bibliography). — P. Camo, *Maillol, mon ami*, Lausanne 1950.

MALEVICH, CASIMIR. Born February 11, 1878 in Kiev. Until 1910 painted in style of Russian Fauves, then up to 1913 a Cubist. 1913, founding of Suprematism. 1918, taught at Moscow Academy. From 1921 teacher at Leningrad Academy. 1926, trip to Germany where he met Kandinsky at Bauhaus. Died 1935 in Leningrad. Exhibition at Whitechapel Art Gallery, 1959.

*Publication: Die gegenstandslose Welt.* Bauhausbuch 1927.

*References:* Seuphor, *L'Art Abstrait*, Paris 1949. — Cat. of exhibition at Kunstverein Braunschweig 1958 (bibliography). Camilla Gray in *Burlington Magazine*, May 1960.

MANESSIER, ALFRED. Born December 5, 1911 at Saint-Ouen (Somme). Studied in Amiens and from 1931 in Paris. 1935 met Bissière at Académie Ranson. Friendship with Le Moal and Bertholle. 1936-39, at Saint-Ouen. 1939-40, military service. 1940-41, continued studying with Bissière. 1949, series of lithographs on the subject of Easter and windows for the church at Bréseux (Doubs). Lives in Paris.

*Reference:* J. Cayrol, *Manessier*, Paris 1955.

MANGUIN, HENRI CHARLES. Born March 23, 1874 in Paris. Studied with Moreau. Belonged to first group of Fauves round Matisse. Friendship with Signac. Later veered towards Cézanne. Died December 25, 1943 at Saint-Tropez.

*Reference:* G. Duthuit, *Les Fauves*, Geneva 1949.

MARC, FRANZ. Born February 8, 1880 in Munich. From 1900, studied in Munich. 1902, trip to Italy. 1903, trip to Paris and Brittany. From 1904 worked independently in villages in Upper Bavaria. 1906, trip to Greece. 1907, stay in Paris. 1910, settled at Sindelsdorf. Met Kandinsky and Macke. Joined Neue Künstler-Vereinigung. Founder member of Blaue Reiter. 1912, edited *Blaue Reiter*. 1913, helped to organise 'Erster Deutscher Herbstsalon' in Berlin. 1912, trip to Paris with Macke and meeting with Delaunay. 1914, moved to Ried and entered Army. Killed March 4, 1916 at Verdun.

*Publications: Briefe, Aufzeichnungen und Aphorismen,* Vol. I, Berlin 1920. — *Briefe aus dem Felde,* Berlin 1940. — *Aufzeichnungen und Aphorismen,* Munich 1946.

*References:* Schardt, *Franz Marc*, Berlin 1936. — K. Lankheit, *Franz Marc*, Berlin 1950. — Bünemann, *Aquarelle und Zeichnungen*, Munich 1948.

MARCHAND, ANDRÉ. Born February 10, 1907 in Aix-en-Provence. Studied in Paris. Friendship with Tal Coat and Gruber. Designs for Manufactures d'Aubusson. Lives in Aix and Paris.

*Reference: Art-Documents* No 37, *André Marchand* Geneva 1956.

MARCHAND, JEAN. Born November 21, 1883 in Paris. Studied in Paris. A moderate Cubism starting from Cézanne. After First World War influenced by Derain; arrived at a hard realistic style. Died 1940 in Paris.

*Reference:* R. Jean, *Jean Marchand*, Paris 1920.

MARCOUSSIS, LOUIS (LOUIS MARKUS). Born November 14, 1883 in Warsaw. Studied at Warsaw Academy and from 1903 in Paris. Friendship with Roger de la Fresnaye. From 1910, association with Cubism. Friendship with Braque, Picasso, Apollinaire. 1912-13, belonged to Section d'Or. 1914-18, served in Army. 1933, trip to U.S.A. Died October 22, 1941, at Cusset near Vichy.

*Reference:* J. Cassou, *Marcoussis*, Paris 1930.

MARIN, JOHN. Born in 1870 at Rutherford, N.J. 1889-95, studied and practised architecture. 1899-1901, studied painting at Pennsylvania Academy in Philadelphia. 1901-03, studied at Art Students' League in New York. 1905-09 and 1910-11, travelled in Holland, Belgium, Italy, and lived in Paris. 1909, first one-man show at '291', became a member of the Stieglitz group. 1911, return to U.S.A. 1913, represented at Armory Show. 1936, retrospective at Museum of Modern Art, New York. 1950, showed at Venice Biennale. From 1913, spent summers in Maine, winters at Cliffside, N. J. Died 1953 at Cape Split, Maine.

*Publications: Letters of John Marin,* ed. H. J. Seligman, New York 1931; *Selected Writings of John Marin,* ed. D. Norman, New York 1949.

*Reference:* MacKinley Helm, *John Marin*, Boston 1948.

MARLE, FELIX DEL. Born October 27, 1889 at Pont-sur-Sambre (Nord). Studied in Lille, Brussels, Paris. 1913, joined Futurist movement. From 1920, association with Kupka and Mondrian. Joined Neo-Plastic movement. Then representational painting. From 1943, return to the geometrical variety of abstract art. Worked on polychrome architecture. From 1947, general secretary of *Réalités Nouvelles.* Died December 2, 1952.

*Publications:* Excerpts from letters in *Art d'Aujourd'hui*, January 1953.

*References:* V. Bresle, *Der Maler Del Marle*, 1930. — L. Degand, *Témoignages pour l'Art abstrait*, Paris 1952.

MARQUET, ALBERT. Born March 27, 1875 in Bordeaux. 1890, studied at Paris School of Applied Art. 1897, Atelier Moreau, Ecole des Beaux-Arts. Met Matisse. Participated in Fauvist movement. From 1908, extensive travels from Tangiers to Norway. 1913, trip to Morocco with Matisse. 1915, moved to Marseilles. 1916-19, Marseilles and Nice, in close contact with Matisse. 1923-25, frequent stays in North Africa. 1928, trip to Egypt. 1934, trip to Tiflis and Moscow. 1936-37, Switzerland. Winter 1938 in Stockholm. 1940-45 in Algiers. 1945, return to Paris. Died June 14, 1947 in Paris.

*References:* M. Marquet, *Marquet*, Lausanne 1953. — F. Jourdain, *Marquet*, Paris 1959.

MARUSSIG, PIERO. Born May 16, 1879 in Trieste. Studied in Trieste, Vienna, Munich, Rome, Paris. 1920, moved to Milan. Co-founder of Novecento. Died October 13, 1937 in Pavia.

*Reference:* R. Carrieri, *12 opere di Piero Marussig*, Milan 1942.

MASSON, ANDRÉ. Born January 4, 1896 at Balagny (Oise). 1914-18, served in Army. Studied painting in Brussels and Paris. From 1919, lived in Paris. 1924, first showing at Galerie Simon. 1925-29, close association with Surrealist group. 1929, 'excommunicated' by Breton. 1933, exhibition with Miró in New York. 1934-36, stay in Catalonia. 1937, return to Paris. 1941-45, New York and Connecticut. 1946, return to Paris. Living since 1947 in Aix-en-Provence.

*Publications:* Texts of Portfolios: *Mythologies* (1938-40), New York 1942, Paris 1946. — *Anatomie de mon univers* (1940/42) New York 1943. — *Métamorphose de l'artiste*, 2 vols. Geneva 1956.

*References:* M. Leiris and G. Limbour, *André Masson et son Univers*, Geneva-Paris 1947. — Provisional Catalogue of graphic work and illustrated books in Exhibition Catalogue 'Das graphische Werk von André Masson', Bremen 1954.

MATHIEU, GEORGES. Born 1921 in Boulogne-sur-Mer. Studied jurisprudence, philosophy, and philology. 1942, began to paint. 1944, first non-figurative work. 1947, moved to Paris. Showed at Salon des Réalités Nouvelles and Salon des Surindépendants. With Bryen and other 'Lyrical Abstractionists' organised 'L'Imaginaire' exhibition at Galerie de Luxembourg. In 1948, organised a second group exhibition entitled 'H. W. P. S. M. T. B.' at Galerie Allendy — in opposition to abstract formalism. A third exhibition 'White and Black' was held at the Galerie des Deux Iles. Arranged an exhibition of American and French painters (De Kooning, Hartung, Gorky, Pollock, Wols, Rothko, Tobey...) at Galerie Montparnasse. 1950, first one-man show at Galerie René Drouin, Paris. 1952, first exhibition in New York at Stable Gallery. 1954, 1955, 1957, exhibitions at Kootz Gallery in New York. 1956, exhibition at Institute of Contemporary Art in London. 1957, trip to U.S.A. and to Tokyo, where he exhibited. 1956, did a painting twelve feet high on the stage of the Théâtre Sarah Bernhardt *(Hommages aux Poètes du monde entier)* in connection with the Festival international d'Art dramatique. Lives in Paris.

*Publications:* *Analogie de la Non-figuration*, Paris 1949; see *Art Digest*, 1953 and *United States Lines Paris Review*, Paris 1953.

*References:* *Art News,* New York, February 1955; F. Roh in *Kunstwerk*, April 1959, pp. 18-30 (with interview).

MATISSE, HENRI. Born December 31, 1869 at Le Cateau-Cambrésis (Nord). 1887, studied law. Began to paint in 1890. Winter 1891-92, studied at Académie Julian under Bouguereau. 1893, entered Atelier Moreau. 1896-97, approach to Impressionist style. 1898, Corsica and Toulouse. 1899, Paris. Influence of Cézanne. 1903, founded Salon d'Automne. 1904, first one-man show at Vollard gallery. Summer 1904, at Saint-Tropez where he associated with Signac and Cross. Influence of Neo-Impressionism. 1905, showed at Salon d'Automne with his friends. Leader of the Fauves. 1907, *Bonheur de Vivre*. 1908-09, trip to Germany. 1910-11, travels in Spain and Russia. 1911-13, trips to Morocco. 1917, moved to Nice. 1920-25, 'Odalisques'. Work for Diaghilev's ballet. 1930-31, travels to U.S.A. and Tahiti. 1931-33, worked on *The Dance* for C. Barnes. From 1938, in Nice-Cimiez. 1943-48, lived at Vence. January 1949, return to Cimiez. 1949-51, worked on Vence chapel. Died November 4, 1954 in Nice.

*Publication: Notes d'un peintre,* 1908.

*References:* A. H. Barr, *Matisse: his Art and his Public*, Museum of Modern Art, New York 1951. G. Diehl, *Henri Matisse*, Paris 1954. — W. S. Liebermann, *Henri Matisse, 50 years of his graphic art*, London 1957.

MATTA, ROBERTO SEBASTIAN ANTONIO MATTA ECHAURREN. Born in 1912 in Santiago, Chile. Spanish and French extraction. 1934, studied architecture at Le Corbusier's Paris office. 1937, joined Surrealist group. 1938, began to paint. Moved to New York in autumn of 1939. Friendship with Duchamp, Tanguy, Max Ernst, André Breton. 1941, Mexico. 1945, began to paint demonic fantasies. 1949, return to Europe. Long stays in Italy, England, and France. Lives near Paris.

*Publications:* K. Dreier and Matta, *Duchamp's Glass*, New York 1944;; see Max Ernst, *Beyond Painting*, New York 1948, p. 193; *Pro Arte* (Santiago) No. 171, June 1954; *Reality* (New York), No. 2, Spring 1954.

*References:* W. Rubin in Museum of Modern Art Exhibition Catalogue, New York 1957; J. T. Soby, *Contemporary Painters*, New York 1948, pp. 61-68.

MAURER, ALFRED H. Born April 21, 1868 in New York. Trained in lithography. Study at National Academy of Design. 1897, studied at Académie Julian in Paris. 1901, returned to U.S.A. studied at Pennsylvania Academy. Gold medal at Carnegie International Exhibition. 1902, moved to Paris, influenced by the Fauves. 1906, trip to Italy. 1909-14, New York and Paris. 1909, exhibited at Stieglitz's gallery with John Marin. 1913, represented at Armory Show. 1914, returned to the U.S.A. Died in 1932.

*Reference:* E. McCausland, *Alfred H. Maurer,* 1951.

MEIDNER, LUDWIG. Born April 18, 1884 at Bernstadt (Silesia). 1903-05, studied in Breslau. 1905-06, fashion designer in Berlin. 1906-07, in Paris, Académie Julian, friendship with Modigliani. From 1907, in Berlin. 1912, first exhibition at Sturm gallery. 1916-18, fought in war. 1918, group showing at Cassirer gallery. 1925-32, devoted himself to literature. 1935-39, taught drawing at Jewish high school in Cologne. August 1939, emigration to London. 1940-41, interned. 1949, group exhibition in London. 1952, trip to Germany. 1953, returned for good and settled in Frankfurt.

*Publications: Hymnische Prosa,* 1916-18. — *Gang in die Stille,* 1929.

*Reference:* L. Brieger, *Ludwig Meidner,* Leipzig 1919.

MEISTERMANN, GEORG. Born June 16, 1911 in Solingen. 1929-33, Düsseldorf Academy under Heuser, Nauen, Mataré. 1937-39, travels in France, Holland, England. From 1937, numerous church windows. 1953, called to Städel Art School in Frankfurt. Since 1955 professor at Academy in Düsseldorf. Lives in Cologne.

*Reference:* C. Linfert, *Georg Meistermann,* Recklinghausen, 1958.

MENSE, CARLO. Born May 13, 1889 at Rheine. Studied in Düsseldorf under P. Janssen and in Berlin under L. Corinth. After the War, exponent of Neue Sachlichkeit. 1925-32, taught at Breslau Academy. Lives at Honnef (Rhineland).

*Reference:* F. Roh, *Nachexpressionismus,* 1925.

MENZIO, FRANCESCO. Born April 3, 1899 at Tempio Pausania in Sardinia. Co-founder of the Turin Post-Impressionist group 'dei Sei' (1928). Lives in Turin.

METZINGER, JEAN. Born June 24, 1883 in Nantes. 1903, moved to Paris. Influence of Neo-Impressionism. From 1910, connection with Cubism. 1912, joined Section d'Or. After the war, brief Neue Sachlichkeit period. Lives in Paris.

*Publication:* In collaboration with Gleizes: *Du Cubisme,* 1912.

*References:* Apollinaire, *Peintres Cubistes,* Paris 1913. — John Golding, *Cubism,* London 1959.

MEYER-AMDEN, OTTO. Born February 20, 1885 in Berne. 1892, admitted to Berne orphan asylum. 1900, apprentice in lithographic workshops in Berne and Zurich. Studied at Zurich school of Applied Art. 1906-07, Munich, Paris, Strasbourg. 1909-12, student of Hoelzel in Stuttgart. Circle of young artists formed round him: Baumeister, Itten, Pellegrini, Schlemmer. 1912, moved to Amden artists' colony. 1928, appointed teacher at Zurich School of Applied Art. Died 1933 in Zurich.

*References:* O. Schlemmer, *Otto Meyer-Amden, Aus Leben, Werk und Briefen,* Zurich 1934. — Catalogue of exhibition at Basle Kunstmuseum, 1952.

MICHAUX, HENRI. Born 1899 in Namur, Belgium. Grew up in Brussels. 1924, moved to Paris. Known as a poet. Has done occasional drawing since the Second World War. Lives in Paris.

*Publications: Passages,* N.R.F.; *Le Point du Jour,* 1950.

*References:* M. Bense, 'Henri Michaux' in *Kunstwerk* April 1959, pp. 31-32.

MIDDLEDITCH, EDWARD. Born March 23, 1923 at Chelmsford, Essex. Studied at Royal College of Art, London. 1954, first exhibition at Beaux Arts Gallery, London. 1956, represented at Venice Biennale. Teaches at Chelsea Polytechnic and St. Martin's School of Art, London.

MIES VAN DER ROHE, LUDWIG. Born March 27, 1886 in Aix-la-Chapelle. Architect. 1905-07, studied in Berlin with Bruno Paul. 1908-11, assistant to P. Behrens in Berlin. 1912-14, independent architect in Berlin. 1914-18, served in Army. 1919-20, plans for large glass buildings in Berlin. 1927, director of the Werkbund exposition at Weissenhofsiedlung in Stuttgart. 1929, German pavilion of World Fair in Barcelona. 1930-33, director of Bauhaus at Dessau and in Berlin. 1938, move to U.S.A. Head of Architecture Department at Armour Institute in Chicago and since 1946 of Illinois Institute of Technology.

*Publication:* 'Baukunst und Zeitwille' in *Der Querschnitt,* 1924.

*References:* P. C. Johnson, *Mies van der Rohe,* Museum of Modern Art, New York 1947. — L. Hilbersheimer, *Mies van der Rohe,* Chicago 1956.

MILLARÈS, MANOLO. Born 1926 at Las Palmas in the Canary Islands. 1948, turned to Surrealism. 1952, *Pictografías canarias.* Editor of art review *Arqueros.* 1953, organised the exhibition *El dibujo en la joven pintura española.* Founder member of El Paso group in Madrid. 1955, moved to Madrid. 1957, showed at São Paulo Biennale. 1958, at Venice Biennale. Lives in Madrid.

*References:* C. L. Popovici, *Las arpilleras de Millares.* Madrid 1957; J. Gallego in *Goya* No. 9, 1955, pp. 197-203.

MINAUX, ANDRÉ. Born September 5, 1923 in Paris. Association with Buffet. Attracted attention by his Existentialist Realism. Lives in Paris.

MIRÓ, JOAN. Born April 20, 1893 at Montroig near Barcelona. From 1907, studied painting in Barcelona. 1919, trip to Paris and meeting with Picasso. 1925, showed at first Surrealist exhibition. Collaboration with Max Ernst. Influence of Klee. 1928, trip to Holland. 1931-32, sets for *Jeux d'Enfants* at Ballet de Monte Carlo. 1937, mural for Spanish pavilion at Paris World Fair. 1940, return to Barcelona. 1942, ceramic decorations. 1947, trip to U.S.A. Mural for Hotel Plaza in Cincinnati. 1948, return to Barcelona, where he lives and works. Frequent trips to Paris.

*References:* Greenberg, *Joan Miró,* New York 1948 (bibliography). — M. Leiris, *The Prints of Joan Miró,* New York 1947. — S. Hunter, *Joan Miró, His Graphic Work,* New York 1958. — J. T. Soby, Mus. Mod. Art, New York 1959.

MODERSOHN-BECKER, PAULA. Born February 8, 1876 in Dresden. 1888, moved to Bremen. 1892, London, began to learn drawing. 1896-97, attended private art school in Berlin. 1898-99, Worpswede, studied with Mackensen. 1900, first trip to Paris. 1901, married Otto Modersohn. Lived at Worpswede. Visits to Paris in 1903, 1905, 1906-07. Died November 30, 1907 at Worpswede.

*Publication: Briefe und Tagebuchblätter,* Munich 1921.

*References:* G. Pauli, *Paula Modersohn-Becker,* Berlin 1919. — Catalogue of Exhibition at Bremen Kunsthalle, 1947.

MODIGLIANI, AMEDEO. Born July 12, 1884 at Leghorn. Studied painting in Florence and Venice. 1906, moved to Paris. 1908, first contribution to Salon des Indépendants. 1909-10, brief stay in Italy. Friendship with Brancusi; sculpture. 1918, first group show at Berthe Weill gallery. Winter 1918-19, Nice and Cagnes. Died January 25, 1920 in Paris.

*Publication: Note e ricordi*. Genoa 1945 (with catalogue and bibliography).

*References:* A. Ceroni, *Modigliani*, Milan 1958. — J. Modigliani, *Modigliani senza leggenda*, Florence 1958. — C. A. Cingria, *Dessins de Modigliani*, Lausanne 1958. — On the sculpture, *Cahiers d'Art 25* (1950), p. 231.

MOHOLY-NAGY, LASZLO. Born July 20, 1895 at Basebarsod, Hungary. Studied law, then painting. 1919, influence of Malevich and Lissitsky. 1920-23, Berlin. 1923-28, master at Bauhaus. 1928-34, Berlin, active in film, photography, and theatre. 1934, Amsterdam. 1935-37, London. 1937, founded the New Bauhaus in Chicago. Died November 24, 1946 in Chicago.

*Publications: Malerei, Photographie, Film*, Bauhausbuch 1927. — *Vom Material zur Architektur*, Bauhausbuch 1929. — *The New Vision and Abstract of an artist*, New York 1947. — *Vision in Motion*, Chicago 1947.

*References: In memoriam Laszlo Moholy-Nagy*, Museum of Non-Objective Painting, New York 1947. — S. Moholy-Nagy, *Moholy-Nagy*, New York 1950.

MOILLIET, LOUIS. Born November 6, 1880 in Berne. 1900-03, studied with Mackensen at Worpswede. 1904, studied with Kalckreuth in Stuttgart. 1910, settled at Gunten on Thuner See. 1911, friendship with Macke. 1911-12, visited Klee in Munich. Association with Blaue Reiter painters. 1912, showed at Sonderbund exhibition in Cologne. 1913, Macke spent winter with him at Thuner See. 1914, trip to Tunisia with Klee and Macke. 1915-18, Switzerland. After 1919, extensive travels. 1934-36, windows for Lukaskirche at Lucerne. 1943-44, windows for Zwinglikirche at Winterthur. Lives at La-Tour-de-Peilz on Lake of Geneva.

*Reference:* Bibliography in Catalogue of Exhibition at Kunsthalle, Berne 1951.

MOLL, OSKAR. Born July 21, 1875 at Brieg. From 1897 in Berlin. Studied painting with Corinth, Leistikow, Hübner. Extensive travels in Europe and Near East. 1907-08, Paris. Friendship with Purrmann and Levy, co-founder of Matisse School. 1908-18, Berlin. Annual stays in Paris. 1912, trip to Corsica with Purrmann. 1918-31, teacher at Breslau Academy. 1932, Düsseldorf Academy. Dismissed as 'degenerate'. 1934, moved to Berlin. Died August 19, 1947 in Berlin.

*Publications:* A few letters in Catalogue of Memorial Exhibition, Dortmund 1950.

*Reference:* H. Braune, *Oskar Moll*, Leipzig 1921.

MONDRIAN, PIET. Born March 7, 1872 at Amersfoort, Holland. Studied at Amsterdam Academy. 1910, moved to Paris; association with Cubism. 1914, return to Holland. 1917, founding of the Stijl movement. 1918, return to Paris. 1920, published *Le Néo-Plasticisme*. 1938, moved to London. In Paris, participation in Abstraction-Création, in London, in the 'Circle'. October 1940, moved to New York. 'Boogie-Woogie' series. Died February 1, 1944 in New York. One man show at Whitechapel Art Gallery, 1958.

*Publications: Neue Gestaltung, Neoplastizismus*, Bauhausbuch 1925. — Collected articles in *Piet Mondrian, Plastic art and pure plastic art*, New York 1947.

*References:* Michel Seuphor, *Piet Mondrian*, Cologne 1956. — H. L. C. Jaffé, *De Stijl*, Amsterdam 1956.

MONET, CLAUDE. Born February 14, 1840 in Paris. Studied at Ecole des Beaux-Arts. Friendship with Renoir and Sisley. Influence of Courbet. 1871, trip to London with Pissaro. Influence of Turner. Elaboration of Impressionism. Played a leading part in first Impressionist Exhibition in 1874. 1883, settled at Giverny (Eure). Began the series: 1890-91, the 'haystacks', then the 'poplars', 'Rouen Cathedral', finally the *Nymphéas*. 1895, trip to Norway. 1901-03, stay in London. 1908, Venice. Died December 6, 1926 at Giverny.

*References:* G. Geffroy, *Claude Monet*, Paris 1922. — G. Clémenceau, *Claude Monet*, Paris 1928.

MONFREID, GEORGES DANIEL DE. Born March 14, 1856 in Paris. Impressionist. From 1890 belonged to circle round Gauguin with whom he carried on an important correspondence. Died November 26, 1929 in the Pyrenees.

*References:* Paul Gauguin, *Briefe an George Daniel de Monfreid*. Potsdam 1920.

MOORE, HENRY. Born July 30, 1898 at Castleford (Yorkshire). 1916, taught at elementary school. 1917, wounded in war. 1910-21, scholarship at Art School in Leeds. Then study at Royal College of Art in London. 1925, grant to travel in France and Italy. On return, taught at Royal College and at Chelsea Art School. Frequent trips to Paris, Spain, Italy, and 1951, Greece. Teacher at Slade School and Chelsea School of Art. 1948, sculpture prize at Biennale. Lives in Much Hadham, Herts.

*References:* J. J. Sweeney, *Henry Moore*, Museum of Modern Art, New York 1946. — H. Read, *Henry Moore*, New York-London 1949, vol. 2 1955. — W. Grohmann, *Henry Moore*, Berlin 1960.

MORANDI, GIORGIO. Born July 20, 1890 in Bologna. Study in Bologna. 1912, vague association with Futurists. 1914, influence of Cézanne and Cubism. From 1916, the series of still lifes. 1918-20, joined Pittura Metafisica and some connection with *Valori Plastici* (1922). Since 1930, teacher at Bologna Academy. 1948, grand-prize for painting at Biennale.

*References:* A. Beccaria, *Giorgio Morandi*, Milan 1939. — C. Gnudi, *Giorgio Morandi*, Florence 1946.

MOREAU, GUSTAVE. Born April 6, 1826 in Paris. Influenced at first by Chassériau. 1858-60, Italy. Association with Puvis de Chavannes in Rome. 1885,

402

trip to Holland where he studied Rembrandt. Influence of Pre-Raphaelites. Died April 18, 1898.

*Reference:* G. Geoffroy, *L'œuvre de Gustave Moreau*, Paris 1900.

MORENI, MATTIA. Born November 12, 1920 at Pavia. Studied with Casorati at Turin Academy. Lives in Bologna and Paris.

*References: Cahiers d'Art* 27 (1952), p. 253; L. Venturi, *Otto Pittori Italiani*, Rome 1955.

MORGNER, WILHELM. Born January 27, 1891 at Soest (Westphalia). 1908, at Worpswede studying with Tappert. 1911, some time in Berlin in Neue Sezession circle. 1912, association with Blaue Reiter and Sturm. Entered Army autumn 1913. Killed in August 1917.

*References:* H. Seiler, *Wilhelm Morgner*, Recklinghausen 1958. — Catal. of one-man show at Städtisches Museum, Wuppertal 1958 (bibliography).

MORISOT, BERTHE. Born January 14, 1841 at Bourges. Studied in Paris. Pupil of Corot. Friendship with Fantin-Latour and Manet. From 1873, connected with Impressionists. 1881-82, travels in Italy. Died March 2, 1895 in Paris.

*Publication:* The Correspondence of Berthe Morisot, ed. D. Rouart. London 1960.

*Reference:* A. Fourreau, *Berthe Morisot*, Paris 1925.

MORLOTTI, ENNIO. Born September 21, 1910 at Lecco (Lombardy). Studied with Achille Funi. Member of Corrente and Fronte Nuovo delle Arti. Lives in Milan.

*Reference:* G. Testori, *Morlotti*, Ivrea 1957.

MOSES. See Grandma Moses.

MOTHERWELL, ROBERT. Born in 1915 in Aberdeen, Washington. Studied philosophy at Harvard University. 1938, studied in Grenoble and Paris; began to paint. From 1939, association with group of European Surrealists in New York. Friendship with Matta with whom he spent six months in Mexico. Belonged to group including Pollock, Gorky, De Kooning, Baziotes. 1944, first one-man show at Art of this Century (Peggy Guggenheim) Gallery. Since 1946, annual exhibitions at Kootz Gallery. 1947-48, co-editor of *Possibilities*. 1948, founded an art school with Newman, Rothko, and Baziotes. 1951, became editor of 'The Documents of Modern Art' series and in 1952 of 'Modern Artists in America'. 1954-55, travels in Europe. Since 1951 has been teaching at Hunter College in New York. Lives in New York.

*Publications:* See *Arts and Architecture*, Vol. 68, September 1951; *The Catholic Art Quarterly*, Vol. 14, Spring 1951; *Partisan Review*, Vol. 11, Winter 1944.

*References:* Clement Greenberg in *Partisan Review*, Vol. 22, 1955, p. 179 ff. — E. C. Goossen, in *Art International*, Vol. 3, 1959.

MUCHE, GEORG. Born May 8, 1895 at Querfurt. 1912-15, studied in Berlin and Munich. 1916-20, teacher at Sturm Art School in Berlin. 1920-27, master at Bauhaus. 1927-31, teacher at Itten's art school in Berlin. 1931-32, taught at Breslau Academy. 1933-38, Berlin, Since 1939, teacher at textile school in Krefeld.

*Publications: Buon Fresco*, Tübingen 1939. — *Die Kunst stirbt nicht an der Technik,* private printing of a lecture delivered in January 1954.

*Reference: Georg Muche, Fresken, Zeichnungen,* Tübingen 1950.

MÜLLER, OTTO. Born October 16, 1874 at Liebau (Silesia). 1890-95, apprenticed to lithographer in Breslau. 1896-98, studied art in Dresden. 1898-1908, lived in Riesengebirge. 1908, moved to Berlin. 1911, joined Brücke. 1912, with Kirchner in Bohemia. 1915-18, served in Army. 1919-30 taught at Breslau Academy. Died September 24, 1930 in Breslau.

*Reference:* E. Troeger, *Otto Müller*, Freiburg 1949.

MUNCH, EDVARD. Born December 12, 1863 at Loeiten, Norway. 1881-84, studied in Oslo. 1885, first stay in Paris. Winter 1889, long stay in Paris. Association with Toulouse-Lautrec, Gauguin, Van Gogh. Trip to Germany. 1891, travels in France and Italy. 1892, exhibition at Verein Berliner Künstler, closed after a few days. 1895, contributed to *Pan*. In Paris, the first lithos. 1896, first woodcuts. Sets for Théâtre de l'Oeuvre. 1897, *Frieze of Life* shown at Indépendants. 1898-1901, travels in Germany. 1902, exhibition at Berliner Sezession. 1903-04, second *Frieze of Life* for Mr. Linde at Lübeck. 1906, Reinhard ordered a third *Frieze of Life* for entrance to Berliner Kammerspiele. 1908-09, psychiatric clinic in Copenhagen. 1905-15, murals for the hall of Oslo University. 1920-22 trips to Berlin, Paris, Italy. Died January 23, 1944 on Ekely. One man show at Tate Gallery.

*References:* J. P. Hodin, *Edvard Munch*, Stockholm 1948. — F. B. Deknatel, *Edvard Munch*, Mus. Mod. Art, New York 1950. — On graphic work: G. Schiefler, *Verzeichnis des graphischen Werkes*, Berlin 1907 and 1927. — P. Gauguin, *Graphikeren Edward Munch*, 2 vols. Trondhheim 1946.

MÜNTER, GABRIELE. Born February 19, 1877 in Berlin. From 1901, studied art in Munich. 1902, studied with Kandinsky at Phalanx Art School. 1904-08 travels with Kandinsky. From 1908 with Kandinsky at Murnau. 1909, member of Neue Künstler-Vereinigung, Munich. Joined Blaue Reiter. 1914 to 1920 Scandinavia. 1920, return to Germany. Since 1931 at Murnau (Upper Bavaria).

*References:* J. Eichner, *Kandinsky und Gabriele Münter*, Munich 1957. — H. K. Röthel, *Gabriele Münter*, Munich 1957.

NASH, PAUL. Born May 11, 1889 in London. Father a lawyer. 1906-07 studied at Chelsea Polytechnic, 1910 Slade School. 1914, connected with Fry's Omega Workshops. 1914-17, served in Army. 1917-18, Official War Artist. 1918, exhibition of war pictures at Leicester Gallery. 1919, member of New English Art Club. 1922, visit to Paris. 1926, 1932, 1938 showed at Biennale. 1933, founding member of 'Unit 1'. 1936, showed at International Surrealist Exhibition in London. 1938, showed at Internatio-

nal Surrealist Exhibition in Paris. 1940-45, Official War Artist. Specialised in pictures of aerial warfare. Died July 11, 1946. Memorial exhibition at Tate Gallery in 1948.

*Publications: Outline: an autobiography and other writings,* London 1949. — *Poet and Painter, Correspondence,* Oxford University Press, 1955. — *Fertile Image,* London 1951.

*Reference:* A. Bertram, *Paul Nash,* London 1923 and 1955; — H. Read, *Paul Nash,* London 1944. — Margot Eates, *Paul Nash,* London 1948.

NAUEN, HEINRICH. Born June 1, 1880 in Krefeld. Studied in Düsseldorf, Munich, Stuttgart. 1902-05 in Flanders and Lower Rhineland. 1905-11, Berlin, then at Dillborn near Brüggen (Rhineland). 1912-14, murals at Drove Castle near Düren. 1920-36, taught at Düsseldorf Academy. Died November 26, 1941 at Kalkar.

*Reference:* P. Wember, *Heinrich Nauen,* Düsseldorf 1948.

NAY, ERNST WILHELM. Born June 11, 1902 in Berlin. 1925-28, study with Hofer in Berlin. 1928, Paris. 1930, Prix de Rome and stay in Italy. 1936-37, Norway. 1939-44, fought in war. 1942-44, stationed at Le Mans, where he was able to paint. 1945-51, at Hofheim (Taunus). Has lived in Cologne since 1951.

*Publications: Vom Gestaltwert der Farbe,* Munich 1955.

*References: Kat. der Kestner-Gesellschaft,* Hanover, April 1950. — W. Haftmann, *Ernst Wilhelm Nay,* Cologne 1960.

NESCH, ROLF. Born January 7, 1893 at Oberesslingen (Württemberg). Studied in Dresden. 1914-20, war and imprisonment. 1920-23, Dresden. 1924, visit to Kirchner at Davos. 1926-27, Berlin. 1927-30, Esslingen. 1930-33, Hamburg. 1933-51, Oslo. Friendship with Munch. Has been living at Aal, Norway, since 1951.

*Reference: Kat. der Kestner-Gesellschaft,* Hanover 1949/50.

NEVINSON, C. R. W. Born August 13, 1889. 1908-12, attended Slade School. 1911-12, Paris. Encounter with Cézanne's painting and Cubism. 1912, encounter with Futurism on the occasion of the Futurist exhibition in London. 1913, friendship with Marinetti, Severini, and Lewis. 1914, collaborated with Marinetti on the Futurist manifesto *Vital English Art.* Member of the London Group. 1914-16, fought in Flanders. 1915, showed at Vorticist Exhibition. 1916, exhibition of his Futurist war pictures at Leicester Gallery. 1917, Official War Artist. 1918, first examples of aerial painting. Exhibition of his war pictures. 1922, exhibition in New York, which he attended. 1939, Associate of Royal Academy. Died in 1946, in London.

*Publications: Paint and Prejudice,* London 1937 (Autobiography).

*Reference:* O. Sitwell, *C. R. W. Nevinson,* London 1925.

NEWMAN, BARNETT. Born 1905 in New York. 1922-26, studied at Art Students' League in New York. 1948, founded a school of painting with Baziotes, Motherwell, and Rothko. Lives in New York.

*Reference: The New American Painting,* Museum of Modern Art, New York 1959, p. 60.

NICHOLSON, BEN. Born April 10, 1894 in Durham. Son of the painter William Nicholson. 1911, attended Slade School. 1911-14 in France, Italy, Madeira. 1914-17, in London and North Wales. 1917-18, California. 1920-31, London and Cumberland. 1922, first one-man show. Married Barbara Hepworth. 1933-35, membership of 'Unit 1'. Member of Abstraction-Création. 1936, exhibition at Museum of Modern Art in New York. 1937, edited *Circle* in collaboration with Naum Gabo. 1940-55 lived at St. Ives in Cornwall. 1952, Carnegie Award. 1954, one-man show at Biennale. 1956, International Award of Guggenheim Foundation. 1957, Prize of the São Paulo Biennale. 1957, visit to the U.S.A. Has been living since 1958 at Ronco (Ticino), Switzerland.

*Publications:* 'Aims of the Modern Artist' in *The Studio,* December 1932, p. 333. — Statement in *Unit 1,* London 1934, pp. 88-94. — 'Notes on Abstract Art' in H. Read, *Ben Nicholson,* Vol. 1, London 1955, pp. 23-27.

*References:* H. Read, *Ben Nicholson,* 2 vols. London 1948, (1955) and 1956. — J. P. Hodin, *Ben Nicholson,* London 1957.

NOLDE, EMIL (EMIL HANSEN). Born August 7, 1867 at Nolde-Schleswig. 1884-1888, School of Applied Art at Flensburg. 1889, study in Karlsruhe. 1892-98, taught at technical school in St. Gall. 1899, studied with Hoelzel at Dachau. 1898-1906, in Munich, Paris (1899), and Copenhagen. From 1906 in Berlin. 1906-08, member of the Brücke. 1909, beginning of religious pictures. 1910, stay in Hamburg. Founding of the Neue Sezession in Berlin. 1911, trip to Netherlands. Meeting with Ensor. 1912, association with Blaue Reiter. 1913-14, trip to Far East and South Seas. After the war, moved back and forth between Berlin and his estate at Seebüll. 1933, denounced as 'degenerate'. 1941, forbidden to paint. Died April 13, 1956 at Seebüll.

*Publications: Das eigene Leben,* Berlin 1931 and Flensburg 1949. — *Jahre der Kämpfe,* Berlin 1934. — Letters, ed. Sauerlandt, Berlin 1927.

*References:* M. Sauerlandt, *Emil Nolde,* Berlin 1922. — W. Haftmann, *Emil Nolde,* London 1960. — On the graphic work: G. Schiefler, *Das graphische Werk Emil Noldes,* Berlin 1911 and 1927.

OBRIST, HERMANN. Born May 23, 1863, Zurich. Sculptor and leader of applied art movement. Studied in Karlsruhe, Weimar, Paris. 1892, founded an embroidery workshop in Florence. From 1894, lived in Munich. One of the chief promoters of art nouveau. Died February 26, 1927.

*Publication: Neue Möglichkeiten in der bildenden Kunst,* Jena 1903.

*References:* W. C. Behrend, *Der Kampf um den Stil im Kunstgewerbe und in der Architektur,* 1920. — Peter Floud, 'Art Nouveau', *The Burlington Magazine,* Vol. 94, 1952, pp. 322-325.

O'KEEFFE, GEORGIA. Born in 1887 at Sun Prairie, Wisconsin. 1904, studied at Art Institute of Chicago and 1907, at Art Students' League in New York. 1916, first exhibition at Stieglitz gallery. 1924, marriage to Stieglitz. From 1926, regular exhibitions at Stieglitz's galleries. 1929, moved to Taos, New Mexico. 1943, large one-man show at Art Institute of Chicago. 1950, first trip to Europe. Lives mostly in New Mexico.

*Reference:* D. C. Rich, 'Georgia O'Keeffe' in Catalogue of Exhibition at Art Institute of Chicago, 1943.

OPHEY, WALTER. Born March 25, 1882 at Eupen. Studied in Düsseldorf. 1911, stay in Paris. At first under influence of Neo-Impressionism. Died January 11, 1930 in Düsseldorf.

*Reference:* G. Rehbein, *Walter Ophey*, Recklinghausen, 1958.

OROZCO, JOSÉ CLEMENTE. Born November 23, 1883 at Ciudad Cuzmán, Mexico. Trained as agronomist. 1908-15 studied at Academy in Mexico City. Influence of Indian folklore. 1913, at outbreak of revolution, political caricaturist. Friendship with Rivera and Siqueiros. From 1923, large murals. 1930-34, in U.S.A. and trip to Europe. Died 1949 in Mexico City.

*Publications: Autobiografia,* Mexico City 1945. — *Textos di Orozco,* Mexico City 1955.

*References:* J. Fernandes, *José Clemente Orozco,* Mexico City, 1942. — A. Reed, *Orozco,* New York 1956.

OUD, J. J. P. Born February 9, 1890 in Pumerend, Holland. Architect. Study in Amsterdam and Delft. 1911, studied in Munich under Fischer. Influence of Frank Lloyd Wright. 1917, co-founder of Stijl movement. 1918, municipal architect of Rotterdam. Spokesman of the strict Dutch trend in architecture.

*Publication: Holländische Architektur,* Bauhausbuch 1926.

*References:* H. R. Hitchcock, *J. J. P. Oud,* Paris 1931. — G. Veronesi, *J. J. P. Oud,* Milan 1953.

OUDOT, ROLAND. Born July 29, 1897 in Paris. Studied in Paris. Exhibited from 1919. Rug designs for Manufactures d'Aubusson. Lives in Paris.

*Reference:* C. Roger-Marx, *Roland Oudot,* Geneva 1952.

OZENFANT, AMÉDÉE. Born April 15, 1886 at Saint-Quentin. Started out under influence of Segonzac. 1915, founded *l'Elan.* 1918, with Le Corbusier founded Purist movement. 1920, edited *L'Esprit Nouveau.* Engaged chiefly in teaching, in Paris, London, New York. 1939, moved to New York.

*Publications: Après le cubisme,* 1918. — *La peinture moderne,* Paris 1925. — *Art,* 1928.

*References:* K. Nierendorf, *Amédée Ozenfant,* Berlin 1931. — *Cahiers d'Art* 2 (1927), p. 156; 3 (1928), p. 437; 22 (1947), p. 154.

PASCIN, JULES (PINCUS). Born March 31, 1885 at Vidin, Bulgaria. Studied in Vienna and Munich. 1903, Munich. Drawings for *Simplicissimus.* 1905,

moved to Paris. 1914, to New York. Acquired American citizenship. 1924, trip to Spain and North Africa. From 1928 lived in Paris. Committed suicide June 20, 1930.

*References:* André Warnod, *Pascin,* Monte Carlo 1954. — P. d'Ancona, *Modigliani, Chagall, Soutine, Pascin,* Milan 1952.

PASMORE, E. VICTOR. Born December 3, 1908 at Chelsham, Surrey. Father a physician. Self-taught. Attended night classes at the Central School. Worked in an office up to 1938. 1928-35, influence of Fauvism, Cubism, abstract painting. 1933, member of London Group. Friendship with Coldstream and Graham Bell. 1934, member of Objective Abstraction. 1937-39 helped to found Euston Road School, where he also taught. 1947, beginning of a new abstract period. 1948, experiments with collages. 1949-50, pictures with spiral motifs. 1951, beginning of three-dimensional constructions inspired by Gabo. Since 1954 has been teaching at Durham University.

*Publications:* 'A Note on Abstract Painting' in the catalogue of his exhibition at Redfern Gallery, London, December 1948. — 'The Artist Speaks' in *Art News and Review,* February 24, 1951. — 'Statement' in Alloway, *Nine Abstract Artists,* London 1954.

*References:* C. Bell, *Victor Pasmore,* Penguin Books, 1945. — J. Reichardt, 'Victor Pasmore' in *Art News and Review,* September 27, 1958. — A. Ehrenzweig in *Quadrum* IV. 1957, S. 51-60.

PECHSTEIN, MAX. Born December 31, 1881 at Zwickau. Apprenticed to painter. 1900, studied in Dresden. 1906, meeting with Heckel and Kirchner. Member of the Brücke. Lives since 1908 in Berlin. Member of Neue Sezession in Berlin. 1913-14 trip to Palau Islands. 1916-17, served in Army. From 1919, Berlin. 1923, teacher at Berlin Academy. 1933, dismissed. From 1945, again teacher at Berlin Academy. Died June 29, 1955 .

*Publications:* See *Künstlerbekenntnisse,* ed. Westheim. — 'Ruf an die Jugend' in *Aussaat,* Stuttgart 1946.

*References:* M. Osborn, *Max Pechstein,* Berlin 1922. — P. Fechter, *Das Graphische Werk Max Pechsteins,* Berlin 1921.

PERMEKE, CONSTANT. Born July 31, 1886 in Antwerp. Studied at Academies of Bruges and Ghent. 1912-14, Ostend. 1914, wounded in War, evacuated to England. 1918. return to Belgium. 1936, took up sculpture. Died 1952 at Ostend.

*Reference:* E. Langui, *Constant Permeke,* Antwerp 1947.

PEVSNER, ANTOINE. Born January 18, 1886 in Orel, Russia. Studied in Kiev and St. Petersburg. 1911, trip to Paris. 1913-14, stay in Paris. Friendship with Archipenko. Influence of Cubism. 1914, moved to Norway with his brother Naum Gabo. 1917, Moscow. Collaboration with Tatlin and Malevich. 1921, moved to Germany and in 1923 to Paris. Since 1946, a leading member of the Salon des Réalités Nouvelles. Lives in Paris.

*References:* H. Read, *Naum Gabo — Antoine Pevs-ner*, Museum of Modern Art, New York 1948. — R. Massat, *Antoine Pevsner et le constructivisme*, Paris 1956.

PICABIA, FRANCIS. Born January 22, 1878 in Paris. Studied in Paris at Atelier Cormon. 1909, connection with Cubism. 1911-12, participated in founding of Section d'Or. 1912-13, trip to U.S.A. Met Stieglitz. 1915, second trip to U.S.A. Collaborated with Duchamp and contributed to magazine *291*. End of 1916, Barcelona. 1917, publication of *391*. Return to U.S.A. 1918, stay in Lausanne. Associated with Dada group in Zurich. 1919, moved to Paris. From 1924 in active contact with Surrealists. 1926, return to representational painting. 1940-45, southern France. 1945, Paris. Return to abstract painting. 1949, one-man show at Gal. Drouin in Paris. Died December 1953.

*Publication: Poèmes et dessins de la fille née sans mère*, 1918.

*Reference:* Marie de la Hire, *François Picabia*, Paris 1930. — *DADA, the Dadaist Painters and Poets*, ed. R. Motherwell, New York 1950. — G. Hugnet, *Aventure Dada*, Paris 1957.

PICASSO, PABLO (PABLO RUIZ PICASSO). Born October 25, 1881 in Malaga. Studied in Barcelona. 1900, first visit to Paris. 1901 and 1902, further visits to Paris. Friendship with Max Jacob. Beginning of 'blue period'. 1903, Barcelona. 1904, moved to Paris for good. 1905, friendship with Apollinaire. Beginning of 'rose period'. 1906, meeting with Matisse, Braque and Kahnweiler. Began *Les Demoiselles d'Avignon*. 1909, summer at Horta de Ebro. Beginning of Analytical Cubism. 1911, summer at Céret with Braque. 1912, first 'papiers collés' and beginning of Synthetic Cubism. 1913, summer at Céret with Gris. 1917, trip to Rome and work for Diaghilev. 1920, 'Neo-Classical Period'. 1925-27, influence of Surrealism. 1928, summer at Dinard. 1934, long stay in Spain. 1935, Surrealist writings. 1937, *Guernica* for the Spanish pavilion at World Fair. During the war, the over life-size sculpture *Man with the sheep*. 1946, founded pottery works at Vallauris near Nice. 1947-50, intense graphic work. 1953, one-man shows in Rome and Milan. 1955/56, extensive itinerant show in Paris (Musée des arts décoratifs), Cologne, Munich, Hamburg. Living since 1947 in South of France.

*Publications:* See Bibliography in Barr.

*References:* C. Zervos, *Picasso (Cahiers d'Art)*. — A. H. Barr, *Picasso, Fifty years of his art*. Museum of Modern Art, New York 1946. — W. Boeck, *Picasso*, Stuttgart 1955. — On the sculpture, D. H. Kahnweiler, *Les sculptures de Picasso*, Paris 1949. — On the ceramic work: Special number of *Cahiers d'Art*, 1948. — On the lithographs: F. Mourlot, *Picasso, lithographe 1919-47* (catalogue), Monte Carlo 1949.

PICKETT, JOSEPH. Born in 1848 at New Hope, Pa. Owned a general store and shooting gallery at New Hope. Began to paint at the age of 65. Died at New Hope. Discovered in 1930 by Holger Cahill, who showed two of his pictures at the 'American Primitives' exhibition in the Newark Museum.

*Reference:* Sidney Janis, *They Taught Themselves*, 1942, pp. 110-116.

PIGNON, EDOUARD. Born February 12, 1905 at Marles-les-Mines (Pas-de-Calais). Began life as a miner. From 1927, in Paris. Evening classes in art. Since 1940 represented in all exhibitions of young independent painters in Paris. At first influenced by Matisse, then by Picasso. Lives in Paris.

*Reference:* H. Lefebvre, *Pignon*, Paris 1956.

PIPER, JOHN. Born December 13, 1903 at Epsom. Father a lawyer. 1926-30, studied at Royal College of Art and Slade School. 1933, Paris, where he met Hélion, Braque, Léger, and Brancusi. Turned to abstract art. Joined London group. Contributed to *Axis*, the organ of English abstract art. 1938, first one-man show at London Gallery. 1940-42, Official War Artist. Since 1951 has done sets for several plays and ballets.

*Publications: Wind in the Trees*, 1924; *British Romantic Artists*, London 1942. — *Buildings and Prospects*, London 1948.

*Reference:* John Woods, *John Piper*, London 1955.

PISIS, FILIPPO DE. Born May 11, 1896 in Ferrara. After brief contact with Pittura Metafisica in 1918-19 developed an Impressionist lyricism based on Manet and Guardi. 1920-40, in Paris. Active also as a poet and critic. Lived in Venice and Paris. Died April 2, 1956.

*Publications: Prose e articoli*, Milan 1947.

*References:* S. Solmi, *Philippo de Pisis*, Milan 1941. — Catalogue of exhibition at Castello Estense, Ferrara, 1951. — G. Raimondi, *Philippo de Pisis*, Florence 1952.

PISSARRO, CAMILLE. Born July 10, 1831 on St. Thomas (West Indies). From 1855, studied in Paris. Meeting with Corot. 1857, friendship with Monet. 1866, acquaintance with Manet and shift to plein-airism. 1871, trip to London. Impact of Constable. 1873, friendship with Cézanne. From 1874, participation in Impressionist exhibitions. 1883, acquaintance with Gauguin. 1884, association with Seurat, adopted the technique of the Neo-Impressionists. Died November 13, 1903 in Paris.

*Reference:* L. Pissarro and L. Venturi, *Camille Pissarro, son art, son œuvre*. 2 vols. Paris 1939.

PISSARRO, LUCIEN. Eldest son of Camille Pissarro. Born February 20, 1863, in Paris. 1870 and 1883, trips to London. 1890, moved to London. 1894, founded Eragny Press. Active as a printer of books up to 1914. 1906, member of New English Art Club. 1911, member of 'Camden Town Group'. 1913, first one-man show at Carfax Gallery, London. Since 1934 showed at the exhibitions of the Royal Academy. Died July 10, 1944.

*Publication: Notes on the Eragny Press*, London 1957.

*Reference: Camille Pissarro, Letters to his son Lucien*, London 1943.

PIZZINATO, ARMANDO. Born October 7, 1910 at Maniago (Udine). Member of Fronte Nuovo delle arti.

Developed an abstract style based on expressive, Futurist tendencies. Since 1948, neo-realistic paintings in the style of Socialist Realism. Lives in Venice.

*Reference:* G. Ghiringhelli, *Pittura moderna italiana,* Turin 1949.

POLIAKOFF, SERGE. Born 1906 in Moscow. Travels in southern Russia including the Caucasus. 1919 emigrated. Travelled with his aunt, the singer Nastia Poliakoff, whom he accompanied on the guitar, to Constantinople, and later to Sofia, Belgrade, Vienna, Berlin, and Paris. 1923, settled in Paris, where he made his living playing the guitar. 1930, studied at Académie Frochot, Grande Chaumière. 1935, moved to London. Worked at Slade School. 1937, in Paris, meeting with Kandinsky. 1938, regularly attended gatherings of painters at the studio of Sonja and Robert Delaunay. 1945, first one-man show at L'Esquisse Gallery. 1947, Kandinsky Prize. 1952, deeply impressed by Malevich's painting. 1953, one-man show at Palais des Beaux Arts in Brussels. Lives in Paris.

*References:* M. Ragon, *Poliakoff,* Le Musée de Poche, Paris 1956; — D. Vallier, *Serge Poliakoff,* Ed. Cahiers d'Art, Paris 1959.

POLLOCK, JACKSON. Born on January 28, 1912 at Cody, Wyoming. Spent his childhood in Arizona and California. 1925, started art school in Los Angeles. 1929, moved to New York and studied under Thomas Benton at Art Students' League. 1938, WPA Art Project. 1942, represented at International Surrealist Exhibition in New York. Associated with the New York Surrealist Group and with De Kooning, Motherwell, Matta, and Baziotes. 1943, first one-man show at Art of this Century gallery. 1946, moved to Easthampton, N.Y. 1948, shown with Peggy Guggenheim's collection in Venice, Florence, Milan, Amsterdam, Brussels, and Zurich. 1950, first one-man show in Europe (Venice and Milan) and represented at Venice Biennale. Killed in a car accident on August 11, 1956.

*Publications:* See *Arts and Architecture,* February 1944; *Possibilities* I, 1947-48, p. 4.

*Reference:* Frank O'Hara, *Jackson Pollock,* New York 1959.

PRAMPOLINI, ENRICO. Born April 20, 1894 in Modena. 1911, study in Rome. From 1912, member of Futurist movement. 1919, member of November group. Joined Section d'Or in 1922 and Abstraction-Création in 1931. Signed manifesto of Aeropittura in 1929. 1925-37, Paris. Died June 18, 1956 in Rome.

*Publications:* See *Archivi del Futurismo,* Rome 1958.

*References:* E. Pfister, *Enrico Prampolini,* Milan 1940. — P. Courthion, *Enrico Prampolini,* Rome 1957.

PRENDERGAST, MAURICE. Born 1859 in St. John's, Newfoundland. Grew up in Boston. 1886-89, studied in Paris at Académie Julian. 1898, saw paintings by Cézanne in Paris. 1908, participated in 'The Eight' exhibition. 1909-16, lived in France. 1913,

represented at Armory Show. 1916, returned to New York. Died in New York in 1924.

*Reference:* Catalogue of Maurice Prendergast exhibition at Addison Gallery of American Art, 1938.

PURRMANN, HANS. Born April 10, 1880 at Speyer. After apprenticeship as decorator, 1898-1900 School of Applied Art in Karlsruhe. 1900-05, studied under Stuck at Munich Academy. 1906-14, Paris. Founded Matisse School in Paris with Lévy and Moll. 1916-29, Berlin. 1935, director of Villa Romana in Florence. 1943, moved to Lugano. Lives at Montagnola, Switzerland.

*Publications: Kunst und Künstler* 1922, 1928-33; *Werk,* 1946, 1947, 1949.

*Reference:* E. Hausen, *Hans Purrmann,* Berlin 1950.

PUY, JEAN. Born November 8, 1876 in Lyons. Studied in Lyons and from 1898 in Paris at Académie Julian. Association with Matisse. Belonged to first group of Fauves. Lives at Roanne (Loire).

*References:* G. Duthuit, *Les Fauves,* Geneva 1949. — *Jean Puy, Art-Documents,* No. 104, Geneva 1959.

RADICE, MARIO. Born August 1, 1900 at Como. Self-taught. Joined Futurist movement. From 1930, one of the promotors of Italian abstract painting. Edited magazines *Quadrante* and *Valori Primordiali.* Lives at Como.

*Reference: Cahiers d'Art* 25 (1950).

RANSON, PAUL. Born 1862 in Limoges. 1880 study at Académie Julian. Joined Nabis. 1892, worked with Bonnard, Vuillard, Sérusier on decorations for Théâtre d'Art. 1893-94, lithographs for *Revue Blanche.* 1895, tapestries. 1897, showed in Nabi exhibition at Vollard gallery. 1908, founded Académie Ranson with support of Nabis. Died February 20, 1909 in Paris.

*Publications:* 'L'Abbé Prout', *Mercure de France,* Paris 1902.

*Reference:* M. Denis 'Paul Ranson', in *Théories,* Paris 1920. — A. Humbert, *Les Nabis et leur époque 1888-1900,* Geneva 1954.

RAY, MAN. Born 1890 in Philadelphia. Studied architecture and engineering. 1908, took up study of painting at National Academy of Design in New York. 1915, friendship with Duchamp. 1917, joined Picabia and Duchamp in New York Dada movement. 1920, organised the Société Anonyme with Duchamp and Katherine Dreier. From 1921, experiments with photography. Rayograms. Lived in Paris from 1921 to 1940. Took part in French Surrealist movement. Worked also as a photographer. 1940, returned to U.S.A. and settled in Hollywood. 1951, moved to Paris, where he lives.

*Publications: Revolving Doors, New* York, 1916; *Les champs délicieux,* Paris 1921-22; *To be continued unnoticed,* Beverly Hills, 1948; *Alphabet for Adults,* Beverly Hills, 1948.

*Reference:* P. Waldberg in *Quadrum* (Brussels) VII, 1959, pp. 91-102.

REDON, ODILON. Born April 20, 1840 in Bordeaux. 1858, Paris, studied at Atelier Gérome. 1863, first engravings, influence of Rembrandt. 1870, friendship with Fantin-Latour, who taught him lithography. Trip to Holland. 1879, the ten lithos for *Dans le Rêve*. 1884, showed at first Salon des Indépendants. 1883-89, exclusively graphic work. 1891, close association with Symbolist poets, particularly Mallarmé. 1899, exhibition at Galerie Durand Ruel. From then on, chiefly painting with preference for pastel. From 1909, lived in retirement at Bièvres near Paris. Died July 6, 1916 in Paris.

*Publications:* Odilon Redon, *A soi-même, Journal* (1867-1915). Paris 1922. — *Lettres*, Paris 1923. — *Lettres à E. Bernard*, Brussels 1942.

*References:* A. Mellerio, *Odilon Redon*, Paris 1923 (Catalogue of graphic work). — M. and A. Leblond, *Odilon Redon*, Paris 1941. — R. Bacou *Odilon Redon*, 2 vols. Geneva 1956.

REGGIANI, MAURO. Born August 11, 1897 at Nonantola (Modena). Studied in Florence. Has been living in Milan since 1925. Belonged to the first group of Italian abstract painters. Under influence of Morandi, representational painting for a brief period c. 1940, followed by a return to concrete art.

*Reference: Cahiers d'Art* 25 (1950), p. 261. — Ponente, 'Mauro Reggiani', in *I 4 Soli*, Turin, November 1955.

RENOIR, AUGUSTE. Born February 25, 1841 in Limoges. 1845, moved to Paris. 1854-61 worked as porcelain painter. First studies at Louvre. 1861-69, Ecole des Beaux-Arts. Meeting with Monet, Sisley, Cézanne. Influence of Courbet. 1874-77, belonged to Impressionist group and participated in its exhibitions. 1881-82, travels in Italy. 1894, began to suffer from gout. Also did sculpture in the last years of his life. Died December 2, 1919 at Cagnes (Alpes Maritimes).

*References:* J. Meier-Graefe, *Renoir*, Paris 1912. — A. Vollard, *Renoir*, New York 1925 and Paris 1954. — P. Haesserts, *Renoir's Sculpture*, New York 1947. — J. Rewald, *Renoir Drawings*, London, New York 1958. — F. Daulte, *Auguste Renoir, watercolours, pastels, drawings*, London 1959.

RHO, MANLIO. Born February 5, 1901 at Como. Since 1932 one of the leading abstract painters in Italy. Lives at Como.

*Reference: L'Arte* LI, 1948/51, p. 56.

RICHTER, HANS. Born 1888 in Berlin. 1913, first contact with Sturm. 1915-16, fought in war. From 1914, influence of Cubism and from 1916, association with Dadaism. 1917, first abstract work. 1918, meeting and collaboration with Eggeling. 1920, member of Novembergruppe. Association with De Stijl and Constructivism. 1921, first abstract film, *Rhythmus 21*. In ensuing period active chiefly in avant-garde cinema. Moved to France in 1933. Moved to U.S.A. in 1941. Lives in New York and teaches at City College. 1947, in collaboration with Duchamp, Ernst, Léger, Man Ray, and Calder, produced film *Dreams that Money can Buy*.

*Publication:* see *Magazine of Art*, February 1952. *Reference:* Seuphor, *L'Art abstrait*, Paris 1949.

RIOPELLE, JEAN-PAUL. Born 1924 in Montreal, Canada. 1940-42, studied mathematics at Montreal Polytechnic. Began to paint 1945, did his first non-objective work under the influence of Breton's *Surréalisme et la Peinture*. 1946, trips to France, Germany, New York. 1947, moved to Paris. Exhibited at Salon de Mai and elsewhere. 1951 shown at São Paulo Biennale. Lives in Paris.

*References:* G. Duthuit in Catalogue of Riopelle exhibition at Galerie Rive Droite, Paris 1954; *Preview* 47-48, July-October 1959, Vol. XII, pp. 448-450.

RIVERA, DIEGO. Born December 8, 1886 at Guanajuato, Mexico. 1898-1904, studied in Mexico City. 1907, received grant to study in Europe. Studied in Madrid and 1909 in Paris. Association with Cubism, travels in Italy, Germany, and Russia. 1921, return to Mexico where the New Socialist government commissioned him to do monumental frescoes. He was the pioneer of the monumental art of the new Mexican school. Died November 25, 1957 in Mexico City.

*Reference: Diego Rivera, 50 Años de su labor artistica*, Mexico City 1951.

ROBERTS, WILLIAM P. Born June 5, 1895 in London. Son of a carpenter. 1910-13 studied at Slade School. 1913, trip to Paris and Italy. Influence of Cubism and Futurism. Connected with Roger Fry's Omega Workshops. 1914-15, member of Vorticist Group. Showed at second exhibition of London Group. 1917-18, Official War Artist. 1920 member of Group X. Since 1915, member of London Group.

*Publications:* Four leaflets attacking the 'Lewis and Vorticism' exhibition at the Tate Gallery, July-August 1956.

*References: William Roberts, Some Early Abstract and Cubist Work*, 1919-20, London 1957. — *William Roberts, Paintings 1917-1958*, London 1959.

RODCHENKO, ALEXANDER. Born 1891 in St. Petersburg. Studied at Kazan Art School. From 1914, influence of Suprematism and Constructivism. From 1922, industrial designer. Lives in Moscow.

*References:* A. Barr, *Cubism and Abstract Art*, Museum of Modern Art, New York 1936. — Seuphor, *L'Art abstrait*, Paris 1949.

RODIN, AUGUSTE. Born November 12, 1840 in Paris. 1855-64 studied at Ecole des Arts décoratifs. 1864-71 in Sèvres porcelain manufactory. 1871-77, in Belgium. Met Meunier. 1875, trip to Florence and Rome. 1877, trip through France to study cathedrals. 1890, moved to Bellevue near Sèvres. From 1894, lived at Meudon where he died on November 17, 1917.

*Publications: Les Cathédrales de France*, Paris 1911. — *L'Art*, Paris 1919.

*Reference:* F. Lawton, *Auguste Rodin*, London 1906. — E. Waldmann, *Auguste Rodin*, Vienna 1945.

408

ROGERS, CLAUDE. Born January 24, 1907 in London. Son of a physician. 1925-29, attended Slade School. 1930, in Paris. 1937-39, taught at Euston Road School which he helped to found. 1939-45 war service in Royal Engineers. Since 1938 member of London Group. Teaches at Slade School.

ROHLFS, CHRISTIAN. Born December 22, 1849 at Niendorf (Holstein). From 1874, student and later teacher at Weimar Art School. 1901, appointed by Osthaus to Folkwang School at Hagen. 1905-06, summer months at Soest. 1910-12, Munich. 1912, returned to Hagen. 1927, moved to Ascona, where he spent the greater part of the year. Died January 8, 1938 at Hagen.

*Reference:* Cat. of Memorial Exhibition, July 1949, Landesmuseum in Münster. — Paul Vogt, *Christian Rohlfs*, Cologne 1956. — Paul Vogt, *Rohlfs, Aquarelle und Zeichnungen*, Recklinghausen 1958.

ROSAI, OTTONE. Born April 28, 1895 Florence. 1913, association with Soffici and the Futurists. 1915, Army. 1919 beginning of his succinct, neo-primitive Realism. Lived in Florence and taught at Academy. Died May 13, 1957 at Ivrea.

*References:* A. Parronchi, *Ottone Rosai*, Milan 1941. — P. C. Santini, *Ottone Rosai*, Ivrea 1957.

ROTHKO, MARK. Born 1903 at Gvinsk, Russia. Emigrated to U.S.A. in 1913. 1921-23, studied at Yale University. Began to paint in 1926 and studied in New York under Max Weber. 1935, founded 'The Ten' group. 1936-37, WPA Art Project. 1945, one-man show at Art of This Century Gallery. 1948, founded an art school with Baziotes, Motherwell, and Newman. Taught in San Francisco in 1947 and 1949. 1951-54, taught at Brooklyn College, Brooklyn, N.Y. Lives in New York.

*Publications:* See *Possibilities* I, 1947-48, p. 84; *The Tiger's Eye* I, October 1947, p. 67.

*Reference:* E. De Kooning in *Art News Annual*, November 1957. pps. 88-97, 174-179.

ROUAULT, GEORGES. Born May 27, 1871, in Paris. Trained as glass painter. 1891, student of G. Moreau at Ecole des Beaux-Arts. Meeting with Matisse. 1898, on death of Moreau, curator of Musée Moreau. 1902, some connection with Fauves. 1903, meeting with Huysmans and Léon Bloy. Showed at first Salon d'Automne. 1914-27, work on graphic series 'Miserere' on commission from Vollard. 1929, sets for *Le fils prodigue*, for Diaghilev's ballet. From 1940 exclusively religious themes. 1948, first trip to Italy. Windows for church at Assy. 1949, trip to Netherlands. Died February 13, 1958 in Paris.

*References:* L. Venturi, *Georges Rouault*, Paris 1948. — J. T. Soby, *Georges Rouault*, Museum of Modern Art, New York 1945.

ROUSSEAU, HENRI. Born May 20, 1844 at Laval. 1870-71, non-commissioned officer in Army, then received position in Paris customs service. 1885, pensioned. Active as painter and musician. 1885, first showing at Salon des Indépendants. 1890, met Gauguin, Redon, Seurat, Pissarro. From 1891, exotic paintings. 1905, first showing at Salon d'Automne. 1906, met

Delaunay, Picasso, and Apollinaire group. 1907, friendship with Uhde. 1908, banquet given for him by Picasso. Died September 4, 1910 in Paris.

*References:* W. Uhde, *Henri Rousseau*, Paris 1911. — Philippe Soupault, *Henri Rousseau*, Paris 1927 (contains a few of Rousseau's letters). — D. C. Rich, *Henri Rousseau*, Museum of Modern Art, New York 1946.

ROUSSEL, KER-XAVIER. Born December 10, 1867 at Lorry-les-Metz. 1883, school friendship with Vuillard. 1888, Académie Julian. 1889, member of Nabis. 1891, showed at Le Barc de Boutteville gallery. 1893-94, lithographs in *Revue Blanche*. 1906, visit to Cézanne with Denis. 1908, teacher at Académie Ranson. 1913, decorated Théâtre des Champs-Elysées. 1914-18, Switzerland. Decorations in stairway of Magazin at Winterthur. Died 1944 at Etang-la-Ville.

*Reference:* L. Werth, *Ker-Xavier Roussel*, Paris 1930.

ROY, PIERRE. Born August 10, 1880 in Nantes. Studied in Paris. Friendship with Apollinaire. Influenced by Chirico. Joined Surrealists in 1925 and participated in their exhibitions until 1932. Lives in Paris.

*Reference:* A. H. Barr, *Fantastic Art, Dada, Surrealism*. Museum of Modern Art, New York 1937.

RUSSELL, MORGAN. Born in 1886 in New York. Studied art with Robert Henri. 1906, moved to Paris. Friendship with MacDonald-Wright. 1912-13, founded Synchromism in Paris with MacDonald-Wright. 1913, represented in Armory Show. Exhibition at Bernheim Jeune gallery in Paris and, in Munich with MacDonald-Wright. Returned to representational painting in 1919. 1946, return to U.S.A. 1951, represented at exhibition of 'Abstract painting and Sculpture in America' at Museum of Modern Art. Died 1953 at Broomall, Pa.

*Reference:* Catalogue of 'Abstract Painting and Sculpture in America' exhibition, Museum of Modern Art, New York 1951.

RUSSOLO, LUIGI. Born April 30, 1885 at Portogruaro near Venice. 1910, founder member of Futurist group. Greatly interested in music, inventor of 'Bruitism'. Died February 4, 1947 at Cerro di Laveno.

*References:* *Cahiers d'Art* 25 (1950). — *Archivi del Futurismo*, Rome 1958.

RYEPIN, ILYA. Born August 5, 1844 at Chuguiev (Kharkov). Studied in St. Petersburg. From 1873, trips to Vienna and Rome. Spent two years in Paris. 1893, appointment at St. Petersburg Academy. Most important representative of social-minded naturalism in the second half of the nineteenth century in Russia. Died September 29, 1930 in Russia, at Kuokkala.

*Reference:* I. Grabar, *Ilya Ryepin*, Moscow 1933.

RYSSELBERGHE, THEO VAN. Born November 23, 1862 at Ghent. Studied in Ghent and Brussels. From 1898 in Paris. Associated with Pointillism. Died December 13, 1926 in Saint-Clair.

*Reference:* F. Maret, *Theo van Rysselberghe*, Antwerp 1948.

SANTOMASO, GIUSEPPE. Born September 26, 1907 in Venice. Founder member of Fronte Nuovo delle Arti. Association with Braque, Léger, Morandi. Development towards an abstract hermeticism. Lives in Venice.

*References:* G. Marchiori, *Santomaso*, Venice 1954. — U. Apollonio, *Giuseppe Santomaso*, Amriswil 1959.

SAURA, ANTONIO. Born 1930 in Madrid. Began to paint during a long illness in 1947. From 1953, numerous visits to Paris. Since 1956 has exhibited regularly at Galerie Stadler, Paris. Founder member of 'El Paso' group of painters and writers. Extensive literary activity. Lives in Paris.

*Publications: Programio,* 1957; *Espacio y gesto,* 1957; Contributions to *El Paso.*

*Reference:* J. C. Aznar in *Goya,* No. 10, 1956, pp. 279-281.

SAVINIO, ALBERTO. Born August 25, 1891 in Athens. Literary surrealist, greatly influenced by his brother De Chirico. Started out as writer of poetry and prose. From 1927 devoted himself chiefly to painting in surrealistic style, incorporating the classic elements of De Chirico. Died May 6, 1952 in Rome.

SCHLEMMER, OSKAR. Born September 4, 1888 in Stuttgart. 1909-19, studied at Stuttgart Academy with Hoelzel. 1914-1918, served in Army. 1920-29, teacher at Bauhaus. 1922, production of Triadic Ballet in Stuttgart. 1929-32, teacher at Breslau Academy. 1932-33, taught at Berlin Academy. Discharged. 1934-37 at Eichberg (South Baden). 1937-43, at Sehringen near Badenweiler. 1940, worked in paint laboratory in Wuppertal. Died April 13, 1943 at Baden-Baden.

*Publications: Die Bühne im Bauhaus,* Bauhausbuch 1925. — *Meyer-Amden,* Zurich 1934. — *Briefe und Tagebücher,* Munich 1958.

*Reference:* H. Hildebrandt, *Oskar Schlemmer,* Munich 1952.

SCHMIDT-ROTTLUFF, KARL. Born December 1, 1884 at Rottluff near Chemnitz. 1905, studied at Dresden Technical School. Meeting with Kirchner and Heckel. Co-founder of Brücke. 1906, stay on island of Alsen with Nolde. From 1911, Berlin. 1915-18, served in Army. 1924, trip to Paris. 1930, protracted stay in Rome. 1931, member of Prussian Academy in Berlin. 1933, dismissed. 1941, forbidden to paint. Since 1947, teacher at Berlin Academy.

*Reference:* W. Grohmann, *Karl Schmidt-Rottluff,* Stuttgart 1956.

SCHNEIDER, GERARD. Born April 28, 1896 at Sainte-Croix (Switzerland). 1916-20, study in Paris. 1924, return to Paris and work as decorator. Since 1947 abstract painting in Paris.

*Reference:* Marcel Pobé, *Gérard Schneider,* Musée de Poche, Paris 1959.

SCHOLZ, WERNER. Born October 23, 1898 in Berlin. Lost left arm and one eye in war. Studied in Berlin. Acquaintance with Nolde. 1933, condemned as 'degenerate'. 1939, moved to Alpbach (Tyrol). In the post-war period chiefly pastel illustrations of Old Testament. Lives at Alpbach.

*References:* A. Behne, *Werner Scholz,* Potsdam 1948. — Heinz Köhn, *Werner Scholz,* Essen 1955.

SCHRIMPF, GEORG. Born February 13, 1889 in Munich. Self-taught. 1915, worked as labourer in Berlin. First paintings shown at Sturm gallery. c. 1920 turn to the ideas of *Valori Plastici.* Trips to Switzerland and Italy. 1926-33, teacher at School of Applied Art in Munich, then at Art School in Berlin-Schöneberg. Died April 19, 1938 in Berlin.

*References:* C. Carrà, 'Georg Schrimpf' in *Valori Plastici,* Rome 1923. — M. Pförtner, *Georg Schrimpf,* Berlin 1940.

SCHUFFENECKER, EMILE. Born December 8, 1851 at Fresne-Sainte-Mamès (Haute Saône). Studied in Paris. From 1884 exhibited at Indépendants. Friend of Gauguin, Pissarro, and Seurat. Died in August, 1934 in Paris.

SCHULTZE, BERNHARD. Born May 31, 1915 at Schneidemühl (Pomerania). 1934, study at Berlin Academy. 1939-44, served in Army. Lives in Frankfurt.

SCHWITTERS, KURT. Born June 20, 1887 in Hanover. 1909-14, studied at Dresden Academy. 1915, Hanover. 1918, influence of Kandinsky; first exhibition at Sturm gallery. 1920, in Hanover, invented MERZ, a variety of Dada. 1920, meeting with Arp. From 1922, collaboration with Doesburg. From 1923, edited MERZ magazine. 1932, member of Abstraction-Création. 1937, emigrated to Norway. After German invasion in 1940, fled to England. Died January 8, 1948 at Ambleside.

*Publications:* See *Der Sturm* 1919-24 (poems and articles). — *Anna Blume, Gedichte,* Hanover 1919 and 1922.

*References:* O. Nebel, *Kurt Schwitters,* Berlin 1920 (Sturm-Bildbücher IV). — H. Bergruen, *Kurt Schwitters,* Paris 1954. *Ausstellungs-Katalog der Kestner-Gesellschaft,* Hanover 1956. — S. Themerson, *Kurt Schwitters in England,* London 1958.

SCIPIONE (GINO BONICHI). Born Febuary 25, 1904 at Macerata. 1928, in collaboration with Mario Mafai formed the expressive Roman school, drawing on Pascin and Soutine and opposing the formalism of the Novecento. Died November 9, 1933 in Rome.

*Publications: Carte Segrete,* Florence 1943.

*References:* G. Marchiori, *Scipione,* Milan 1939. — U. Apollonio, *Scipione,* Venice 1945. — Cat. of one-man show at Gall. d'Arte Moderna, Rome 1954.

SCOTT, WILLIAM. Born February 15, 1913 at Greenock, Scotland. Grew up in Ulster. 1928-31, studied at Belfast College of Art. 1931-35, studied at Royal Academy Schools. 1937-39, travels in Italy and France. 1942-46, served in war. 1947, taught at Bath Academy of Art. Since 1948, regular exhibitions in London. 1950, member of London Group. 1953, visit to the U.S.A. 1954, first showing in New York. 1958, summer in Venice. Exhibition at Biennale Venice. Lives in London.

*Publications:* 'Statement' in L. Alloway, *Nine Ab-*

410

*stract Artists*, London 1954. — 'Statement' in Catalogue of 'The New Decade' Exhibition at Museum of Modern Art, New York.

SEEHAUS, PAUL ADOLF. Born September 7, 1891 in Bonn. After studying history of art in Bonn and Munich became a student of August Macke in Bonn in 1911. Belonged to the circle round Marc. Died March 13, 1919 in Hamburg.
*Publications: Briefe und Aufzeichnungen*, Bonn 1930.
*Reference:* P. O. Rave, in *Wallraf-Richartz-Jahrbuch* II (1925), p. 181.

SEGALL, LASAR. Born July 8, 1891 in Vilna. Studied in Berlin and Dresden. Connected with Berliner Sezession. Acquaintance with Grosz, Dix, and Schwitters. End of 1912, trip to Brazil. 1913, return to Europe, settled in Dresden after brief stay in Paris. 1920, exhibition at Folkwang Museum, Hagen. 1922-23, Berlin. 1923, moved to Brazil. Died on July 31, 1957 in São Paulo.
*Reference:* P. M. Bardi, *Lasar Segall*, São Paulo 1952.

SEGONZAC, ANDRÉ DUNOYER DE. Born July 6, 1884 at Boussy-Saint-Antoine (Seine et Oise). Studied in Paris. Came to Cubism through Cézanne. 1914-18, served in Army. From 1920 painted in Derain's Classicist style. 1952, large one-man show in Geneva. Lives in Paris.
*References:* C. Roger-Marx, *Dunoyer de Segonzac*, Geneva 1951. — A. Lioré and P. Cailler, *Catalogue de l'œuvre gravé de Dunoyer de Segonzac*, Geneva 1958.

SERAPHINE, DE SENLIS (SERAPHINE LOUIS). Born at Assy 1864 (Haute Savoie). Moved to Senlis and worked as cleaning woman. 1911, discovered by W. Uhde. 1934, died in home for the aged at Senlis.
*Reference:* W. Uhde: *Fünf primitive Meister*, Zurich 1947.

SERPAN, JAROSLAW. Born 1922 in Prague of Russian parents. 1927, moved to France. Studied biology and mathematics at the Sorbonne. 1940, began to paint. Association with Surrealism. From 1947, regular exhibitions in Paris. 1954, exhibition in Milan at Galleria del Naviglio. 1956, exhibition in Wuppertal. Extensive literary activity. Lives in Paris.

SÉRUSIER, PAUL. Born 1864 in Paris. After studying philosophy entered Académie Julian in 1886. 1888, meeting with Bernard and Gauguin at Pont-Aven. Founded Nabi group with Denis, Bonnard and Ranson. 1889-90, with Gauguin in Brittany. 1891, meeting with Verkade. Exhibition at Le Barc de Boutteville gallery. 1893, collaborated on Théâtre de l'Oeuvre. 1895, with Denis in Italy. Trip to Prague with Verkade who acquainted him with Beuron school. 1897, visited Verkade at Beuron monastery. 1899 second visit to Beuron. 1903, moved to Châteauneuf-du-Faou (Finistère). 1904, trip to Rome and Monte Cassino with Denis. 1907, trip to Munich. 1908, teacher at Académie Ranson. 1914-27 lived in retirement in Brittany. Died October 6, 1927 at Morlaix (Finistère).

*Publication: ABC de la peinture*, Paris 1950 (3rd edition).
*References:* M. Denis, *Sérusier, sa vie, son œuvre*, Paris 1943. — A. Humbert, *Les Nabis et leur époque 1888-1890*, Geneva 1954.

SEURAT, GEORGES. Born December 2, 1859 in Paris. After preparatory studies at a school of design and at Louvre, entered Ecole des Beaux-Arts in 1878. Studied colour theories of Chevreul and Delacroix. 1884, *La Baignade* at Salon des Indépendants. Friendship with Cross and Signac. 1885, summer at Grandcamp near Le Havre. Meeting with Pissarro. 1886, showed at eighth Impressionist exhibition. Summer at Honfleur. 1887, Brussels for exhibition of 'Salon des XX'. 1890, at Gravelines. February 3, 1891 attended famous Symbolist banquet presided over by Mallarmé. Died March 29, 1891.
*References:* J. Rewald, *Georges Seurat*, Paris 1947. — G. Seligmann, *Drawings of Georges Seurat*, New York 1947. — Jacques de Laprade, *Georges Seurat*, Paris 1951.

SEVERINI, GINO. Born April 7, 1883 at Cortona. 1901, moved to Rome. Meeting with Boccioni and Balla. 1906, moved to Paris. Association with Modigliani, Jacob and Braque. 1910, signed the Futurist Manifesto. Meeting with Picasso. 1912, showed at international Futurist exhibitions. 1915-21, developed from Cubism to Neo-Classicism under influence of Picasso and *Valori Plastici*. c. 1930, return to a decorative Cubism. In the last few years influenced by Concrete Art. 1950, Biennale prize. Lives at Meudon.
*Publications: Du Cubisme au Classicisme*, Paris 1921. — *Raggionamenti sulle Arti Figurative*, Milan 1936. — *Tutta la vita di un pittore*, Milan 1946.
*References:* P. Courthion, *Gino Severini*, Milan 1945. — J. Lassaigne, *Les dessins de Severini*, Paris 1947. — *Oeuvres futuristes et cubistes*, ed. Bergruen, Paris 1956.

SHAHN, BEN. Born in 1898 in Kovno, Russia; son of a carpenter. 1906, emigrated to U.S.A. Studied painting at City College of N.Y. and at National Academy of Design. 1927-29, travels in France, Italy, Spain, North Africa. 1931-32, series of pictures of Sacco and Vanzetti, which were exhibited in 1932. Collaborated with Diego Rivera on murals for Rockefeller Center. 1933, WPA Art Project as muralist and draughtsman. 1938-39, murals for Bronx Post-Office in New York. 1940-42, murals for Social Security Building in Washington. Lives in New York.
*Publication: Paragraphs on Art*, 1952.
*References:* J. T. Soby, *Ben Shahn*, New York 1947. — S. Rodman, *Ben Shahn, Portrait of the Artist as an American*, 1952.

SHEELER, CHARLES. Born 1883 in Philadelphia. 1902-06, studied at Pennsylvania Academy. 1904-05 trip to England, Holland, Spain. 1908-09, Italy and Paris. 1912, devoted himself to photography. 1913, represented at Armory Show. 1920, film work with Paul Strand. First one-man show at De Zayas Gallery in New York. Beginning of Cubo-Realism. 1929,

trip to Europe. Has been living in Irvington, N.Y. since 1942.

*References:* William Carlos Williams, *Charles Sheeler,* Museum of Modern Art, New York 1939. — W. C. Williams and others, *'Charles Sheeler'* in exhibition catalogue of Art Galleries University of California, Los Angeles 1954.

SICKERT, WALTER R. Born May 31, 1860 in Munich. Son of a painter. 1868, moved to England, 1881, studied at Slade School and with Whistler. 1883, moved to Paris. Met Degas. 1885, met Gauguin in Dieppe. 1889, organised 'London Impressionists' exhibition at Goupil Gallery. 1893, opened a school of painting. 1899-1905 in Dieppe and Venice. 1905, returned to London. Taught at Westminster Institute. Friendship with L. Pissarro, Gilman, Gore. 1908, joined 'Allied Artists Association'. 1924-1935, member of Royal Academy. 1927, President of Royal Society of British Artists. Died January 22, 1942.

*Publications: A Free House or the Artist as Craftsman, being the writings of Walter R. Sickert,* ed. Sitwell, London 1947.

*References:* L. Browse, *Sickert,* London 1943 and 1960. — R. Emmaus, *The Life and Opinions of William R. Sickert,* London 1941.

SIGNAC, PAUL. Born November 11, 1863 in Paris. Studied in Paris. Became acquainted with Impressionism through Guillaumin. 1884, friendship with Seurat and Cross. From 1886, worked on theory of Neo-Impressionism whose chief representative he became after the death of Seurat. 1888, showed at Salon des XX in Brussels. 1889, visited Van Gogh. 1899, publication of his book on Neo-Impressionism. From 1892, spent summers at Saint-Tropez. 1907, trip to Constantinople. From 1898, president of Salon des Indépendants. Died August 15, 1935 in Paris.

*Publications: D'Eugene Delacroix au Neo-Impressionisme,* Paris 1899. — Preface to Exhibition 'Seurat et ses amis', Paris 1933/34. — Letters in J. Rewald, *Seurat,* Paris 1948. — *'Fragments du Journal de Signac'* in *Arts de France,* January 1947.

*Reference:* G. Besson, *Paul Signac,* Paris 1934.

SINGIER, GUSTAVE. Born February 11, 1909 at Warneton (Flanders). In Paris since 1919. Trained as decorator and interior decorator. Since 1936, encouraged by Walch, has shown at all major exhibitions. Since 1946 also engaged in tapestry design.

*References:* Catalogue of one-man show at Kestner-Gesellschaft, Hanover 1957. — G. Charbonnier, *Gustave Singier,* Musée de Poche, Paris.

SIQUEIROS, DAVID. Born 1898 in Chihuahua, Mexico. Studied at art school in Mexico City. Took part in the revolution. 1919-22, travelled and studied in Belgium, France, Italy, Spain. Return to Mexico. Social Realism with Surrealist elements.

*Reference:* B. S. Myers, *Mexican Painting in our Time,* New York 1956.

SIRONI, MARIO. Born May 12, 1885 at Sassari (Sardinia). Studied in Rome, friendship with Balla and Boccioni. 1914, moved to Milan, connected with Futurism. Strongly influenced by Léger. From 1915, served in Army. Influence of Pittura Metafisica. Founder member of Novecento. Large frescoes for Milan Triennale and University of Rome. Lives in Milan.

*References:* Agnoldomenico Pica, *Mario Sironi,* Milan 1955. — *Archivi del Futurismo,* Rome 1958.

SISLEY, ALFRED. Born to English parents in Paris, October 30, 1839. Studied in Paris. From 1860, friendship with Monet and Renoir. Showed with the Impressionists from 1874. From 1880 strongly influenced by Monet. Died January 29, 1899 at Moret-sur-Loing (Seine et Marne).

*Publication:* See *Formes* II (1931), p. 151.

*Reference:* F. Daulte, *Catalogue raisonné de l'œuvre peint,* Lausanne 1959.

SLEVOGT, MAX. Born October 8, 1868 at Landshut. 1885-89, study at Munich Academy. 1889, at Académie Julian in Paris. Trips to Italy, Holland, Egypt. 1895, first contacts with Impressionism. 1901, moved to Berlin. From 1907, luminous plein-air painting. 1917, appointed teacher at Berlin Academy. Died September 20, 1932 at Neukastell.

*Publication:* Bibliography in Thieme-Becker.

*References:* E. Waldmann, *Max Slevogts graphische Kunst,* Dresden 1921. — E. Waldmann, *Max Slevogt,* Berlin 1923.

SLOAN, JOHN. Born August 2, 1871 at Lock Haven, Pa. Studied at Pennsylvania Academy in Philadelphia. Artist-reporter for newspapers. Friendship with Henri. 1904, moved to New York. Leading member of Ash Can Group. 1911-16 Art Editor of *The Masses.* From 1926 contributed to *The New Masses.* Died 1951 in New York.

*Publications: The Gist of Art,* 1939 (with Helen Farr); see also O. M. Sayler, *Revolt in the Arts,* 1930 pp. 318-321.

*References:* L. Goodrich, *John Sloan,* New York 1952; Van Wyck Brooks, *John Sloan,* 1955.

SMITH, JACK. Born June 18, 1928 in Sheffield. 1944-50, studied at Sheffield College of Art and St. Martin's School of Art. 1950-53, Royal College of Art in London. 1953, first exhibition at Beaux Arts Gallery, London. 1954, trip to Spain, 1955, stay in Venice. 1956, represented at Biennale Venice 1957, took up abstract style. Since 1957 has been teaching at Chelsea School of Art.

*Reference:* Catalogue of his exhibition at Whitechapel Art Gallery, London, May-June 1959.

SMITH, MATTHEW A. B. Born October 22, 1879 in Halifax. Father a manufacturer. 1900-04, studied at Manchester School of Art. 1905-07, Slade School. 1908, lived at Pont-Aven. 1910, Paris, where he studied with Matisse. 1916-19, served in war. 1920, member of London Group. 1920-26, lived chiefly in Paris. 1926, first one-man show in London. 1930-32, Paris. 1933, Cagnes. 1934-40, Aix-en-Provence. 1938 and 1950, showed at Biennale. 1953, Retrospective at Tate Gallery. 1954, knighted. Died September 29, 1959 in London.

*Reference:* Philip Hendy, *Matthew Smith,* Penguin Books 1944.

412

SOFFICI, ARDENGO. Born April 7, 1879 at Rignano. Studied at Academy in Florence. 1900-07, Paris. Followed Italian development through Futurism to the Novecento. Also active as a critic. Lives at Poggio a Caiano.

*Publications: Rete mediterranea*, Florence 1920. — *Ricordi di vita artistica*, Florence 1942.

*References:* G. Papini, *Ardengo Soffici*, Milan 1933. — *Archivi del Futurismo*, Rome 1958.

SOLDATI, ATANASIO. Born August 27, 1896 in Parma. 1930, moved to Milan. Between 1930 and 1935 developed his abstract, strictly geometrical style. Founder member of Movimento Arte Concreta. Died 1953 in Milan.

*Reference:* G. Marchiori in *Panorama dell'arte italiana*, Turin 1951, pp. 121-128.

SONDERBORG, K. R. Born April 5, 1923 at Sonderborg (Alsen), Denmark. After business training, studied at Landeskunstschule, Hamburg from 1947 to 1949. 1951, trip to Italy. 1953, stay in Paris where he studied with S. W. Hayter. 1957, stay in England. Lives in Paris.

*Reference:* G. Stein and E. Trier, *Junge Künstler* 58/59. Cologne 1958, pp. 41-58.

SOULAGES, PIERRE. Born December 24, 1919 at Rodez (Aveyron). Self-taught. Influence of Romanticism and Van Gogh. 1940, served in Army. 1946, returned to Paris, took up abstract painting. 1959 trip to Japan. Lives in Paris.

*Reference:* H. Juin, *Pierre Soulages*. Musée de Poche, Paris 1959.

SOUTINE, CHAIM. Born 1894 at Smilovich near Minsk in White Russia. 1910 attended Academy in Vilna. 1913, moved to Paris. Meeting with Chagall, Laurens, Léger, Cendrars, and Modigliani. 1919, stay at Céret. 1922, return to Paris. 1925, stay at Cagnes. 1926, Paris. 1929, stay at Châtel-Guyon. Died August 9, 1943 in Paris.

*References:* M. Wheeler, *Chaim Soutine*, Museum of Modern Art, New York 1950. — P. d'Ancona, *Modigliani, Chagall, Soutine, Pascin*, Milan 1952.

SPAZZAPAN, LUIGI. Born September 8, 1890 at Gradisca (Friuli). Starting from the Fauves, he has recently found his way to a visionary, almost abstract Expressionism. Lives in Turin.

SPENCER, NILES. Born in 1893 in Pawtucket, R.I. 1913-15, studied at Rhode Island School of Design in Providence. 1915, went to New York where he studied with Bellows and Henri at Art Students' League. 1916, moved to New York. 1921-22 and 1928-29, stays in France and Italy. From 1923, regularly represented in exhibitions at the Whitney Studio Club. 1925, first one-man show at Daniel Gallery in New York. 1923-40 moved back and forth between Provincetown, Mass. and New York, findly settling in the latter. 1943, turned to abstract Purism. Died 1952 in New York.

*Publication:* Autobiographical text in Newark Museum, 35th Anniversary Exhibition Catalogue, 1944.

*References:* M. Mannes, 'Niles Spencer' in *Creative Art*, July 1930, pp. 58-61: Holger Cahill, 'Niles Spencer' in *Magazine of Art*, November 1952, pp. 313-15.

SPENCER, STANLEY. Born June 30, 1891 at Cookham, Berkshire. Son of an organist. 1908-12, studied at Slade School. 1912, showed at Second Post-Impressionist Exhibition, London. 1915-18, war service in Macedonia. December 1918, returned to England. 1922, spent summer in Yugoslavia. 1926-32, religious murals for Burghclere Chapel. 1932, represented at Biennale. 1935, associate of Royal Academy. 1933-36, trips to Switzerland. 1938, represented at Biennale. 1939-45, Official War Artist. 1950, member of Royal Academy. 1954, trip to China. 1955, Retrospective at Tate Gallery. Knighted. Died December 14, 1959.

*Publications:* 'Domestic Scenes' in *The Saturday Book*, London 1946, pp. 249-256. — 'Notes' in *Stanley Spencer's Resurrection Pictures*, London 1951.

*References:* Elizabeth Rothenstein, *Stanley Spencer*, London 1945. — Tate Gal. Exh. Cat. 1955 (with bibliography).

DE STAEL, NICOLAS. Born January 5, 1914 in St. Petersburg into a family of officers of Baltic origin. 1919, emigrated to Poland. 1922, after the death of both parents, moved to Brussels. 1922-31 educated at Jesuit School in Brussels. 1932-33 studied at Académie Royale des Beaux Arts in Brussels. Trip to Holland and Paris. 1934, trips to Spain and Italy. 1935, return to Brussels. 1936, trip to Morocco. 1937, short stays in Algiers, Italy, Paris. 1937-39, Paris. 1939, on outbreak of war, enlisted in Foreign Legion and served in Tunisia. 1940, demobilised. Settled in Nice. 1942, beginning of his abstract painting. 1943, return to Paris. 1944, friendship with Georges Braque and Lanskoy. Exhibited at 'Peintres Abstraits' exhibition at L'Esquisse gallery in Paris with Kandinsky, Magnelli, Domela; one-man show at same gallery. 1948, acquired French citizenship. 1949, trip to Amsterdam, The Hague, Brussels. 1950, exhibition in New York. 1957, trip to London. 1953, trips to Italy and U.S.A. Shown at São Paulo Biennale. 1954, Venice Biennale. Painted in Paris, on the Channel coast, and at Antibes. Trip to Spain. Died on March 16, 1955 at Antibes.

*References:* G. Duthuit, *Nicolas de Staël*, Transition Press, 1950. — R. V. Gindertael, *Nicolas de Staël*, Paris 1951.

STAMOS, THEODOR. Born in 1922 in New York. 1936-39, studied sculpture at American Artists' School in New York. 1948-49, France, Italy, Greece. 1950, taught at Black Mountain College. Lives in New York. Teaches at Art Students' League.

*References:* See *The Tiger's Eye*, No. 2, December 1947, p. 42 ff. — *The New American Painting*, Museum of Modern Art, New York 1959, p. 72 ff.

STEER, P. WILSON. Born December 28, 1860 at Birkenhead. 1878-81, studied at Gloucester School of Art. 1882, moved to Paris. 1882-84, studied at Académie des Beaux-Arts and Académie Julian. 1886,

founder member of New English Art Club. 1899-1930, taught at Slade School. 1907, went to Paris to attend Cézanne exhibition. 1929, Retrospective at Tate Gallery. 1940, blindness. Died March 21, 1942. 1943, memorial exhibition at National Gallery, London.

*Reference:* Dugald S. MacColl, *Life Work and Setting of P.W. Steer*, London 1945.

STEINLEN, THÉOPHILE. Born November 10, 1859 in Lausanne. Study in Lausanne. From 1882 lived in Paris. Chiefly produced satirical drawings for left-wing satirical magazines. Died December 14, 1923 in Paris.

*References:* C. Aveline, *Steinlen*, Paris 1926. — F. Jourdain, *Un grand imagier: Steinlen*, Paris 1954.

STELLA, JOSEPH. Born in 1877 at Muro Lucano, Italy. After briefly studying medicine began to paint on his own. 1900, emigrated to U.S.A. 1902, studied at New York School of Art. Worked as illustrator. Did drawings in the Pittsburgh steel mills for *The Survey Graphic*. 1909-11, Italy and France. Met the Italian Futurists. 1912, return to New York. 1913, represented at Armory Show. 1920, represented in exhibitions of the Société Anonyme. 1940, trip to the West Indies. Died in 1946 in New York.

*Publications:* 'On Painting' in *Broom* I, 1921, pp. 119-123; 'Confession' in *The Little Review*, Spring 1929, pp. 79-81; 'The Brooklyn Bridge (a Page of my Life)' in *Transition* Nos. 16-17, June 1929, pp. 86-88.

*References:* Stella number of *The Little Review*, Autumn 1922. — Catalogue of Joseph Stella exhibition, Newark Museum, 1939.

STILL, CLIFFORD. Born in 1904 at Grandia, North Dakota. Studied at University in Spokane, Washington. 1941, moved to San Francisco. 1946-50, taught at California School of Fine Arts. 1950, moved to New York. From 1952, teacher at Hunter College, New York. Lives in New York.

*Reference:* *The New American Painting*, The Museum of Modern Art, 1959 New York, p. 76 ff.

STUCK, FRANZ VON. Born February 23, 1863 at Tettenweis (Bavaria). From 1882, study in Munich. Influence of Böcklin. 1893 co-founder of 'Sezession'. From 1895, teacher at Munich Academy. Active also as a sculptor. Died August 30, 1928 at Tetschen.

*Reference:* F. von Ostini, *Das Gesamtwerk von Franz von Stuck*, Munich 1909.

SULLIVAN, PATRICK. Born March 17, 1894 at Braddock, Pa. Made his living as a steel worker and house painter. 1916-19, served in Army.

*Reference:* Sidney Janis, *They Taught Themselves*, New York 1942, chap. 4.

SUTHERLAND, GRAHAM V. Born August 24, 1903 in London. Son of a lawyer. Educated at Epsom College. After brief period as a railway employee studied art from 1921; to 1925 in London. Specialised training in graphic techniques. 1928, conversion to Catholicism. 1926-1940, taught graphic techniques at Chelsea School of Art. 1935, began to paint. 1936, represented at International Surrealist Exhibition, London. 1937, moved to Trottiscliffe, Kent. 1941-45, Official War Artist. 1946, first exhibition in New York. Commissioned to do a Crucifixion for St. Matthew's in Northampton. Beginning of the 'Thorns' series. Since 1947, regular visits to southern France. 1949, beginning of the 'Standing Forms'. 1952-53, one-man shows at Biennale, in Paris, Amsterdam, Zurich and London. São Paulo Prize. Travelling exhibition in U.S.A. 1954-55, travelling exhibition in Germany. 1955, one-man show at the São Paulo Biennale. 1957, stay in Venice. Appointed to Order of Merit, 1960.

*Publications:* 'Thoughts on Painting' in *The Listener*, September 6, 1951, pp. 376-378. 'On Painting' in Exh. Cat. The Arts Council, London May 20-August 9, 1953.

*References:* R. Melville, *Graham Sutherland*, London 1951. — E. Sackville-West, *Graham Sutherland*, Penguin Books 1943 and 1955.

TAEUBER-ARP, SOPHIE. Born January 19, 1889 at Davos. 1908-10 art school in St. Gall. 1911-13, study in Munich. 1912, School of Applied Art in Hamburg. 1916-29, taught at School of Applied Art in Zurich. 1916-20, associated with Dada movement. 1921, married Jean Arp. 1927-28, collaborated with Arp and Doesburg in decorating a restaurant in Strasbourg. 1928-40, at Meudon. 1931-36, association with Abstraction-Création. 1941-43, Grasse. Died January 13, 1943 in Zurich.

*Reference:* G. Schmidt, *Sophie Taeuber-Arp*, Basle 1948.

TAL-COAT, PIERRE. Born December 12, 1905 at Clohars-Carnoet (Finistère). Started as a sculptor. 1924, moved to Paris. 1940-44 at Aix-en-Provence, in house formerly inhabited by Cézanne. Since 1945 showed at all major exhibitions of Paris school.

*References:* 'Tal-Coat' in *Le Point*, Paris, December 1947. — J. Lassaigne, 'Unité de Tal-Coat' in *Quadrum* No. 2, 1956, pp. 127-132.

TAMAYO, RUFINO. Born in 1899 at Oaxaca, Mexico. 1917, attended Academy in Mexico City. Influence of modern French painting and of Mexican tradition and folk art. 1933, murals for Mexico City Conservatory. Appointed teacher at Mexico City Academy. 1938, moved to New York. Murals for Smith College in Northampton, U.S.A. 1950, trip to Europe.

*Reference:* R. Cogniat, *Rufino Tamayo*, Paris 1951.

TANGUY, YVES. Born January 5, 1900 in Paris. Merchant seaman. 1924, saw a work by Chirico, which led him to take up painting. 1925, association with Surrealists with whom he showed, beginning in 1927. 1939, moved to U.S.A. Naturalised American, from 1942 lived at Woodbury, Conn., where he died in 1955.

*References:* A. Breton, *Le Surréalisme et la peinture*, Paris 1928. — J.T. Soby, *Yves Tanguy*, Mus. Mod. Art, New York 1955.

TAPIÈS, ANTONIO. Born December 23, 1923 in Barcelona. After studying law, began to paint in 1946.

414

Self-taught as a painter. 1950, grant from French government for a stay in Paris. First one-man show in Barcelona. 1951, trips to Belgium and Holland. 1953, trip to New York in connection with his first American exhibition. 1956, Lissone Prize. Regular exhibitions at Galerie Stadler in Paris. 1958, showed at Venice Biennale and received Carnegie Award. Lives in Barcelona.

*References:* M. Tapié, *Antonio Tapiès et l'œuvre complète*, Paris 1956. — M. Tapié, *Antonio Tapiès* (in preparation).

TATLIN, VLADIMIR. Born 1885 in Moscow. Studied at Moscow Academy. From 1910, connected with Fauvism and Cubism. 1913, first relief constructions. 1919, teacher at Moscow Academy. Lives in Moscow, working as draughtsman.

*References:* Seuphor, *L'Art Abstrait*, Paris 1949. — Camilla Gray in *Burlington Magazine*, May 1960.

THIELER, FRED. Born 1916 at Königsberg. From 1937, studied medicine. Painting since 1941. 1946-48, Munich Academy, under Carl Caspar. 1949, beginning of abstract development. From 1950, member of Zen group. 1951-52, Paris. Teacher at Berlin Academy.

*Reference:* J. Roh, 'Der Münchner Maler Fred Thieler' in *Kunst und das schöne Heim*, Vol. 56, 1957/8, pp. 55-57.

THORN-PRIKKER, JAN. Born June 5, 1868 in the Hague. Studied in the Hague. From 1904 in Germany. 1904-10 taught at Krefeld School of Applied Art. 1910-19, taught at Folkwang School at Hagen and in Essen. 1919-23, teacher at Munich Academy. 1923-25, in Düsseldorf. 1925-32, teacher at Cologne Art School. Died March 5, 1932 in Cologne.

*References:* A. Hoff, *Die religiöse Kunst Jan Thorn-Prikkers*, Düsseldorf 1924. — A. Hoff, *Jan Thorn-Prikker*, Recklinghausen 1958.

TOBEY, MARK. Born December 11, 1890 at Centerville, Wisconsin. Attended Art School in Chicago. Did advertising art work. 1911, moved to New York. 1917, first stay in Seattle, where he settled in 1922. 1925, trip to Paris and Near East. 1931, trip to Mexico. 1931-38, taught at Dartington Hall School in England. 1934, trip to Japan and China to study Chinese calligraphy, spent some time in a Zen monastery in Japan. 1935, beginning of 'white writing'. 1938-39, WPA Art Project. 1939, return to Seattle. 1944, first one-man show in New York. 1951, exhibition in San Francisco. 1958, first prize at Venice Biennale; travels in Europe. 1959, visit to Moscow and travels in Europe. Lives in Seattle.

*Publications:* See Exhibition Catalogue, Portland Art Museum, 1945; *Magazine of Art*, October 1951; *College Art Journal*, Autumn 1958.

*Reference:* Catalogue of one-man show at Seattle Art Museum, 1959.

TOMLIN, BRADLEY WALKER. Born August 9, 1899 in Syracuse, N.Y. 1917-21, studied art at Syracuse University. 1921, moved to New York. 1923-24 and 1926-27, visits to Europe and art study at Académie Colarossi in Paris. 1928 and 1934, travels in Europe.

1932-41, taught at Sarah Lawrence College in Bronxville, N.Y. From 1948, moved in circle of Motherwell, Pollock, and Gorky. Died May 11, 1953.

*Reference:* Catalogue of Whitney Museum, New York 1957.

TOOROP, JAN. Born December 20, 1858 at Poerworedjo, Java. Studied in Amsterdam and Brussels. 1890, friendship with Maeterlinck and Verhaeren. Turned to Symbolism. 1905, converted to Catholicism and turned to religious art. Died March 3, 1928 in the Hague.

*Reference:* M. Janssen, *Jan Toorop*, Mönchen-Gladbach 1927.

TOSI, ARTURO. Born July 25, 1871 at Busto Arsizio. Study in Milan in tradition of Lombard landscape painting of late Ottocento. Association with Cézanne. Member of Novecento. Died January 3, 1956 in Milan.

*References:* G. Scheiwiller, *Arturo Tosi*, Milan 1942. — G. C. Argan, *Tosi*, Florence 1942.

TOULOUSE-LAUTREC, HENRI MARIE RAYMOND DE. Born November 24, 1864 at Albi. 1878, crippled by an accident. 1881, moved to Paris. Studied at Atelier Bonnat and Atelier Cormon, where he met Bernard and later Van Gogh. Influence of Degas. 1885, moved to Montmartre. 1889-90, exhibitions at Indépendants and at Salon des XX in Brussels. 1891, first posters. 1892, first colour lithos. 1893, contributions to *Revue Blanche*. Showed at Libre Esthétique exhibition in Brussels. Meeting with Van de Velde. 1895, trips to London where he met Wilde and Beardsley. 1899-1900, breakdown and sanatorium. September 9, 1901 died at his mother's home at Malromé.

*Publication: Cahiers de Zig-zags*, Nice 1881; reprinted in *l'Amour de l'Art*, No. 4 (April 1931).

*References:* M. Joyant, *Henri de Toulouse-Lautrec*, Paris 1921 (basic). — D. Cooper, *Henri de Toulouse-Lautrec*, Stuttgart 1955. — Henri Focillon, *Dessins de Toulouse-Lautrec*, Lausanne 1959. — On the graphic work: L. Delteil, *Le peintre-graveur*, Vol. 10, Paris 1920. — On the posters: E. Julien, *Les affiches de Toulouse-Lautrec*, Monte-Carlo 1950.

TOZZI, MARIO. Born October 30, 1895 at Fossombrone (Umbria). Studied at Bologna Academy. 1921, moved to Paris. Connection with Novecento. Lives in Paris.

*Reference:* L. Fiumi, *Mario Tozzi*, Paris, no date.

TRIER, HANN. Born August 1, 1915 in Düsseldorf-Kaiserswerth. 1934-38, Düsseldorf Academy under Heuser. Trips to France, Holland, Italy, Switzerland. Lives in Berlin, where he teaches at the Academy.

*Reference: Kat. der Kestner-Ges. Hannover*, 1959.

TRÖKES, HEINZ. Born August 15, 1913 at Hamborn on the Rhine. 1931-32, study at Krefeld School of Applied Art. 1933-36, studied with Itten in Berlin. 1940, with Muche in Krefeld. From 1941 in Berlin, from 1950 in Paris. 1951-56, at San Antonio, Ibiza. 1956, appointed at Hochschule für bildende Künste, Hamburg. Lives on Ibiza in Balearic Islands.

*Reference:* W. Grohmann, *Heinz Trökes*, Berlin 1959.

TRÜBNER, WILHELM. Born February 3, 1851 at Heidelberg. Studied in Karlsruhe, Munich, Stuttgart. From 1871, association with Leibl and Schuch. Trips to Italy, England, Low Countries. From 1892, connected with Münchner Sezession. Lived in Munich until 1896, then in Frankfurt. 1903, appointment at Karlsruhe Academy. Died December 21, 1917 in Karlsruhe.

*Publications* and *References*, see Thieme-Becker.

TWORKOV, JACK. Born in 1900 at Diala, Poland. Emigrated to U.S.A. in 1913. 1920-23, studied at Columbia University. 1923-25, National Academy of Design. 1925-26, Art Students' League. 1937-41, WPA Art Project. 1948-55, taught at Queens College, New York. Has been teaching at Pratt Institute, Brooklyn, N.Y. since 1955. Lives in New York.

*Reference: The New American Painting*, Museum of Modern Art, New York 1959, p. 84.

UTRILLO, MAURICE. Born December 26, 1883 in Paris. Illegitimate child of Suzanne Valadon. 1899, went to work in a bank. 1900, first stay at an institution for alcoholics. Began to paint in 1902. 1903, influence of Pissarro. 1908-1910 'white period'. Began to show at Salon d'Automne. 1912, sanatorium at Saunois. 1918, long stay in institution for alcoholics. 1923, exhibition at Bernheim Jeune gallery that made him famous. 1927, beginning of richly coloured period. Died November 5, 1955 at Dax (Landes).

*References:* A. Basler, *Maurice Utrillo*, Paris 1925. — J. Jourdain, *Maurice Utrillo*, Paris 1948.

VALADON, SUZANNE. Born September 23, 1867 at Bessines near Limoges. Moved to Paris as a child and from early age made her living as dressmaker, acrobat, and model. Renoir and Toulouse-Lautrec encouraged her to paint. By 1910 had developed a style of her own. Later somewhat influenced by Matisse and Derain. Died April 1938 in Paris.

*Reference:* A. Basler, *Suzanne Valadon*, Paris 1929. — *La Trinité Maudite, Valadon, Utrillo, Utter*, Paris 1952.

VALLOTTON, FÉLIX. Born December 28, 1865 at Lausanne. 1882 study in Paris. 1890, first wood-cuts. 1891, showed at Indépendants. First contributions to *Revue Blanche*. 1892, showed at first Rose-Croix exhibition. 1893, association with the Nabis. 1903, showed at first Salon d'Automne. 1908, taught at Académie Ranson. 1913, trip to Russia, Italy, Germany. 1921-22, visits to Cagnes. Died December 28, 1925 in Paris.

*Publications:* From 1890, art critic for *Gazette de Lausanne*. — *La Vie meurtrière* (novel), Lausanne 1930. — *Les Soupirs de Cyprien Morus*, Geneva 1944.

*References:* H. Hahnloser-Bühler, *Félix Vallotton et ses amis*, Paris 1936 (basic). — L. Godefroy, *L'Oeuvre gravé de Félix Vallotton*, Lausanne 1932. — F. Jourdain, *Félix Vallotton* (documentation complète), Geneva 1953.

VALTAT, LOUIS. Born August 8, 1869 at Dieppe. From 1893 showed at Indépendants and from 1903 at Salon d'Automne. Associated with first group of Fauves.

*Reference:* Edouard-Joseph, *Dictionnaire biographique des artistes contemporains*, Vol. III, Paris 1934.

VANTONGERLOO, GEORGES. Born November 24, 1886 in Antwerp. Studied in Antwerp and Brussels. 1917, collaborated in Stijl movement as sculptor. Moved away from representational subjects, established spatial relations by geometrical means. 1927, settled in Paris. 1931, vice-president of Abstraction-Création. Also active as an architect.

*Publication: L'Art et son avenir.* Antwerp 1934.

*Reference: Georges Vantongerloo, Paintings, Sculptures, Reflections*, with introduction by M. Bill, New York 1948.

VASARÉLY, VICTOR DE. Born April 9, 1908 at Pecs, Hungary. Studied in Budapest. Influence of Bauhaus. 1930, moved to Paris. Commercial art, advertising, and decoration. Since 1944 has painted independently in concrete style. Belongs to group round Galerie Denise René.

*References:* J. Dewasne, *Vasarély*, Paris. Collection Artistes de ce temps. — Guy Habasque, *Quadrum* III, pp. 63-78.

VEDOVA, EMILIO. Born August 9, 1919 in Venice. Studied in Rome. Member of Corrente. By way of Cubism and Expressionism developed an explosive kind of abstract painting, still strongly tinged with Futurism. Since 1953, influence of Wols and approach to Tachisme. Has been living in Venice since 1945.

*Publication: Blätter aus dem Tagebuch.* Introd. Werner Haftmann, München 1960.

*Reference:* L. Venturi, *Pittori Italiani d'oggi*, Rome 1958, p. 146 ff.

VELDE, HENRI VAN DE. Born April 3, 1863 in Antwerp. Started out as a Neo-Impressionist painter. 1892, began to design furniture and interiors. Wrote extensively in favour of the new ideas. 1901, teaching appointment at Weimar. 1902-14 founded and directed Seminar of Applied Art in Weimar. 1915-20, Switzerland and Brussels. 1926, founded School of Applied Art in Ghent and became professor of history of architecture at University of Ghent. After Second World War, moved to Switzerland. Died October 25, 1957 in Zurich.

*Publications: Kunstgewerbliche Laienpredigten*, Leipzig 1902. — *Zum Neuen Stil*, Munich 1955 (w. bibliography of publications). C. Rességuier *Die Schriften Henry van de Veldes*, New York 1955.

*References:* K. E. Osthaus, *Van de Veldes Leben und Schaffen*, 1920. — *Hommage au maître architecte Henri van de Velde à l'occasion de son 70e anniversaire*, Brussels 1933.

VENARD, CLAUDE. Born 1913 in Paris. Studied at Paris School of Applied Art and in restoration section of the Louvre. Member of Neo-Realist group round Buffet.

416

VERKADE, WILLIBRORD. Born September 18, 1868 at Zaandam, Holland. Studied in Amsterdam. 1891, visit to Paris where he met Gauguin and his circle, and the Symbolists. Joined Nabis. Stay at Pont-Aven and Huelgoat. 1892, entered Catholic Church. Trip to Florence where he became a member of the 'Third Order'. 1893, visit to Beuron monastery. 1897, novice at Beuron. 1898, took monastic vows. 1903-04, Monte Cassino. Visited by Denis, Sérusier, and Bernard. 1906, murals in church at Aichhalden (Black Forest). Studies in Munich. 1907, Paris. 1909 and 1912, visits to Palestine. From 1915, busy on his memoirs. Died 1946 at Beuron monastery.

*Publications: Die Unruhe zu Gott, Erinnerungen eines Malermönches*, Freiburg 1920. — *Der Antrieb ins Vollkommene*, Freiburg 1937. — *Spuren des Daseins*, Mainz 1938.

VIEIRA DA SILVA, MARIE-HÉLÈNE. Born June 18, 1908 in Lisbon. Studied sculpture under Bourdelle and Despiau. Pupil of Dufresne, Friesz and Léger. Lives in Paris.

*References:* M. H. Guéguen, 'Vieira da Silva' in *XXe Siècle*, Paris, June 1956. — René de Solier, *Vieira da Silva*, Musée de Poche, Paris.

VILLON, JACQUES (GASTON DUCHAMP). Born July 31, 1875 at Damville (Eure). 1894, Paris, studied at Atelier Cormon. 1911, association with Cubism. 1911-12, member of Section d'Or. 1914-19, served in Army. 1919, first abstract period. 1920, chiefly graphic reproductions. 1930, return to painting. 1931-33, second abstract period. 1935, trip to U.S.A. 1939, showed at first Salon des Réalités Nouvelles. 1950, Carnegie Award. Lives in Paris.

*References:* P. Eluard *Jacques Villon*, Paris 1948.— J. Auberty and Charles Perusseaux, *Catalogue de l'œuvre gravé*, Paris 1950. — W. S. Liebermann, *Jacques Villon, His Graphic Art*, Mus. of Mod. Art, New York 1953.

VIVIN, LOUIS. Born July 27, 1861 at Hadol (Vosges.). Non-professional painter. 1879-1922 postal clerk. 1889, moved to Paris. After being pensioned devoted himself entirely to painting. Died 1936 in Paris.

*References:* W. Uhde, *Fünf Primitive Meister*, Zurich 1947. — C. Estienne, 'Vivin,' in *Graphis*, Vol. 9, 1953, pp. 480-85.

VLAMINCK, MAURICE DE. Born April 4, 1876 in Paris. Racing cyclist. Taught himself to draw and paint. 1896 military service. 1900, earned his living as musician. Meeting with Derain. Shared studio with him at Chatou near Paris. 1901, deeply impressed by Van Gogh exhibition at Bernheim Gallery. Met Matisse. 1905, with Picasso and Apollinaire. Showed at famous Fauves exhibition at Salon d'Automne. 1908, influence of Cézanne. 1914-18, served in Army. Died October 11, 1958.

*Publications:* c. 1902, several novels: *D'un lit dans l'autre; Tout pour ça; Ame de mannequin — Histoire de mon époque*, Paris 1919; *Tournant dangereux, souvenirs de ma vie*, Paris 1929.

*Reference:* M. Sauvage, *Vlaminck, sa vie et son message*, Geneva 1956.

VOGELER, HEINRICH. Born December 12, 1872 in Bremen. Studied in Düsseldorf. From 1894 at Worpswede. Leading member of Worpswede artists' colony. 1914, Army. 1919, founded Socialist Workers' School at Worpswede. Has been living in Russia since 1925.

*Publications: Dir*, a book of poems, Insel-Verlag, Leipzig. — *Expressionismus der Liebe*, Hanover 1918. — *Erinnerungen*, Berlin 1952.

*Reference:* Heinrich Vogeler, *Werke seiner letzten Jahre*, Deutsche Akademie der Künste 1954.

VORDEMBERGE-GILDEWART. Born November 17, 1899 at Osnabrück. Studied architecture at Hanover Technical School. From 1919, Constructivist painting with the simplest elements. 1919-35, lived in Hanover, took several trips to Paris, Switzerland, Italy. Association with van Doesburg, Lissitsky, and Stijl group. 1925, long stay in Paris. 1936, Berlin. 1937-38, Switzerland, 1938, settled in Amsterdam. 1954, appointed teacher at Hochschule für Gestaltung, Ulm.

*Publications:* Extensive activity as a publicist. Bibliography, see below.

*References: Vordemberge-Gildewart*, Preface by Jean Arp, Amsterdam 1949. — *Vordemberge-Gildewart*, Hochschule für Gestaltung, Ulm 1957.

VUILLARD, EDOUARD. Born November 11, 1868 at Cuiseaux (Saône-et-Loire). 1877, moved to Paris. 1888, Académie Julian. Meeting with Bonnard. 1889 joined Nabi group. 1891, shared studio with Bonnard and Denis. 1893, decorations for Théâtre de l'Oeuvre. 1894, decorative murals for Natanson. 1905, brief stay in Hamburg with Bonnard at invitation of Lichtwark. 1908, teacher at Académie Ranson. 1913, trip to England and Holland with Bonnard. Decorations for Théâtre des Champs-Elysées. 1930, trip to Spain. 1937, decorations for Palais de Chaillot. 1939, decorations for League of Nations Palace in Geneva. Died June 21, 1940 at La Baule.

*References:* C. Roger-Marx, *Edouard Vuillard*, Paris 1945. — C. Roger-Marx, *L'œuvre gravé de Vuillard*, Monte Carlo 1948. — A. C. V. Ritchie, *Edouard Vuillard*, New York 1954.

WADSWORTH, EDWARD. Born October 29, 1889 at Cleckheaton, Yorkshire. Studied from 1908 to 1912 at Slade School and in Munich. 1913, influence of Cubism and Futurism. 1914-15 member of Vorticist Group. Translated Kandinsky for *BLAST*. 1914-17, served in war. 1920, member of 'Group X'. Travels in Italy and France. Visits to Paris. 1933, member of 'Unit 1'. 1943, associate of Royal Academy. Died 1949.

*Publications: The Black Country*, 1920. — *Sailing Ships and Barges of the Western Mediterranean and the Adriatic Seas*, 1926.

*Reference: Edward Wadsworth*, Ed. Sélection, Antwerp 1933.

WALKOWITZ, ABRAHAM. Born March 28, 1880 at Tumen, Siberia. Came to U.S.A. as a child. 1906, studied at National Academy of Design in New York. 1906-07, Paris, studied at Académie Julian. 1912-17, exhibition regularly at '291'. 1913, represented in Armory Show. 1914, trip to Europe. 1918-20, Vice-President of Society of Independent Artists. From 1920, exhibited with Société Anonyme, whose president he became in 1934.

*Publications: Faces of the Ghetto*, New York 1900 *and 1916; A Demonstration of Objective, Abstract and Non-Objective Art*, Girard, Kansas 1945.

*References:* B. Kopman, *Abraham Walkowitz*, Paris 1925; Brooklyn Institute of Art, *100 Artists and Walkowitz*, 1944.

WAROQUIER, HENRI DE. Born January 8, 1881 in Paris. Selftaught. At first influenced by Seurat, after 1918 by Cézanne. Beginning 1912, annual trips to Italy. From 1906, showed at Indépendants and Salon d'Automne.

*References:* P. Laprade, *Henri de Waroquier*, Paris 1927. — J. Auberty; Henri de Waroquier, *Catalogue de son œuvre gravé*, Paris 1951.

WEBER, MAX. Born 1881 in Byalystok, Russia. 1891, emigrated to U.S.A. and settled in Brooklyn. 1898-1900, studied at Pratt Institute in Brooklyn. 1900-05, taught drawing at public schools. 1905, moved to France, studied at Académie Julian. Trips to Spain, Italy, Belgium, Holland. 1906, met Henri Rousseau, Matisse, Picasso, Delaunay. 1907, represented at Salon d'Automne. 1907-08, studied with Matisse. 1908, return to New York. From 1910 belonged to '291' circle. 1924, one-man show at Bernheim-Jeune gallery. 1930, Retrospective at Museum of Modern Art, New York. 1949, Retrospective at Whitney Museum, New York.

*Publications: Cubist Poems*, London 1914; *Essays on Art*, New York 1916; *Primitives*, New York 1926; *Max Weber*, 1945 (53 reproductions with commentaries by the artist).

*References:* H. Cahill, *Max Weber*, Ed. Downtown Gallery, New York 1930; L. Goodrich, *Max Weber*, Whitney Museum, New York 1949.

WEREFKIN, MARIANNE VON. Born 1870 at Tula near Moscow. Studied with Ryepin in St. Petersburg along with Jawlensky. Both moved to Munich in 1896. Member of Neue Künstler-Vereinigung. 1914, moved to Switzerland. Died in 1938 at Ascona.

*Reference:* J. Roh 'Marianne v. Werefkin,' in *Die Kunst und das schöne Heim*, Vol. 57, 1959 Nr. 12, pp. 452-455.

WERNER, THEODOR. Born February 14, 1886 at Jettenburg (Württemberg). 1908-09, Stuttgart Academy. 1909-14, travelled and studied abroad. 1919-29, Grossachsenheim near Stuttgart. 1930-35, Paris. From 1932, association with Abstraction-Création. 1935-45, Potsdam. Since 1946 in Berlin. In 1947, exhibition at Galerie Rosen in Berlin made him known in Germany. Lives in Munich.

*Publication:* 'Aphorismen' in *Ausstellungskatalog der Galerien Franke und Möller*, Munich and Cologne 1951/52.

*References:* See above-mentioned catalogue. — *Cahiers d'Art* 24 (1949), p. 148; 25 (1950).

WHISTLER, JAMES. Born Juli 10, 1834 at Lowell, Mass. Studied at West Point. Studied art in Paris. Friendship with Fantin-Latour. Met Courbet. Influence of Manet for a time. 1859, moved to London. 1884, moved back to Paris where he opened a school. Returned to London in 1896. Died July 17, 1903 at Chelsea.

*Reference:* See Thieme-Becker.

WINTER, FRITZ. Born September 22, 1905 at Altenbögge (Westphalia). Trained as electrician. Worked as miner. 1927-30, Bauhaus. Studied with Klee, Kandinsky, Schlemmer. 1930-33, Berlin. Meeting with Gabo. From 1933 in Munich circle. 1939-45, fought in war and prisoner of war until 1949. Lives at Diessen (Upper Bavaria). 1955, appointed teacher at Werkakademie Kassel.

*Reference:* W. Haftmann, *Fritz Winter*, Berne 1951. W. Haftmann, *Fritz Winter, Triebkräfte der Erde*, Munich 1957.

WOLS, WOLFGANG SCHULZE. Born May 27, 1913 in Berlin. After training as violinist, brief study at Bauhaus in Berlin under Mies van der Rohe and Moholy-Nagy. 1932, moved to Paris, association with Surrealists. Worked as photographer. Long stay in Spain. 1939-40, interned. Then moved to southern France. Painting became his chief activity. 1945, moved back to Paris and held first show at Galerie Drouin. Dry point illustrations of Sartre, Kafka, Paulhan, etc. Died September 1, 1951 in Paris.

*References:* Catalogue of Exhibition at Gal. Claude Bernard. Paris 1958. — Gillo Dorfles, *Wols*, Milan 1958.

WOOD, GRANT. Born in 1891 in Iowa, where he spent his whole life. 1928, trip to Munich, where he studied Flemish and German painting of the fifteenth and sixteenth centuries. Chief representative of Middle Western regionalism. Died in 1942 in Iowa.

*Reference:* D. Garwood, *Artist in Iowa. A life of Grant Wood*, New York 1944.

WYNTER, BRYAN. Born September 8, 1915, in London. 1938-40, studied at Slade School. Since 1947, regular exhibitions in London. 1949-56, taught at Bath Academy. 1956, influence of American painting (Tobey, Tomlin). Lives at Zennor, Cornwall.

*Publication:* 'Statement' in Exh. Cat. of ICA Gallery, London, January 16 to February 23, 1957.

*Reference:* A. Bowness, 'The paintings of Bryan Wynter' in *Art News and Review*, March 1959.

ZIGAINA, GIUSEPPE. Born April 2, 1924 at Cerrignano (Friuli). Expressive Realism, influenced by Guttuso. Lives at Villa Vicentina (Udine).

*Reference:* Renata Usiglio, *Zigaina*, Milan 1954.

# List of Illustrations appearing in Volume One